The Art of
East Asia

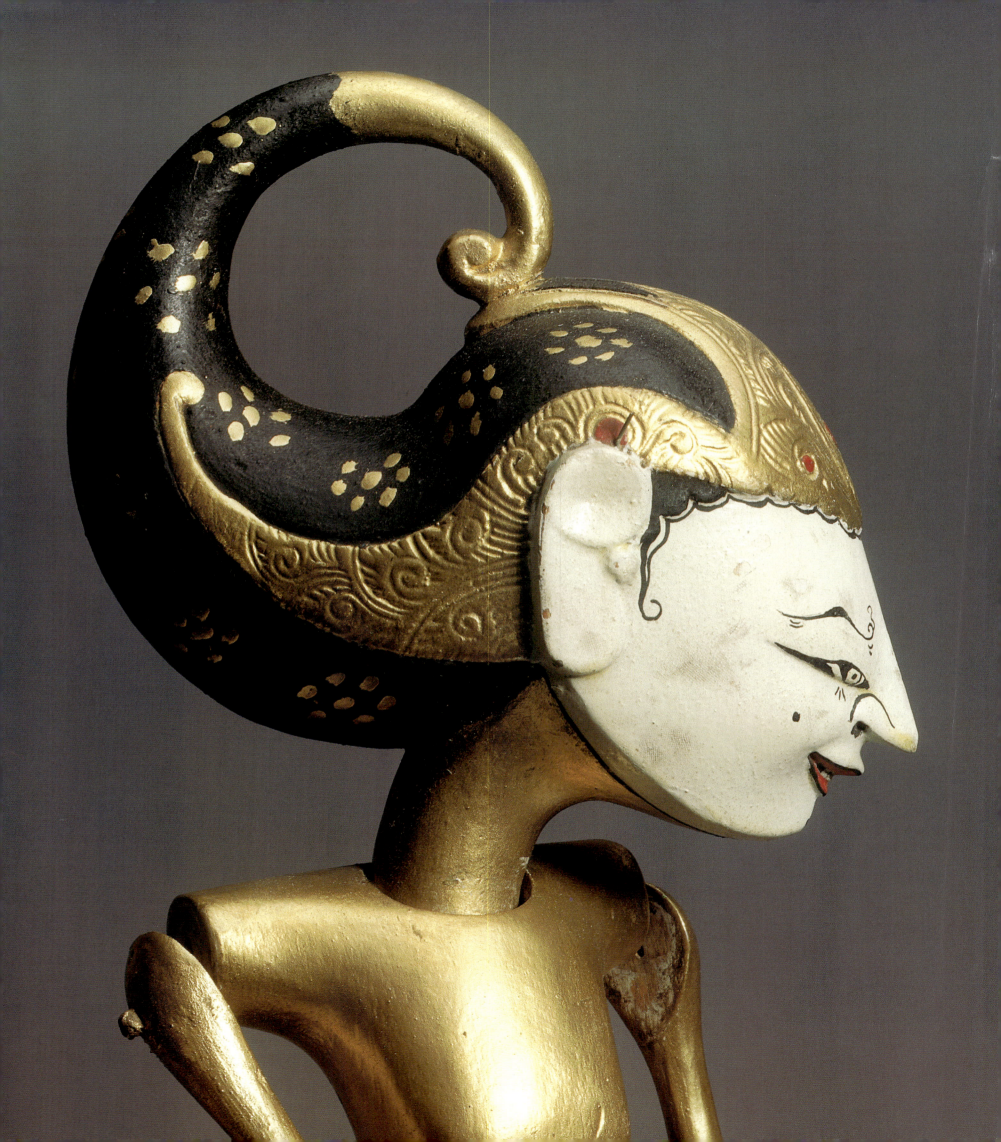

Gabriele Fahr-Becker

(Editor)

The Art of East Asia

Volume 1

Contributing authors are
Sabine Hesemann
Michael Dunn
Sri Kuhnt-Saptodewo

KÖNEMANN

Notes: where dimensions of objects are given in captions, the order is:
height x width, or height x width x depth.

If the location of the objects shown is not given, they are in private
ownership or unidentified collections.

Transcription of Southeast Asian names and terms follows largely the
customary English-language transcription, without diacritical signs except for
the unavoidable length marks. In the chapter on Thailand, the transcription
follows largely that current in Thai.

Endpapers: design based on a traditional Japanese pattern.

Frontispiece, Vol. 1: *Ksatriya* figure, *wayang golek*, pre-1925, Staatliches
Museum für Völkerkunde, Munich

Frontispiece, Vol. 2: Statue of Buddha, Kyauktawgyi pagoda, completed 1878,
Mandalay, Burma

Ills. pp. 4(5, Vol. 2: Obaku Kōsen (1633–1695), *Hotei's bag and stick,*
Collection of J. E. V. M. Kingadō

© 1998 Könemann Verlagsgesellschaft mbH
Bonner Str. 126, D–50968 Cologne

Art direction and design: Peter Feierabend
Project coordinator of the German: Birgit Dunker
Layout: Sabine Vonderstein and Bernd Elfeld (Chapter on *China*)
Picture research: Barbara Linz
Production Manager: Detlev Schaper
Production: Mark Voges
Reproduction: CDN Pressing, Verona

© 1999 for the English edition:
The author Michael Dunn wrote his text in English
Translation from German for the rest of the text: Paul Aston,
Peter Barton, Anthea Bell, Sandra Harper, Christine Shuttleworth
Editor of the English edition: Chris Murray
Project coordinators: Jackie Dobbyne and Bettina Kaufmann
Typesetting: Goodfellow and Egan, Cambridge
Printing and binding: Neue Stalling, Oldenburg

Printed in Germany
ISBN: 3-8290-1745-6

10 9 8 7 6 5 4 3 2 1

Foreword

It is undoubtedly an immense undertaking to portray the arts of East and Southeast Asia within the compass of a single publication; yet the task is also rewarding and hugely enjoyable. The result will, we hope, offer the reader an account that is both fascinating and visually stunning. One of the most fascinating aspects of the subject is the fact that the cultures we will look at display an incredible variety, and yet also share important features. Religions – ranging from the most diverse forms of Buddhism to the Confucianism of China and Zen Buddhism of Japan – play a linking role, most notably in the images of the Buddha, the Enlightened One, and the divinities and spirits that accompany him. Other links were established by migrating populations and by political relationships, and also by the shared conditions of flora and agriculture: rice, for example, is grown as the staple foodstuff in all the countries of East and Southeast Asia. Clearly distinct from India – whose influence is nevertheless marked in many ways – East Asia possesses an art and a culture that form a unique, often conflicting, and yet richly interconnected totality.

East Asia (China, Japan, and Korea) and Southeast Asia (Cambodia, Burma, Laos, and Vietnam) are presented, not with the intention of setting down a definitive, comprehensive account, but with the aim of presenting many of their most outstanding and individual masterpieces. China, whose culture begins with works of art dating back to prehistory and is marked by the often dramatic rise and fall of successive dynasties; Japan, whose traditional art inspired the modern art of Europe and still acts as a source of ideas for Western design; Korea, with its exquisite ceramics; and finally Southeast Asia – Burma and Cambodia, with the most extraordinary religious shrines in the world, at Pagan and Angkor; Thailand and Laos with their elegant, sumptuously decorated and almost fragile temple buildings; Vietnam, with the imperial city of Hué; and the vast island realm of Indonesia, which stretches from the Indian Ocean to the Pacific, and which, as early finds bear out, once asserted cultural sway over many areas of mainland Southeast Asia. To their joint benefit, all the arts of these lands share a common heritage.

Three separate sections are devoted to arts preeminently East Asian: calligraphy, jade work, and the textiles art of Southeast Asia, all of which stamp the aesthetic profile of East Asia in equal measure.

Because of the richness and variety of the material, the volumes are organized in a deliberately heterogeneous manner. In this way, both the diversity and the shared features of East Asian art, as so expertly depicted by the contributors, will become more readily apparent. Adapting individual styles and approaches, the authors provide a range of scholarly yet highly readable texts, supported by hundreds of superb pictures, that will open the door to these supposedly so distant and yet so accessible cultures... cultures that are, in the words of the United Nations, an integral part of the "cultural heritage of mankind."

Gabriele Fahr-Becker

Volume 1

[*] Co-author: Detlef Kuhnt
[**] Co-author of the section on modern choreography: Maria Darmaningsih

Volume 2

* Co-author of the captions: Maria-Theresia von Finck

CHINA

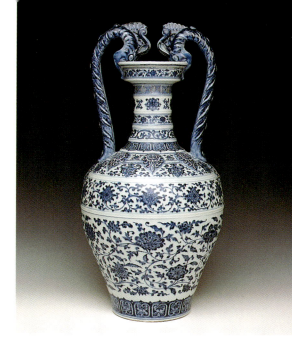

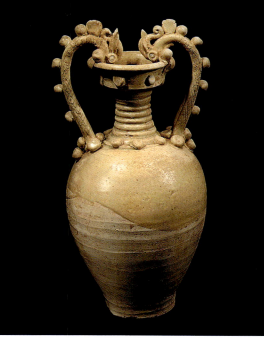

A First Look at China

"One only admires what one has first learnt to see."[1]

For centuries Chinese works of art have captivated the West; their first appearances in commerce were rare, though in time they were to become ever more sought after and traded. But the cabinets of curiosities and porcelain collections of European courts housed practical items from Imperial China and much that was thought exotic; collectors seldom took any interest in the art that was most revered in China: painting. Even at the end of the 19th century, the collectors responsible for establishing the largest collections of Chinese art were still more interested in arts and crafts; in 1873 the celebrated French collector Henri Cernuschi brought back "des potiches de bois sculpté, des laques, des céramiques, des bronzes, des ivoires"[2] (carved wooden vases, lacquer work, ceramics, bronzes, and ivories).

Chinese painting, by contrast, constantly encountered prejudice in the West, beginning with the missionaries of the 16th century who, from a Eurocentric perspective, frequently elevated themselves to the statues of arbiters of Chinese art and culture. Chinese painting was poorly regarded because of its "lack of perspective" and was usually completely misunderstood.

It is quite remarkable that the high arts of calligraphy and painting were generally practiced by artists who had been groomed for a career at court or had been educated as officials, and who were therefore members of the elite. From the point of view of European art history, this gives rise to a curious state of affairs: for in China both the producers and consumers of art (the collectors) belonged to one and the same social class, and so they could fulfill both roles at the same time; moreover, they were amateurs, not professionals. Their pictures were not for sale; instead, they formed part of an elaborate social ritual of giving and receiving. Often, painters like Xie He (6th century A.D.) were art critics as well as leading artists, something not confined to this era alone. There were also, however, painters whose relationship to their clients was no different from that between European artists of the Baroque and the princes, clerics, or merchants who commissioned works from them. The names of these individuals, however, are rather better known than their works.

Quite apart from the "strangeness" of Chinese art, the Western viewer also has to come to terms with a completely different concept of tradition. Forms which had proved their usefulness, or which were thought by the art community to have attained a state of perfection, were copied over the centuries and passed on to successive generations – as can be clearly seen in ceramics, furniture, and painting. For the Westerner, this seems like plagiarism or even forgery. The Chinese painter would counter by saying that he had named his source and perhaps slightly modified it; or that he was in effect expressing his respect for an artistic predecessor; or that his work, which imitated the composition and brushwork of another, was but a study. Trained painters were attentive pupils of past works. They either quoted their forerunners in full (as if quoting a poem), or in part, whether in the depiction of individual objects or the use of a single technical nuance (as if quoting just a few lines of a poem).

Nevertheless, a loyalty to tradition did not prevent new paths from being opened up in art; moreover, it is extremely important when considering Chinese painting to remember that the practice of copying helped to preserve works and styles from the distant past.

There were, however, also "genuine" forgeries: paintings, calligraphy, and art objects intended to fool the collector and so enrich the forger. Forgers found a ready market in art collecting, which in China dates back to the Tang dynasty.

In China calligraphy is at least as highly regarded as painting, if not more so. It is difficult,

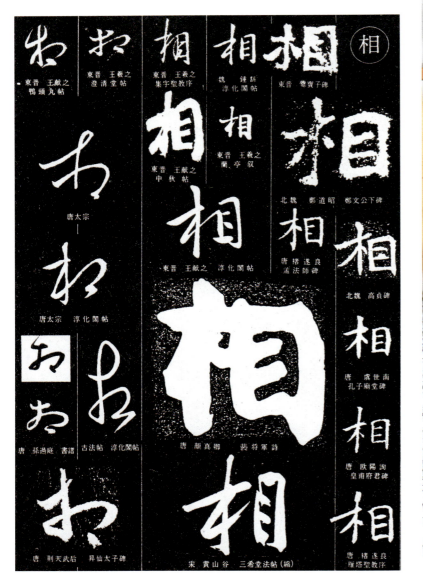

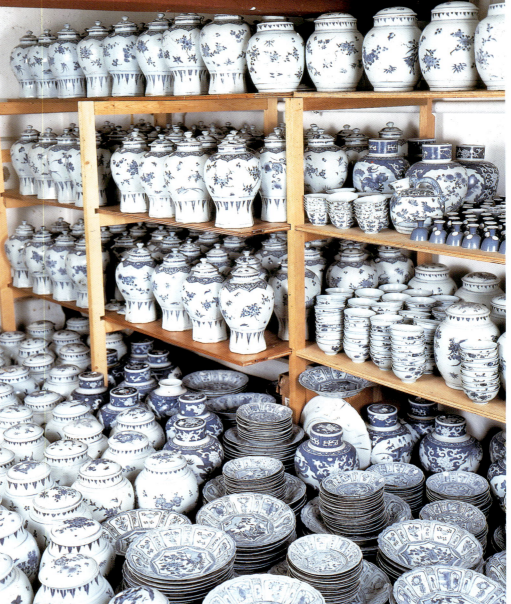

if not impossible, to convey the art of writing and its aesthetic, where no previous knowledge of Chinese characters exists, and this explains why with the exception of specialist literature Chinese calligraphy has been almost totally ignored by the West. It will scarcely be possible to provide a survey of all the facets of this art form, though we will look at several examples.

By contrast, the applied arts were, and indeed still are, the focus of keen Western interest. Until Friedrich Böttger reinvented the process in the first years of the 18th century, porcelain was a real treasure that European technology was not able to reproduce, and so was sought avidly.

In spite of all the admiration shown for these art objects, much remained hidden from the Western view: the cultural and historical background of motifs and decorative devices; their frequent literary origins; their ritual, religious, and philosophical context; and the way in which they enriched the lives of the Chinese themselves.

Chinese architecture was known from travel accounts which appeared in Europe from the 16th century, although their illustrations appear somewhat absurd compared with the originals. Its striking difference from European architecture led to its appearance as "whimsies" in English-style landscaped gardens. These copies clearly delighted in taking artistic license and therefore varied in their faithfulness to the Chinese original. But one of the most important characteristics of Chinese architecture could not so easily be transplanted: the techniques of constructing in wood. In terms of research into Chinese architecture, this fact creates what might seem a virtually insuperable obstacle: wooden architecture decays and the oldest preserved structure dates from the 9th century A.D. But this problem is in great measure solved because of the Chinese habit of adhering to tradition: even architectural forms have been preserved for thousands of years through repetition, and some forms can now be reconstructed using archaeological finds (including small clay models of buildings).

But Chinese artistic traditions do not begin with painting or porcelain; they begin 5,000–6,000 years ago with elaborate pottery, small sculptures, and ritual bronzes. As is the case with other cultures, new material is regularly being unearthed so that our ideas about early Chinese art forms are constantly changing.

Apart from neolithic artifacts (which speak for themselves), the treasures and tomb furnishings of the second and first millennia B.C., and art preserved from later eras, Chinese literature makes some of the most important contributions to our understanding of Chinese art. Chinese manuscripts either fill gaps in our present knowledge or provide clues as to the state of art during a particular epoch. And in order that we learn to see art in the way the Chinese themselves saw it (and still see it) writers who have expressed their opinions on art should also have their say. In addition to the inventories of collections and evaluations of antiquities, written documents are literary texts which convey a keen engagement with painting and calligraphy. It was writers who first made a clear distinction between "high art" on one hand, and "the rest" on the other.

The first chapter is intended as an overview of the art of China, the country with the longest uninterrupted cultural history in the world and should serve as a key to an understanding of Chinese art. The extent of the material may mean that one or other aspect can only be touched upon; the predominant art forms of each epoch, however, will be discussed.

Clearly defined, chronological notions of style as they are used in Western art are alien to China. For this reason, the ordering and development of Chinese art are closely linked to dynastic history. Therefore, Chinese art history begins with the neolithic era, with the art of stone and ceramics.

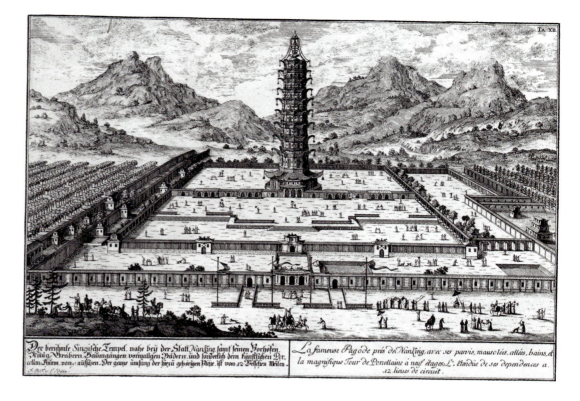

Above
Porcelain pagoda in Nanjing

Johann Bernhard Fischer von Erlach nach Nieuhof, architectural engraving, 18th century

Below, left to right
Pagoda of the Jiming monastery

Nanjing, renovated 1990

Great Pagoda

Sir William Chambers, Kew Gardens, London, built 1761

Chinese Tower

Englischer Garten, Munich, built 1789, reconstructed 1951/1952 after fire 1944

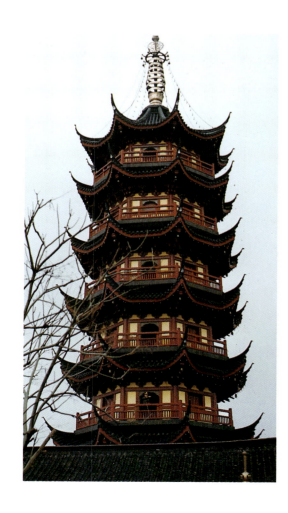

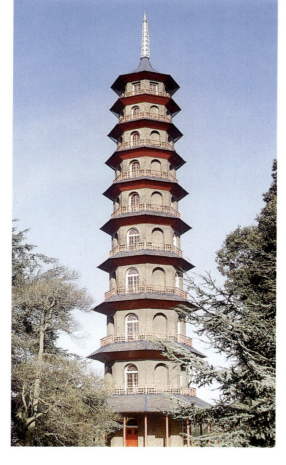

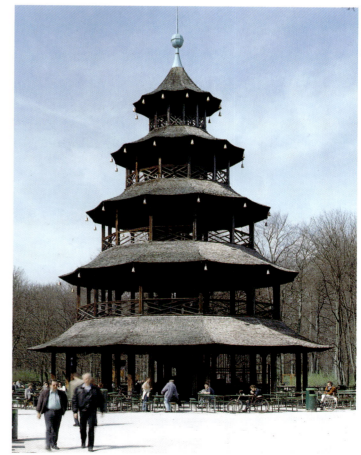

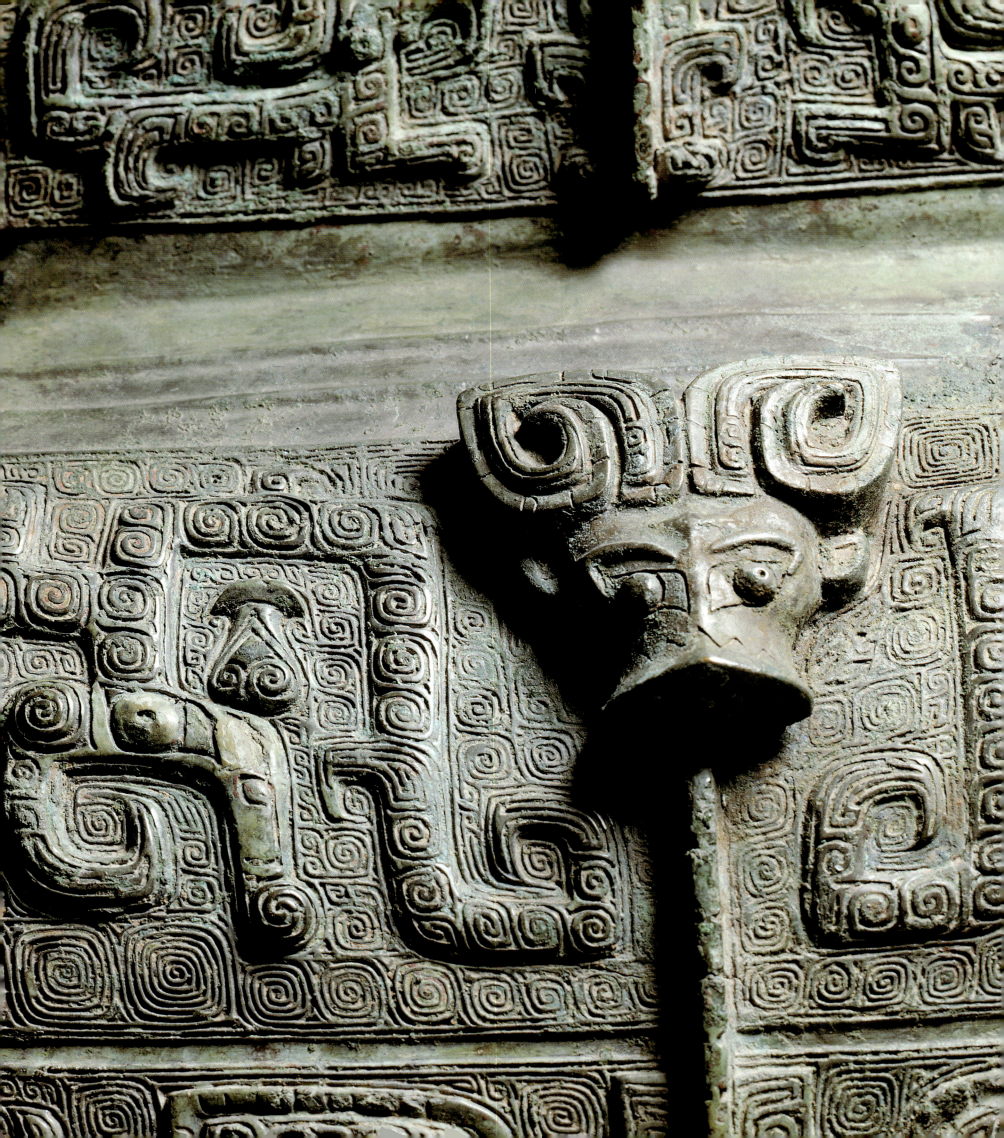

Watched Over by Gods and Ancestors

The art of early societies developed mainly through the shaping and embellishing of objects that had an important place in the life of the community. In China, early art traditions flourished as part of the cults of gods and ancestors, with exquisite works in jade, ceramic, and metal being produced. The high point of Chinese culture became the ritual bronzes, decorated in relief, which dominated art for more than 1,000 years.

Bronze *fanglei* vessel

(Detail), Staatliches Museum für Völkerkunde, Munich

People of the 2nd and 1st millennium B.C. made offerings of food and drink to their gods and ancestors in elaborately ornamented bronze vessels.

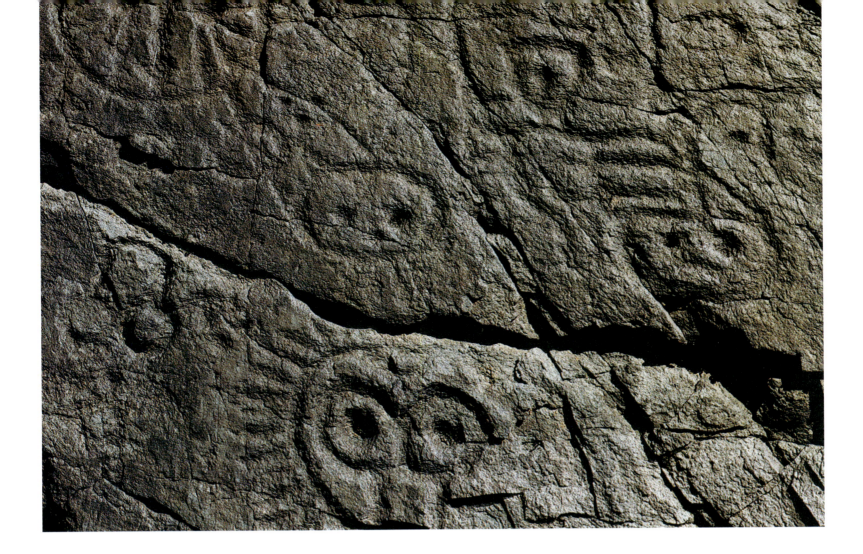

The Neolithic Era: Art in Stone and Ceramics

Two masks

Rock carvings in the Yin Mountains

Within the space of four decades, the image we have formed of stone age man has changed dramatically; and many recent finds, like those of the cave paintings in southwestern Europe, are modifying it still further. In modern China, too, archaeological finds are giving rise to a more coherent picture of neolithic cultures and their chronological and geographical connections.

Until a few years ago it was thought that there were only two great cultural groups in early China: the earlier Yangshao culture (about 4000–2500 B.C.), whose range was from Gansu, through Shaanxi and Henan to Hubei; and the Longshan culture (about 2500–1800 B.C.), from what is today Shandong and northern Jiangsu. This simple scheme, however, has since had to be abandoned.

Complex and very different cultures have been discovered. They were not only distributed throughout the areas traditionally described as being the cradle of Chinese culture, but also beyond them on all sides. The finds have also necessitated a revision of the dates ascribed to other, previously known periods.

The cultures are today named after the locations of their most important finds. To simplify matters, we can speak of two areas into which the majority of these local cultures can be divided: the inland cultures, and the cultures of the east coast. The table at the left shows an overview of our present state of knowledge on the dates and places of the individual cultures and their various subgroups. These subgroupings are often called types. The table could be expanded to include finds from the east of the present Autonomous Region of Inner Mongolia and the Liaoning

Chronology of Neolithic China (ordered by provinces)						
B.C. / Gansu	Shaanxi	Henan	Hubei Shandong	N. Jiangsu/ Zhejiang	S. Jiangsu/ Taiwan	Fujian
5500	Shianmiaogu Peiligang Proto-Yangshao (6500–5500)					Quemoy (ca. 5300–4200)
5000				Qinglian'gang	Hemudu 4	
4500	Banpo (4865–4290)	Houkang (4135)		Liulin (ca. 4000)	Majiabang (4700–4000)	Dapenkeng (ca. 4300)
4000 Yangshao				East Coast cultures		
	Yangshao	Miaodigou I (3900)	Yangshao	(North)	(South)	
3500		Dahecun (3800–3070) Yangshao-Longshan- Transitional phase		Huating	Songze (4000–3000)	
3000 Majiayao (3100–2600)				Dawenkou		
		Miaodigou II (2780)	Qujialing		Liangzhu (3300–2300)	
2500 Banshan (2400)	Longshan					
	"Shaanxi-Longshan"	"Henan-Longshan"	"Henan-Longshan"	"Classic" Longshan (ca. 2400–1900)		Fengbitou
2000 Machang (2300–2100) Qijia (2150–1780)	Erlitou (2035) Xia? Bronze age				Liangzhu	
1750					Hushu Late geometric culture of the East Coast	
	Shang		Shang			

Province, whose earliest artifacts date from the 6th millennium B.C.

The cultural legacy of Chinese art works in stone and ceramics is extremely diverse. Ceramics have been found in the form of vessels as well as tools, architectural components, and small statues. A few cultures had discovered how to work jade so that attractively formed jade shapes and sculptures have been found. Before people decorated their vessels and tools, however, their ancestors (the early hunter-gatherers) left behind rock drawings that are valuable cultural and art historical objects.

In China, too, the people of the Stone Age gave free rein to their artistic impulses on rock walls. The rock drawings so far discovered reach back to the time of the hunter gatherers but are not as old, for example, as the cave paintings of Magdalénien (16,000–12,000 B.C.) in Europe. The purpose of these pictures may have lain in their much debated magical powers. Today it is claimed that hunter gatherers depicted an animal in order to catch it (a form of artistic magic) or because they had already caught it. There is also a theory that the pictures served as a kind of inventory, for other members of the tribe who may have been passing through, of the animals available in the region.

Geographically, rock drawings are known from the periphery of modern China: they have mainly been found in Yunnan, Guangxi, in the Ordos region, and also in the Autonomous Region of Inner Mongolia.

The depictions have been scratched into the rock as well as painted on with mineral pigments, and have been executed on sheer rock walls in the open; cave paintings have not as yet been discovered. Because rock pictures were also made much later, at a time when writing had already been established in the central Chinese regions, and peoples who did not possess the skill of writing inhabited just those areas where the pictures have been found, the dating of Neolithic rock pictures (already a difficult task) is all the more complicated. The dating process utilizes a number of factors: stylistic comparisons, motifs of animals whose extinction in the region can be dated, precise examinations of weathering and scientific methods such as the analysis of the carbon isotope C14. The rock pictures of the north are older than those of the south. Depictions of elephant species in Qilianshan (Gansu) and of ostriches in the Yinshan mountains (Inner Mongolia) can be dated at around 8000 B.C., as these animals were already extinct by then.

Besides individual portrayals of animals, the canon of motifs includes whole hunting scenes, masks, hand and hoof prints, prints of beakers, and abstract motifs such as zigzag lines, circles, and spirals. In this respect, Chinese rock drawings differ little from those found in other parts of the world.

The animals were generally portrayed realistically or in a manner close to nature; any variations from this style were caused by the picture surface (rock walls) or the technique employed (scratching or painting).

In recognition of the work of Chen Zhaofu, Emmanuel Anati[1] of the Centro Camuno di Studi Preistorici, Val Camonica, in Italy, has made it clear that the chronological sequence of Chinese rock pictures based on stylistic characteristics can only be provisional. Nevertheless, a distinction can be made between the following epochs: rock pictures with large animal figures of the epipaleolithic hunters (10000–6000 B.C.); modern hunters

Below
Mask-face

Carved depiction found at Lianyungang, Jiangsu, around 3,000 B.C.

The date is supported by the proximity of paleolithic and neolithic finds.

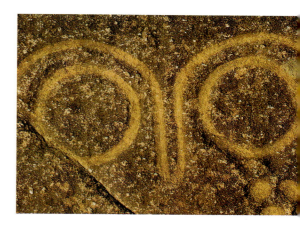

Below right
Scene with dancing (?) people

Red pigment, found at Huashan, second phase, 1200–200 B.C.

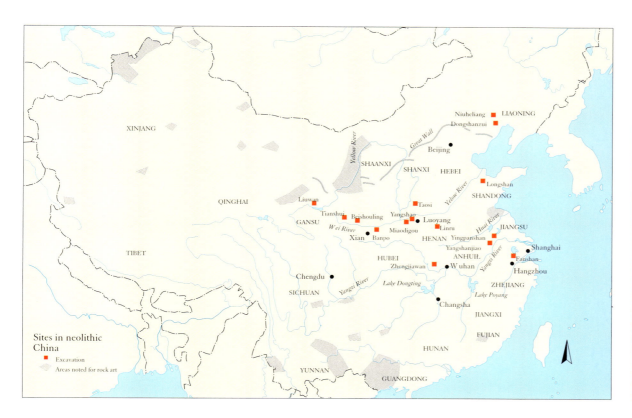

Sites in neolithic China
■ Excavation
▲ Areas noted for rock art

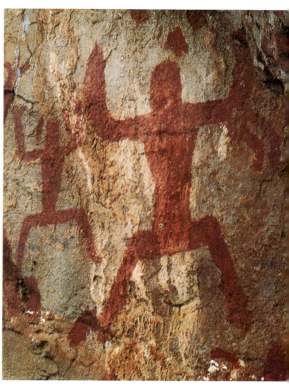

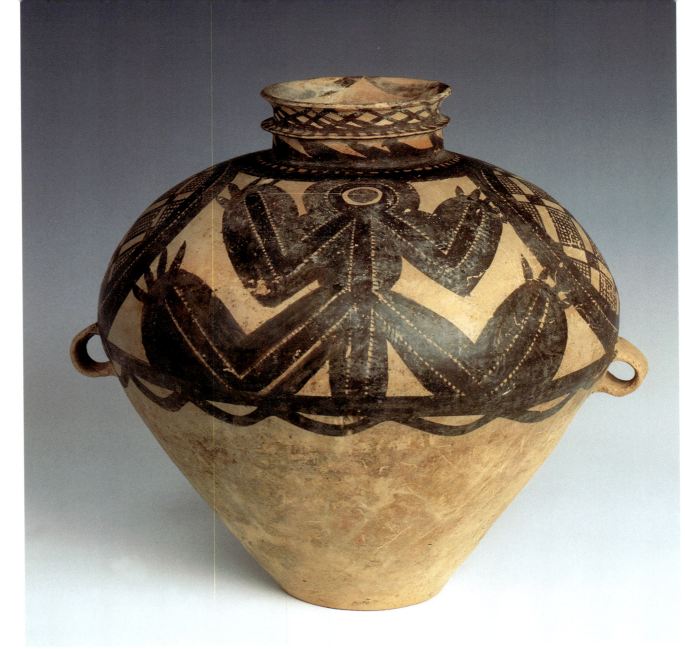

Large *guan* vessel

Machang phase, Yangshao culture, end of the 3rd millennium B.C., zoomorphic patterns, terracotta, painted after firing, H 44.2 cm, dia 47 cm, Linden Museum, Stuttgart

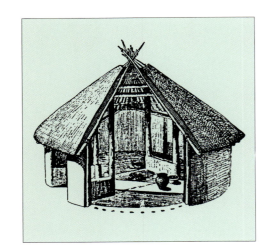

Reconstruction of a round house

5th millennium B.C., Banpo

(8000–4000 B.C.); shepherds and cowherds (3500–2000 B.C.) with their depictions of domesticated animals and cultic rites. These stylistic epochs were extended in two further phases, between 1200–200 B.C. and A.D. 900–1600, especially in areas inhabited by non-Han ethnic groups (see page 17, bottom right).

Another group is formed by the depictions of masks which may have been made between 5500 and 3500 B.C. (see page 17, top right).

An examination of these sequences, further complemented by local styles (some of which still exist today), serves to highlight the difficulty in determining dates for the period of production.

The artistic skills of neolithic peoples are more easily and more precisely dated from the forms and decorative patterns of their ceramics. Neolithic potters were the artists of their age. Within the sedentary tribal community they took up the lively use of line, which had already begun to manifest itself in the rock drawings, and developed it still further. Curved vessels were produced whose forms can be described today as timelessly elegant.

Very different types of vessels and decorative patterns were developed by cultures separated in both time and space, and some of the uses to which these items were put have been reconstructed. The nature of their similarities has yet to be convincingly explained. While contacts between various groups cannot be ruled out, such contacts are often only hypothetical. The following section does not provide a survey of all neolithic cultures, but concentrates instead on certain interesting groups. The chronological series is not intended as a history of developments.

Yangshao culture:
the transition to agriculture

Excavations in the village of Banpo, near modern Xi'an, have uncovered a neolithic settlement from the 5th millennium B.C. This village had been inhabited for several centuries by a group of people who dwelt along the river. The find (the most significant to date) revealed a settlement composed mainly of round houses whose walls were half covered in earth. The dwellings were

between 12 and 40 square meters (129 and 431 square feet) in area, but there was a building of 160 square meters (1,722 square feet) which, on the basis of its prominent size, has been interpreted as either a communal dwelling or a meeting house. The entrance faced south. Beside it was found a "potters' district" with simple kilns sited east of the residential area, as well as a graveyard for adults separated from the village complex by an enclosure. Most children had been buried in urns.

These clay urns (*wengguan*) had different shapes; clay bowls served as lids. Offerings were rarely found in the funeral urns although precisely the opposite was the case for the adult graves. They were buried with personal and practical items, including jars, jewelry, and tools. These offerings, along with the contents of the rubbish and provision pits, provide us with clear evidence of the painting skills of the potters.

The prehistoric inhabitants of Banpo produced painted ceramics that have earned their culture the name "Painted Pottery" – in contrast to the "Black Pottery" people of the east and southeast, who produced unpainted vessels in unusual shapes.

The red ceramic vessels have black painted designs of animals as well as fish, frogs (toads), stags, and birds, as well as fish with human faces or masks. But the potters also made use of a large number of geometrical patterns such as triangles or border ornamentation.

In contrast to the decorative patterns, the vessels themselves were limited to a small number of different shapes. There were variations on the theme of the bulging pot (*guan*), the bowl (*pen*), and the amphora-like bottle (*ping*). This may have as much to do with their use as containers for provisions as with the manner of their manufacture: the Yangshao ceramics are all built up from long ropes of clay, although the smooth working of the surface conceals this masterfully.

The mask motif was found in slightly different variations on bowls of the *pen* type, on broad-shouldered storage jugs, and on pointed amphorae of the Yangshao culture at three different sites; archaeologists have yet to find them elsewhere. The mask is depicted as a circle with lines for eyes, nose, and mouth (see right). Where the ears should be there are small hooks pointing upwards, which are sometimes continued as stylized fish or are replaced entirely by fish.

On top of the circle (the head) sits a triangle with its apex at the top. Small lines radiate from the triangle. At the level of the mouth, flat triangles protrude from the circle. One look at the mask invites an immediate comparison with a fish.

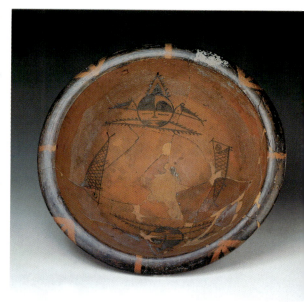

Pen bowl with "mask" motif

Yangshao culture, H 65 cm, dia 39.5 cm, Banpo, Shaanxi Province, Historical Museum, Beijing

Guan vessel

Yangshao culture, 3rd millennium B.C., H 18.6 cm, dia 24.9cm, Linden Museum, Stuttgart

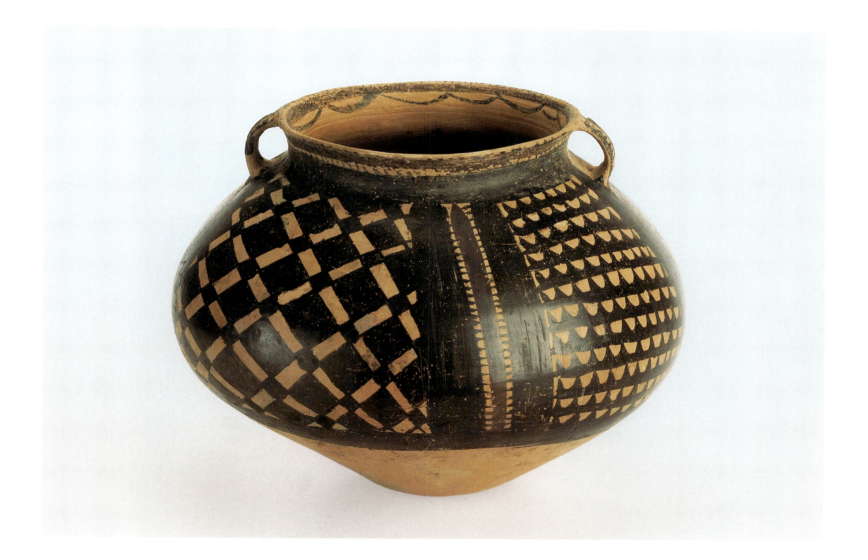

Mosaic of a dragon and a tiger, tomb M45, Yangshao culture, L about 170 cm, sketch of the grave layout (after Brinker)

In Chinese mythology, the dragon was considered the lord of all water animals. The tiger was the lord of all land animals, a symbol of courage and strength.

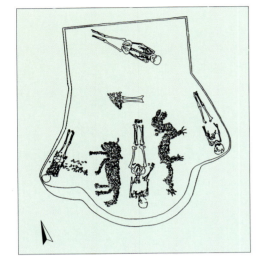

Bottom left
Mirror with relief decoration of two coiled dragons

Han era (206 B.C.–220 A.D.), Staatliches Museum für Völkerkunde, Munich

Bottom right
Shallow *bo* bowl with a depiction of a frog

About 3800–2000 B.C., painted pottery, H 5 cm, dia 16.5 cm, Archaeological Institute, Beijing

What might the fish have meant? It seems most likely that the fish depictions were intimately connected with the need to find food. The inhabitants of Banpo lived on the Wei River, a tributary of the central course of the Yellow River. There may well have been rites that guaranteed a good catch. Perhaps the masks embody a fish god or a magician priest who prayed for a good catch while masked in fish-like headgear.

The discovery of two funeral urns with fish decorative devices on the lids seems to point to the conclusion that the hypothetical river or fish god was the beneficiary of a sacrificial cult.

Another tomb (Xishuipo) from the Yangshao culture confronted archaeologists with yet a different decorative element: the depiction of a dragon, a creature seen by later ages as the symbol of fertility. This is the earliest known representation of a dragon – a mosaic of mussel shells set into the floor of the tomb beside the corpse. On the opposite side is a mosaic of a tiger facing west.

The same grouping of figures appears again 3,500 years later as the decoration on a lacquer chest. It is worth remembering that both dragon and tiger belong to the oldest of those creatures crucial to Chinese ritual, and are of great significance as motifs. It is impossible to conceive of Chinese culture without the dragon, and on the basis of this find we are able to see the deep roots of its symbolic significance and to trace its development over the course of several thousand years.

East coast cultures north and south of the Changjiang

Typical signs of the early East Coast cultures have been found on Hemudu (discovered in 1973 and since excavated, dated to about 4400–3300 B.C.) in the province of Zhejiang between Shaoxing and Ningbo, therefore placing it south of the Changjiang. Contemporaneous with Hemudu was Qinglian'gang (discovered in 1951; 4000–3000 B.C.) north of the Changjiang. Both cultures apparently used intensive agricultural techniques.

The people of Hemudu cultivated rice in paddy fields and raised livestock intensively. They used certain types of ceramics for everyday use; one of these types was painted and another was ornamented with an impressed cord pattern. To the north, the Qinglian'gang painted their vessels. They lived in huts with walls of loam supported by posts. Grave finds are extremely rare and their offerings are of indifferent quality so that it can be assumed that these people were of a practical disposition and concerned themselves little with thoughts of the afterlife. Impressed patterns were by no means rare in neolithic ceramic ware, even if more attention has hitherto been paid to painted decoration. In Dapenkeng (Taiwan), a site which has posthumously given its name to a 5th millennium culture, ceramic vessels with an impressed pattern have been found. (It is interesting to note here an intriguing, if not demonstrable, connection to the neolithic Jōmon culture of Japan, which also decorated its ceramics by impressing.)

In some areas, such as textile technology, agriculture, and architecture, the early coastal cultures were superior to the cultures that have until now shaped our idea of the Chinese neolithic era. And even in later ages, the "southern states" of the great empire would in many respects go their own way – in the production of porcelain, in textile art, in literature, and painting – in order

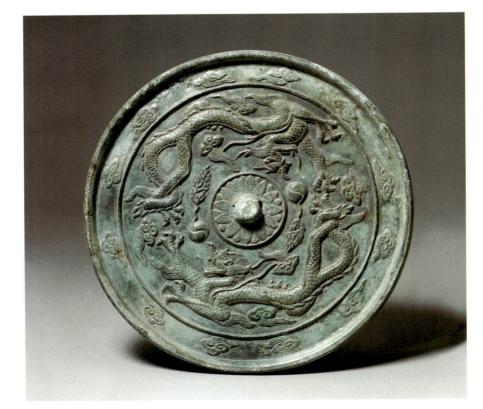

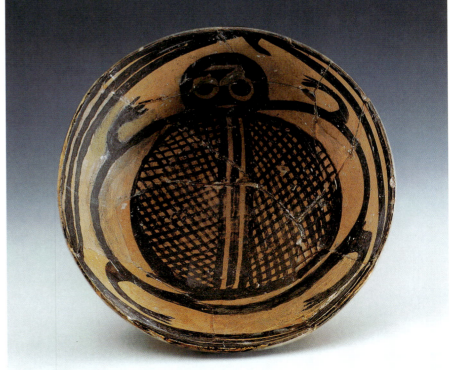

to make their own distinctive contribution to the way Chinese culture perceived itself.

The joy of seeing, or the joy of painting?

The Majiayao culture (also known as the Gansu-Qinghai phase of the Yangshao culture) was discovered in extensive excavations in the Liuwan region in the 1970s. From the long period between 3800–2000 B.C. richly painted and semi-sculpted pottery from this cultural group were found. Modeled faces on a dark painted ground regard the viewer from the sides of their vessels. In fact, the human form plays a special role as a decorative motif, both in relief form on the outside of the vessel or as a modeled mask with a painted skeletal body.

Another popular motif is that of the frog or toad, which in today's myths is associated with the Moon. Line ornamentation covers the vessels in waves while spirals, swirls, serpentines, and grid patterns convey the impression of a graceful, rhythmic brush stroke.

Interestingly, decoration is found only on those parts of the object that would have been visible to the neolithic viewer: in most cases this means the shoulders and neck of the vessel, as well as the inside surfaces of bowls. In neolithic dwellings these vessels would have stood on the floor and a standing or crouching viewer looked at them from above. This visible zone was embellished – decoration below this would have been wasted, good reason, in other words, to believe that the pleasure of the viewer determined the areas decorated.

A broader range of decorative types on a limited number of vessel shapes seems to be one further result of this development; the actual shapes of the vessels had barely evolved at all from the early Yangshao culture.

The early relief decorative elements with their hermaphroditic representations of humans (hermaphroditic because scholars cannot agree whether men or women are represented, not necessarily because they were meant that way) lead us back to the question of the decoration's meaning. Were they ritual decorations connected with fertility cults? Or were shamans depicted? It seems that agreement on the matter will never be reached. The finds have not yielded unequivocal clues on the spiritual world of the ancient Chinese, but some cultures have left relics behind which can be interpreted as cult objects.

The Hongshan culture: female figurines or goddesses?

A spectacular group of finds from the period around 3500 B.C. has been discovered in the northeast of China, specifically the western part of the Autonomous Region of Inner Mongolia and Liaoning, northern Hebei, and parts of Jilin. The Chinese researcher Xu Guangji believes the find to have yielded relatively little material, quantitatively. In view of the context of the find, however, this has little relevance. At two sites – Dongshanzui and Niuheliang, both in Liaoning Province – female statues were found in a building complex. Among them were small figures of naked, pregnant women less than ten centimeters (four inches) high, but there was also a large figure as well as fragments of oversized female figures. The torsos are evidence of the observational skills

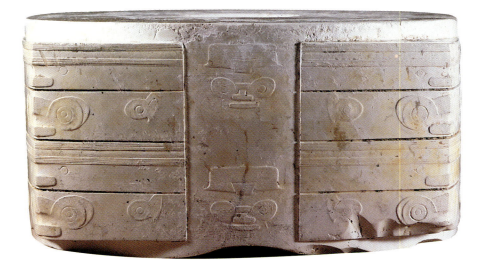

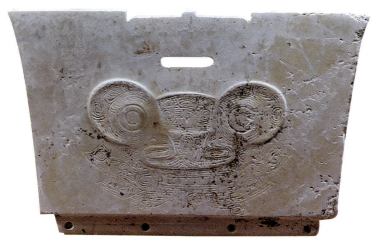

Above, left
Jade *cong* with carved relief decoration

Liangzhu culture, H 8.8 cm, dia 17 cm, Institute for the Archaeology and Culture of Zhejiang Province

Above, right
Guanxingqi with relief decoration of a horned creature

Liangzhu culture, jade, H 6 cm, W 9.15 cm (top), 7.5 cm (bottom), thickness 0.35 cm, Institute for the Archaeology and Culture of Zhejiang Province

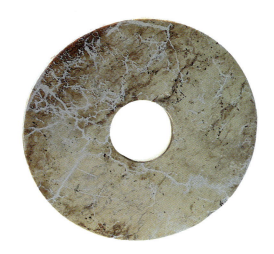

Bi disc

Liangzhu culture, jade, thickness 0.7–1 cm, dia 18 cm, Institute for the Archaeology and Culture of Zhejiang Province

of these early sculptors: the proportions are correct, as are their implied movements.

Both finds have allowed a ritual center to be reconstructed; dwellings and an altar as well as pottery, stone implements, and human and animal bones were found in an enclosed area. The female torsos and figures have given rise to much speculation and some scholars have seen them as the embodiment of a matriarchal society. The figures may also have been an expression of a fertility cult with the temple complex serving as a place of worship for maternal divinities; however, it must be added that there were other cultures which had phallic cults.

The temple foundations at Niuheliang provide us with an idea of how the oldest known building complex looked; it boasted both central and ancillary structures, grave mounds of stone and an altar. The entire complex is oriented north to south with the main buildings lying on the central axis. Lei Congyun interprets this spatial arrangement as a harbinger of later architectural layouts, emphasizing the profound influence this complex had on the structures of later eras. He also sees in the relics of ritual sacrifices a clear indication of the type of religious life led by this society: shamanism.[2] The pottery of this culture, with its dark painted patterns on a red or brown ground, shows a characteristic pattern in the form of the character *zhi*. Apart from pottery, the graves also yielded jade including bracelets, rings, and jade *bi*, thin discs with a hole in the middle.

We do not know what significance these discs may originally have had, but they were in use until the Han era. They are as puzzling as the carved rectangular jade blocks called *cong*. Dragon and pig figurines were also found, the dragons being interpreted as part of a dragon cult. This fascination with the dragon is one of the oldest and most important motifs in Chinese iconography. From the literature of later ages we know that the dragon was considered the giver of rain, and, therefore, of

fertility. According to this belief, the dragon was a water-dwelling creature with the ability to cause rain. River-dwelling crocodiles may have served as a model for the depictions of dragons; when they were sighted from time to time, it may have seemed to the ancient Chinese these very real dragons had a magical connection with water.

The Hongshan people were not the only ones to depict and, presumably, worship dragons (the Yangshao and Longshan did so too). The worked jade objects of the Hongshan culture are but one indication of the preoccupation of the early Chinese with this colorful but difficult material. One of the coastal cultures demonstrated exceptional skill in this area, its jade pieces forming the largest proportion of the worked grave offerings of that region.

Liangzhu culture: jade and death cults

The Liangzhu culture flourished between 3300–2300 B.C. and its peoples dwelt in the delta of the Yangzi River. Finds indicate a quite profound death cult as the grave offerings are most laboriously worked. In the graves at Fanshan, in Zhejiang Province, large quantities of jade reliefs were found, among them the rectangular *cong* blocks, jade *bi* discs, body adornments, and necklaces. Some bear a relief pattern that, featuring large, round eyes, is reminiscent of a mask, or an animal with curled horns. Trapezoid jade shapes are especially typical of Liangzhu culture, a form from which modern science derived the culture's name: the crown-like object *guanxingqi*, or the crown-like ornamentation *guanzhuangshi*.

Until now these strangely formed shapes have not been found beyond the borders of the Liangzhu region and they certainly do not appear in later epochs. Their purpose is unknown: they may have served as a type of head ornament, as they have either been found at shoulder or head height on the dead. Others researchers have seen

in them ornamentation for wooden idols (wooden remnants were also found in the graves), which may have been amulets for ritual purposes or symbols of authority. In part, their form can be compared with that of ritual bronze axes from later periods.

The bird seems to be have been an extremely important decorative figure in this culture; it is depicted in relief on jade, either in simple naturalistic style or in abstract forms. In addition to birds, there are also various small, naturalistic pendants in the form of fish or, in one case, a turtle. To the north of these archaeological sites there later appeared on the historical stage those clans and tribes we know today as the Longshan culture.

Longshan

The tribes belonging to the Longshan culture dwelt from about 2500–200 B.C. in what is today Shanxi, Henan, and Shandong. Their historical and geographical division into Henan-Longshan (2600–2000 B.C.), Shanxi-Longshan (2300–2000 B.C.) and Shandong-Longshan (2500–2000 B.C.) is less helpful. The second phase of the Miaodigou culture (2900–2800 B.C.) is also now considered part of the Longshan culture. Because of the geographical location of the Miaodigou culture, researchers – who constantly seek to establish a continuity between cultures – see in it a possible connection between the Yangshao and Longshan.

The most important characteristic of these cultural groups is the lack of painted pottery so familiar to us from the Yangshao cultures. Instead, the Longshan potters had mastered the art of the pottery wheel and made pots complicated in both form and structure, such as beakers with long stems, tall jugs, and goblets; some of these pieces are only millimeters thick and therefore known as "eggshell pottery." These ceramics are black, gray, or brown and decorated with etched or impressed patterns.

The artistic execution of the form more than makes up for the lack of painted ornamentation. Elaborate pieces such as a ringing beaker, whose sound was produced by a tiny ball built into the stem, testify to an astonishing mastery of form and firing techniques.

The great variety of forms is shown in the range of tripod cooking vessels: the so-called *ding*, cauldron-like with short legs; the *yan*, a long-

Guanxingqi with relief of a horned creature

(Detail), Liangzhu culture, jade, H 6 cm, W 9.15 cm (top), 7.5 cm (bottom), thickness 0.35 cm, Institute for the Archaeology and Culture of Zhejiang Province

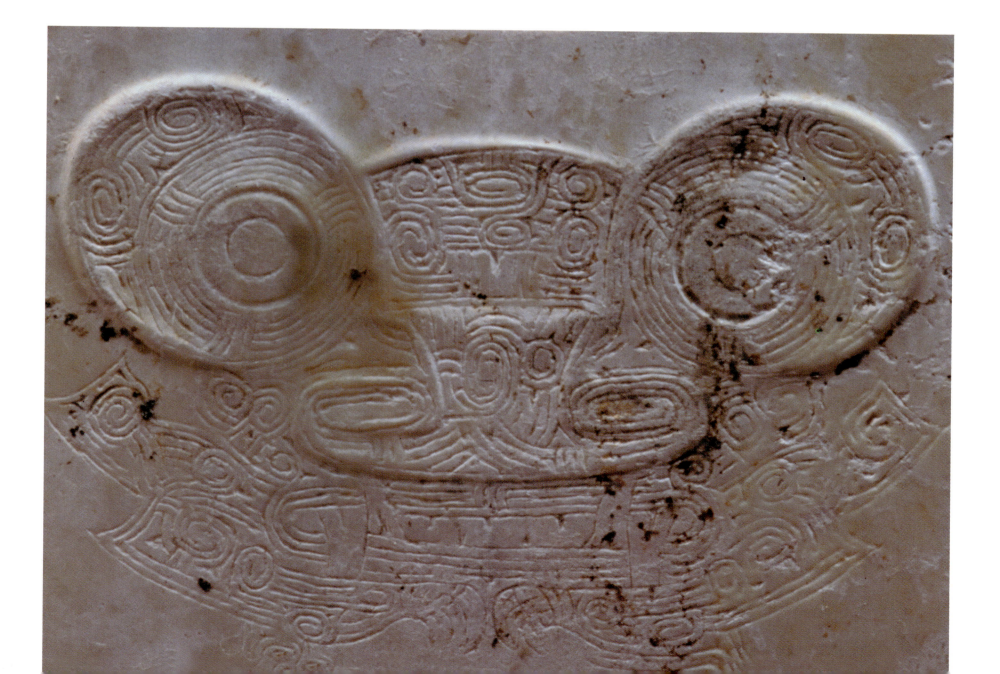

Right
Three legged *gui-li* vessel

Handle of two twisted strands, body of the vessel simply decorated by a band made separately and impressed on the vessel, earthenware, H 22.3 cm, Linden Museum, Stuttgart

Far right
He pouring vessel

Erlitou culture, bronze, H 24.5 cm, Chinese Institute for Social Sciences

Below
Goblet

About 2300 B.C., Dawenkou, black thin-walled ceramic, pierced shaft, H 21.75 cm, Shanghai

legged *ding* combined with a simple, solid *weng*; and the *jia*, also shaped liked a cauldron but with longer, thicker legs. There were also storage vessels with an inward-curving opening (*guan*), bowls (*pen*), beakers with handles (*bei*), and elaborate goblets either with tall stems or smaller, thicker stems (*dou*); the Shandong finds also revealed tripod jugs with spouts (*he*, *gui*).

The most conspicuous characteristic of these cooking vessels is their three legs, and in some cases three handles. Why this insistence on three legs? The reason was probably practical: a three-legged vessel always remains stable even if its legs are not of identical length. A four-legged object with this problem would always wobble and might even tip over – to be avoided at all costs when they were placed directly on the fire. Three handles are also extremely practical: when the pot is hung up they prevent it from overbalancing.

Of course, the various grave sites show that different social strata existed: the majority of individual Shandong-Longshan graves in Sanlihe, for example, had no offerings at all while a very few had small amounts. One grave (Sanlihe 2124) serves as an example of the type of wealth with which some graves were furnished: four tall goblets, three *yan* and three tripod bowls (*pen*), as well as 20 other pottery objects, tools, and animal bones. The same thing has been observed at other sites: there are graves richly equipped, and those containing nothing other than the corpse.

Animal teeth and bones were also placed in the grave, in particular a large number of dogs' lower jaw bones, which were possibly part of a ritual observance. It is possible that the dog was seen as a guardian, but dogs were also eaten and the ownership of a large number of dogs was equated with the ownership of many pigs: it signified wealth. Another culture of this period illustrates the importance of animals in neolithic culture.

Toys from the Shijia River?

The Shijiahe culture (about 2400–2000 B.C.), discovered in present-day Hubei, created the finest animal statues that have yet been unearthed at Chinese neolithic sites.

Around 5,000 fully-formed animal figurines have been found in Dengjiawan, and they were the result of excavating rubbish pits rather than graves. The animals represented are birds (mostly chickens), pets (generally dogs), and game animals, the most common of these being the elephant. Both animal and human figurines can be identified by their stylized features and their ability to sit perfectly on flat surfaces.

One can assume that the statuettes were not made as ornaments and that, because of the effort needed to produce them, that they were not mere toys. They may have been used in ceremonies to ensure a good hunt and/or the successful breeding of livestock. But why were they thrown away? Perhaps the people of the Shijia River believed that the figurines could possess magical properties once only. There is another possible explanation: later texts like the *Liji* state that sacrificial goods were to

remain with the dead and could not be used again for any other purpose.

If the animals were associated with certain rites, then clearly they could not be used a second time. Given the current state of research, however, all such explanations must remain purely speculative.

It is interesting to note that objects from Dengjiawan reached Hunan and as far away as the regions of the Longshan cultures. Other tribal communities, therefore, also sought out the assistance of these small, "magical" animals.

An investigation of the Shijiahe culture, or the Qijia (about 2000 B.C.) from the region of the Gansu-Yangshao culture, brings us nearer to the dynasties referred to in Chinese histories.

Did the Xia dynasty mentioned in Chinese histories actually exist? The question of whether any trust can be placed in the chronology developed by early Chinese historians, and in particular in their notion of an imperial and aristocratic society, is a fruitless one in my opinion. There were several highly developed cultures at the turn of the 3rd through the 2nd millennium B.C. about which all too little is known, despite extensive archaeological digs. They might all have been the Xia dynasty, if the Xia is understood as a developed tribal society that exploited technology and innovation.

It is, however, one of the burning desires of scholars to prove that the Xia did exist, and especially to establish which of the early cultures is the most likely candidate.

The debate still rages about whether the Erlitou culture (sometimes called the Erlitou period), which was based around Henan and dates from the 21st through the 17th century B.C., can be cited as historical proof of the (still mythological) Xia dynasty. The finds at the sites of Erlitou settlements indicate a transition to a city state; large scale foundations of what must have been palace complexes (100 by 100 meters and 72 by 58 meters: 328 by 328 feet, 236 by 186 feet) as well as smaller dwellings have been identified. The graves are generally furnished with pottery but they are also the source of the first great bronzes of Chinese cultural history.

Although they are unornamented, the technical execution of these pieces indicates that they were not the very earliest bronzes, a conjecture based on the complex forms of their legs and spouts as well as the open work of the handles. They are the "apprentice pieces" of early bronze art.

Formally, the objects derive from contemporaneous pottery, though bronze weapons were also manufactured. In China, the great Emperor Yu (the traditional founder of the Xia dynasty) is considered the discoverer of bronze. This temporal overlap, as well as the placement of the Erlitou culture at a time when the Xia dynasty is traditionally thought to have flourished, leads one to believe that the Xia dynasty is indeed an historical entity and synonymous with the Erlitou culture. The origins and eventual fate of the Erlitou culture are controversial; the outcome of the debate for and against an historically verifiable Xia dynasty has still to be decided.

This, however, is only one of the issues to which the discovery of different cultures has given rise. The pieces shown here served a purpose for the various Stone Age cultures that was not confined to the everyday: they were used for cultic rituals. (At this early stage of development art was bound by ritual or religion.) But one should not forget that, as well as "ceremonial objects," large quantities of undecorated pottery for everyday use were found within the settlements. However, Mary Tregear is absolutely correct when she maintains that there can be no doubt that even in this very early epoch, before the arrival of metal and higher civilization in China, there was a great richness and variety of artistic expression.[3]

These ceramics should rouse our curiosity as to what the early Chinese artisans and artists were able to create when they had completely mastered bronze casting. Was pottery abandoned in favor of bronze, or did bronze art occupy another niche in life as in death? An answer can be found in the pottery and bronzes from the graves of the Shang dynasty, the first dynasty on Chinese territory to have an unassailable historical basis.

Kneeling figurine
2400–2000 B.C., loamy clay, H 9.5 cm, Museum of the Jingzhou Region, Hubei Province

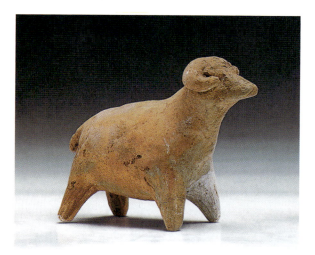 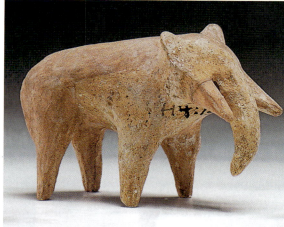

Far left
Ram

2400–2000 B.C., loamy clay, H 7.5 cm, L 10 cm, Museum of the Jingzhou Region, Hubei Province

Left
Elephant

2400–2000 B.C., loamy clay, H 6.8 cm, L 10.5 cm, Museum of the Jingzhou Region, Hubei Province

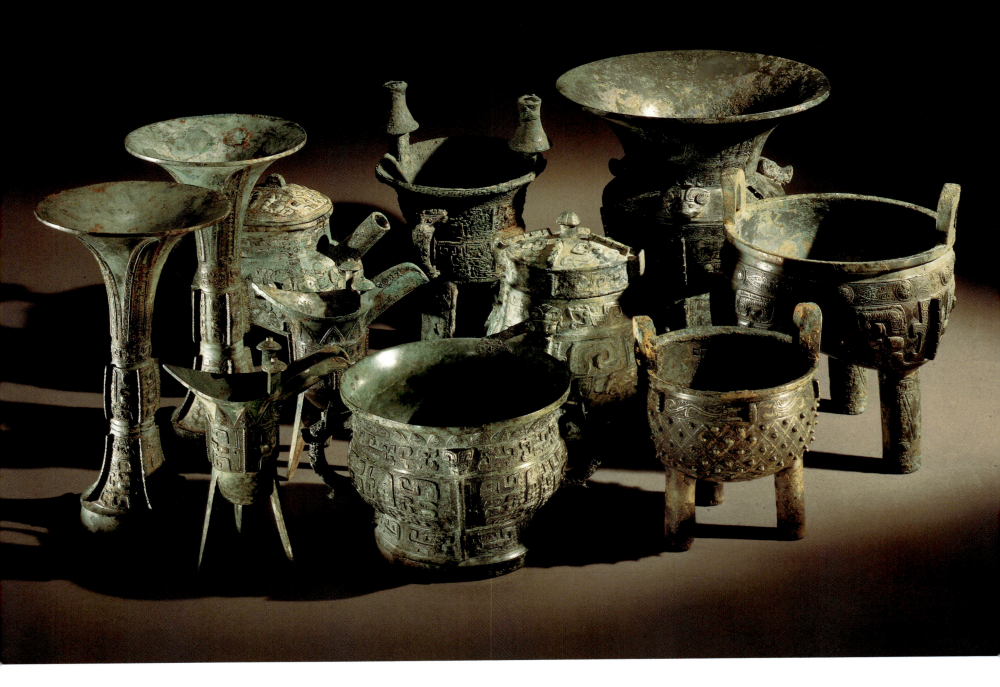

The Bronze Age and the Shang Dynasty

(18th–11th centuries B.C.)

Bronze vessels of the Shang era

12th century B.C., H (max) 30 cm, British Museum, London

Examples of the range of bronze vessels from the Shang era: two *gu* goblets, two three-legged *jue* pouring vessels, a *he* pouring vessel with spout, a *gui* bowl with handles, a tripod *jia* vessel with prominent upright handles (middle, back), a squarer *fangyi* vessel with lid, a high round *zun*, and two *ding* tripods.

It has been established beyond doubt that bronze casting was already known during the Erlitou epoch.[1] Vessels were found as well as jewelry whose exact use has not yet been established.

The beginnings of Chinese bronze casting are still uncertain. Some scholars believe its origins are to be located outside China to the west, while others believe a sort of "technology transfer" took place from the north, as there is known to have been a center of bronze art around Lake Baikal. Yet a third group proposes an independent and spontaneous development within China.

Regardless of what the correct explanation may ultimately prove to be, the sheer variety of form in Chinese bronzes, their types of ornamentation, and their casting techniques all combine to make them a spectacular contribution to world art. With the exception of pottery, bronzes are the oldest Chinese art form and the products of the Shang era (16th–11th centuries B.C.) – weapons, ritual objects, musical instruments, tools – testify to the high artistic value and technological skills its artisans attained.

But what were the cultural circumstances which led to bronze casting becoming an art form?

According to traditional Chinese history, the Shang peoples from the lower reaches of the Huanghe overthrew the Xia dynasty (whose historical authenticity scholarship has neither proved nor disproved). The names of the Shang kings, however, were recorded in inscriptions on oracle bones and they correspond to those names documented by China's first historians at the time of the Warring States and the early Han era.

The written documents of the Shang themselves have finally banished historians' doubts as to their dynasty's existence. The bones portray early versions of today's Chinese characters. The vocabulary was wide, and the pictograms reveal how concrete objects, depicted with just a few characteristic strokes, became established as symbols, and how abstract concepts developed from symbol pairs – to name but two of the six ways in which Chinese characters are formed (see page 270).

The empire of the Shang lay on the plains of the Huanghe. The empire did not have one capital but several fortified residences; possibly the court was itinerant (as was the Carolingian empire in medieval Europe) but there may have been only a single move when a new ruler ascended the throne. One of the residences was in Bo (today's Shanqiu in Henan Province), another in Yin (in what is now Xiaotun near Anyang). There were two different periods: the Erligang phase, with finds close to the modern city of Zhengzhou (1600–1300 B.C.); and the Anyang phase (1300–1100 B.C.).

The state was ruled by a hereditary monarchy in which the king was the supreme head of the army and of ritual. Archaeological finds, complemented by tradition, has created the following picture.

It was warlike culture which maintained its superiority on the basis of its use of bronze weapons and chariots. Possession of bronze was a monopoly of the ruler and his immediate associates. Only a tiny social elite could afford the costly metal, and the rest of the population at this early stage had no access whatsoever to this precious material.

Religion was a fertility cult and determined by the agrarian character of the culture (crops included wheat, millet, oats, and sorghum). Nature divinities were worshipped, as was the power of the ancestors. The pantheon of gods was hierarchical, and the all-powerful godhead was known as Di.

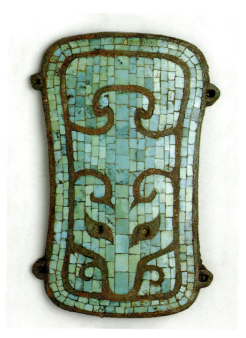

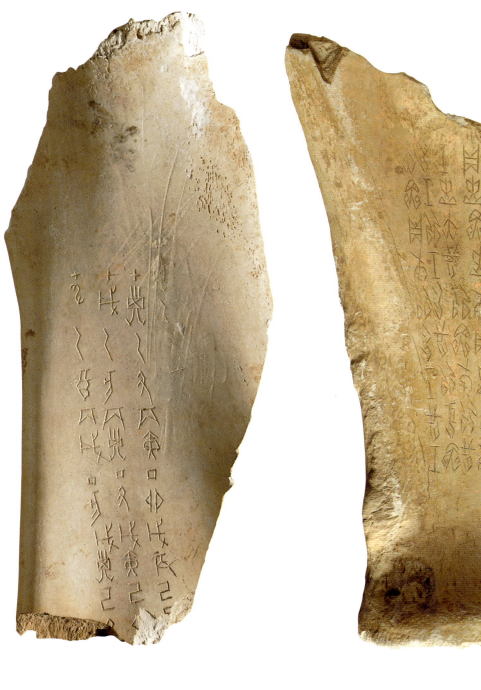

Above
Fox's head

Erlitou era, bronze plaquette with turquoise inlay, Eskenazi, London

Far left
Oracle bones

14th–12th centuries B.C., L 14.5 cm, Museum für Völkerkunde, Leiden

Left
Oracle bones

Anyang phase, Shang dynasty, L about 15 cm, Staatliches Museum für Völkerkunde, Munich

The inscriptions on both oracle bones have not yet been deciphered.

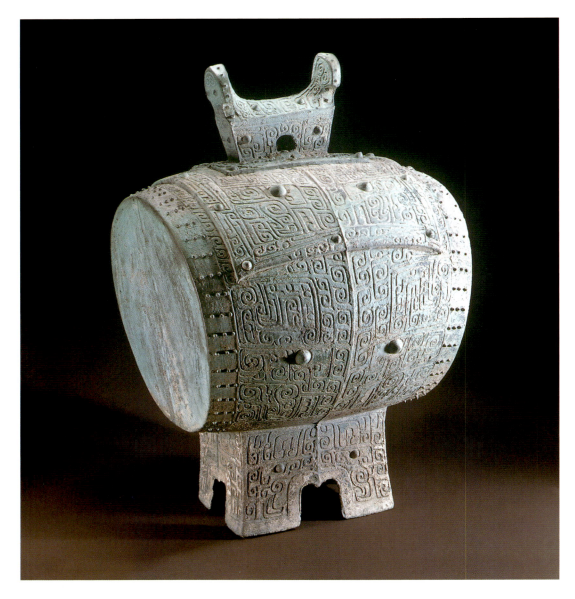

Drum

Late Shang era, bronze, H 17.5 cm, Hubei Provincial Museum

The drum has angled surfaces on both sides, and is decorated with *taotie* masks in low relief

Opposite

You **vessel with lid and handle**

Anyang phase, bronze, H 41.5 cm, Chinese Institute for Social Sciences

Three-dimensional rams' heads serve as supports for the handle. The vessel also features dragons' heads with serpents' bodies as well as prominent casting burrs.

She controlled the rain, which of course was of utmost importance for an agrarian culture: too much or too little rain meant a failed harvest. Nevertheless "there is no image on the bronzes which depicts Shang Ti (Shang Di), the most powerful god who had a human form."[2] Shamans mediated the contact with gods and ancestors either by means of oracles, or music and dance.

The Shang year was divided into 12 months of 30 and 29 days. Their concept of a calendar was therefore oriented to the solar rather than lunar year, and occasionally a leap-month was necessary.

Throughout the year the Shang attempted to keep inexplicable events such as sickness or catastrophes at bay by paying obeisance to ancestors; inquiring of divine oracles whether various undertakings were destined to be successful or not; and ensuring the goodwill of gods or ancestors by means of sacrifices, thanks offerings, and conciliatory rites such as ritual purification. The ancestors the Shang worshipped were "hybrid beings, at once protecting as well as punishing gods."[3] Exercising power in this life meant having power in the afterlife as an ancestor. The descendants of

such ancestors would have to be sure to cultivate their favor. Sickness was often interpreted as the wrath of ancestors, as seen from various texts taken from oracle bones such as the following:[4]

"The King has a buzzing in his ears. Will it become painful? Has grandmother Chi cursed the King?" (Chang 1.4)

Painful conditions, for example, meant asking the oracle what sort of sacrifice was the most appropriate: "I have toothache. Will it get worse? Should a dog be sacrificed to dead father Keng, and should a sheep be sacrificed by ritual slaughter?" (Chang 4.11)

During the Anyang phase, putting questions to the oracle was a ritual reserved for the ruling class, but it was also one of their duties. The methods were scapulamancy (interpreting the shoulder blades of cattle), and pyromancy (interpreting the flames of a fire). Questions were scratched into ox bones or the under shell of a turtle, while on the reverse side of the oracle bone holes were drilled into which heated rods were inserted. The heat from the rods produced cracks at the front of the bone, and it was these cracks that provided the oracle's answer. While those requesting an oracle were always members of the aristocracy, their request was mediated by a priest or shaman who wrote the text, applied the hot metal rods, and then interpreted the oracle.

As well as separating the ruler from the people, the Shang also made a distinction between different social strata and circles; between, in effect, agriculture and the trades. In other words, there was a division of labor, a system that meant that no obstacles were placed in the path of technological development.

The close cooperation of two separate trades was necessary for the manufacture of bronzes: bronze casting itself and also pottery, for the techniques of pottery ensured the precision of the original clay model.

Analyses of Chinese bronzes made before the Qin dynasty have found that copper and tin were not the only elements used. Lead was also added (as much as 16 percent), which gave the bronzes a silvery metallic sheen.

Very early bronzes found in Zhengzhou, however, contain only a small percentage of lead. Freshly made, these bronzes had a characteristic golden sheen that quickly oxidized to a patina on exposure to the air.

These once golden bronzes were probably the result of commissions or of artisans working for patrons, an assumption suggested by the proximity of the forges to palaces or the centers of power in the cities. The excavation of a forge in Nanguanwai near Zhengzhou (probably one of the first capital cities of the Shang) unearthed over 1,000 clay molds for making bronzes, as well as an enormous number of crucibles in an area covering 1050 square meters (11,300 square feet).

As numerous finds have shown, vessels were not made by the lost-wax method (*cire perdue*) but by means of a clay model. Finds of these have

Zun vessel

12th/11th centuries B.C., *with ram and snake decoration, H 58.3 cm, probably of provincial origin, Historical Museum, Beijing*

The decorative fields are separated by casting burrs, which serve as axes of symmetry.

ended the seemingly endless debate of earlier years, when some scholars were unable to accept the idea of early bronzes having been cast either with clay molds or by the *cire perdue* method.

The finds also explained how complicated decorative elements such as sculptural animal heads were produced. These rams' heads or snakes' heads with horns, as well as the legs of a vessel, were made separately and then incorporated or cast into the original model. The ram's

head *zun* with four horned heads separated by dragons' heads, today in the Historical Museum at Beijing (see above), required 21 individual steps from the casting of its parts through to completion. The parts themselves could be used several times, which meant that identical objects could be made. In some instances twin objects were placed in pairs in the grave.

Casting using the lost-wax method can be dated from the 5th century B.C. At first this date appears

to be contradicted by the fact that the bee was first domesticated in the 3rd century B.C.: but clearly the wax necessary for casting must have come only from colonies of wild bees.

Bronze vessels made using the *cire perdue* method are rather rare. The method made an improvement in quality possible, however, as proved by the bronzes from the tomb of the Marquis Yi of Zeng (Zeng Hou Yi) (see page 54). The number of bronzes made by this process underwent a boom around 1,000 years later in the Han dynasty after the domestication of the bee, and was used for both large and small statues. The famous "Maidservant with Lamp" from the tomb of princess Dou Wan, 2nd century B.C., was made in this way (see page 92).

The belief in some sort of life after death led to tombs being luxuriously fitted out, particularly in the Anyang phase of the Shang dynasty. The social status people had enjoyed in life was to be reflected in their grave furnishings; the grave was to be the new dwelling place of the deceased equipped with items of personal significance and everything required for daily existence in the afterlife.

Princely graves of the Shang era had established a ground plan in the form of the character *shi* (ten) comparable to a Roman cross (see right, top). In these complexes the dead were buried in two coffins, an inner *guan* in which the body lay, and a larger outer *guo*. The grave goods were placed either in the intermediate space between the inner and outer coffins (as in Grave 18 in Anyang) or on the stamped earth podium, the *ercengtai*, on which the outer coffin rested. Only a few objects have been found in the inner coffin.

The tomb of the "Amazon," Fu Hao, wife of the Shang king Wu Ding, was discovered in 1976 and dates from the period around 1250 B.C. The large number of almost 2,000 grave goods, including 468 large and 109 bronze pieces, testify to the status of the dead woman, and their decorative patterns represent a veritable treasure trove for the comparative dating of other finds (see right).

As they were intended for the grave of a queen – the only one so far found – the pieces also represent a high point for quality. In the area around the royal necropolis were 191 sacrificial pits. It is simple to distinguish between the graves and the pit-like sacrificial sites on the basis of content: the pits contained 1,500 human victims, two bronzes, several pieces of pottery, and 20 animals. Generally the opposite held true for the grave: here, the deceased received vast quantities of offerings.

Finds from the period preceding the Shang, the Erligang period, are less likely to be found in graves than in individual finds or hoards.

The Shang and later also the Zhou bronzes had a sacred and a social function. If in the neolithic era the graves of the rich were full of pottery and those of the poor were empty, then there is a parallel with the Shang era: the ruling class equipped their dead with numerous bronzes, while the graves of the "common man" held pottery, and those of slaves usually nothing at all.

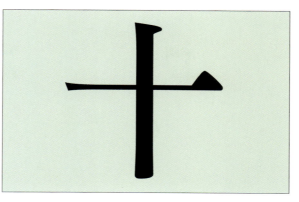

Left
The character *shi*

The layout of princely tombs from the Shang era has its origins in this shape.

Below
Ivory beaker

About 1250 B.C., with turquoise inlay, H 30.5 cm, tomb of the "Amazon" Fu Hao, Historical Museum, Beijing

Probably an item for the queen's personal use, this beaker is etched with *taotie* decoration and turquoise inlay.

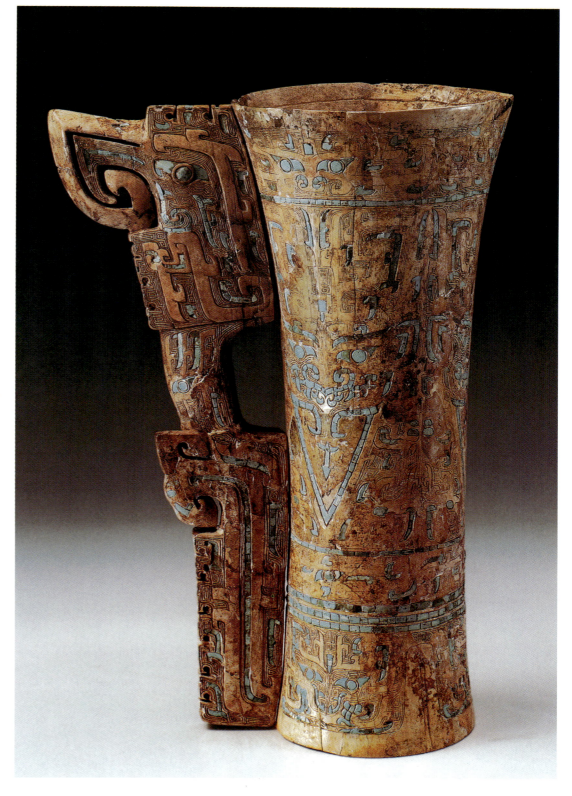

This symmetrical, stylized face of an animal with the body of a snake (an artificially constructed hybrid) is the most prominent decorative motif on Shang bronzes.

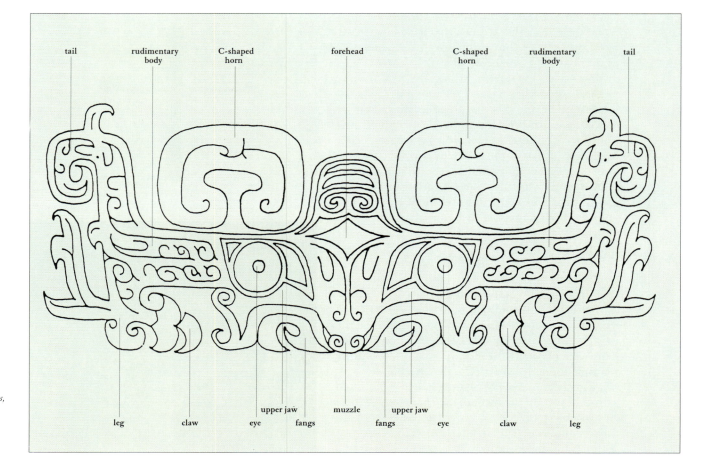

tail | rudimentary body | C-shaped horn | forehead | C-shaped horn | rudimentary body | tail

leg | claw | eye | upper jaw fangs | muzzle | upper jaw fangs | eye | claw | leg

Jia vessel

Symmetrically decorated, with pointed legs, taotie decoration, handle in the form of a stylized animal's head with trunk, bronze, H 39.5 cm, dia of mouth 24 cm, Museum für Ostasiatische Kunst, Cologne

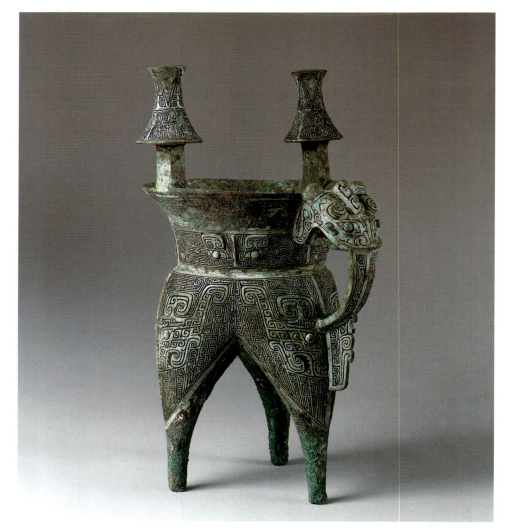

The bronzes from these graves came in a wide range of forms.

Classical Chinese has 27 characters for the various forms of bronze vessels, and these were sometimes used for their ceramic equivalent (see page 394 of volume two). Oracular texts have already provided eight characters which clearly mean "vessel;" other terms were coined in the course of later epochs. Besides vessels, bells too were connected with both cultic and military events; they have no clapper, the sound being produced by striking them with wooden mallets, and have the same symmetrically ordered motifs as the vessels.

The vessels were either round or rectilinear and belonged to the three main groups of containers for food, wine, and water. So that readers may familiarize themselves more closely with these terms, a list of names according to these three categories follows: as cooking vessels and containers for food there were *ding*, *li*, *yan*, *gui* and the ladle *bi*; as wine vessels, the goblets *gu* and *zhu*, as well as the wine containers *jue*, *jia*, *he* (used for warming wine and drinking it), and (as storage vessels for wine) *zun*, the zoomorphic *zun*, *gong*, *fangyi*, *you*, *hu*, *lei*, *bu*, and *pou*; and finally the water containers *pan* and *yu* (deep bowls).

Thanks-offerings of wine or liquids were of paramount importance in the ritual of the Shang; vessels of this type are the most widely found and show the greatest variety in shape. Formally there was considerable variation within one vessel type,

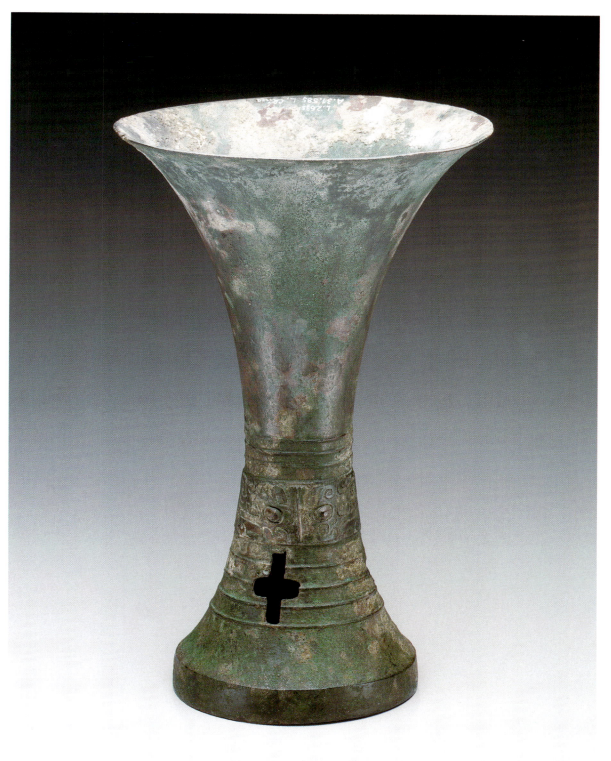

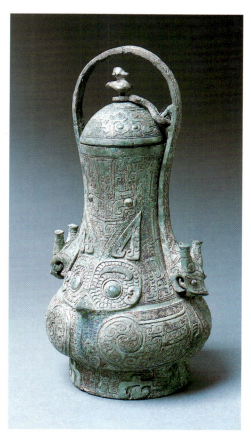

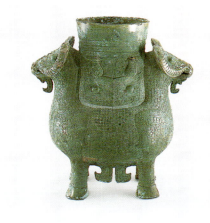

for example *ding* tripods sometimes had round legs, sometimes dagger-like legs.

Handles could be bow-like or end in elaborate animal shapes (see right, top). Right from the start of bronze casting, decoration became increasingly complex. Undecorated early bronzes, which recall the black pottery of the Longshan, were replaced over time by pieces with increasingly decorated surfaces (see above).

According to Tregear, the development of hieratic motifs is so impressive that it cannot rightly be called "decoration" any longer.[5] Decoration became artistic expression. After the merely abstract decorative borders of the early bronzes came an emphasis on individual areas of the vessels, areas that were decorated in low relief. These were succeeded by objects decorated all over and, finally, vessels which had a combination of decorative patterns in low relief and projecting semi-sculptural (see right, bottom).

These last named types were even overshadowed by the detail on the zoomorphic *zun* (vessels

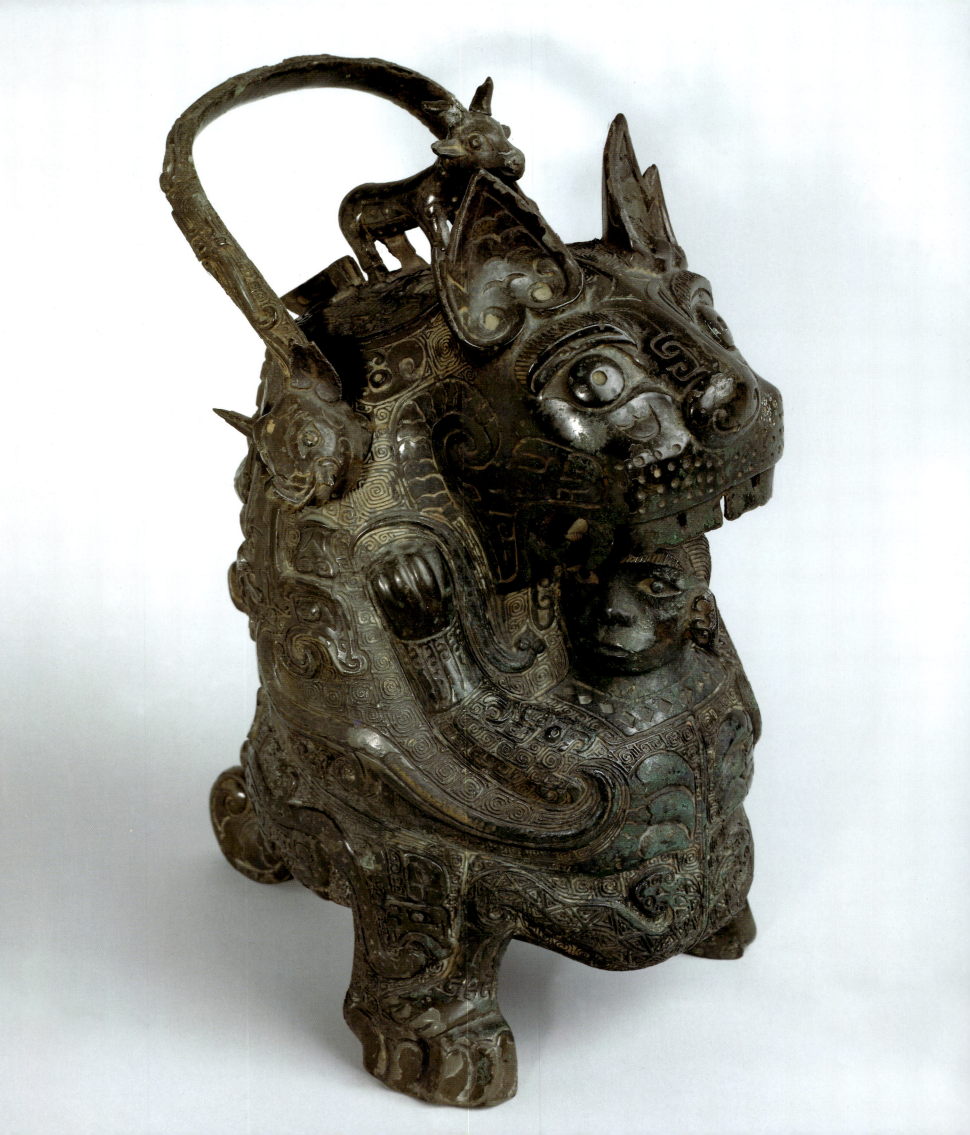

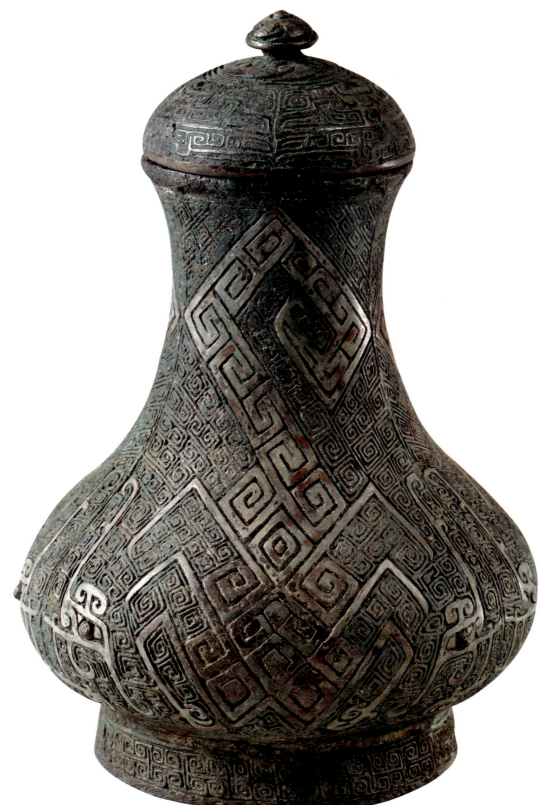

in the shape of animals and decorated entirely in relief) and the "tiger-eating-a-man" *you* vessels, which seem almost like sculptures. They were made at the end of the Shang era (see opposite).

Jade and inlay work from the Erlitou period were the first of those pieces that depict creatures in profile or from the front. These are conspicuous for placing realistic animal decorations, like rams' heads, alongside linear or abstract relief decoration such as bands of birds. The birds are reduced to their characteristic features (beak, neck, eye, wing, or tail feathers) and are therefore readily identifiable as such. In the same way, lines create endless bands of pattern, as in the square spiral, the so-called "thunder pattern" or *leiwen*. Animals from the natural world look down at the viewer from the vessels, as do mythological dragons and, finally, the "button eyes" of the *taotie*. The *taotie* mask, one of the standard motifs of bronze decoration even in the early Zhou era, is constructed symmet-

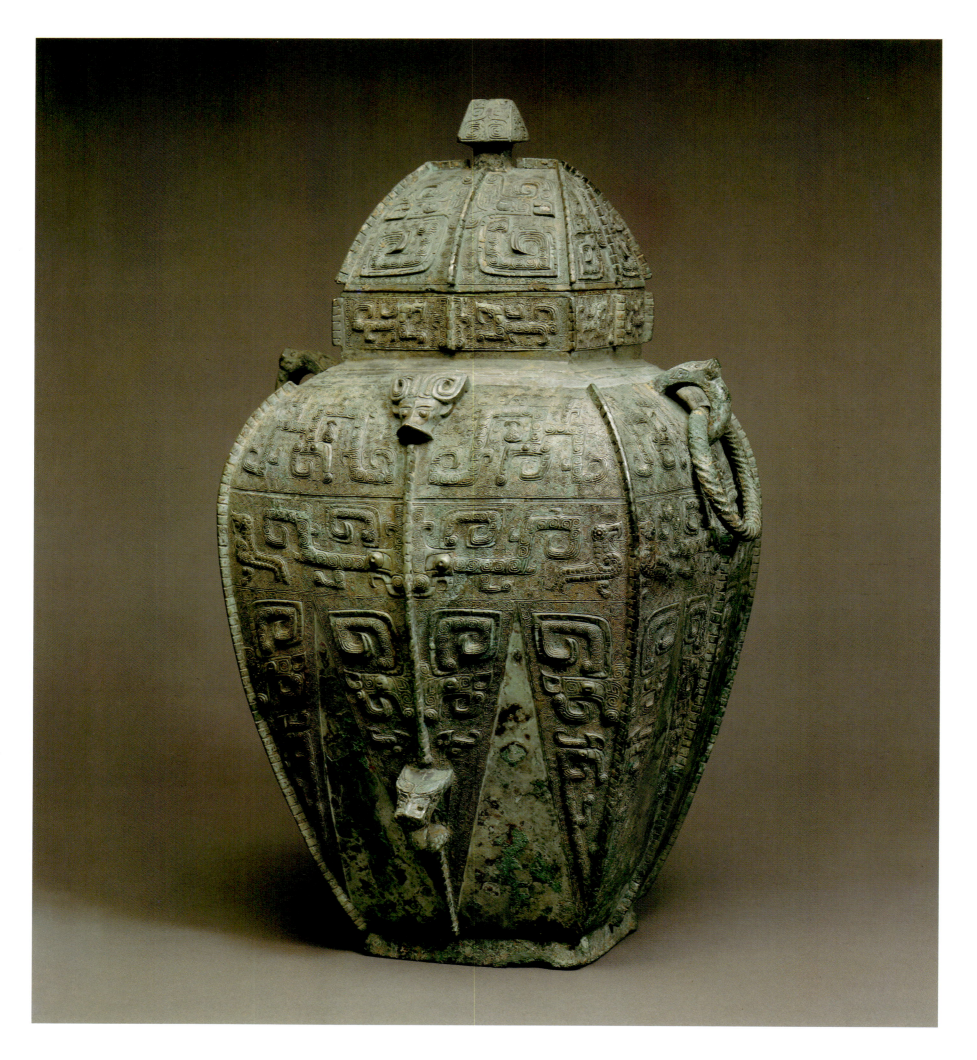

rically; one can make out the frontally depicted face of an unidentifiable creature with a mustache, nostrils, large button-like eyes, horns, and sheep's ears (see opposite).

On both sides of the mask on this jar (as on many others) one can see the snake-like body of a hybrid creature. The body is shown in profile, sometimes with legs. The *taotie* (the term does not derive from oracular texts but is an invention of Chinese scholars of the Zhanguo era) was thought to have apotropaic powers, in other words was able to ward off evil. This constantly recurring motif enables us to reconstruct a chronological order with which we can catalog bronzes of this decorative type. It can clearly be seen that decorative compositions first depicted in contours become increasingly replaced by depictions in low relief. Numerous recent finds from the end of the Shang era (in other words the Anyang Epoch) mean that bronzes of the period can generally be divided into five stylistic groups, as formulated by Max Loehr at the start of the 1950s. The first of these groups is the simple "thread relief" type, a style which then became employed in decorative bands across the entire vessel. The further application of this style (later called the Zhengzhou style) allowed the simple decoration to become a background pattern, after which the appearance of sculptural motifs became more pronounced. Loehr thought the high relief pattern the most advanced of the decorative styles, of which the "tiger-eating-a-man" *you* was the best example.

But the most prominent are probably the vessels decorated with motifs sculpted in relief. These depict the *taotie* pattern but also other stylized animals, including birds (see right).

As well as the jade carving of an owl found in Fu Hao's tomb, there are decorations which

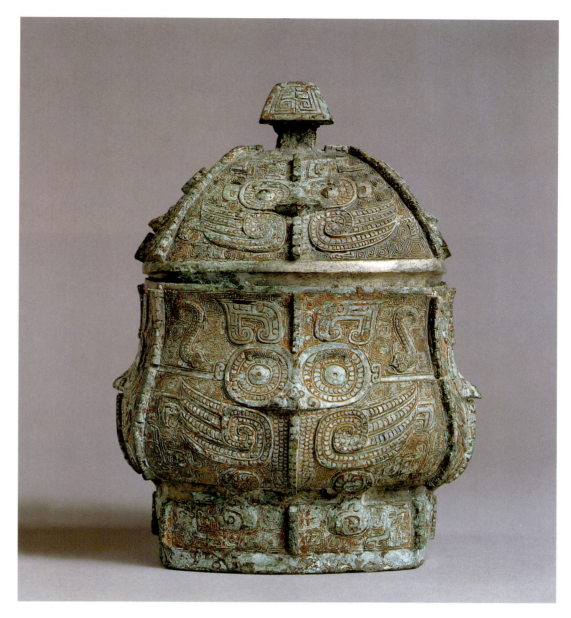

feature an identified bird, usually referred to as a phoenix (*feng*): it is swanlike but with a reduced body. Squares and waves as well as symmetrical patterns ornament pieces from the Anyang phase, often in the background but occasionally as the main decorative device. Cicadas, depicted in the form of their wings, are depicted as compressed, narrow, symmetrical shapes on the feet or lips of vessels where they form friezes (see left).

Like the geometric patterns already discussed, or the cicadas, decorative bands of *feng* birds help to divide the surface up into zones.

A particularly interesting feature in recent finds in the west of China is the elephant decoration (see page 38, bottom).

The elephant was depicted realistically in both decorative patterns and as a vessel (the elephant shaped *zun*). In addition, one should bear in mind further abstract forms which may have been inspired by the elephant, such as the tapered legs of the *jia* (see page 32). Its iconographic meaning has not been explained, but it is striking that elephant tusks have been found in the sacrificial

Above
Fangyi ritual vessel

12th century B.C., the decoration of the lid is in the form of a duck while the vessel's body depicts a stylized owl, H 22.5 cm, Museum für Ostasiatische Kunst, Cologne

Left
Ding vessel

Late Shang era, with decorative band with stylized cicadas below, H 21.8 cm, Linden Museum, Stuttgart

Opposite
Fanglei vessel

H 50.1 cm, Staatliches Museum für Völkerkunde, Munich

The surface is divided into decorative zones. Above the small, modeled heads in the lower third of the vessel, the first *taotie* mask is clearly identifiable. In the decorative zone below the vessel's shoulder there is a second *taotie* mask, this time with a snake's body. In addition birds are depicted in profile at the corners.

graves of the Sanxingdui, a western culture not related to the Shang; there may have been a connection between the cultures in earlier centuries.

An elephant must have made an enormous impression on earlier cultures; doubtless in order to attain its strength, or as part of a hunting ritual, they made sacrifices to it or attempted to control it through magic. Among the bronzes from the succeeding Zhou era are objects whose legs are clearly trunks (as in the bronze find at Shandong, Liutaizi, tomb no. 6, Xi-Zhou period).

Fish and turtles – which later became symbols for wealth (the Chinese for "fish," *ya*, also means "surplus"), long life, endurance, and strength – were generally depicted in symmetrical form. These were depicted even before the Shang era and are amongst the oldest motifs in Chinese art. In some places one can still see turtles of stone or bronze that bear an inscription tablet.

Another very characteristic feature of later Shang bronzes and their decoration are the prominent flanges or casting burrs that were incorpo-

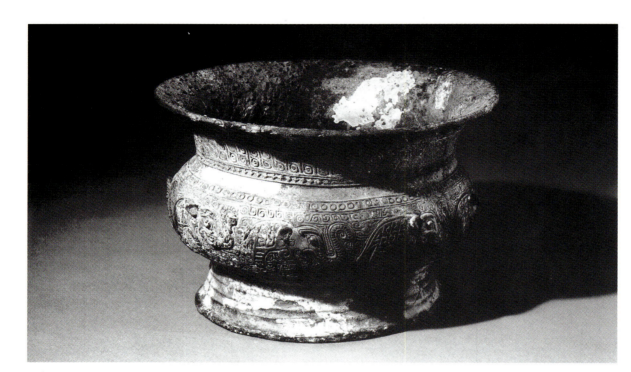

Opposite, vessel on left
Fanggu vessel

Late Shang era, with prominent casting burrs at all four corners, surface divided horizontally into three zones and vertically into four zones by these joins, H 30 cm, opening 13.5 cm, Museum für Ostasiatische Kunst, Cologne

Left and below
Gui vessel

(Full view and detail), late Shang era, strongly patinated in places, H 13.4 cm, dia 21 cm, Museum für Ostasiatische Kunst, Cologne

The body of the vessel is divided into decorative zones, the main decoration being formed by a frieze of elephants that face the same way; this motif is enhanced by a geometrical decoration in the form of square spirals.

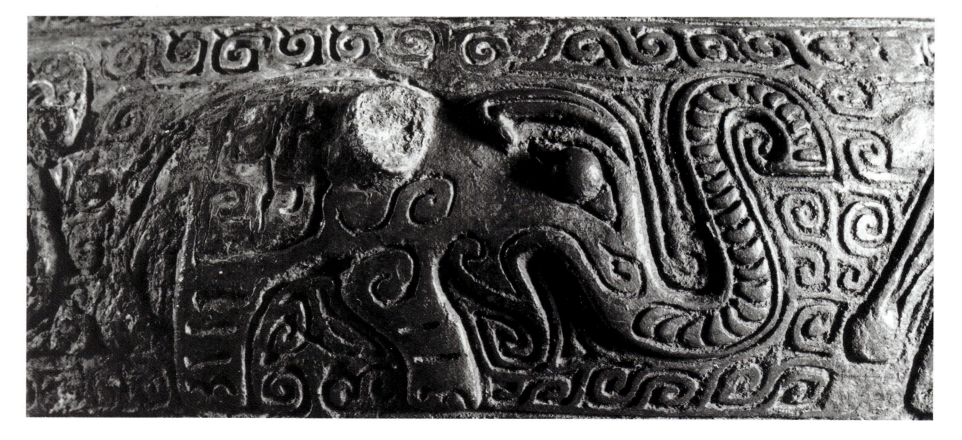

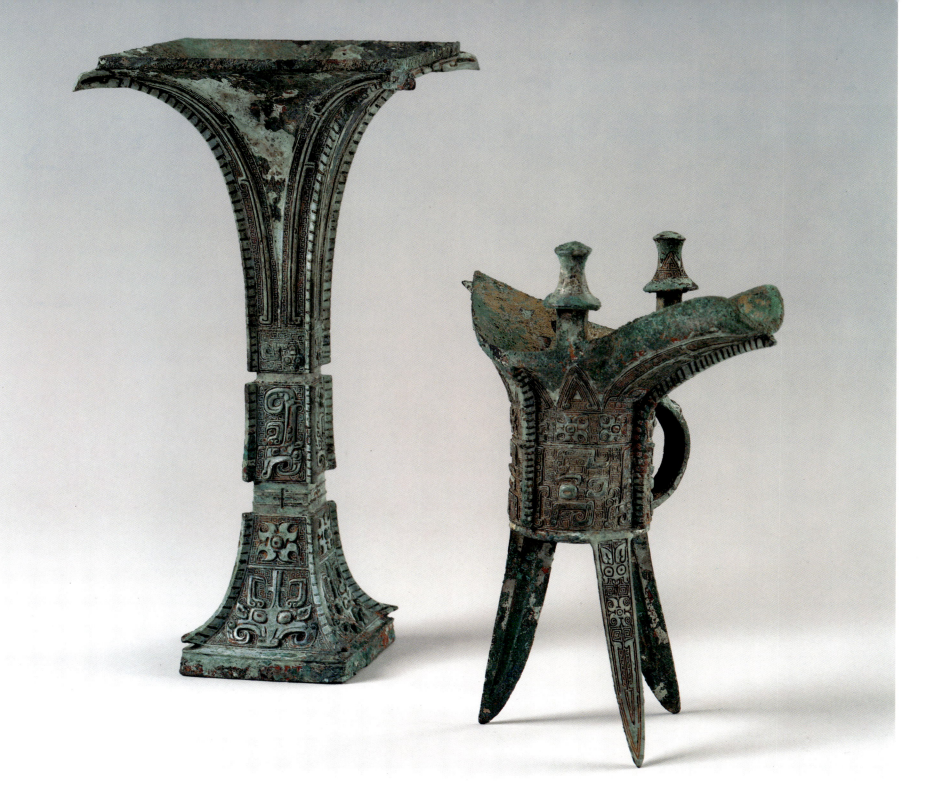

rated into the decorative scheme (vessel on the left above). They reinforce the symmetry of the object as they serve as a type of symmetrical axis for many of the motifs. The decorative zones of the early bronzes are always defined by the four sides of the mold used for casting; there is as yet no uninterrupted pattern encompassing the object. The crimped joins conceal the actual vertical division of the patterns. When inscriptions do appear on Anyang bronzes (and most have none at all) they are very short, perhaps containing only the tribal name, a dedication, or sacrificial inscription.

If there are inscriptions on the items, then they usually refer to the person interred in the tomb. A

fang ding 80 centimeters (31 inches) high found in the tomb of Fu Hao, for example, bears a cast inscription consisting of three characters "Hou mu xin," possibly a name bestowed by posterity.

In light of the variety of decorative types it is worth asking whether the human form, apart from as the victim of a tiger, was ever depicted as a decorative motif on Shang bronzes or, indeed, whether bronzes of the human figure were ever made. Until now no additional depictions have been found other than those which appear as semi-sculptural heads in the jaws of tigers or as faces on bronze jars of other types. However, ritual axes exist that feature the human face as a decorative

Above, vessel on right
Jue vessel

Late-Shang era with Three-Character inscription, dagger-like legs, H 22.5 cm, Museum für Ostasiatische Kunst, Cologne

The decoration of the vessel's body is interrupted by heavy casting burrs, and the legs are ornamented by stylized cicadas and also feature an animal visage. The inscription is identical to that of the square vessel next to it.

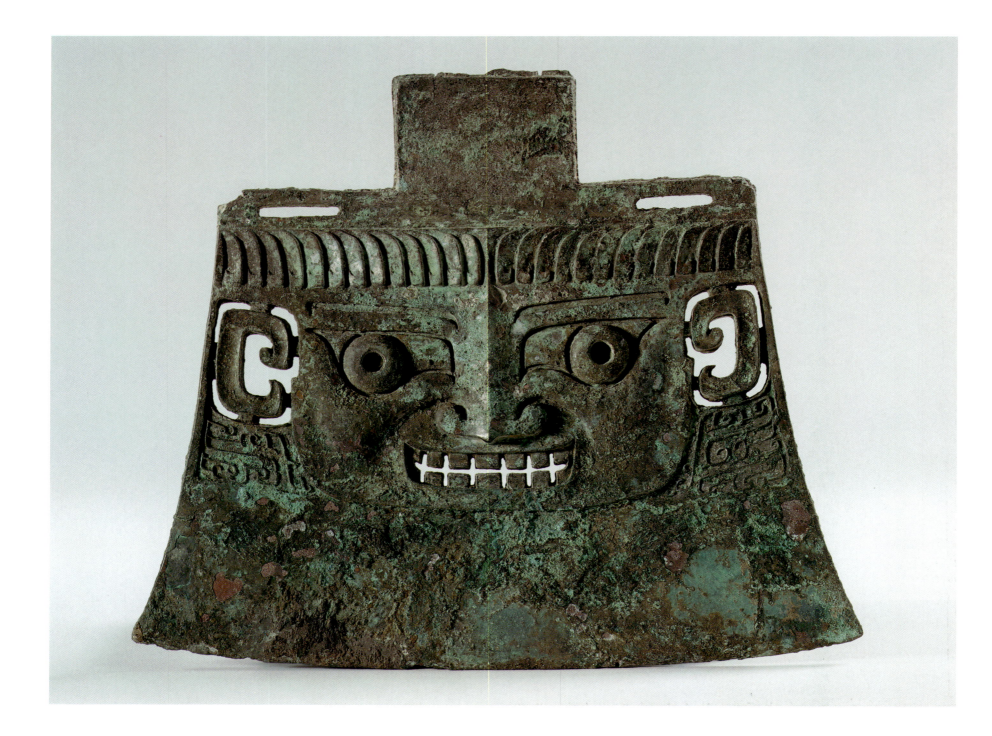

Top

Yue ax

12th/11th centuries, bronze, H 30.4 cm, B 35 cm, Museum für Ostasiatische Kunst, SMBPK, Berlin

The human mask shown on this sacrificial ax is depicted in relief form on both sides and the bronze has been pierced to show both mouth and ears.

Opposite

Standing figure

Shu culture, 13th–10th centuries B.C., bronze, H 262 cm, Institute for the Archaeology and Culture of Sichuan Province

device (see page 40). Masks are also ornamented by faces, reduced to eyes, nose, and mouth.

The finds at Sanxingdui in the 1980s shook the world of traditional archaeology. Until then it had always been taken for granted that the cradle of Chinese culture was on the plains along the Yellow River and was embodied by the high culture of the Shang. Sanxingdui, in what is today Sichuan Province near the city of Chengdu, lies well outside this postulated cultural homeland. In this distant western location, then, there existed a high culture at the same time as the Anyang phase of the Shang. Apart from breathtaking bronzes (see opposite page), it also produced utterly unique forms of pottery, jade, and gold.

In terms of size, the excavated city is comparable with Anyang and the finds leave no room for doubt that this was a center of a highly developed civilization. Two pits (rather than graves) are silent witnesses to the cultic rites performed here during the 13th–12th centuries B.C. The cult of the Shu, as the circumstances of the finds show, was different from that of the Shang and so too was the Shu aesthetic. The difference between the rituals becomes clear if we compare the 191 sacrificial pits of the Shang located close to their royal necropolis, or even those at Hougang, with the two pits at Sanxingdui. Animals and objects, including bronze copies of human heads, were sacrificed at Sanxingdui, whereas with the Shang the main currency of the sacrifice was clearly not artifacts but human life.[6]

The bronze *zun* at Sanxingdui were filled with cowry shells or jade blades. These blades, whose

function is not yet fully understood, have been seen as the counterpart to the piles of jade jewelry from the Fu Hao grave. However, no jade has been found in the sacrificial pits of the Shang; it was reserved for the grave of the deceased. Comparisons between Sanxingdui and the Fu Hao grave (which is anything but a sacrificial pit) or between Sanxingdui and the Anyang culture are unfortunately often not justified; while they may highlight affinities they also show up huge differences. Anyang texts refer to the cultic cremations of large numbers of animals, and this matches what was found at Sanxingdui. Apart from almost inconceivable quantities of animal bones – 3 cubic meters (4 cubic yards) in Pit 1 – the sacrificial pits contained elephant tusks, jade blades, and 50 bronze replicas of bronze discs, the latter being a unique find. The sacrificial pits at Sanxingdui held mostly artifacts of jade and stone. To the astonishment of archaeologists, a large number of bronze heads were found that have enormous eyes and angular, almost abstract features. These life-sized heads, with their surreal expressions, are the most spectacular recent contribution to archaeological research. The facial features of the heads differ greatly and have big, often bulging, eyes and large mouths. Their simplified linear forms call to mind qualities such as decisiveness and strength (see page 42).

The first reaction of some researchers was to reject the finds because they did not fit in with the established image of Chinese culture. As Craig Clunas has observed: "In other words, they did not look like the things that had been used to construct an idea of Chineseness."[7]

Already during the neolithic era it seems there was no such thing as a "central Chinese culture." Even recent finds such as the Sichuan sculptures or the forms of artistic expression created by cultures contemporaneous with the Han or Zhou, which do not fit the pattern of a central Chinese culture, continue to modify our ideas of what Clunas has so aptly called "Chineseness."

Mutual exchanges and contacts between both cultural groups cannot be ruled out. Texts indicate that at the time of Wu Ding, the Shang were at war with the Shu, the inhabitants of the region around Sanxingdui. This brings us back to the warlike nature of Shang culture and the way it was enacted in ritual – and, of course, to their weapons for ritual axes and blades, like bronze vessels, have survived the passage of time.

If the oracle required a ritual act, bronze weapons were used, though these presumably served the purpose of ritual slaughter and were not intended for general military use. One oracular text, for example, asks whether, as an offering to King Wu Ding, 30 people should be beheaded and three pairs of oxen slaughtered with the ritual ax (Chang 9.13) – an act which, according to a text appended to the oracle, was in fact carried out. The character for "ritual ax" means "ax with a broad blade." Today, these axes are associated with the most elaborately decorated of finds (see page 43).

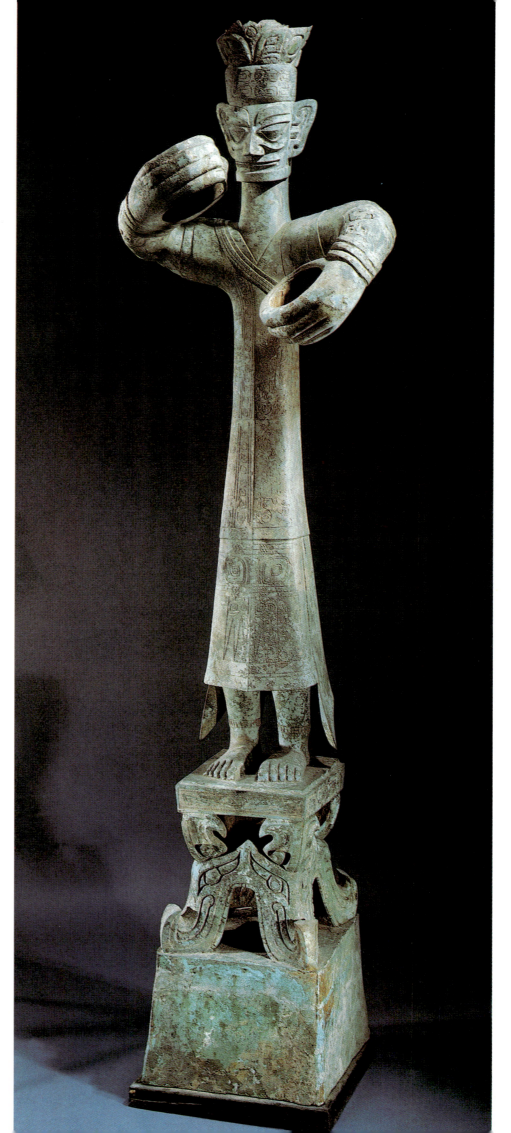

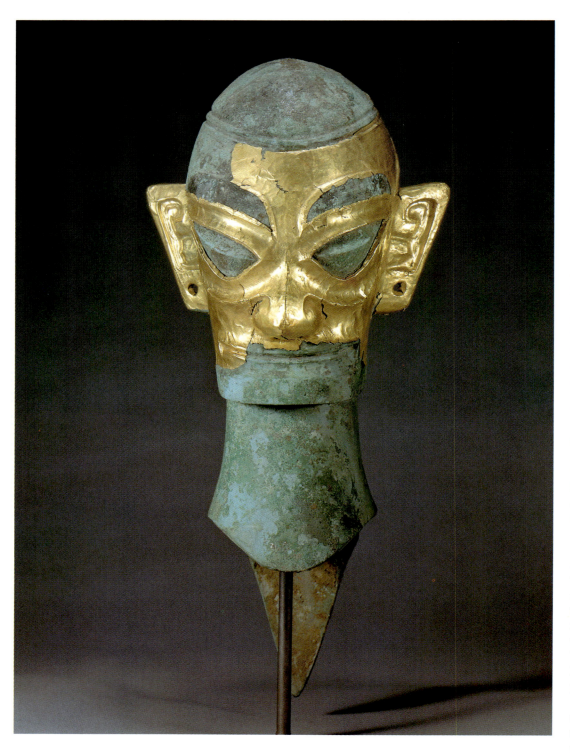

Bronze head with "mask" of gold leaf

H 48.5 cm, Sanxingdui, Grave 2, Institute for the Archaeology and Culture of Sichuan Province

of warfare. Besides ritual objects and the relics of war, the first (albeit rare) mirrors of the Shang were also found near Anyang. Chinese mirrors were essentially round discs without a handle, in the Western sense of the term. In the middle of the reverse side was a bridge-shaped button through which a ribbon was drawn for the user to hold the mirror still. These objects are between 7 and 12 centimeters (2.8 and 4.7 inches) in diameter and bear a geometrical decoration, as well as lines resembling the teeth of a comb.

Bronzes seem almost omnipresent in their tombs. The treatment of bronze surfaces as decorative zones leads one to believe that pottery, a much older craft, would show similar forms also. There should not have been any technical difficulties, for the bronze decorations were already present in negative form on the ceramic casts. Interestingly, however, there are no further parallels between bronzes and ceramics. There were different types of pottery, such as fine, white ceramics for the upper class and more coarse, gray and brown material for the everyday use of the rest of the population. The surface treatment took a step backwards; pottery was ornamented solely with impressed or etched patterns.

Lacquers, which were later to play a major role in the applied arts of China, are also in evidence from the Shang era onwards. Lacquer, the first "natural synthetic," was used for large objects and has been found at archaeological sites in China from the Shang dynasty onwards. The first such find was a small red lacquer bowl from the neolithic settlement at Hemudu.

According to tradition, the mythical Emperor Shun (2258–2206 B.C.) had an eating bowl which was painted with lacquer – indeed, he is considered the inventor of lacquer. It is therefore obvious what the main purpose of lacquer was: as a varnish for all types of wood; at first for kitchen vessels, then weapons, furniture, and decorative objects. Traces of lacquer found on the coffin of Lady Fu Hao are evidence of its early use for sacred purposes also.

Lacquer itself does not present a problem for conservators; the problems are caused rather by the material it has been applied to: wood, bamboo, wickerwork, leather, metal, clay, porcelain, textiles, paper. These last mentioned materials are especially important for the dry lacquer technique. The clearest example of the problems of conservation, however, is illustrated by lacquered wood: almost all early lacquered objects show wrinkled surfaces because the inner structure of wood has reacted to moisture, temperature, or other changes in the nature of its composition by shrinking or otherwise distorting.

Although the lacquer was always applied on top of a primer, this was never sufficient to compensate for changes in the raw material. If lacquered work is discovered today, it often happens that conservation measures come too late to prevent the lacquer becoming detached from its base. In many cases only the sketches made in the first few hours

The Shang used a horse-drawn chariot, but horses may well have been bred in other regions, so that raids had to be carried out to obtain suitable stock. "On the day of Chia-Ch'en of the first month, Cheng asked the oracle: We wish to campaign against the Land of the Horses. Will Ti aid us?" (Chang 15.15).

Even later, in the Han dynasty, China's horses were considered inferior to the noble steeds of Ferghana (Central Asia). If trade did not work they were acquired by force. The bronze fittings of the chariots, which, along with ritual objects have been unearthed in finds from that era, document the technical achievements of the Shang in the art

after the unearthing of the finds exist, the objects having since disintegrated.

Other objects besides ceramics and bronzes from the Anyang phase have been found: stone and jade carvings; small sculptures (of owls and other animals) that are difficult to distinguish from the two-dimensional depictions on bronze vessels; figurines of people; and the strange *cong* blocks and *bi* discs, which were already in use in the neolithic era. The latter were associated with Chinese cosmology; the earth was seen as square and the sky as round, concepts united in the *cong*. Unfortunately, the oracular inscriptions do not offer more detailed information on these objects other than that the *cong* were sacrificed, although not in any specific sense: "On the day of Wu-wu the oracle was asked: Should the king sacrifice to the Turtle River three pairs of sheep by cultic cremation and three pairs of sheep and a jade Ts'ung by cultic burial?" (Chang 12.46).

One can, however, compare the surface decoration and contours of jade objects with those already known from the surfaces of bronzes. Only the *taotie* was not used as a decoration for jade.

In conclusion, it can be said that an established canon of form and content (*signifiant* and *signifié*)

already existed. Even the possible origin of bronze decoration in the jade decorations of previous eras supports this interpretation. Today, we look at the form and admire the realistic way in which animals were depicted; but we can never know what these depictions meant for the contemporary Chinese viewer or for the artists who made them. The frequency and the continuity with which these decorations were used, and their relation to one another, show that they were deeply embedded in their cultural context. Ultimately, their significance may have lain in the religion of the day.

According to traditional historical texts the Shang dynasty ended in tyranny and chaos. From their homelands to the west the tribes of the Zhou were able to penetrate Shang territory and spread out even more widely. The Zhou were a steppe people who gradually adopted the culture of the Shang while holding on to some of their own traditions. This phenomenon, which also occurred later with other peoples, is called "Sinocization" — the complete adaptation to Chinese culture. The synthesis of Zhou and Shang culture brought changes in almost every sphere and affected spiritual life and art in equal measure.

Yue ritual ax

Late Shang era, bronze, H 16.7 cm,
W 17.7 cm, Sotheby's

This ax has characteristic *taotie* decoration (below the shaft), from which the body of a winged animal is emerging. This motif is similar to the bat decoration common to later Chinese traditions. The curve of the wings emphasizes the spiraled ends of the ax.

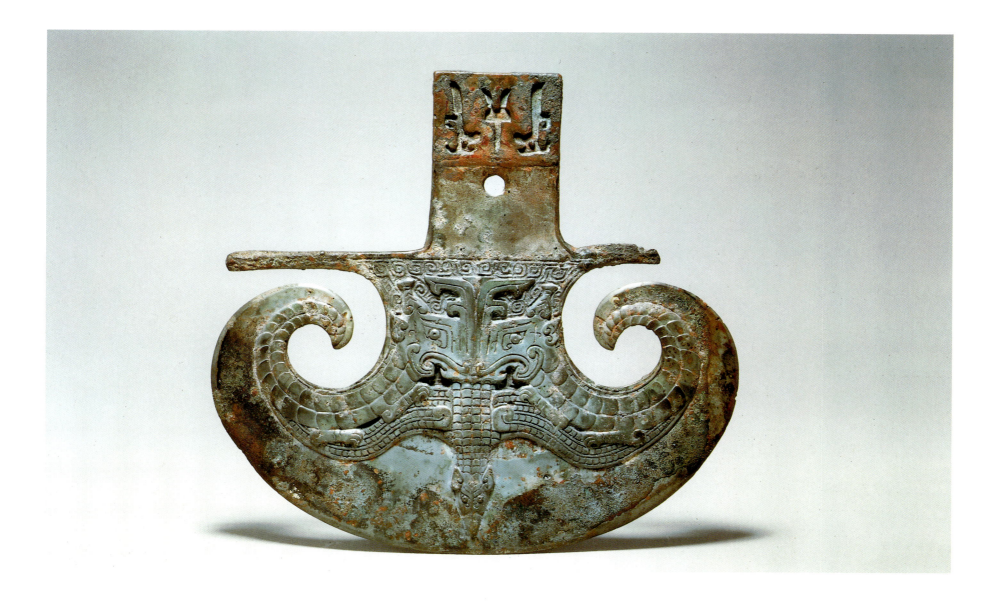

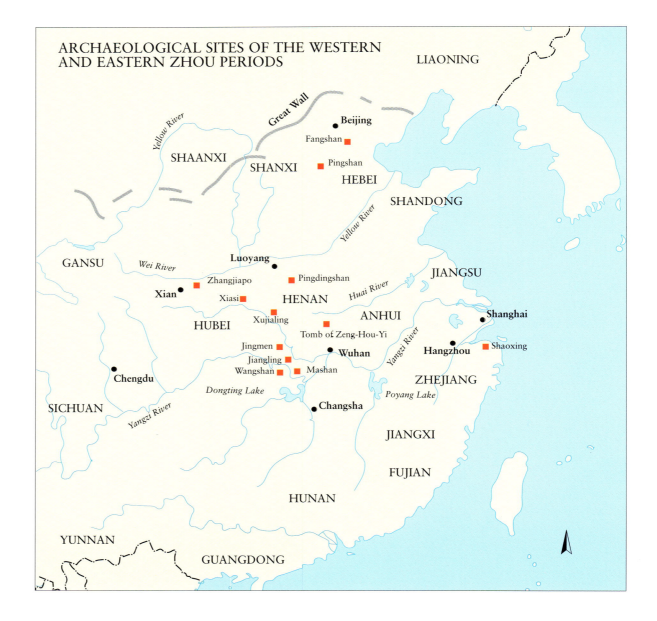

ARCHAEOLOGICAL SITES OF THE WESTERN
AND EASTERN ZHOU PERIODS

The Zhou: One Dynasty, Three Epochs, and the Great Philosophers of China

(1066–256/221 B.C.)

"King Yuan of Song summoned a meeting of painters. All the artists had gathered; they bowed, and then stood moistening their brushes with their lips and preparing the ink. Half were still outside. One artist arrived too late, strolling along at his ease. After making the usual obeisance, he went straight in without more ado. The king sent people to see what he was doing. He had removed his garment and was sitting there naked. 'This is a true painter,' said the king."

Zhuang Zi (about 314–275 B.C.),
in Tian zi fang[1]

Zhuang Zi's philosophical work dates from the last part of a great period. He was not the only Chinese philosopher to make early references to painting in China. Kong Zi (551–479 B.C.) – Confucius is his more familiar name – and later Han Fei Zi (died 234 B.C.) put forward ideas that

are relevant in the widest sense to Chinese attitudes to painting. These three lived in turbulent times. The Zhou dynasty held power for over 800 years (1066–256/221 B.C.), a period divided into three sections by far-reaching social upheavals. Like traditional Chinese historians, we still distinguish between the Western Zhou period (11th century through 771 B.C.) and the Eastern Zhou period (770–256 B.C.). The latter in turn is subdivided into the Chunqiu period (Spring and Autumn Annals, 722–476 B.C.) and the Zhanguo period (Warring States, 476–221 B.C.).

The Zhou Dynasty originated in the west; a warlike people threatening the native land of the Shang had already been mentioned in the Shang dynasty oracle texts of the 14th to the 12th centuries B.C. After the Zhou overthrew them Shang territory was divided up and a feudal system was introduced. The leader of the Zhou became king,

pledging himself to his followers by investing them with feudal tenure. The feudal lords were to defend the borders of the realm for the king at the head of the system, perform military service, pay tribute, and supply laborers to work the royal domains. The king was the supreme feudal lord and spiritual leader, but the extent of his real power is a matter of controversy today, since precise details of the system are unknown.

Another invasion from the west brought an end to the Western Zhou dynasty on the death of the ruling king You (reigned 781–771 B.C.). After the loss of their old crown lands in the 8th century B.C., the Zhou kings had no real power left, and continued merely as a matter of protocol.

China in the Chunqiu period was a feudal society. The aristocratic hierarchy was further differentiated on the basis of the hereditary rights of primogeniture: ranks such as dukes, feudal princes, margraves, counts, and baron were introduced. The peasants were serfs, obliged to pay dues and do forced labor. Craftsmen and merchants were exclusively at the service of the aristocracy, who also had slaves at their disposal in the form of prisoners of war and criminals. In the scale of social prestige, the nobility were followed by scholars; next came peasants, then craftsmen, and finally traders. Over the course of time land passed into private ownership, and after 594 B.C. feudal dues were replaced by taxes. During the Chunqiu period some of the feudal states were temporarily ruled by several kings. Around 490 B.C. the feudal league disintegrated in a struggle for supremacy, with each of the princes trying to seize control of the whole realm. The turbulent period that followed saw the emergence of China's great philosophers: Lao Zi and Zhuang Zi, who were Daoists and founded the only school of philosophy approximating a religion, since it inquired into the origin of being and the course of natural processes; Confucius, Meng Zi, and Xun Zi, representing different branches of Confucianism; and a number of other thinkers, such as Mo Zi and Han Fei Zi.

Religion was still much the same as in the Shang period: ancestor worship was highly developed and nature deities were venerated, but the supreme god of the Zhou was *tian*, Heaven. Whereas Shang rulers had been deified after their deaths as *di*, and were thought to be close to the supreme god Shang Di, the belief in *tian* created a gulf between the ancestral spirits and the supreme god of the Zhou. *Tian* was an external power from which the Zhou kings derived their mandate to rule. When the Han emperors came to power as rulers of a united realm, they again referred to *tian* as the authority for their mandate to rule.

The life of Confucius falls directly into the period of "transition from magic concepts of religion to rationality."[2] Like other philosophers, he moved from one to another of the mutually hostile kingdoms as teacher, adviser, and scribe, offering suggestions for improving the situation — that is to say, the situation of the ruler, and, in some cases, of the people as well. One of his themes was the question of how a nobleman could become worthy to receive the mandate of Heaven. The philosophical content of his doctrine, as it emerges from the writings of his pupils and of later generations, may be interpreted in social and political terms. Master Kong put forward an ideal of

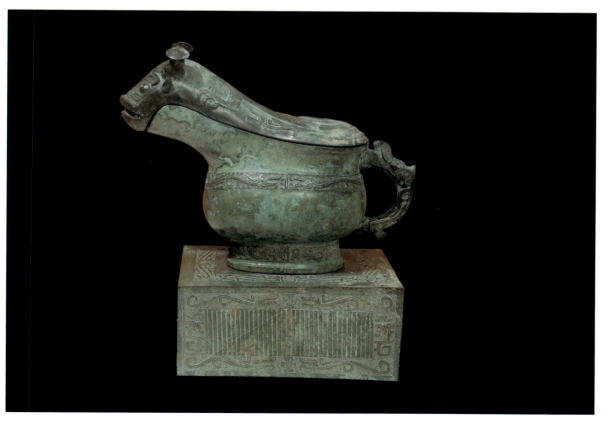

Vessel of the *gong* type on a bronze table

Early Western Zhou period, overall H 50 cm, H of vessel 31.2 cm, L 41 cm, Copenhagen

This vessel derives its present name of the Gao Tian Gong from the two-character inscription *gao tian*. The lid, shaped like the head of a dragon, bears decoration in relief, and the body of the vessel has bands of decoration in the shape of the long bodies of dragons in front of a *leiwen*. The shorter sides of the table are pierced and decorated in low relief; the longer sides have an ornamental pattern consisting of the abstract bodies of dragons, symmetrically arranged, and a series of uprights.

成門

virtue, a model which, he suggested, had existed in the past: Confucian morality consisting of human goodness (*ren*), justice (*yi*), and childlike obedience or piety (*xiao*). *Xiao* included piety to the dead: family members who had become ancestors and still needed to be cared for in the next world. They were supplied with food, drink, and material goods. Confucius made moral demands on his followers: if everyone, high and low alike, lived in accordance with his ideal morality then all would be well with the individual, the family, the nation and its ruler, and there would be peace in the land. Seen against the chaotic background of the time, the political content of his teaching is a call for peace, unity, and the exercise of authority by the man best able to wield it, as in the case of the emperors and kings of the distant past, and he saw that man as someone whose morality and ethics were unimpeachable. His thinking was not widely influential until the Han dynasty period, when Confucianism became the state ethical system.

The Zhanguo period, the time of the Warring States, was marked by wars, annexations, short-lived peace treaties, and changing allegiances. Seven states had emerged victorious from the preceding feudal period, and now confronted each other in the struggle for control. In territorial terms, they ruled the modern provinces of Liaoning, Hebei, Shandong, Shaanxi, Shensi, Henan, Hubei, northern Jiangxi and Zhejiang, as well as Anhui, altogether about a fifth of the present area of China. The king of Qin, the best strategist, finally won supremacy, deploying vast armies, a powerful cavalry, and adroit negotiating skills.

Yet again, the creative works produced during these 800 turbulent years show that there was no single form of Chinese art. However, it is interesting that the ruling house set standards for the territorial princes, commissioning and preserving works of art that were regarded as the norm and were expected to endure for thousands of years.

The customs of the Zhou period changed the funerary cult in two respects: the design of graves changed and the number of human sacrifices was greatly reduced. The pit burials of the Shang were replaced by burials in mounds or tumuli. These

Above
Statue of Confucius

Ming dynasty (1368–1644), Confucian temple, Kong miao, Beijing

The idealized depiction of the philosopher shows him wearing a robe and the cap of a Chinese state official.

Opposite, right
Rectangular vessel of the *hu* type

Late Western Zhou period, 12-character inscription, H 66 cm, Hubei Provincial Museum

This piece has a wave motif filling six decorative areas with different patterns. The handles were made separately and the lid has a superstructure resembling a crown.

Opposite, left
Stand for drum

Zhanguo period, coiling dragons in openwork bronze, dia 54 cm, tomb of Count Yi of Zeng, Hubei Provincial Museum

tumuli still contained large quantities of magnificent objects once used by the dead in everyday life. A change in the concept of the grave itself is also perceptible. In contrast to the cross-shaped pit burials of the Shang aristocracy, the Zhou laid out underground "buildings," with rooms connecting as they would in a dwelling house. The grave contained copies of everyday utensils and may be described as the dwelling of the dead person.

Territorial princes who wished to partake of this splendor imitated the customs of the ruling house. Bronzes made at the courts of the aristocracy were still the most usual grave goods. Eventually a branch of production developed to supply the demand for objects designed for use as grave goods; the word used for them was *minqi*, whereas the word for items used in daily life was *shengqi*.

Bronze vessels differed from the ornate ceremonial vessels of the Shang in their massive sculptural forms (see right). In the later phase, bronzes became elegant and mannerist in both form and ornamentation (see below).

The largest complex of bronzes of the Zhou period was found between 1956 and 1961 in Houma in Shaanxi, once the metropolis of the feudal state of Jin (584 B.C.) and then the seat of the feudal lords of the Wei (from 450 B.C.). Smelting furnaces and crucibles (*kanguo*) were found, together with over 30,000 clay molds for bronze casting.

Finds from graves around Zhuoyuan, and many other items from hoards, provide valuable information about the kinds of bronzes made in the first period of the Zhou dynasty. Most of the many bronzes found in hoards date from the period of the western invasion in the early 8th century B.C., which would make 771, the year when the western capital was destroyed by Quan Rong armies, the *terminus ante quem* for dating a number of finds. The Zhuangbai hoard from the district of Fufeng, including bronzes commissioned by four generations of the same family, even allows us to trace stylistic developments. The bronzes bear inscriptions naming clan leaders and are made in different styles. The earliest were commissioned by the clan chieftain Zhe, and have prominent flanges left by

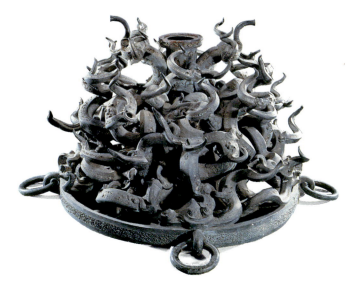

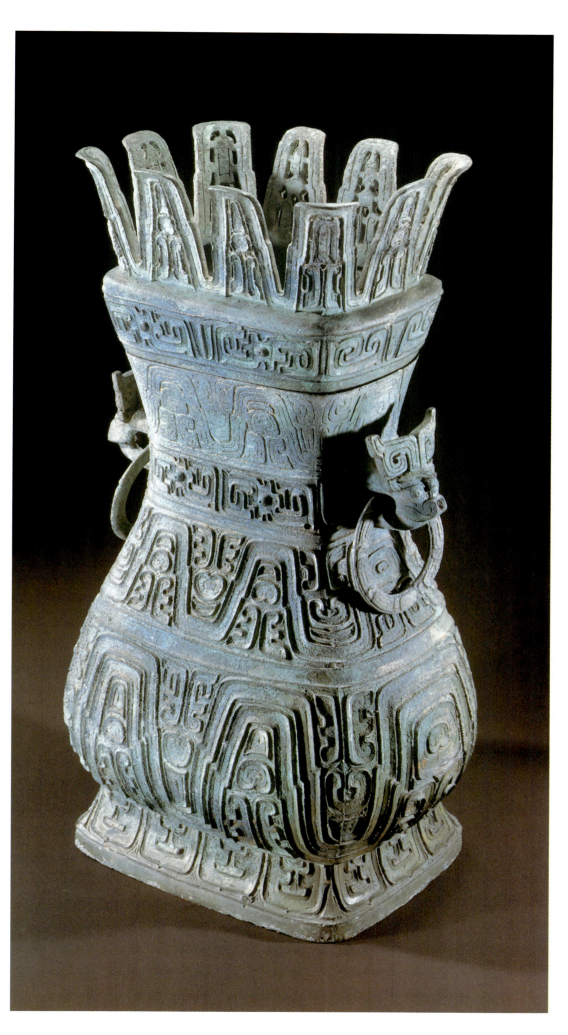

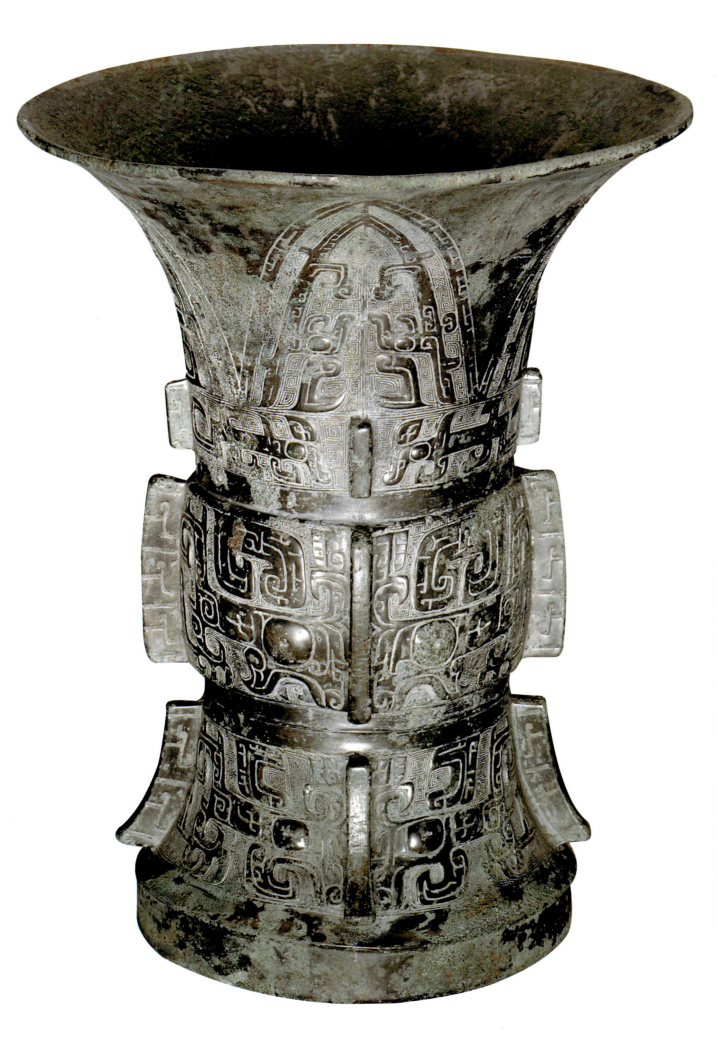

Opposite, left
Wine container of the *you* type

10th century B.C., H 16.8 cm, in the Zhuangbai hoard, Zhouyuan Museum

This vessel has no casting flanges. Three-dimensionally worked animal heads are set on the rings of the handle and in the flat decorative area below the rim.

Opposite, right
Lidded container of the *you* type

10th century B.C., H 24.8 cm to handle, British Museum, London

This vessel shows symmetrical decoration with a bird motif between the flanges.

Left
Vessel of the *zun* type

Early Western Zhou period, 11th century B.C., H 30.5 cm, dia 23.8 cm, Baoji Municipal Museum

This vessel is ornamented above the central section with long, stylized dragons endowed with elephants' trunks, and in the upper area of the curved mouth with vertical dragons in cicada-shaped fields.

Below
Tripod

Early Western Zhou period, 11th to 10th century B.C., H 89.5 cm, Shaanxi Provincial Museum

The decorated area is directly below the rim, and the two upright handles are ornamented with two feline creatures.

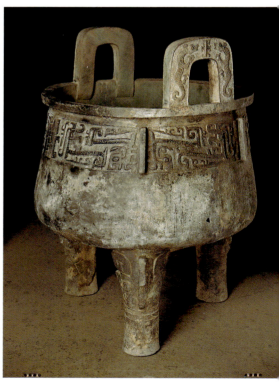

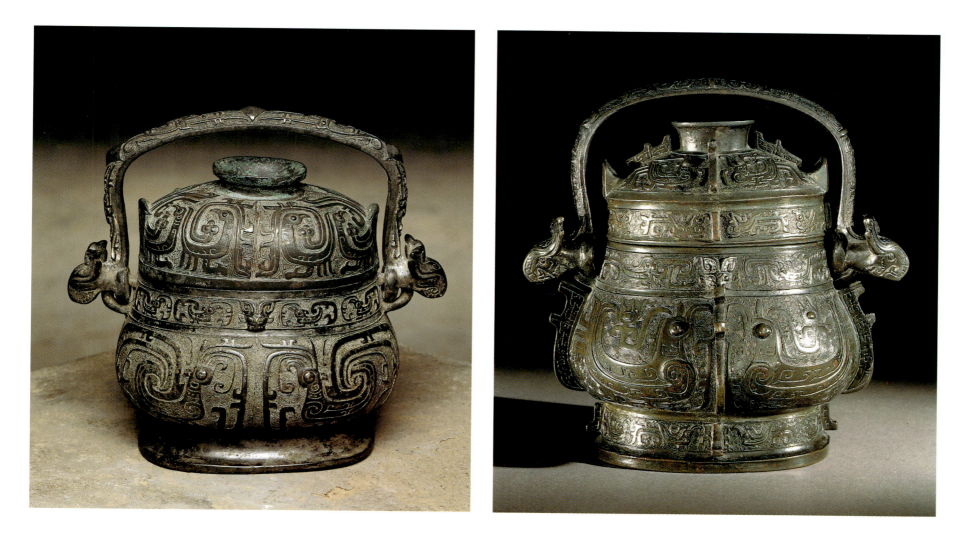

the casting process. The strong profile of these flanges gives these early Zhou bronzes a massive, almost menacing appearance; they were phased out during the Chunqiu period.

So far as we know, the most common decorative motifs of the early period were first the ornate *taotie* mask, then a bird with feathers held erect, some drooping to the ground again in front of the bird's head. In the middle of the Western Zhou period the bird gradually superseded the *taotie* mask. The clan leader Feng commissioned works ornamented with motifs of the long-tailed bird type and without prominent flanges (see above, left). The leader after Feng left some very abstract bird ornamentation in what are called the Shi Qiang pieces. The last generation to contribute to this hoard was that of Xing (also known as the Wei Bo Xing bronzes, from their inscriptions). The Xing bronzes are notable for the large number of *jue* pouring vessels among them.

The development of bronzes during the Western Zhou period can be summed up follows. First, the adoption of Shang forms and decoration was characteristic of the early period, the main motif being the *taotie*, with ornamentation clearly divided between zones. The Shang sculptural style, flanges left after casting, and the *zun* animal (see page 50) were all adopted in the early period.

Originally round forms of vessels were increasingly made in an angular style and shape; the round goblet (*gu*) of the Shang is an example of this trend. In the course of this development tripod vessels acquired a fourth leg, a shape of vessel called *fang ding* (see page 51, top right).

In the middle of the Western Zhou period flanges disappeared and shapes became softer. Decorative bands become genuinely continuous for the first time, and there were no flanges marking vertical divisions. Coiling dragons joined the birds as ornamental motifs, and surfaces were delicately worked all over. Areas of low relief in graphic patterns bore a main ornamental motif such as a bird, or the lines of the ornamentation might be doubled. Animal motifs were integrated into pattern bands, with dragons stretched out full length featuring as decorative motifs. Naturalistic forms were subordinate to stylized ornament. There was also all-over decoration such as fish scale patterns (see opposite, left), and ornamentation consisting of continuous decorative bands with plain, undecorated areas left between them.

A characteristic of the last phase of the Western Zhou bronzes was a formal change. Food containers were now predominant among grave goods, and there were fewer vessels to hold wine; only the *hu* vessel remained. Some food containers were made in new shapes: the *fu*, a rectangular container with a lid identical to its body; the rectangular *xu*, a shape borrowed from the *gui* container; and the *dou*, a bowl on a low foot

Lidded vessel of the *you* type

An 18th-century illustration of the lidded *you* vessel shown above, from the Qianlong catalog *Xi qing gu jian*, an extensive textual account of the collection of the Qing Emperor of the Qianlong era (1736–1795), recording the history of the piece after it was found.

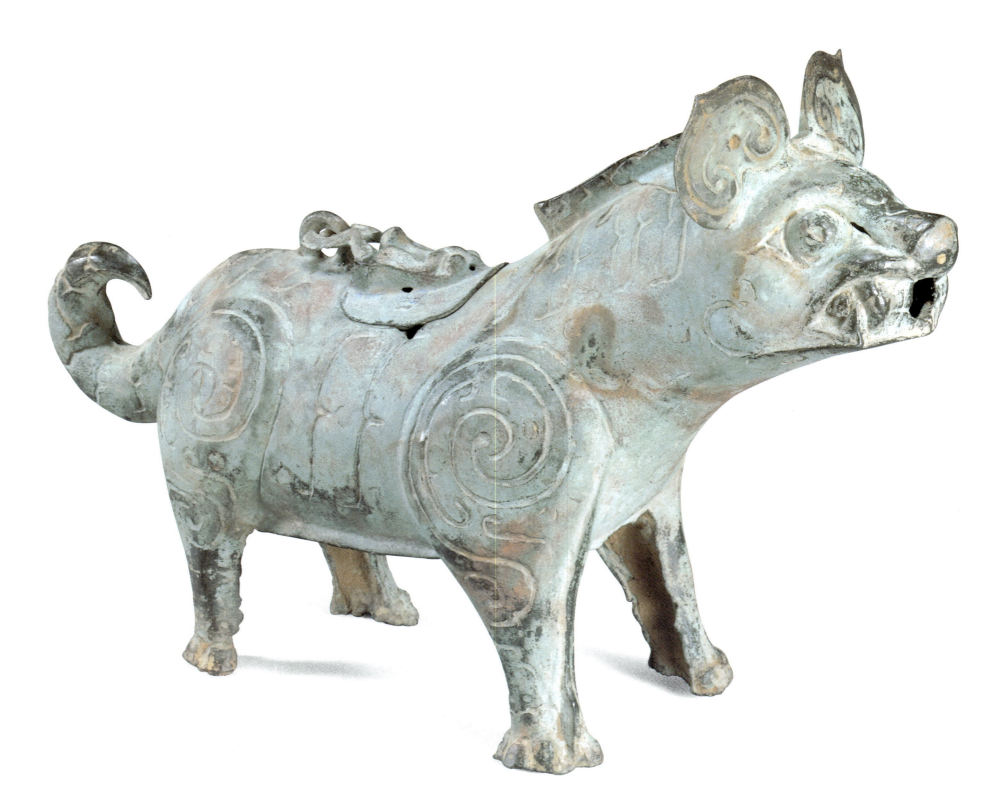

Zun animal

About 1013–879 B.C., H 21.8 cm,
Jingzhou Museum

This *zun*, in the form of a tiger with
clearly emphasized fangs, has
ornamentation on the surface of the body,
although it does not imitate the markings
of a tiger's skin. The ears are decorated
with volutes.

deriving from the neolithic ceramic *dou*. Besides
these innovations of form, bronze workers also
introduced new decorative styles. Zoomorphic
ornamentation was greatly simplified to form
abstract designs. Large abstract wavy bands in low
relief became as fashionable as continuous
patterned bands (see opposite page, below right).

The development of the continuous band
(introduced with the disappearance of the vertical
divisions caused by the casting mold) culminated
in optically three-dimensional ornamentation: it
has been rightly observed that Western Zhou
casters invented interlace patterns.[3] Parts of the

ornamentation or whole motifs interlock, and
decorative motifs penetrate one another to create a
new sense of depth. Interlace patterns and contin-
uous bands were to be the norm in the Eastern
Zhou period.

Another feature of early Zhou bronzes was the
increasing length of their inscriptions. The type of
script used was "greater seal," *da zhuan*. At first the
inscriptions related only to a dedication or a sacri-
fice, and were intended to convey news of impor-
tant events or to ask the ancestors questions, but
later they might record imperial decrees or infor-
mation about the conquest of territory, occasions

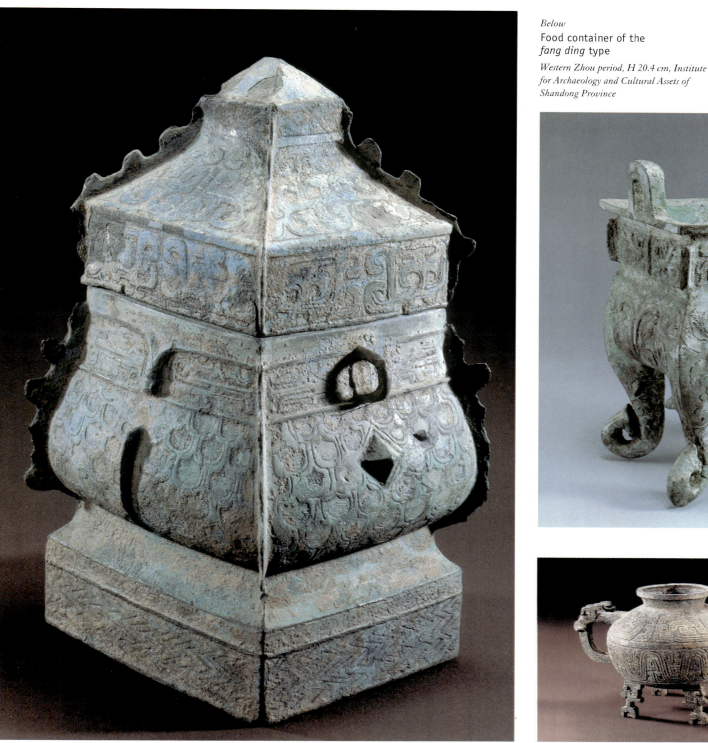

Food container of the *fang ding* type

Western Zhou period, H 20.4 cm, Institute for Archaeology and Cultural Assets of Shandong Province

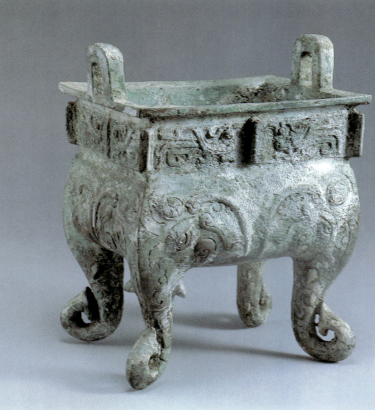

This vessel has feet shaped like elephants' heads and trunks and a surface design in the shape of the spiral *yunwen* cloud pattern. Below the mouth of the vessel there is a band ornamented with the phoenix motif in front of *leiwen* symbols.

of rejoicing, punitive expeditions, military campaigns, appointments, promotions, and enfeoffments. Such inscriptions provide scholars with useful historical records. The inscriptions are seldom found on the outside of the bronzes, but are located inside or underneath. The Tripod of Duke Mao (*mao gong ding*) bears one of the longest inscriptions, in all 32 lines of text and 500 written characters and located on the bottom of the interior of the vessel. So far as we can tell from the finds, however, there was no standard location for inscriptions. The Eastern Zhou period brought with it great regional diversity in bronzes: the fash-

ions, technical capabilities, and styles of one small state were not necessarily those of its neighbor.

Regional styles developed at different times and in various places, and exerted very different influences on each other, or related to very different models. The artistic situation of the period is even more confusing than its political situation. Bronzes from the feudal states of Chu, Qi and Yan, Jin, and Qin illustrate the great diversity of artistic expression now current. The interlace pattern, however, was not abandoned.

A grave pre-dating 655 B.C. in the feudal state of Guo contained many bronzes ornamented with

Above left

Food container of the *fang yi* type

Late Western Zhou period, H 32 cm, Hubei Provincial Museum

This *fang yi* container is decorated with a fish-scale pattern.

Above right

Pitcher of the *he* type

Late Western Zhou period, H 20.5 cm, Hubei Provincial Museum

This pitcher stands on four zoomorphic feet.

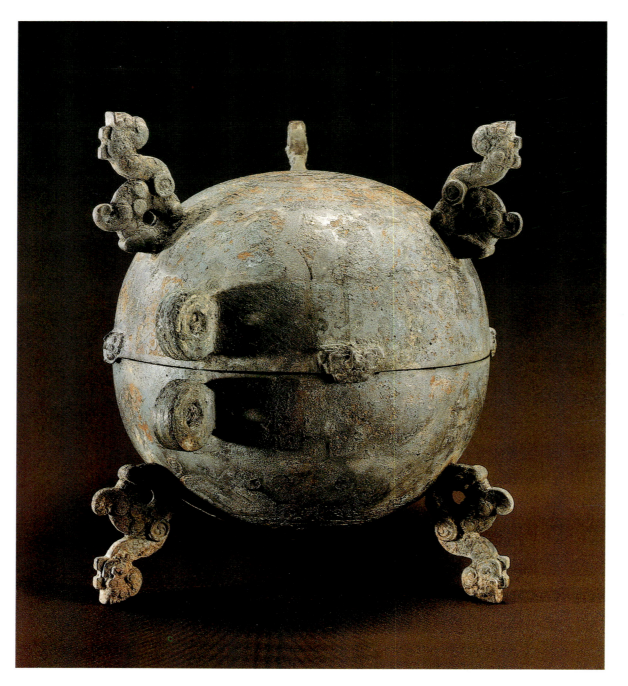

Left
Food container of the *dui* type

Chunqiu period, bronze, H 27 cm, dia 21.5 cm, site of find previously in the state of Chu, Hubei Provincial Museum

Opposite
Vessel of the *hu* type

Chunqiu period, H 67.1 cm, feudal state of Zheng, Institute for Archaeology and Cultural Assets of Henan Province

The vessel has interlace decoration of an abstract pattern in high relief, with linear ornamentation in low relief worked into it. The animal heads suggest a relationship to bats, but with their button eyes and flat noses are probably to be regarded as abstract.

looped interwoven bands. The surface gives a unified, densely worked impression. The territory of the feudal state of Jin, where the Houma find was made, has provided bronzes made in the Liyu style of interlocking ornamentation: serpentine bodies adorned with textural intaglio lines, grouped together as dragon shapes in higher relief. In the southern states of Wu, Cai, and Chu, where the *taotie* masks and the feathered birds of the Western Zhou bronzes of the capital were still used as motifs, foreground and background ornamentation was introduced. The dense Huai style, together with patterns of coiling snakes and reptiles against a crosshatched background, developed in the state of Wu; coiling lines and recurrent textures were applied not in horizontal bands but over the whole surface of the vessel.

The bronze workers of Chu copied examples of the early Western Zhou period, combining them

with interlaced reliefs. We may assume that the ornamental casting flanges of the early Zhou developed into the pierced bronzes of Chu, where not only the handles and feet of vessels but their entire bodies were decorated with three-dimensional openwork ornamentation. Horizontal bands of relief passed around the walls of the vessel, with openwork curlicue patterns superimposed on them.

Musical instruments bore a decoration similar to that of the vessels of the time; it is found on *gu* drums, a new kind of tubular drum (played standing on its end with the head of the drum facing up), and on bells. Inscriptions, always on the exterior of musical instruments, complemented their ornamentation. Bells seem to have enjoyed new importance at the time, judging by the innovations of shape and the large number of bells necessary to make up a set. Another type of

Rubbing of the inscription of the Zhou Jing Dui

Sinologisches Institut of Frankfurt University

The script is "greater seal" script.

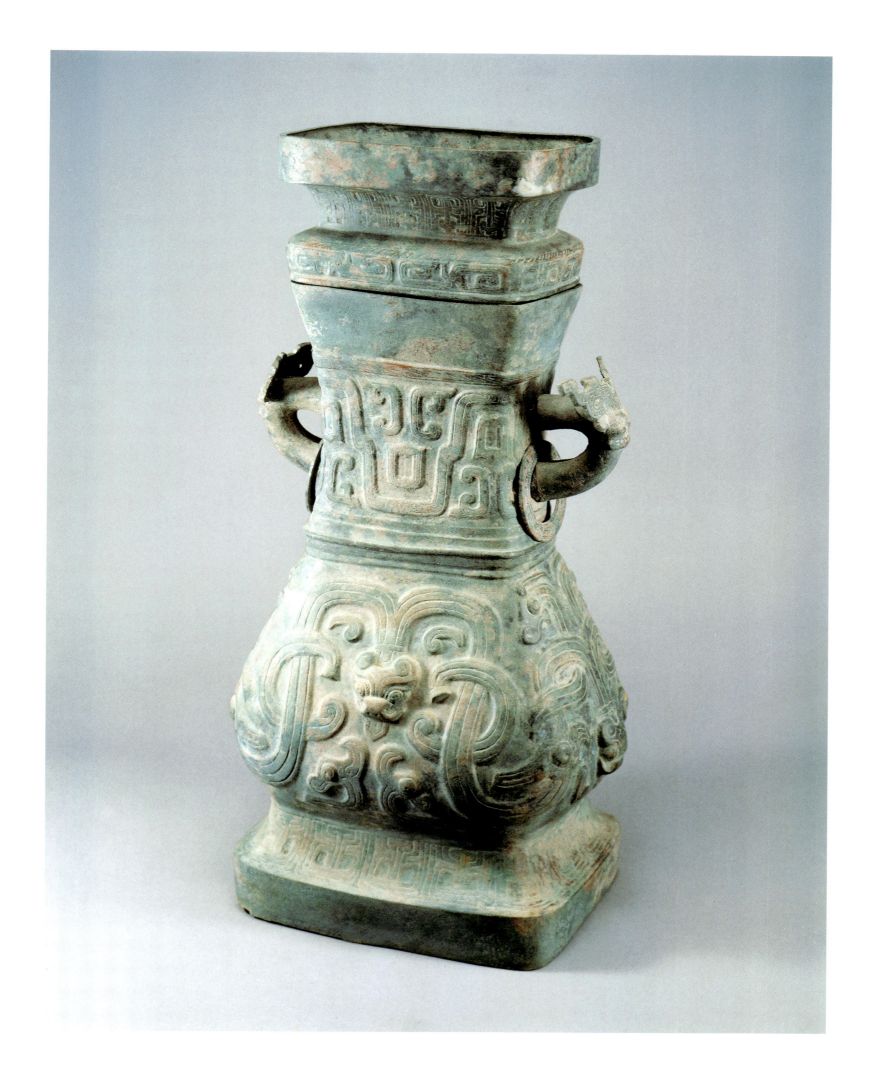

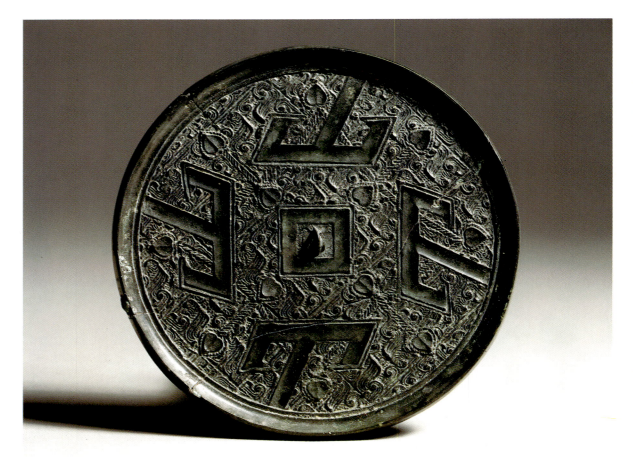

bell, for military use, was probably introduced
during the Zhanguo period: the *chun* bell, rather
like the European cowbell in shape.

The *zhong* bell developed from the *zheng* bell of
the Shang period. It was still a ritual musical
instrument, but the concept behind its design had
changed and it now had to hang from a frame or
stand. There were two types: the relatively small
bian zhong bells and the large *te zhong (bo-)* bells.
Both sides of a bell usually bore the same decora-
tion. Further developments in ceremonial music
called for bells of different pitch, and the 65 deco-
rated bells found in 1978 in the tomb of Count Yi
(Zeng Hou Yi), in the modern city of Suizhou in
the province of Hubei, are striking both for their
dense ornamentation of spirals and small knots
and for their magnificent stands.

This find from the Zhanguo period, with 65
bells divided into eight registers, comprises 64 *bian*
bells, and one *bo* bell weighing 203 kilograms (445
pounds) and 1.53 meters (5 feet) in height. Each of
the *bian* bells is marked with its pitch, and the
inscription on one provides information dating the
tomb to 433 B.C. Figures in human form are used
as the uprights of the beams from which the bells
hang. These three-dimensional bronzes wear
swords and headdresses; their arms, too long for
their bodies, support the crossbeams of the bell
holders, and tiger clasps hold the bells themselves
in place (see opposite, below).

The fittings of the beams are also covered with
relief work; the line again seems to become a

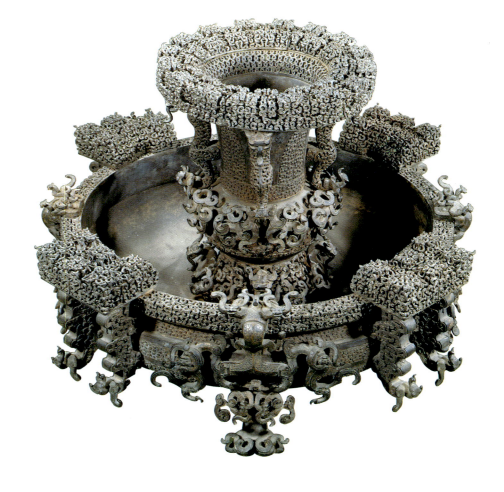

constituent part of the whole. Progressive methods of ore mining had led to further technological improvements in bronze casting during the Chunqiu and Zhanguo periods. It was the only way to produce large quantities of ritual objects, not to mention weapons. The spread of the *cire perdue* method of bronze casting made it much easier to cast the three-dimensional figures.

The collection of grave goods in the tomb of Count Yi of Zeng represents the high point of filigree openwork decoration. Interlocking dragons, waves and curlicues are the ornamental features of a kind of "Rococo" of the Zhou period (see opposite, bottom).

Despite this richness of ornamentation, there was less diversity in shape during the Chunqiu period. However, many water containers (*yi* and *pan*) were still being made, and there was also a new large shallow bowl called the *jian*. But diversity of form was further reduced in the Zhanguo period, until only ten shapes were left.

While the Longshan potters had concentrated on the form rather than the ornamentation of their vessels, the precise opposite was the case with the bronzes of the middle and late Zhou periods: decoration was more important than form. However, there is another possible explanation of this phenomenon: changes in religious ritual during the Zhou period meant that fewer types of vessel were now required, and consequently there was room for the artistic development of ornaments in high or low relief.

Decoration became very ornate, covering the walls of vessels and the backs of mirrors profusely. The sculptural bronzes of the time, for instance the uprights of bell stands, can be described as mannerist. The Zhanguo period saw an increase in relief work showing dragons, birds, strange creatures, and graphic motifs with wavy patterns surrounding depictions of everyday life such as evening entertainments, hunts, and battle scenes. Colored metal and gemstone intarsia work was also introduced; the earliest intarsias of copper and gold used as figurative or graphic decoration on bronze vessels date from the 6th century.

The Shang had used turquoise inlay in bronzes, but an understanding of the technique seems to have been lost in the long period from the 11th century to the 6th century B.C. Scholars are still undecided about the origin of metal inlay techniques. Some see it as an independent Chinese development, like the invention of bronze casting itself, while others regard it as a technological borrowing from neighbors to the northwest.

Independently of the origin of the technique, it is certain that two different decorative styles developed in Chunqiu bronzes: pictorial motifs on the one hand, calligraphic and geometrical motifs on the other.

Pictorial themes changed over the course of time from S-shaped animal figures to combinations of men and animals in hunting scenes, and then to hunting scenes with the animals no longer confined to horizontal zones but going in all direc-

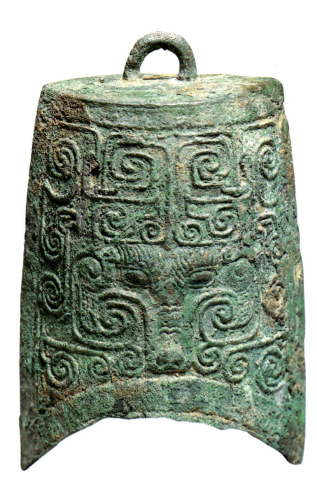

Right

Bronze bell of the *bian* type

Zhou period, H 6.5 cm, Staatliches Museum für Völkerkunde, Munich

The bell bears geometrical relief ornamentation.

Below

Bell stand

About 433 B.C., entire length of the L-shaped stand 10.83 m, H of the short arm 2.73 m, H of the long arm 2.65 m, from the tomb of Count Yi of Zeng, Hubei Provincial Museum

Beams painted in colored lacquer act as a frame on which bronze bells were hung. The bells are ornamented with knots and circular ornamentation in relief, and are held in place by bronze clasps representing three-dimensional figures of tigers.

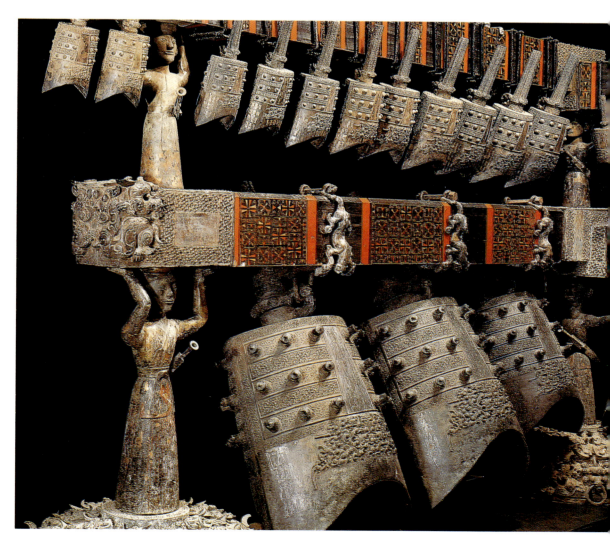

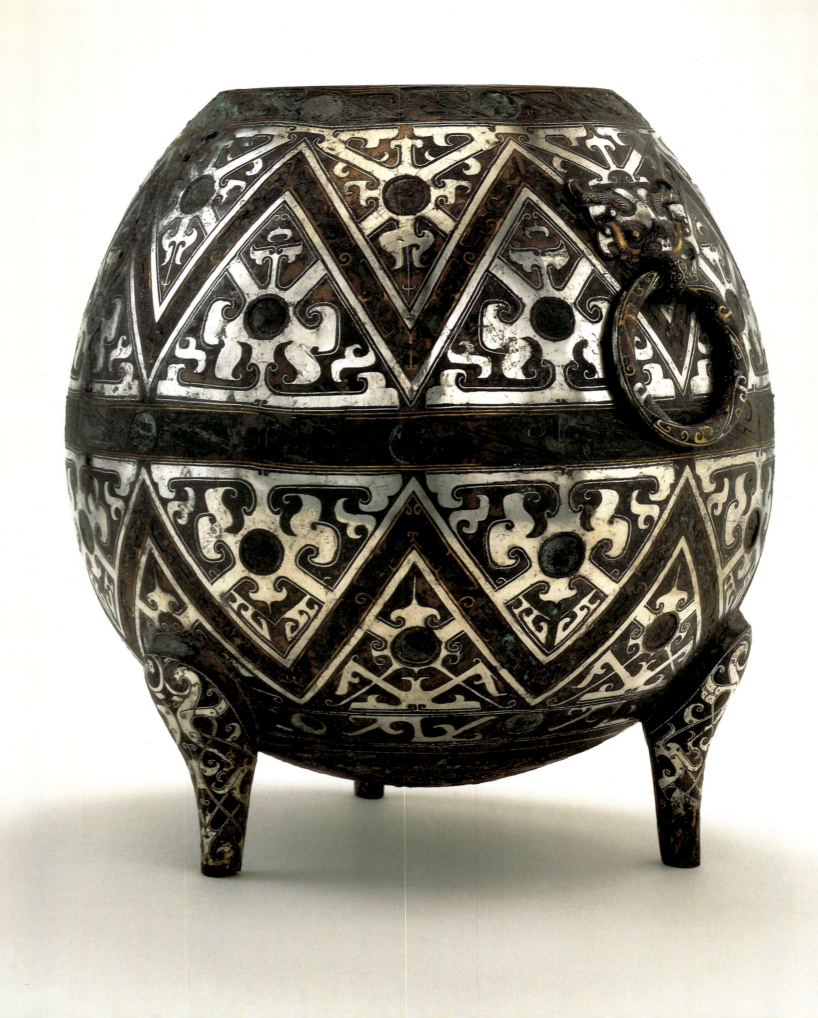

Opposite

Food vessel of the *dui* type

4th century B.C., bronze with silver inlay, H 30.5 cm, British Museum, London

The recurring pattern of abstract ornamentation consists of broad and narrow lines and sections of silver inlay.

Goblet of the *zun* type

Zhanguo period, bronze with gemstone intarsia work, H 11.7 cm, dia 8 cm, Staatliches Museum für Völkerkunde, Munich

The gemstone intarsia work forms a regular mosaic pattern, graphic in shape. The goblet stands on three feet and has a ring handle in the form of a dragon.

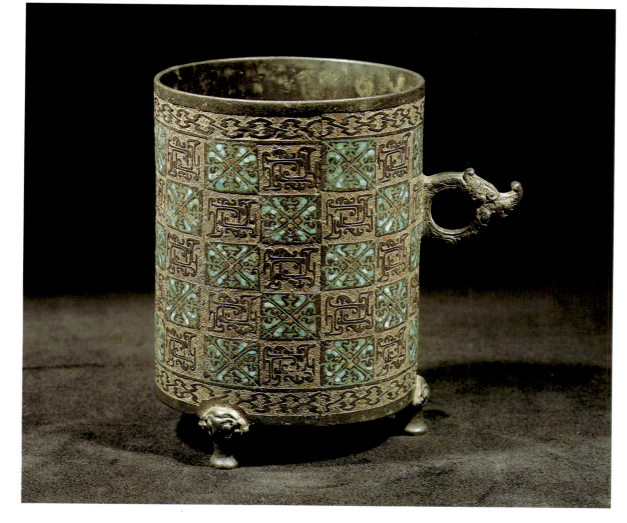

tions. Order was created out of chaos again, and finally this decorative style showed scenes of daily life and court ceremony in horizontal zones again. The earliest find of the calligraphic style also dates from the 6th century B.C. This kind of ornamentation usually occurs on bronzes from Chu, Wu, and Yue, that is to say from the south. A typical feature is the use of thick and thin strands of inlay work imitating the variation of breadth in the strokes of written characters. Such characters, executed in "bird script" with strokes of different width, are only one aspect of calligraphic decoration; another is the use of complicated gemstone mosaic ornamentation on bronze weapons, bronze fittings, and goblets (see above). Various scripts have been found in inscriptions dating from the Chunqiu period. During the Zhanguo period inscriptions again became less important, with the exception of characters in gold inlay. Bronze now shared its role as the material of record with others; by now there were books in the form of writing on bamboo strips, or thin wooden plaques bound together with thread that could be rolled up and kept. It was no longer necessary for great deeds to be recorded in bronze.

Those few inscriptions that have been found, together with the pictorial depictions of daily life on the vessels, show that bronzes were becoming secular rather than sacred objects, at the same time as radical changes were taking place in the society of the Chunqiu and Zhanguo periods.

As well as weapons and vessels, more mirrors were now being made. At this time the mirror was probably seen not just as an item in everyday use but also a magical object. In fact stories of magic mirrors suggest that despite its utilitarian aspect, the Chinese mirror never lost this aura of magic.

By comparison with the few Shang mirrors, which were ornamented with graphic designs, bronze mirrors of improved quality were obviously made in ever-increasing numbers during the Zhou period, a phenomenon that may be connected with technological developments. The reflective face of the mirror was highly polished, although the reflection itself was dull and muted. The back offered opportunities for decoration, and relief ornamentation on mirrors, usually in concentric designs, shows as much diversity as the ornamentation of vessels. The decorated surface of a mirror was in two distinct parts, and certain types of decoration appear only in the background, others only in the foreground. Typical background motifs are swirling clouds and thunder patterns, while the foreground is adorned with animal motifs or the much distorted character *shan* (mountain; see page 54, top), with crouching dragons or floral ornamentation based

The colored lacquer painting bears stylized
dragon ornamentation, the motifs
reflecting each other along an axis
halfway up the height of the coffin.

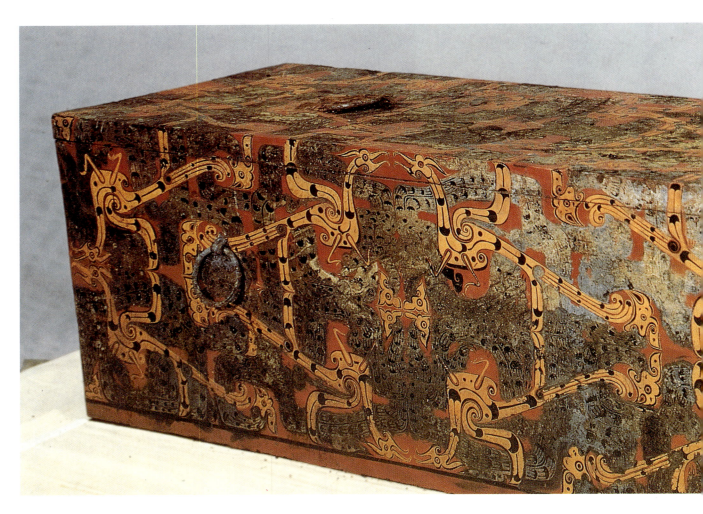

Lady with the Phoenix

*The original painting is in the Beijing
Historical Museum*

Drawing of the main features.

on the flower of the water nut. There are also
scenes, flowers, and petal motifs painted in lacquer.
Color was not confined to bronze mirrors; it is also
found in the ornamentation of beakers, weapon
handles, and bronze fittings, which might both be
inlaid with turquoise and painted. It seems as if
competition from colored lacquer ware meant that
relief decoration on bronzes was insufficient for the
discriminating eye.

Depictions of scenes from everyday life allow us
to draw a few tentative conclusions about the
nature of painting at the time, as does lacquer
decoration. At first lacquer was plain and applied
in a single color, but a find from the Western Zhou
period shows that some lacquer ware had inlay
work. Much decorative lacquer ware from the time
of the Warring States has been preserved, some on
a wooden body, some consisting of dried lacquer
items. Among the decorative techniques known at
the time were the varnishing of carved motifs,
inlay work using turquoise, mother of pearl and
precious metals, and colored lacquer painting.

All the pieces of the Zhanguo period are in an
excellent state of preservation considering the
length of time they spent as grave goods in a
tumulus or buried in the ground. Items found
include household objects such as vessels from
which wine was drunk (eared dishes known as
erbei), screens, musical instruments, and weapons
and their accessories.

Among other items, the tomb of Count Yi of
Zeng (died 430 B.C.) contained 23 sarcophagi
covered with lacquer, as well as hundreds of other
lacquer objects, some of which were magnificent
vessels. Even less magnificent tombs, such as
Tomb 2 in the Jingmen mountains in the province
of Hubei, contained a great deal of lacquer ware,
including several large items. The decorative style
of the late Zhanguo period had some very orna-
mental features, and over the course of time moved
toward realistic motifs showing animals, plants,
clouds, and dragons. Though lacquer painting is
regarded as an independent art form, at the same
time it represents the earliest extant form of
Chinese painting. The ornamentation is painted
in sweeping lines with a thin brush, following the
line of the surface to be decorated, so that most
ornamental motifs are concentric (on round
vessels), oval, or long (on long items), combining
linear ornamentation with depictions of animals.

Lacquer surfaces provided artists with very
different opportunities for expression from those
offered by bronzes, on which relief decoration is
more rigid and linear, with the exception of
4th-century B.C. gold and silver inlay work in the
calligraphic style. Inlay work from Jincun shows
that this style employed abstract motifs with
strokes of varying width. Bronzes thus decorated
invite comparison with painted lacquer ornamen-
tation, which conjures up a lively image of the

hand that executed it. Line predominates, but becomes a living ornament, looking as if it were modeled on the natural forms of a branch, a leaf, or a tendril. Figures appear among ornamental motifs that recur, or are arranged side by side. A bird is often the central motif and is always associated with the phoenix (*feng*). The general effect of the decoration, however, remains abstract and ornate. The bright tints of the originals cannot be fully reconstructed today, since the lacquer has changed in color over the centuries. In fact it was long believed that only three colors (red, black, and brown) were employed at this early period, but art historians now think that several colors were in use. Red, black, yellow, brown, blue, green, gold, silver, and silver gray were among the favorite colors of the Warring States period.

The phoenix also appears in a poorly preserved but famous silk painting found in excavations at Changsha, formerly in the state of Chu. The famous Lady with the Phoenix, a fragment measuring about 20 by 30 centimeters (8 by almost 12 inches), probably dates from the 5th century B.C. (see opposite, left). A slender woman, her silhouette shown in profile, is turning toward a phoenix and a dragon. This work, described by Sirén as the earliest Chinese painting, is ornamental in character. Unfortunately no other finds cast further light on the painting of the time. Because of this, art historians resort to written accounts, one of them quoted at the beginning of this chapter. The literary sources clearly show that painting was a feature of the period, but they say nothing about methods used.

Qu Yuan (343–277 B.C.), in the text known as the *Tian wen* (Questions of Heaven), mentions wall paintings on historical and mythological subjects. Han Fei Zi writes: "Dogs and horses are much harder to paint than demons, since everyone is acquainted with dogs and horses, but no one has ever seen demons." Huai Nan, writing in the 2nd century B.C., takes up the same idea. The painting competition at court mentioned by Zhuang Zi (quoted at the beginning of this chapter) may have been of significance to all later artists working in the Daoist spirit, and at least freed them from the demands of officialdom.

The painting of the period is not the only artistic form that is now known very largely through written accounts. Zhou architecture too has survived only in the form of bronze fittings (see right), ornamental components of buildings, and in texts; as little is known of it as of Shang architecture. Finds of components such as bronze door fittings or architectural ceramic features generally date from the end of the Zhou period, and can serve as only a vague indication of architectural styles and construction.

The names of palaces and cult sites were recorded on the bronzes of the Western Zhou period, but unfortunately no detailed descriptions of buildings are extant. It is therefore impossible to reconstruct their style or trace any stylistic development, although the *Book of Songs* (Shijing), praises

Right
Eared dish of the *er bei* type

Zhanguo period, lacquer on wood, dia 14.5/11.8 cm, Linden-Museum, Stuttgart

The lacquer painting in this *er bei*, an eared dish of the kind from which wine was drunk, is in black on a red ground. It depicts a stylized design of a phoenix (*feng*) surrounded by mirror images of line ornamentation accentuated by circles and hooks.

Below
Door fitting

Eastern Zhou period, 8th century B.C., bronze, H 28.6 cm, L 22.6 cm, W 7.9 cm, British Museum, London

The ornamentation is a stylized depiction of a human being in profile, with dragons.

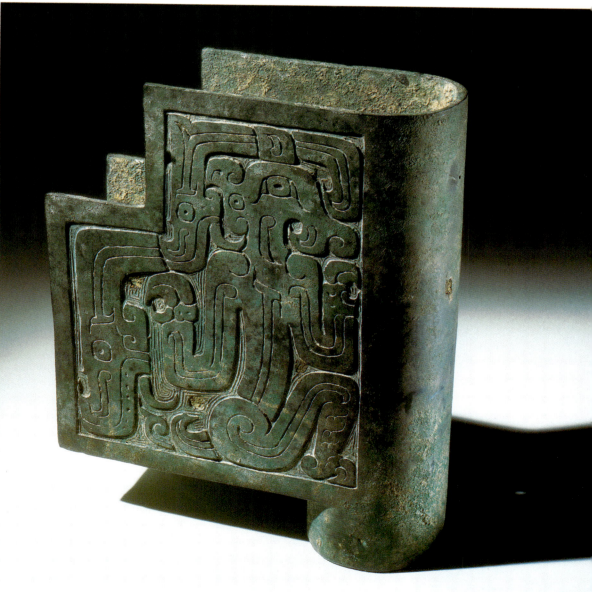

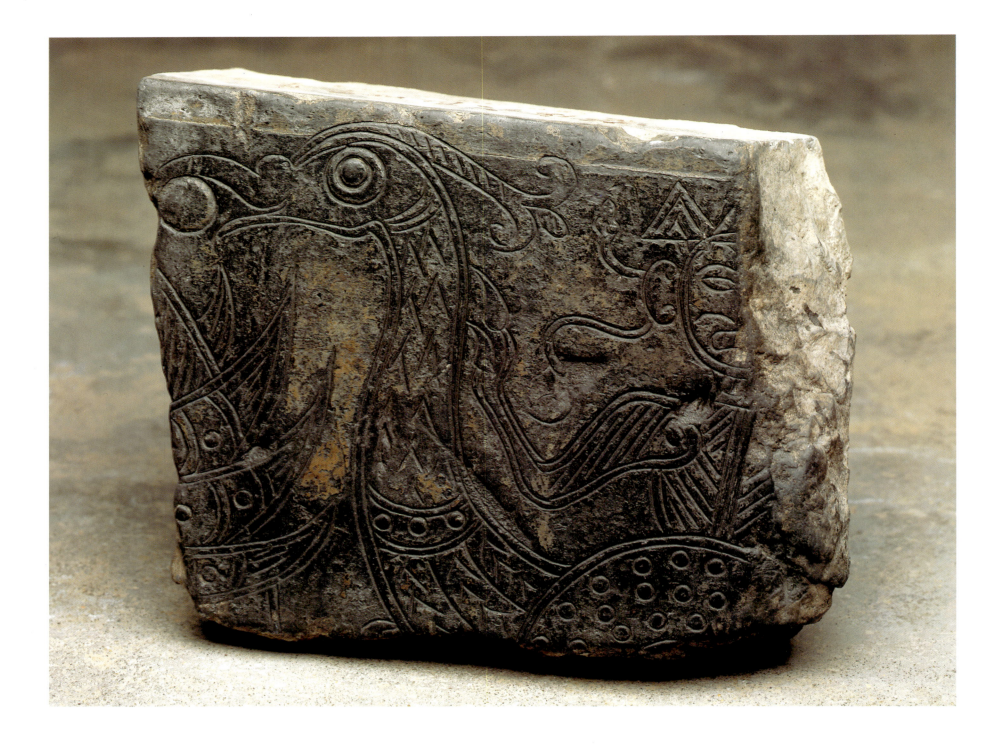

Fragment of a brick

*Zhanguo period, H 28.6 cm, L 72 cm,
W 7.9 cm, Qin, Xianyang Municipal
Museum*

The incised decoration shows a phoenix
with a pearl in its beak carrying a human
rider. The highly stylized human figure
(top right-hand corner) is shown
full front.

the palaces of rulers, exquisitely built of fine
timber and roofed with tiles made of precious
woods, mentioning their size and the elegance of
their setting among courtyards. We are told that
the walls were made of compact earth between tall,
straight pillars, and dwelling houses already had
walled kitchen gardens attached to them.

Wall paintings are thought to have adorned
buildings in the Chunqiu period. The chronicle
known as the *Lü shi chunqiu* mentions renovations
in which the pillars of a memorial hall were
painted red and the walls had new decorations.
Etiquette of the Zhou period is set out in the *Liji*
(Book of Rites), which states that the emperor's
pillars were to be painted red, the pillars of feudal
princes black, those of high officials blue-green,
and those of landowners yellow. Literary sources

mention various architectural features: towers,
terraces, fishponds, pavilions affording fine views,
belvederes, and single-story dwelling houses.

In fact it is possible to reconstruct certain archi-
tectural layouts from the accounts of rituals in the
Yili and *Liji*: for instance, a gate would lead into a
courtyard, with the main hall set on a terrace at the
far side. There might be other rooms to right and
left of the hall, and sometimes further low-roofed
rooms lay beyond it. Archaeological finds have
shown that ceramic roof tiles first came into use
during the Chunqiu period. Another kind of
architectural ornament also occurs with increasing
frequency after the end of the Zhanguo period:
pottery eaves tiles, fired bricks, and floor tiles with
incised or impressed ornamentation. They show
that the lively scenes depicted on lacquer ware

(and presumably in wall paintings) were gradually extending to entire buildings. The ornamentation of semicircular eaves tiles was either symmetrical, showing a pair of animals (stylized or realistic), or consisted of half a motif that was originally concentric in composition. However, it must be added that only the most important buildings of an architectural complex would have had such magnificent roof decoration.

Systematic study of urban architectural complexes is at present in progress; half a dozen of considerable dimensions have been found on Chinese soil since the founding of the People's Republic of China. One is a town that may have been the capital of the feudal state of Qi. It measured two kilometers (1.3 miles) east to west and four kilometers (2.5 miles) north to south, but was not entirely rectangular, and it was surrounded by a wall about nine meters (30 feet) high. However, literary references to the architecture of capital cities are permeated by the mystique of numbers, with the figure nine appearing frequently: "nine times nine *li* [a total of 450 meters (1,476 feet)]

with nine streets north to south and nine streets east to west, each street the width of nine carts, with the temple of the ancestors to the west, the temple of earth to the east, the law court to south and the market place to the north."

The palace was probably a square structure at the center of the complex. But literary texts, for instance in the book entitled *Zuo zhuan*, condemn architectural extravagance as evidence of bad government: rulers living in great magnificence without regard for the people who existed in wretched conditions were in danger of losing their mandate from Heaven. This was one way of defining the process common to many advanced civilizations, when excess and decadence lead to the fall of the ruling house.

Much that is said about the architecture of the Zhou period must remain supposition, since different translators offer different interpretations of the relevant textual passages. But it may be said in general that buildings were made of timber and earth. The builders of the Zhanguo period already had the technology to erect multistory buildings,

Eaves tiles

Left: Zhanguo period, dia 15 cm; right, Han period (206 B.C.–A.D. 220), dia 15 cm, both in the Staatliches Museum für Völkerkunde, Munich

The semicircular eaves tile on the left bears ornamentation in the form of animals with a stylized tree between them. The round eaves tile on the right is decorated with volutes and written characters. Its size and the style of its ornamentation illustrate the continuity of this decorative form.

although the material fittings, as suggested by extant specimens of decorated tiles, must probably be thought of as rather Spartan except in the palaces of the aristocracy.

The appearance of household utensils can be deduced from ceramic grave goods. Pots were unglazed, or sometimes fired with a slip coating, often squat in shape and bore simple impressed decoration. These shapes, and others comparable in form to the bronzes of the time (see above, left), give some idea of the ceramic art of the Zhou.

By far the majority of pots found as grave goods are food containers, ritual vessels, or items of household use. The impressed and incised ornamentation suggests an imitation of woven or textile surfaces (see above, and below left).

In the Chunqiu period and the Zhanguo period, however, the custom of placing ceramic models of figures in tombs as grave goods became more common. It may be assumed that there was a direct connection between the spread of Confucian ethics, which condemned the barbarity of human sacrifices as companions for the dead, and the appearance in burials of these pottery models. Ceramic grave goods in human form were a substitute for the human sacrifices that until the beginning of the Chunqiu period had accompanied the dead to the next life. Such figurines would have become increasingly popular as a sacrificial substitute, until in the end they were the sole form of human companions given as grave goods. Our picture of life in the courts and palaces of the late Zhanguo period is complemented by replicas of furniture; the sculptors of the time showed greater skill in making these models than in depicting human beings. Models of stoves may have been part of the repertory of *mingqi* figures from the early Zhou period onward, and are a particularly

interesting group, especially since they were to feature among traditional *mingqi* in subsequent centuries. The model illustrated shows that the wok still in use today derives from a tradition 2,000 years old (see below).

Artistic design was by no means homogeneous throughout the 800 years of the Zhou period. Besides the different objects used in ritual, as grave goods and for personal ornament, and manufactured in the central states ruled by the Zhou, with their variants distributed throughout the feudal states, the tribes of the Ordos region and the native ethnic groups of the west and southwest had their own artistic forms of expression (see page 65).

Today these areas and the archaeological finds made there are within China's sphere of influence, but the art of the peoples living on the frontiers of that earlier time, and the art of steppe-dwelling tribes, is often excluded from studies of Chinese art.

Certain forms of artistic expression arising from the different lifestyles of these people are conspicuously different from what is now regarded as Chinese. The royal tombs of Zhongshan, in the Pingshan district of the present province of Hebei, were burial sites of the Di people, who brought to the subsequent development of Chinese art a sculptural tradition previously unknown to it: bronzes that were not vessels but consisted of

Model of stove

2nd half of 3rd century B.C., fired earthenware, H 15.6 cm, L 27.2 cm, Institute for Archaeology and Cultural Assets of Shaanxi Province

This model stove has two rings to take vessels, and the opening for stoking the stove bears a diamond pattern of linear motifs.

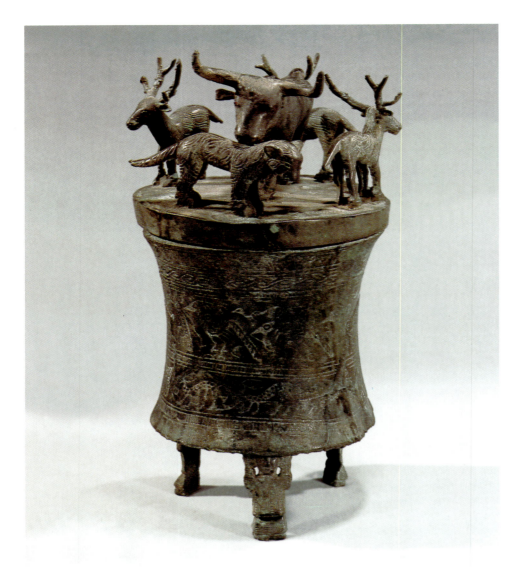

Money container

*Zhanguo period, bronze, H 34.5 cm,
Yunnan Provincial Museum*

The money container stands on three feet
in the form of kneeling human beings; the
lid is adorned with five three-dimensional
realistic animal figures, while the body of
the vessel is ornamented with friezes in
low relief showing the outlines of birds
and game animals, stylized by comparison
with the three-dimensional figures.

three-dimensional animal figures. The Middle
Kingdom made carved jade figures of animals, but
no freestanding bronzes. Fighting animals and a
winged beast of prey resembling a tiger were
particularly popular themes.

Mirrors and ornaments for robes have been
found in the Ordos region, as well as weapons,
tools, and vessels. It is thought that their orna-
mental motifs influenced a trend toward the
realistic representation of animals even in central
Chinese areas. One motif never found among the
Zhou, however, seems to be the animal within an
animal (see opposite, bottom).

The sculptural works made in the settlement
areas are similar to those from the northwest. The
sophisticated culture of the Dian, who inhabited
the present province of Yunnan during the late
Zhanguo period and throughout the Western Han
dynasty, created some extraordinary works of art in
bronze. One type of object, the money container is
particularly interesting. Much attention has been
paid to the ornamentation of these containers,
which have extremely realistic and lifelike animal
bronzes arranged in circles on their lids. The
animals are shown hunting, walking, or fighting,

and in many cases one animal stands out from the
rest, occupying a central position and being larger
than its companions (see left). Such containers
were "money-boxes" for cowrie shells, the
currency of the Dian, and they were buried as
grave goods with members of the land-owning
upper classes of Dian society to ensure prosperity
in the next life. Since the Dian lived with their
cattle, the prominence of figures of cattle in their
culture may be regarded as both a symbol of
wealth and an image of daily life.

Finally, the whole range of Zhou art raises the
question of the significance of its ornamental
motifs. In the context of the revolution in ritual at
this time, the great preponderance of bird motifs is
often interpreted as illustrating changes of relig-
ious belief. Birds, which can fly, could mediate
between the world of men and the heaven, *tian*,
venerated by human beings, so it would not be
surprising to find birds ornamenting vessels.
According to classical Chinese writings the
phoenix, *feng*, was also the lord of all the birds, and
one may draw the logical conclusion that only the
ruler of the birds can ensure contact with *tian*.
Consequently the phoenix, a bird that no one can
ever have seen in reality, is shown as a hybrid avian
creature with particularly magnificent plumage.

However, it is possible to detect a process of the
secularization of bronzes going together with the
secularization of decorative motifs: most of the
inscriptions of the time, for instance, record
notable secular events. In that context, do the
decorative motifs still have any real significance or
are they simply traditional? Ornamentation, like
the object it adorns, could express the owner's rank
and status, and the same may apply to written
decoration in the form of inscriptions praising the
deeds of the man who commissioned a craftsman
to cast the vessel bearing them. Alternatively,
perhaps the depictions of daily life on bronzes of
the Zhanguo period reflect Zhou festivals and
should not be seen in a secular light at all.

The non-Zhou peoples, on the other hand, depict
creatures that threatened the basis of their economic
life: beasts of prey taking their sheep, their cattle, and
their donkeys. At least, that is one possible interpre-
tation; another is that the person wearing such orna-
ments, whether a man or a woman, wished to
emulate the strength and power of the beast of prey.

Whenever attempts are made to explain the role
of the ornamental motifs of the Shang and Zhou
periods at the time of their creation, there is a
tendency to cite ideas that really date from later
centuries. The most sensible way of approaching
the bronzes and their decoration is simply to study
their motifs, their distribution, and their manufac-
ture, which is why they have been described here
in all their diversity. To give an account of all the
different interpretations would be beyond the
scope of this chapter, and important as the litera-
ture of the time may be, it cannot provide explana-
tions for everything. The same comment holds
true for the art of the first united empire, which
will be described in the next chapter.

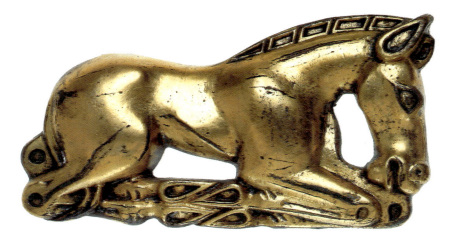

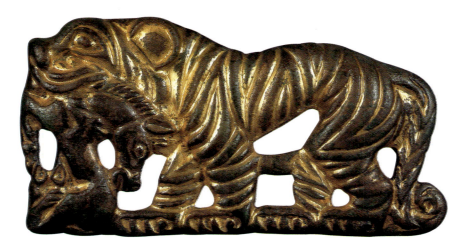

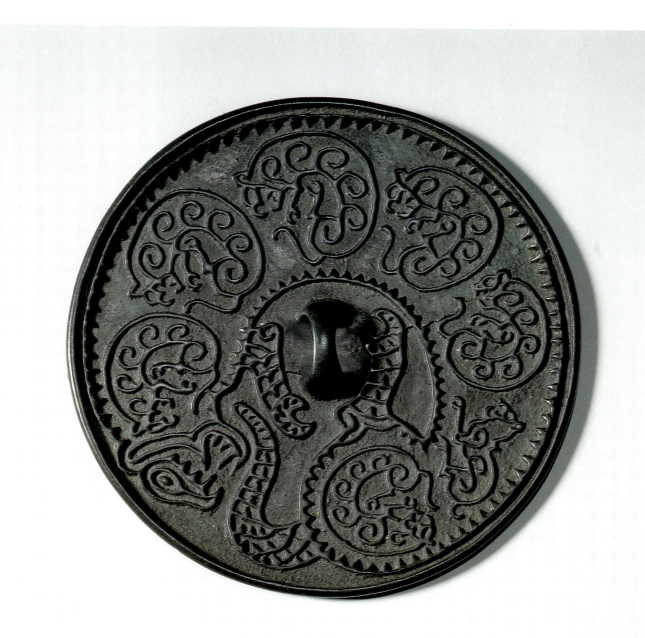

Above left
Bronze donkey plaque

*5th to 4th century B.C., ornament for robe
in the form of a donkey, bronze, gilded,
H 7.8 cm, L 13.9 cm, Museum für
Ostasiatische Kunst, SMBPK, Berlin*

Above right
Bronze tiger plaque

*5th to 2nd century B.C., gilded bronze,
L 3.3 cm, Ordos region, Museum für
Ostasiatische Kunst, SMBPK, Berlin*

This tiger-shaped ornament for a robe uses
the motif of an animal eating its prey, in
this case a tiger with a donkey in its jaws.

Left
Mirror

*8th to 6th century B.C., bronze, dia 10 cm,
Ordos region, Museum für Ostasiatische
Kunst, SMBPK, Berlin*

The back of this mirror is decorated in low
relief with the theme of a leopard within a
leopard.

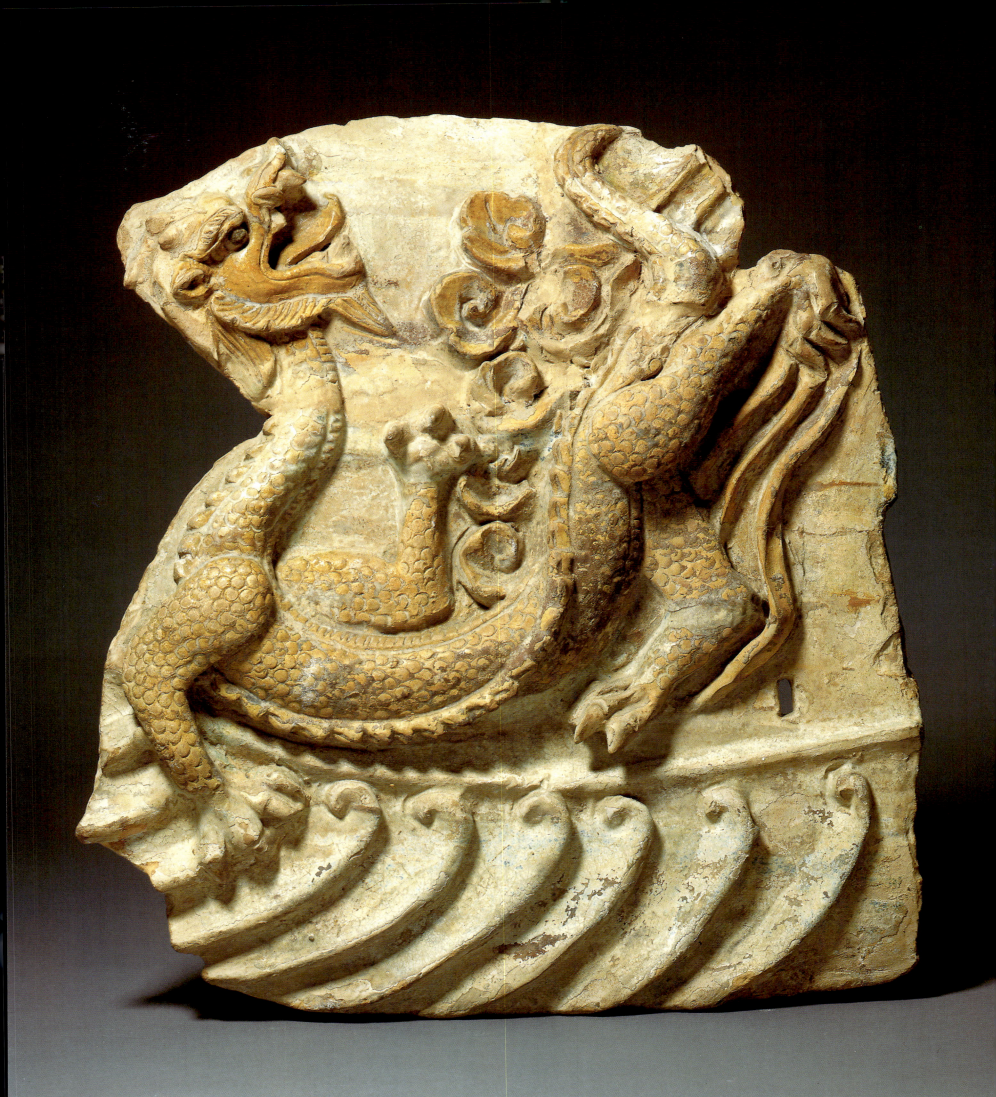

A United Empire Protected by the Dragon

Many accepted, recurrent themes and motifs in Chinese art were rooted in mythological and cosmological ideas. Chinese myths and legends tell of the great emperors of a distant past, and in that distant past itself the dragon was already regarded as a very important guardian figure. In the historical period China first became a united empire ruled by an emperor in 221 B.C., under the Qin dynasty. From the time of the succeeding Han dynasty at the latest, the divine, life-giving, benevolent dragon was regarded as the symbol of the emperor himself, father and mother to the Chinese people. During the 2,000 years in which emperors ruled on the dragon throne, art moved on from its ritual function to achieve independent status, though without ever entirely losing its connections with the mythological and cosmological tradition.

Relief of a dragon

(Fragment), architectural ceramic decoration, about 1100, Staatliches Museum für Völkerkunde, Munich

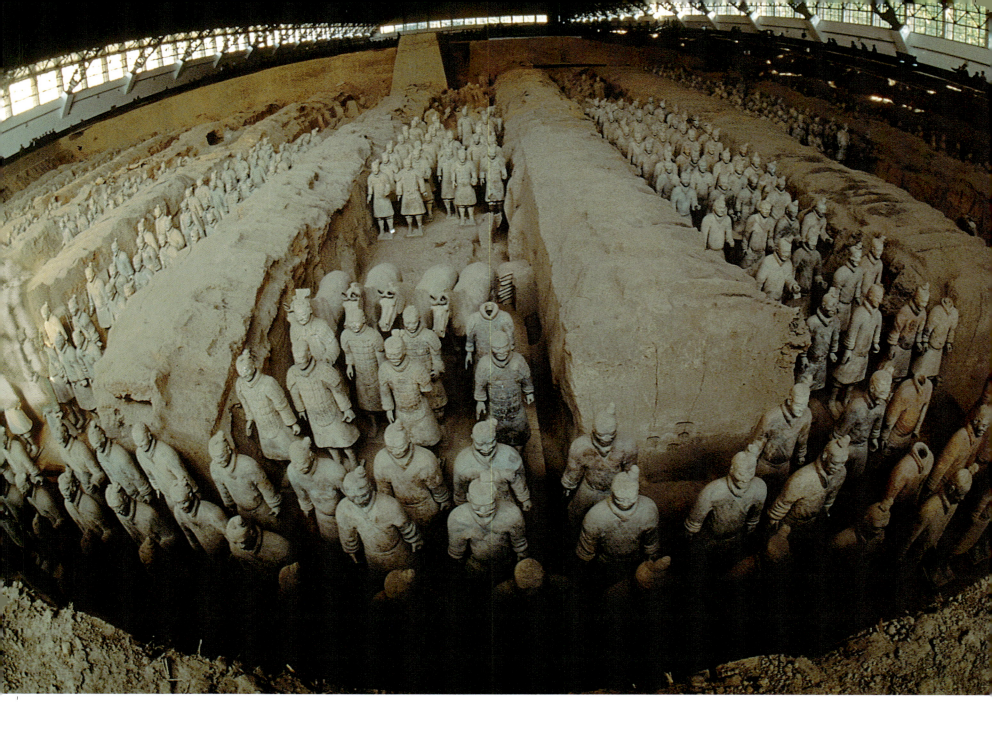

The Qin Dynasty: China Becomes a Nation

Art under the rule of a brilliant despot

The terracotta army from the First Emperor's monument

End of 3rd century B.C., Xi'an

A vast structure has now been built over the tomb to cover the finds, many of which are now very delicate.

"The man who became the first Qin emperor was the son of King Zhuang Xiang of Qin. […] When he was 13 years old, King Zhuang Xiang died, and Zheng [the future emperor's first name] ascended the throne in his place and became king of Qin."[1]

This is an account of the year 246 B.C. given by the Chinese historian Sima Qian (145–86 B.C.).

The young king entrusted the business of government to his leading ministers of state. He had come to the throne in the middle of a struggle for supremacy between feudal kingdoms that still owed nominal allegiance to the Zhou dynasty king, although his power existed only on paper. Matters were actually decided by intrigues and pacts of aggression and non-aggression between the remaining individual states. The power of the feudal state of Qin, strategically and technologically superior in many military fields, increased with every victory, and one by one the feudal states came under Qin rule. Twenty-six years after the king had come to the throne as a boy, all his rivals were defeated. He embarked upon a program of measures designed to demonstrate his claim to power, even after his death.

The kingdom had been greatly extended, and now comprised an area almost half the size of modern China. The king of Qin chose for himself the name of Huang Di – both parts of the name mean "supreme lord" – thereby assuming titles associated with great rulers of the past. Tradition told of the San Huang (the three great lords Fu Xi, Shen Nong, and Huang Di) and the Wu Di (five

Weight

About 210–206 B.C., Shaanxi Provincial Museum

Probably meant to be a 1 *jun* (7,687.5 grams; about 17 pounds) weight, although it deviates by about 220 grams (nearly 8 ounces). The inscription carries two pieces of information in *xiao zhuan* or lesser seal script, the usual script of the Qin period.

Following pages
The "Terracotta Army"

Late 3rd century B.C., life size or larger, Shaft 1, Mausoleum of the First Emperor

The picture shows a line of infantrymen, seven ranks of soldiers without armor who were probably carrying weapons with long shafts, with men in armor behind them. The folds of the clothing, the different positions of the knots of hair, and the facial characteristics are particularly remarkable.

Written character, *mu*

Four variants on the same written character, *mu* (tree).

rulers traditionally dated to 2952–2205 B.C.), to whom, among other things, the great inventions of antiquity were ascribed. The king was thus placing himself on a par with his legendary predecessors, said to have been of divine origin and to have ruled a united empire.

So the Qin dynasty began with the unification of the empire by the First Emperor, Qin Shi Huang Di, in the year 221 B.C.; it ended in 206 B.C. with a peasants' revolt under his first and only successor.

Despite its short duration, however, the Qin dynasty laid the foundations for a great united Chinese empire. The First Emperor abolished the feudal system and set up a central government. The empire was divided into 36 provinces, each governed by three officials: a civil administrator, a military administrator, and a censor, who supervised his colleagues. Officials down to regional government level were directly appointed to their posts, or removed from them, by the emperor himself. Above the provincial governments there were nine state secretaries, and above them again were the grand chancellor, the grand censor, and the prime minister, with the emperor himself at the very top. Many unifying measures were brought in, including a legal code based on the principle of equal justice for all without respect of person or rank; the introduction of standard weights (see above), measures, and currency; and even the standardization of the gauge of cartwheels and the style of written characters. Li Si, Qin Shi Huang Di's chancellor, issued an official catalog of written characters in the 3rd century B.C.. Its purpose was to curtail the proliferation of variants and introduce another unifying factor: a written language that could be read and understood throughout the empire. The text of this decree was written in so-called "lesser seal script," *xiao zhuan*, which was to be used in all official documents. *Xiao zhuan* may be described as the third generation in the chronological development of written characters (see right).

The earliest form of writing was *jiaguwen*, oracle bone script. "Greater seal script" was used on bronzes, and was complemented by the first decorative form of script, "bird script." Lesser seal script came into use around the Zhanguo period. The development of scripts was to continue under succeeding dynasties as improvements occurred in brushes and writing surfaces.

Finally, a drastic measure to promote standardization was the forcible resettlement of former feudal lords to the imperial capital – where they were under the emperor's eye. Building projects included major roads with posting stations for a change of horses, a line of defences against the northern barbarians, and palaces of extraordinary size. The emperor undertook journeys of inspection throughout the empire; these journeys were a constant subject of artistic speculation for painters of later periods. There was a burning of books, said to have destroyed all previous writings apart from legal documents and technical literature on agriculture, sacrificial rites, the questioning of oracles, and the art of healing. Tradition has it that a large number of scholars were buried alive as well, but perhaps this story is to be understood only symbolically. The emperor toured the country, leaving inscriptions here and there in token of his visit; carved in stone, they praised his great deeds, and look today like yet another of his methods of consolidating his claim to power.

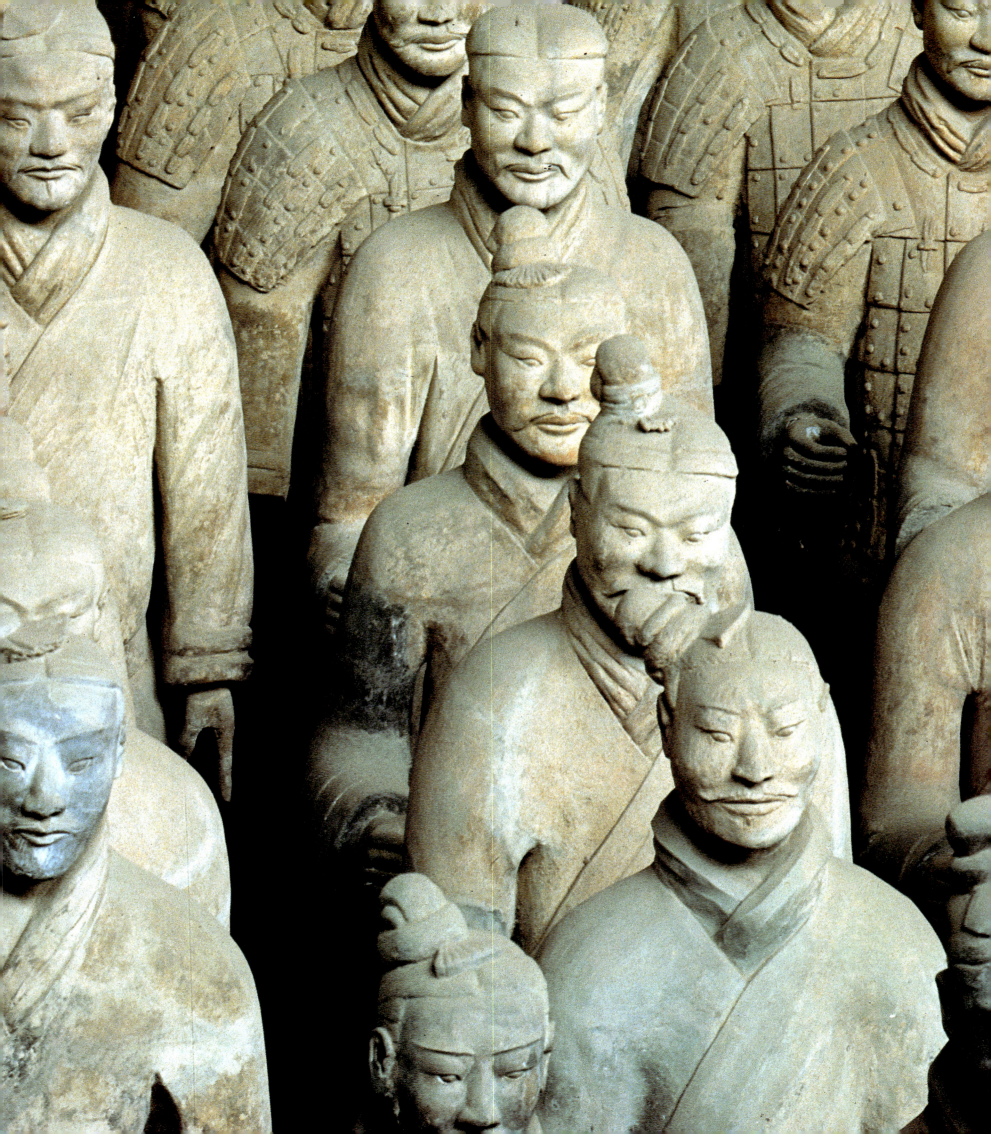

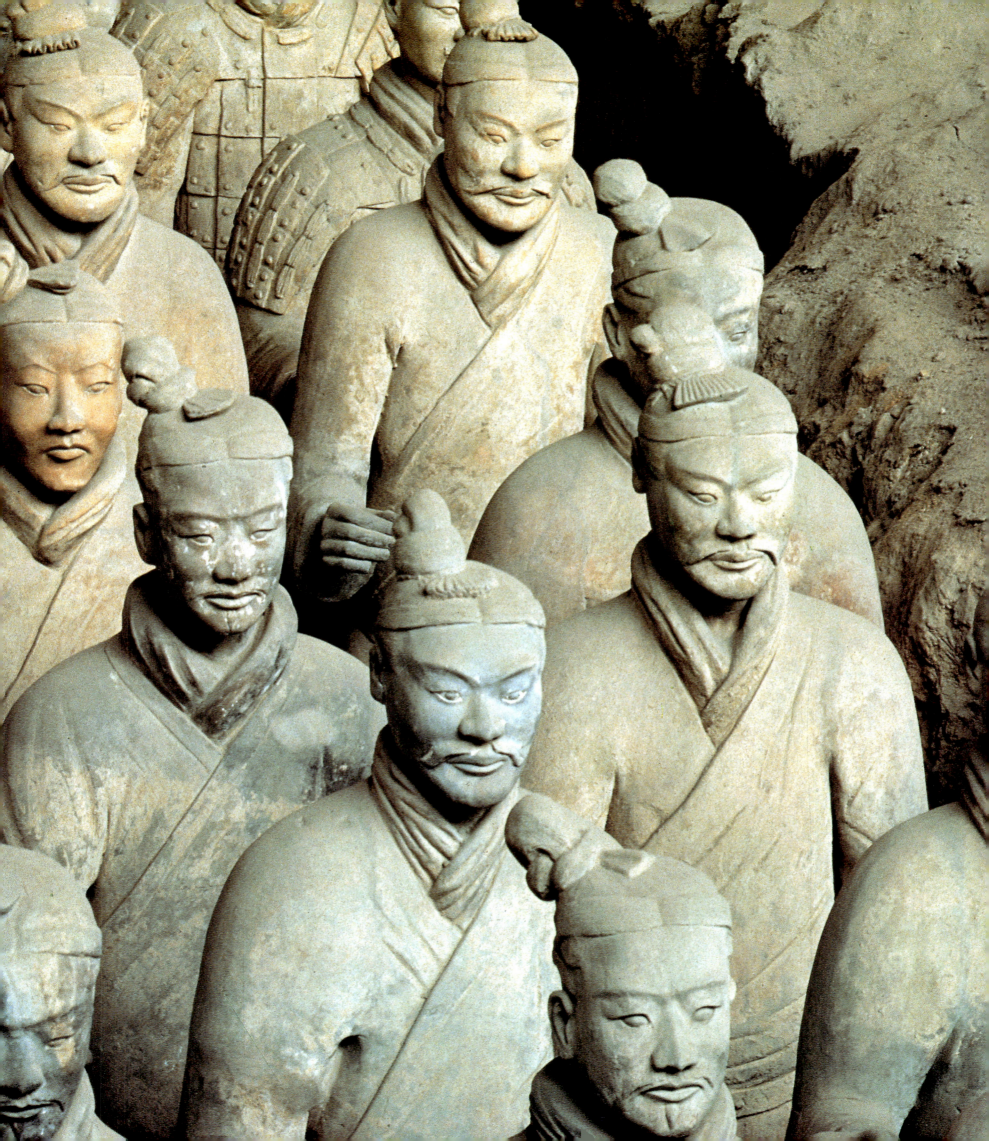

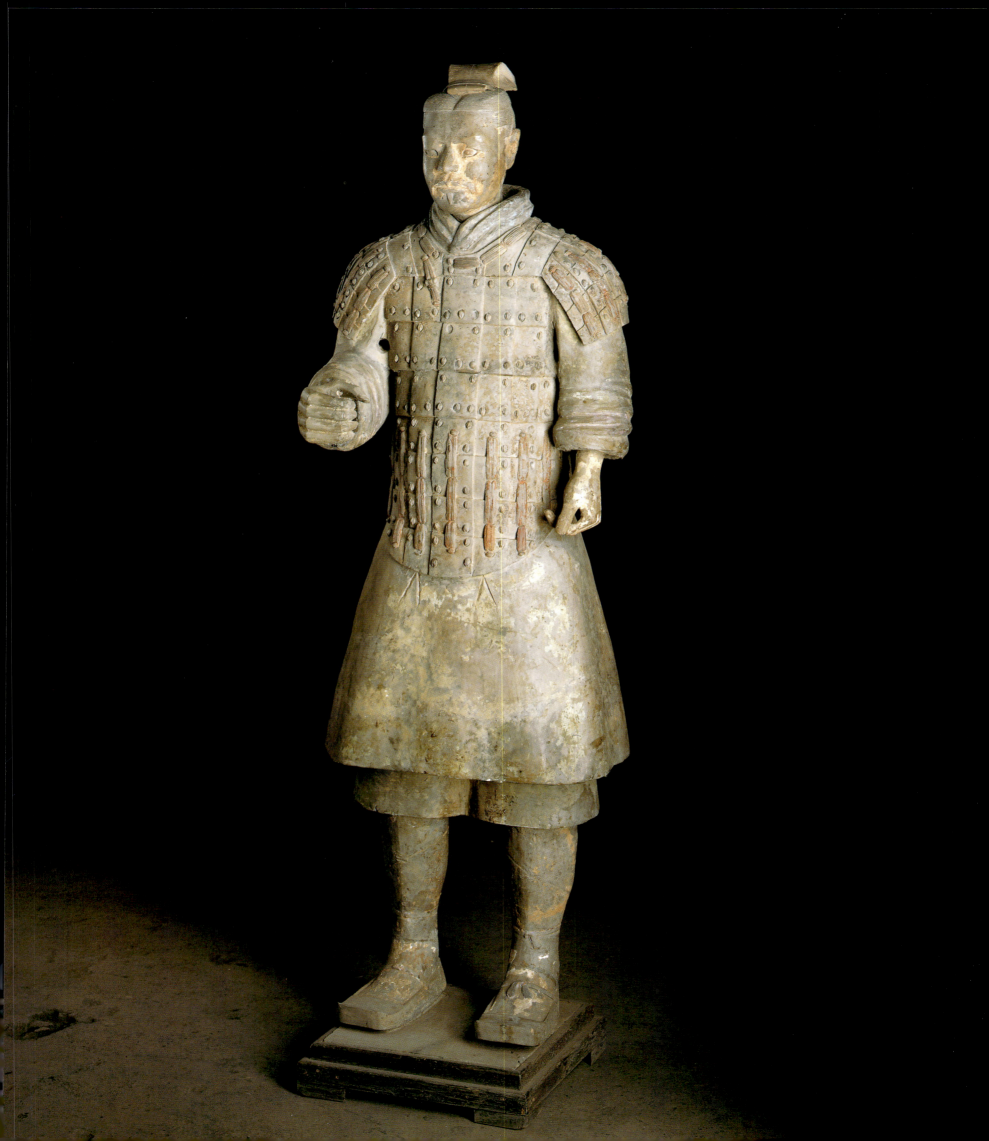

Sima Qian writes: "In the 28th year [of his reign, i.e. 219 B.C.] the emperor went east to visit prefectures and districts, and climbed Mount Zouyi. [He had] a stone raised, and after consulting with scholars from Lu had an inscription carved into the stone praising the virtues of Qin, and he took advice on sacrificial places, and on the rituals of sacrifice to mountains and rivers."[2]

Although many of the measures introduced by the imperial administration sound strange, they are to be understood as the outcome of systems of thought concerning the creation of the world and its position in the cosmic structure. The philosopher Zou Yan (about 350–270 B.C.) constructed a theory of the world, using the doctrine of the five elements as a way of elucidating scientific and social phenomena: the great One, *taiji*, brings forth shadow (receptive) yin, and light (active) yang, and these in turn bring forth the five phases (elements), *wuxing*. All concrete objects can be assigned to a dualistic fivefold system: the four points of the compass and the center, the seasons, the colors, and the five elements of earth, metal, water, wood, and fire, which may be mutually productive, *xiangsheng*, or mutually destructive, *xiangke*. Changes of rulers were also interpreted as part of the process of decline and renewal. The rule of the First Emperor was under the sign and magical power of the element of water, conquering the Zhou, who were under the sign of fire. The state color was black, the basic number six. The beginning of the year was set in winter, the season of the element of water; its planet is Mercury and its point of the compass is north.

Animals were part of the system as well, and symbolized the four quarters of the compass: the blue-green dragon stood for the east, the red bird (a phoenix) for the south, the white tiger for the west, and the black turtle for the north. Concepts leading at first only to curious stipulations about the colors of banners or the width of roads became an independent iconography during the Han dynasty, and many such symbols established themselves as pictorial motifs.

In art and artistic policy, the First Emperor was an adherent of monumentalism. According to Sima Qian, his hopes of becoming immortal led him to have huge bronze figures cast, and throughout his reign he sent out expeditions to discover ways of ensuring his eternal life. And the legacy he left has given him immortality, although hardly as he presumably envisaged it.

The *Historical Record* (Shiji) quoted several times above, and compiled by the historian Sima Qian some 100 years after the death of the First Emperor, gives a chronological account of the history of the Middle Kingdom, Zhong Guo, reconstructing it from the time of the mythical Yellow Emperor up to Emperor Wu Di of the Han dynasty, which followed the Qin. Much doubt has been cast on what Sima Qian wrote, in particular when he is speaking of events remote from him in time. We have Sima Qian to thank not only for the account quoted at the beginning of this chapter,

but also for his description of the imperial tomb complex, which for decades was regarded as suspect because of its apparent exaggeration of the splendor of the internal furnishings of the tomb. Yet in 1974 his account received archaeological confirmation, at least in part. A find made almost by chance during the sinking of a well was the first of about 7,000 terracotta figures: the First Emperor's army drawn up in battle order.

Sima Qian himself says not a word about the army, so we may conclude that both the making of the figures and their placing in the tomb complex were kept a close secret.

The terracotta warriors include infantrymen bearing various weapons, members of the rank and file, charioteers and their horses with the remains of the chariots themselves, cavalry horses and their

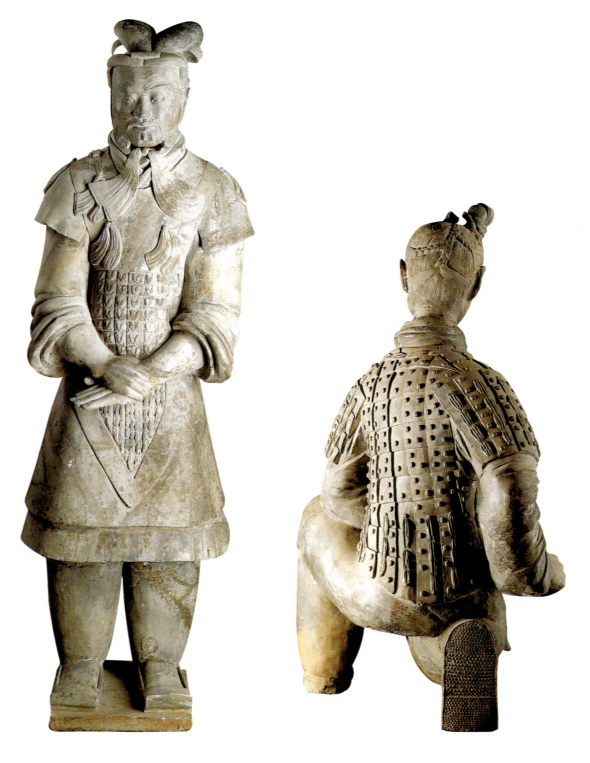

Above left
Officer in armor
H 196 cm, Museum of Terracotta Figures from the Tomb Complex of the First Emperor, Xi'an

Above right
Kneeling archer
(Back view), H 122 cm, Museum of Terracotta Figures from the Tomb Complex of the First Emperor, Xi'an

Opposite
Infantryman in armor
Remains of colored painting, H 184.5 cm, Museum of Terracotta Figures from the Tomb Complex of the First Emperor, Xi'an

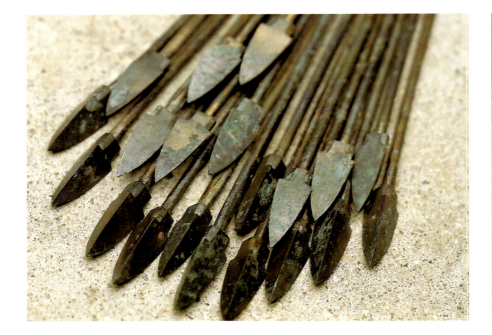

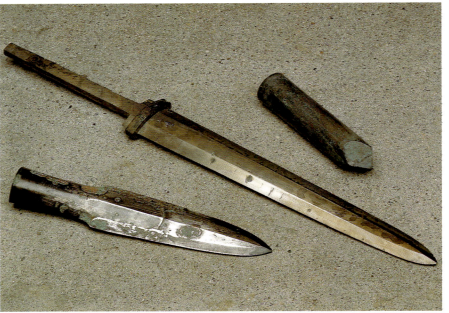

Above left
20 arrowheads from arrows
for crossbows

*Bronze, arrowhead L 2.6–2.8 cm, Museum
of Terracotta Figures from the Tomb
Complex of the First Emperor, Xi'an*

Above right
From bottom upwards: *mao*
spearhead; *pi* head of shafted
weapon; and *shu* battle club.

*Bronze, length of shafted weapon 35.3 cm,
Museum of Terracotta Figures from the
Tomb Complex of the First Emperor, Xi'an*

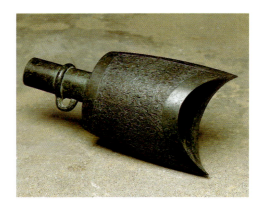

Above
War bell of the *yong* type

*Bronze, W 25.9 cm, Museum of Terracotta
Figures from the Tomb Complex of the
First Emperor, Xi'an*

The ornamentation is made up of patterns
stamped repeatedly on the cast body of
the bell.

Opposite
Horse's head

*(Detail), horse from a team of four, life size,
Museum of Terracotta Figures from the
Tomb Complex of the First Emperor, Xi'an*

pottery riders. So far about a quarter of the terra-cotta figures have been excavated, many of them astonishingly intact, others broken after falling over. The figures, made of fired earthenware – they have hollow bodies with walls about 7.5 centimeters (3 inches) thick, and stand on massive legs – are life size or larger. The detailed realism of their execution is remarkable, extending as far as small details of clothing and hairstyles, though today most original paint has gone and only the reddish brown of the terracotta remains.

The basic shape was archaic – linear and axial – and sometimes out of proportion, but the absence of symmetry and the detail prevent the viewer from dwelling on that. The figures present us with "lively variety and stylistic consistency."[3] The faces are types of different regional origin, and strikingly true to life (see pages 70–73). Most of the figures were made in molds, but individual features seem to have been added by hand later. The existence of eight basic types of heads, modified by hand, confronts us with the problem of describing a number of different and realistic faces that none the less cannot be called portraits.

In fact they are both types and individuals. The impression of individuality is heightened by the different attitudes of the figures, but these too are stylized. Charioteers reach out both hands in front of them: they were once holding reins that have not survived. Archers kneel or lunge forward. The figures can be identified from their positions alone.

There are other individual touches, such as the incorrectly adjusted shoulder armor of one of the terracotta warriors, and the distorted arm of another. One can only speculate as to whether these features were intentional or simply mistakes arising in mass production. The hairstyles, caps, and armor of the warriors identify their rank and the troops in which they served (see pages 72–73).

The colored painting of many of the figures can be reconstructed from the remnants left on them,

it too serves as identification. The army looked extremely impressive in full color. The officer in armor probably wore a green tunic, but the red bars between the plates of his armor can still be seen today. His face has remnants of paint on it; we are looking at a man with a black beard.

Another officer is even more splendid in appearance (see page 73). He wears trousers and a tunic with armor over it, and with his striking cap and the scarves and tassels around his neck he stands out from the rest. His hands are held together in front of him; he may once have been leaning on a sword. What makes this officer so lifelike? The index finger jauntily pointing away from him, perhaps, and the knotted scarves "fluttering" gently in front of his chest certainly breathe life into him. The remains of paint allow us to conclude that figures of this type were very colorfully depicted.

A horse, one of a chariot team, shows how lifelike an idea the potter had in his mind as he set to work (see opposite). The mane falling between its ears divides in two, distended nostrils seem to be snuffing the viewer, the mouth is open and the wide eyes are alert, looking around. Or is the horse breathless, having only just come to a halt? Stylistically the terracotta figures, men and horses alike, suggest a hybrid form between archaic and realistic sculpture. The archaism can be seen in the rigid, compact, square bodies, their movement suggested only by the clothing; the illusion of realism is conveyed by facial characteristics, hairstyles, a wealth of detail and stylized positions. The movements of the figures are frozen, yet, whether they are kneeling archers or charioteers, they seem both static and animated. The modeling of the arms and hands that once held weapons conveys a lifelike, three-dimensional effect. The weapons themselves have gone; their shafts were made of wood and could not survive the passage of time. But bronze bridles and the bronze tips of

arrows to be fired from crossbows (see page 74, above left), the remains of close combat weapons (see page 74, above right), axes (*ge*), and bells for giving signals (see page 74, below left), to mention only a few of the finds, help to complete our picture of the equipment of the army of the dead. The actual significance of the figures, however, is a matter of controversy. Much emphasis has been laid on the "realistic," portrait-like nature of the warriors' faces, cited in support of the theory that they are based on the real imperial guard. In that case they may be seen as a substitute for specific people, in the style of the *mingqi* (a term used as early as the Zhou period to denote items made especially for use as grave goods). By the time of Qin Shi Huang Di, there would have been ethical and economic reasons why living men should not be consigned to the grave. If this theory is correct, the army's function, as in life, was to protect the emperor. Another hypothesis is based on the eastward-facing stance of the warriors, that they should be seen as an expeditionary army sent to discover the Eastern Paradise. This interpretation is based on the emperor's Daoist inclinations and his search for immortality. However, the fact that pits containing grave goods surround the tumulus casts doubt on its validity.

It is particularly interesting to note that finds in the area include not only the figures that were part of the tomb complex, but also tools, parts of buildings, metal fittings, and implements. The find of a neck ring is evidence that convicts were indeed used to work on the tomb complex. Sima Qian tells us that the builders were not volunteers, and mentions 700,000 laborers who worked on both the Great Wall and the emperor's mausoleum.

So far, however, there is no proof of the accuracy of Sima Qian's description of the tomb, since the burial chamber has not yet been opened. If he is right, this is the scene archaeologists may see:

"As soon as the first Emperor had ascended the throne, he had digging and building work done on Mount Li, and when he had unified the empire he set over 170,000 men to work there. They dug three rivers deep, they brought down copper for the outer coffin, and the tomb was filled with grave goods in the form of palaces, models of administrative buildings, fine vessels, jewels, and other rare items. He ordered the carpenters to make devices of bows and arrows to shoot any intruders. The 100 rivers [of the country], the Yiang [Yangzi] and the He [Yellow River] and the sea were made of quicksilver, and there was a mechanism causing them all to circulate, flowing into each other. The starry firmament was shown on the ceiling and a land map on the floor."[4]

Pits containing grave goods have been found at several different points in the complex. Bronzes and ceramic models smaller than the terracotta warriors (see right) have been found west of the tumulus containing the tomb, which is up to 76 meters (250 feet) high in parts and almost square, measuring 350 by 345 meters (1,148 by 1,132 feet) along the sides. Considerable numbers

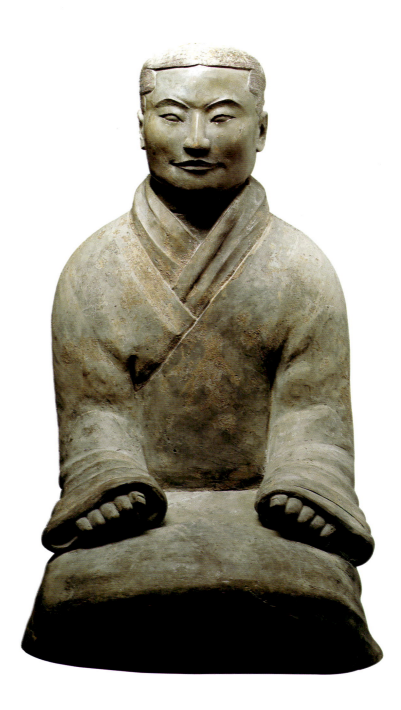

of horse skeletons, 300 to 400 of them southwest of the tumulus between the inner and outer ramparts, and more beyond the outer wall to the east of the complex, with terracotta grooms to tend them, suggest that live animal sacrifices were made to accompany the dead. Test drillings have also uncovered earthenware coffins containing the remains of small creatures, including birds.

The finds provide an insight first into the "strategic and military situation" and second into the "technological and artistic achievement of the centrally governed society of the time," as Herbert Bräutigam puts it.[5] But what happened to the many people who created this technological masterpiece? According to Sima Qian, the workmen suffered the same fate as those of ancient Egypt: they were walled up by order of the emperor's successor so that they could not reveal the secrets of the security precautions. Sima Qian also informs his readers of a positive boom in

Seated groom

H 68 cm, Museum of Terracotta Figures from the Tomb Complex of the First Emperor, Xi'an

The figure wears a plain outer garment; his facial expression appears quiet, friendly, abstracted. The expressive face contrasts with the rigid, block-like body.

Opposite
Floor tile

(Detail), Qin dynasty, fired clay, H 4 cm, L 42.5 cm, W 31.3 cm, Museum of Terracotta Figures from the Tomb Complex of the First Emperor, Xi'an

The repeat pattern is made up of rhomboids and narrow parallelograms containing S-shaped lines, small circles, and larger circles with volutes and bars. The pattern in the larger circles is comparable to water-nut flower patterns or the volute patterns on roof tiles.

Below, left
Floor tile

(Detail), Qin dynasty, H 3 cm, L 34 cm, W 27 cm, Museum of Terracotta Figures from the Tomb Complex of the First Emperor, Xi'an

The tile is decorated with a pattern showing a circle surrounded by four rhomboids and two volutes. The motif at the top is a *yunwen*, or "cloud motif."

Below right, top
End tile of rook with "cloud motif"

Qin dynasty, dia 15.8 cm, Museum of Terracotta Figures from the Tomb Complex of the First Emperor, Xi'an

This tile was found on the site of ceramics workshops. The *yunwen* cloud motif was popular in the Qin period.

Bottom right
Round lid of box of the *lian* type

H 6.7 cm, dia 22.2 cm, black lacquer ground painted with red and gray, Hubei Provincial Museum

The lid is divided into four concentric decorative areas, with an expressive, almost calligraphic curved ornament in the middle, of the kind often described as the cloud and bird pattern. The inside of the box is plain red.

construction work during the reign of the First Emperor. "He therefore had imperial palaces built south of the Wei River, in the Shanglin hunting park. First the *afang* was built, the front hall of the palace, measuring 500 paces from west to east, and 50 zhang [about 175 meters; 574 feet] from south to north. [...] Over 700,000 convicts condemned to penal servitude worked first on the *afang* palace and then on Mount Li [the imperial monument]. Stone and timber were requisitioned from the northern mountains and were also supplied by the villages of Shu and Chu. Within the pass [in the core area] over 300 palaces were built, and to the east of it over 400. [...] He gave orders to have the palaces within the 200 li around Xianyang, more than 270 of them, linked by paths and walks, and furnished with wall hangings, bells, drums, and beautiful women, and a suitable place was allotted to everyone." The imperial capital, Xianyang of the Qin period, was about halfway between modern Xi'an and present-day Xianyang. The city was founded in the feudal state of Qin as early as 350 B.C., and had been the capital ever since.

A survey of the remains brought to light by archaeologists in the last 30 years or more supports Sima Qian's account. The remains of a wall of compacted mud, terracing dating from the feudal Qin period, and craftsmen's and residential quarters have been found in an area measuring 6 by 4 kilometers (3.7 by 2.5 miles) and now identified as the site of the city. The excavations so far carried out on the mud wall show it to have been of considerable dimensions. It probably surrounded a rectangle measuring roughly 900 by 600 meters (2,950 by 1,970 feet). The compacted mud terraces, some of them still rising several meters above the surrounding fields, were the foundations of the palaces, and three of the 27 foundation terraces so far discovered have been studied for whatever architectural information they can provide (see page 76).

Some idea of the architecture itself can be gleaned from finds of colored ceramic floor and roof tiles with stamped ornamentation, water pipes and drainpipes of fired clay, and fragments of wall paintings. The nobility of the Qin dynasty surrounded themselves with attractive decoration and animated, multicolored wall paintings. A fragment of one painting shows a team of horses at the gallop, drawing a chariot and charioteer; other finds enable us to reconstruct scenes of people, horses, and mythical creatures. The ornamental painting already found on Zhanguo lacquer ware continued into the Qin period. Curving patterns painted freehand and repeat patterns of ornamental bands are found on lacquer items that can be clearly dated to the Qin period.

The *yunwen* decorative "cloud motif" was another characteristic feature of the Qin dynasty style. It consisted of volutes or bars ending in volutes, arranged in V-shapes, a motif known to us from the end tiles of roofs (see below, right). Other

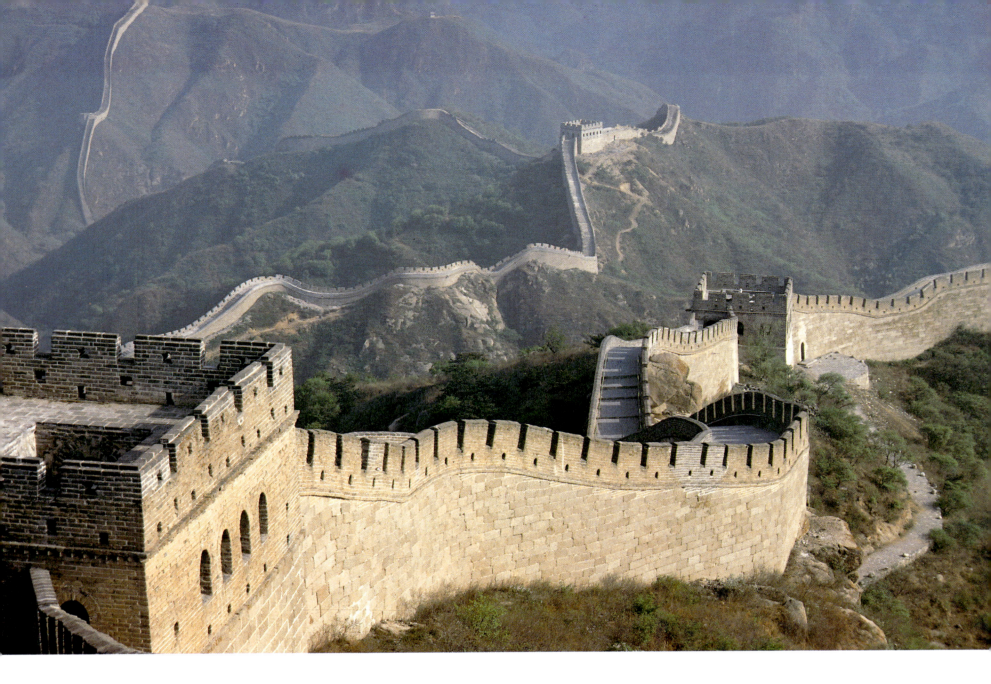

decorative motifs were dragons and phoenixes, and geometrical ornamentation consisting of rhomboids, circles, and squares. These patterns were added to the pottery before it was fired. There were several ways of applying them: by using a stamp to leave a negative impression of the ornament on the earthenware, by freehand incision, or by using a wooden mold with the ornament carved into which clay was pressed.

Indoors, then, people surrounded themselves with attractive decoration. But out of doors a very different problem was tackled under the Qin dynasty: the building of the Great Wall.

The construction of the Great Wall as a continuous defence against raids by nomadic horsemen from the north and northwest was one of the many remarkable measures upon which the First Emperor embarked. A defensive wall about 2,200 kilometers (1,367 miles) long, and wide enough for eight soldiers to walk abreast on top of it, guarded the empire against the outside world. Certain defences already erected as barriers by feudal lords could be included at the planning stage. Under the rule of Qin Shi Huang Di, these sections were linked together into what was then the longest border fortification in the world. In the west, the only comparable structure was Alexander's wall in Bactria, built a century earlier, although it was lower and neither so long nor so massive. Both walls served to protect the farming population from swift raids by mounted nomads from the steppes, who got supplies of grain and other commodities by looting.

Despite all these security measures, the territory of the Chinese empire was under constant attack in the following period. The emperors of the Han dynasty that succeeded the Qin used a number of methods, including marriage policies, in attempts to ensure peaceful coexistence with the nomadic tribes of the steppes of Central Asia.

The Han – the term used to this day by the largest ethnic group of Chinese for themselves and for the language of the whole country – founded a unified empire that would last for over 400 years. The methods and achievements of the Qin had laid the foundations for the Han empire.

Part of the Great Wall

This section of the Great Wall, at Badaling, was rebuilt by the Ming emperors. The old wall built by the Qin had already wound its way through this inhospitable terrain. The latest restoration work on the Wall dates from the 1950s and 1960s, and its present appearance is not at all like that of the Wall built in the Qin period.

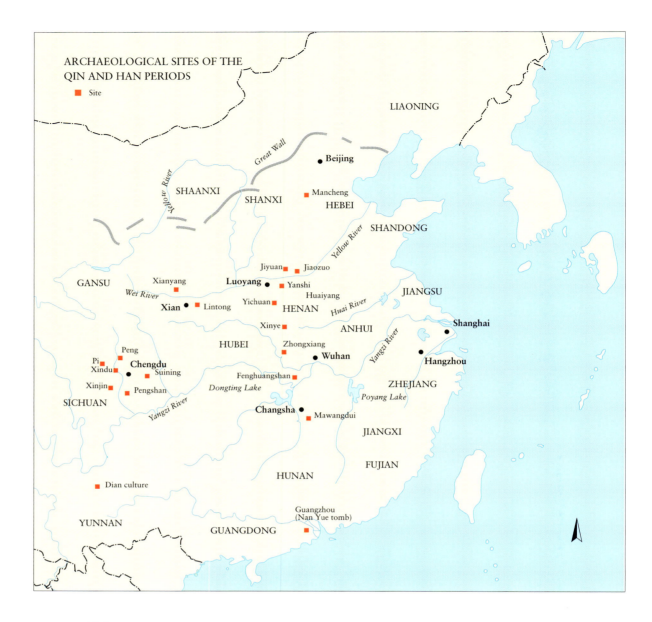

ARCHAEOLOGICAL SITES OF THE
QIN AND HAN PERIODS
■ Site

Han China:
Inventions and Discoveries

(206 B.C. to A.D. 220)

The rise of the Han dynasty brought China almost 400 years of continuity and prosperity. There are good reasons for describing the period as the country's first golden age, a time when the close relationship between politics, art, and intellect brought about a cultural flowering.

After a man of humble birth named Liu Bang had emerged victorious from the violent fighting after the fall of the Qin and founded the Han dynasty in 206 B.C., an imperial state was set up by a well-organized administration following the ideals of Confucianism. Liu Bang – who was given the name of Gao Zu, "Distinguished Ancestor," after his death – made use of Confucianism to continue, though by another name, the ideas of unity supported by the Qin on the basis of their own administrative structure. He retained the tripartite Qin division of the upper half of the hierarchical administration, and still relied on nine state secretaries, but tenure by the feudal lords was

revived. However, the feudal system was abolished in the middle of the 2nd century B.C., when 13 provinces were established.

Today, a distinction is still drawn between the Western or Former Han dynasty of 206 B.C.–A.D. 9, and the Eastern or Later Han dynasty of the period from A.D. 25–A.D. 220. In between the two comes the brief interregnum of Wang Mang, who attempted to establish his own Xin dynasty while acting as regent for an underage emperor. A violent civil war lasting almost 30 years ensued, with Chang'an, the capital city of the Western Han dynasty, razed to the ground. Finally order was restored and the Han Empire flourished once more. Luoyang became the capital of the Eastern Han dynasty. In the 2nd century B.C. there was further unrest as a result of the economic development which, despite all the progressive innovations, worked to the detriment of most of the population. The poverty of a majority of the

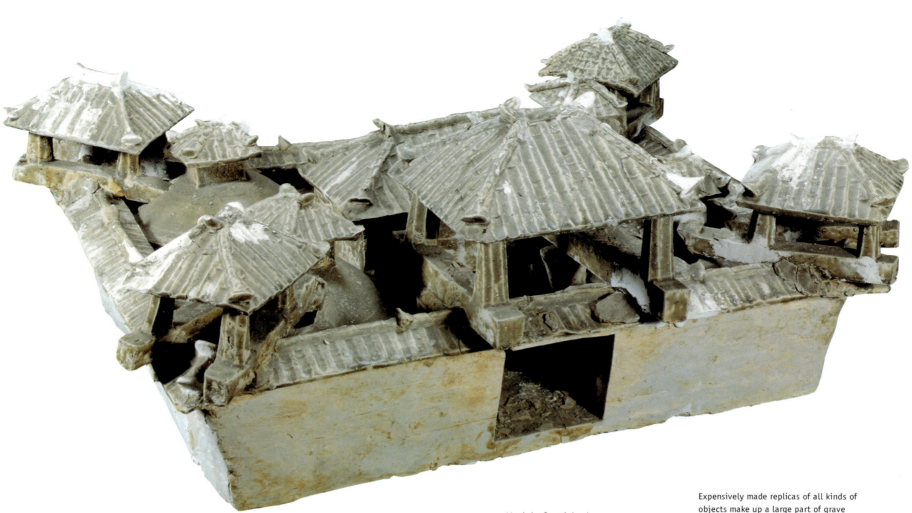

Model of a tithe barn

Sanguo period (A.D. 220–265), celadon glaze, H 31.8 cm, D 57.5 cm, L 71.8 cm, Ezhou Municipal Museum

Expensively made replicas of all kinds of objects make up a large part of grave goods from the Zhou period to the Tang period. Such intricate models enable us to reconstruct the architecture of these epochs with considerable accuracy.

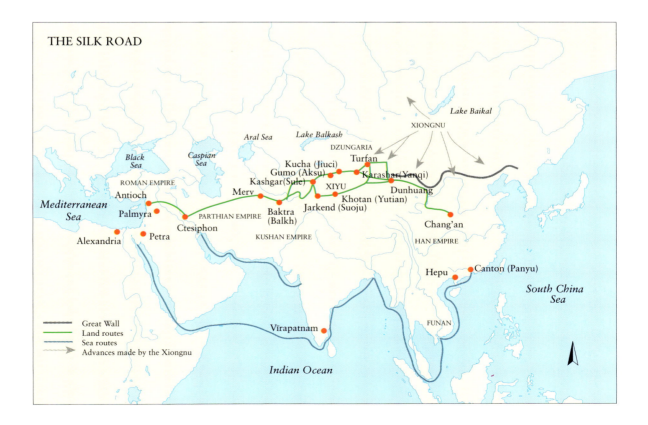

THE SILK ROAD

Lake Baikal

XIONGNU

Aral Sea

Lake Balkash

DZUNGARIA

Black Sea

Caspian Sea

Turfan

Kucha (Jiuci)

Gumo (Aksu)

Karashar (Yanqi)

ROMAN EMPIRE

Kashgar (Sule)

XIYU

Dunhuang

Mediterranean Sea

Antioch

Merv

Palmyra

PARTHIAN EMPIRE

Baktra (Balkh)

Jarkend (Suoju)

Khotan (Yutian)

Alexandria

Ctesiphon

Chang'an

Petra

KUSHAN EMPIRE

HAN EMPIRE

Hepu

Canton (Panyu)

South China Sea

FUNAN

━━━ Great Wall
━━━ Land routes
━━━ Sea routes
→ Advances made by the Xiongnu

Vīrapatnam

Indian Ocean

people on the one hand, and the unfulfilled lives of the unproductive but prosperous classes on the other, also led to a search for escape into various religious and philosophical sects.

In their years of prosperity, the Han emperors pursued a policy of territorial expansion. At times the area they ruled extended to present-day Korea in the northeast and Vietnam in the south. The Han also controlled access to the trade routes of Central Asia, and they therefore came into conflict with the nomadic peoples of the north and northwest of the country and of Central Asia. The most powerful and dangerous of these peoples was a tribe called the Xiong Nu; so attempts at conciliation were made through marriage alliances, non-aggression pacts, and the payment of tribute. Equally important, however, was the great "defensive wall" built by the preceding dynasty.

In its prime, the Han dynasty influenced all areas of cultural life. A number of developments led to social restructuring, ranging from highly progressive innovations to improve agricultural production – the construction of irrigation systems, canals for swift transport of grain, and dams, together with the use of oxen – to expeditions along the westward trade route known as the Silk Road (see map on page 81), and thus the introduction of previously unknown plants, animals (including the donkey), materials, and technologies. There were also improvements in industry and the crafts, for instance iron casting and the establishment of factories to process lacquer work and silk. Merchants made their fortunes, and it was now possible to own large landed estates. Consequently there were more potential patrons to commission works of art – works intended to give pleasure in this world and even the next (see opposite, top right).

The invention of paper and ink, like the improvement of the brush used for script, encouraged the further development of writing (see left).

As a result of further development of the brush used in calligraphy, "official script," *lishu*, became a static, angular variant of the earlier "lesser seal script," *xiao zhuan*, a comparatively tall but more rounded form, written in a rectangle that must be visualized as taller than it is broad. The Han period also saw the emergence of "clerical (normal) script" (*kaishu*), an attractive variant of official script said to have been introduced by the scholar Wang Qizong, and is traditionally dated to the governmental period of A.D. 76–83. The form of the script shows a clear movement away from the horizontal, tending toward the upper right-hand corner; the characters have a slanted appearance.

All three types of calligraphy described above could be used for official administrative docu-

Letter in *lishu* script

32–7 B.C., India ink on silk, about
23 x 11 cm, Gansu Archaeological Institute

This, the earliest Chinese private letter ever found, is in remarkable condition.

ments in public life. Such documents might be chiseled in stone or written on silk, bamboo or paper (see below). The next two types of script were designed for more private purposes. Since writing with a brush was faster, a cursive script soon developed (*xingshu*, also translated as semi-cursive script). The distinctive features of this script are the rounding off of originally angular forms and the link or ligature between formerly isolated strokes within a character. That was not the end of the development. The brush "was also an invitation to carelessness, sacrificing the form of the written characters to speed of execution."[1] While *xiao zhuan* was still in common use, some attempts had been made in the private domain to curtail these complicated characters, culminating in the invention of a shortened or "draft script" called *caoshu*. *Caoshu* means "casual or careless writing," and denotes a form of calligraphy with long, arching, interlinking strokes. *Caoshu* draft script (also known as cursive script to authors who term *xingshu* semi-cursive script) is not a form of shorthand in the modern sense, with a methodical set of abbreviations agreed upon by a community of scribes, but a genuine art form originally containing abbreviations that were personal to individuals. A distinction is drawn between two variants: *xiao cao*, "lesser draft script," with abbreviations still observing some extent of organization; and *da cao*, "greater draft script," which often presents even Chinese readers with difficulties. As calligraphic styles were handed on, personal abbreviations were preserved, and later artists sometimes added abbreviations of their own. The principal features of draft script are the compression of individual characters and the presence of

Bowl

Western Han period, H 5.5 cm, dia 25.8 cm, Stadtmuseum Jingzhou

The painting on this lacquer dish shows three birds (*feng*) against a background of flowing ornamentation, all executed in graceful calligraphic brush strokes.

Stone sarcophagus of Wang Hui

About A.D. 212

This rubbing taken of a stone sarcophagus shows an inscription in *lishu* script, with a winged being half concealed by the inscription and looking out from it.

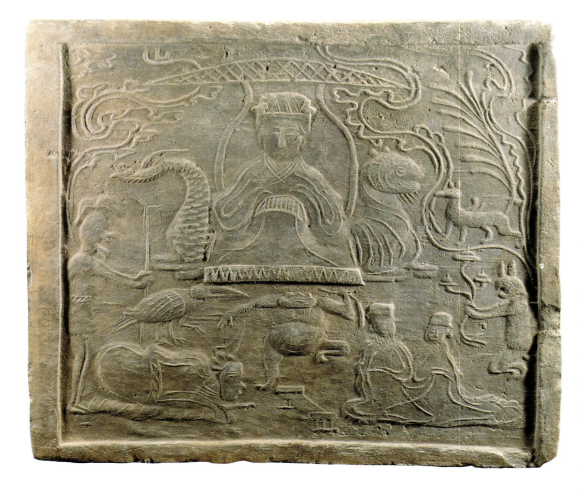

ligatures between them. Clerical script – the standard type from the time of the Six Dynasties onward – remained formally unchanged over the centuries until the early years of the People's Republic, when the written characters were simplified as systematically as possible to facilitate the spread of literacy. It allows scholars to read handwritten texts from the time of the Han dynasty. Dictionaries and printed Chinese literature also use this form of script.

The other scripts have survived in calligraphy and art. The introduction of different kinds of scripts, a development that concluded with the end of the Han dynasty, laid the foundations of one of the great arts of China. From the end of the Han period onward calligraphy offered scribes opportunities for self-expression, and the influence of personality on writing, through the stamp it left on traditional styles, was to become a criterion of artistic ability and achievement.

In the further course of the history of calligraphy both the original and the "personal" forms of characters were passed on from generation to generation. The names of calligraphers of the Han period can be found in a work by Wei Heng of the Eastern Jin period, entitled *Si ti shu shi* (The Situation of the Four Types of Scripts), but unfortunately no original examples of their calligraphy are extant. Original specimens of *lishu* in the Han dynasty form have been preserved in textual fragments such as the letter illustrated on page 82, in

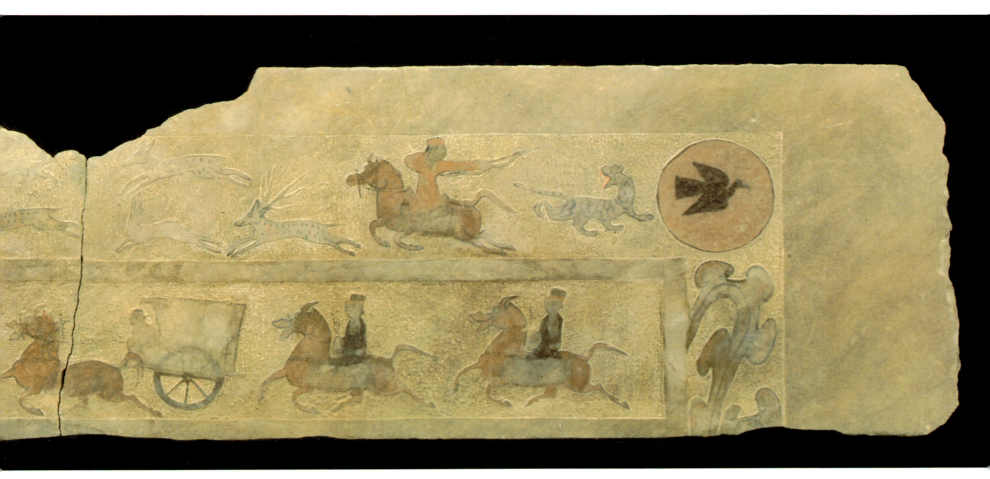

inscriptions on stone stelae, on strips of silk and bamboo, in books, in inventories of grave goods from the Mawangdui tombs (about 168 B.C.), and as explanatory comments on wall paintings.

Wall paintings from tombs help us to form a better idea of the Han period, and illustrate the development from ceremonial art to the secular use of decorative themes.

While the existence of art had once been justified by ritual and religious ceremonies – serving to create and decorate ceremonial items, and also, over the centuries, to glorify the power and prestige of great families in this world – there was a perceptible change during the Han period. Art steadily developed a narrative and expressive character: it became more secular. Instead of merely warding off bad luck, the subjects now tell stories. The stories, drawn from myth and fable, illustrate cosmological notions such as the concept of the animals of the four points of the compass – the white tiger (west), the black turtle (north), the blue-green dragon (east), and the red phoenix (south) – which are closely connected with the doctrine of the five elements (see opposite).

Characters of folk mythology such as the Queen Mother of the West (Xi wang mu), who guards the peaches of immortality in the Pamir Mountains, and is herself first among the Immortals, are now brought to life in art, and so are such subjects as the Three Islands of Immortality in the eastern ocean. For the first time in Chinese history, the Han period produces works of art that posterity can clearly classify as "paintings."

Paintings of the early period are known to us chiefly from texts, since no picture has been found earlier than the banner with the lady and the phoenix. From the Han period onward, however, wall paintings of considerable size were executed with great care. Those still extant are in tombs, but that does not mean there was no secular art. Indeed, it may be assumed that our ideas of the history of early Chinese painting derive from only a very small sample of the entire body of work that once existed. The ornamented wall panels of palaces have decayed along with the wooden structures of the buildings themselves. Any survey of Chinese art should bear in mind possible losses, to avoid easy generalizations that may give a false impression of the facts. We can never know what great works have been lost while we admire other, perhaps lesser, pieces. In the case of the Chinese art of the Han period, scholars can now be sure that naturalistic sculpture and a formally simple style of painting, with outlines suggestive of drawings, could exist side by side. Large stone statues such as those from the tomb of General Huo Qubing (2nd half of the Xi Han period) and fine bronze sculptures like the pieces from Mancheng show lifelike realism and movement replacing the rigidity of the Qin terracotta figures. The painting of the period is also realistic in style, but its treatment of contour produces a linear, flat effect like

Above
Stone relief

Eastern Han period, H 40 cm, L 196.5 cm, painted, door lintel, Shaanxi Archaeological Institute

The lintel has two decorated horizontal areas, the upper showing a hunting scene and the lower a procession of chariots and horsemen; the work combines bas-relief and painting.

Far left
Fragment of stamped brick from a tomb

40.7 x 48.9 cm, Chengdu

This stamped brick shows the Queen Mother of the West, seated on a throne in the shape of a tiger and with four accompanying figures: the fox, the hare with the herb of immortality, the toad of the Moon, and the raven.

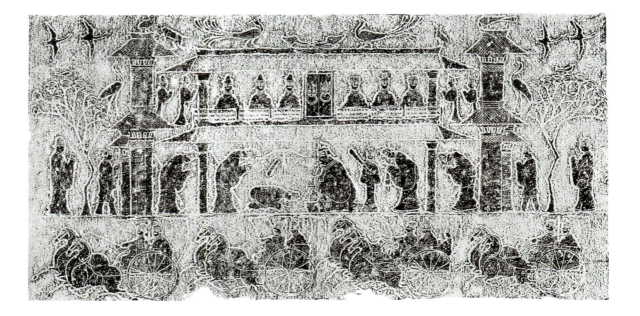

Reception scene in a two-story building

Stone relief; measurements and location unknown

A procession of horse-drawn chariots stands outside the house; birds perch on and beside the building. The composition is symmetrical, placing identical pictorial elements – a tree, birds, approaching figures – on both sides of the house.

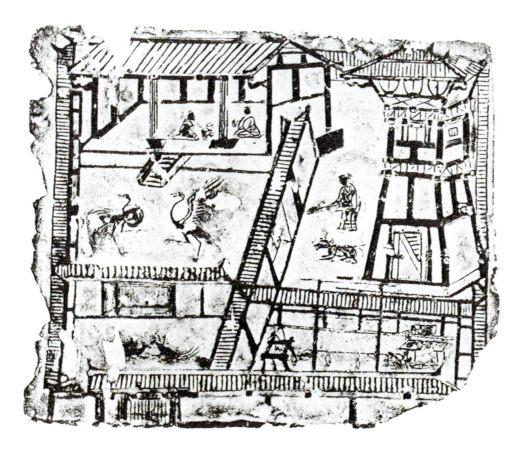

Stone relief

40 x 44.8 cm, Chongqing

The depiction shows a complex of buildings: we can make out several courtyards, a hall with seated figures, a tower, a well, a pond, and several animals.

that of a sketch (see pages 84–85, top). It is often described as resembling caricature, but that is too negative an assessment. Prominent in its subject matter are moral and educational themes.

Centuries later Zhang Yanyuan (9th century A.D.), author of a work entitled *Compendium of Paintings Famous since Ancient Times* (Lidai ming hua ji, A.D. 845), mentions that the Han Emperor Wu Di (emperor 140–87 B.C.) had a secret pavilion in which he collected maps and pictures, and that Emperor Ming Di (A.D. 58–88) loved paintings and kept a special room for them. Zhang also refers to the first great loss of pictures, around the end of the Han dynasty period, in the civil war between A.D. 189 and 192 through the ignorance of the troops, when the silk on which they were painted was used for tents and sacks. None the less, we are told that 70 cartloads were taken to safety, although half of this treasure was lost in bad weather. Zhang gives the names of Han dynasty painters, but laments the loss of their works.

Painting at the time was probably a relatively anonymous profession. Like other craftsmen, painters may well have received commissions from the imperial court or from notable men to decorate buildings. The first artists known to us by name and mentioned by Zhang were Cao Buxing, Wei Xie, Gu Kaizhi, and Lu Tanwei, who lived in the period of the 3rd through the end of the 5th century A.D. Gu and Lu are regarded as the true originators of the art of painting in China, and will be considered further.

The compositions of wall paintings and reliefs found in tombs consist of individual figures that at this early period do not yet relate with each other: they are shown as if they were a set of official seals arranged side by side. All kinds of subjects were considered worthy of artistic representation: the everyday life of ordinary people, including scenes of fishing, weaving and cooking, plowing, sowing, and hunting; festivals, and the pleasures of the upper classes with their teams of horses, riders,

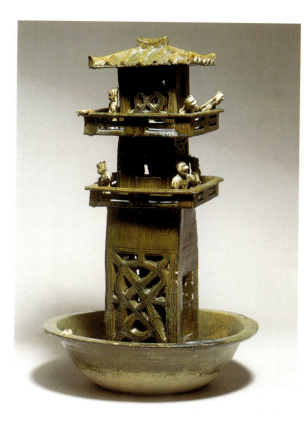

hunting expeditions, evening entertainments, performers, dancers, and musicians. Then there were strange scenes showing dragons, tigers, winged animals, and human beings, and also animal fights (see opposite). Landscape and architecture are not yet pictorial themes in their own right, only minor details. While the beginnings of landscape painting can be detected before the 6th century, architecture is not considered a suitable pictorial theme until around the Song period. None the less, stone reliefs serve to help historians of architecture reconstruct the architectural style of the time, in particular that of complexes of buildings (see opposite, below).

The original buildings themselves, constructed on a timber framework, were perishable, and all that has survived are some fittings, bearings of swinging doors, and roof tiles, items made from more durable materials. Fortunately we can gain an idea of the architecture of the time from depictions on reliefs and from models of houses buried with the dead as grave goods. Faithful copies, they reveal not only the architecture of the period, but also how the world beyond was conceived. The dead might have passed into another dimension of being, but they were accompanied by familiar

Watchtower

Han period, tower with several floors, green lead glazing, H 74 cm, Staatliches Museum für Völkerkunde, Munich

Model of a *zhuangyuan* farmhouse

Pottery with remains of painting applied cold; can be taken apart. H 89 cm, L 130 cm, W 114 cm, Henan Provincial Museum

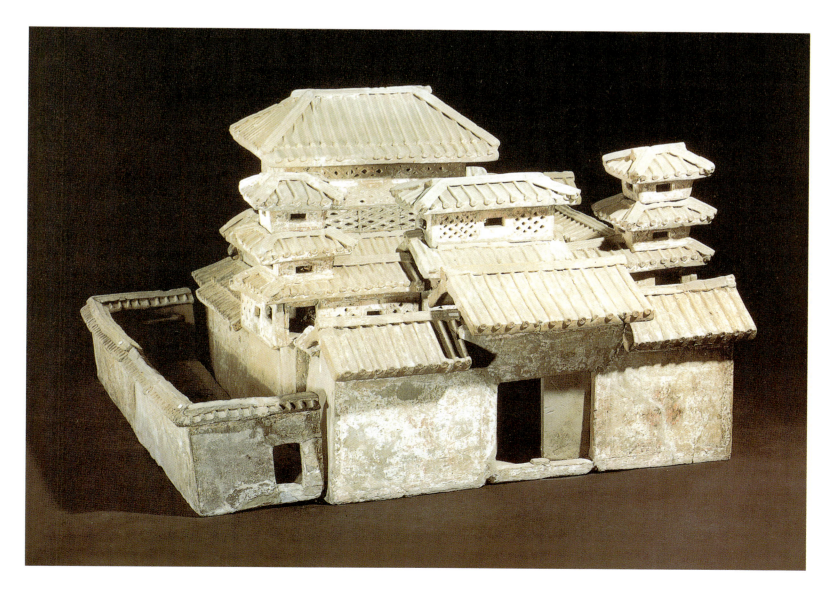

Top left
Model of a granary

*Han period, ceramic with green glaze,
H 36 cm, dia 19 cm, Staatliches Museum
für Völkerkunde, Munich*

Above right
Model of a well

*Han period, pottery with iridescent glaze,
H 30.5 cm, Staatliches Museum für
Völkerkunde, Munich*

Above left
Round end tile

*Qin to Han period, with twelve-character
inscription in xiao zhuan script,
dia 16.5 cm, Shaanxi Provincial Museum*

items, which were also, literally, in a different dimension. There were buildings of several floors, watchtowers, and houses, sometimes small, sometimes extensive. Besides architectural models of houses, the dead took models of farm buildings to the grave with them: tombs have provided many models of granaries, enclosures for ducks, wells, and pigsties, which were also used as lavatories.

A particularly interesting example shows an agricultural building or large tithe barn of a very common type: such at least is one possible interpretation of a model (see page 81) dating from the Sanguo period (A.D. 220–265). The English term "tithe barn" may be justified in this case: the layout of a walled courtyard with watchtowers, four round granaries and a main hall, together with

subsidiary buildings, suggests that either a large landowner collected his dues here and had to store them under guard, or that the place was a large grain depot owned by the state. The timber-frame method of building usual in both sacred and secular architecture up to the end of the Qing dynasty was already in use at this time. Even the roof structure is comparable with that of many models of towers or dwelling houses. The undersides of the beams are elaborately worked, and the rooftops themselves are ornamented.

The architectural function of the roof ridge ornament was to provide a suitable "transition" between the building and the air above it by emphasizing the contours of the roof; its related mythological function was to protect the house

and its inhabitants from evil influences. Until the Ming period the whole environment, including the air, was thought to be populated by countless demons; many legends describe these demons, and also the hungry souls of neglected ancestors, hovering in the air. Deities and symbols of good luck were portrayed on the eaves and roof ridges of buildings as a double guarantee of protection. According to popular belief, they kept good fortune, prosperity, and long life inside the house and defended it against outside attack by demons.

Finial roof tiles known as *dizi* and *goutou* show that bas-relief ornamentation existed as early as the Qin dynasty. In the Han period a number of very different themes were commonly used on the round *dizi* – the animals of the points of the compass, and hares and dragons depicted individually on circular tiles. Two or three concentrically arranged animals in quite large numbers were shown on eaves ornamented with written characters. The *yunwen* cloud pattern of the Qin dynasty was also still in use.

Human figures began to appear as roof decoration in the years between the change from the Qin to the Han dynasty at the very end of the 2nd century A.D. Roofs with figures of monks and nuns ended in the upward curving ends of the roof ridge and had reinforced end tiles. These features first begin to make an occasional appearance on a few models buried as grave goods. The find of an end tile showing dragons' heads dates from the 2nd century A.D. Through the following epochs a canon of architectural motifs for roof decoration

Lavatory with pigsty and millstone

Han period, pottery with iridescent glaze, H 18 cm, L 17 cm, W 16.2 cm, Staatliches Museum für Völkerkunde, Munich

became well established, and eventually the status of the building could be precisely determined by the number of ornamental figures on its roof ridges and the color of the tiles.

Our knowledge of palaces and dwelling houses comes from the preservation of their less perishable components – floors, roofing tiles, and also from the terraces for foundations. Tombs, unlike palaces, were built of stone, and many pagodas up to the Tang dynasty period were made of fired brick. Structures classified as works of civil engi-

Roof ridge ornament of a building from the Forbidden City complex

Glazed ceramics, Ming period, Beijing

Most of the roof ridge ornaments seen today in museums and exhibitions date from the Ming period, and represent the culmination of a development that began under the Han dynasty.

Boshan lu incense burner

*Pre-113 B.C., bronze with gold inlay,
H 26 cm, max dia 15.5 cm, Mancheng,
tomb of Liu Sheng, Hebei Provincial
Museum*

Incense burners shaped like mountains can
be regarded as the first independent
depictions of nature in Chinese art.

neering (fortifications, bridges, and streets) provide evidence of the expertise of Chinese architects when they built in stone.

Vaults presented as little of a problem to the architects of the epochs following the Han period as did arched gateways – though the oldest extant bridge with stone vaulting, Anji Qiao, is later than the Han dynasty and was erected between A.D. 590 and 616. Nevertheless, the timber framework method still predominated for traditional dwellings and also for palaces and temples. Wood was the building material for the living, stone for the dead. But the settings in which the buildings stood, as well as their architecture, have been preserved in the models buried as grave goods.

A fish pond comprising three basins, one containing only lotuses, can be regarded as a kind of kitchen garden pool (see opposite, bottom).

There can be no doubt that the first imperial gardens developed from the game reserves of the nobility. Textual records show that Emperor Qin Shi Huang Di was one of the first to use such a park as a demonstration of his power. His garden was called Shang lin ("highest grove"), and it contained rare plants and animals, accommodated in a huge complex containing 145 buildings, as well as a number of mountains and large expanses of water. Mountains were thought to be the dwelling places of the Immortals, and consequently artificial hills were created in gardens from the time of the Han dynasty. The Han emperor posthumously known as Wu Di is regarded as the man responsible for this essential component of a garden, introduced to entice the Immortals to the garden; his mountains were the example for such garden compositions in rock for

Opposite, top
Harvest Moon over a dew terrace

*Yuan Yao (active 1739–1780), Indian
ink and paint on silk, hanging scroll,
215 x 137 cm, Museum für Ostasiatische
Kunst, Cologne*

A depiction of architecture against a
landscape background, in the style of
jiehua linear painting. In the foreground
are the palace and garden, showing large
artificial mountains. Employing the linear
style of the northern Song period and its
great master Guo Zhongshu (died about
A.D. 977), Yuan paints the Jianzhang
palace by moonlight.

Opposite, bottom
Model of a garden pond

*Eastern Han dynasty, L 51 cm, W 31.5 cm,
Sichuan Provincial Museum*

centuries. Another interesting feature in this connection is the shape of bronze *boshan lu*, incense burners. There are all kinds of designs for the specimens found in tombs, but the rugged miniature mountain landscape of the burner from the possession of Prince Liu Sheng, populated by such creatures as tigers, fish, monkeys, and wild boar, and with perforations to let the smoke out, is the first individual depiction of nature in Chinese art (see opposite). The initial impulse came from the Daoist belief that the Immortals might be encountered in the mountains, or that humans might themselves become immortal if they reached the paradise situated in the western mountains or the islands in the eastern sea. Religious practices such as the burning of drugs were part of the search for immortality, as were the taking of miracle-working substances such as powdered jade, metals like quicksilver, and fungi, and the building of structures that the Immortals were believed to prefer – gardens and garden structures came into this category.

It is said that Wu Di's park was a restoration of the layout of the Shang lin gardens, and that he placed 3,000 exotic plant species from all parts of the empire in it. It was also the scene of hunts in the fall and the celebration of religious rites. Symbolizing the realm, the garden was a microcosm of the empire. Wu Di is also credited with the "invention" of the raised garden terrace.

Although archaeological finds confirm that terraces – as raised foundations of halls – existed in earlier times, the Han dynasty is traditionally regarded as having originated this architectural feature in gardens. An 18th-century artist called Yuan Yao painted a hanging scroll showing the dew terrace of Emperor Wu Di (see right). Bowls placed on the terrace were thought to attract the Immortals in the same way as mountains did. The belief was that the dew falling into these bowls was the Immortals' favorite drink and would also bestow immortality on the emperor. This was a very widespread belief, as is shown by the presence of a dew basin made of precious metal among the grave goods in the tomb of the king of Nan Yue. However, the emperor was not the only man to own a garden. Local administration headquarters were complexes of buildings arranged around several courtyards and a garden. It also seems reasonable to assume that the rich upper classes might have had private pleasure gardens.

The idea of making miniature copies of a large garden also developed in the Han period: palace gardens were a microcosm of the empire, the imperial family a microcosm of the people. Distinctions were drawn between menageries, vegetable gardens, and ornamental gardens. One result of urbanization was the creation of a horticultural art with the aesthetic aim of recreating nature on a small scale. And as the natural landscape itself attracted more attention, it became a subject for painting and poetry. The constituent elements of the garden (water, mountains, architecture, and plants and trees) were firmly established in the Han period and

Changxin palace lamp, the
Maidservant with Lamp

Before 150 B.C., gilded bronze, H 48 cm,
Hebei Provincial Museum

Top of a money tree

(Detail), A.D. 25–220, H in all 198 cm,
Miangyang Municipal Museum

Looking down, the top of the money tree
consists of a phoenix, a *bi* disk with the
Queen Mother of the West under it (see
the stamped brick illustrated on page 84),
and a ring disk ornamented with birds, and
bearing two dragons and two attendants
with long-handled weapons.

were then handed down as a firm tradition, though
the flowering ornamental plants used in the garden
were subject to changing tastes over time.

So models and wall decorations intended for the
dead can help us to reconstruct the world of ordi-
nary life; but what else does the manner of their
burial tell us? Large numbers of figures among
their grave goods suggest that human sacrifices
had at last been replaced by substitutes. Finds of
carefully arranged groups show that the scenes
depicted on reliefs also had fully three-
dimensional versions. The tombs contained life-
like figures of dancers and musicians, servants and
horsemen. These figures are an interesting interim

stage in the Chinese understanding of sculptural
form, and their graphic contours show that the
attempt to represent physicality predominated (see
opposite, bottom right). Even in miniature, the
lady's face is realistic, but her body remains a rela-
tively undefined shape hidden by the simplified
sculptural form created by her garments. The
same feature appears in the representation of
dancing girls with their movements suggested by
the fluttering sleeves of their robes. Despite being
three-dimensional figures, the effect is much the
same as that of the two-dimensional silhouette of
the *Lady with the Phoenix* from the Zhanguo
period, or the sketch-like style of painting in the

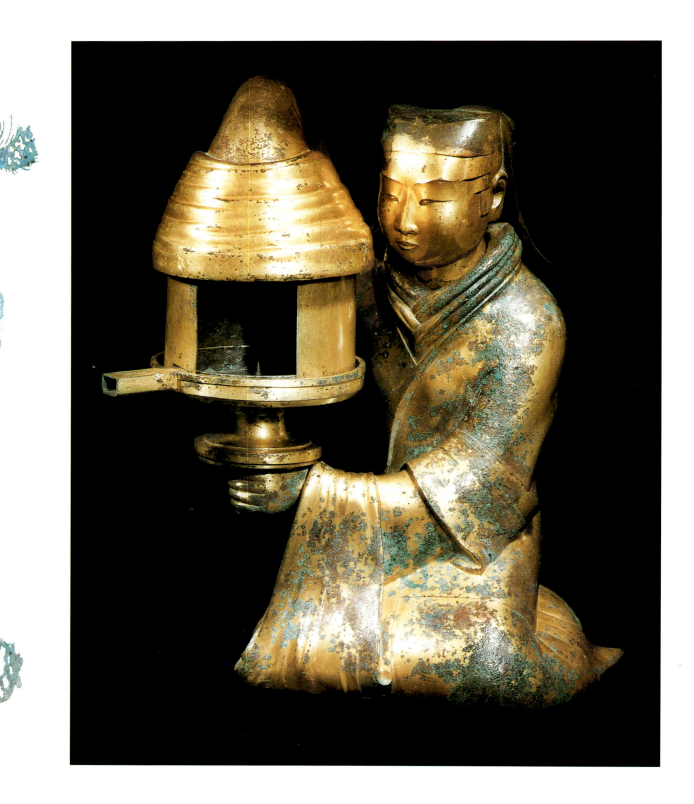

Han period. But the appearance of bronzes of the time differs from that of the stylized ceramic figures, which have their parallels in stone statues. Small human figures in bronze such as the *Maidservant with Lamp* (see opposite) are notable for their soft, flowing forms and expressive faces. The casting by the *cire-perdue* or "lost wax" method made these figures possible, and also grave goods of filigree work, such as money trees.

Replicas of servants were not the only grave goods: money and offerings of food was also placed in ceramic or bronze bowls specially made for the use of the dead. The Shang preferred to make offerings of drink, the Zhou offerings of food; judging from the vessels themselves, the Han seem to have made offerings of both in equal amounts. Such shapes as the angular *fu* bowl, wide, shallow, carefully ornamented and enlivened with animal faces, show that items worked in bronze were still a part of ritual equipment (see above).

To the family of the dead, however, such arrangements were far from adequate as full provision for the dead. Jade now appeared in a number of different forms as grave goods, and was supposed to confer protection against decay. Ordinary people were buried with jade disks in their mouth or a small jade plaque on their breast, and body orifices were also stopped up with jade. Members of noble families, however, were buried wearing entire suits of jade – not instead of a coffin, but as an incorruptible garment that would preserve the body. Twelve complete and 27 incomplete jade suits (and one of marble) have so far been found on Chinese archaeological sites (see page 94). From the literature of the Han dynasty, and the assessment of some 10,000 finds in tombs dating from the Han period, it is obvious that the living were concerned with preserving the body intact for survival in another dimension, and also with the welfare of a person's two souls, the *hun* and the *po*. The *hun*, the spiritual soul, must find its way to paradise; but the *po*, the physical soul, was not to be neglected either, and offerings were made to prevent it from turning against its descendants. The many replicas of *mingqi*, vessels given as grave goods, served this purpose, as did food and drink. Wall paintings and painted fabrics must also have been of considerable significance.

The Mawangdui tombs contained funerary banners described in the inventories of their contents as *fei yi*, "flying garment." They are T-shaped pieces of painted fabric and are among the most famous specimens of early art. In the tomb of Marchioness Dai (tomb M1) the banner was draped over the coffin (see page 95).

Iconographically, the banner over the wife's coffin scarcely differs from that over the coffin of, for instance, the son. The area of the silk is

An offerings bowl of the *fu* type

Han period, bronze with bas-relief ornamentation, geometric in shape with a fox face on the handle, H 4 cm, L 20 cm, W 27 cm, found at Lolang in present-day Korea, now in the Staatliches Museum für Völkerkunde, Munich

Lady Nüyong

Western Han dynasty, ceramic, H 72.5 cm, Staatliches Museum für Völkerkunde, Munich

vertically divided into three zones – or four, if the part depicting this world is seen as divided into life and death. The upper zone shows heaven (the horizontal part of the T shape), and the lower shows the underworld, with the grave goods in the upper area of this zone. In between, the earthly world appears in the form of a female figure with serving maids. The banner is very colorful, using the pigments cinnabar, red ochre, powdered silver, indigo, India ink, and a white made from ground shells, and its iconography can be interpreted with the aid of folk traditions. Heaven is symbolized both by the toad and the hare above the crescent moon, and also by the raven perching in the circular sun. Dragons and immortals also occupy this zone, since heaven is their element. In Chinese mythology the moon hare has a mortar in which it crushes the herb of immortality. A stem bearing strange leaves, the leaves of the same herb of immortality, is present in the scene showing the toad and the hare; the significance of this theme can be gathered from depictions on reliefs from other tombs. A gateway flanked by two guardian figures separates this area from the world below, and at this point, where the material becomes narrower, the change of format further emphasizes the division between heaven and earth. The underworld, represented by two large fish with coiling bodies, is optically distinguished from this world by an ornament made of *bi* disks and the coiled bodies of dragons, and a wide tassel sweeping apart like the curtain in a theater. The underworld itself is in two parts: above, it shows the tomb with its grave goods, and below are the fish and strange zoomorphic forms: two have horns yet their bodies are those of big cats, while another couple have what are obviously turtle shells combined with serpentine necks. These turtle creatures are typical representations of the "Dark Warrior," the symbolic animal of the north, darkness, and winter. Owls perch on their shells. The horned cats bear a noticeable resemblance to the ceramic figures of guardians known as *zhen-mushou*, seated figures with manes and horns. The message conveyed by the figures of owls can only be guessed at, but they remained a ritual theme for well over 1,000 years as *shang* (jade) grave goods, and as a decorative motif on bronzes. Their position on the banner also indicates that they belong to the kingdom of the dead. Life before death is shown in the images of a lady leaning on a stick, two kneeling servants, and three other women enveloped in long robes. They are situated on a patterned plateau with spotted cats underneath it; spotted cats in the form of leopards are also known from a rather later tomb site at Mancheng in the province of Hebei, containing the tombs of Liu Sheng and Dou Wan (see opposite, left). The leopards found in a number of tombs are often

Jade suit of Princess Douwan

Before 104 B.C., nephrite plaques and gold wire, L 172 cm, Mancheng, Hebei Provincial Museum

simply interpreted as weights and counted among the personal possessions of the dead; but closer inspection of the banner casts doubt on this theory, suggesting that they can be regarded as guardians averting ill luck. The ritual of the *fangxiang shi*, the shaman, was practiced during the Han period: wrapped in an animal skin, the shaman touched the four corners of a tomb with his sword, a ceremony of cleansing which was intended to banish evil.

Archaeologists have also found leopards stationed at the four corners of the area containing grave goods on some sites, suggesting that the creatures may be interpreted as ever-present guardians, in line with the *fangxiang shi* ceremony. At the end of the *danuo* festival celebrating the end of the year, for instance, the two wings of double doors were painted with tigers to prevent evil powers from entering. It might be concluded from this that one pair of guardians was sufficient. A further consideration is that there is some doubt whether tigers and leopards were regarded as separate concepts in the Han period: dictionaries of the time define *bao* as a "tiger, but with spots."

Even this brief survey shows what difficulties the interpretation of decorative motifs present, since different sources constantly have to be considered in relation to each other.

The artist who painted the banner was following the ideological conventions of his time, and produced images whose forms we can recognize and to some extent classify. The banner should not be seen as an independent work of pictorial art – one created, like wall paintings in tombs, in the context of aristocratic funerary customs. Its ornamental motifs clearly present a programmatic theme, wishing for the protection and immortal survival of the dead. The ritual significance of the banner is the subject of much controversy. Some scholars believe it was carried at the front of the funeral procession, others see it as a ritual robe. The latter theory may be influenced by the description of the object in the inventory as *fei yu* ("flying garment"). A new theory attempts to interpret it as a "name banner:" was it a kind of

Right
Funerary banner

About 168 B.C., painted silk, 205 x 92 cm, grave of the Marchioness Dai, Hunan Provincial Museum

The horizontal area of the banner depicts heaven; below is this world, in the form of a female figure with servants. The lower part of the banner shows the underworld.

Leopards lying down

Before 104 B.C., bronze sculptures, partly gilded, with silver and gemstone intarsia work, H 3.5 cm, L 5.8 cm, tomb of Dou Wan, Hebei Provincial Museum

Two beautiful worked bronze statues with gemstone eyes; the markings are imitated by silver intarsia work and gilding.

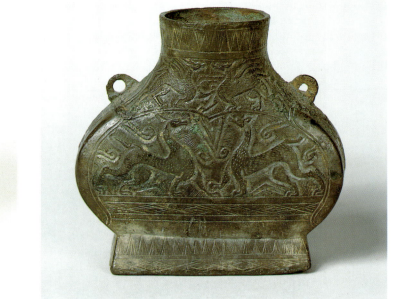

Lacquer bowl of the *erbei* type

Western Han period, decorated with a fox motif, found as grave goods, dia 21 x 16 cm, Hebei Provincial Museum

passport for the *hun* soul on the way to heaven? The fact that it shows both the lady and her grave goods would seem to support this.

Han grave goods did not consist solely of replicas of buildings or items for personal use. Other objects included ceramic vessels, bronzes, and also, during an economic boom during the Zhanguo period, lacquer ware, patterned fabrics, and ceramic figures. How far fish motifs may be interpreted as the symbol of plenty, in line with our present iconographic understanding, is open to question in view of the fish on the banner and those on neolithic pottery vessels. However, a particular phenomenon of Chinese iconography, one rooted in the language, should be mentioned: many objects became symbols of a particular blessing because the words for them sounded the same: for instance the salary of an official, symbolized by *lu* (a stag), or wealth, *yu* (see bottom left), or peace, *ping* (a vase of flowers).

A keen awareness and appreciation of the craftsmanship in the manufacture of decorative items for daily use became part of the social life of the Han period. This craftsmanship found particularly elegant expression in colorful lacquer ware and brightly painted ceramics. In many cases the shapes of items thus decorated were known in earlier centuries, and can therefore be described as traditional. Lacquer ware was not among the grave goods within the means of ordinary people: a text of the Han period informs us that lacquer was ten times more expensive than bronze (see top left). Gracefully painted lacquer ornamentation continues the decorative lacquer style of the end of the Zhanguo period and the Qin period, and the traditional forms of vessels themselves are preserved, as are red-painted ceramics. However, artistic activity was not confined to the center of the country. The sending of members of the imperial house to all the imperial provinces to subdue the barbarians, and consequently the transfer

of current values and artistic norms to the more remote regions of the country, led to encounters with local cultures that had already developed their own ideas of art.

As Han historians saw it, the "barbarians" were people of uniformly low standards, uncivilized and uncultured, and their difference from the Chinese of the center was regarded in a purely negative light. Modern finds, however, show that the Shu (contemporaneous with the Shang in Sichuan) and the Dian (about 400–109 B.C., in present-day Yunnan) had mastered the same technologies as the inhabitants of the central area. The Dian bronzes – about 80 percent of the 7,000 finds from the area around the Dian Lake are bronze – show scenes of everyday life in both peace and war. They are lively in form and realistically executed (see opposite).

A great many of these bronze pieces are weapons, including hunting and ritual weapons. Richly ornamented agricultural implements and drums, as well as many waisted bronze cylinders with bases and lids (containers for cowrie shells), have been found in the tombs of members of the upper classes. The lid ornaments typical of this culture are lively scenes showing realistic human and animal figures in movement. A central motif, widely dispersed and with many variations, is that of cattle; they appear on the lids of money containers and in the ornamentation of bronze fittings. Cattle must have played a central part in the life of the Dian as both domestic and sacrificial animals. A rich society of several classes such as the Dian, who produced and traded in large livestock, metal ores, gold, and silver, presumably performed rituals that sought to ensure the fertility of their domesticated animals, and also gave thanks for their work. There is nothing to suggest that domestic animals would not have been sacrificed; even totemic animals were slaughtered at special

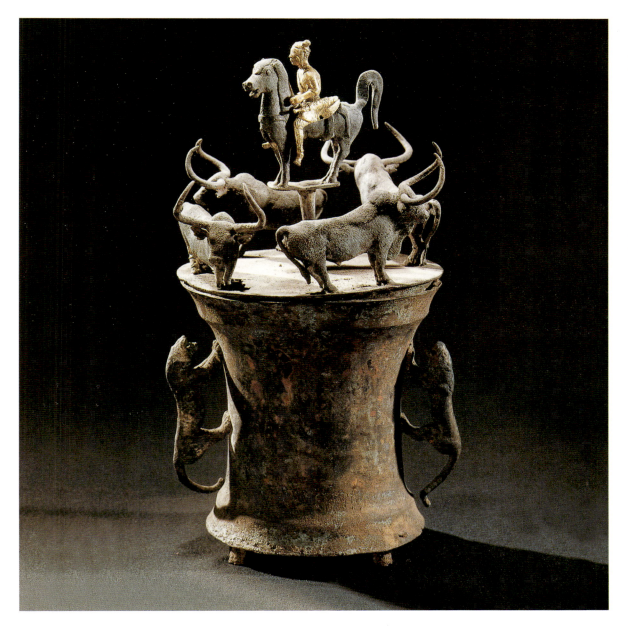

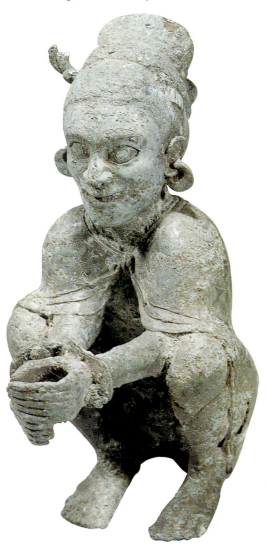

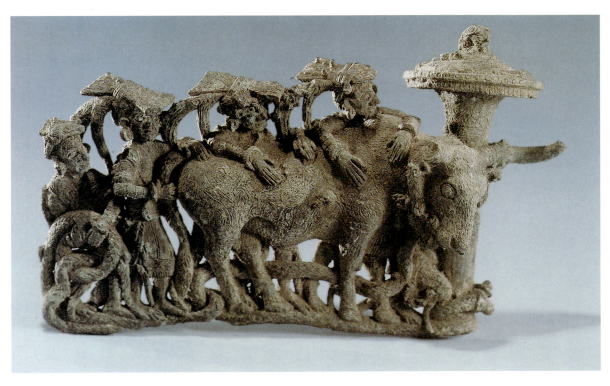

Left

Money container

Bronze, H 50 cm, 150–50 B.C., Yunnan Provincial Museum

The handles of this money container are in the form of tigers and the lid is adorned with cattle, a horse, and its rider.

Bottom left

Decorative plaque

About 150–50 B.C., bronze, L 16 cm, Yunnan Provincial Museum

The observation of the Dian bronze workers reproduces the smallest details in the depiction of this subject. Five men are tying an ox to a post, so tightly that it cannot move; one holds it by the tail, another is bending down to tie the rope.

Above

Crouching figure

Bronze, H 27.5 cm, Yunnan Provincial Museum

The figure is that of a man of the Dian people, wearing large earrings, a sword, a belt with a plaque and a cloak ornamented with animal motifs. Originally he was probably holding the wooden handle of a bronze umbrella.

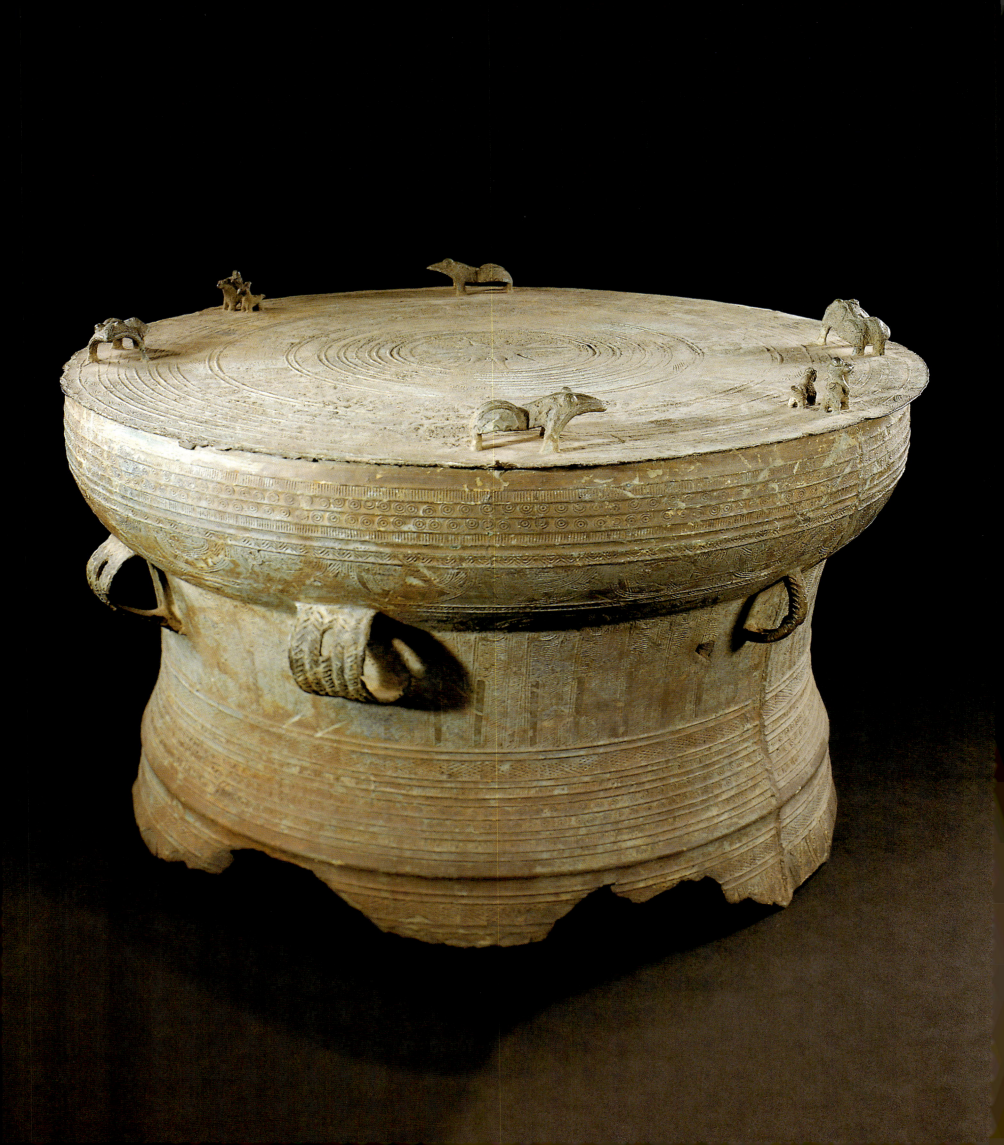

festivals. Bullfighting can be traced to this early period on the evidence of a decorative bronze plaque, and can thus lay claim to a history of over 2,000 years in southern China. The execution of these bronzes is notable for its great naturalism: human and animal sculptures alike are accurate and true to life.

The evidence of the architectural models found in Dian graves proves that the Dian people built much more in the style of Southeast Asia than of central China (see right).

The numerous decorated bronzes, sculptures, and ornamental plaques of the Dian are striking evidence of an artistic concept very different from that which developed in Han China. It is far more naturalistic, and places greater emphasis on animals and humans. The artistic ideas of the Dian may have represented the culmination of various influences from several cultures: certain features taken from the Shu, motifs from the Chu, the depiction of animals in the style of the steppe-dwelling tribes, and influences from the Yue, contemporaries of the Dian on their eastern borders, with whom they had lively exchanges.

The Yue cultures (of Guangxi, Guangdong, and North Vietnam) lived by agriculture, fish farming, and trade; at the beginning of the Han dynasty they had combined into a kingdom which was actually ruled by a Chinese foreigner. The Yue lived in houses on stilts and had preserved rites fundamentally different from those of the north; they venerated objects in different forms. Large bronze drums with graphic ornamentation and animal figures are particularly typical of the decorative style of the Yue. Their finely engraved patterns reappear as background decoration on Dian bronzes (see opposite).

The tomb of Zhao Mo, king of Nan Yue (122 B.C.), discovered in 1983 in present-day Guangzhou (Canton), is a synthesis of Yue and Han styles. Although the king was of Chinese descent, he ruled Nan Yue for 16 years. He was accompanied to the grave by fifteen human sacrifices and 2,000 grave goods, so many they could not all fit into the burial chamber and had to be stored in the passage leading to it. The tomb itself, made of stone slabs, is remarkable, since in the north members of the ruling house were laid to rest in deep pits or tombs of brick masonry (as at Mawangdui and Mancheng). The Yue, on the other hand, buried their dead in boat or vessel coffins, in pits in the ground.

The Nan Yue tomb does not fit into any one tradition. The king was buried in a suit of small jade plaques, presumably made from scraps of the precious material, and with all kinds of significant objects such as *bi* disks, many of ceramic and a few of jade. He was accompanied to the next world by furniture, instruments, bronzes, ceramics, mirrors, lacquer ware, statuettes, and household implements of great interest to posterity such as a ginger grater and an ant trap. His jade suit suggests that the furnishings of the tomb reflects the royal tomb of Mancheng, except that this southern tomb is an

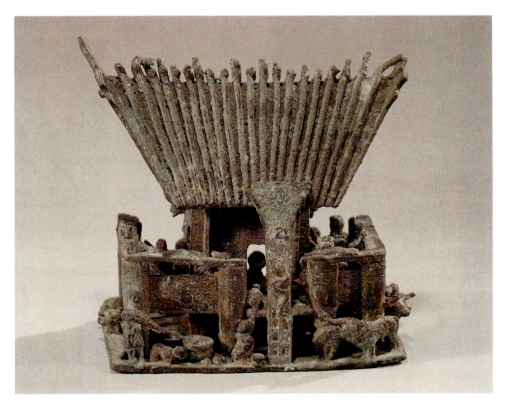

economy version, with glass and ceramics frequently used as a substitute for jade. Was it a deliberate imitation of the courtly norms of the north? Was the king presenting himself as a Han Chinese through the design of his last resting place, or was he merely remembering old traditions? These questions can never be answered for certain. He was surrounded by traditions of north and east, such as the use of jade in the cult of the dead (in *bi* disks and small sculptures) and motifs of dragons and phoenixes, but also by items from the south: bronzes with simple geometrical relief ornamentation, vessels typical of Sichuan, tripods with the curved legs of the Yue culture, and most notably a jade drinking horn adorned with the face of a fox. The Dian people also used foxes in ornamentation, and so, much earlier, did the inhabitants of the archaeological site of Erlitou. Chinese beliefs traditionally credited foxes with the magical ability of turning into human beings. In both the north and the south, foxes were credited with moving between two worlds.

Cultural conditions differed greatly between north and south, but there are many indications of exchanges between the two areas. A new separation came only with the fall of the Han dynasty, when its effects were more far-reaching than before. The art of the Han period was continued in the time of the Three Kingdoms (Sanguo) until the middle of the 3rd century A.D., with foreign influence preventing stylistic stagnation. In their different ways, rulers from extremely dissimilar cultures (the successors of the Han dynasty on the one hand, nomadic horsemen on the other) encouraged social, intellectual, and artistic evolution in the years that followed.

Above
Model of a dwelling

Western Han period, bronze, H 11.5 cm, W 7.5 cm, L 12.5 cm, Yunnan Provincial Museum

Models of houses built on stilts show that the dwellings of the Dian people followed the Southeast Asian style of architecture.

Opposite
Drum of the *yue* type

Han period, with shallow geometrical decoration, bronze, dia 64 cm, H 41.2 cm, Museum für Völkerkunde, Dresden

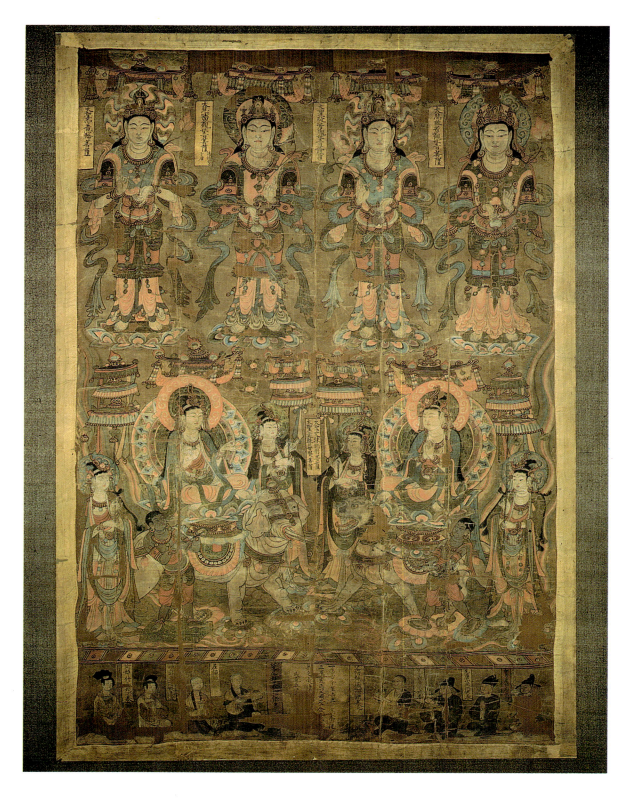

The four manifestations of Avalokiteshvara (Guanyin)

Dated to the year 864, ink and paint on silk, 140.7 x 97 cm, Dunhuang Cave 17, British Museum, London

In his headdress, Avalokiteshvara wears a depiction of the Buddha Amitabha. He is accompanied by Samantabhadra (Puxian) on an elephant and Manjusri (Wenshu) on a lion. They can be identified by their attributes and the animals they ride.

The Advent of Buddhism

The Silk Road: trade and missionaries

Buddhism had already diverged some way from its original form when it reached China in the 1st century A.D., more than 500 years after its initial emergence in the north of the Indian subcontinent. The advanced form that found wide acceptance in China may be described as an Indo-Tocharian version of Buddhism. After its gradual rise to dominance over a 200-year period it was extremely influential, almost uninterruptedly, from A.D. 300 to about A.D. 1100. But whereas other East Asian countries had possessed no written culture before the advent of Buddhism, when the new faith reached China it found a sophisticated civilization already well established in the country and proud of its long history. "By the time Buddhism was introduced China boasted

a civilization already very old, a classic canon, time-hallowed traditions, and the conviction that its society was the only truly civilized society in the world."[1] This attitude explains why, for the first time, the religion was not spread in its original language and script, and why some slight taint of the foreign and non-Chinese always clung to Buddhism in China. It also accounts for the process of the cultural assimilation or "sinocization" of such foreign cultures as the Northern Wei and later the Liao, Jin, and Mongol (Yuan) dynasties, as well as the Manchu, whereby the conquerors adapted to the culture of the conquered until their own had been entirely swallowed up. In this context the iconography of Buddhism is particularly interesting, for it enriched Chinese art with many new themes and much new subject matter (see opposite).

Buddhism was not introduced and spread in China by missionaries in the same way as the Jesuits, centuries later, attempted to export Christianity from the Old World. It was an imported religion. The first "missionaries" were devout Buddhists, merchants and craftsmen, who brought their faith into the country with them along the trade routes. Those with whom they had direct contact in China took an interest in the new religious trend, which was at first regarded as a version of Daoism, so it is easy to see why most of the monasteries built in the first half of the first millennium A.D. lay in a line along the two Silk Road routes between Isfahan and the Tang capital Chang'an (see below). But word of the new faith also reached south and east China, and here the importance of the sea route has to recognized.

Finally, Buddhism was actively imported into the country because Chinese rulers expressed an interest in it, and monks traveled to the place of origin of the faith to bring religious texts back to China. From the middle of the 3rd century through the 7th century, some 50 delegations of Chinese monks were sent to India. Buddhist teaching promised that their journey would bring them a step closer to Nirvana, the paradise where the immortal soul dwells once it has been freed from the cycle of reincarnation.

A great deal of translation into Chinese was necessary in order to import every aspect of Buddhism, and in the process two languages that could hardly have been further apart syntactically, morphologically, and phonetically encountered each other. The life of the historical Buddha, Prince Gautama or Siddhartha, who lived in India in the 6th century B.C., had to be translated. So did

The Cave of the Thousand Buddhas
Aerial photograph, Dunhuang, Quian fo dong

Situated in northwest China, at the beginning of the Silk Road, this famous Buddhist site is a telling example of the religious and cultural impact the main overland trading route had on China. As the name suggests, the site contains a thousand images of the Buddha, which are set in caves, chambers, and niches. For many centuries it was to remain one of the most important centers of the Buddhist faith in China.

Above

Samantabhadra (Puxian)

8th to 9th century A.D., ink and paint on silk, banner, 57 x 18.5 cm, Dunhuang, Cave 17, British Museum, London

Samantabhadra, riding an elephant, is shown in the *varada mudra* position.

Opposite

Statue of the Buddha

Early style, 5th to 6th century A.D., partly rounded statue, sandstone, Yungang

This statue of Buddha is notable for its Indian features and for the shallow cascading pattern of the folds of the figure's garments.

his teachings as recorded by his pupils, as well as the theological terminology of Buddhism. Differences of cultural background meant that Chinese had no corresponding terms, or only very few. It should be mentioned once again that the written characters could not be arbitrarily reconstructed, nor could an infinite number of new characters be devised.

The earliest translators were monks from Parthia, Sogdia, and Kushan, in other words natives of central Asia, and they were responsible for translating most of the Mahayana canon. Mahayana Buddhism was widespread in south and east Asia. Mahayana, the "Great Vehicle" – the vehicle for achieving salvation, the release of the immortal soul from the cycle of reincarnation through its entry into Nirvana – requires active ethical conduct on the part of the faithful. They are duty bound to do good to others, to love their neighbors, leading them on the path to salvation, purifying their own hearts, and avoiding sin. Souls living in this noble way can become Buddhas, while others, who have also earned their entry into Nirvana but abstain in order to continue doing good for their fellow men, are known as bodhisattvas. This concept of salvation created a mythology featuring saviors to whom prayers might be addressed, and whom seekers after truth thought likely to render aid in time of trouble. Large quantities of cult objects such as pictures and figures of bodhisattvas were made.

It is interesting that a Chinese term for Buddhism is *xiangjiao*, which translates as "pictorial teaching." In accordance with the Mahayana, the faith was spread in China by whatever means were suitable. The monks adapted to the Chinese mentality, sanctioning the existing cult of the state and ancestor worship. In the hands of Chinese Buddhist scholars, the long path to the condition of a Buddha through meditation and prayer was complemented by sudden enlightenment; according to Chinese interpretation, any human being might become a Buddha, a concept impossible in the socially restricted caste system of India.

The introduction of Buddhism into China is traditionally dated to A.D. 67; some sources give the year as A.D. 65. Emperor Ming Di, "the Radiant" (reigned A.D. 58–75), had sent an embassy to the west, and in that year his envoys returned to China bringing word of the new religion. The first Buddhist community on Chinese soil was founded in A.D. 148 and consisted entirely of non-Chinese. Their faith permitted the worship of images, and consequently they continued to create religious images in their new home. Existing traditions of Chinese wall painting and sculpture began a process of exchange with the art of the new faith, for Buddhism brought its own painting and sculpture into the country. Buddhist art did not develop any personal style in this early phase, and the leading artists remained anonymous. They worked in a traditional formal language, at first producing sculpture like that of their native lands, for the craftsmen who accompa-

nied the monks initially clung to their own traditions. Two styles of Buddhist art gained currency in China: Gandhara art, an Indian style subject to Greek influence; the other was Hindu Buddhist art. Artistic exchanges made Buddhist sculpture in the style of the Indian province of Gandhara (now Afghanistan and the Peshawar valley) the model for the Chinese sculptures of Yungang (see opposite).

During the Han period Buddhism was still very much at odds with Confucianist morality. The ideals of homelessness, the monastic begging life, and celibacy were in marked contrast to the Confucianist family tradition, which promoted a hierarchical system of relationships within the family for the good of the state. The family was regarded as a microcosm, reflecting the same relationships and values as the macrocosm of the state.

However, Buddhism gradually attracted more and more adherents. When the empire broke up first into the Three Kingdoms of Wu (A.D. 222–280), Shu (221–263), and Wei (220–265), then into several kingdoms in the north and south during the period from A.D. 317–589, Buddhist teaching and its worship of images became increasingly popular. In the 4th century A.D. Buddhism finally reached the common people. Around A.D. 300 there were some 180 monasteries with about 1,000 monks in Chang'an and Luoyang, the urban centers of the Han period. It was not until A.D. 355 that Chinese were permitted by an imperial edict to become Buddhist monks. The following years saw the rise of various Buddhist sects, or more accurately schools, arising from the work of monastic communities on the translation and interpretation of either one main text or a homogeneous group of texts in the Buddhist tradition. Their influence depended on the patronage of the ruling classes. Seen from the historical standpoint, each period and each class of society preferred a different tendency. For instance, *zhen yan*, "the True Word," an esoteric school, was at its height in the 8th century A.D. The doctrines of many schools, such as the "Pure Land" or *qing tu* sect, with its promise of salvation, fell on fertile ground among ordinary people; while others, for instance the more complex philosophical ideas of the *tiantai* or *huayan* schools, were confined to the elite classes of society. The monks most prominent in developing these traditions became the patriarchs of the various schools.

Under the Northern Wei dynasty (A.D. 386–535), also called the Tuoba-Wei, a Buddhist state church was established in the north. The emperor, who was regarded as a reincarnation of Buddha, appointed a monk as superintendent of the monasteries. More and more were founded under imperial patronage, and work began at this time on the building of the famous cave monastery complexes of Yungang and Longmen.

Over the centuries, these great complexes underwent alteration, extension, and rebuilding. As a result, many of them contain Buddhist sculptural works of different periods and different styles that can be admired side by side.

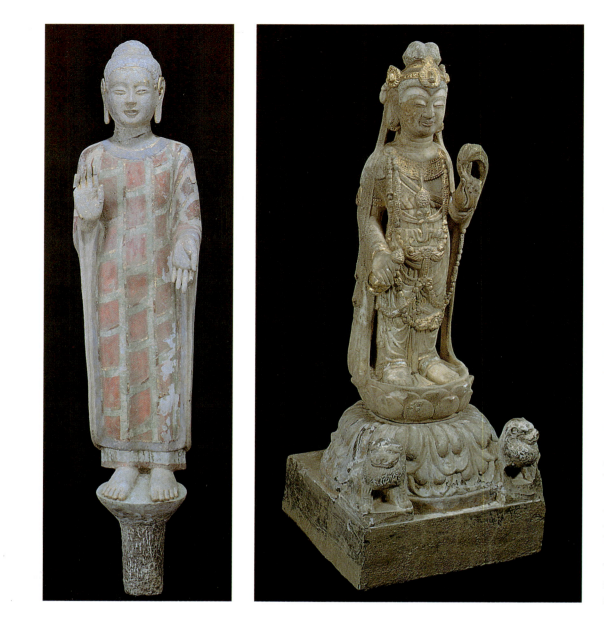

Three stylistic epochs are distinguished in the pre-7th century Early period: the archaic style (5th century); the elongated or Wei style (to the middle of the 6th century); and the columnar style (late-6th century in the northern Qi kingdom; see far left). They were followed by the Late period styles: the Sui style (Sui dynasty, A.D. 581–618) and the Tang style, prevalent during the period of that name, both distinguished from the three early stylistic periods by a greater sense of relaxation and movement. The grouping of figures *in situ* also provides useful indications for dating. In Yungang, one of the earliest complexes, single massive figures predominate. They are succeeded by groups of figures that relate more fully to each other. After pairs of figures, which exist in many comparable examples (the most famous is now in the Musée Guimet), compositions showing a single Buddha with a symmetrical number of companions became popular. There are many 7th-century groups of five figures: a Buddha, two bodhisattvas, and two pupils (*luohan*). Many temple complexes of later periods, such as the Temple of the Azure Clouds, Bi Yun Si, devote entire halls to the *luohan*, or they may be placed in the ambulatory around the sanctuary in the main hall of the monastery (see bottom left).

In general, in sculptures as well as paintings, *luohan* are depicted in groups of 16, 18, or 500, and wearing monastic robes.

The archaic style, including the earliest works in Yungang, is notable for a striking similarity to its Indian models. Even the form of the cave temple goes back to Indian origins.

The oldest temple complex was built in Yungang under Tan Yao, in A.D. 460–465, just after the first major persecution of Buddhists. The depiction of human figures in both sculptures and

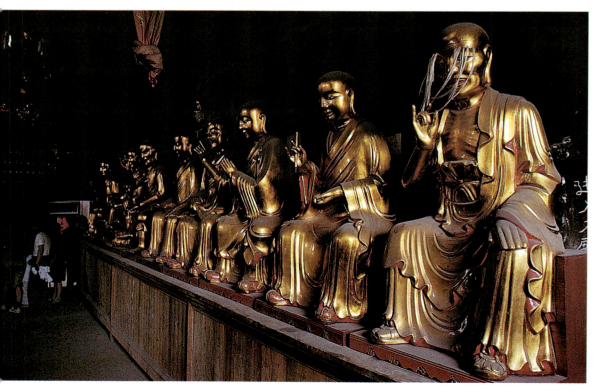

Above left
Standing Sakyamuni
Northern Zhou kingdom, A.D. 550–577, stone, painted, columnar style, H 97 cm, Qingzhou District Museum

Above right
Gilded bodhisattva
Northern Zhou kingdom, A.D. 557–581, stone with remains of gilding, H 94 cm, Xi'an Archaeological Institute

Figures of this type mark the transition to the more lifelike figures of the Sui and Tang periods.

Left
Luohan sculptures
Jiuhuashan, Baisui temple in the modern province of Anhui

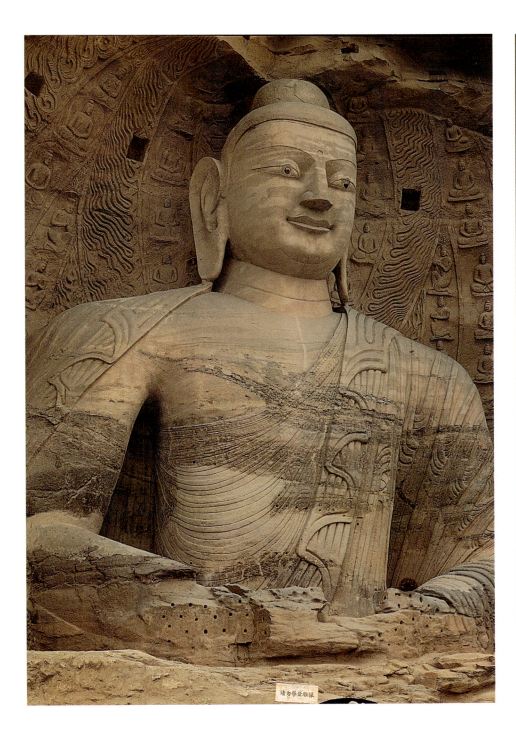

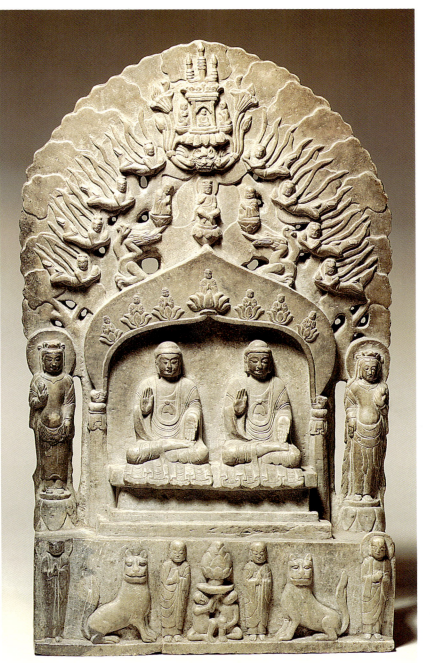

wall paintings is extremely symmetrical: the folds of garments, the seated or standing positions of the figures facing full front, their hair and features, are all regular and rigid in effect (see above, left). The Yungang statues are carved from coarse sandstone, restricting artistic expression – sculptors could not execute the same fine lines in sandstone as in the hard gray limestone worked in honor of the Buddha in Longmen.

In A.D. 495 the Wei moved their capital city to Luoyang, further south. Chang'an, which they had conquered in A.D. 430, and their first capital, Pingcheng, thus lost a great deal of their importance, and so did nearby Yungang. The temples of Longmen were built near the new capital.

Caves were carved out of the Longmen mountains from the Northern Wei period until the later years of the Qing dynasty. The most important caves of the late Wei period (1st quarter of the 6th century A.D.) include Binyang, Lianhua, and Guyang, which are typical of the Wei style.

The sculpture here is more delicate and slender, and elegant depictions of figures from the Buddhist pantheon are characteristic. They have flat faces, almond eyes, and necks of a truncated cone shape, and they are enveloped in several garments. The undergarment is visible at the throat, they wear ribbons around the waist, and an outer garment cascades down over the body. The cascade effect, like the rather elongated neck, reinforces the impression of height. The folds are still symmetrical. A very fine piece, carved much further to the east at about the same time, shows similar characteristics (see page 106, right).

(see page 106, right).

Left
Colossal Buddha Amitabha

About A.D. 460–493, Northern Wei period, sandstone, H 13.7 m, Yungang, Cave 20

This gigantic statue shows the regular folds of garments typical of the period.

Right
Stone stele

About AD 500, H 50 cm, Staatliches Museum für Völkerkunde, Munich

The relief shows two Buddhas in the meditation position in a niche, each flanked by a bodhisattva, and above them, in a "wreath" of trees, winged *apsaras* and a triad of figures. Below them are four monks, two big cats, and a lotus vessel held up by small human figures.

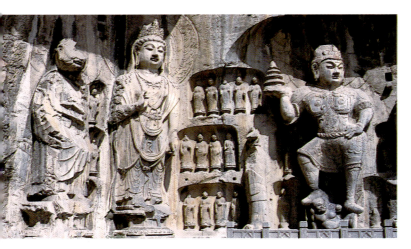

As well as major works of art in the Wei style and inscriptions (see opposite, bottom right), the Longmen caves contain fine works of the Tang period on myth and legend. The Fengxian temple, Fengxian si, built in A.D. 675, has some of the most impressive in the entire complex (see above).

It is said that Wu Zetian, later Empress Wu (reigned A.D. 690–705) contributed 2,000 strings of *cash* from her cosmetics budget to the finances of the Longmen temples. The chronicles even record some of the names of the sculptors who worked here: Li Junzan, Cheng Renwei, and Yao Shizhi.

The figure of the seated Buddha Vairocana, the Buddha of the Center (an esoteric school of Buddhism, *Hua Yan*), is 17.4 meters (57 feet) high, carved out of the rock, and wears the three collars typical of the Tang style. They are also worn by the pupils and bodhisattvas beside him. The colossal statue of a bodhisattva on the northern cliff wears a crown of lotus tendrils, and a halo is carved into the rock behind the figure in bas-relief, its outer rim consisting of a circle of flames. Another indication of the figure's divinity is the elongation of the ears. In Chinese Buddhist art it is easy enough to distin-

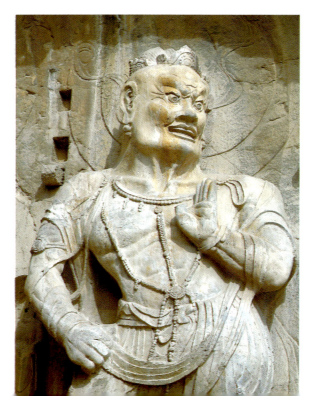

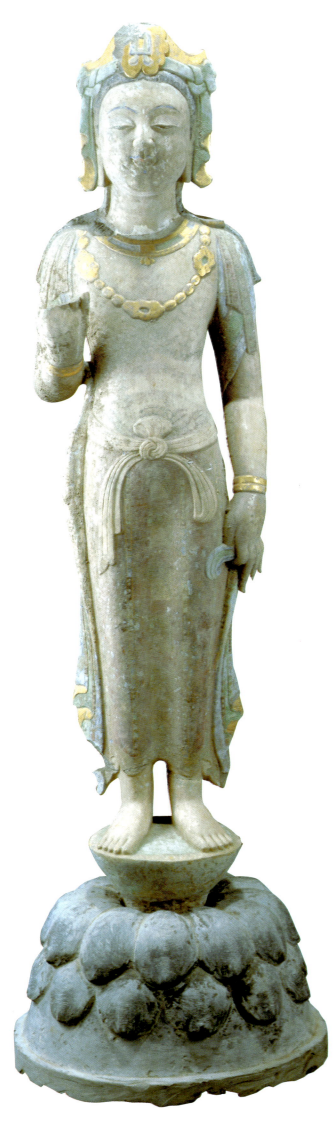

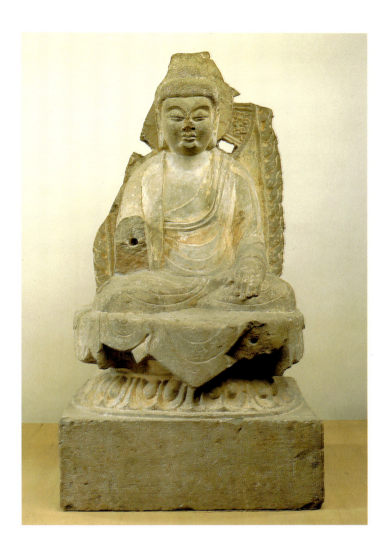

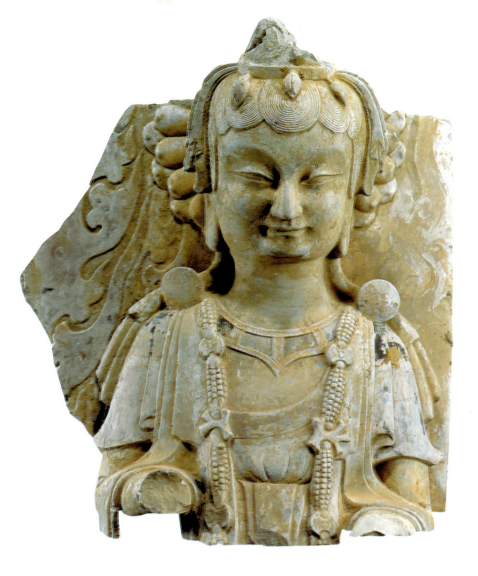

guish Buddhas from bodhisattvas, since Buddhas are shown in only a very small number of attitudes (seated in the meditation position, recumbent, standing, very occasionally walking) and also few gestures (*mudra*, the symbolic position of hands and fingers in Buddhist images). Their outward appearance reflects the characteristics of a Buddha as defined in sacred texts: there are 32 main and 80 subsidiary features, including the protuberance on the skull, the lock on the forehead, the flame of enlightenment around the head, and the elongated ear lobes (see above, left). Ornaments were among the worldly things that the historical Buddha Sakyamuni laid aside, along with his rank, so that figures wearing ornaments are to be interpreted as bodhisattvas rather than any of the various manifestations of the Buddha. This is of particular importance in identifying fragments, and classifying them correctly (see above right).

The lifelike depiction of the other companions of the Buddha is also obvious; their bodies show movement and tension, turning at an angle from the axis of the spine. The muscles and sinews, features and eyes of the guardian of Buddhist doctrine illustrate the fierce determination he brings to his task (see opposite, bottom left), while the statue of the King of Heaven displays one of the usual attributes of this figure: his right foot is raised to stand on a demon (see opposite, top left).

He is shown in armor, carrying a votive pagoda in his raised right hand, and the pagoda identifies him as the Guardian King of the North. The four Kings of Heaven, the *sida tianwang*, can all be identified by their attributes: the King of the South, Virudhaka (Molihong in Chinese) carries a sword; the King of the East, Dhrtarastra (Molihai in Chinese) a musical instrument, the pipa lute; the King of the West, Virupaksa (Moliqing in Chinese) a snake and a pearl; and the King of the North, Vaisravana (Bishamen or Duowen in Chinese) has a pagoda in his hand. They protect the four continents located by Buddhist tradition in the four oceans surrounding the world mountain of Sumeru. Each has 28 *yaksa* warriors to assist him in his task. Originally the four kings symbolized the four elements (earth, air, fire, and water), but in China their significance was extended. With his raised foot and body twisting away from its axis, this Vaisravana is a strong and active figure.

The forceful determination of these defenders of the faith may serve several purposes. Craig Clunas mentions the conflicts set off by aggression from Tibet, and it is possible that the Fengxian temple may have been built to ensure supernatural support for the Tang troops; it was certainly constructed in response to Tibetan aggression.

However, the great wave of Buddhist art was not confined to the central part of the empire. Far

Above

Scroll repeatedly imprinted with a seated Buddha

9th century, ink on paper, colored later, each imprint 10.7 x 9.3 cm, British Museum, London

Below

Buddha and four companions

Tang period, Dunhuang, Cave 328

The group depicts five holy figures, a typical theme of the Tang period. Buddha is in the center, with his pupils Ananda (a young man) and Kasyapa (an old man) one on each side of him, wearing monastic robes. They in turn are flanked by two seated bodhisattvas.

to the west, where the Silk Road began, were the Mogao caves, also known as the Thousand Buddha Caves, Qian fo dong. Work on them continued from the 4th-century Liang period to the Yuan period. Under the Tang dynasty, over 1,000 caves or niches were made, and the place remained a Buddhist center until the Yuan period. According to legend, the name derives from a dream in which the monk Lezun saw a cloud with a thousand Buddhas flying along one side of the valley. He settled there in honor of his vision, and the first cave was carved out of the rock.

The caves contain huge quantities of both sculptures and wall paintings. It is particularly significant that in many of them two-dimensional and three-dimensional works virtually merge. The Buddha shown below, his outer garment only partly concealing the seated position (known as *vajrasana*) and cascading down over the seat itself, is making the gesture of exposition (*vitarkamudra*). The bodhisattvas can be recognized by their more relaxed seated position. Meanwhile the fresco duplicates the scene; foreground and background create an illusion of fully three-dimensional art with remarkable harmony. Some scenes include what can only be called *trompe-l'oeil* effects. Another striking feature is the way in which never-ending rows of small representations of Buddha cover many of the walls like patterned wallpaper. This kind of depiction, also found in prints, is based on the idea that repetition of the picture, like repeated utterance of the name of Buddha, brought salvation to the faithful or helped them to climb higher on the ladder of enlightenment (see left).

Sculptures, wall paintings, and pictorial depictions on banners and scrolls all played a prominent part in the Buddhist liturgy. At Dunhuang, the basic features of the different kinds of composi-

tions and choice of themes can be followed in parallel on walls and pictorial scrolls or banners.

It is possible to make distinctions of style and period in dating the wall paintings at Dunhuang on the basis of the color palette used and the figure composition. The early caves (of the Northern Liang and Northern Wei dynasties) present a synthesis of Chinese art and art brought from further west: bright colors are rendered through graduations of light and shade, while the contour lines, typically Chinese, provide Buddhist images with settings already familiar from the painting on walls and gates in the Han period.

In the Tang period, bright blue falls into disuse and the landscapes become more detailed. In group compositions of the early Tang period there is still a clear separation between the figures of Buddhas, bodhisattvas, servants, *apsaras* (winged heavenly beings), monks, and donors (sometimes with their families), conveying a sense of spatial depth; while at the end of the Tang period the figures move closer together on the background and appear crowded.

Large, ornamental halos and mandorlas extend the traditional range of motifs, and donors now feature more prominently than in previous centuries. Indeed, they even seem to be making a display of their wealth in these sacred pictures. Ladies are shown wearing their jewelry and rich robes – just two of a number of departures from the old norms that record a change in the way in which donors regarded themselves (see opposite). On the other hand, especially in wall paintings, the color palette is more restricted than before, and there are hardly any nuances. One reason may be the decline of Buddhism after the persecutions of the middle of the 9th century, when the monasteries and their finances suffered severely. However, it may also have been a question of taste and the result of a certain tendency toward stagnation.

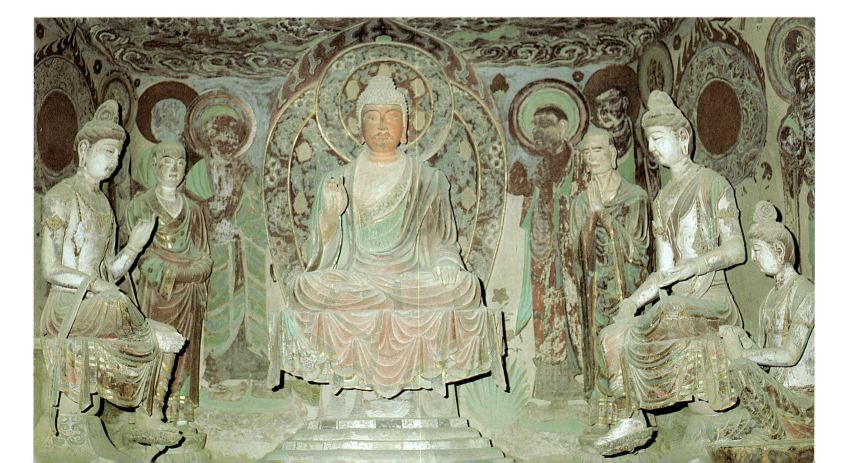

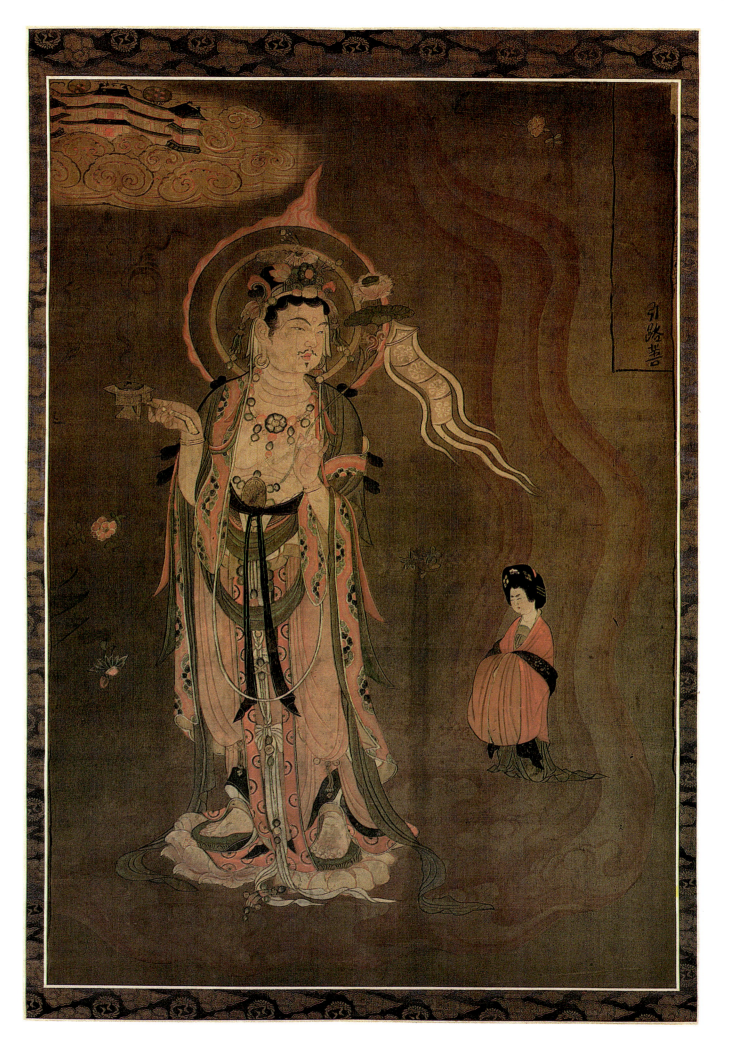

Bodhisattva

Late-9th century A.D., ink and paint on silk, banner, 80.5 x 53.8 cm, Dunhuang, Cave 17, British Museum, London

The Bodhisattva Yinliu, the guide of souls, accompanies a rich lady.

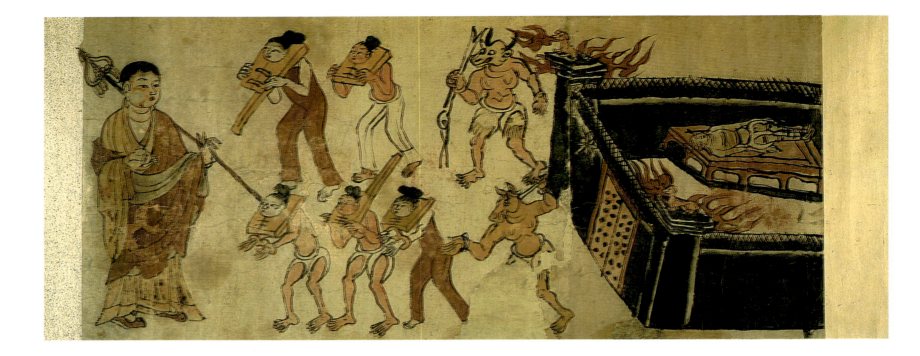

Illustration to the sutra of the Ten Kings of Hell

(Detail), earliest date late-9th century A.D., 27.8 x 239.9 cm, British Museum, London

This detail shows, on the left, Bodhisattva Ksitigarba, who according to Buddhist belief can save souls from Hell.

Monk in attitude of meditation

Late-9th to early-10th century A.D., ink on paper, 46 x 30 cm, British Museum, London

Wall paintings in the early caves show Buddhas, bodhisattvas, patron saints, the Kings of Heaven, and various donors; they illustrate stories from the Buddhist texts (*jatakas*), and depict many earthly subjects of a rustic character (such as pigs) as well as heavenly musicians or *apsaras*. Many other themes, however, are not from the Buddhist canon. The walls of Buddhist cave temples are also adorned by motifs clearly deriving from popular mythology, such as the Queen Mother of the West, Xi wang mu, her male counterpart Dong wang fu, the fabulous beast Qilin, dragons, or the animals of the four quarters of the compass. The caves of the Tang period (A.D. 618–907) increasingly depict the Teaching Buddha and scenes of paradise, and like the frequent narrative scenes, these are connected with the textile illustrations used by the Pure Land sect as the basis of their teaching. Historical events and the pilgrimages of Chinese patriarchs are deemed worthy of depiction, and secular scenes of life in the Tang period also feature. From the middle of the Tang period there are more themes from the milieu of esoteric Buddhism (*mijiao*), for at this time (A.D. 781–848) Dunhuang was under Tibetan rule. Eleven-headed or multiarmed Guanyin figures are frequently shown, as are multiarmed and multi-eyed *manjusri*, tutelary divinities. The following dynasties saw a trend in Buddhist art toward detail on a small scale and lavish ornamental decoration, a tendency accompanied by a loss of dynamism.

The present stock of works in Dunhuang comprises some 2,100 statues. They are not carved, because the local stone was no use for the purpose, but molded from clay on a wooden framework. There are also 45,000 square meters (54,000 square yards) of wall paintings. Like the pictures on paper and silk, they have been well preserved in the dry desert climate.

The subjects of the wall paintings are comparable with those of pictures found in walled-up caves, where it may be assumed that a number of banners and pictorial scrolls showing the judges of Hell, bodhisattvas, monks, and *jatakas* were for use as wall decorations. These items are among the treasures brought back by Sir Aurel Stein from an expedition at the beginning of the 20th century. In line with the hierarchy of Buddhist belief, we can start on the lowest rung and look first at an illustration to the sutra of the Ten Kings of Hell, Shiwang jing (see above). The Ten Kings of Hell make their appearance in 9th-century China first in texts, then in pictorial depictions. The illustration shows the kings sitting in judgement and attended by their animal-headed henchmen, who are equipped with all kinds of implements of torture, while condemned souls suffer punishment. Those found unworthy are subjected to dreadful torments. Despite the simple outline style of the painting, the reproduction is very vivid, horrifically illustrating the concepts of the various hells, each worse than its predecessor, images showing the believer what he could expect if he strayed from the path of virtue. The colors, the tense, injured bodies of the sinners, and the distorted faces of the kings' assistants were an awful warning. Even the uneducated could "read" this work in the manner of a *biblia pauperum*, a pauper's Bible. The illustration dispenses with any embellishments such as background or framework, concentrating entirely on judgement and Hell.

The itinerant monk (see left) could expect a better future. Probably a portrait of an ideal type rather than an actual individual, the picture shows a monk in a trance, enveloped in voluminous robes. He can hardly have been an ascetic, for he is shown as rather fleshy, but even the economical strokes of the outline make it clear that his eyes are fixed on the distance in meditation. His prayer

mat, a water bottle, a wallet, and a string of prayer beads (in Sanskrit, *aksamala*) similar to the Roman Catholic rosary show that he is a traveler. The wallet and prayer beads hang on a gnarled, leafless tree. The picture, painted entirely in a linear style, is comparable to the woodcuts of sacred art in the West. This linear style was still extremely common on banners in the Wudai period (the 10th century). Stylistically, pictures of monks always show a strong tendency toward mimic art, and that tendency and the monk's physiognomy portray his intellectual origins in this picture.

The guardians of the faith (see below, right) are very different in appearance. Vaisravana, one of the four Devarajas (guardian kings) is shown here dressed as a military officer. A cloud bears the Guardian King of the North and his retinue over the water. His sister Sri Devi is in front of him, holding a golden vessel containing flowers, and a

number of assistants, some with the heads of demons, stand behind. The Devarajas are depicted as warriors in the battle against evil. Iconographically, Vaisravana can be identified by the two-pronged spear in his right hand and the pagoda held up on the cloud in his left hand. The colorful group is set against a stylized landscape with curling waves, while mountains appear as simple triangular shapes in the background. Demons fly through the air overhead.

A bodhisattva, "one whose whole being is enlightenment," regarded by believers as someone who would help and intercede for them, is identified by the attributes of a staff and a jewel. The picture of one saint with these attributes cannot be identified with any of the Bodhisattvas Guanyin, Puxian, and Wenshu shown on preceding pages. This is Ksitigarbha (see below, left), whose importance to the faithful lies in his ability to snatch

Below left
Ksitigarbha Seated in the Meditation Position

Early-10th century A.D., ink and paint on silk, 55.5 x 39.8 cm, British Museum, London

The boyish figure of a donor is shown below Ksitigarbha.

Below right
Vaisravana Hovers above the Water

Mid-10th century A.D., ink and paint on silk, 61.8 x 57.4 cm, British Museum, London

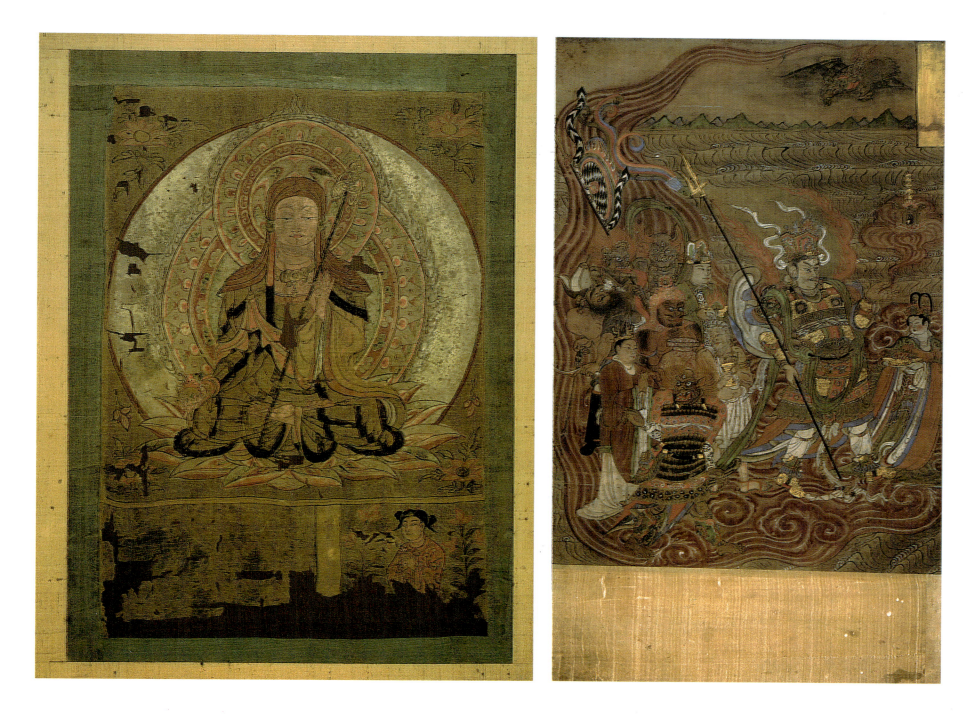

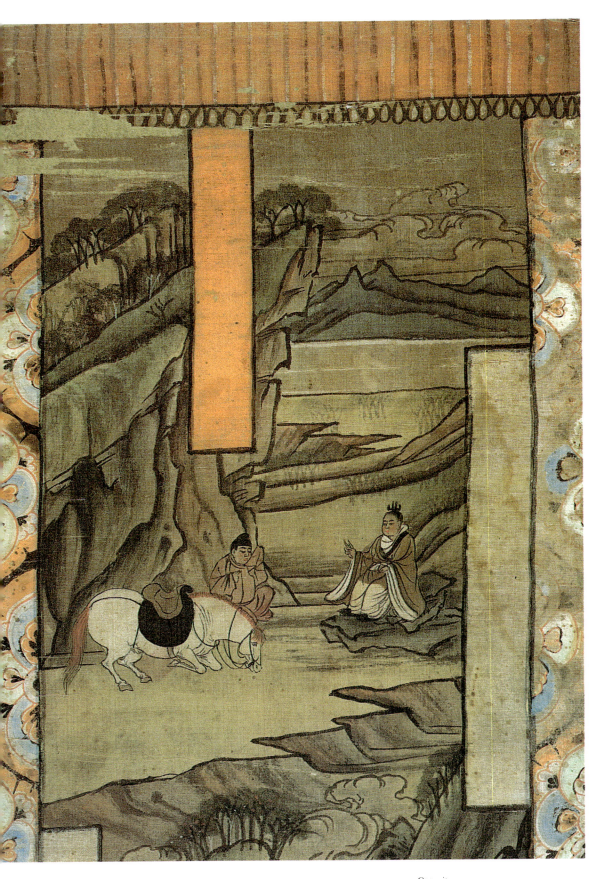

Scenes from the *Life of the Historical Buddha*

(Detail), 8th to 9th century A.D., banner, 58.5 x 18.5 cm, British Museum, London

This section shows the Buddha saying farewell. The landscape of the background illustrates the style of landscape painting in the Tang period.

Opposite
Paradise of Sakyamuni

Early-9th century A.D., 168 x 121.6 cm, British Museum, London

Illustrations from the Bao'en sutra frame the densely crowded composition.

souls back from Hell and return them to the cycle of favorable reincarnations. He is therefore a savior in their time of greatest need, and is depicted with his staff and a jewel in the illustrations to the sutra of the Ten Kings of Hell. Iconographically, one feature of this particular votive picture is found in China only in Dunhuang: he is wearing the cowl of a traveler. None the less, Ksitigarbha was not one of the most prominent bodhisattvas, the most popular of all was undoubtedly Guanyin (Avalokiteshvara in Sanskrit). Those in need of mercy sought his aid, and he was regarded as the guide of souls and one who would bring the blessing of many children. Over the course of time the masculine depiction of Guanyin changed to a more feminine image (this can be seen clearly is a votive picture of the Tang period is compared with a porcelain figure of the Qing period); this transformation was complete as early as the Song period. Only Buddhas are greater than bodhisattvas.

A Buddha comes at the very top of the hierarchy, and depictions of a Buddha may illustrate the life of the historical Prince Gautama. One such picture, to be viewed from top to bottom (as opposed to the hanging scroll, a later development in secular painting, which was to be viewed from bottom to top), shows scenes in his ascent from the world of earthly dust: his farewell, his cutting of his hair, his simple life surrounded by flowers (see left).

Such *jataka* illustrations often use a recurrent pattern of landscapes as the background motif to the incident depicted. Conclusions about the secular art of the same period, and the slow establishment of the genre of landscape painting, are often drawn from these compositions and their style, although such conclusions are ultimately based only on textual evidence: no ascriptions can be definitely made to painters known by name. Landscape elements in religious pictures are stylized compositions of the green valleys where the story takes place, with tree-covered, overlapping mountain ranges rising behind and beside them. These mountains are in the middle ground of the picture; a diagonal line marks both a rise in the landscape and the beginning of a new scene.

This selection of pictorial Buddhist motifs began at the bottom of the hierarchical scale with images of Hell, and ends at the other extreme of the Buddhist faith, with images of paradise adapted to suit the Chinese world (see opposite).

The central theme – the Buddha enthroned in front of a palace which has a great deal of ornamental roof decoration and is extremely reminiscent of Tang palace architecture – is framed to right and left by the *jataka* story of The Flight, a subject of the Bao'en sutra. The center of the picture is occupied by the heavenly musicians already mentioned above. The donors are ranged below the central motif: on the right men in winged hats, a typical form of headgear in the Tang period, and on the left ladies with their hair dressed high. The painting of all the figures in this

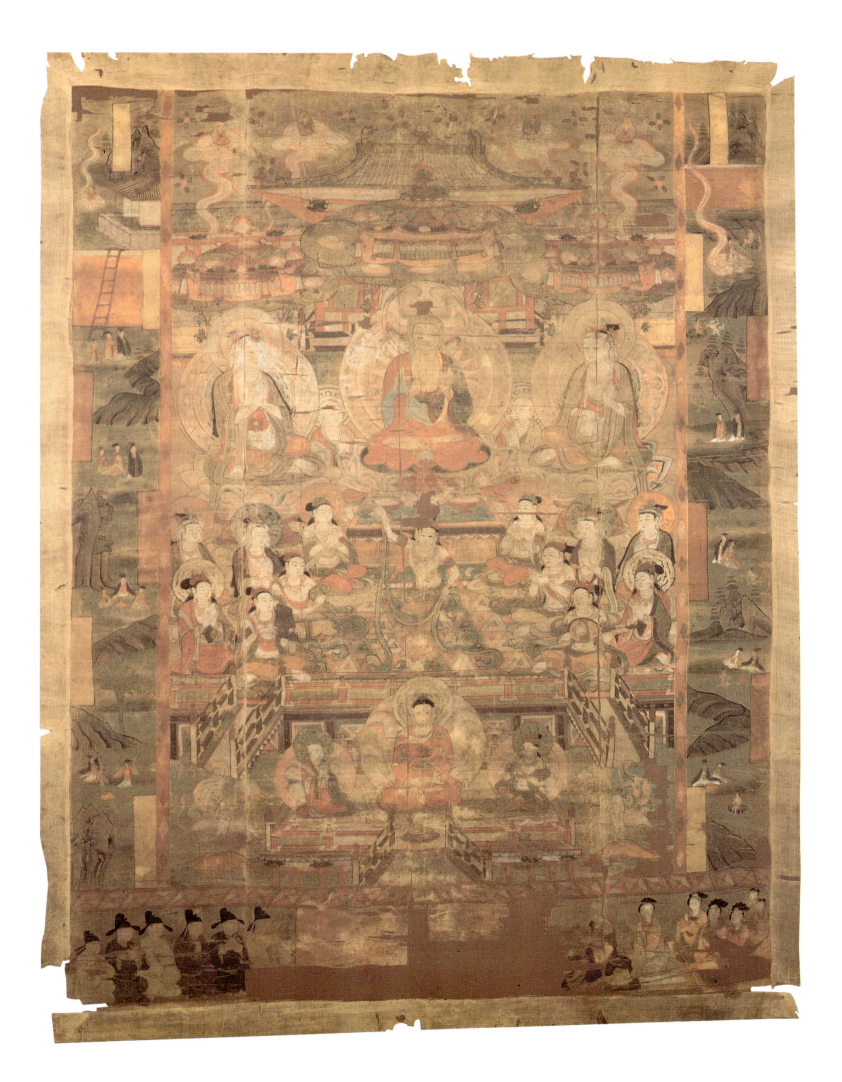

picture, both in terms of composition and in the depiction of their clothing, is in a simple style that has not yet been over-elaborated.

During the Song period, religious figure painting acquired a new delicacy and skill. Without exception, a calligraphic style employing lines of varying thickness was the standard form.

Buddhist motifs were also popular with the scholar painters or *literati*. Among the artists who applied the techniques of monochrome ink painting to Buddhist subjects was Li Gonglin (1040–1106). His interpretation of the subject of Vimalakirti Expounding Doctrine is a good example of the transfer to the devotional picture of monochrome methods of ink painting, with thickened, undulating lines. However, such compositions were to remain the exception rather than the rule, and had little effect on the classic areas of Buddhist art.

Most of the devotional pictures and votive offerings required for ceremonial purposes were created in workshops attached to the monasteries, the majority are therefore anonymous. Professional painters handled themes from Buddhist iconography in a colorful and decorative manner until the time of the Qing dynasty. Small-scale works were made for this market from the Song period onward; most also remain anonymous.

Subsidiary areas of Buddhist art

The south and east did not lag behind the north and northwest in building monasteries, or in carving niches from the rock in monastery complexes set in areas of natural beauty. Because it has often been assumed that they were provincial, however, the sculptures created in these parts of China are less well known and have not been so closely studied.

This is the place to mention, briefly, both a temple badly damaged by Red Guards during the Cultural Revolution of the 1960s, and also another monastery complex in the south. They contain works of late Buddhist sculpture from around the 11th and 12th centuries (see below, and opposite).

The Quixia temple near present-day Nanjing was built during the Northern and Southern dynasties period, renovated in the Five Dynasties period following the Tang dynasty, and was still one of the places visited by the Qing dynasty emperor of the Qian Long reign (1736–1795) on his journeys of inspection in the south. Nothing of the original temple complex has been preserved except for the octagonal Sheli stone pagoda (the Sarira Pagoda), 15 meters (49 feet) high, which illustrates the eight Buddhist traditions, and the figures carved in the rock. A colossal statue of a King of Heaven survived the final onslaught of the Cultural Revolution walled up in a niche.

The sculptural representation of this figure shows him as a high-ranking military officer, but his sacred significance as a King of Heaven is obvious from the ribbons waving around him. The statue differs from non-Buddhist sculpture chiefly in the sense of movement conveyed, which is very different, for instance, from the rigidity of the figures erected on the roads leading to tomb complexes. The unknown artist who carved this King of Heaven introduces another and surprising feature in the use of *contrapposto*. As in Greek art, this erect position lends the figure life and expression. The character of a guardian king as described in written tradition accounts for the lifelike, determined appearance of the statue. It would have been most unusual to depict a bodhisattva in such a position. In the majority of cases, bodhisattvas are shown enthroned or standing, and with a serene expression; any movement is only slightly indicated by a short step forward.

In the 10th century Hangzhou, the capital of the Southern Song dynasty from A.D. 1138 under the name of Lin'an, was a center of communication between various and sometimes hostile schools of Buddhism. The monastery of the Refuge of Souls, Ling-yin Si, founded during the Southern dynasties period in the 4th century A.D. by an Indian monk, still has many niches containing sculptures carved out of the rock on the slopes of the "peak that has flown," *feilai feng*. They are in the late, mannered style of the 10th to 13th centuries. Almost 400 depictions of saints were carved in the rock here, and they vie for attention with a plump, smiling Buddha of the Future, Maitreya, shown seated on a lotus flower with a string of beads in his hand. Stylistic characteristics in common to all these figures are soft lines, rounded, fleshy bodies, and the elaborate ornamentation of their attributes, their crowns, or the places where they sit.

Niches with figures of saints

The Thousand Buddhas cliff, qian fo ya, Qixia Shan, Nanjing

Although the heads of the saints have been struck off, their attributes show that the figure on the left is a Buddha and the figure on the right a Vaisravana.

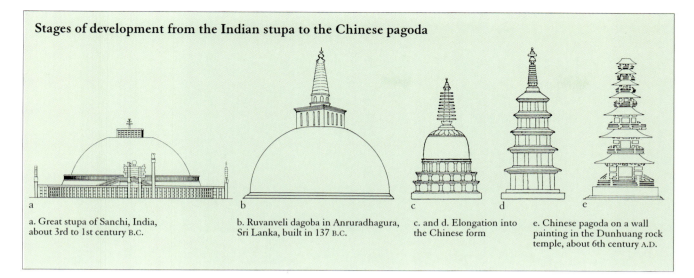

Stages of development from the Indian stupa to the Chinese pagoda

a. Great stupa of Sanchi, India, about 3rd to 1st century B.C.

b. Ruvanveli dagoba in Anruradhagura, Sri Lanka, built in 137 B.C.

c. and d. Elongation into the Chinese form

e. Chinese pagoda on a wall painting in the Dunhuang rock temple, about 6th century A.D.

Below

Bodhisattva holding a lotus flower

Song period, H not known, Lingyin Si, Hangzhou

This bodhisattva is wearing a richly ornamented crown with a Buddha figure.

Bottom

King of Heaven

H not known, Qixia temple, large niche to the north of the Sheli stone pagoda

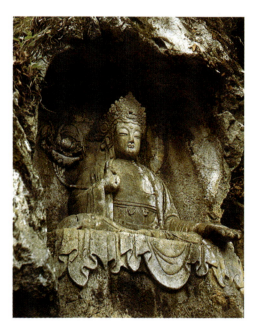

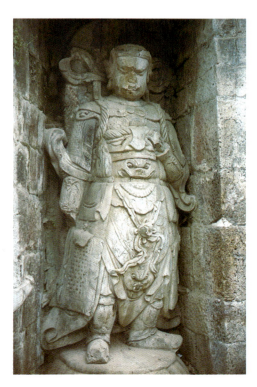

The most important contribution of Buddhism to Chinese art is regarded as its monumental sculpture in the round, including a number of colossal statues. Qin Shi Huang Di's terracotta warriors had been the first step in this direction, but they led to no further developments during the Han period apart from some remnants of sculpture on the Ways of Souls leading to tombs; the artistic claims and merits of these works cannot be properly assessed from the few extant pieces. Small figures and bas-reliefs were art objects commonly found in tombs, but there are clear differences between Buddhist reliefs and the stamped bricks from earlier tombs. The bricks look flatter, since the structure of the design is shallower; they show subjects from everyday social life and the objects represented are seldom in any spatial relation to each other. Buddhism contributed to pictorial composition a new way of arranging objects to suggest spatial depth, and a more obvious relationship between individual pictorial elements.

It is probable that the shape of the banner, a long, rectangular piece of silk, influenced the development of the hanging scroll in painting. The formal similarity of the scroll to the banner supports this assumption, as does the fact that the hanging scroll is the most recent format in secular painting: there are no extant specimens older than the banners of the Wudai period. Even Song period literature provides no evidence to the contrary.

Besides painting and sculpture, Buddhism also enriched architecture, principally through the development of the pagoda, which derived from the traditional Indian Buddhist reliquary, the stupa. The synthesis of the stupa with the multi-story buildings constructed from the Han period onward (houses, watchtowers, and gate towers) gave rise to a new architectural form.

The stupa is a building closed to the outside world; its interior is inaccessible. In the transitional phase, its Chinese descendant was also of massive construction. However, later pagodas could be climbed by way of a spiral staircase. No wooden pagodas of this period survive, but brick pagodas like the one in the Song Yu temple in Henan provide information about the earliest forms. The Song Yu pagoda dates from the time of the Northern Wei (A.D. 386–534).

The Chinese pagoda also shelters a Buddhist relic, usually under the central pillar, the "heart pillar." The relics (and here Buddhism is comparable with the Christianity of the Middle Ages) may be parts of the bodies of Buddhist saints, or alternatively religious scriptures. When the Lei Feng pagoda in Hangzhou, a building from the Five Dynasties (A.D. 907–960), collapsed in 1924, each brick was found to contain a small sutra scroll. The scrolls were discovered only in the ruins.

With the development of a Buddhist monastery culture in China, monastery gardens were laid out, for the life of the historical Buddha contains several references to gardens in connection with Buddhist doctrine. The concept of Amitabha's Western Paradise surrounded by mountains, or of the mountain of Sumeru as the center of the universe, encouraged the veneration of mountains as the abodes of Daoist immortals, a concept dating back to the Han period and the imitation of mountains in gardens. Buddha had received enlightenment under a tree and had taught in a garden, so a peaceful natural atmosphere could be seen as the proper environment for the faithful seeking salvation. The most famous monastery garden was in the complex founded by Huiyuan on the mountain of Lushan in the 4th century A.D.. Pilgrims who saw it spread word of the beauty of its design. Such poets as Li Bai (A.D. 701–762) visited the place, and even Mao Zedong, founding father of the People's Republic of China, was still praising the landscape of Lushan.

When he did so, he was referring to a form of literature extant in China for 1,500 years: poems on nature. Nature poetry had given a strong impetus to the development of painting in the centuries of great cultural difference between the south and the powerful northern area, the latter more strongly influenced by Buddhism. While Buddhism left its mark on art under the Northern Wei dynasty, nature became the principal theme of poetry, and gradually, of painting in the south.

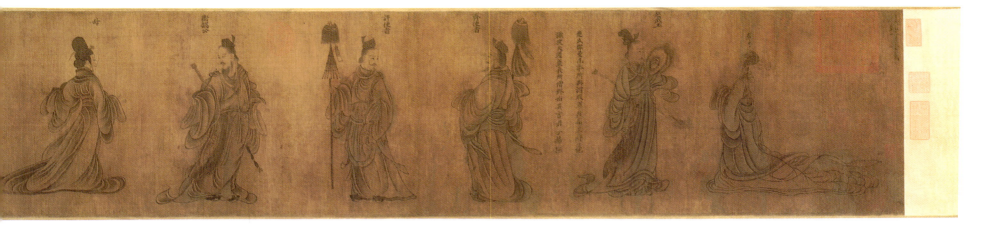

The Jin Period: The Oldest Extant Scrolls

Theory and practice (4th–5th centuries A.D.)

Buddhism and Buddhist art have taken us some years forward in the dynastic history of China. We must now step back into the past again, for while Buddhist art was spreading through the country, painting, calligraphy, and a keen appreciation of nature were assuming great importance in the life of Chinese society.

This chapter will look at the early paintings of Gu Kaizhi, known to us from copies, and the calligraphy of Wang Xizhi. It will also cover the basic technicalities of ink painting and calligraphy – with their materials of brushes, ink, pigments, paper, and silk – and will consider the phenomenon of transmission through copies, an artistic concept that seems strange to the European mind.

The word "Jin" in this chapter heading derives from one of a large number of states that splintered off when the imperial unit was dissolved. North and south saw a rapid succession of such states set up between A.D. 220 and 581. Because their periods of supremacy were often short they are usually described by more general terms, for instance the "Three Kingdoms," the "16 Kingdoms" (A.D. 304–349), and the "Northern" and "Southern Dynasties" (Nanbei chao, A.D. 386–589, being the earliest and most durable). The Jin state was set up in the south around the modern city of Nanjing, and divides into the Western Jin period, A.D. 265–316, and the Eastern Jin period, A.D. 317–420. The term Jin is also used as a synonym for the place of origin of a number of major painters and calligraphers, as well as the first art theoreticians.

Not only were wall paintings and sculptures inspired by Buddhism created in the northern cave temple complexes of the first quarter of the 3rd century, but painting also continued to develop in the south after the fall of the Han dynasty.

The first extant scrolls – not originals, but copies in the style of those early years – are backed up by writings on theoretical principles, and the same is the case with calligraphy. Wei Heng (died 291) was one of those who concerned themselves with calligraphy in both theory and practice.

The names of early painters are known to us from contemporary catalogues or classifications, the earliest written by Xie He (active in the Nan Qi and Liang periods). He set out his own principles on painting in the *Gu hua pin lu* (Classification of Ancient Painters). A portrait painter with a place in art history himself, he classifies the painters of the past and his own contemporaries by comparison with each other and according to their mastery of the "six elements" of painting. The *Xu hua pin* (Catalogue of Painting) by Yao Zui (active during the middle of the 6th century A.D.) is a continuation of this work, naming and classifying 20 more painters who worked after the *Gu hua pin lu* had been completed. However, Yao merely lists them in chronological order without comment. Later generations added explanatory notes to both works, and in the copying process some notes have merged with the original text.

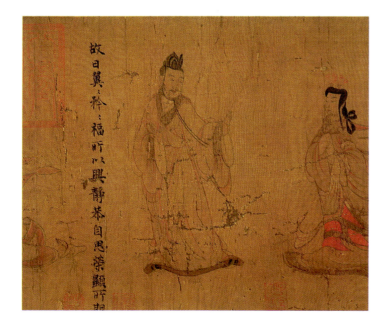

Scroll of the *Distinguished Ladies* (Lienü tu)

Ascribed to Gu Kaizhi

(Section), ink and paint on silk, horizontal scroll, overall measurements 25.8 x 470.3 cm, Beijing Palace Museum

The pictures are based on a literary text, and the standing figures show rulers and their ladies who are to be regarded as exemplary characters. The style of this early didactic narrative painting is notable for the isolation of the figures in the composition, and for the natural color and flowing style of the contour painting.

Opposite

Lacquer painting on wood

A.D. 484, H of panels 80 cm, W 38 cm, tomb of Sima Jinlong, Datong Civic Museum

Left

Admonitions to the Court Ladies (Nü shi zhen juan)

After Gu Kaizhi
(Section), ink and paint on silk, H 25 cm, British Museum, London

In all there are nine scenes on this scroll, which may be a Tang-period copy of Gu's work. They illustrate tales of heroism intended to serve posterity as instruction and moral edification.

Analysis of these historical works therefore calls for intensive literary and textual critical study, and translators who have tackled the texts have tried to provide it. The following passages are based mainly on William R B Acker's translation.

Xie He's ideas about the origin of painting, the six elements of that art, and his classification of the painters molded the approach of critics in later periods and were sometimes regarded as the ultimate authority. They will therefore be surveyed here. But before we allow Xie He to have his say, some even earlier expressions of theoretical opinion deserve mention.

Cao Zhi (A.D. 192–232), the scholar poet who lived in the Three Kingdoms period, wrote that painting had developed from "bird script" calligraphy and was a suitable medium for instruction. He speaks of portraits that aroused reverence in the viewer, while others inspired horror. This idea derives from earlier attempts in the Han period to present painting as a didactic medium. Cao Zhi was a famous poet and is thought to have been a painter as well, but the traditional ascription to him of a certain painting is impossible.

For a period of over 100 years after Cao, hardly any notable theoretical ideas on painting have been preserved, but thereafter texts proliferate, and they provide evidence of the development of landscape painting in particular. It is interesting that both nature poetry and the first prose writings on the beauty of the landscape are mentioned in the historical writings of the time. The first mentions of private gardens and large landed estates are also of this period, and indicate the new light in which the landscape was now regarded.

How did this new interest in landscape affect one of the first painters whose scrolls, and thus their subjects, are known to us – not just from a brief mention in a list but from works that have been preserved, or at least transmitted in copies?

Gu Kaizhi (A.D. 346–407), whose man's name (zi) was Changkang and whose epithet (hao) was Hutou, is regarded in China as the father of painting. He was active in the 4th century in the capital of the Eastern Jin dynasty (A.D. 317–420). Tradition says that he painted figures and Buddhist pictures. His subjects, known to us from copies in a few extant scrolls, were very probably of a narrative character and may be classified as figure painting (see opposite, top).

The scrolls *Nymph of the Luo River* (Luoshen fu tu juan), the *Admonitions to the Court Ladies* (Nü shi zhen juan), the *Distinguished Ladies* (Lienü tu), which is also from a work by Gu, and the landscape with Daoist figures, known to us only from his own textual description, are all didactic works. Three aspects of Gu's painting may be taken as evidence of his creative powers. The *Nymph of the Luo River* (see pages 118–119) is a pictorial interpretation of a rhapsody by Cao Zhi (A.D. 192–232) on the literary subject, very common during the Han period, of an encounter with a river goddess. The *Admonitions* scroll explicitly sets out to illustrate a didactic text: a series of written injunctions

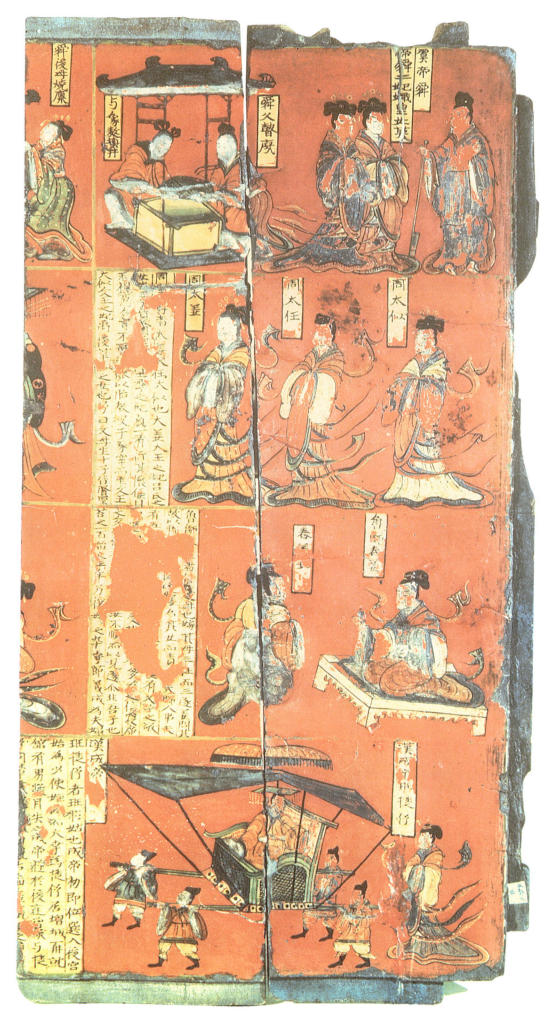

for court ladies, each illustrated by figures relevant to the text, which is by Zhang Hua (A.D. 232–300) and deals with correct behavior in the imperial household, or more accurately the harem. In both scrolls the figure painting illustrates real or fictional events. The painting is in several colors chosen to suit the subjects, filling in the black ink outlines, and the same method is used in the scroll of the *Distinguished Ladies*, probably based on the 1st-century B.C. text *Lienü zhuan* (Biographies of Distinguished Ladies) by Liu Xiang. These works have traditionally been ascribed to Gu Kaizhi, but it has always been necessary to study them on the basis of later copies which may therefore diverge from the originals. These copies are usually thought to date from the 6th–8th centuries A.D.

Sometimes a version of the same subject painted on lacquer shows that copies are very close to the original (see page 116, bottom). Wooden panels found in the tomb of Sima Jinlong (died A.D. 484) display characteristic features of early painting on silk, which becomes perishable as it ages. Again, the combination of text and pictures creates a series of narrative scenes; the figures stand out strongly from the background and may seem rather flat because of the contour painting, but floating ribbons and flowing lines convey a sense of movement. The text is in "clerical" or "normal script," placed in areas reserved for it on a yellow lacquer background and providing internal breaks between the separate and independent scenes.

Gu's painting in the scrolls described above, which now seem to be closer to the original than was previously thought, present two main features: they are illustrations linked to or deriving from a text, and the pictorial structure of the figure painting in the *Nymph of the Luo River* is already enriched with landscape elements.

The scroll of a landscape with Daoists, which can now be reconstructed only from Gu's account of it, illustrates the third aspect of his painting.

Gu wrote a description of his painting of the Yuntai mountains, *Hua yuntaishan ji*, in which he seems to create a landscape composition before the reader's eyes. The landscape of the "cloud-terraced mountains," cleft by ravines, containing many paths and waterfalls and covered by a canopy of clouds, formed a spectacular setting for the human figures meeting there. A master and his pupils were seated on a peak, and two pupils identified by name appeared again in a grotto in another part of the picture. The circle of the Daoist Zhang Daoling was the subject of this picture. Gu gives data for both the size of the seated figures in relation to the mountains and the colors of the various elements. The landscape also contained wild animals: a white tiger drinking from a waterfall to the west of the mountains, a phoenix perching on a rock on the cloudy terrace. A scroll of this nature told the stories of the Daoist and his pupils in pictorial form – and to that extent the picture still illustrated a narrative, whether real or fictional – but the relation between man and the landscape had changed. The figures seemed to be surrounded by the superior force of nature. Landscape became a stage upon which the actors appeared, and at the same time it conveyed Daoist religious ideas.

The appearance of the same groups of figures several times within the landscape indicates that even this powerful style of landscape painting had not yet liberated itself from the typical narrative figure painting of the period. It would be pure speculation to try tracing the emergence of landscape as an independent artistic subject back to pictures that have not survived as originals. None

the less, it is clear that landscape was regarded as a suitable part of the structure of a painting, and served as a setting for scenes with figures.

The repeated depiction of figures in consecutive scenes is typical of the narrative character of early horizontal scrolls, as in the *Nymph of the Luo River*. The combination of real landscape with legendary literary figures, historical characters, and mythological creatures seems to have been a prominent feature of early painting. A story can be told in pictures showing a number of separate scenes (see above). The scroll in the Beijing Palace Museum with the copy of Gu Kaizhi's Luoshen picture – it is one of three such scrolls, the others being in the Liaoning Provincial Museum in Shenyang and the Freer Gallery in Washington – illustrates the way in which horizontal Chinese scrolls were viewed. The picture is over 5 meters (16.4 feet) long, but a mere 30 centimeters (11.8 inches) in height, and is unrolled by the viewer like a film: as his left hand unrolls the scroll and his right hand rolls it up again, only a section the width of the distance between his arms is visible. This way of viewing a horizontal Chinese scroll shows that it was "read" from right to left, a feature that is reflected in the composition of a picture as a whole. The direction in which the figures are looking guides the viewer through the picture, and elements such as birds apparently flying out of one scene and into another link them together. The structure includes steep mountains or dense stands of trees for purposes of demarcation. The narrative axis is also the pictorial axis. Figures clearly relate to each other as they communicate or look in the same direction, and the viewer can follow the story through its composition along the axis of the picture.

The real and imaginary worlds are kept apart. Supernatural beings have ribbons wafting around them and sometimes hover in the air, while people in the real world are literally earthbound. The scholar poet Cao Zhi and his retinue always have solid ground under their feet.

The landscape background continually unfolding behind the narrative axis appears stylized, but there are differences between the trees; association suggests that one may be a willow and another a pine. Simple triangular and round-topped mountains, some covered with trees, separate one scene from the next.

The scroll containing the *Admonitions* (see page 116, bottom), which is damaged at the opening end and therefore incomplete, shows the relationship of figures to each other within a scene particularly clearly, even without the aid of a background. The text certainly gives some optical assistance to the structural divisions, but is not really necessary to define the relationship of the standing figures to each other, or show they belong in the same scene.

In the *Nymph of the Luo River*, on the other hand, the artist enriches the composition both by showing the relationship of the figures and by adding landscape features to the structure. It is rather like a film unrolling before the viewer's eyes; the scroll depicts the chronological sequence of events from the original literary text, and is thus a continuum of time although not of place.

The outlines of the figures and the internal contours of folds, hunting bows, and loops of ribbon convey an impression of lavish abundance even without light or shade to give depth. Different colors are used to represent different fabrics, although the actual texture of the fabrics is not suggested by the painting.

Gu's figures, the main actors in the narrative and the subsidiary characters, are shown as types: finely robed courtiers, concubines, and groups of

Nymph of the Luo River (Luoshen fu tu juan)

Ascribed to Gu Kaizhi

Ink and paint on silk, 21.7 x 572.8 cm, Beijing Palace Museum

Calligraphy

Emperor Huizong (1082–1135), circular fan, script of the caoshu type, ink on silk, 28.4 x 28.4 cm, Shanghai

spectators; their faces may have different expressions but who cannot be regarded as portraits.

The stylistic concepts of the late Han period are still evident in the scroll of the *Nymph*, despite the landscape elements: the figures relate to each other and consist of lines, curves, and undulations, with simple faces reduced to their essentials. However, one should be cautious in describing Gu's style: no homogeneous idea of it can be formed for the reason that no extant paintings are definitely attributable to him, and the artistic talents of the early painters who made the copies must have varied.

Attempts have often been made to show that Gu's scroll of the *Admonitions* was a step in the development of the pictorial scroll from the earlier book format. Illustrated Buddhist texts may also provide evidence of a gradual development from the concept of text and pictures, with the text predominating, to a concept of pictures with text (perhaps represented by Gu's *Admonitions*) where illustrations predominated, and culminating in a version consisting solely of pictures that no longer required any text (since the deployment of a large number of pictorial building blocks could express a story, scene, or idea fully).

The similarity of the book format and the pictorial format strongly suggests this model, but in that case how should we regard wall paintings and reliefs, which were not found solely in tombs? They too, around the end of the Han period, were composed in a horizontal format, and were far wider than they were high. Where the height of a composition was in fact greater than its breadth, it was intended for a certain part of a building having that shape: reliefs on pillars, ornamental triangular tiles, doorposts, decorated gables.

Finsterbusch's index of Han period subjects shows that works in the horizontal format made up the majority of large-scale reliefs, and the pictorial composition of reliefs and wall paintings must also have played a part in the development and artistic use of that format. The painters would in any case have been familiar with it from their environment and from visual habit. It should be seen as a synthesis of the Buddhist combination of text and pictures with book format, and the usual pictorial format of reliefs.

But to return to other theoreticians of this early period of artistic development: during the second half of Gu Kaizhi's life, a painter and theoretician called Zong (also Song) Bing (A.D. 375–443) wrote a work entitled *Hua shanshui xu* (Introduction to Landscape Painting), which confronts the reader more clearly than ever with the shifts in emphasis between landscape and figures already indicated by Gu Kaizhi. Zong sees painting as a means of representing large subjects in a small area by depicting their *qi* (the "breath," or figuratively the inner essence that makes an object what it is). The essence of a mountain range, for instance, can be captured on a surface measuring a few square centimeters. He speaks of sacred Buddhist places in referring to the mountains Hua and Lu, and tentatively describes the relationship between painter and viewer. "What the eye comprehends and what finds an echo in the heart is [...] also comprehended by the eye of the beholder, and finds an echo in his own heart if the representation is successful."[1] Zong transfers himself to the essence of the scene depicted: to him, contemplation of the mountains means to be there, to feel and empathize with their inner nature. The sense of being at one with nature indicated here is intellectually rooted both in Buddhism (withdrawal to the mountains for contemplation in order to concentrate the mind on essentials, purify the heart, and gain access to another dimension) and in Daoism (the search for the One, the Dao, immanent in all things, access to another dimension, nature as the ideal counterpart of the state). An important aspect of the search for the real self in Daoism is "non-action," *wu wei*, refraining from interference in the cycle of nature in order to enter into harmonious contact with it. In his old age, Zong achieved a sense of being at one with the universe through the contemplation of pictures. When young, he had lived in a hut on Mount Heng, and he walked in the natural landscape as long as he was able. He was reputed to be a good player of the qin zither, and the frequently depicted subject of a single scholar playing that instrument out of doors may

allude to Zong. However, playing the zither served the same purpose in general as experiencing nature: it brought the player into harmony with the universe through music. Even in Confucianism, music is already seen as a suitable occupation for a man of noble mind, and Daoism raised it to the status of a contemplative activity undertaken in order to achieve harmony with nature. The depiction of nature is thus not a case of art for art's sake; even though Zong no longer speaks of the figures populating the landscape,[2] the religious aspects cannot be denied.

Similar ideas about the landscape were expressed in *Xu hua* (On Painting) by Wang Wei (A.D. 415–443), a theoretician who held no official appointment and should not be confused with the great Tang period poet and painter Wang Wei, the inventor of monochrome ink painting. The earlier Wang Wei quotes one of his contemporaries who saw painting as an artistic exercise in attempting to achieve harmony with *xiang* (the visible revelation of both abstract and material phenomena), as defined in an appendix to the *Yiying* (Book of Changes). Painting, he suggests, operates on two levels: through a combination of symbols it reflects both the visible, outer form or *zing*, and also the inner essence, the soul or *ling*. The same principle is at work in calligraphy. A point of particular importance in Wang Wei's ideas is that he transferred calligraphic concepts describing the management of brushstrokes into the technical language of painting. Only a *yiguan zhi bi* brushstroke can be used to copy all forms of the universe, *ni*. Script too can "copy" a meaning by using a symbol. The sense of the term "pictorial building block" can be understood in Wang's text: a certain hook identifies a mountain as Mount Song, a fast, expressive stroke "for the saints" has a distinct meaning, and so does a short, broken stroke. Wang also points out to his readers that landscape may also contain architectural features, ships, vehicles, and animals. Was he thinking of such pictures as Gu Kaizhi's *Nymph of the Luo River*?

Using cryptic terminology, as Delahaye[3] has convincingly shown, Wang describes the two major genres of painting in his time, landscape and portrait.

The painter Xie He, at the end of the 5th century, was able to read these texts and see works such as those of Gu Kaizhi. His classification of painters and pictures became one of the most influential of all works on Chinese painting. Who was Xie He, and what were his ideas? What would he have to say if he could look down from the pantheon of Chinese art critics today? Putting together a number of sources,[4] we may assume it might be something like this:

"I am often cited as an authority, and much has been written about me. Zhang Yanyuan took up my theory of the six elements but misquoted it. An author of the 14th century called Tang Hou actually left out one of my elements, judging it opportune to do so in order to support his own ideas. Even the scholars of the 20th century, from whom I am separated by some 1,500 years and the loss of many great works of art, cannot agree on the interpretation of my writings, since the classical language will not translate into modern Chinese or into foreign tongues entirely without ambiguity. All the same, I would like to tell you a little about my book, which both sets out my ideas on painting and lists the names of many painters. Their works are lost now, but I was able to see some of them. I wrote during the Southern Qi dynasty (A.D. 480–502) and at the beginning of the Liang dynasty.[5] I divided those painters who seemed worthy of inclusion in my work into six categories. The first I thought the highest, and it contains only five painters; perfection is difficult. To my mind, the greatest of all painters was Lu Tanwei (active during the rule of Emperor Ming in A.D. 465–502), who had mastered all six fundamental elements, neglecting none. You ask what my six elements or rules are, and I will name them:

– first, resonance of the atmosphere, which means vitality: *qiyun, shengdong shi ye*
– second, structural composition through the action of the brush: *gufa, yong bi shi ye*
– third, correspondence to the object in the form of things: *ying wu, xiangxing shi ye*
– fourth, a suitable choice of colors: *sui lei, fu cai shi ye*
– fifth, composition: *jing ying, wei zhi shi ye*
– sixth, transmission by copying: *zhuan yi, mo xie shi ye*.

The opinions of Western and Eastern literary critics and art historians on the meaning of most of these terms differ. They cannot agree on the sense of this important passage, since semantic change over the centuries has left the classical language open to broad differences of interpretation. So do not be surprised if you find my terms translated differently from time to time.[6]

But let us return to my favorite painters: one is Lu Tanwei, the other is Wei Xie. My classification is a purely personal list of preferences. You ask about Gu Kaizhi? I placed him only among painters of the third class, perhaps because his works did not particularly appeal to me. And perhaps I do not like the similarity of his subjects to my own. I wrote that while his style was refined and his execution good, and he never painted without thinking first, his works did not come up to the standard of his ideas. I wrote at greater length on other painters.

I also told posterity of painters who had concentrated on mastering one theme, like Gu Junzhi, who specialized in grasshoppers and sparrows. I mentioned Yao Tandu's pictures of demons and fairies. I commended Xia Zhan for his masterly use of color, and Dai Kui for his *Wise Men*. These painters have retained their places in later classifications. If I look at my intellectual successors, right up to the 20th century, none of them seem to have deviated from my idea of enumerating the subjects with which a painter was particularly successful.

I did not reject painters who went their own way in brushwork and composition, but in the case

氣韻生動是也
骨法用筆是也
應物象形是也
隨類賦綵是也
經營位置是也
傳移摸寫是也

Original text of Xie He's "Six Elements"

Colophons

After Guo Zongshu (?–977)

(Sections), xingshu script for the painting of Wang Chuan, Wang Wei's country residence, in a Ming-period version, H 29.5 cm, Museum für Ostasiatische Kunst, Cologne

Works of calligraphy are regarded in China as valuable art works in their own right, but many have also been preserved as appendices or introductions to pictures, as in the case of these copies of colophons. They are not subordinate to the picture, but are on an equal level with it.

of many I mentioned the masters from whom they had learned. I placed Zong Bing, of whom you have already heard, in the sixth class. I did not think him a painter of outstanding quality, but one may learn from his ideas and copy them. I briefly discussed 27 artists in all, and with many of them my views have been confirmed in versions transmitted in copies. As for those artistic subjects I thought worthy of special mention, they belong to all genres: I considered landscapes, animal painting, and portraiture. I also mentioned two wall painters who had both mastered the format of temple walls and could work on a smaller scale. The mention of wall painting will inform the attentive reader that sacred pictures were painted in my time. I ought also to add that the painters of my era were still regarded as artisans. They were in the service of the imperial court, or of sacred places like the Buddhist monasteries, or they were employed by various official bodies. Only some generations later did independent painters who did not live entirely by their art join the court painters who were in regular employment.

All things considered, my text surveys the painting of my period as a whole. I was in good company with the art of calligraphy, for at that time people took an interest in the theory of a number of subjects and studied language and writing. Poetry flourished in the form of the *fu* poem, a rhapsody. In such works poets described the country life or a retreat to the mountains in wonderful metaphorical lines which positively demanded pictorial illustration. Many subjects were given visual expression in the same way as Gu Kaizhi painted the nymph from the poem. Alas, nothing is left of them but their memory … and a few copies."

This, or something like it, is what Xie He might say today, and since the word "copies" was mentioned several times above, it is now time to consider the phenomenon of transmission through copying rather more closely. The artists of later centuries, calligraphers and painters alike, copied their predecessors. They would immerse themselves in a great master's subject matter, composition, and brushwork techniques in order to learn from his style, and in the case of the most capable to create their own variations on it. Chinese painting developed forms of copying with deliberately different degrees of accuracy; they can be classified as imitation, appropriation, and transformation. Imitation meant an exact copy, in Chinese *mo* or *ta*, often done by tracing in later centuries; appropriation was a free copy, in Chinese *lin*; transformation involved the artist's creation of his own interpretation of a work from its pictorial elements, techniques, and patterns of composition, or from the pictorial ideas of the predecessor he was copying. There are several terms for this kind of copy in Chinese, found in particular in inscriptions on pictures in the 2nd century A.D.: *fang, yi, zao, bi yi*. The crucial point is that copying was highly regarded in the context of tradition as a means of showing veneration for the past and displaying an artist's own abilities and knowledge through his quotations from it. The same was true of the copying of calligraphic artists.

Even at quite an early date Chinese literature frequently indicates the close connection between painting and calligraphy, and with good reason. First, both arts began by using the same materials: brushes and ink or paint, applied to paper or silk. Second, in both arts symbols were varied according to the artist's personality. A calligrapher who had mastered the technique of script would eventually be in a position to introduce his personal form of structural expression into the conventional written characters. He would be judged by the extent of his success in precisely this.

A painter used a certain number of pictorial symbols or building blocks derived from nature, but his quality still consisted in his ability to express his own concept of the nature of things, rather than simply producing a good likeness.

In the same way as the calligrapher systematically learned the written characters, the painter had to acquire his artistic vocabulary of pictorial building blocks. A method in common to both was to study many examples and then copy the symbols; an artist who hoped to rise above the common run of painters had to contribute something of himself, his own ideas or feelings, to the standard forms of artistic language. This approach, anticipating developments in the Tang period, was the basic training of all calligraphers and nonprofessional painters – but not of court portraitists and artists producing Buddhist paintings or paintings in documents. Professional painters were expected to create pictures that would be naturalistic and traditional, with subjects comprising narratives, mythological and sacred

themes, and portraits. Buddhist painting developed the Chan style employed by amateur monastic painters, which found its own way out of the obligation to depict traditional subjects, allowing painters to express themselves in the portrayal of faces and those new themes the Chan style regarded as worthy subjects.

The synthesis of the artist's personality and his theme makes widely differing demands on the viewer of a picture or a calligraphic work. Pictures may be seen horizontally or vertically, or may be mentally interpreted rather than actually viewed. The scenes of a picture existed on several levels in the painter's creative mind, to be reconstructed in the mind and eye of a beholder who could decode the meaning of the pictorial building blocks. The degree of the viewer's pleasure would vary according to his own interpretative abilities. In the case of calligraphy he could even reconstruct the moment of artistic creation itself. The content of the text came second to the visual form. In this way art by and for an elite was created in the Tang dynasty by the educated civil servants who spent their life in writing and administration, but who painted and practiced calligraphy for pleasure. There were three *san jue* (perfections) to be cultivated: poetry, calligraphy, and painting. This idea greatly enriches Chinese painting, although its profundity is difficult to grasp fully.

Scholar, calligrapher, or painters?

It may be assumed that the early painters had the benefit of a Confucianist education and were at the service of the state in the widest sense, executing works on commission as protégés of the emperor. They were professional painters. Scribes were professionals too; as servants of the state, they created the models for inscriptions on stone, as epitaphs and for memorial stelae.

From the Tang dynasty onward, however, sharp distinctions between scholars, calligraphers, and painters are difficult to draw. Biographies of scholars will praise one and the same person sometimes as a painter, sometimes as a calligrapher, a brilliant administrator, a poet, or a writer of prose, depending on the source.

Here we have a phenomenon that was never common in Europe: the merging of different arts in one person. The closest comparison is with the artists of the Renaissance who were both painters and sculptors, or the polymath scholars of later epochs. In China, famous painters were often also calligraphers, or vice versa, although calligraphy too had struck out along new paths of its own.

To facilitate an understanding of the Chinese art of calligraphy, rather a difficult art to comprehend, a few comments at this point will help to explain the nature of the written characters and the calligraphic technique. Innumerable possibilities of expression could be achieved through the brushwork, the precise mixture of ink and water, and the nature of the writing surface. Ink techniques were as important in calligraphy as in painting. Until the first half of the Tang dynasty (A.D. 618–907), as the scrolls and the texts both show, ink and paints were on a par as a chosen means of artistic expression. Traditionally, red, yellow, blue, white, and black were regarded as the five basic colors, and it was believed in the Tang period that ink "contained" them all (black being seen as a blend of all colors). Monochrome ink painting developed on the technical basis of the different brushstrokes established in calligraphy, combined with polychrome styles mingling ink with water-soluble paints, and thus created an independent artistic technique that represented the quintessence of Chinese painting.

What, then, were the technical principles of the two arts? The brush enabled a stroke of varying breadth to be drawn, depending on the way in which it was pressed down on the painting or writing surface and then lifted off. The stroke varied in strength according to the force exerted, and depending on the way the brush was applied, moved, and lifted the line appears "ragged" or fluid, maybe either broad or very fine at the beginning, may tail off into a pointed tip or break abruptly. Painters too made use of rhythmic brushwork for both the outline of the subject represented and its texture (where the strokes were used within an outline).

The dynamic of the line was an aesthetic criterion, although the calligraphic artist was not entirely free here. A written character is a combination of any of the eight different basic strokes: the dot, *dian*; the horizontal stroke, *heng*; the vertical stroke, *shu*; the left diagonal downward stroke, *pie*; the right diagonal downward stroke, *na*; the upward stroke, *ti*; the hook, *gou*; and the curved stroke, *zhe*. Their points of departure and their direction were obligatory; nor could the calligrapher vary the order in which the individual strokes of a written character were formed (there could be up to 28 of them in all), in obedience to a convention that had proved its worth over centuries of practice. The characters in a text, whether they consisted of one stroke or 28, also had to fit into virtual squares of the same size. Apart from these formal requirements, only "greater" and "lesser seal script," *da* and *xiao zhuan*, which were art forms based on archaic scripts, and such decorative forms as bird script, were laid out within a rectangle higher than its width.

The aesthetics of calligraphy are defined by the expression of individuality: the scribe's ability to adapt the rules, his rhythmic brushwork – rounding or pointing the alternating direction of strokes – and the composition of the text as a whole. Are his characters all arranged on the same axis, or do some fall out of line? Is there horizontal regularity, for instance, or do the spaces between characters differ in size? Are the characters harmonious or do the strokes look shaky? Are the characters thick, applied with heavy brush pressure and much ink, or are they thin and dry? If the scribe uses ligatures between characters in "draft script," *caoshu*, they should be ingenious in appearance

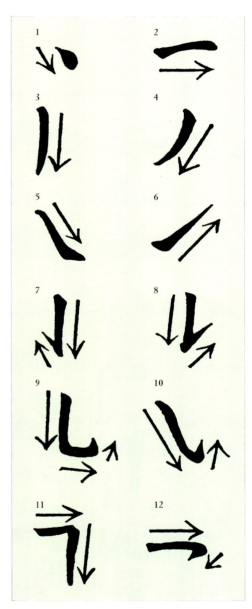

The basic strokes of Chinese script, with arrows showing their direction
1. The dot, *dian*
2. The horizontal stroke, *heng*
3. The vertical stroke, *shu*
4. The left diagonal downward stroke, *pie*
5. The right diagonal downward stroke, *na*
6. The rising stroke, *ti*
7–10. The hook, *gou*
11–12. The curved stroke, *zhe*

Festival of Purification at the Orchid Pavilion

Zhu Ming

Ming period, late-16th century, ink and paint on gold paper, fan, 17.8 x 57.5 cm, Museum für Ostasiatische Kunst, Cologne

Below

Preface to the Meeting at the Orchid Pavilion (Lanting xu; Shenlong ben version)

After Wang Xizhi

Calligraphy, xingshu script, Beijing Palace Museum

and may link units of meaning. Unusual forms, asymmetrical emphasis on characters, a stroke breaking out of the virtual rectangle or the decreasing of distance between the characters were features much appreciated (see page 120).

As explained above, the characters of Chinese script developed in part from pictorial symbols or pictographs. From time to time calligraphers emerged who continued the process of abstraction from picture to pictograph by allowing the meaning of the sign (*le signifié*, the signified) to flow back from the calligraphic execution of its form, or on into it. They tried to make meaning visible in the written character. An example, although of a later date, is a famous work by the scholar poet, painter, and calligrapher Mi Fu (1052–1107). His written version of the poem "Sailing on the River Wu," now in the Metropolitan Museum, New York, employs different ink tones, structures, and types of script. The climax of the text, in which the men are struggling to free a boat that has run aground, is reflected in the calligraphy, where each character occupies the entire height of the area allotted to a

line, and the character for "struggle" is executed powerfully in dark ink, with forceful strokes.

Mi was a famous artist, but only one among the many calligraphers who followed the great Wang. Wang Xizhi and his son Wang Xianzhi (A.D. 344–388) are regarded as unsurpassed to this day. They were the first and the best: art lovers and experts have been unanimous in that assessment since the 4th century A.D. It is thought certain that the elder Wang learned the art of calligraphy from Lady Wei Shuo (A.D. 272–349). Wang's family had connections with the powers that established the Eastern Jin dynasty, so it is not surprising that he was able to move in educated and cultured circles. His teacher herself came from a family of famous calligraphic scholars. Lady Wei Shuo's father Wei Heng (died A.D. 281) had written a theoretical work entitled *Si ti shu shi* (The Situation of the Four Types of Script), in which he gave a historical account of four scripts (*guwen, zhuan, li,* and *cao*) and four forms of art (*cao, zhangcao, li,* and *sanli*). Wang's knowledge of script was therefore based on both the practical and the theoretical talents of his teacher. On his travels in famous mountains, Wang saw the calligraphic legacy of other famous scribes on rocks and stelae, and studied Han inscriptions and stelae of the Wei period.

Wang was a cultured but unconventional civil servant, with little professional ambition, and he was also a practicing Daoist. He retired from his official post in A.D. 355 to a pleasant place in the country. His circle of friends followed, thus freeing themselves from external constraints. In Wang's time there was an honorable tradition of life in retirement from public office in order to find personal fulfillment, and this was to be a major theme of Chinese intellectual history. The ideal and its protagonists were subjects frequently portrayed in painting. Zhu's interpretation of a meeting of literati, painted 1,000 years after the event, shows scholars beside a stream playing a game popular with poets: wine comes floating down the stream in little boats, and when a boat reaches the bank where one of the poets is sitting

he must drink the wine and compose an impromptu poem. The scholar in the open pavilion in the background is intended to represent Wang Xizhi (see opposite, top).

None of Wang Xizhi's original works is extant, since it is said that the Tang emperor Taizong (reigned A.D. 626–649) took his famous *Preface to the Meeting at the Orchid Pavilion* to the grave with him, but he is regarded as the greatest figure in the history of Chinese calligraphy because he "liberated" the script. It already had over 1,000 years of history behind it as a means of recording events when Wang Xizhi developed his own style from all that he had seen and learned. It is said that his brushwork "danced like clouds sweeping over the sky" and was as "forceful as a flying dragon." If the manuscript of the *Preface* is regarded as a faithful copy of Wang's style, one can indeed follow the tension in the lines created by the pressure of the brush and the flow of ink. Wang uses *xingshu*, or "cursive script." Ligatures between the lines are clearly visible, the lines themselves are vertically balanced, but the horizontal regularity of the letter from the Han period has gone. Although none of the characters breaks out of the frame of its virtual square, they appear to vary in size.

Wang Xizhi's art found only one notable successor within his family, his youngest son Wang Xianzhi. He trained himself from his father's calligraphic works and those of a certain Zhang Zhi (late-2nd century A.D.), a scribe working in *caoshu* script. It is thought that the younger Wang developed his own style on this basis. Zhang, the "great figure of *cao sheng* script," was considered equal to Wang Xizhi in the literature of the Southern Dynasties. He too, according to the arbiters of taste, was one of the very best. Examples of his script have been preserved in *Chunhua ge tie* (Collection of Calligraphy of the Chunhua Era). This Song period compilation was made at the request of Emperor Taizong of the Song dynasty in the late-10th century, under the supervision of the calligrapher Wang Zhu. It was based on the contents of the imperial collection of writings, and is a work that both helped to preserve classic examples of the art of calligraphy and obliges us to face the fact that these classic models exerted a formidable kind of censorship. Most of the texts in this collection in the form of stone rubbings are from Wang Xizhi's circle and milieu.

Stone rubbings of important inscriptions are still taken, and over the centuries they have preserved written evidence from stone stelae that themselves are no longer extant. From time to time new stelae have been carved to preserve these written texts. Emperors would also have favorite texts carved in stone in the style of a particular master of calligraphy. The procedure developed in China for taking a positive image is relatively simple. Wet paper is placed over the inscription and sinks into the engraved characters. The craftsman goes carefully over the raised surfaces with a wad of fabric soaked in ink, the areas sunk into the engraved characters remaining white. The result is an image of the script not in black on white, but vice versa.

Above left
Kuai xue shi qing tie

Wang Xizhi

Calligraphy, xingshu script, Taipeh Palace Museum

Above right
Taking a rubbing from a stele
1990, the group of stelae at Xi'an

These rubbings allow the nature of an inscription to be seen as it was in the original. Everything that would have been visible in the original work of calligraphy is reproduced in the rubbing, always supposing the script carved into the stone was faithful to the original in the first place.

In one way calligraphy goes far beyond painting as an art form. When pure writing was recognized as art, it became a unique form of expression in which the viewers' knowledge of the written characters enabled them to follow the chronological sequences of the process. Like paintings, works of calligraphy were collected by educated people, and many of the literati admired these written texts more than pictures. However, paintings and calligraphy alike might have notes written on them. Particularly from the time of the Song dynasty, collectors or critics claiming valuable pieces as their property tended to inscribe them with titles or effusions of their own inspired by the works themselves, situated on, beside or under a work, or added as an appendix. In some circumstances this practice added to the value of a work of art, but above all, it provided a record of the work's history.

A piece of calligraphy by Wang Xun (A.D. 350–401), a nephew and pupil of Wang Xizhi, is believed to be the only authentic calligraphic work of the period to have survived the last 1,500 years (see below). The five original lines by Wang Xun (in the center) clearly show the style of his brushwork, which was said to resemble that of Wang Xianzhi. Here we can see Wang Xun display his artistic range, from watery, fat black lines to

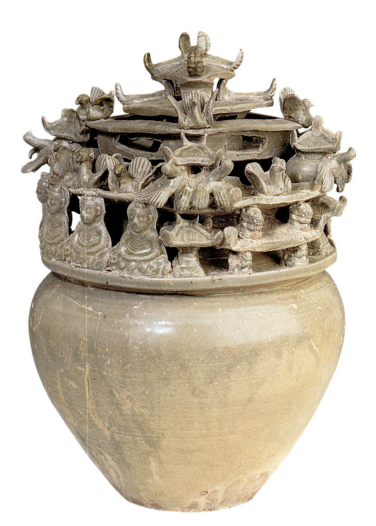

Urn given as grave goods

Stoneware with celadon glaze, H 40.1 cm, dia 27.5 cm, Linden-Museum, Stuttgart

This urn, buried as grave goods, shows a multistory architectural structure resembling a temple. Its modeling is fully rounded and ornamented with figures of Buddhas and birds.

Opposite
Ceramic vessel with lotus ornamentation

Southern Dynasties, blue-green celadon glaze, H 43.7 cm, Hubei Provincial Museum

Below
Letter to Bo Yuan (Bo Yuan tie)
Wang Xun

Calligraphy in xingshu cursive script, ink on paper, 25.1 x 17.2 cm without colophon inscriptions, Beijing Palace Museum

The inscription by Dong Qichang (1555–1636) is on the left and the inscription by the Quianlong emperor (reigned 1736–1795) on the right.

extremely delicate strokes traced with the tip of the brush and very gentle pressure, using compressed characters with large distances between them.

The original is placed between notes written by its collectors to left and right of it. On the left is an annotation by Dong Qichang (1555–1636) in fine cursive script, in this case deviating very little from clerical script; on the right is the handwriting of the Quianlong reign emperor (1736–1795), which is fine, well balanced, and slender. Both additions show that Wang Xun's calligraphy was highly regarded both in the second half of the 16th century and in the 18th century. Yet the actual text was not even very significant in content. The Quianlong emperor also added the picture of the leafless tree in front of rocks. No reference to the text itself is intended, since Wang's note merely expresses his regret at his inability to meet his friend Bo Yuan on account of sickness.

It should not be forgotten, however, that over and above calligraphy and painting, the idea of life after death remained the subject of artistic activity. In accordance with religious beliefs, companion figures were still placed in the tomb with the dead, ceramic vessels were filled with provisions for them in the next world, and favorite items of personal use were buried with them. Collections of tales of supernatural phenomena, mysterious events and ghost stories provide a literary view of the Chinese perception of the world. For the Chinese, it was very important to care for the souls of the dead and ensure that they were protected.

As a result, some interesting ceramics date from these years of division between the north and south of China. Many very elegant funerary figures from all walks of life have been found in the north. In the south, kilns were built to fire stoneware vessels with celadon glazes in the present province of Zhejiang.

It was probably in the southeast that the custom developed of placing in tombs urns with sculptural ornamentation showing figures and animals. They symbolized wealth and abundance, and could be expected to provide the same good things in the next world. The majority of symbols derived from indigenous mythology; depictions of Buddhist figures are ornaments less commonly found. However, Buddhism was more deeply rooted in the south and on the coasts in the 3rd and 4th centuries A.D. than has previously been thought.

Study until now has probably concentrated too much on the north and the land route, largely neglecting developments in the south. In her critique of the Kongwang Shan dating,[7] Müller has suggested that difficulties of interpretation led to a failure to recognize figural representations from the Buddhist canon for what they really were; since no one expected them, they went unrecognized. However, the existence of pictorial depictions of Buddhas, bodhisattvas, and *apsaras* after the Sanguo period can certainly be proved, so there is no reason why they should not adorn grave goods whose owners perhaps followed or sympathized with the new faith (see right).

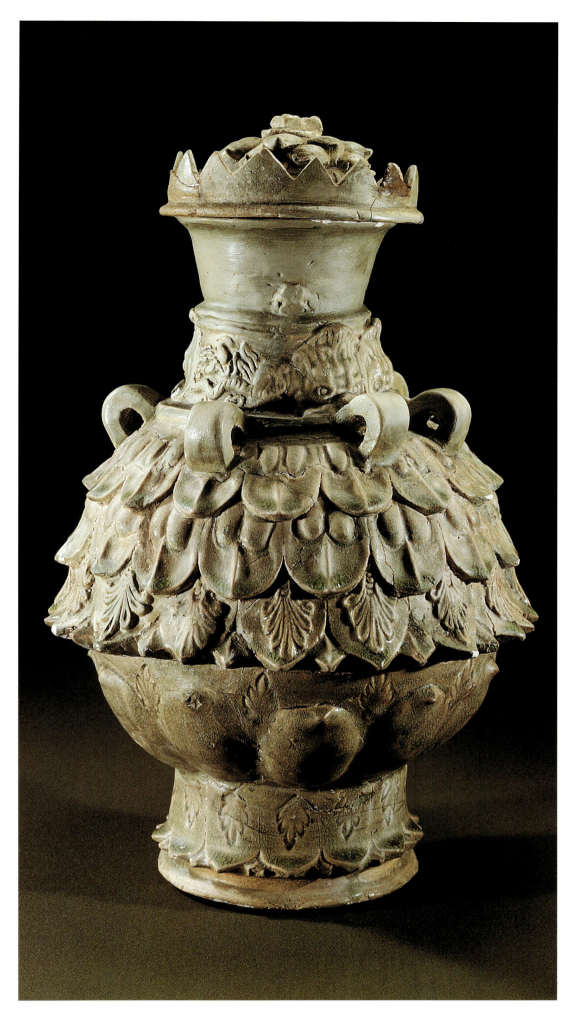

The Sui Period: the Second Great Reunification
The Tang Period: Internationalism and Xenophobia

(6th–10th centuries A.D.)

"The true Golden Age of China was ushered in by the Sui ... and Tang ... dynasties, and reached its peak between the middle of the 7th century and the first half of the 8th."[1]

The Sui dynasty (A.D. 581/89–618) was a dynasty of only two emperors, and in historical terms it echoed the situation in the Qin and Han dynasty periods. Emperor Wen Di (reigned A.D. 589–604) tried to consolidate the empire by creating or re-establishing institutions designed to preserve unity: an administrative apparatus in which the same language had to be spoken (a measure taken to counter the use of dialects); the publication of a phonetic encyclopedia, *Bei tang shu chao*, to provide everyone with a common basis of knowledge; the building of granaries, the allocation of land to the peasants, the construction of irrigation systems to improve agriculture, and the building of the imperial canal linking the north and south of the country. Yang Di (reigned A.D. 605–617), the second and last Sui emperor, then went rather too far in exploiting the people. His ambitious building projects called for the unpopular compulsory conscription of huge numbers of workers. Meanwhile, he was deploying large armies in the west against the incursions of invading Turkic peoples. However, two important dates marking mainland China's contact with Taiwan, then known as Liuqiu, fall into his reign. In A.D. 607 Chinese envoys visited Liuqiu, and they were followed in 610 by a troop of 10,000 men. From that date on, the slow but steady settlement of the island by mainland Chinese went ahead.

Economic reasons led to the murder of the second Sui emperor by conspirators. The Sui dynasty may have been of short duration, but it laid the foundations (as the Qin dynasty did for the Han) for the cultural flowering of a unified empire under the Tang rulers (A.D. 618–906).

Both art and literature bear eloquent testimony to the culture of this period. Finds from tombs illustrate the continuity of the process whereby the Sui-dynasty rulers adopted the aesthetic ideas of their predecessors, in turn conveying them to their own successors. That continuity is reflected in both the paintings of the Sui period, although they are known to us only from later copies, and the ceramics that can be dated to this time. The rich ornamentation on the horse (see left), for instance, appears in a similar form on unglazed pieces of the Beiwei period, and the pale green glaze may be of the same technological origin as the celadon glazes applied to items of southern manufacture. The following Tang dynasty thought highly of such glazes and developed similar ceramics in an unprecedented range of colors.

The founders of the Tang dynasty were the Lis, father and son. In the first years after taking power from a Sui puppet emperor, Li Yuan acted with great political acumen. He came of a distinguished family, was an educated man, and understood the machinations of power. He removed envious rivals, and relied on a centralist administration for the Chinese empire, staffed by officials of aristocratic origin who had to pass a state examination.

The empire flourished both socially and economically. The period to the middle of the 9th century is conspicuous for its commercial success, its cosmopolitan thinking and its religious freedom. China set an example to many other Asiatic states. The Tang dynasty's institutions, principles, and methods of government were imitated in many parts of Asia.

Notable achievements of this time include the introduction of a legal code based on common law, and the strict examination system for officials which divided them into eight ranks, from the

Saddled and bridled horse

Sui dynasty, A.D. 581–618, funerary ceramic model, pale green glaze on sand-colored base, H 27 cm, Museum für Ostasiatische Kunst, SMBPK, Berlin

lowest grades of the civil service to the highest ministerial office. Culturally the period saw the beginnings of opera; a flowering in poetry (with the *shi* style), reflected at least quantitatively in the fact that about 50,000 poems have survived; and a great period of painting in which the landscape style was further developed. Stimulated by strong imperial interest, calligraphy also continued to develop. Calligraphers were trained on the classic works of the great calligrapher Wang, and the Tang period left some very fine examples of *caoshu* script of whose authenticity is in no doubt.

The state philosophy was Confucianism, but Buddhism and Daoism had great influence. Many emperors seem to have ignored potential conflicts, and, at times, imperial protection even made Buddhism a kind of state church. Many temples and monastery complexes were refounded under Tang rule. The Buddhist communities represented a major economic and financial force, since large donations were often made to the temples and they were exempt from tax. This preferential treatment led to persecution of Buddhists, and subsequently to the secularization of the monasteries. The services provided by communities of monks and nuns ranged from hospitals, nursing homes and guesthouses to banks and warehouses.

Territorially, the Tang emperors of the 8th century ruled from the Liaoning district in the north, along the coasts to the Mekong and Sichuan in the west, through the Gansu corridor to take in another wide strip of land, ending to the west at the river Syr-Darya in eastern Uzbekistan.

Despite internal political unrest with the An Lushan rebellion of A.D. 755, and some years of autocratic rule by a widowed empress, the Tang empire lasted for 300 years. After a brief period of crisis affecting the entire country between A.D. 918 and 960, the result of attacks by nomads from the northwest, the empire regained its unity under the Song emperors, although its territory was reduced.

The art of the Sui and Tang period includes both sacred and secular painting and sculpture, as well as architecture and gardens. These arts created the setting for the others, and will therefore be surveyed first.

The great urban centers of the Tang period, Chang'an (the capital, with over a million inhabitants), Luoyang, and Yangzhou were planned as if on a drawing board, with a rectangular grid of parallel streets and boulevards (see above).

These notable achievements in town planning should not be overlooked in favor of individual architectural works, especially in view of the continuing tradition of symmetry and the rectangular layout. This was already an important basic feature of architectural complexes in the Han period. Its general outline can still be recognized today in the imperial city of Beijing and its immediate surroundings, and in the town plans of many modernized large cities of ancient origin. So far as topography allowed, towns were laid out to a rectangular scheme in accordance with the plan of the ideal city from the Zhou li (Rituals of Zhou).

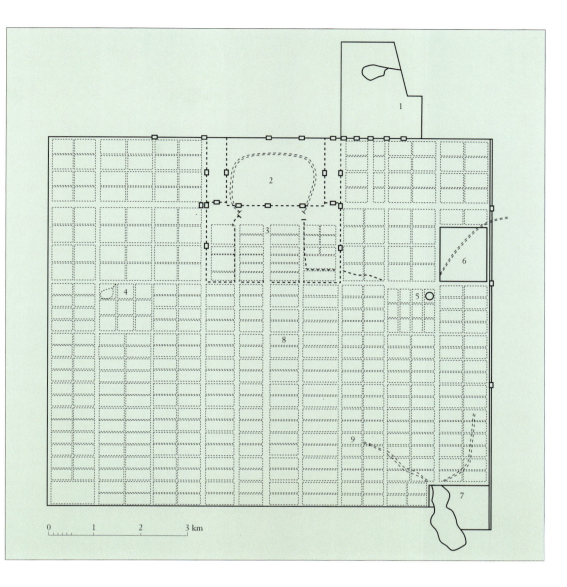

The capital Chang'an, which had several waterways running through it, was divided into separate urban districts accommodating different groups of the population. To the north lay the "imperial city," containing the walled imperial palace, the palaces of the aristocracy, and administrative buildings. The residential quarters of the ordinary people – the outer city – surrounded this central area to the south, east, and west. In the west and the east, trade and commerce were conducted in two great markets with access to waterways. The city was divided symmetrically down its north-south axis. It was further divided into quarters (*fang*) with space for dwelling houses and temples. Each *fang* was walled, and the walls had two to four gates that were closed at nightfall. To counteract the severity of the walls, the boulevards, 20 to 40 meters (22 to 44 yards) wide, were planted with trees, and an imperial garden open to the people throughout the year was laid out within the city.[2]

Urbanization may be seen as the first reason for the creation of many gardens. Tang gardens as described in literature, for instance by Bai Juyi (A.D. 772–846) and Wang Wei (A.D. 699–759), and in travel writings with extensive passages on land-

Plan of the city of Chang'an
(A.D. 618–906)

1 Damming palace
2 Taiji palace
3 Imperial city
4 West market
5 East market
6 Xingqing palace
7 Furong garden
8 Small Wild Goose pagoda
9 Great Wild Goose pagoda

scape, provided relief from the urban life led by administrative officials. These texts, after all, were written and read by an educated elite destined for public service, living in the capital and the provincial administrative centers.

The Sui emperor Yang Di's imperial garden, Xi yuan (a project undertaken to demonstrate his imperial power) must itself have been a landscape garden of vast extent; it is said to have included among its features a lake 10 kilometers (6.2 miles) in length with three "islands of the immortals" in it. There were also other lakes, waterways, hills, valleys, and a menagerie of rare animals and plants. The concept of Yang Di's garden was a legacy of the Han period. The sources also speak of 16 water palaces within the complex, each surrounded by a garden of its own. This characteristic of the Chinese garden – the garden within a garden (yuan zhong yuan) – remained part of Chinese horticultural tradition up to the landscape gardens commissioned by the Dowager Empress Ci Xi at the end of the 19th century.

The first Tang ruler was not enthusiastic about garden design. It is a commonplace of history that at a time of dynastic change the splendors (whatever their nature), institutions, and actions of the predecessor are devalued: he is condemned by implication, a negative assessment that accounts for his loss of power. If the dislike for horticulture shown by the Tang emperor Gaozong (reigned A.D. 618–626) is taken at face value, it had little effect. Both subsequent emperors and the upper classes of the Tang dynasty went on laying out gardens. Stylistically, splendor and sobriety went side by side in these gardens: poets withdrew in memory of the poet Tao Yuanming to straw huts, which could be situated on country estates, but private pleasure gardens were also laid out in the capital. Among other lovers of gardens, Empress Wu Zetian (reigned A.D. 690–704) had a retreat in the mountains, where she would withdraw to live a "simple life" for a time, while that great patron of art and literature Emperor Xuanzong (reigned A.D. 712–756, also known as Ming Huang) had a liking for water gardens.

The features of both imperial and private gardens recur again and again in a style of composition that links the garden with landscape painting. The traditional garden consisted of as diverse a succession of separate views as possible. A garden was "built" – (zao is the expression in Chinese) – in the same way as, for instance, a bridge (zao yuan, zao qiao). It was an artificially constructed natural landscape, or more precisely, it conveyed the atmosphere of a natural landscape with its beauty enhanced by architectural structures. However, such artificial landscapes always contained allusions to real landscapes or to other gardens. Many gardens gave physical expression to certain lines of poetry, while others alluded to famous places.

A fundamental aspect of garden design was the choice of site, which took account of the principles of geomancy, fengshui. A good situation, for instance, had a mountain to the north of it, lay west of cities, beside water and in an interesting landscape, since the garden itself was to "provide a view" (jie jing). The garden contained buildings of various shapes, and the entire complex of "gardens within a garden" was divided by courtyards, walls, gates, and openings that either obstructed or opened up the prospect seen from artificial bridges and paved paths. Water was important in the form of apparently natural lakes, pools, and enclosed basins, and there were streams with abruptly rising banks to express the dichotomy of yin and yang. Even in the Han period water was an essential part of a garden, as were rocks symbolizing mountains. The concept of "artificial mountains," jia shan, is expressed in the Tang period by realistic miniature mountains made of piled rocks. In later times such mountains might contain artificial caves or grottoes. A traditional canon of plants, all of them with symbolic or religious and mythological significance in literature, provided foliage and fragrance. They included evergreen conifers, bamboos, plum trees (Prunus mume), willows, lotus, chrysanthemums, camellias, peonies, and such climbing plants as wisteria.

Varying conditions of landscape and climate meant that two different tendencies of garden design developed in China, one northern and one southern. Both shared their basic principles, and they differed chiefly in the actual plants that were grown. The dialectic of a northern and a southern culture, which can also be traced in painting and ceramics, seems to have made its way into all artistic fields.

The concepts behind the gardens of this period spread east to Japan along with Chinese culture and Buddhism and made themselves at home there, laying the foundations for the Japanese art of the garden.

Ever since the 5th century, nature poets had sung the praises of such gardens and their natural settings, but had not gone closely into their actual design. During the Tang period, the poetic treatment of the subject was supplemented by prose writings, and garden descriptions closely akin to travel writings were composed. This genre

Wang Chuan

Calligraphy by Li Dongyang

1507, colophon (inscription mounted on the picture above right) to the Wang Chuan cycle of poems, Museum für Ostasiatische Kunst, Cologne

continued into the 19th century. It was exclusively devoted to gardens and their design, and such accounts were frequently written by someone who himself owned the garden concerned, or by one of his contemporaries or friends, but might also be written considerably later by a visitor to the garden. It is true that one cannot usually reconstruct the actual ground plan of a garden from such descriptions, but they do give a clear picture of the aesthetics and traditions of the garden.

A long list of famous poets who immortalized themselves by writing on gardens could be drawn up, but the names mentioned as examples here, since they provided subject matter for horticulturists and painters of later centuries, are those by two of the literati, Bai Juyi's *Cao tang ji* (Account from the Straw Hut), and Li Deyu's *Pingquan Shan ju cao mu ji* (Description of the Grasses and Trees of the Pingquan Mountain Retreat). Li also collected rare plants.

Finally, the painter Wang Wei, the father of monochrome ink painting (the main subject of which was landscape), owned a country estate

called Wang Chuan. This place too became a favorite subject of art, and not just because Wang himself had celebrated it in poetry and paintings, although his views of the estate are extant only in copies (see above). The scroll clearly shows a series of several gardens or parts of gardens in linear succession, illustrating the scenery around Lake Yi. The composition is said to derive directly from Wang Wei's own painting. His literary and pictorial depictions greatly influenced the ideals of the landscape painters and landscape designers of later dynasties. Gardens of this kind may also have become known in Japan when a second wave of Chinese culture spread eastward. An argument in favor of this theory is that many fundamental Chinese architectural ideas found their way to Japan after this second major cultural contact early in the 8th century. For instance, the town planning principles evident in Chang'an, described above, were employed in Japan for the capital city of Nara, which was founded in the 8th century A.D.

Within the Middle Kingdom other towns and cities were also planned in accordance with the

Wang Chuan, country estate of Wang Wei

After Guo Zhongshu (died A.D. 977)

Ming period version, 29.5 x 474 cm, Museum für Ostasiatische Kunst, Cologne

Left

Hall of the temple of the Radiance of Buddha (Fo guang si)

Tang period, A.D. 857

The main hall stands on a high terrace. The remains of the former entire complex, which was symmetrically laid out about a central axis, are clearly visible.

Right

Great Wild Goose pagoda (Da yan ta)

First half of the Tang period, between A.D. 652 and 704, H 59.9 m, length of side on ground floor 25 m

Chang'an design, and the rebuilding of Luoyang in particular followed the same model. Tang architecture is generally thought of as single-storied, although buildings might in fact be on several floors. Tang poetry frequently mentions multistory dwelling houses, *lou*. The walls of the imperial city and the buildings on terraces within it towered above a sea of mainly single-story buildings. So did the Buddhist temple pagodas, for instance the Great Wild Goose pagoda, Da yan ta.

This pagoda conveys an impression of solidity, rigidity, and weight, although the seven stories taper upwards, decreasing in height from floor to floor. The projecting pillar reliefs produce the same visual effect as the pillars of a wooden building, dividing the elevation of a pagoda into nine or seven and five elements. The term for the distance from pillar to pillar, *jian*, came to be used as a measurement – in a way comparable to the European term "yoke" – and the number of *jian*, always an odd number, determines the aspect of the side of a building. Although the buildings of the ruling class, like the later palaces, have graduated roofs, and their halls stand on graduated terraces, apart from those elements their most conspicuous feature is their breadth.

Not only does one of the oldest and most famous masonry buildings of China date from the Tang period, but the main hall of the Fo-guang Temple (Fo guang si) on Mount Wutai, China's oldest extant wooden structure, is another fine example of Tang architecture (see above, left). The building divides horizontally into three areas: the terrace, the main body of the building, and the roof. The terrace fulfills several functions: first technical, since it provides each wooden pillar with a "foundation" of its own in the shape of a stone slab, thus helping to protect the wood from decay; second ceremonial, since the faithful assembled for religious rituals on the terrace; and third symbolic, for the terrace symbolized the world mountain Sumeru. The main body of the temple is a timber-frame building, with only the load-bearing pillars taking the weight of the roof; the walls are merely masonry infilling. This timber-frame method of construction had the advantage of allowing large doors and windows to be fitted into the facade between the pillars.

In Chinese architecture the roof developed into a genuinely sophisticated architectural component (see opposite). The roof trestles, open on the inner side, and the undersides of the eaves give a view of the *dougong* bracketing system in which longitudinal beams, crossbeams and bracket arms, ingeniously fitted together in equilibrium, determined the upward and outward slope of the roof, and provided resting points for the rafters. This type of roof construction leaves one in no doubt that Chinese architecture was an art as much as a craft. In later periods the longitudinal beams and crossbeams provided surfaces for artistic treatment and were painted in bright colors.

Roofs built in this way were reserved for official buildings, the homes of high-ranking officials, palaces, and temples. The earliest text on building with timber, the *Yingzao fashi* (Methods of Building), published in 1103 by Li Jie, head of the department of public works at that period, postdates the Tang dynasty, but its account of architectural sophistication as displayed in both text and pictures shows that the art was not merely of recent development. Hipped roofs supported on the pillars of the main body, their eaves extending far beyond the beams, adorn the main buildings of ambitious architectural complexes. Dwelling houses and their outbuildings had simple saddleback roofs, but all forms of roofing showed a great range of variation. At a later date the roofs, as well as the location of structures in relation to their neighbors, served to indicate the significance of an individual building within a complex. Thus the main buildings of monastery and palace complexes had tall and complex hipped roofs, sometimes double or graduated, with more roof ornamentation than other buildings.

On the evidence of temple complexes still extant in Japan (at Shitennoji, Askadera, Horyuji, and Yakushiji), it seems likely that Chinese sacred buildings too were symmetrically designed on an axis, the characteristic feature of both sacred and secular architecture.

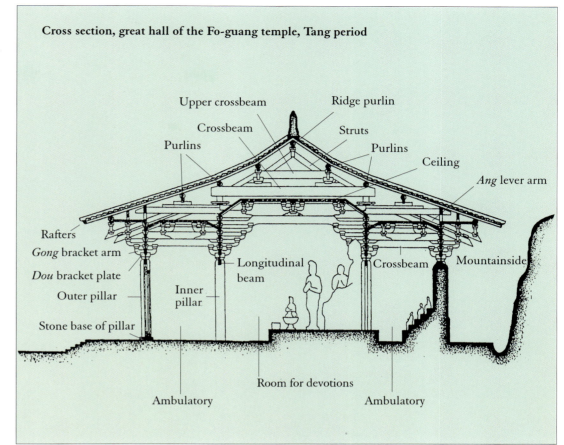

Cross section, great hall of the Fo-guang temple, Tang period

Upper crossbeam
Ridge purlin
Crossbeam
Struts
Purlins
Purlins
Ceiling
Ang lever arm
Rafters
Gong bracket arm
Dou bracket plate
Longitudinal beam
Crossbeam
Mountainside
Outer pillar
Inner pillar
Stone base of pillar
Ambulatory
Room for devotions
Ambulatory

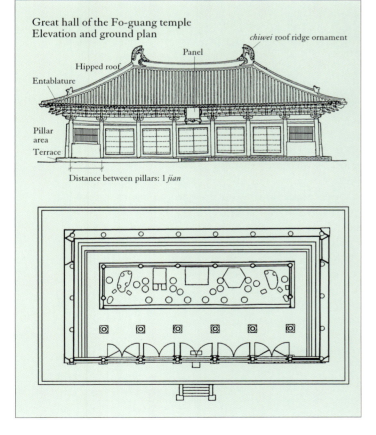

Great hall of the Fo-guang temple
Elevation and ground plan
chiwei roof ridge ornament
Panel
Hipped roof
Entablature
Pillar area
Terrace
Distance between pillars: 1 *jian*

Brightly painted beams

18th century, Yonghe Gong lama monastery, Beijing

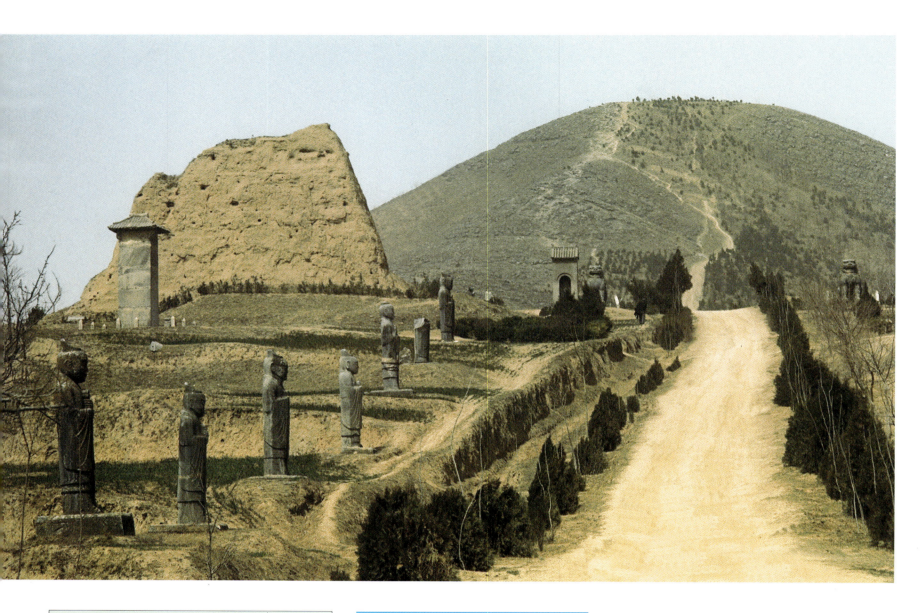

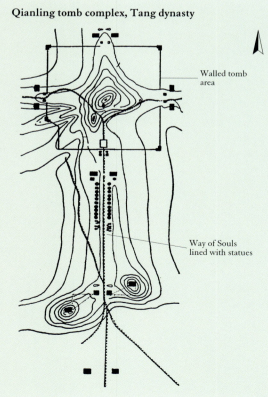

Qianling tomb complex, Tang dynasty

Walled tomb area

Way of Souls lined with statues

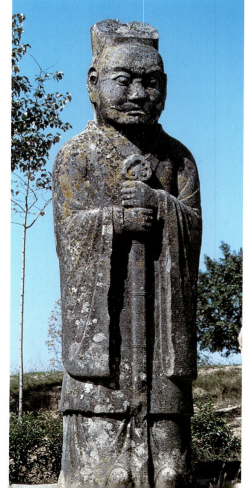

All Chinese architectural trends followed this basic concept, from the complex consisting of a main hall, courtyards, and outbuildings (its symmetrical design already evident in the *mingqi* of the Han period) to temple and palace architecture, with the main buildings laid out on a central axis. This concept too was to last for centuries.

However, a number of elements, whether in towns or temples, were excluded from the symmetry of the whole. Gardens, for instance, as in the great park of Chang'an, did not fit into the design, and cemeteries were situated outside cities and did not relate to them symmetrically.

Art in the tomb

Tombs provide as valuable an insight as literature into the everyday life of the Tang period. It remains true, as Yang Xizhang said in his essay on the cemeteries of the Shang period, that: "Life below ground reflects life above ground."[3] The tombs of the upper classes of society were richly furnished with grave goods and adorned with wall paintings. Although research has been carried out on the emperors' tombs, so far only some of the

tombs of imperial relatives have been methodically excavated. There are 18 tombs near the city of Xi'an and two more, those of the last two emperors of the dynasty, in the present province of Shandong. The stone statues placed along the access roads to the complexes in Xi'an are remarkable works (see opposite). The *shendao*, the "Way of Souls," of the Tang emperors is lined by an impressive series of monumental stone figures leading to the entrance of the tomb complex. The tomb area is rectangular, the tomb itself is cut into the mountain; in all, 16 of the 20 imperial tombs follow this pattern. Qianling, the tomb of Emperor Gaozong, gives the best idea of a Way of Souls, since most of its limestone figures, although badly damaged, are still in place. They stand in pairs, comprising columns, winged horses, slabs with reliefs showing birds, saddled horses with their grooms, as well as 20 statues of officials, stelae crowned with dragons, and two brick pillars. All the sculptures are of a weighty nature, closely bound in form to the original stone block, and appear static. The figures are defined by their outline, and no attempt is made to suggest the material of their garments. At first sight the legs of the horses look strange, and they were probably shortened for technical reasons: the smaller the distance between the horse's body and the base on which the statue stands, the more stable it would be. In another tomb complex the space between the bodies of animal statues and their bases is filled in with the familiar "cloud motifs," serving the same purpose but in decorative disguise. The rectangular, block-like carving of the statues of human guardians gives them a rigid look, an impression reinforced by the symmetrical design of the folds of their garments, the way they hold their arms close to their bodies, and the fixed expressions on their faces. They are in no way comparable with the lifelike figures of Buddhist sculpture, where guardians are shown bending to one side, with a foot raised, or with features into which emotions can be read. However, it must be remembered that the figures along the Way of Souls were freestanding, fully rounded stone statues. Stone relief slabs and wall paintings are not at all like these rigid, awkward works, and indeed such wall paintings as those found in the 7th-century tomb of Prince Zhanghuai are notable for their extremely lifelike scenes of movement (see right, top).

Wall paintings in many colors – in China generally applied *al secco* (on dry plaster) – convey a sense of life and action. We see horsemen with waving banners, galloping at full speed on their realistically depicted horses, yet the pictures are rather sketch-like. The painters left works that cannot be described as fully realistic, despite their precision of detail. It is as if the characteristic features of both horses and riders were simulating realism. Attitudes convey the impression of movement. The pictures are evidence of an attempt to provide a realistic depiction (form and color are authentic), and the artist's talent for observation can be seen in the attitude of a rider bending low

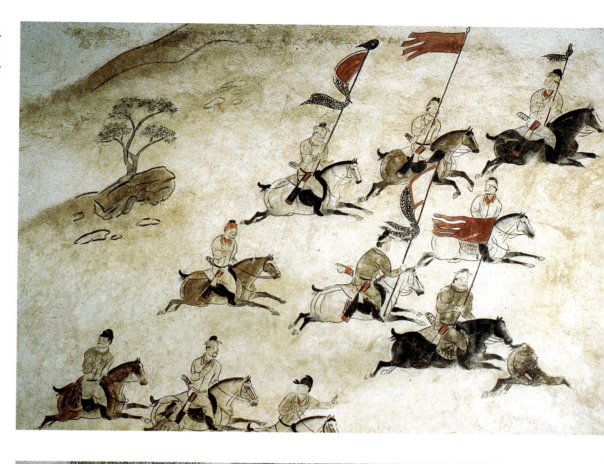

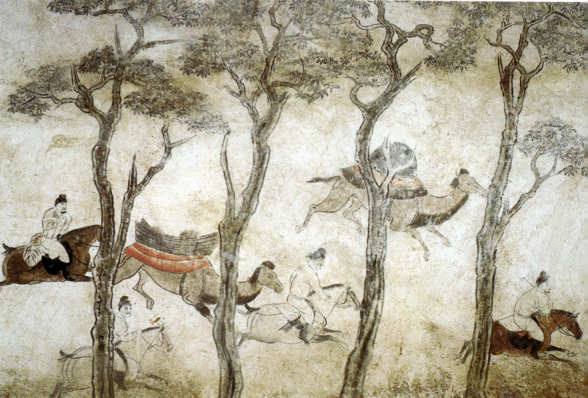

Opposite
Way of Souls leading to the Qianling tomb complex of Emperor Li Zhi

Late 7th century A.D. (Gaozong, reigned A.D. 650–684), Xi'an

Far left, plan of the site; left, one of the statues of officials lining the Way of Souls.

Above
Game of polo and hunting scene

A.D. 706, wall painting, tomb of Prince Zhanghuai

Horsemen and camels carrying loads run past behind the trees.

Right
Landscape with pine trees
and rocks

*Tang period, wall painting, 114 x 105 cm,
tomb of Prince Jiemin, east wall of the
entrance ramp*

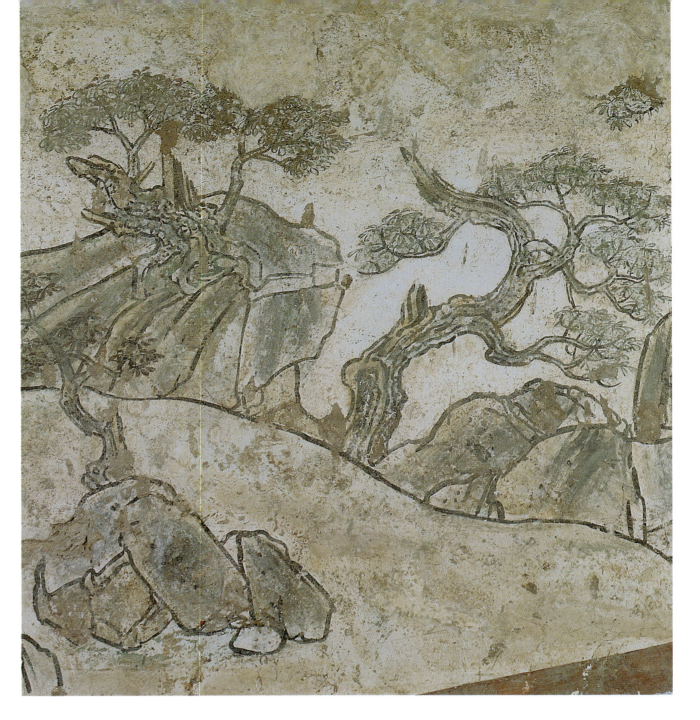

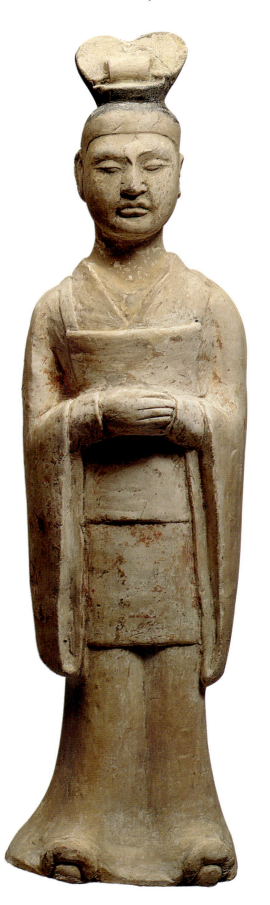

over the neck of his mount, or the depiction of different phases in the movement of a gallop – compare the horse of the rider with the red banner with the horse behind it. Yet one feels that the outlines were part of a pattern. It is the same in the wall painting showing a scene of horsemen and camels (see opposite, bottom).

The background to the figures, however, is sometimes executed in an interesting landscape style, and many features of later painting occur in the depiction of plants, landscapes, and animals – features such as the diagonal composition of mountains stretching away into the background; the black outlines of silhouettes and their internal contours, subsequently filled in (see above); and the style that achieves structural effects solely through graduated shades of color without outlines (the "boneless" style). The modeling of ceramic figures also shows that realism was thought desirable and could be achieved. After the

Han period, the Tang dynasty marks a second high point in the art of funerary ceramics. Two equally expressive types of ceramic ware were made for use as grave goods: glazed pieces and unglazed, cold-painted models, *mingqi*, representing all kinds of everyday activities and objects.

It is a pity that the finely worked unglazed pieces, whose predecessors appeared under the Han dynasty and during the period when the empire had split up, are not very popular now, probably because to the modern taste for vivid color the glazed ceramics of the Tang period seem more attractive. The unglazed models are of dogs, pigs, human figures, zoomorphic guardians, unidentifiable animals, and winged beings. They are covered only with a film of chalk that may have served as the priming for paint, but they all convey a lifelike effect, and in the case of real creatures are true to life. Although they are not freely modeled, these figures leave an impression of elegance also

found in the figures of Buddhist sculpture from this period (see opposite, left).

A feature common to all is that although they are the stylized types inevitable in mass production, the craftsmen who made them were able to give lively expression to their own observations of their subjects as they worked. The result is often detailed and lifelike realism in figures that were mass-produced but then touched up by hand.

These observations are accurately transferred to the ceramic models, for instance in the seated dog, a slender, elegant creature sitting up on its hind legs. The pig, on the other hand, a boar with large tusks, is crouching on the ground. Depictions of pigs in a religious context were by no means confined to grave goods. Buddhist wall paintings, for instance, contain pigs when the artist wants to emphasize the rural character of a scene.

The pig too is modeled in a lifelike and realistic style, and these were constant features of animal figures from the Han period onward. The pig's snout still shows remnants of red paint, and in view of the naturalistic style of Tang art as a whole it is quite possible that the entire animal was originally painted in naturalistic colors.

When there was a death in the family, the choice of glazed or unglazed ceramics as grave goods must have been a financial consideration. All types of glazed ceramics had their unglazed counterparts. Funerary figures representing human beings are multicultural, like Tang society itself.

The differences of size in the figures that have been found is further evidence of the relative influence of prosperity on grave goods: they vary from a few centimeters to a meter in height.

A man who had accumulated riches through his position and high office could afford to have his tomb magnificently furnished, and his grave goods would include glazed, colored figures in the three-color *sancai* ornamentation, which was the latest achievement in ceramics.

Great technological progress was made in the art of ceramics, particularly during the Kaiyuan era (A.D. 713–741) under Emperor Xuanzong, and more attention was now paid to surface detail. It is from this period that the famous three-color sancai decoration dates. *Sancai* pottery had lead silicate glazes, usually in a combination of three colors (*san cai* literally means "three hues"): blue, green, and beige; or blue, brown, and green, more rarely yellow. Sometimes it had four colors. The modeling of forms also became more sophisticated.

A great many Han period grave goods were only cold-painted. Some, however, had a ground in the form of white slip, a kind of glaze made from a diluted mixture of clay. At the same time, Chinese potters were experimenting with lead silicate glazes (*quian you*) colored with copper oxide (green after oxidization by firing) and iron oxide (amber yellow). This glazing technique probably reached China from the east along the Silk Road. Technically, the glazes were not easy to handle, for

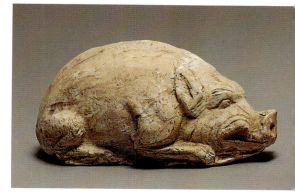

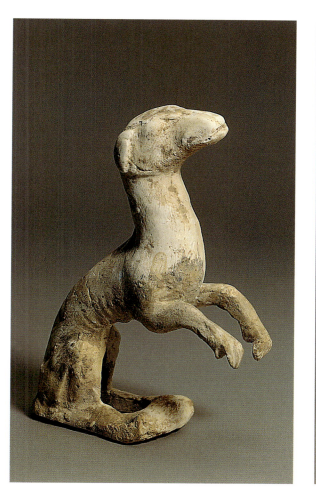

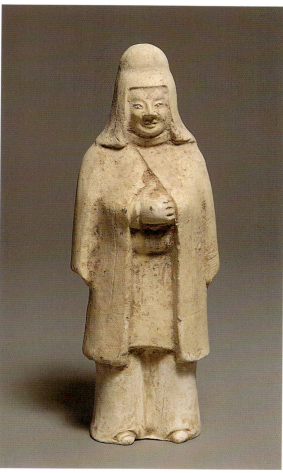

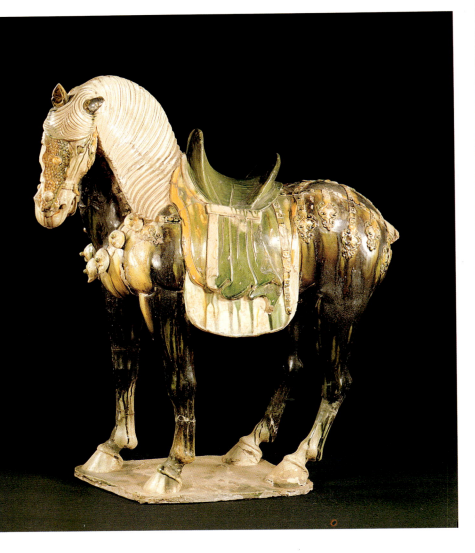

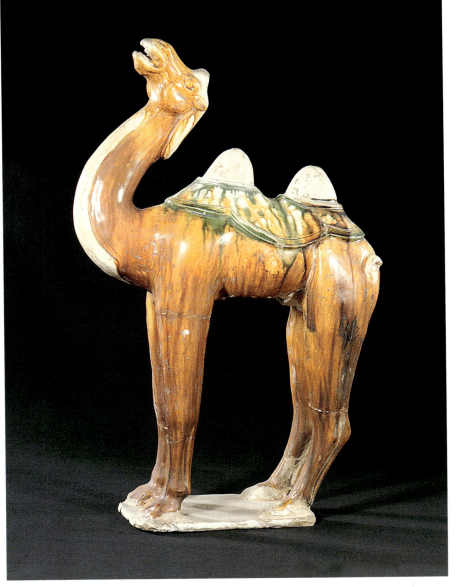

Horse

Tang period, ceramic model given as grave goods, sancai glaze, H 69 cm, Porzellansammlung, Dresden

Camel (*luotuo*)

Tang period, sancai decoration in the colors green (copper), brown (iron), and yellow (antimony), H 66 cm, Porzellansammlung, Dresden

they were unstable and difficult to apply. They were apt to run during firing, and when cool there would be cracks in the glazing, giving a craquelure effect as the result of different degrees of expansion in the earthenware model and its glaze.

It was in the Tang period, which has provided so many finds of grave goods with *sancai* decoration, that craftsmen mastered this type of glaze. They did it by using a firing technique in two stages: first, the basic ceramic model was fired at about 1,150 degrees centigrade (2,100 degrees Fahrenheit), then it was fired again to oxidize the glaze at 950 degrees centigrade (1,750 degrees Fahrenheit). This method made it possible to control the glazes, since pigments would cling to the pottery better once it was already fired. All the same, colors running into each other by accident produced some attractive patterns, and the potters seem to have been aware of the limitations of the sancai technique when it came to adding detail – or there would not be so many otherwise glazed figures with faces left unglazed to be cold-painted after firing. The pigments used in paint were copper, iron, and cobalt imported from the west. Cobalt ore was present in large quantities in the south of China in Zhejiang and Yunnan, but it was not mined before the Ming dynasty. These valuable

pigments, like other goods, were transported by camel; they and their drivers were a familiar sight in markets in Chang'an (see above, right).

The upper-class taste for all things foreign is reflected in the many models of western subjects found as grave goods; as well as figures of Chinese officials and ladies, there were camels, oriental camel drivers, horses from Ferghana, and figures of members of foreign races, including musicians. Shapes of vessels not hitherto typical of China are also found. Among the ceramic replicas of everyday utensils there are pieces in forms deriving from central and west Asian metalwork (see opposite, bottom left). On the other hand, an interesting little beaker, found relatively recently, suggests the influence of the animal-shaped *zun* vessels of the Shang and early Zhou period (see opposite, top right). The scalloped rims of bowls, platters, and jugs may have originated in the floral shapes of Persian silverwork. There seems to have been increased interest in metalworking, but Chinese craftsmen in this field, unlike their Western and Central Asian colleagues, almost always preferred the casting technique, and it is unusual to find chased or embossed pieces (see opposite, top right).

On several occasions the Tang rulers felt it advisable to legislate on the maximum permissible

quantity of funerary figures. In the middle of the 9th century, depending on a dead man's status, a minimum of 20 and a maximum of 100 pieces might be buried with him in the tomb.

The realistic effect of these models is reinforced by extreme precision of detail and the attention paid to such aspects as the depiction of clothing and headgear. This eye for detail shows that the artists, who were trying to produce naturalistic copies, had a keen gift of observation. The details make it possible to identify the subjects of the models as, for instance, members of a certain non-Chinese ethnic group or a certain social class: peasants, musicians, warriors, officials. However, they are still types rather than individuals. The figures of officials are distinguished by their headgear: a man wearing a headdress with the figure of a swooping falcon on it, for example, is a military and not a civil administrator. The funerary figures of civil servants, who wear the same clothing as the military officials but with an additional sash around the waist and differently shaped caps, clearly show that the faces are designed as types: the civil servants have round faces with thick, fleshy lips, broad noses, and almond eyes (see page 144, left).

In the 7th century A.D., figures of women were modeled with slender, long bodies and rather rectangular heads. In the 8th century, the female figures suggest a change in the ideal of beauty: their figures are opulent and heavy, and their faces round (see page 144, right). This change has been connected with the imperial concubine Yang Guifei (A.D. 719–756), whose beauty is supposed to have been of that type.

Grave goods now included not only models of foreigners but another important addition: the guardians of tombs became more important than ever. They were usually in pairs, and fell into two groups. Guardian deities stood together and resembled the *tian wang*, the Kings of Heaven of Buddhism (savage warriors with alarming facial expressions), and so did fabulous creatures with horns and unruly manes (see opposite, below right).

These guardians were supposed to protect the tomb from disturbance by demons, and also to prevent the soul from leaving it. In the Tang period, the second group (demons) were described by the term *qi tou*, and earlier on the fabulous guardian creatures were called *shenmushou*.

As in the Han period, replicas of objects used in ordinary life were given as grave goods, including

Top
Small bowl with foot

Tang period, chased and embossed silver with floral decoration, remains of gilding, H 6.5 cm, dia 5.6 cm, Museum für Ostasiatische Kunst, SMBPK, Berlin

Above
Beaker in the form of a small bird

Sancai glaze, Tang period, H 7.2 cm, Beijing Archaeological Institute

The back of the phoenix is shaped like a beaker.

Far left
Phoenix-headed jug with pictorial panels

Tang period, sancai glaze, H 32.8 cm, Staatliches Museum für Völkerkunde, Munich

The panels on the body of the vessel bear different decorative motifs. This side shows a horseman delivering the Parthian shot, rising in his stirrups as he gallops away and aiming an arrow behind him from his bow.

Left
Maidservant with lion cub on her lap

Tang period, ceramic, sancai glaze, H 34.7 cm, Sotheby's

The maidservant is modeled on the type of figure showing a foreign wine merchant with a wineskin on his lap.

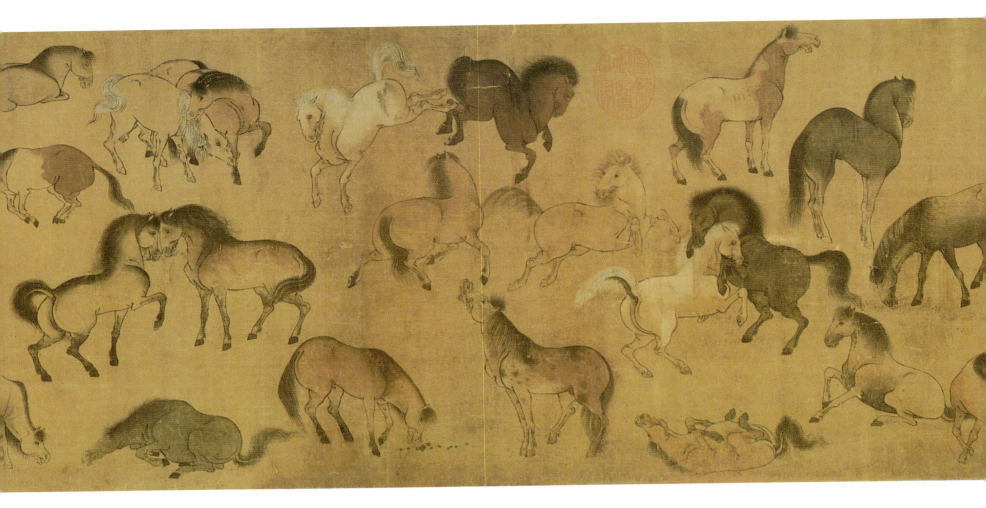
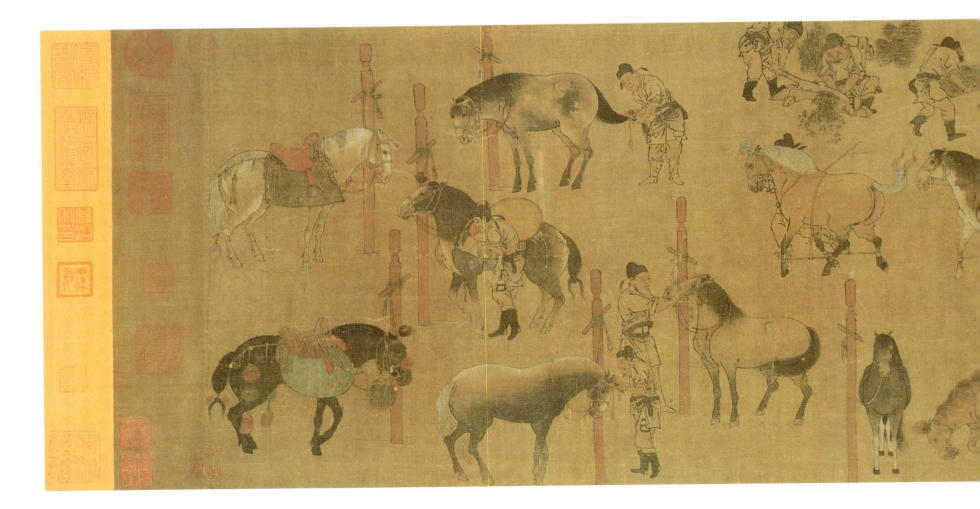

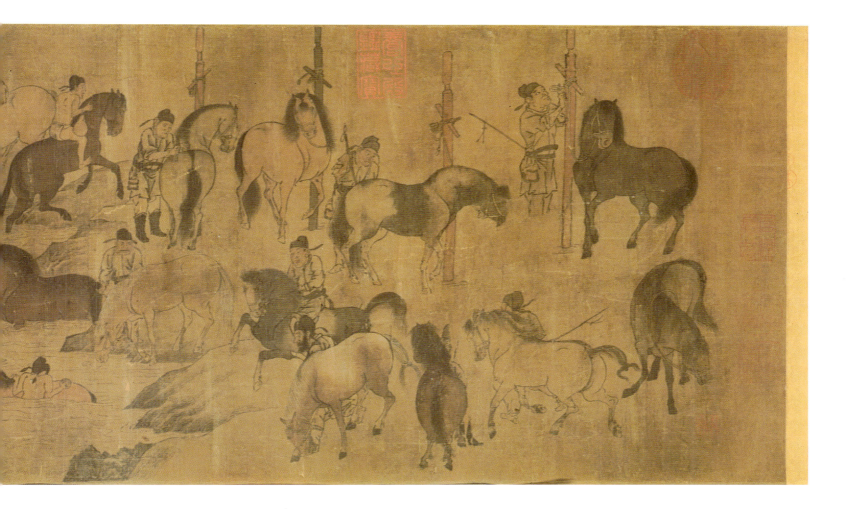

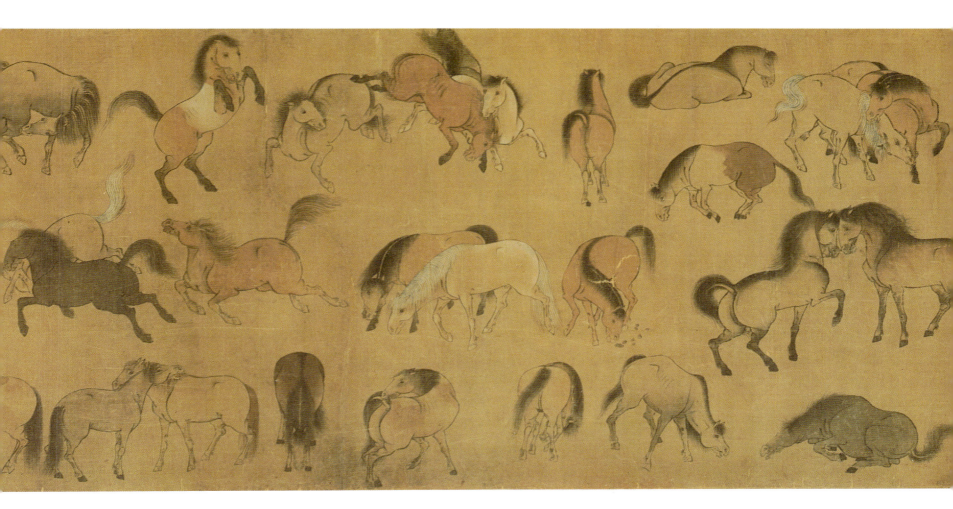

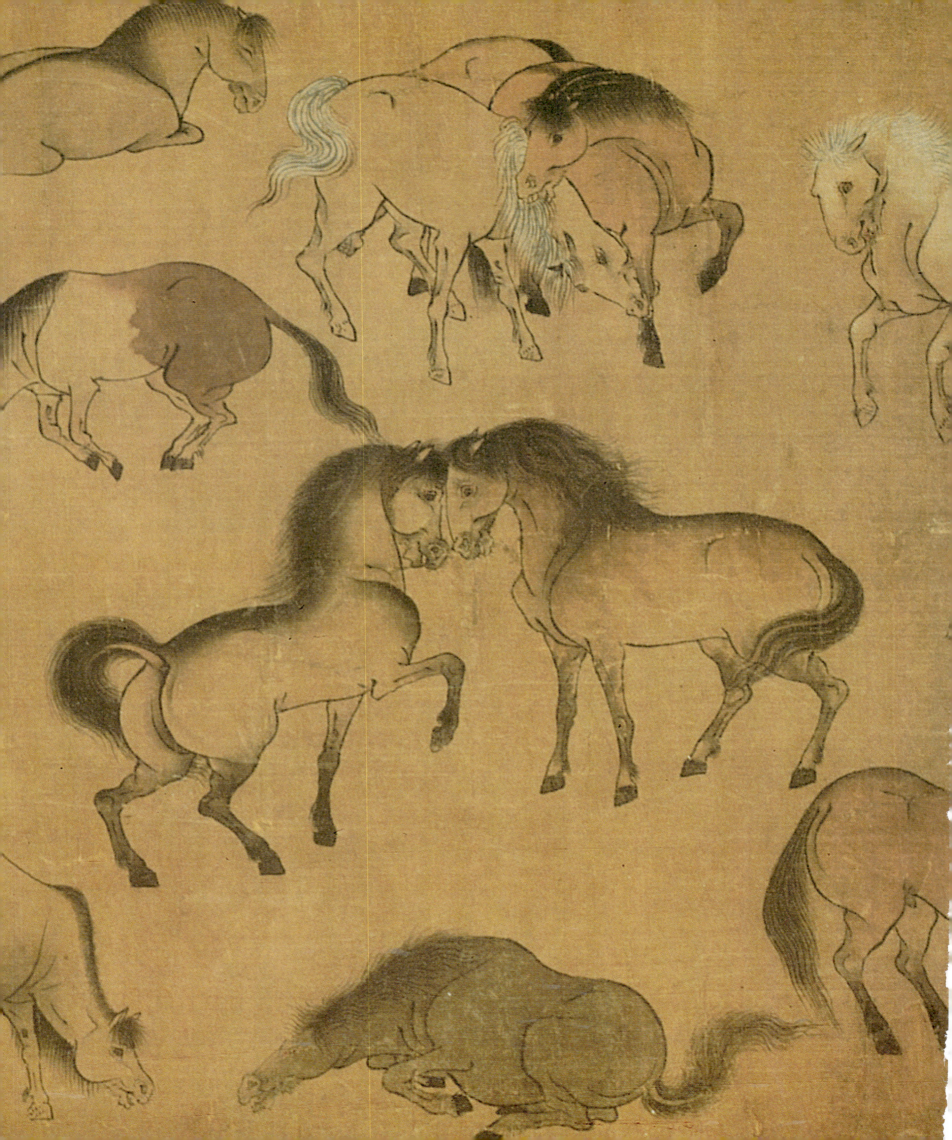

Preceding folded pages

Scroll of a Hundred Horses

Anonymous

Tang period, influenced by Han Gan, ink and paint on silk, 26.7 x 302.1 cm, Beijing Palace Museum (the scroll is viewed from right to left, beginning on page 142 above)

the "ox cart *mingqi*," with its realistic depiction of the animals. Grave goods in the form of domestic items were also buried in the brief Sui period (see opposite, top). In the Song period the traditional practice of burying grave goods continued; it was not until cremation became common at the beginning of the Ming period that ceramic grave goods were superseded by sacrificial gifts made of paper; in tradition-conscious circles, paper replicas are burnt to this day beside graves for the sustenance of the souls of the dead. However, there are some extant ceramic replicas from the Ming period.

The potters of the Tang period, craftsmen who fulfilled an important social function in supplying models for use as grave goods, mastered the difficulty of firing lead silicate glazes, created lively and realistic scenes of everyday life, and saw a new age of ceramic artistry ushered in. But now they came up against competition.

It is impossible to put a precise date to the step which completed the development of ceramics from earthenware to stoneware and finally to porcelain; the exact time when porcelain was invented is still unknown.

Chinese authors give a date as early as the 1st century B.C. for the invention of porcelain, or rather of proto-celadon, a kind of porcelain (the definition of these early products differs from text to text). Du Boulay believes that Ding ware was the first genuine porcelain, and thus dates it to the Tang dynasty (A.D. 618–907). Similarly, Wiesner places the earliest porcelain manufacturing in the 8th or 9th century. Goepper considers that Ding ware and Yingqing ware were the only genuine porcelain of the Song period, seeing the latter as an early form of the court-approved Yuan ware and the origin of later works of decorated porcelain.

The history of the development of porcelain followed two courses, one in the north and one in

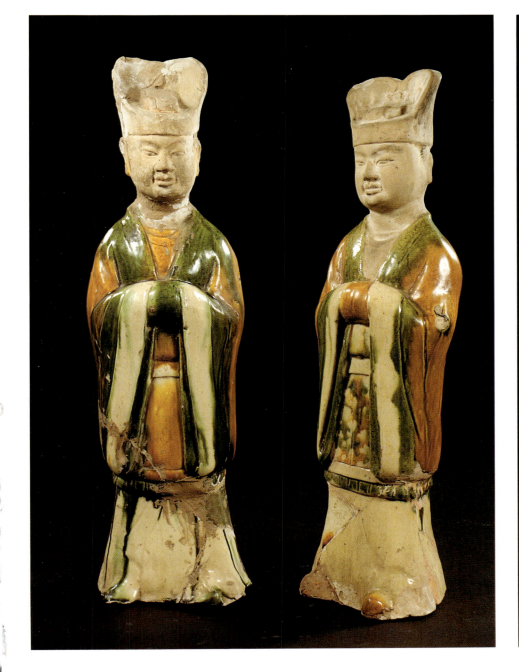

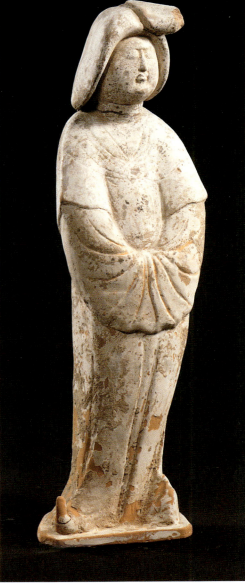

Far left

Wenguan funerary figures

Tang period, earthenware with sancai glaze, faces and necks left unglazed, originally painted, H 41 and 43 cm

Left

Nüyong lady

First half of 8th century A.D., ceramic with white coating, H 36 cm, Staatliches Museum für Völkerkunde, Munich

Opposite, above left

Ox cart with draft oxen

Tang period, ceramic, unglazed, oxen, H 16 cm, L 23 cm, cart 15 x 14.5 cm, Hubei Provincial Museum

Opposite, above right

Kitchen scene with figures washing dishes

Sui period, ceramic models given as grave goods, kneeling man washing dishes, H 12.9 cm, standing woman washing dishes, H 21.9 cm, dishwashing bench, H 10.6 cm, L 23 cm, W 10.2 cm, Hubei Provincial Museum

This replica of a scene from daily life clearly shows a kitchen servant and a woman washing dishes, as well as various household utensils. The group also contains an equally lifelike cook and his assistant, who is lighting a fire (not shown).

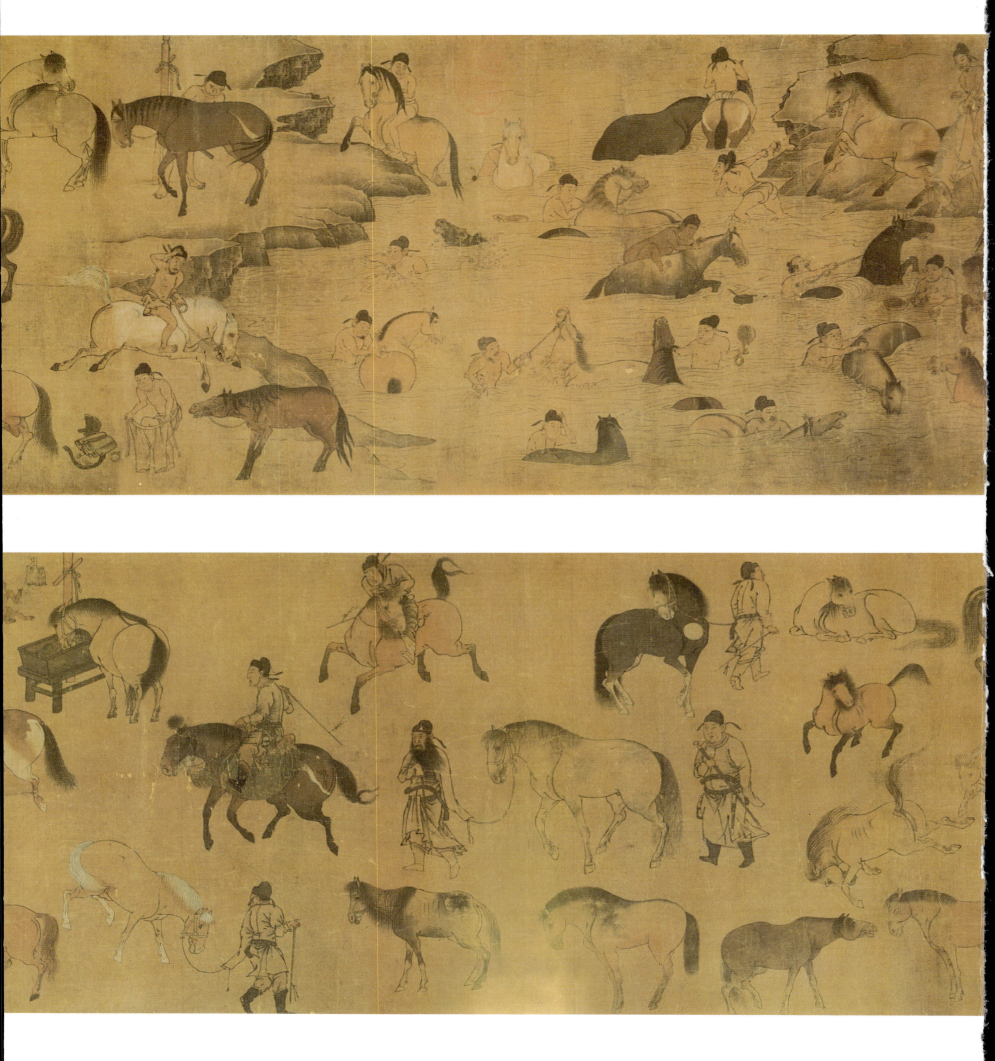

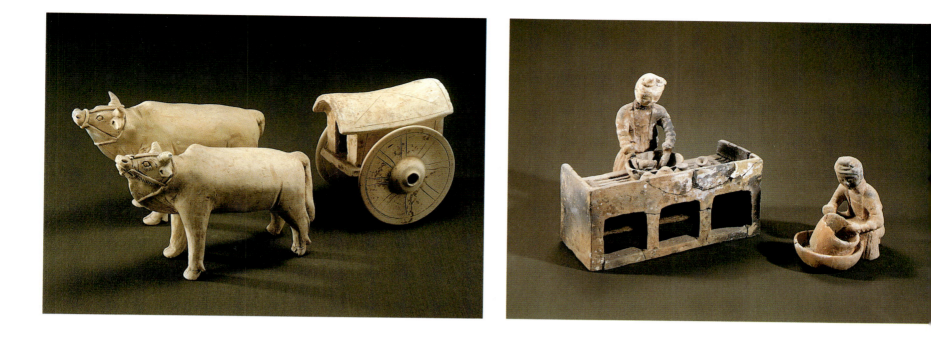

the south. In the north, firing was carried out in a vaulted kiln which had a single firing chamber with little draft and a high flame, heated by charcoal. The disadvantage was the long time the pots took to cool and the difficulty of controlling reduction. The south used the so-called "dragon kiln" or *longyao*, which was built on a slope, had several firing chambers and a good draft and was easily heated, again with charcoal. The good air supply enabled reduction to be controlled, and heating and cooling were rapid. Celadon ware was made here. In the north, craftsmen worked to develop a purer form of clay, and in the second half of the 6th century achieved their aim. A find from an Anyang tomb complex of A.D. 575 is regarded as the first white ware (*baici*). Its glaze still has a faint greenish tinge. Porcelain had been created.

From the middle of the Tang period onward there was a move from ordinary stoneware to a finer material, denser and less porous, and fired at temperatures of about 1,300 degrees centigrade (2,400 degrees fahrenheit). In the north (Xingzhou, Dingzhou, Gongxian) the altered basic material, which now had a higher aluminum and magnesite content, was further developed. The potters of the Tang period concerned themselves not so much with artistic achievement as with the chemical qualities of their material, experimenting with different consistencies.

At the same time muffles, *xia*, came into use: capsules of fireproof lined clay to hold the items to be fired, protecting ceramics from the direct heat of the kiln. As a result there were fewer accidents in firing and the glazes became purer. Literature tells us that at the end of the Tang period the kilns of Yue were commissioned to manufacture a secret kind of porcelain called *miseci*. For many years this tale was regarded as pure fantasy, since no such ware had been found in the tombs of any princes or noblemen. But the first items made of this "secret porcelain" were found in 1988, during excavations under the Famen Pagoda in Fufeng (Shaanxi). Nineteen

ceramic objects with dense, strongly bonded bodies and a polished blue celadon glaze had been donated to monastery 874, together with other treasures of Emperor Xizong (reigned A.D. 874–888), and they had been walled up there ever since.

Painting and calligraphy

Many art treasures were preserved because they were walled up or buried, but the same processes destroyed others. Some objects known to us from the traditions of Chinese literature, such as the Lanting manuscript mentioned above, are no longer extant. The most perishable of the Chinese artistic genres were always painting and calligraphy because of the fragility of the silk and paper to which they were applied. Again, an impression of the painting of the time can be gained from the walls of tomb complexes, and an idea of its calligraphy from the collections of scripts made in the following Song dynasty. The Song also exercised censorship, and some works of calligraphy, such as the Buddhist inscriptions of the Northern Wei dynasty, were not accepted into these collections.

Original works of art in both genres consisting of Buddhist writings and pictorial scrolls have been preserved by monasteries in China and Japan (see page 147, top). Secular painting is also represented both by copies of scrolls and by the work of Zhang Yanyuan, already mentioned several times above, which in its time was the most comprehensive of all Chinese catalogs of painters and pictures. There were so many painters and calligraphers in this period that they cannot possibly all be listed, so only the best known will be mentioned.

Many artists lived under the patronage of the cultivated emperors of both the Sui and the Tang dynasties. Besides carrying out his official duties, Emperor Wen of the Sui dynasty must have made an extensive collection of paintings. A classification compiled at the very beginning of the Tang

Below
Zhenmushou tomb guardian

Tang period, sancai glaze, H 72 cm, Xi'an Archaeological Institute

The tomb guardian is shown as a four-legged hybrid creature.

dynasty and entitled Zhen'guan gong si hua lu (Catalog of the Painting of Imperial and Private Collections of the Zhen'guan Era), the work of Pei Xiaoran (active around A.D. 630) lists 293 paintings of the Jin to the Tang period, most of them in the imperial Sui collection.

Pei seems to have had a scholarly mind, for he is one of the first to consider which works were genuine and which false. Unfortunately, he does not define his criteria. However, he was certainly able to view some genuine works of Zhan Ziqian at this time, whereas today we have only an early copy of one of Zhan's works.

Zhan Ziqian was a famous painter of the Sui period. He came from the present province of Shandong and stood high in the favor of Emperor Wen Di. His artistic range is said to have embraced all the genres of his time, and he painted on both walls and movable surfaces. His subjects were from the Buddhist and Daoist repertory; he painted buildings, figures, animals (he was especially skillful in his depiction of horses), and narrative scenes. He is also said to have shone as a landscape painter. The one extant picture by him, or at least in his style, is a landscape: *Excursion in Springtime* (You chun tu; see above).

This painting is regarded as a great work in the "blue and green" style that was to dominate landscape painting throughout the Tang period. Zhan's carefully composed landscape follows the diagonals formed by the river into the infinite

distance. An abruptly rising mountain range in the upper right area of the picture contrasts strongly with the peacefully flowing water, while the white blossom of the fruit trees (*Prunus*) also forms a contrast with the dark contours and blue and green color of the hills. The coloring creates a surreal effect. Despite the presence of figures, it is obvious the real subject of this picture is not the people on an excursion but the destination itself, the springtime landscape. It might well be a real view, but the picture is first and foremost an expression of mood, conveying a sense of spring in the country.

In this picture Zhan Ziqian seems to have followed Xie He's principle of expressing the essence of an object, its spirit or "breath." The landscape painters of the Tang period continued to work in the blue and green style. Notable artists among them were the administrative officials Li Sixun (A.D. 651–716) and his son Li Zhaodao (first half of the 8th century A.D.).

Li Zhaodao is sometimes said to be the painter of the famous picture The Journey of Emperor Minghuang to Shu, though chronologically this attribution cannot be correct. The picture illustrates the story of the flight of Emperor Xuanzong to Sichuan in the year A.D. 756, fleeing from the rebels headed by An Lushan, and his retinue is shown amidst a vast mountain landscape. The blue and green mountains surrounded by abrupt contours, and the cloud canopy with its strong outlines, are characteristic elements in the land-

Above
Excursion in Springtime
(You chun tu)

Ascribed to Zhan Ziqian (active late-6th century A.D.)

Possibly a copy from the Song period (10th to 13th centuries A.D.), paint on silk, horizontal scroll, 43 x 80.5 cm, Beijing Palace Museum

This landscape painting is a typical example of the blue and green style. However, it was not usual to add a title and inscription during the Sui and Tang periods, and any that occur on original paintings of the time are later additions.

Opposite, center and bottom
Lady with servants

Zhou Fang (2nd half of 8th century A.D.)

Ink and paint on silk, horizontal scroll 33.7 x 204.8 cm, Beijing Palace Museum

scape painting of this period. However, this is a different type of landscape, showing the wild, menacing west of the empire, the place to which the emperor used to exile troublesome officials, now he was fleeing there himself. Among the sharp outlines of the rocks, he looks like a prisoner.

A painter called Wu Daozi (active A.D. 710–760) enjoyed extraordinary fame during the Tang period for his landscape pictures and "portraits" of gods. None of his works, not even copies, have come down to us. However, he deserves mention as an exceptional case, showing that even a man of poor family could rise to become a court painter.

The subject of portraiture leads to the most important genre of all in painting at the end of the Tang period: figure painting. There is a marked difference between the secular and sacred portraits of the period. The demands for a faithful likeness in religious figure paintings, such as portraits of patriarchs or of *luohan*, were not the same as those of secular portraiture.

The aim of the sacred pictures was to portray historical characters (see right). They might show iconographic attributes, or features deriving from a textual description. It is said that Lu Lengjia was a pupil of Wu Daozi, and painted temple walls

Portrait of the 8th *Luohan*

Ascribed to Lu Lengjia

Ink and paint on silk, 10 x 53 cm, Beijing Palace Museum

One of a series of six extant pictures. There were once 18 paintings of *luohan*.

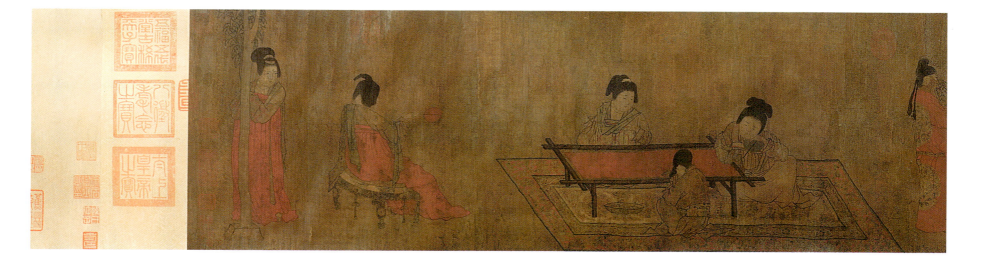

together with that master and with Han Gan; according to the Lidai minghua ji, Lu was responsible for the pictures of the religious pupils, the *luohan*. It is possible that in such cases he worked in the same way as in the other pictures attributed to him. The figures are surrounded by striking details such as furniture, scholars offering gifts, and miniature landscapes, but the mood is conveyed chiefly by the faces of the *luohan*. The portraits themselves show monks enveloped in simple, much-mended robes (see page 147).

Secular figure painting, on the other hand, reflects the atmosphere of palace life and its leisure activities. These pictures are of three types: the high-born lady, the scholar poet, the servant. Loosely related figures or groups of figures still dominate the composition of these scenes. Using a style employing distinct contours, the figure painters present interior scenes, carriage rides or visits to gardens, or illustrate historical events such as the arrival of envoys bringing tribute.

Zhou Fang (mentioned in documents of the second half of the 8th century A.D.), who had two epithets, first Jingxuan and second Zhonglang, is only briefly mentioned in Zhang Yanyuan's work on painting, more particularly as the creator of Buddhist pictorial works.

The scroll regarded as typical of his approach and that of other figure painters is one of three works that are certainly by his hand. It shows servants and ladies, on a hot summer day, busy with various occupations around a high-born lady. The portrayal of the seated lady full front makes it clear that she is the chief personage. All the other figures are intent on what they are doing; their eyes are either lowered or directed toward their mistress. Although she does not tower above her retinue, the painter clearly and ingeniously indicates her position in the group by allowing her direct eye contact with the viewer of the picture She is also the only woman in the scene who has no occupation but is simply being fanned by a servant, and she wears the most expensive clothing and the finest headdress (see page 147, center).

Again, the ideal of beauty embodied in the sculptural funerary figures resembling the imperial concubine is clearly recognizable: the ladies have opulent figures and round faces, they wear flowing robes, and their hair is dressed high. The furniture shown here is typical of the Tang period: a carpet, stools, and low tables, since people still usually sat on the floor.

Such groups of figures did not need a very detailed background. A few elements, such as the furniture in this case, sufficed to define the location of a scene. The final section of the picture in particular, showing a lady behind a tree, was a convention or even a theme of Tang painting. The subject of a human being with a tree had its precursors in Daoist tradition, seen in tomb reliefs and mythology, and in Buddhism. In this case, however, the tree may simply symbolize a garden.

When an artist wanted to show people in an outdoor environment rocks and trees were the means generally used (see below).

Han Huang (A.D. 723–787), whose epithet was Taichong and who came from Chang'an, was a painter famous for rural genre scenes and figure

Opposite, top
Autobiographical Text (Zixu tie)
Huaisu
(Detail), A.D. 777, ink on paper,
28.3 x 755 cm, Taipei Palace Museum

Opposite, bottom
A rubbing of the temple stelae of
the Yan family
Yan Zhenqing (A.D. 709–784)
(Detail), 8th century A.D., clerical script

Below
Garden with Literati (Wenyuan tu)
Han Huang (A.D. 723–787)
Ink and paint on silk, 37 x 58.5 cm, Beijing
Palace Museum

painting. He is said to have drawn his inspiration from Lu Tanwei, an artist from the city of Wu (today Hangzhou in the province of Jiangsu), who lived around A.D. 440–500, and painted both portraits and animal pictures. A picture of scholars showing four literati in a garden is ascribed to Han Huang, himself a high-ranking administrative official. A servant is waiting on them, and is shown making important preparations for the scholars' occupation: he is rubbing ink for them. The scholars with their stiff winged caps stand out from the surface of the picture, and so do the servant and the garden landscape, symbolized by a crooked, partly withered pine tree and some rocks. The loose composition of the figures leaves the viewer to guess who is meant to be in the foreground. All four, leaving aside the small, stooping figure of the servant, dominate the scene. The viewer is looking over the shoulder of these literati during their leisure activities: the perusal of scrolls of script, the composition of poetry, and the practice of calligraphy itself were the ideals of an official administration that strove to emulate such great predecessors as the calligrapher Wang Xizhi, or the nature poet Tao Yuanming. Perhaps Han was depicting some contemporary poets after a meeting in the Liuli hall, or perhaps one of the figures may be Wang Xizhi himself, watching the geese flying away and surrounded by like-minded members of his circle. The inscription on the scroll, merely a calligraphic title, may be by the hand of the Song emperor Huizong (Zhao Ji, reigned 1101–1125); it shows certain characteristics of his handwriting and says simply "Picture of Scholars and a Garden." By showing the literati

The Five Bullocks (Wu niu tu)

Han Huang

Tang period, ink and paint on silk,
20.8 x 136.8 cm, Beijing Palace Museum

The picture bears an inscription by the
emperor of the Qianlong reign
(1736–1796) and many collectors' seals.

engaged in writing, Han Huang depicts one of the pillars of Chinese culture.

During the Tang period, attention to calligraphy and admiration for the early scribes was so great that Emperor Taizong (reigned A.D. 626–649) collected manuscripts from far and wide and had exact copies of them prepared. His envoys often employed such disreputable means of acquisition as theft. In the years A.D. 626 and 628 two academies were founded in which the sons of the imperial family, aristocrats, and high-ranking officials could develop their talents (the Court for the Improvement of Literature, *hongwen guan*), while officials of lower rank studied the course of calligraphic training known as *shu xue*. The emperor's preference for works by the "two Wangs" made their style of cursive and draft script the standard for all calligraphy of the early Tang court. He was guided by his advisers, the calligraphers Yu Shinan (A.D. 558–638) and Chu Suilang (A.D. 596–659) and their contemporary Ouyang Xun (A.D. 557–641). The script for official proclamations and texts to be carved on stone, as established by these three advisers, was very regular in structure, reflecting the pressure of the brush, and was thus a fluent version of *kaishu* script. In the middle of the

Tang period Yan Zhenqing (A.D. 709–784) created his variant of clerical script on the Yan family stela (Yanshi jiamiao bei), and he is regarded as a leading master (see page 149, bottom). His thick brushstrokes give the general impression of the script a new effect, since they have a visual quality and are no longer merely constituent parts of the written characters.

The internal coherence of the characters is not disturbed, but the effect of the calligraphy is powerful. Yan's fame was further increased by his draft script, but the true artists working in that style in his time were those who opposed the institutionalization of the Wang scripts (or rather its adoption as the convention, for all self-respecting scribes now copied Wang) and found new possibilities in draft script. Their development of the free draft script *kuang caoshu* is regarded as the major calligraphic innovation of the epoch. Zhang Xu (active A.D. 713–740) and his pupil Huaisu (A.D. 737 to after 798) are regarded as the founders of this almost inimitable style, ruled by spontaneity alone. Zhang Xu allowed himself to complement the Wangs' cursive style (*xingshu*) by spontaneous and unconventional distortions, enabling the characters to be seen as self-expression reflecting

his own artistic attitude. Wang Xianzhi in particular was his example.

It is difficult to decipher the script because of its distortions, and most of all because of the ligatures. It is said that Zhang Xu wrote many of his works under the influence of alcohol. In view of the number of fine poems of the Tang period allegedly written in similar circumstances, the mention of intoxication is not intended to be derogatory. Apparently Zhang's pupil Huaisu was also addicted to wine, and he too developed an expressive and wild form of calligraphy. According to tradition, when drunk he would write on anything that came within reach of his brush: walls, clothing, or household utensils (see page 149, top).

In the most famous of his texts, Huaisu writes of his concern with calligraphy and his studies, and sets down poems praising the art of calligraphy. It is easy to make out the vertical lines of the written characters, sometimes formed without the removal of the brush from the writing surface. Flowing and harmonious, Huaisu's scroll is an elegant piece of work. He does not press the brush down hard on the paper and produces narrow lines. If we put ourselves into the artist's mind, we can see his main aim was to set the text down fluently on the paper; but we can also admire his concentration on regularity of brush pressure and the flowing movement of his hand.

Huaisu was a Buddhist monk who began devoting himself seriously to calligraphy during the 860s; ministerial officials became aware of his talents quite early. Huaisu was always trying to refine his style, and in order to do so, despite the difficulties in his way, he traveled widely in the empire. Everywhere he went, he sought advice from those whom he regarded as examples. His journeys made him a familiar figure in the regions he visited, and the number of his admirers constantly grew. There were many calligraphers among them. Besides his autobiographical manuscript, another three works by Huaisu are thought to be authentic.

Toward the end of the Tang period free draft style was to exert particular influence on Chan Buddhist calligraphic artists, and with its refinements it was also adopted by the Song literati, who trained themselves in calligraphy on the works of Zhang Xu and Huaisu as exponents of the tradition of the two Wangs. However, a calligrapher would have learned clerical script before he ventured to experiment in free draft script. To many of them, clerical script still provided a way to express their own styles and personalities. Despite the competition, there was no denying the influence exerted by Yan Zhenqing.

It is almost possible to see the theory of calligraphy splitting between a formalist camp, represented by Ouyang and Yan, and an expressionist camp represented by Zhang and Huaisu.

Liu Gongquan (A.D. 778–865), an administrative official, remained a formalist, like Yan Zhenqing. He became one of the great exponents of clerical script, setting an example to generations of scribes (see right). His own calligraphy, as preserved in the Xuanbi pagoda text, is carefully formed with attention to both vertical and horizontal dimension. Every character is in balance, the strokes pointed and clear, the pressure of the brush and the use of its tip and side give great diversity to the strokes within the character. For all its regularity his script never seems monotonous. It could be said that where Yan's brushstrokes are fleshy, his style was "bony."

Calligraphers were not confined to a single type of script, although they are famous today for one or the other. They chose one type for personal reasons, another at the request of a patron. Painters of the time did not specialize in a single area either. Han Huang is representative of a great many artistic colleagues who produced genre scenes of everyday life, rural life, landscape paintings and animal paintings (see opposite page). These depictions clearly strive for realism, and there is a comic element in the different attitudes of the animals. The bullocks are obstinate or skittish, with specific features such as prominent bones, and horns are curious in appearance. Technically, the artist is employing outline and color to define physical characteristics, and not light and shade. A deliberate ink stroke portrays folds in the flesh; the use or omission of color conveys the markings of the animals' coats. The depiction remains a surface representation.

The most famous horse painter of the Tang period was Han Gan, who lived in the first half of the 8th century A.D. The Emperor Xuanzong appointed him to teach pupils to depict horses, but the results always lagged far behind the master's own. Zhang Yanyuan writes on the contact between teacher and pupil: "Many open doors and windows by themselves, others do not reach even the gate or the outer wall."[4] Yet if we look at Han Gan's horse paintings, for instance The Horse Moonlight now in the Metropolitan Museum, New York, with its full body and conventional posture, it is difficult to share the aesthetic appreciation of his contemporaries and echo their lavish praise.

As we would see it today, there are far finer, livelier and more expressive horse pictures than those of Han Gan's tethered animals (see pages 140–142; the scroll begins on page 142, top right, and is should be read right to left).

This picture by an unknown artist reflects the life of grooms and the horses in their care, portraying the liveliness of the horses themselves and the activities involved in working with them. Its composition traces a succession of events: first the horse is untied and washed, then it plays, is fed and groomed, and finally two splendidly caparisoned animals clearly mark the end of the pictorial scroll, their heads pointing back to its beginning. This is a compositional feature found in many horizontal scrolls, including those on historical subjects.

The next period brought new scrolls on new themes and subjects, yet they were still variations on their predecessors – not surprisingly, in view of the traditional context linking them all.

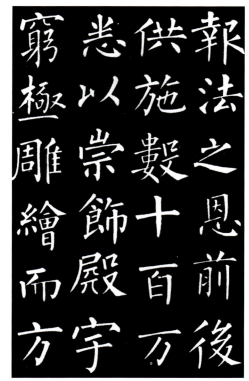

Stone rubbing from a stela in Xi'an
Liu Gongquan
(Detail), clerical script

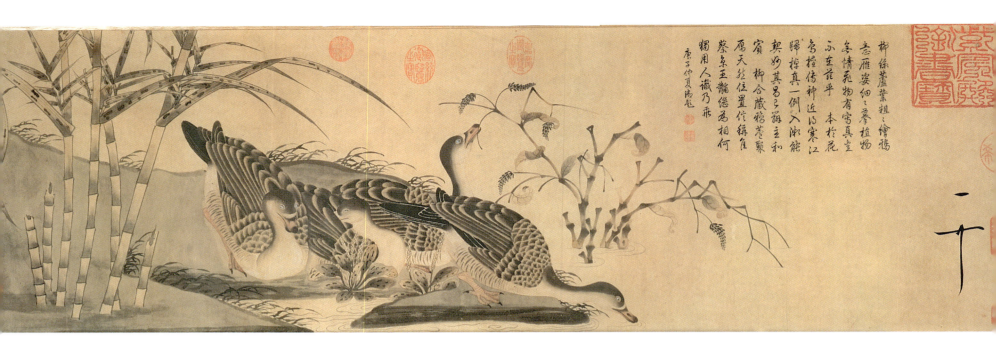

The Song Period and the Aesthetics of Simplicity

(10th–13th centuries)

"At those moments when I relax from the cares of state, my greatest delight is in painting."

Emperor Huizong (reigned 1101–1126)[1]

The Song dynasty (A.D. 960–1126/1279) was preceded by the early 10th-century Five Dynasties or Wudai period (A.D. 906–960), during which the empire was again split into north and south for five decades. Pressed hard in the north by hordes of nomadic tribes, the great empire continued to develop along social and intellectual lines similar to those of the time of the first north-south split.

The prosperity of the south was founded on geographical factors: a mild climate, plenty of water, and more than one harvest a year. Trade, craftsmanship, and agriculture all flourished. Intellectual and economic elites formed on a durable basis. As Kuhn has summed it up: "The China of the aristocracy became the China of scholar officials."[2] Potential patrons of art and literature were the rich merchants, the proprietors of great landed estates, and an economically secure administrative class which, though not aristocratic, had received an elitist education.

In painting, the period brought several fundamental changes and further developments by comparison with the Tang dynasty, and this chapter therefore devotes a relatively large amount of space to the mere 50 years of its duration.

The legitimate and illegitimate dynasties that followed the Tang were indebted to them culturally in many areas, including tombs and tomb furnishings, where changes were only slight but showed evidence of transitional forms (see opposite). A strange type of ceramic grave goods has been found, dating from the time of the Five Dynasties to the Northern Song period and consisting of anthropomorphic models: human bodies with the heads of cows and monkeys, and also doves, fish, and snakes with human heads, and pigs with wings. No satisfactory interpretation of these has yet been put forward, although there may be some mythological connotation. A possible comparison could be with the roof-ridge ornaments thought to avert ill luck, particularly those depicting heads of cattle or animal signs of the zodiac. Other grave goods were figure sculptures, more lifelike in appearance than the Tang figures, with natural gestures and expressions. The fact they seem less stylized may be regarded as typical of the general artistic tendencies of the Wudai period.

At the end of the Tang period there had been some depictions of "phantasmagorical creatures,"[3] both in landscape and in the painting of plants, animals, and figures, but they were superseded by more realistic forms in the Five Dynasties period, when "animals became animals again."[4] Major artists in the history of Chinese painting were such men as Huang Quan (A.D. 903–968), Xu Xi (active in the Wudai period), Li Cheng (A.D. 919– 967), and Dong Yuan (active A.D. 937–976). All genres were produced in this period: bird and flower painting, with its subgenre of bamboo painting, monumental landscape painting, paintings on religious subjects and legends, figure painting.

The authenticity of paintings still has to be considered. In his analysis of the landscape painting of the 10th century Wen Fong says it is likely that only a single landscape by an unknown 10th-century painter is extant; the work was found in a tomb. Otherwise, as he points out, the early founders of the monumental style of landscape painting – Jing Hao (active about A.D. 870–930), Guan Dong (active about A.D. 907–923), Dong Yuan (active A.D. 937–976), Ju-ran (active A.D. 960–

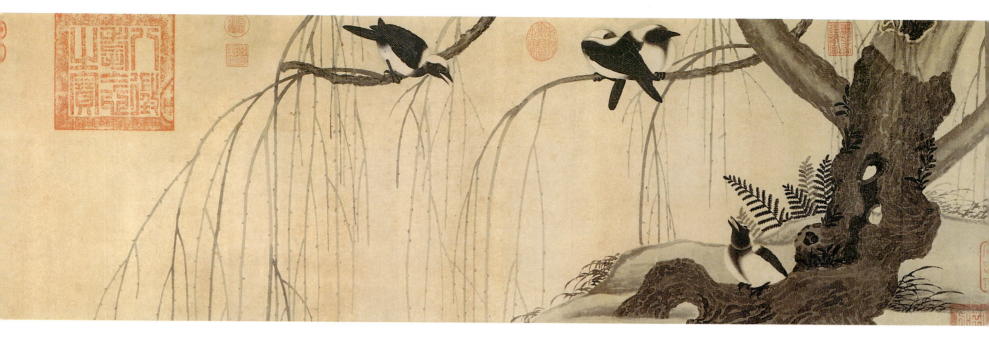

980), and Li Cheng (A.D. 919–967) – who lived and worked in the Five Dynasties period and early Northern Song period, are known only through attributed paintings, copies of their works, and copies of copies.[5] The same is true of other genres. However, as certain artists of the time influenced artistic creation for centuries to come, we should look at some of these attributions.

Huang Quan was born in A.D. 903 in Chengdu, then in the kingdom of Shu, and died in A.D. 968

in the Song capital of Kaifeng. He was famous even among his contemporaries as a bird and flower painter. A pupil of Diao Guangyin (about A.D. 855–935), also a master of bird, flower, and butterfly painting, he became court painter at the Shu Academy in A.D. 919. After the surrender of Shu to the Song he followed his sovereign to Kaifeng, where he became an esteemed painter at the Kaifeng Imperial Academy. He was to have enormous influence on the Academy style of bird

Tomb of Wang Chuzhi

Late Liang dynasty, A.D. 923, found 1995, tomb relief, marble with remains of colored painting, H 82 cm, W 136 cm, Province of Hebei Archaeological Institute

The relief shows an orchestra of ladies, its members embodying the accepted ideal of beauty from the second half of the Tang period onward.

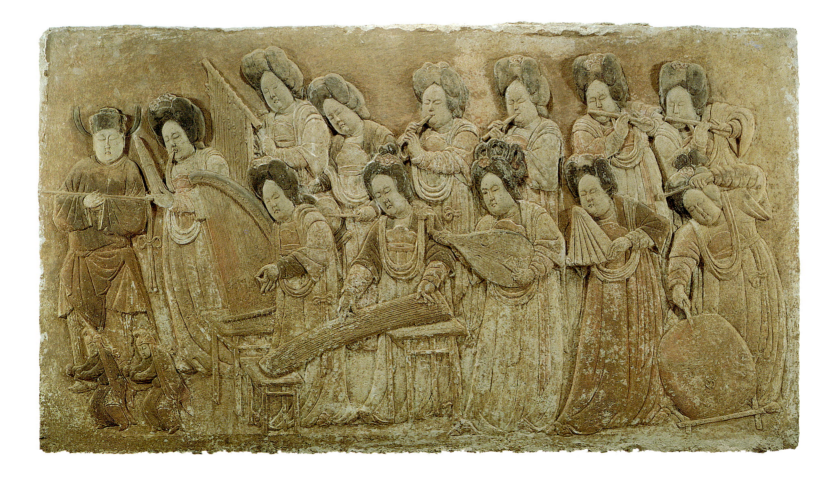

and flower painting until at least the middle of the 11th century, and he and another bird and flower painter, Xu Xi, were regarded as examples to all in the genre until well into the Qing dynasty.

A famous picture by Huang Quan shows birds, insects, and two turtles in a loose composition where they stand unrelated but are portrayed with meticulous precision. It could be described as a "study" in the Western sense. The artist's depiction is so lifelike that one can even identify the different bird species. Realistic representation was the ideal of this period and was very highly valued. Characteristics of Quan's technique are his precise tracing of outlines, his use of shading and accuracy of color, achieving a previously unknown degree of naturalism. His manner was described as the "life painting" style, *xie sheng*, meaning that the artist painted accurately from nature.

Xu Xi (died before A.D. 975), lived and worked in one of the southern kingdoms that succeeded the Tang dynasty. His role at the court of Nanjing was similar to that of Huang Quan in Shu. The major stylistic differences between the two painters arise from their different concepts of art. Xu Xi too aimed to depict natural forces by realistic means, but his execution is more spontaneous in character, in a style described as the *xieyi* or "idea painting" style. Xu Xi used bristly brushes and did

not outline his subjects with precise contours, employing loose, free brushwork that achieved its effect solely through contrast and color shading. Stylistically, then, Huang Quan and Xu Xi represent the two opposite poles of strictly naturalistic *xie sheng* painting, and spontaneous although also realistic *xieyi* painting, or the dualism setting the rich and elevated, *fu gui*, against the wild and free, *ye yi*. Xu Xi had no imitators in the Song Academy until the second half of the 11th century.

The landscape painters of the period, whether from the south or the north, continued the development whereby their works, in contrast to the works of the Tang period, became organic units. Human figures were subordinated to landscape, which now became the dominant subject of the picture. While Tang landscapes had been collections of pictorial elements that can only be described as patchwork in terms of composition, the landscapes of the Wudai, in particular the early Song, periods are genuine compositions comprising misty mountains, water, trees, and buildings. The Tang style of simply adding one element to another had been superseded. Extant copies of the works of landscape painters of the Wudai present organically complete scenes with restrained coloring, showing the way the landscape may actually have looked. Landscapes are no

Study of wonderful birds and other living creatures

Huang Quan

Ink and paint on silk, double album leaf mounted on a scroll, 41 x 70 cm, Beijing Palace Museum

More of a fragment or a study than a composition, this painting is thought to be an authentic work by Huang Quan.

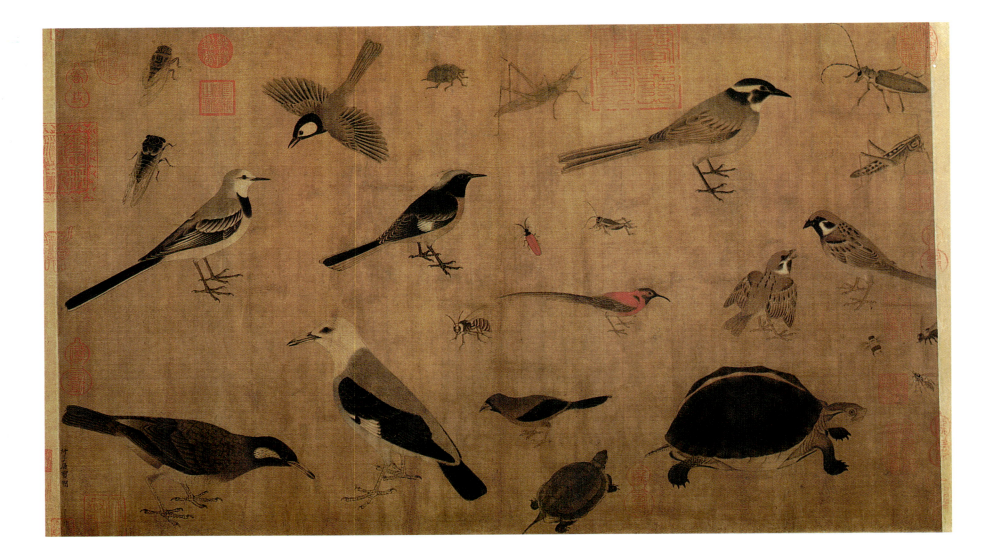

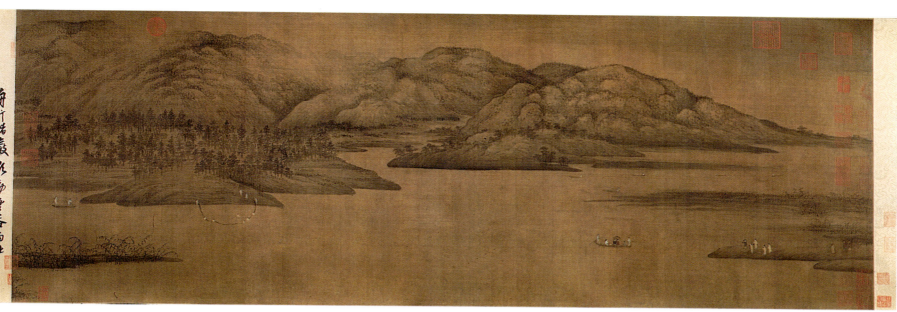

longer merely the setting for narrative, but are depicted in their own right. This process of change reached its conclusion in the 11th century.

The differences between landscape painters of the Wudai period lie chiefly in their subjects. The landscapes that the painters actually saw before them are reflected in these compositions. Li Cheng, a painter from the north and probably inspired by the work of Jing Hao (about A.D. 870–930), painted the steep mountains familiar to him from his home, with waterfalls and ravines ranged one behind another to achieve the effect of depth, while he emphasized the effect of height by the use of vertical textural strokes ("raindrop" strokes).

On the other hand Dong Yuan (active about A.D. 937–962), an official in the imperial parks administration at the court of Nanjing and thus a man of the south, created an effect of great scope in his landscape compositions. He took his subjects from his native region, and painted landscapes with many lakes and chains of hills, using flat effects in the distance and rather horizontal textural strokes which further emphasize width (see above).

The *Xiao and Xiang* scroll, for instance, shows one of these wide landscapes. Technically, it combines the use of wet ink, *shui mo*, with the rather dry textural lines of the "hemp fiber stroke," *pima cun*, particularly obvious in the oblique lines of the mountain slopes in the left-hand part of the picture. Dong's creative process was first to trace the outlines, then to add lines of shading, and finally to add further emphasis to the contours here and there. His subject in the example above is the meeting place of two rivers, the Xiao and the Xiang, south of Changjiang. The composition of the tiny figures shown provides a contrast: on the right there is a boating party, on the left men are at work by the river. Dong shows the fishermen of a village, hidden among pine trees, hauling in their nets. Depictions of the landscapes of both rivers and of the confluence of the Xiao and the Xiang became favorite subjects for paintings by scholar painters. There was

a legend connected with the subject: the Xiao and the Xiang were said to be where the wives of the mythical Emperor Shun (daughters of the also mythical Emperor Yao) drowned themselves in their grief at Shun's death; according to the legend, they were then turned into river goddesses. The beauty of the landscape itself, however, is a more likely reason for its frequent choice as a subject. To mention one famous example, a monastic painter named Muqi of the Yuan dynasty that followed the Song painted views of the Xiao and Xiang, and so did painters of the Ming and Qing Dynasties. The picture of a fairylike figure on water could also be a symbol of the Xiao or the Xiang; in such almost abstract cases the river is symbolized by the goddess instead of vice versa.

Besides painting landscapes, using light color as well as ink, Dong Yuan was well known for his pictures of dragons, cattle, and tigers, evidence that the painters of this transitional period were continuing to work in the popular genres of the Tang dynasty. He was the most famous painter of the Academy, and was followed by many pupils, including Juran (late-10th century A.D.). Together, these artists are regarded as the founders of the traditional school of literati, chiefly notable for the ink technique of the *pima cun*, and later for the use of heavily applied dots of ink to symbolize distant vegetation, a device known as *fantou*, "alum outcrops," or as *dianfa* when the dots were employed to suggest a green landscape. The scholar painters also chose landscape or details of landscape as their main subjects, and painted in monochrome (an example is Juran's *Searching for Truth in the Mountains in Fall*, in the Taipei Palace Museum).

Painters and calligraphers were concerned with their materials as well as the subjects they depicted. Ink, made from pine carbon and glue, offered fewer opportunities for experiment than paper and brushes. Many artists manufactured their own paper from plant fibers or rag. Painters

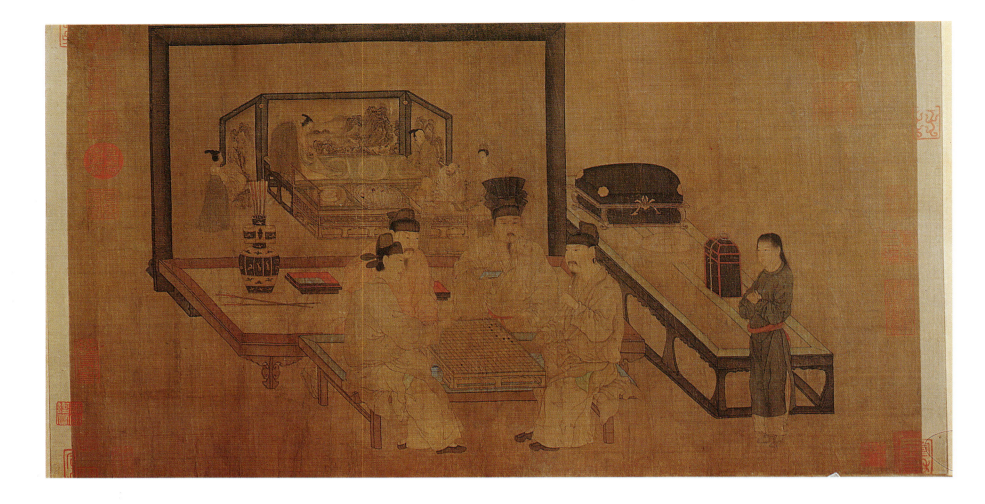

Playing Chess in Front of a Double Screen

Ascribed to Zhou Wenju

Probably a Ming period copy of the
10th century, ink and paint on silk,
40.3 x 70.5 cm, Beijing Palace Museum

and calligraphers were aware that the surface of the paper could itself influence the pictorial effect. One such artist, apparently, was the Tang period poetess and calligrapher Xue Tao (A.D. 768–831), who wrote on a decorated paper, called *xuetao*, and poetry paper, *xuetao shizhi*. Rough paper, for instance, would make the ink look lighter because it did not fill the grooves between the ridges. Different kinds of paper often bore the names of their "inventors" or the places where they were made. To this day *xuan* paper, *xuanzhi* from the city of Xuancheng, is a term used to describe high quality paper for calligraphy and painting. Paper with flecks of gold in it was popular, particularly during the Ming dynasty, and emphasized the elitist character of a painting or a piece of calligraphy. The painter Juran was inventive in his approach to paper, and experimented with various different kinds to determine their suitability for painting. The strength of a brush and the amount of wear and tear on it were important factors, and so was the choice of hairs. Frayed brushes, like rough paper, allowed the painter to create effects by letting the white show through. Many painters and calligraphers were said to have worked with bundles of rags, with their caps, or with their fingers. In some cases such techniques have indeed obviously been used (as in the work of Gao Qipei, 1660–1734); alternatively, as in the 13th-century picture by Chen Rong entitled *Nine Dragons*, they show up under magnification.

In figure painting, portraits, and bird and flower painting, experimentation with the ground of a painting or with brushstrokes was rather unusual before Gao Qipei. The conventional wishes of the patrons who had commissioned a work had to be met. If a patron wanted an interior or a portrait he would turn to such an artist as Zhou Wenju, regarded as a master of interior scenes, and particularly as a painter of high-born ladies. Zhou (active 2nd half of the 10th century) came from the area near modern Nanjing, and from A.D. 961 he was a member of the royal Hanlin Academy of the kingdom of Nan Tang. Besides his figure painting and interior scenes, he also painted landscapes and architectural subjects.

The work shown above, probably a copy from the Ming period, is a favorite subject of Chinese painting, the picture within a picture. Four figures are seated on a large bench around a chessboard, in front of a screen which itself bears the picture of a couch, several maidservants, and a scholar at his desk in front of yet another screen, this time an adjustable folding screen. The screen within the screen has a landscape on it, while the first screen is a variation on the interior shown in the foreground. Zhou Wenju is regarded as the inventor of the "layered screen"[6] motif of a multiple screen, or a screen within a screen.

Figure paintings such as this show how portraiture was handled at the time. From the standpoint of European ideas of art, one cannot but wonder

whether these portraits actually reflected the outward appearance of the artist's subject, and if so how far. Non-Chinese art historians in particular have pursued this question. It was well put by Brinker, who has said that: "A portrait is always the artist's subjective interpretation of an individuality."[7] Given the nature of Chinese portraiture, the European viewer must not expect individuality. The artist is portraying a type, and a "good likeness" is of secondary importance. The portrait seeks to depict internal qualities through a kind of pictorial cipher and the use of compositional devices. Scenes with figures are also very important because they provide information about the everyday life of the period. This one, for instance, contains furniture that may be considered typical: the low, wide bench, the couch with its ornamentally worked legs, the folding screen, a table, and the decorative items, including a long-necked flask of Cizhou ware with arrows in it, and containers holding items of value to their owner. A servant is waiting at a suitable distance, where he can hear if he is called. The chess players wear headgear identifying them as scholar officials; the hat worn by the man facing full front is particularly tall.

According to a Song source (Wang Mingqing, of the Southern Song period), the man shown full front here is Li Jing, ruler of Nan Tang. Study of figure groups in Chinese art reveals that generally the most important personage is shown facing front, and people of high rank often appear larger than their companions. A portrait of an individual such as the emperor was expected to illustrate his elevated character through the depiction of his appearance. Such people had to be corpulent, tall, richly clothed, and posed in elegant attitudes. Their subjects and servants, on the other hand, were shown as thin, small, wearing everyday clothing, and with their eyes lowered. Only the portraits of ancestors of the more distinguished classes of society, kept locked away in private apartments, show people full front and wearing festive robes. This approach produced idealizations rather than genuine portraits.

The significance of the kingdoms of the transitional Wudai period for art and calligraphy cannot be overestimated. First, continuity was ensured through the members of academies existing at the courts of the post-Tang period, who were later to found the Academy of the Song court. Second, this was also the period when the foundations were laid for subsequent painting in all genres: monochrome landscape painting in the manner of Li Cheng, Dong Yuan, and Juran; figure and portrait painting after Guan Xiu; bird and flower painting in the manner of Xu Xi or Huang Quan. The 10th century also saw the introduction of a new pictorial format, the hanging scroll. The composition of pictorial elements in this format, already established in Buddhist banners and wall paintings, many of them known to us from their mention in the 9th-century inventory *Lidai minghua ji*, was devised by landscape painters, particularly those who chose to paint steep mountains. The pictorial composition of a hanging scroll called for a different visual approach. The scroll was "read" from bottom to top, and the viewer's standpoint in relation to it would vary: an important feature was a guideline such as a road, a watercourse, or a waterfall that could lead the eye on up into the mountains, or down into the depths and ravines and the realm of the invisible.

The first Song emperor, Taizu (reigned A.D. 960–976; see below), borrowing ideas from the two kingdoms of Hou Shu and Nan Tang in the Five Dynasties period preceding his reign, set up an Academy of Painting and other institutions devoted to the promotion of the arts, such as the Academy of Calligraphy. The academies became centers of art and culture in general.

The Song dynasty founded by Taizu lasted for an initial period of 110 years, during which northern China again became part of the empire (the Bei Song period), and continued in existence for another 150 years after the ruling house, under pressure from advancing tribes of nomadic

Portrait of Emperor Taizu

Anonymous

2nd half of 10th century, ink and paint on silk, hanging scroll, 191 x 169.7 cm, Taipeh Palace Museum

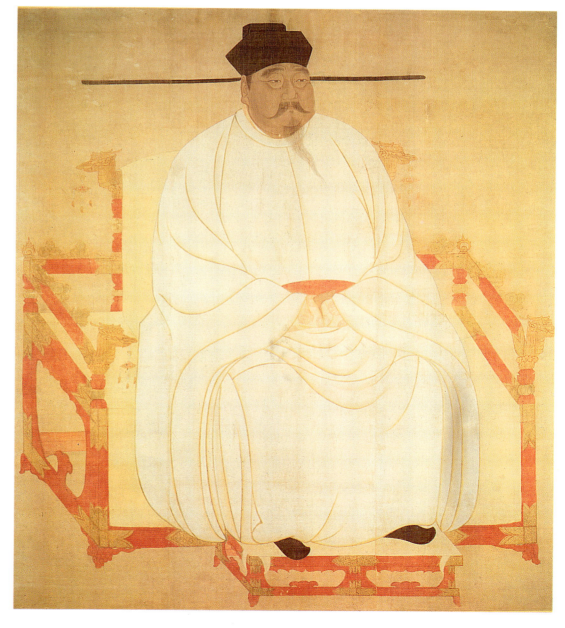

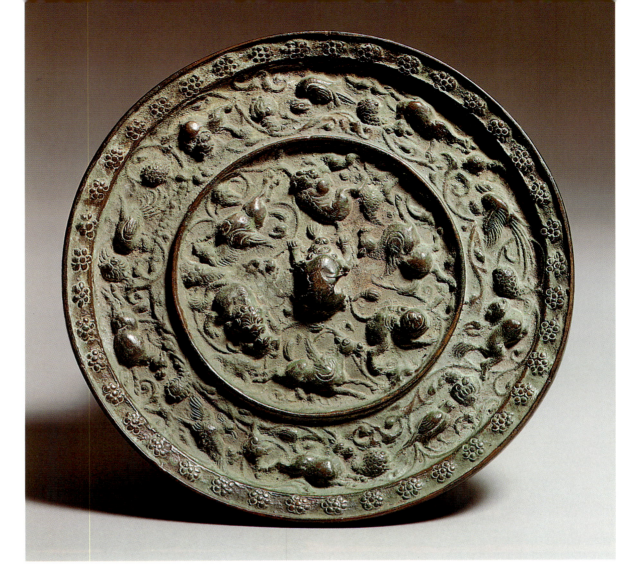

Mirror with relief decoration of "bunches of grapes and animals" motif

12th century, bronze, dia 21.5 cm, Staatliches Museum für Völkerkunde, Munich.

The decorative "bunches of grapes and animals" motif is of Manichean Persian origin and was particularly popular in the Tang period.

Big-bellied vase
Song period, bronze, H 30 cm, Victoria and Albert Museum, London

This almost undecorated vase has small handles added separately.

horsemen, had lost the capital city of Kaifeng and with it the north of the country (the Nan Song period). In geographical extent the empire of this period could not compare with the Chinese Empire of the Han and Tang Dynasties. The Jin approaching from the north (not to be confused with the Jin period discussed earlier) took Kaifeng in 1126, and once again the empire was partitioned. Emperor Huizong (reigned 1101–1126), the "imperial dreamer," was taken prisoner and had to kneel before the leader of the invaders in token of submission, the most humiliating attitude imaginable for an emperor. He did not return alive from Manchuria, and many members of the imperial family and the court had been taken there with him. The Jin and their allies now ruled the north, while the south continued to be ruled by a Song emperor who had to pay tribute to the Jin rulers. The Song court fled first to Nanjing, and after 1135 to Hangzhou. The south bank of the Changjiang seemed safer, and the north was left to the invaders until they reached the gates of Hangzhou itself. Gaozong (reigned 1127–1162) finally entered into an alliance with the tribes of nomadic horsemen, guaranteeing them unlimited rule over the north if they undertook not to attack the south, the granary of China. The dangers and confusion of the time are reflected most clearly in its literature.

The dominant feature of Song culture was its tendency to dwell on the wealth and traditions of the ancient Chinese past. For centuries Confucianism had been at the root of the state organization, and its philosophy was now revived as the intellectual basis of the scholar officials who ruled the empire. Thinkers sought to modernize the state philosophy by studying its origins. Emperors with a taste for the fine arts revived old rituals and ceremonies, one result was a lively interest in collecting old bronzes and the rare ceramics that had survived. Pictorial scrolls and works of calligraphy had already been collected, cataloged, and copied during the preceding Tang dynasty. The first records of a very large number of ancient bronzes date from the Song dynasty, and show how highly they were valued.

Bronzes with inscriptions were considered the most valuable. The first catalog of inscriptions on stone and bronze, the *Jigu lu*, is the work of a scholar and poet called Ouyang Xiu (1017–1072) and dates from the year 1063.

When ceremonial rituals were reintroduced, the ritual vessels mentioned in the literature of earlier periods were of course in demand. Buddhist communities needed bronze vessels too, and there was a revival of bronzeworking. As compared with the allover decoration of the Zhou period, the bronzes made by Song craftsmen are notable for

the brilliance of their surface finish, their inlays of precious metal and gemstones, and their graceful shapes. Besides making ritual items, these artists also created vases that did not copy any religious models, but derived in form from contemporary secular ceramic ware. Iconographically new and exotic items were also made, and the imagination of the craftsmen took these objects further and further from their original forms. A hybrid mythical creature of Indian origin, called a *mojie* in Chinese, spread to the south of China, where it acquired wings which then steadily increased in size and decorative structure (see below).

The revival of interest in old and antique pieces, however, brought with it an increase in forgery, and consequently inventories of antiquities are accompanied by information on how to recognize the patina of a bronze as good (in other words both old and genuine). This information incidentally provided the recipe for forging a patina, no doubt much to the satisfaction of the forgers themselves.

Many works of art were described in writings such as those of Mei Yaochen (1002–1060), who wrote on antiquities and art as well as four other large subject areas. Art – painting and calligraphy – acquired a theoretical structure in the hands of literati such as Su Shi and such artists as Guo Xi. One of the major occupations of Emperor Huizong, together with his own painting, was the cataloging of the art collections of the imperial house. They were extremely extensive; the figure of 6,000 paintings has been mentioned. Under the emperor's aegis, painting was regarded as the most important of the arts practiced at the Academy.

Crafts were also practiced in state workshops. Textile manufacture, porcelain making, and lacquer work flourished. Again, craftsmen in these fields worked partly from models of a past perceived as glorious, in the form of pieces that had emerged from the earth by chance or had survived the centuries in collections.

The internal politics of the time were marked by an antimilitaristic tendency favoring the extension of the civil service to create a bureaucratic central government. Civilians took over from military men, and a new class of scholar-officials without any aristocratic background replaced the nobles who had previously held the highest governmental posts. The basis for this change had been created by the Tang rulers' introduction of examinations for officials. Another factor was the contribution made by the printing trade. The Wudai period had seen ambitious publishing projects such as the printing and distribution of the canonical scriptures of Confucianism, Daoism, and Buddhism, not to mention the *Wen xuan* poetry collection, an anthology originally compiled in the 6th century A.D. Later, illustrated catalogs of collections were also published using the same relief process – block printing, with an entire page carved in mirror writing from a wooden block. In theory more of the population now had access to knowledge than in the past, when texts circulated privately in elite circles, or were available only in palace or temple libraries.

In art, the revival of Confucianism took the form of a rejection of excessive ostentation. Luxury became unobtrusive.

The self-image of the scholar-officials who were also amateur painters brought a change in the general attitude to those who produced art. A two-tier artistic society developed out of the twin concept of professional and amateur painters. A professional who earned his living from painting works on commission, was by no means in the same class as the amateur painter, who was regarded as superior by virtue of his education alone.

The pictorial works of the Song dynasty present the viewer with the problem of telling one of these kinds of art from the other.

The art of the scholar-officials, as they defined it, was called *shiren hua* ("painting of scholars," from Su Shi) or later *wenren zhi hua* ("painting of

Lotus and ducks

Anonymous

13th century, Buddhist cult picture, paint on silk, hanging scroll, 128 x 78 cm, Museum für Ostasiatische Kunst, SMBPK, Berlin

This polychrome picture represents the type of devotional work produced by professional painters.

Mojie

Song dynasty, bronze, H 14.8 cm, L. 34 cm, Nandan Archaeological Institute, Autonomous District of Guangxi

The hybrid *mojie* creature is a mythical being of Indian origin known in China since the Sui period.

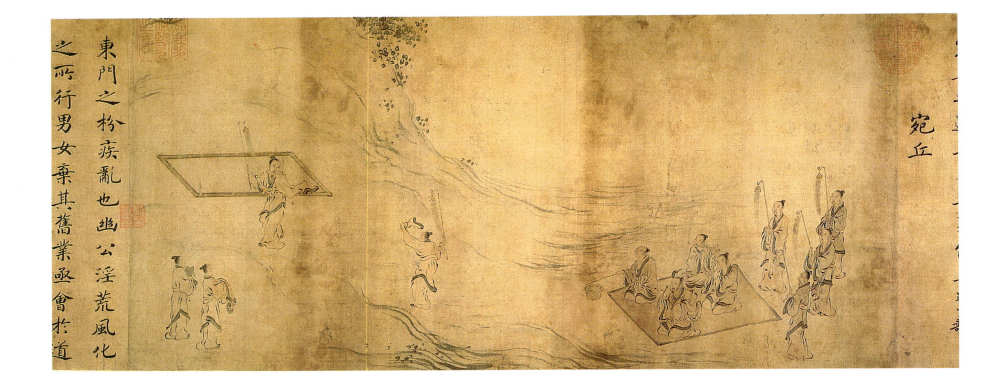

The Odes of Chen

Ma Hezhi (active about 1131–1162)

(Detail), ink and paint on silk, horizontal scroll, 26.8 x 187 cm, British Museum, London

The picture is part of an imperial commission for illustrations to the 1st-century B.C. Shijing collection of songs. The illustrations were commissioned by Emperor Gaozong (reigned 1127–1179). In terms of composition and technique, the picture reverts to the painting of the Jin period. This section illustrates the first poem of the ten odes of Chen, entitled "The Hills of Yuan," and concerns a nobleman pursuing his own pleasure in summer and winter alike.

literati," from Dong Qichang). This painting differed in its choice of themes and preferred techniques from that of professional painters.

The professional painters were, first, those who had patrons and created sacred works of art such as wall pictures or ornamentation for religious buildings. They all employed a realistic style using natural color. Second, there was another branch known to posterity as Academy painters because they had been appointed to the imperial Academy in Kaifeng. The Hanlin tuhua yuan, the Hanlin Painting Academy, brought both advantages and disadvantages to the painters themselves. It allowed anyone with talent to practice the art of painting after taking the entrance examination, and to rise according to his merits, and it provided a secure existence with the status of an official, though one without any kind of political power. After taking many examinations, artists were appointed to the Academy as servants of the state, and wore a robe in accordance with their rank, a kind of uniform. Every artist, rich or poor, thus at least had the chance of being able to earn his living as a member of the Academy, who was ranked as an official. But the Academy also meant censorship and conformity. It limited artistic freedom; the emperor himself exerted influence over choice of subjects and technical methods. The Academy painters too, then, were under the protection of patrons, although not the same as those of the professional painters working in the field of sacred art.

The literati also differed from Academy painters in choice of subjects. They preferred landscape, and sometimes figures or flowers. Many great painters such as Guo Xi (about 1020–1090) found themselves in a dilemma: as Academy painters they were duty bound to satisfy the wishes of their patrons; but in "another life" they gave expression

to their ambitions as free landscape painters, and so initiated change by introducing pre-Academy influences into the Academy itself.

Confusions of terminology

The Northern versus the Southern School (terms which have nothing to do with the splitting of the dynasty into a Northern and Southern period, or with any geographical frame of reference); the Academy style versus the style of the literati; the dialectics of north and south in painting: what concepts lie behind these terms? Definitive Chinese artistic terminology derives chiefly from a Ming artist and theoretician called Dong Qichang, but he merely gave a written summary of the situation illustrated by the pictures themselves.

The blue-and-green style of the Tang period is considered a feature of the Northern School, because the "founders" of that school, Li Sixun and Li Zhaodao, practiced their craft in the Tang period's northern capital of Chang'an, and the style became established as a court norm in the north. Eventually all landscape styles using color as a means of expression were classed together as typical of the Northern School.

The Southern School was the school of Wang Wei and monochrome ink painting, and of all artists following that tradition. They used ink in every possible variety of shading, and a calligraphic style of brushwork; color was secondary, and only muted shades, if any, were used. In his classification and terminology, Dong was making use of terms that already existed and divided Buddhism into a Southern and a Northern School, by no means purely geographical descriptions.

Monochrome landscape painting itself, however, divided into two lines of tradition

depending on an artist's choice of subject within the genre: the Li Guo tradition and the Dong Ju tradition. To make matters yet more complicated, there were the distinctions between amateur and professional painters, for which the terms Academy style and literati style are used. The descriptive and originally analytical art theory of the Ming and Qing periods tried to cover all painters active during and after the Song dynasty and fit them into this scheme.

The dialectic of north and south also relates to themes: landscapes were northern (stony) or southern (earthy), and inspired different groups of artists irrespective of their allocation to the Northern or Southern Schools.

The landscape painters of the Northern Song dynasty

The number of landscape painters connected with the Song Academy was relatively high, but it must be remembered that painters were not confined to a single pictorial genre. Today the outstanding representatives of the Northern Song School are considered to be the landscape painters Guo Xi (1020–1090) and Fan Kuan (died 1030), and the animal painter Li Gonglin (also known as Li Longmian, 1049–1106). They all saw their professional task as the depiction of the essence of nature, not the reproduction of a precise copy. An approximation to reality was enough. Consequently color became superfluous, the effect of the landscape was paler, and the importance of the overall impression gave way to emphasis on certain sections. The best format for these purposes seemed to be the hanging scroll, as the majority of ascriptions suggest. Typical of the landscapes of the Northern Song period is a rather rigid composition with a mighty mountain range occupying the center of the picture, detailed elements such as trees and rocks with an elaborate surface structure in the foreground, spatial depth without detail being conveyed in the middle ground, while a dotted effect represents undifferentiated vegetation seen in the distance in the background. Juran painted compositions of this nature, and so did Fan Kuan (2nd half of the 10th century) and Guo Xi (1020–about 1090). The two last-named painters were influenced by the Wudai painter Li Cheng, who is said to have preferred such compositions. Guo Xi was one of the first to depict effects of light on mountains, basing them on precise natural observation. There is no single source of light, as in European painting, but Guo paid great attention to detail in his rendering of areas of sun and shade. Fan Kuan added tiny figures to his mountain ranges, emphasizing the monumentality of the mountains themselves and thus of nature. He regarded nature as the only true teacher, though the influence of Li Cheng is perceptible in his brushwork. Like Li, Fan used "raindrop" strokes for effects of height. There is another connection between Fan Kuan and Guo Xi in a subject they both liked, the winter land-

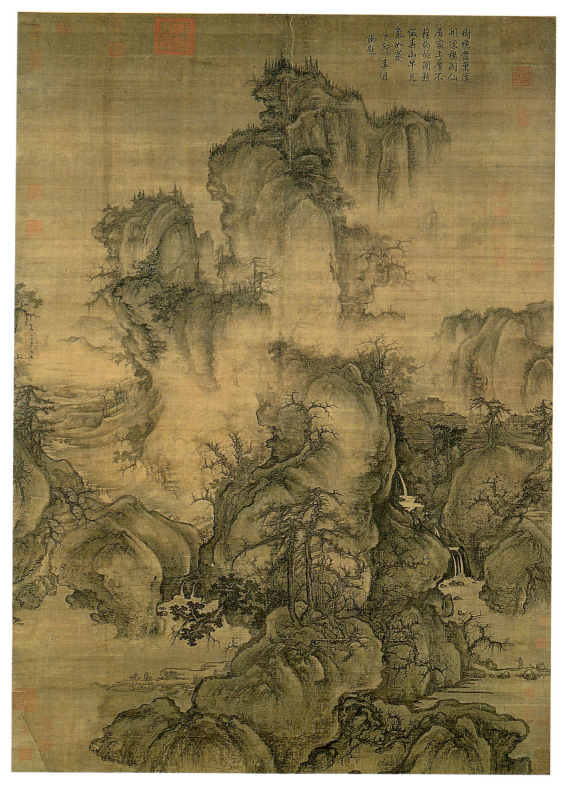

Early Spring (Cao chun)

Guo Xi

1072, authenticity of dating recognized, ink on silk, hanging scroll, 158 x 108 cm, Taipeh Palace Museum

Calligraphy

Mi Fei

(Detail), semi-cursive script, ink on silk, written scroll, 27.8 x 270.8 cm, Taipeh Palace Museum

scape. The calligraphic line used for the surface elaboration of these rocky landscapes runs on into the depiction of the leafless trees. Guo's bizarre trees, their branches reaching into the air like crab's pincers, had forerunners in Li Cheng's compositions featuring bleak, leafless deciduous trees. The realism present increases the effectiveness of the picture, conveying the chill atmosphere of winter with its cold and freezing mists.

In reference to the intellectual fathers of this style of composition and painting, later landscape paintings are described as being in the Li and Guo tradition, a synonym for the Northern Song style. Guo Xi's theoretical writings on painting were published by his son Guo Si in the year 1110. When Guo Xi was appointed to the Academy by the Song emperor Shenzong (reigned 1063–1085), he already had a reputation as a great artist. He did not entirely conform to the current Academy landscape style. His theoretical concepts, as formulated in *Linquan gao xhi (ji)* (Elevated Notes on Groves and Springs), can be summed up in simplified fashion as follows: landscape painting is a substitute for the experience of landscape that cannot be reconciled with public office; the picture is a substitute for nature and can arouse the same feelings in the viewer as the experience of nature itself. What is required is a style of painting that will convey the essence of nature; it need not be an actual reproduction. Variation in the picture allows the eye to wander, and the painter should produce effects of depth by changing the proportions. In mountain landscapes, the illusion of

spatial depth derives from the "three distances:" the upward view, *gaoyuan*; the inward view, *shenyuan*; and the view on the level (i.e. into the distance), *pingyuan*. It also derives from the illumination of objects in the background and the portrayal of "mist" (nothing) in the middle ground, and from the "three sizes", or *san da*, the proportional relationship of objects to each other (mountains being large, trees smaller, and human figures smaller still), as well as the miniaturization of features shown in the distance. Guo himself is said to have had perfect mastery of these technical refinements. The scholar painters sought to follow the same principles.

Toward the end of the Northern Song dynasty a number of multitalented figures made their appearance in artistic life, attracting attention through their theory, their painting, and their calligraphy alike, but they were not regarded officially as painters. They distanced themselves from the Academy, and more particularly from any obligation to follow its prescribed style.

A circle of like-minded "amateur artists" who had formed around the scholar official Su Shi (1037–1101, known by his poet's name as Dongpo Shanju, "Hermit of the Eastern Slope") supported the idea that the picture should perceptibly express its subject. This demand of Su Shi echoed the first of Xie He's principles, the need to express the life force, *qiyun*. An artist who transferred himself into the object to be depicted could speak for that object itself, reflecting its nature and essence. Xie He's demand for formal similarity is not entirely

rejected, but the notion of copying is only subordinate. Landscape and rocks, old trees, bamboo, and plum blossom seem to have been particularly suitable as subjects. This theoretical approach also gave new stimulation to calligraphy. Painters concentrated on themes in close-up, as if they had zoomed in on certain elements of an impressive landscape with a telephoto lens. In the Xuanhe era catalog of pictures *Xuanhe huapu*, dated to 1120, "pictures of small views" (*iaojing hua*) are included in the "ink bamboo" category, one of ten categories into which all pictures were grouped. They were: Buddhist and Daoist subjects, figures, palaces, foreigners, dragons and fish, landscapes, animals, birds and flowers, fruit and vegetables, ink bamboos. The classification itself was changing at the time, for 40 years later there were eight categories. Since many of these details of landscape also show birds, the transition to the bird and flower genre was obviously a fluid one. Amateur painters focused on rocks, trees, bamboo, or plum blossom not in order to achieve formal similarity (*xing*) but to capture the essence or content (*yi*) of the rock, tree, or bamboo in monochrome on paper. The depictions of rocks, of "ink bamboo" (*mozhu*) and "ink plums" (*momei*) produced by the literati also mark the transition to the genre of landscape detail, which together with monumental landscapes became increasingly popular during the Southern Song period.

Su was the first to define a social aspect of painting by ranking the literati above professional painters. Good painters, according to Su, are not common people, and no nobleman would ever be merely a painter, since he was foremost a scholar.

Members of the circle of Su Shi, poet, essayist, art theoretician, and not least a famous bamboo painter, included the painters Wen Tong (1019–1079), Li Gonglin (1049 to about 1105), the art connoisseur Wang Shen (no dates available), and brilliant scholars, such as the great admirer of garden stones Mi Fei (or Mi Fu, 1052–1107), none of whose original pictures has come down to us.

A single picture, *The Auspicious Pines*, in the Taipeh Palace Museum, seems to approach his style. Mi felt very close to the simplicity of nature. His method of painting in ink applied in several superimposed layers, with washes and horizontal "Mi dots" (*mi dian*), later became a standard for the examination of Academy painters. However, there is also a flowing rhythm in Mi's calligraphy showing the range of variation in his brushwork (see right).

Mi had a very good eye, as comments by other calligraphers on the quality of his copies of works make clear. He was master of many different types of scripts, and could reproduce other calligraphers' personal styles. A great copyist, he sought perfection through the intensive study of manuscripts. He claimed to be playing with the brush in his own style, and his writings expressed natural spontaneity. For instance, he varies the spacing between characters, brings them closer together, or emphasizes their significance by their size.

The poet and calligrapher Huang Tingjian (1045–1105), who was brought to the great Su's attention by some lines of poetry, was another of this group of literati and became a great friend of Su himself in the latter's vicissitudes of fortune.

Huang Tingjian was one of the most famous calligraphers of his time (see below). A master of clerical script, he was frequently copied by later generations of calligraphers. An encounter with an original manuscript by Huaisu had been significant in the development of his own style. At the advanced age of 50, Huang, like his friend Su, was sent into exile, in his case to Sichuan, where he saw an original manuscript by Huaisu that revealed to him "the miracle of calligraphy."

Through intensive study of this manuscript, he further developed his own *xing* and *cao* styles. He set down his theory of calligraphy in his text *Shangu ji* (Notes from the Mountain Valley). Rounded shapes flowing into one another are characteristic of his style. Huang Tingjian is mentioned as one of the four masters of the Song period (*song si jia*), together with Mi Fei, Cai Xiang (1012–1067), and Su Shi.

An excursion that made art history

The Song dynasty was not only a cradle of artistic theory and method, but also the origin of certain standard themes of painting. Among these themes that first became classics at the time is the "excursion to the Red Wall" (see pages 164 and 165). It refers to an actual experience of Su Shi, who wrote an account of a day's excursion, apparently concentrating on his impressions of nature,

**Seven syllable poem
(Shu qi yan shi)**

Huang Tingjian

Calligraphy, xingshu script, ink on paper, exact measurements not known, Taipeh Palace Museum

In this work of calligraphy Huang allows himself the freedom of breaking the seven syllable line convention, and writes not four lines of seven characters each, but five lines consisting respectively of seven, six, seven, six, and two characters.

Excursion to the Red Wall

Dai Xi (1801–1860)

Ink and paint on silk, fan, 17.7 x 51.6 cm, Staatliches Museum für Völkerkunde, Munich

The inscription informs us that the picture is painted in the style of Tang Yin (Ming-dynasty period).

Opposite
Excursion to the Red Wall

Wu Shiguan (active 1st quarter of the 17th century)

Dated 1606, ink and paint on paper, fan, 15.7 x 47.3 cm, Museum für Ostasiatische Kunst, Cologne

although on another level there is a political allegory to be read between the lines. Later scholars would instantly recognize the theme of the "excursion to the Red Wall" (Chi bu tu) from pictorial elements used with almost symbolic force: the boat in front of a steep cliff, the cliff itself, or an overhanging pine tree. How did this come about?

Su Shi, born in Meishan the son of a writer, took the palace examination as a *jinshi* (the equivalent of obtaining a doctoral degree) and embarked on a career as an official. He was later transferred because of his conservative opposition to the social and administrative reforms of the great statesman Wang Anshi (1021–1085), and finally removed from office. Caught between the opposing reformers and conservatives, he traveled the country, sometimes exiled, sometimes magnanimously pardoned and rehabilitated. He spent four years on the island of Hainan in the South China Sea, to the south of present Hong Kong – a dangerous place to live because of its subtropical climate. Su Shi's biography was familiar to all literati, and his texts became obligatory reading.

Su Shi spent the years 1080–1084 "in exile," that is to say away from the court and without any

political power, in a rather remote little town called Huangzhou in the middle of the course of the Changjiang River. During these years Su Shi paid several visits to a steep cliff known as the "Red Wall," famous for the beauty of its landscape and also, he believed, for a historical event, the defeat of General Cao Cao. In his written works he left a moving record of these excursions.

Making music and taking refreshment, we are told, Su and his guests passed the cliff in their boat, drifting on by the light of the rising moon, listening to the wind, their mood cheerfully optimistic and melancholy at the same time, since the moon reminded the poet of the defeat of Cao Cao and the transitory nature of fame and power. Toward morning the company slept heavily, feeling the effects of the wine they had brought with them. In the second rhapsody, Su writes about the rocks of the great cliff, which he also visited from its landward side, climbing uphill through the cleft rocks, overwhelmed by the beauties of nature, but then alarmed by an echo that sent him fleeing straight back to his companions in the boat. In this place, he felt, nature dominated man and could suddenly crush all human ambi-

tions. Impressions of journeys and excursions were popular subjects of both poetry and another literary form which had developed into an independent genre, travel writing. *The Excursion to the Red Wall* was probably the best known of all Chinese travel writings, and it was first depicted in a painting relatively soon after publication.

The first version of the Red Wall subject may have been a horizontal scroll (*Chibi tu*, now in the Taipeh Palace Museum) by a landscape painter, Wu Yuanzhi. It already shows a boat with three tiny passengers and a steersman in front of a mighty cliff overgrown with bamboo. The use of the chopping "ax cut" brushstroke gives the rocks an abrupt, forbidding power. Over the years every famous painter seems to have given his own interpretation of the subject. Further examples are by other Ming artists such as Tang Yin (1470–1523) and Qiu Ying (first half of the 16th century).

Su's excursion illustrates one aspect of the life of the elite during the Song period. Another was represented by their meetings in their own houses.

Painting in the Southern Song period

After the Song dynasty's flight south to its new capital, Emperor Gaozong (reigned 1127–1162) refounded the Academy of Painting. He had inherited his father's interest in art, and was not only a patron but a painter himself. The landscapes of the late Northern Song Academy had shown a tendency to monumental width or height. Panoramas of vast extent – a measurement of ten meters (33 feet) was probably not uncommon – were portrayed in natural color. The new Academy now created a corrective to such works. Possibly under the influence of the literati and their pictures in a small format, for some decades the Academy produced paintings on small, almost round fans,

Excursion to the Red Wall

Li Lin (1558–post-1636)

Ming period, ink and yellow paint on paper, fan, 17 x 53 cm, Museum für Ostasiatische Kunst, Cologne

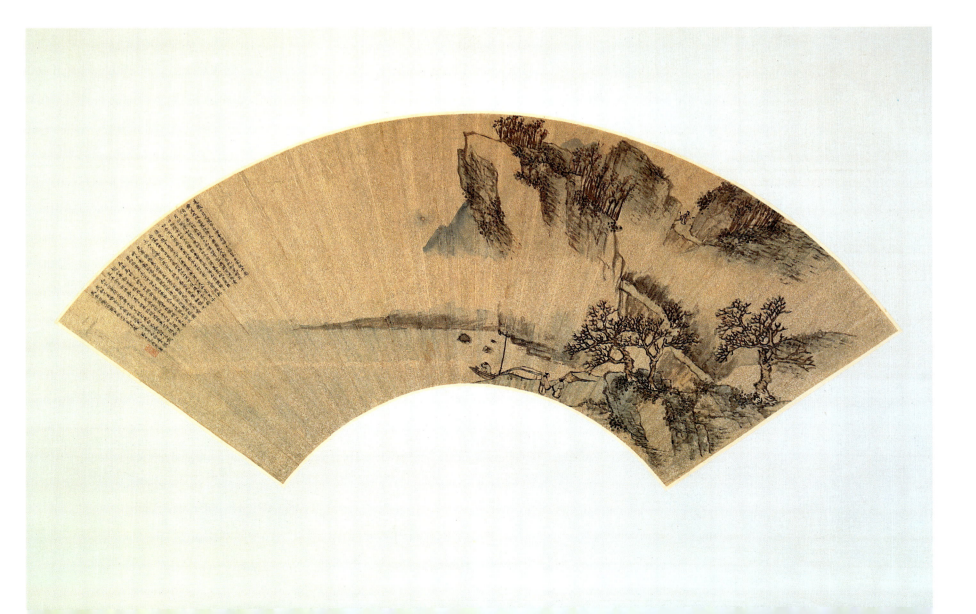

showing landscape subjects from the south in a manner that brought the scenes closer to the viewer.

The four master painters of the Southern Song dynasty are considered to be Li Tang (about 1055–1140), Ma Yuan (active about 1190–1225), Xia Gui (active about 1180–1230), and Songnian (active around the late-12th and early-13th centuries). The dominant subject was the "poetic landscape" of misty hills and lakes; Li Tang was regarded as the originator of this poetic style. He had worked at the old Academy, and in his old age was appointed to the new Academy by the emperor. Li Tang had a creative mind that enabled him to arrange the pictorial elements of a composition in new ways. He also created and introduced a new textural stroke, the "ax cut" stroke (*fupi cun*).

The clearest change in artistic composition was the introduction of the "one corner" style. Where the mighty landscapes of the Northern Song artists had placed mountain ranges centrally, Li Tang and even more notably Ma Yuan shifted the emphasis of the picture to one corner of its area. Ma Yuan eventually developed this feature into a diagonal type of composition which usually concentrates elements in the left corner, with only empty space diagonally opposite (see page 167). Artists used this method to achieve a new kind of tension produced by the contrast of mass and void, near and far. One of the pictures by Ma Yuan's son Ma Lin, the nocturnal scene *Waiting for Guests by Lamplight*, creates an atmospheric mood with this new kind of composition (see left).

Xia Gui, who preferred the large-format horizontal scroll up to ten meters (33 feet) in length for his work, used the one corner style for works in smaller formats. The long scrolls are typical works of the "empty space" type in which Xia guides the eye along the axis of broad chains of hills, banks of mist, and wide stretches of water (without curling waves, since the effect would then have been over-explicit rather than merely suggestive).

The ax-cut stroke introduced by Li Tang became a characteristic of Southern Song painting and a technical means of expression employed by Ma Yuan, Ma Lin, and Xia Gui.

The term Ma-Xia school has been coined for paintings in the style of Ma Yuan and Xia Gui, and is often used as a synonym for the Academy painting of the Southern Song period. The Southern Song Academy also added to the canon of subjects. Southern Song painters depicted the "poetic moment." Pictures showing figures that are neither historical nor didactic in a landscape setting suggest lyrical scenes; they are poems in paint. The figures might be a solitary walker, a scholar in his garden, people meditating in the open air, or scholars on an excursion.

Liu Songnian, who held the rank of a *daizhao* at the Academy from 1190 to 1194, used the same style, but his brushwork is finer and more delicate. Liu's name is linked to one of the earliest sets of

Below
Waiting for Guests by Lamplight

Ma Lin (mid-13th century)

Ink and paint on silk, fan, 24.8 x 25 cm, Taipeh Palace Museum

paintings of the four seasons (*Sijing shanshui tu*, now in the Beijing Palace Museum). Paintings of the seasons showing landscapes changing through the course of the year subsequently became an important kind of domestic ornamentation. Liu's rendering of the four seasons shows each with its "typical" flora, and a scholar pursuing his typical occupation. *Spring* is an embankment with willows, a flowering *Prunus mume* and a wandering scholar; *Summer* shows a garden with a pool of lotus flowers and the scholar strolling in a cool walk; *Autumn* depicts wutong and cassia trees rimed with frost while the scholar sits reading in his hall; and finally *Winter* is a snow-covered landscape with three pine trees defying the storm, while the scholar stands in his hall watching a man on horseback. The main subject of these pictures is the landscape during the changing seasons, complemented by architectural structures.

Architecture, genre painting, and the life of the people

Paintings of buildings, however, were a genre to themselves, and being similar to genre scenes showing ordinary people the two may be considered together. These pictorial genres retain the realism once a feature of landscapes. The artists of architectural pictures meticulously portrayed palaces, temples, buildings where historical events took place, providing an idealized form of the traditional versions of such subjects. *Gongbi*, "letting the brush work," is the expression for paintings executed in fine, precise brushwork with much detail. In the case of architectural paintings, another central term was *jiehua*, linear painting (see page 91, top).

The figure painters who devoted themselves to the *fengsu hua*, everyday life genre, covered all subjects, from festive occasions to craftsmen, jugglers, itinerant doctors, and private interiors.

A lively picture capturing the life and occupations of city folk, perhaps on a feast day, was painted in the 12th century by Zhang Zeduan, a painter from Dongwu in modern Shandong. He depicted the bustle and activity of a street procession in the suburbs by the Bian canal of the capital city of Kaifeng (see above and following pages).

The festival shown is one of the traditional feasts of the peasant calendar, and is among the most important. Although a fixed date in China, the 106th day after the winter solstice, in the western calendar it falls on different days in early April. In this scene Zhang provides interesting glimpses of the everyday life of his time.

The combination of the overhead perspective of buildings and the side views of figures seems strange to the European eye, but this compositional feature is typical of both Chinese and Japanese genre painting.

Before the painting gets to the hurry and bustle of the city itself, it shows us the way there. A path leads through a spring landscape with simple peasant houses. The willows are putting out pale green leaves, the other trees are still bare. The viewer sees the landscape move past as if he were in a ship sailing up the river. Skillfully, the painter allows the density of houses to increase; we are approaching the city. A quay with a number of passenger and freight vessels tied up to it comes into view. We feel like stopping, not to carry sacks like the laborers but to enjoy a drink, for several wineshops with tables out in front of them invite the visitor to linger. The streets the painter allows us to glimpse are full of lively occupation. The water carrier is as important a figure as the wine merchant. Other ships pass by on the river, and we suddenly realize that we are not in fact viewing the scene from one of them but from the opposite bank. The arched wooden bridge is crammed with sightseers greeting the boats coming up the river. There is a cookshop, we see large sun umbrellas, and the picture gives frequent glimpses into backyards. The river bends, the road follows it, the gate of a walled property stands open to our gaze. People are all streaming the same way, toward a ditch and the city gate, beyond which the hurry and bustle really begin. By the end of the scroll we have been given an illustration of the whole idea of city life. In the time of the Song dynasty cities were full of comings and goings, swarming with draft animals, carts, wares for sale, camels, litters, stores full of people. It is not certain whether the subject of the picture is in fact the spring festival, which took people out of the city, carrying food and drink, for a happy celebration at the tombs of their ancestors. Such an interpretation probably assumes too much, and recent suggestions that the title should not necessarily be taken in that way

Life Along the River on the Eve of the Qingming Spring Festival (Qingming shanghe tu)

Zhang Zeduan (active 12th century)

(Section), early-12th century, ink and paint on silk, horizontal scroll, 24.8 x 528.7 cm, Beijing Palace Museum

This picture has to be read from right to left, beginning on page 169.

One corner composition

Schematic version of a one corner composition by Ma Yuan, based on the picture *On a Mountain Path in Spring*.

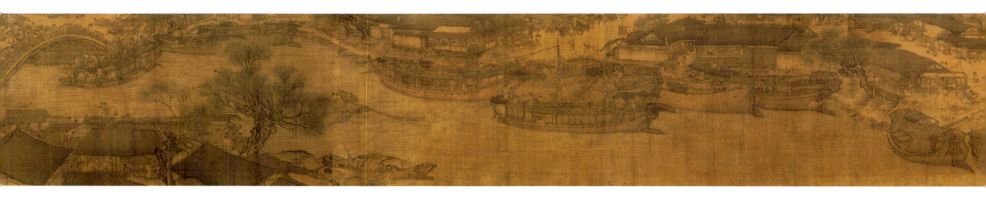

seem justified. "Qingming" could also have been the name of a quarter of the city. It is possible to see the preparations for a festival here, but in essence what the picture depicts is city life.

The buildings in this picture, which are not in the linear style and therefore give a lively effect, may be taken as typical architecture of the Song period: single-story *sihe yuan* houses with court-yards surrounded by walls; multistory *lou* houses; the massive wooden construction of the city gate; and the clearly visible substructure of the roof built on the *dougong* principle. The documentary nature makes it particularly valuable; it is also valuable because the same daily activities it shows could also be painted on single album leaves or round fans. The art of Zhang Zeduan lies in his ability to create a well-balanced composition guiding the eye forward, yet still offering surprises. He depicts people, their occupations, and the buildings around them with detailed precision, and indirectly he is illustrating the pleasures and the variety of life in Kaifeng. Zhang's painting of ships also reflects the pictorial genre allotted to the subject of ships and land vehicles. The scroll invites close and repeated viewing. Its subject could also be seen as the difference between town and country, with the willows growing wild outside the walls and the neatly trimmed trees within them, the scattered buildings in the country and the narrow city streets. The riverside suburb is typical in containing warehouses and businesses, inns and wineshops, but no workshops; it is a place for the shipment of goods. Outside the city there are also large houses with courtyards, and close study will reveal a number of gardens planted with bamboo. This is a symbolic touch. Bamboo is an evergreen, flexible plant that bows but does not bend, a symbol of durability and adaptability. As a pictorial motif, bamboo is suitable for the display of a variety of brushwork techniques, and it was also part of the flora and fauna that were the favorite subjects of Academy painters.

Flora and fauna

The bird and flower painting that had become so popular a genre in the Song period, particularly within the Academy, probably derived from several sources, notably the ornamental flower patterns around the sides of Buddhist wall paint-ings. The effect here was to set the main scenes in a frame made up of ornamental borders or rows of single flowers, as if motifs on a woven fabric. Next came single flowers in the hand of a donor or bodhisattva. Oriental silverware, imported in large quantities during the Tang period and frequently ornamented with tendrils and blossoms, may also have influenced flower painting.

Birds on their own had been an ornamental motif in Chinese art since neolithic times, and they also decorated bronzes and lacquer ware. In the first half of the Tang period, the two themes, flowers and birds, merged. The broken branch motif and compositions consisting of flowers and rocks or flowers and birds date from that period. Craft items of the time (there are no extant pictures) suggest that the composition was symmetrical. The genre itself may well be connected with the Tang period's new under-standing of nature, together with the love of gardens mentioned above, and the pleasure people took in growing flowers in their own gardens.

Again, the Song period brought a greater sense of freedom to such themes. The painting by Huang Quan described above showed birds in the manner of a study. Song artists built on his realism. Nearly half the pictures in the imperial collection of paintings, which contained over 6,000 in all, were of the bird and flower genre. Emperor Huizong, whose personal name was Zhao Ji (1082–1135, reigned 1101–1126) himself painted in this genre, and the museums contain pieces by him of whose authenticity there can be little doubt (see pages 152–153).

Huizong painted both living creatures and the plants surrounding them in a strictly naturalistic way, standing out clearly from the background of the painting. His depictions of birds are extremely realistic, with the outlines accurately traced, the birds' primary feathers clearly visible, their beaks correct for their respective species, and their breast feathers indicated in delicate brushstrokes with touches of color; he painted plants in the same way. In these compositions the birds and plants contrast with the rest of the surface of the picture, an effect sometimes emphasized by a wash.

The emperor's work was a faithful copy of nature, but he was not really rendering natural life,

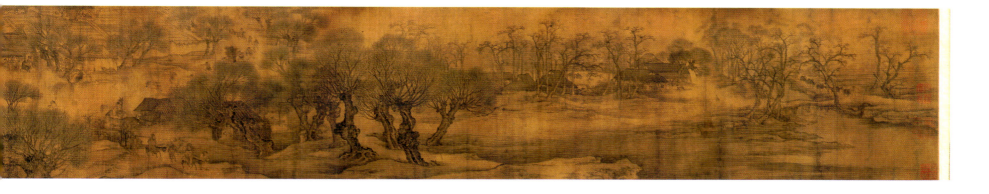

which was to be better depicted in the future, in terms both of technique and composition.

Han Ruozhuo painted his *Sparrows in Ripe Rice* (see below, right) in the first half of the 12th century. He was a member of the Song Academy during the reign of Huizong. It is even said that the artist, who was famous for his realistic depictions and precision of detail, was once sent to Korea to paint a portrait of the king there. The implication of movement shown by the sparrows on this album leaf suggests a snapshot, with one bird clinging upside down to the blades of rice while the second balances on them to eat. A fleeting moment is captured: it seems that next minute the stalks will bend and the birds will move or fly away. The viewer seems to feel the interplay of their movements with the swaying of the blade of rice; the forces and tensions of nature have been caught. The picture is full of life in its composition, in the rendering of the downy plumage and the realistic portrayal of the birds and of the rice blades, nibbled by insects and tossed in the wind.

These two different ways of painting birds could be seen as following in the tradition of the two great masters of the Wudai period. The emperor worked in the spirit of the great Huang Quan, producing accurate outlines in the *xiesheng* style, while Han worked more in the spirit of Xu Xi, who aimed at the depiction of life itself rather than a lifelike copy, and may be said to have owned allegiance to the *xieyi* concept.

Another popular subject was the "100 animals of a species," allowing artists in the *xiesheng* style to record their observations of nature by portraying animals in different phases of movement. Many painters produced such pictures, including Ma Fen (active first quarter of the 12th century) in his *One Hundred Wild Geese*. The origin of the theme, much cultivated by the Academy, may be sought as early as Han Gan and his circle in the Tang period. It was not unusual for Song painting to refer back to Tang artists. Li Gonglin (1049–1106), a member of the Academy and a portraitist and animal painter, besides being a calligrapher, writer, and archaeologist, regarded Han Gan as his great example, and the influence is particularly obvious in his *Picture of Five Horses* (Wuma tu).

The scholar-painters were not much interested in animals, and not all plants struck them as worthy of artistic attention. They refrained from using color to depict plants, considering it unnecessary for setting down the immanent essence of such subjects on paper. Using apparently spontaneous effects of smudged ink and broad brushstrokes, they painted plants that had deep symbolic significance in monochrome, rarely in color, and with no tracing of the outlines (*mogu*). Subjects that the literati could portray, with their skilled brushwork and calligraphic abilities, included ink bamboo (*mozhu*), ink plums (*momei*), and pine trees, subjects with close links to landscape painting. Their repertory also included orchids. In the Ming period these subjects were grouped together conceptually as the Four Noble Kinds

Life Along the River on the Eve of the Qingming Spring Festival (Qingming shanghe tu)

Zhang Zeduan (active 12th century)

(Section), early-12th century, ink and paint on silk, horizontal scroll, 24.8 x 528.7 cm, Beijing Palace Museum

To be read from right to left, ending on page 166.

Sparrows on Ripe Rice

Han Ruozhuo (active 1st half of 12th century)

Possibly a copy by Chen of the Ming period, ink and paint on paper, fan, 25.2 x 25 cm, Museum für Ostasiatische Kunst, SMBPK, Berlin

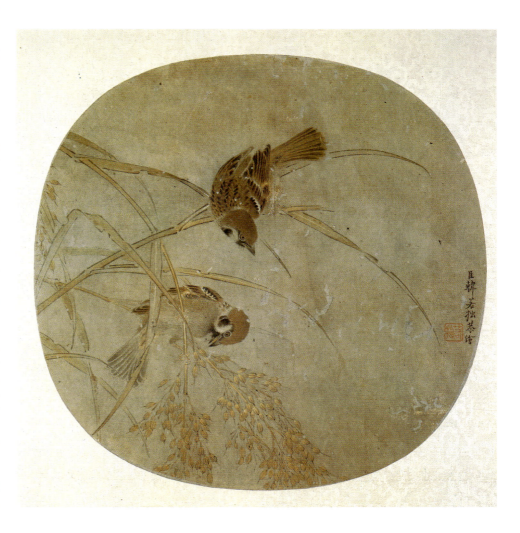

The Seventh King of Hell

Lu Xinzhong (late 13th century)

Ink and paint on silk, hanging scroll, 85 x 50 cm, Museum für Ostasiatische Kunst, SMBPK, Berlin

(*sijun zi*), and their natural form made them particularly suitable for an abstract, calligraphic style, with their silhouettes resolved into linear and curving strokes.

The literati also liked chrysanthemums, the symbol of Tao Yuanming and the life in retreat, and narcissi ("water immortals," *shuixian*), which were supposed to bring luck when put in a vase early in the year.

Sacred art

In the same way as Academy painters and the self-styled scholar-painters divided into two camps, there were two kinds of Buddhist painters: professional painters employed to supply the decoration of a temple (walls, banners, scrolls for monastic cells), and monks who were also painters.

The most important contribution to sacred painting in the Song-dynasty period was made by Chan Buddhist art, created either by Chan artists, or for Chan sanctuaries, or to illustrate personages or events in the Chan tradition. This school of Buddhism emphasized simplicity, renunciation, and rigor, and saw meditation as the way to enlightenment (Chinese *wu*, Japanese *satori*). Paintings for sanctuaries or as illustrations were not necessarily the work of Chan artists; literati and Academy painters also worked on Chan subjects.

The beginnings of Chan painting are to be found in the works of Guan Xiu (A.D. 832–912),

who painted monochrome pictures of *luohan*, using a calligraphic style for portraiture.

There was no single established Chan style, since the artists producing Chan art worked in all traditions of painting. *Baimiao*, "line on white," a style that can be defined as pure line drawing with a regular, thin brushstroke (see page 110), existed side by side with the style employing a modulated ink line of a material, expressive, and dynamic character. It is also possible to detect an affinity with the monochrome works of scholar painters in the Northern Song period, although the Chan always emphasized figure painting (see below).

Stylistically, Chan artists preferred broad, rough brushstrokes and simple, condensed compositions, and forms became very abstract. At the height of Chinese Chan painting in the 12th and 13th centuries, a style developed that made great demands on the viewer's imagination. These pictures were in very pale tones of ink, showing river views, misty landscapes, or nocturnal scenes in which the subjects were merely suggested, hardly seen (*wangliang hua*). This style soon became a target for the mockery of traditionally minded critics such as Deng Chun in his *Huaji* (Notes on Painting, 1167). The general tenor of criticism always seems to be much the same. Deng's remarks might almost have been made by certain modern critics: "All you have to do is cut up a few feet of black silk and hang them in your hall, and you are well on your way to fame."[8] He

Chan Monk

Liang Kai (about 1140–1210)

Ink on paper, hanging scroll, 48.7 x 27.6 cm, Taipeh Palace Museum

Originally conceived as a small-format scroll, the picture has been mounted with six colophons in the manner of a double album leaf.

had not understood the subtle nature of Chan art, which suggested a subject or motif without actually stating it.

Chan painting was particularly progressive in its choice of subjects. Besides the traditional and liturgical motifs for use during the religious year, such as portraits of Bodhidharma (founder of the Chan school), white-clad Guanyin figures, or Buddha coming down from the mountains, Chan artists also painted landscapes and pictures of plants as an aid to meditation. These fruit and vegetable paintings are among the most remarkable phenomena of art history, and have deep significance in the religious thinking of Chan Buddhism, which teaches that spiritual and material good are one. The essence of the Buddha may be present in any part of the universe, however small. Vegetables and fruit are also an expression of the virtues of the simple life, and on the meditative principle that all things are one, aubergines or apricots may be taken to convey enlightenment in the Chan Buddhist sense. Everything is thus worthy of depiction, from the smallest insect to a fruit, from a single stone to a mountain. A particularly well-known picture is the *Six Persimmons* by the monastic painter Muqi (about 1220–1290), which is now in Kyoto, Japan.

The works of Chan artists were exported in large numbers to Japan, where the most valuable pieces are still in collections in temples and museums. The painting of Chan Buddhism, or Zen Buddhism, as it is known in Japanese, found fertile ground in that country, where the tradition of Zen painting continues to the present day. In China of the Yuan period, however, it was already in decline. Yuan and Ming critics considered it ugly and unworthy of their attention, and Chan painting was to be influential in China only once again, when the "Individualist" artists of the 17th century rediscovered it.

Buddhist paintings executed on commission for the instruction of the faithful in temples of other schools of Buddhism are in great contrast to the allusive Chan style. The message of these pictures is rather like a poster with a clear iconographic point to be grasped, and refers to the commonplaces of Buddhist tradition, the bodhisattvas, incarnations of Buddha, *jakatas* (scenes from the Buddha's life), or symbolic plants such as the lotus, representing them in a decorative and colorful form. During the Song period the harbor town of Ningbo in Zheijang was a center of the production of these devotional and votive pictures. Various private studios produced stylized series of such pictures, which Chinese art criticism ignored on the grounds that dilettantes were assumed to be superior to professional artists.

By comparison with the illustration of the sutra of the Ten Kings of Hell from Dunhuang, Shiwang jing, the picture shown here (see opposite, top) shows a Chinese version of the figure of the judge. He sits in traditional official's robes, in front of a screen showing a landscape, studying the written records of the deeds of the delinquent

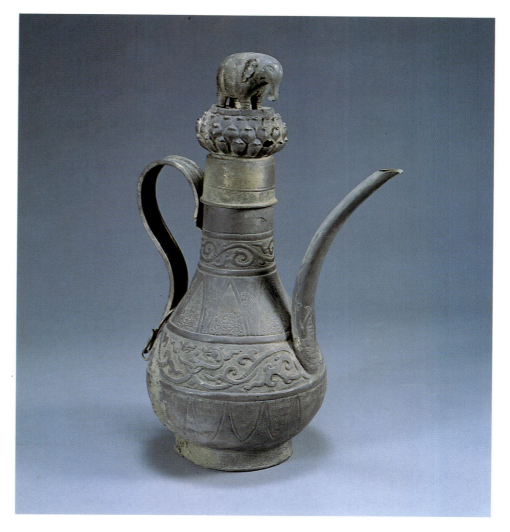

before his desk. In the foreground of the Seventh Hell horned, demonic torturers with skins of various colors are occupied with the punishment of other evildoers.

Series such as pictures of the Kings of Hell were available in grades of different quality, to suit the purses of the patrons who commissioned them.

The atmosphere of luxury

As always, the wealth of a patron and the quality of the items he acquired went hand in hand in China during the Song period.

In the milieu of art-loving rulers and aristocrats, of scholar officials who practiced painting, and of prosperous merchants, luxury extended to the private apartments of their families. The decorative arts were highly regarded in their culture; beautiful objects reflected the prestige of their owners and differed from calligraphy and painting merely in their social function. The private homes of the elite were adorned with lacquer, bronze, ceramics, and sets of vessels in precious metals that clearly acknowledged their Persian models. They were for show, as art was not expected to be: painting and calligraphy were to be enjoyed by artists and the owners of works of art in quiet moments; items of applied art ornamented their

Silver pitcher of west Asian shape
Song period, H 33.5 cm, Pengzhou Municipal Museum, Sichuan

The decorative motifs are as much Buddhist and central Asian as Chinese.

Watering can in the shape of a goose
Song period, bronze, decorative gold and silver inlay, H 16.3 cm, Victoria and Albert Museum, London

A copy of a vessel listed in the *Bogu tulu* catalog of antiquities.

neously regarded as the ultimate achievement of Chinese ceramics, a tradition deriving from the fact that when Europeans became acquainted with Chinese porcelain in the 14th century, this was the latest style. In China itself, Song ceramics with their shimmering glazes were considered superior, even in the Ming period. A survey of the main centers of ceramic art and the pots they produced may help us to appreciate these less famous ceramics better.

There were kilns manufacturing ceramics all over the country at this time. Today their products, differing in the bodies of the pots and the color of their glazes, are classified, to name only a few, as Ru ware (reserved for the imperial household, and extant only in small quantities), Jun ware, Ding ware, Longquan ware, Guan ware, and Jian ware.

These pieces, often undecorated, rely for effect solely on the beauty of their shape and their glazes. Ding ware was being made in the north as early as the end of the Tang dynasty. White ceramics with a white or ivory glaze were manufactured in the Ding kilns of the province of Hebei during the Northern Song period and under the rule of the Jin. Thin-walled pots of this kind were either left entirely undecorated or had a decorative motif incised in the body under the glaze, clearly visible only in the right light conditions. In contrast, the metal binding of the rim of a vessel, copper, gold, or silver, was not only attractive but practical: it reinforced the rim and decreased the risk of irregular covering by the glaze in this vulnerable area. In the late-11th and early-12th centuries, vessels of many different kinds and shapes were already being made with molds that stamped the decoration on them during manufacture, a process that encouraged the production of larger quantities. Incised or engraved ornamentation, however, looks much livelier than stamped motifs, and the effect of both shape and decoration of molded products tends to rigidity.

Ding ware is usually thought of as white porcelain, but for the sake of accuracy it should be mentioned that the kilns of Hebei also produced pieces with green, brown, and black glazes, although they were the exception.

The kilns making lavender-blue Jun ware were also in the north, in what is now the province of Shanxi. These pieces enjoyed considerable popularity from the early Song until well into the Ming period. Beginning with thick-walled vessels of heavy stoneware with a thick layer of glaze, varying in color from pale blue to lavender, the kilns in the Linru and Yuxian region also produced other ceramic items such as neck pillows. An early phase in which the potters of the Jun kilns made pots in a single color, with a velvety, often creamy effect, was succeeded by a phase in which they applied splashes of copper oxide to the vessels before firing them (see opposite, right). This was sometimes applied precisely, sometimes at random, with splashes here and there. Some items were blue on the inside and purple outside.

However, the color range of the ceramic vessels displayed and used in private apartments was by

White plate in trefoil form

10th century Ding ware, dia 13.4 cm, by kind permission of the Percival David Foundation of Chinese Art, London

Shapes of traditional teacups

The teacups are drawn from examples of Jian ware in several museums.

private rooms day in, day out (see above and right). First and foremost, this appreciation of beautiful things led to the production of fine ceramics. A public acquainted with the great past of the empire through literature and also chance finds, surrounded itself with a revival of early forms of porcelain, stoneware, and bronzes copied from antiquities. Today these objects are timelessly elegant and harmonious in shape and design.

Different kilns throughout the empire rivaled each other in producing sophisticated basic shapes with good proportions and simple ornamentation. In Europe, blue-and-white Ming porcelain is erro-

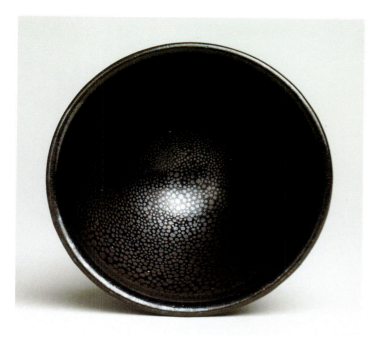

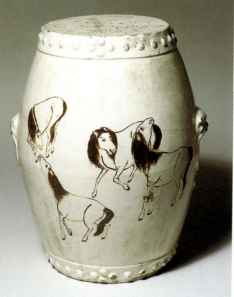

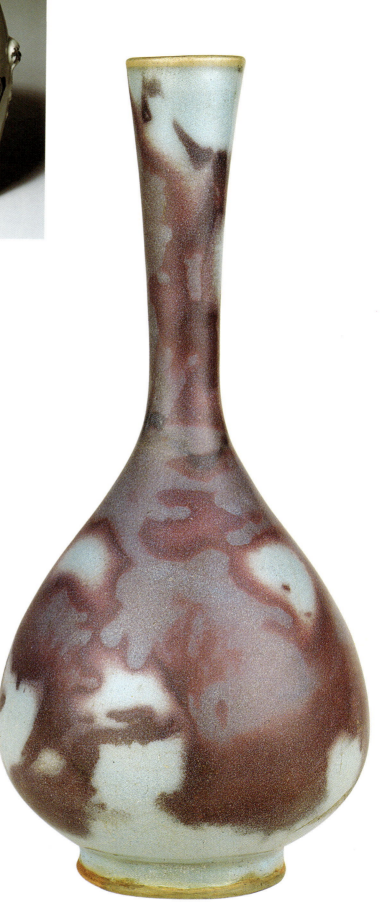

no means confined to white and blue. Henan had many kilns making black vessels with what is known as the "oil spot" glaze (see above left). In shape these pieces are all plain bowls and cups without handles, but the changing surface appearance of their glaze is still fascinating today. Oil spot glaze (Japanese *yuteki*) takes its name from the striking similarity of the round flecks to drops of oil on the surface of water.

Cizhou ware was the mass-produced pottery of the Song period, and it was still being made in the Yuan and Ming dynasty in the same colors and similar decorative techniques. These pots had a white slip coating which was painted with black or brown patterns of flowers and animals, or later with scenes including figures, and then covered with a transparent glaze. Decorations incised in two layers of slip, white and brown, are also classified as Cizhou ware. Such pottery was in use all over the country and was even exported.

When the court moved south there was a shift in the evaluation of the most sought-after ceramic ware. A substitute had to be found for varieties no longer available. In the south, potters were at work making ceramics in different shapes and with different surfaces. By now the custom of tea drinking had assumed the status of a social event in cultivated circles. Tea drinking meant not just enjoyment of the tea itself but of the special atmosphere surrounding the occasion, and elegant little cups were reserved for it (see opposite, lower). They and the tea ceremony were both exported to Japan. Conically shaped Jian ware with a finely streaked "hare's fur" glaze or a speckled "partridge feather" glaze was made in the kilns of modern Fujian for the traditional tea ceremony, and was in great demand. But when the emperor began drinking from white teacups and bowls, the new custom of the court was imitated everywhere and Jian ware went out of fashion.

Above left
Small bowl
11th to 12th century, oil spot glaze, dia 9 cm, by kind permission of the Percival David Foundation of Chinese Art, London

Above right
Garden stool
Yellowish cream body, H 48 cm, Staatliches Museum für Völkerkunde, Munich

The decoration is executed in painting on the glaze.

Vase
12th century, blue glaze with copper oxide splashes, Jun ware, H 29.1 cm, by kind permission of the Percival David Foundation of Chinese Art, London

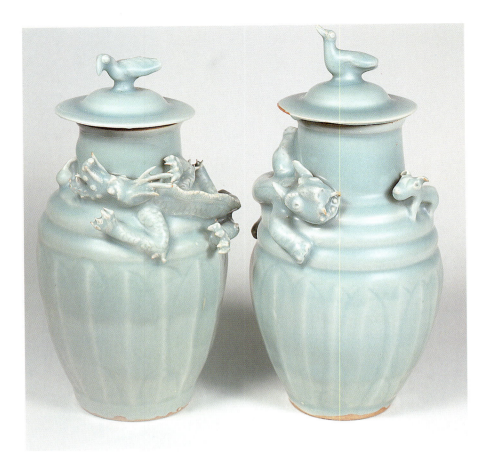

Guan ware was the official imperial pottery of the Southern Song dynasty. Made in the palace in Hangzhou and in small workshops in a suburb of the city, these ceramics provided the court with undecorated pieces of all kinds. They had a blue-gray glaze. The quality depended on their thin walls, the purity of color in the glaze, and the craquelure effect of fine, minute cracks produced by different degrees of expansion of body and glaze during firing and cooling. There were dishes and plates with foliated rims, incense burners of the archaic *gui* type known to the Chinese of the time from bronzes, and bottle-shaped vases displaying typical characteristics of Guan ware (a thin body, almost black after firing, and a blue-gray glaze). But probably the most exotic items were the copies of *cong* pipes made for use as vases (see above, right). The kilns making Longquan ware also copied archaic models very closely. The term Longquan had been in use since the time of the Southern Dynasties for ceramics with a monochrome glaze and appliqué decoration. The Southern Song period brought a demand for incised decoration similar to the Yaozhou ware of the north, and at the same time the potters refined their glazes, eventually firing jade-green surfaces on red-brown bodies. The shimmering blue-green celadon glazes were applied to both archaic and contemporary shapes of vessels.

In Jingdezhen, later known as the "capital of porcelain," white ceramics with a blue tinge known as Qingbai ware were made during the Southern Song period. It was also known as *ying-quing* ("shadow blue"). The raw materials required for making these pots were available in large quantities around the city. Qingbai ware is notable for its thin-walled, pure white bodies, covered with a transparent glaze that has a shimmering blue effect where it ran together more thickly. Classic Qingbai ware was either entirely undecorated, or bore almost imperceptible incised decoration, or was more conspicuously ornamented with carved relief work (see opposite).

The carved or incised decoration of plain monochrome pots did not detract from the artistic shapes of the vessels themselves. Beauty of form was preferred to color as a decorative effect. The preference for carved ornamentation gave particular stimulus to the development of the carved lacquer technique. There were also monochrome dry lacquer pieces with curved walls, but in carved lacquer ware delicate reliefs of landscapes, stylized flowers or a graphic pattern (known as the *ruyi* motif in China and the *guri* motif in Japan) were carved on surfaces consisting of what was usually a wooden body with many layers of lacquer applied in alternating layers of color. The restrained and subtle coloring of these items is visible only on the carved edges of the relief (see left, bottom).

For all this luxury, however, there was an ever-present threat from outside: the threat of "barbarians" who valued none of the treasures of the Song apart from silk and bars of silver.

The Invading Horsemen

The years before the Mongolian conquest (10th–13th centuries A.D.)

The peace, equilibrium, and prosperity of the Song empire were exposed to constant threat, partly because of the state of affairs on its frontiers, which was seldom peaceful. The Song sought to extend their sphere of influence, while the aim of their seminomadic neighbors was the speedy acquisition of food or goods for barter.

As early as the Tang period the emperors had made constant efforts to expand their domains, but they met with little encouragement from the many tribes on their borders. The mightiest of these "barbarians" made frequent and successful raids on the Tang empire, leading up to the destruction of the Tang capital of Chang'an in the late-8th century A.D. when Tibetan aggressors reached the city. When the Tang empire collapsed from political exhaustion at home and abroad in the early-10th century and fell apart, the foundations were laid for 300 years of pressure to be exerted on China from the northwest, the north, and the northeast. Neither the rulers of the southern representatives of the Five Dynasties, eventually superseded by the stronger Song dynasty, nor the Song themselves succeeded in quelling the ambitions of the Khitan (in Chinese, Qidan), their neighbors

and successors. In A.D. 907, under their leader Apaoki (in Chinese Abaoji), the Khitan founded the Liao dynasty and took control of the area south of the central course of the Amur river and north of modern Beijing. Their capital Yanjing was the first to be situated so far northeast, and although its name was changed it was never to be permanently surrendered again, since it was strategically well placed to secure the north of China. Yanjing was west of the modern city of Beijing (see below).

The nomadic shepherd tribe of the Khitan had already picked quarrels with the Tang, and now they considered themselves a dynasty they were more of a threat than ever. At the beginning of the 11th century, in the year 1004, the horsemen of the Liao had reached the center of Henan and were almost at the banks of the Huanghe River. A peace treaty made that year halted their advance. It recognized them as a rightful dynasty and acknowledged their sovereignty over 16 prefectures, also guaranteeing that the Song would pay them annual tribute of 200,000 rolls of silk and 100,000 ounces of silver. The peace lasted for 100 years and was broken – by the Chinese – only when the Liao themselves came into conflict with their former vassals the Jurchen. The Song saw a chance to regain their prefectures with the aid of the Jurchen (later the Jin dynasty), thereby saving a considerable amount of goods and money. However, they were ridding themselves of one evil only to replace it with another. The Jin became strong enough to strike terror into the Song rulers. The Liao had been defeated, but the Song would have the area around Beijing returned to them only so long as they paid a sum which cancelled out taxes payable by the Jin. The Song emperors were clearly not very conscientious about fulfilling their obligations, and the Jin appeared at the gates of the capital Kaifeng in 1126/27 demanding their land and money. The powerful nomadic horsemen of the northeast repeatedly attacked the Song empire, and it was increasingly difficult to preserve its unity. The border of the Jin empire moved further and further south. Once the court itself had retreated south from Kaifeng the horsemen traditionally described by Chinese historians as "the worst and most violent of all barbarians" reigned supreme over the north of China, their rule disputed only by other nomads hostile to them.

Today there is a good deal of excavation of "nomadic settlements," a phrase which ought to be a contradiction in terms, but their burial customs show that the Khitan, for instance, did have certain favorite places where they built richly furnished tombs for their leaders.

The treasures of the Khitan are subject of archaeological research in China in the province of Liaoning and the Autonomous District of Inner Mongolia, and the evidence points to their being not a "barbaric" tribe of nomads but a

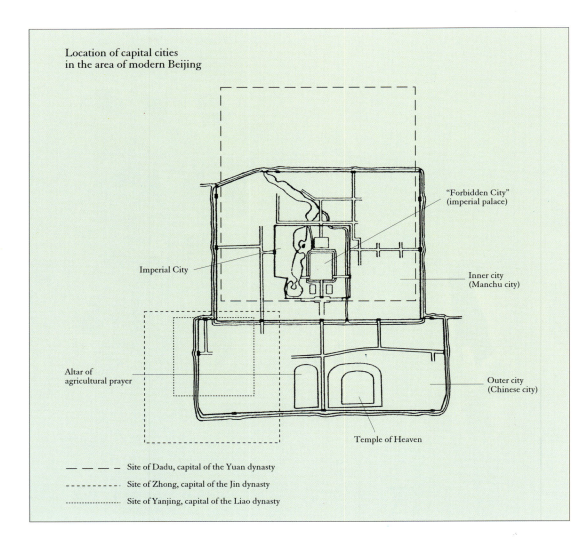

Location of capital cities
in the area of modern Beijing

"Forbidden City"
(imperial palace)

Imperial City

Inner city
(Manchu city)

Altar of
agricultural prayer

Outer city
(Chinese city)

Temple of Heaven

— — — Site of Dadu, capital of the Yuan dynasty

- - - - - - Site of Zhong, capital of the Jin dynasty

· · · · · · · · Site of Yanjing, capital of the Liao dynasty

seminomadic community with a highly developed culture, the forerunners of Ghengis Khan. Both the Khitan and the Jin furnished the tombs of high-ranking clan members with fine objects of gold and silver, jewelry, and everyday utensils.

Metalwork in gold and silver in particular illustrates the links these tribes of horsemen had with the Middle East, especially Persia, where those branches of craftsmanship were very popular and were practiced with great skill (see above, right). The decoration of such pieces derives both from Buddhist motifs and from the Sassanid art of the Persians, but in shape these vessels are modeled on objects of Islamic art. Vine tendrils, ornamental undulations, rosettes, and borders of plant motifs adorn tall jugs with narrow spouts, dishes, plates, cups with foliated rims, shapes which in themselves suggest a floral character.

The craftsmanship, which was communicated through religious art, is astonishing in its technical mastery. Rolled silver and gold were beaten out very flat, and although the material was so thin it was lavishly engraved with ornamentation on Buddhist themes (see above, left). However, handicrafts were not the only arts to flourish in the north

under these two dynasties. The tribal way of life was changed by contact with Chinese culture and ideas along the path taken by the conquering Liao and Jin. Painting, wall painting, sculpture, and graphic art in the form of illustrated Buddhist texts were not suppressed under the Liao and the Jin; many temples were in fact rebuilt.

It is particularly interesting to note that the two great ethnic groups under the sway of the Liao rulers did not mingle: the nomadic tribes kept to themselves both territorially and socially, and so did the subject Chinese population. Nomadic and Chinese arts were therefore cultivated side by side but separately, and came together only in the milieu of the ruling class. The Chinese subjects of the Liao, for instance, continued the tradition of the Tang and used glazes in three colors for vessels or sculptures. An example of one of these glazes on an item not in general use among the Khitan is an ink rubbing stone (see page 178, bottom). Rubbing stones were used to grind solid ink, which was then mixed with water. The ceramic variant here is unusual in itself, since rubbing stones were generally made of slate or other minerals, hence the name, and in addition Liao rubbing stones are

Left
Sutra pagoda

Liao dynasty, gold and silver, H 39 cm, dismountable, containing folded silver sutra scroll measuring 11.3 x 362 cm, Province of Liaoning Department of Cultural Assets

Right
Beaker with foliated rim

A.D. 941, gold, plum blossom shape, H 4.9 cm, weight 71.6 g, provenance, tomb of Yelu Yuzhi, Archaeological Institute of the Autonomous District of Inner Mongolia

The bottom of the beaker is decorated with fish. The outside wall has delicately engraved tendril ornamentation.

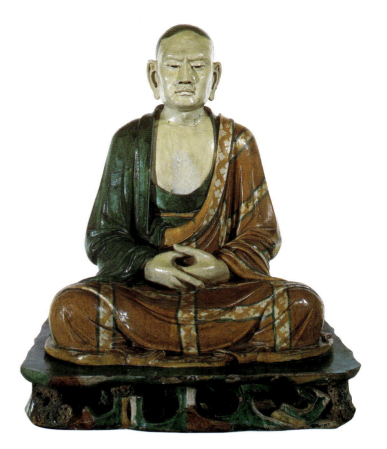

extremely rare. This specimen shows that craftsmen had now mastered the lead glazing technique in which the running of the glazes imparted a unique charm to Tang grave goods. By now kept well within limits, there is still a soft transition between colors. However, larger and better pieces existed, demonstrating the potters' skill in working with colored lead glazes and their abilities in portraiture (see right).

Our picture of the Liao period is constantly changing as new finds are made, but we can conclude from the circumstances and provenance of these finds that although the nomadic shepherd tribes did not have a long tradition of manufacturing ceramics, they were already very skilled in artistic metalworking. They then encountered the inhabitants of the northern half of the Chinese empire where, conversely, metalworking was not as well developed as ceramics. Metal vessels, less fragile than pottery, were more suitable for the nomadic or seminomadic life. The successive adaptation of the two cultures to each other was brought about through the Buddhist faith and the aristocratic upper classes of the Qidan. Envoys sent to collect tribute kept the aristocracy of the Liao in contact with their neighbors, making a certain degree of cultural exchange possible.

A man related to Abaoji, founder of the Liao dynasty, is said to have been a good painter who depicted the nomads and their horses with great mastery. A later ruler of the Liao (Xingzong, ruled 1031–1054) himself painted in color, like his imperial colleague of the Song empire. His picture of a multihorned stag was given to the Song ruler Renzong (reigned 1023–1063). One Liao painter is even said to have painted in the style of Tang artists, and others became familiar with Song paintings. If we compare the few extant Liao paintings (not all ascriptions can be verified), for

instance those of Hu Huai, it is clear, in pictures of horses, that the artists' rendering of anatomical features was very precise. Whereas Tang horses had thin legs out of proportion with their powerful bodies, paintings of the Liao period correct this disproportion. In our present state of knowledge of Liao painting, we may assume that its subjects were largely human beings, horses, and landscape. Because so few paintings are extant, and their attributions are not certain, the quality of Liao art should not be judged from them. Chinese scholars sometimes describe them as inferior to the painting of the Wudai and Northern Song periods, but one senses that an allusion to the conflict between "civilized" artists and "barbarians" can be read between the lines. The motifs of pictorial scrolls also occur on tomb walls. One feature of wall paintings in tombs of the Qidan is the depiction of the four seasons of the year: the landscapes show typical features of the seasons and their characteristic flora and fauna. The relevance of such images to a nomadic culture is immediately obvious: a way of life so subject to the natural cycles of the seasons would naturally wish to see them reflected in another dimension of being. Even after death, a man thus remains part of the cycle of the world. Should we take these as the origin of the series of seasonal pictures popular with the Song? Could Liu Songnian have known them? These questions can probably never be answered for certain. The tombs of the Han nationals in the north of the same period (Chinese tombs) remained very much within the Tang tradition in their furnishings, both wall paintings and grave goods. The Liao had abandoned their

originally shamanic religion and turned to Tantric Buddhism. This esoteric sect saw the way to enlightenment in the rhythmic repetition of mystic formulae (Sanskrit: *tantra*) and sayings (Sanskrit: *mantra*), accompanied by music and gestures. Many-headed and multiarmed statues of bodhisattvas were typical of the Buddhist sculpture of this school. The influence of Hinduism is assumed to have been particularly strong in Tibetan and Nepalese sculpture, and there was a boom in such works, particularly under the Mongol dynasty of the Yuan period. Many leading craftsmen of the time came from Tibet, Nepal, and Central Asia. However, some pieces can be ascribed to Liao dynasty artists (see right).

Some huge timber-frame buildings of the Liao period have been preserved in the north of China. Native builders and traditional Chinese architecture were used for temple complexes and monasteries. The Liao emperor Xingzong ordered a great pagoda to be built in his capital, and it was completed in 1056. This wooden pagoda, seen from outside, has five stories and six overhanging roofs. Inside, there are mezzanine floors, so that it has nine stories in all. Each of the five main floors has a Buddhist group of figures in the middle, forming an axis of religious portraits. The building is about 67 meters (73 yards) high and is thus the tallest well preserved wooden building in China. As an expression of the respect the Liao rulers felt for Buddhism, the temple was centrally situated in their capital, and its main building, the pagoda, towered above all the surrounding structures (see opposite, top left).

The pagoda, which is very sophisticated in its construction and its static equilibrium, proves again that the architecture described in text and pictures in Li Jie's manual of building, the *Yingzao fashi*, was real and not merely ideal. Continuity of architectural tradition was not broken by the new rulers in the north, perhaps because of their nomadic origins. They simply took over the well-established architecture of their subjects, who had centuries of building experience. The Liao were succeeded by the Jin dynasty, their former vassals, another nomadic tribe of horsemen with a similar culture. However, the power of the Jin did not survive unimpaired. History repeated itself. Vassals of the Jin, a confederation of tribes in Mongolia who would later call themselves Mongols, chose an experienced warrior from among them as their leader: Temudjin, better known as Ghengis Khan. The devastating advance of Ghengis Khan, leading Mongol forces from the north, broke the power of the Jin near Beijing in the first quarter of the 13th century. However, there was no final victory over the Jin, and the Song empire in the south was not in immediate danger, for the Mongol leader turned his glance westward first. Once parts of their tribal federation had conquered Central Asia, the Mongols turned to attack the Jin again. With the agreement of the Song emperor they passed over imperial Chinese territory in their move against the Jin, and in the year 1234 took Kaifeng, then the Jin capital, attacking so to speak from behind. In 1260 the Mongols made Beijing their capital, and Kublai Khan founded the Yuan dynasty in 1271. He then in traditional fashion fought his way through to the south, and in 1276 took Hangzhou, the last Song capital.

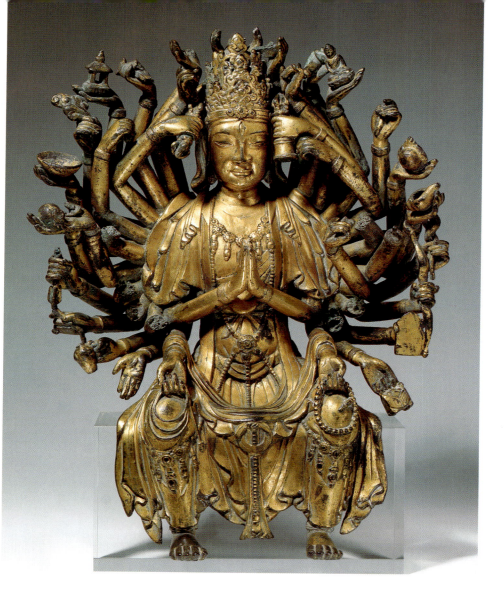

Multiarmed bodhisattva

Liao dynasty, gilded copper, Museum für Ostasiatische Kunst, SMBPK, Berlin

Construction of a hall

From the Song period architectural manual Yingzao fashi

1 "Flying" rafter (*feichuan*)
2 Rafter (*chuan*)
3 Longitudinal beam (*fang*)
4 Bracket plate (*dou*)
5 Bracket arm, parallel to the facade (*gong*)
6 Bracket arm, 90° to the facade (*huagong*)
7 Lever arm (*ang*)
8 Pillar capital bracket plate (*dou*)
9 Cantilever
10 "Moon beam," crossbeam (*yueliang*)
11 Main longitudinal beam (*efang*)
12 Pillar (*zhu*)
13 Coffered ceiling
14 Purlins (*heng, lin*)
15 Roof ridge purlin (*jiheng*)

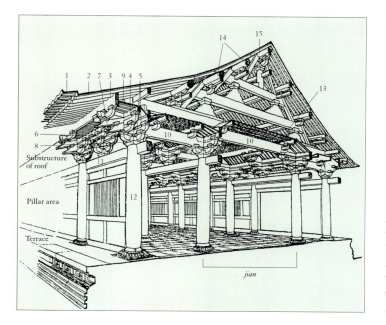

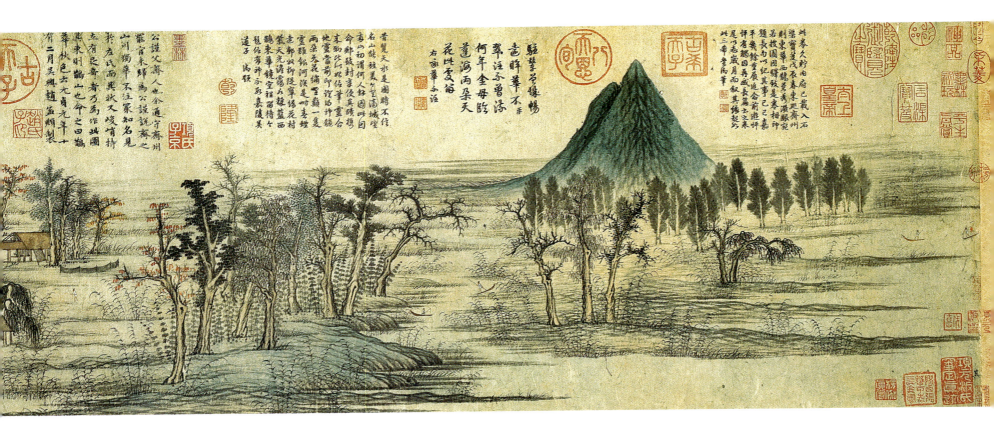

The Yuan Period: Under Mongol Rule

Artists at court and elsewhere
(1279–1368)

Autumn Colors in the Xiao and Hua Mountains (Xiao hua qiu se)

Zhao Mengfu

Dated 1296, ink and paint on paper, horizontal scroll, 28.4 x 93.2 cm, Taipeh Palace Museum

The picture bears a number of artist's seals and the seals of many collectors. See opposite for detail.

Ghengis Khan's grandson Kublai Khan (also known as Khubilai Khan) founded the first Mongol dynasty to rule on Chinese soil, and Beijing became his capital under the name of Dadu (also Khan-Balyq). The former Jin capital did not satisfy the new ruler's requirements, and he had new fortified walls and extensive palace complexes built near the Jin city. In doing so he laid the foundations of the Beijing that was to be the capital of following dynasties and rulers up to the present day (see page 176).

Kublai, Great Khan of the Mongols, may well have been fascinated by the culture of his subjects, but their vast numerical superiority must always have represented a latent threat. In response, he used the centralist form of government established by the Song and developed it further. The Mongols were the upper classes, occupying all key positions in the administration, and their power was reinforced by many garrisons stationed all over the country. The class sought to exploit and oppress the subject peoples, but it was easy enough for the numerically greater mass of the population to organize rebellions, and the seal was soon set on the end of Mongol rule. After the fall of the Yuan dynasty the Mongols withdrew to their hereditary regions north and northwest of the Great Wall, where they remained a power in Central Asia.

Certain cultural trends were prominent at this time, among them music drama, which originated in farces and folksong, and became a means of crit-

icizing the ruling class and maintaining Chinese ways of thought. New crafts such as cloisonné enameling and carpet making, practiced mainly by Central Asian ethnic groups, were also introduced. As the Mongols ruled all Asia north of the Himalayas and sections of their tribal confederation also dominated the west of the continent, east and west were now in direct contact for the first time. Mongol connections with their kin in western Asia brought security to the internal Asian trade routes for the first time, resulting in a marked increase in exchanges between Asia and China. Not only goods but technology and knowledge were distributed in both directions. News of Islam and of western concepts of astronomy reached Khan-Balyq, and Muslim architects were commissioned to design buildings. But the new foreign religion itself made no headway. The Mongols of the east remained attached to the lamaist form of Buddhism, a synthesis of Buddhism and the *Bon* religion of Tibet. Many items that can be dated were votive offerings or donations to religious institutions.

The 13th and 14th centuries also saw the first Christian missions arrive in East Asia. They were tolerated by the rulers of China, and the missionaries included the Franciscan Johannes Pico of Montecorvino (1247–1328), the first Archbishop of Beijing. The documentary evidence for their work is far less controversial than the question of whether Marco Polo ever really went to China; no

Chinese sources mention his visit. The missionaries had little influence on the Mongol-ruled empire, and after the fall of the Yuan dynasty Christianity in China soon died out entirely.

In one way, art was encouraged by the policy of the Mongol rulers in opening up the empire to the outside world and allowing foreign traditions to continue. However, the Painting Academy of the Song period was no longer in existence; it had been dissolved, and an attempt to found another Academy failed because there were not enough painters happy to work for foreign rulers.

What, then, happened at this time to the artists and painters who had played such a leading part in the cultural life of the Song period?

They were in a state of insecurity because the foundations of their existence had disappeared – the old-established rules were now relaxed and they were unused to the freedom of deciding their own subjects and style approach. A few had positions at court, but many left to live and paint in the country, far from city life. Suddenly the security and prestige enjoyed by painters in the Song period were gone. Instead they had artistic freedom, room for personal development in the choice of themes and methods... in short, room for individuality.

Calligraphers and painters had reached a turning point, and it can clearly be seen in the new stylistic directions of painting by the literati. The age of the poetic landscape was over.

However, the changes of style that occurred in the 13th and 14th centuries were not simply a response to the new political climate; they were also the result of developments introduced during the late Song period.

Concentration on small sections of landscape, bringing plants or animals close to the eye of beholder, had ushered in the development of new, independent genres in painting. Representations of the Four Noble Kinds (bamboo, a branch of plum blossom, orchid, and chrysanthemum) and of pine trees and lotus were now regarded as separate genres in their own right. These plants all had great symbolic value that could be given a political interpretation, representing resolution, renewal, purity, retreat from the world. They also represented the values of Confucianism. Painting moved still further away from the physical reproduction of objects, whether of landscapes, plants, or living creatures. Elements placed beside each other or in contrast were preferred; simplified, clear forms replaced realistic, true-to-life depiction in the decorative style.

Many officials with Confucianist leanings, including the scholar-painters, refused to work for the new emperor. Many withdrew from public life and went to their private estates in the country, others emigrated to Japan, many simply refused to accept imperial commissions. But there was also another group of artists who were happy to work for the new ruling house and did not hesitate to accept appointments at court.

Those who did accept commissions from the new ruling house included the painter Zhao Mengfu (1254–1322), whose euphonious artist's name was "Daoist of Pine and Snow." A descendant in the eleventh generation from Emperor Taizu of the Song dynasty, he may perhaps have seen himself as an intermediary who might win the Mongol emperor over to Chinese culture. He came from the south to the capital in 1286 at the emperor's invitation. Zhao had been renowned as a scholar who held high office, and had even been given the title of Duke of Wei. He distinguished himself as a painter in the bird and flower and figure genres, and posterity also regards him as a master of horse and landscape painting. His biographer Yang Cai (1271–1323) wrote that he shone in all genres alike.

His painting displays one aspect of a phenomenon that can be described as the superseding of the opposition of north to south by the contrast between life in office and life in retirement from the world. As an official painter, laden with honors, he turned away from the painting of the Southern Song literati and back to the painting of the Tang period, and he also had an affinity with Wudai works. He can be described as a traditionalist, together with the painters Ren Renfa (1254–1327), whose horse pictures for the emperor had a documentary purpose, Qian Xuan (1235 to about 1301), and Wang Zhenpeng (about 1280–1329). He closely followed the style of Qian Xuan, who never served the new masters of China but who was one of the first to take the painting of the Tang period, both in color and in composition, as the point of departure for his work. Such artists were reverting to the archaic (see opposite). Zhao's models included the painters Lu Lengjia and Wang Wei of the 5th and 6th centuries A.D., and Dong Yuan. To Zhao, the archaic *gu yi* meant restraint in his formal expression and simplicity of technique as a way of illustrating the essential reality of his subjects and the spiritual content of nature. His aim was not to make a faithful copy of nature or to achieve clear development of form, but to concentrate on "naked individual elements" which he portrayed with dry brushstrokes in pale colors contrasting with deep black.

Zhao did not look so far back for inspiration when he was painting monochrome ink works. The composition of mountains in his hanging scrolls shows them ranging into the background, and the spatial effect of depth is reinforced by empty spaces depicting mist. He borrowed his brushstroke techniques from Dong Yuan, making a strong contrast between the water and trees and the mountains. Gnarled pines or fruit trees dominate the foreground, water the middle ground, and mountains the background of his works. Zhao shows that landscape painting was constantly changing at the time. His subjects were not just scenes of landscape, but the old age of the natural cycle and its ability to begin again, "bearing new blossoms and fruits every year."

Autumn Colors in the Xiao and Hua Mountains (Xiao hua qiu se)

Zhao Mengfu

(Detail), dated 1296, ink and paint on paper, horizontal scroll, 28.4 x 93.2 cm, Taipeh Palace Museum

A detail of the painting shown opposite.

In borrowing from Dong Yuan, Zhao Mengfu was very much a man of his time, since Dong Yuan was the most important of all examples for monochrome landscape painting, particularly in the works of the scholar-painters of the Yuan period. Zhao Mengfu had better opportunities than many for studying works of Tang, Wudai, and Song painting, since his noble descent opened many private collections to him on his journeys in the south, and he also had entry to the imperial collection in Beijing. The heterogeneity of his work may be the result of these different impressions and of his constant search for new, individual means of self-expression. His pictures of horses were especially popular with the new rulers; they had, after all, conquered their empire on horseback. While he took his initial inspiration from Han Gan's horse paintings, in this field Zhao did develop his own style of composition, but the "portraits" still show the animals with the powerful bodies of the Tang period.

Zhao Mengfu also dominated the calligraphy of his time. Specimens of his script survive both on his pictures – for instance, in the inscription to the right of the round seal on the scroll *Autumn Colors in the Xiao and Hua Mountains* – and in works of pure calligraphy. Calligraphy of the Yuan period is extant in the work of over 300 calligraphers known to us by name from Tao Zongyi's work on the history of calligraphy, compiled in the Ming period. They cannot all be surveyed in a few pages, particularly as the calligraphers produced as diverse a body of work as the painters. Zhao himself had, of course, mastered the great historical styles, and in his calligraphy, as in his painting, he looked to the past, taking the scripts of the Jin and Tang periods as criteria. He developed a clerical *kaishu* script of great proficiency, whether the characters were written in a large, medium or small format, that derived from Wang Xizhi and Yan Zhenqing: well-proportioned characters, inclining upward from left to right at a slight diagonal, with regular spaces between them, none extending beyond its allotted virtual square.

Zhao Mengfu is thought to be one of the first artists to have added to his paintings inscriptions in poetry composed by himself. In this he was

transferring to a single medium the *sanjue* ideal formulated in the Tang period, mastery of the "three perfections" of poetry, calligraphy, and painting. The pictorial work now surpasses the mere demonstration of its creator's artistic, poetic, or calligraphic abilities, and becomes a means of expressing his inner soul; the painter is no longer simply painting an object but subjectively depicting himself. As well as landscapes in an archaic style of composition, with blank parts of the paper conveying an impression of light and distance, Zhan also painted bamboo and pines.

Here he had contemporary rivals: the famous bamboo painter Gao Kegong (1248–1310), and his own wife Guan Daosheng (1262–1319). She probably came from Wuxing, and was well known under one of her many other epithets as Guan Furen. She was considered a good poet in the *ci* style, a good painter of Buddhist pictures, landscapes and ink bamboos, and she produced works of calligraphy in the *xing* and *kai* styles (see below).

In the time of the Song dynasty, the scholarly tradition of Confucianism would not have given her the chance to become an acknowledged artist – and in that tradition she is known to this day by her husband's name – but in the Yuan period she was able to introduce a thematic innovation, almost a new type of composition, within the bamboo painting genre.

In 1308, according to the artist's own account of it in the inscription on her picture, Guan Daosheng painted a picture during a boating party on a lake, as a gift for a lady of noble blood. It showed thick clumps of bamboo growing beside water, an allusion to the wives of Emperor Shun who, according to legend, drenched the bamboo on the banks of the river Xian with their tears after his death and then threw themselves into the river, thus becoming a symbol of wedded constancy. The tradition of adding inscriptions to pictures began in the Song period at the latest. They are written above the artist's signature and seal, and are basically divided into two types: first, inscriptions added directly to the surface of the painting, *ti*, sometimes including the title mounted on the scroll; and second, inscriptions added separately and known as *ba*, colophons. Inscriptions on a

Opposite
Some of Everything
Wang Zhenpeng

16th-century copy of the picture of a toy merchant signed with the artist's name of Guyun Chushi, ink and paint on silk, hanging scroll, 180 x 117 cm, Museum für Ostasiatische Kunst, SMBPK, Berlin

Below
Bamboo Grove in Mist and Rain
Guan Daosheng

Dated 1308, horizontal scroll, 23.1 x 113.7 cm, Taipeh Palace Museum

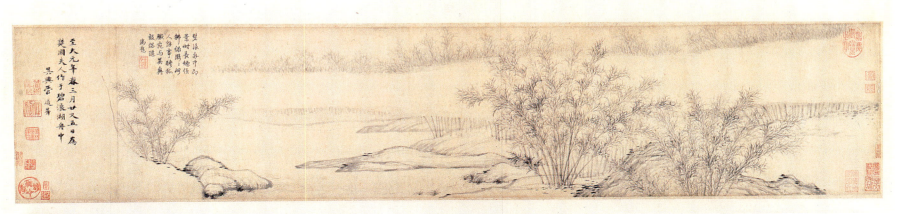

painting may vary in content and literary style, and were not necessarily added by the painter himself. In the case of Guan Daosheng's bamboo painting, the inscription is a short prose account, *tihua ji*, describing the circumstances in which the work was created; but classical poems might also be inscribed in calligraphy on a corner of the picture, or poems by the painters themselves could be added to emphasize the statement made by the work. Both inscriptions and, more particularly, colophons could range far beyond their connection with the content of the picture. When prose texts were not by the painter himself, they might reflect the moods aroused by the picture in a viewer who then felt moved to become artistically active himself by adding calligraphy, or they could express the opinion of a collector or a critical judgement of the painter's work.

There were many women painters among the social elite, but as one of the few whose work has come down to us in copies Guan Daosheng deserves a fuller account of the rest of her creative work. She is also said to have produced Buddhist wall paintings and works of calligraphy at the request of the Mongol emperor. Her repertory included *xiaojing hua* landscape sections, as well as orchids, branches of plum blossom, and ink bamboos, executed with a well-balanced calligraphic line and in rich ink, the powerful black silhouettes forming a sharp contrast with the ground of the painting. A work entitled *Three Bamboos from One House* (Yi men san zhu juan, now in the Beijing Palace Museum) has been ascribed collectively to Guan Daosheng, to her husband, and to one of their sons (Zhao Yong, 1289–1364). It is unusual to find work by three painters on the same scroll with the same subject in Chinese painting, although a picture and its inscription are often by different hands; or an artist may demonstrate his ability to copy various different examples, setting them down in an album or horizontal scroll.

After the dissolution of the Academy, study through copying, one of the most important ways of learning and refining the traditional techniques, was very difficult for painters if they did not have access to the imperial collection that had formerly been linked to it. The majority who became good painters were officials in the service of the Yuan emperors, and opposite them stood the outstanding scholar-painters of the educated elite of the south, representing the "reclusive" side of Yuan painting. In both cases the reason may well have lain in a knowledge of the original works: the officials knew the imperial collection, and the reclusive painters knew private collections.

Wang Zhenpeng, whom Emperor Renzong (reigned 1312–1321) honored with the artist's name of Guyun Chushi, "Hermit of the Lonely Clouds," was another painter who was also a court official. Although his rank was quite humble, his access to the palace library enabled him to copy pictures, and his work shows the continuing tradition of Song documentary and figure painting. He

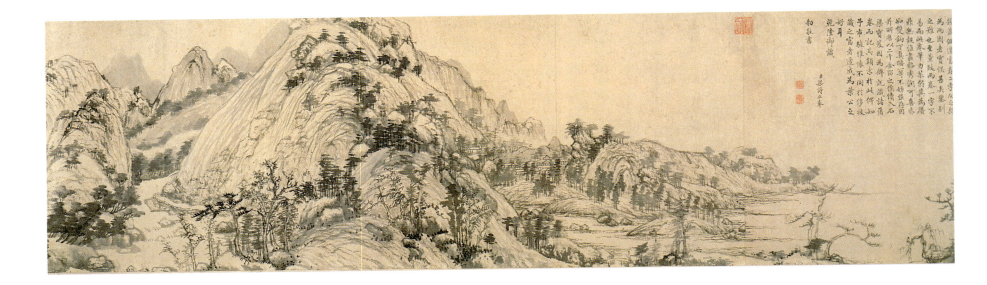

Retreat in the Fuchun Mountains
(Fuchun shanju tu)

Huang Gongwang

(Detail), dated 1350, ink on paper, horizontal scroll, 33 x 639.9 cm, Taipeh Palace Museum

The *Retreat in the Fuchun Mountains* is one of Huang's most important pictures, showing characteristic features of his style: broad landscape composition (landscape was the only subject he thought worthy of painting) in the style of Dong Yuan, with free, calligraphic brushwork, a combination of lines running in different directions to depict physicality, the use of the "hemp fiber" textural stroke typical of the literati, and trees stylized to show only a few types.

is thus a traditionalist in Sirén's sense of the term. He painted architecture meticulously in the *jiehua* manner, as well as festivals and scenes with figures. Wang employed many techniques in figure painting, including the *baimiao* style of fine outlines, for which he is chiefly known. The Northern Song painter Li Gongling, who himself followed Tang models, was a strong influence on Wang, whose figure scenes by no means disown a stylistic allegiance to Northern Song and early Southern Song art.

The subject of the toy merchant may have been painted first by Su Hanchen (known to have been a member of the Academy in the middle of the 12th century), and other painters produced their own variants on it during the Southern Song dynasty (see page 183).

Although this picture is in color, Wang preferred monochrome in the majority of his works, so there is doubt of its authenticity. At least the quality of the copyist is evident in the masterly brushwork of the outlines, and it is true that scarcely any painters of the period were committed to a single style. Authenticity may be an important criterion of Chinese painting, yet the beauty of a copy can actually enhance the original. Wang's fame was founded chiefly on his mastery of the *jiehua* style, some of his contemporaries considered him outstanding, and in that genre his style benefited by transmission through copying. He used smaller formats than Guo Zhongshu, painting on album leaves, but his depictions of buildings are ornate and full of detail. When he painted palaces of the Han period or halls of the Tang period, their historical character rested exclusively on the description given to the picture, not on the architecture shown in it, which resembles that of the contemporary Yuan dynasty or of the Song dynasty.

The artists who were close to the court initiated a revival of Tang painting. Those artists more distant from the court both literally and in their ideals, the "recluses," looked to the painting of the Wudai and Northern Song periods, and in them we may trace the development of a very different phenomenon – individualism – gaining ground.

Painters in the rest of the country

The artists whom modern art historians often group together as the "Four Masters of the Yuan dynasty" – Huang Gongwang (1269–1354), Wu Zhen (1280–1354), Ni Zan (1301–1374), and Wang Meng (about 1308–1385) – lived and worked in the Jiangnan region, at the center of intellectual resistance to the Yuan rulers. Ni Zan formulated the new aesthetic principle that was to mold all the creative work of the literati: the aim of painting lay not in the accurate reproduction of a subject's appearance, but in the manipulation of natural forms with the purpose of self-expression. Whereas in the Song period the atmosphere of a landscape or the depiction of an idea were important, precedence now went to the painter's own frame of mind. The intellectual concept of painting shifted from the subject represented to the artist representing it. In his execution of the pictorial theme, the painter himself and his individuality moved to the fore.

The Four Masters of the Yuan period shared with Zhao Mengfu an interest in Dong Yuan and in Juran, but that was all the common ground between them. The literati preferred to paint on paper, no longer on silk. They used the "monochrome" of ink in contours and in textural brushstrokes and washes, which they could vary from deep black to light gray, depending on the amount of water in the ink. Once more their compositions were symmetrical or centrally placed; they had rejected the "one-corner" style of the Southern Song period (see page 167). Many of their pictures bore inscriptions that were intended to be part of the composition as a whole.

The four were not a group like the circle around Su Shi, and did not all know each other personally. Only the art critics and historians of later centuries have grouped them together, on the grounds of the features they shared mentioned above.

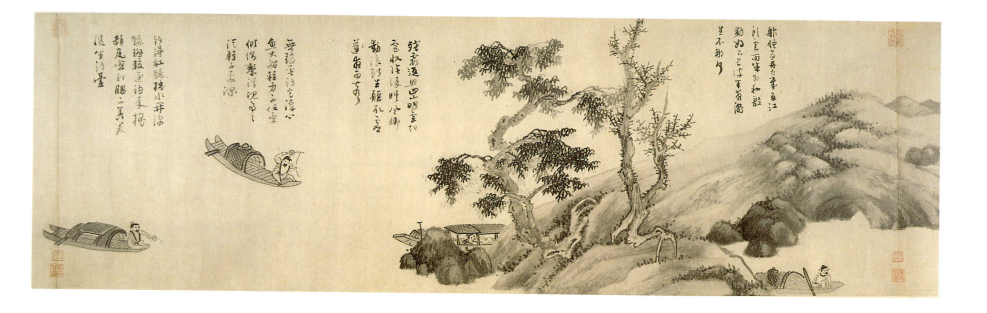

Despite all attempts to see them as a school, they emerge as extremely individual artists. The Daoist Huang Gongwang, who sometimes practiced as a soothsayer after retiring from the administration, liked to paint extensive mountain landscapes using strong and freely varied lines. He probably began painting only late in life. Today some 60 works are ascribed to Huang Gongwang, only a few of them indubitably by his hand (see opposite). Huang Gongwang liked to paint broad water meadows, mountains, and tree-grown hills, with the composition guiding the observer's eye along a zigzag line from the background of the picture to the foreground and then into the background again. He lived in the Fuchun mountains, near the city of Hangzhou, and thus had his subjects ready to hand, for his work was inspired by his immediate environment. He took a long time over a picture: the creative act could last for years. In his theoretical writings – *Xie shanshui jue* (Mysteries of Landscape Painting), extant in an edition of 1366 kept by an admirer – he recommends painters always to carry sketching paper and brushes with them in order to make an instant record of effective and impressive motifs. It is said that he never went out without a sketching scroll himself. When he included an occasional human figure or a building in his mountain landscapes, executed in textural brushstrokes standing out against a wash, he portrayed them with naïve and

Fishermen

Wu Zhen

(Section), 1352, ink on paper, horizontal scroll, 32.5 x 562.2 cm, Freer Gallery, Washington DC

Portrait of Ni Zan

Anonymous

About 1340, ink and paint on paper, leaf 28.2 x 60.9 cm, Taipeh Palace Museum

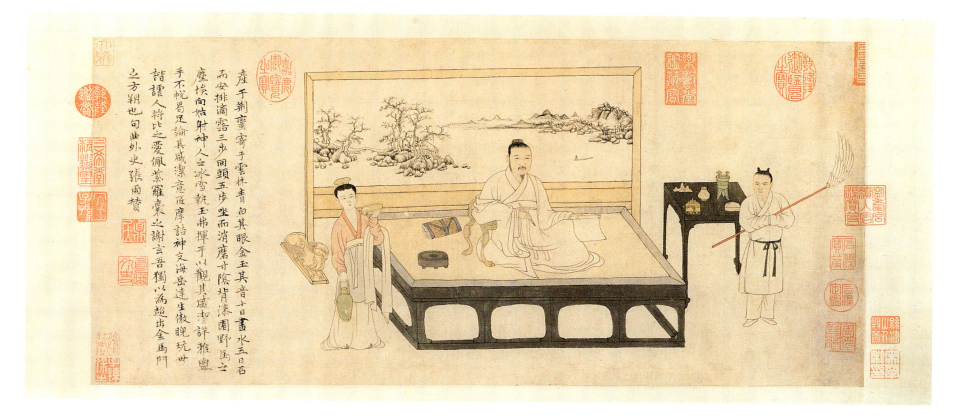

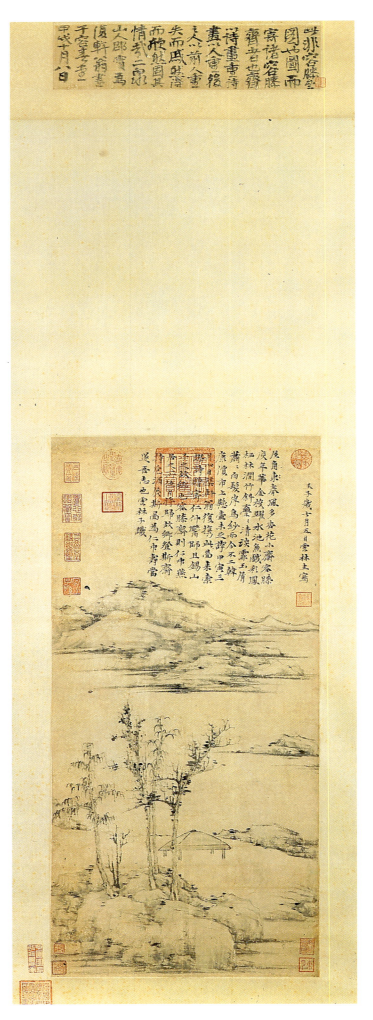

much simplified strokes. The emphasis is clearly on nature and not the work of human hands. Landscape is a symbol of eternity, although when Huang depicts atmospheric conditions or the influence of the weather, he also shows its phenomena as changeable and fleeting.

He found the depiction of light in particular a challenge, and is one of the earliest artists to have been aware of the opportunities it presented.

The second master (ranked chronologically and not in order of merit) was Wu Zhen. He is said to have studied Dong Yuan so closely that his works were erroneously taken for authentic pictures by Dong. Wu Zhen chose to live as a Daoist recluse in the mountains of the modern province of Zhejiang. His favorite themes included fishermen in their boats and single coniferous trees. He relished texture, using broad strokes and depicting distant vegetation diffusely, with dots, and he generally used wet ink. In his representation of nature and people, he clearly defines two opposite poles: natural features are executed with broad strokes and wash, the fishermen and boats drawn in detailed outline, with even the reel of the fishing rod clearly visible (see page 185, top).

Ni Zan's river landscapes are quite different again. Indeed, the actual lives of the artists illustrate the differences between them. The painter and theoretician Ni Zan, who had many artist's names in his career – one of the best known is Yunlin, "Grove of Clouds" – came from a rich family and was surrounded for half his life by the treasures of art and literature they had collected, and to which he himself had contributed (see page 185, bottom).

At the age of about 40 he decided to give away his possessions to his friends and relations and go on his travels. These were the years of the decline of the Yuan dynasty, and it may be assumed that he had two motives for his generosity: a desire first to free himself of the burdens of ownership and enjoy a new, free life in nature; and second, to avoid the threat of expropriation, a method very popular among the Yuan emperors when they wanted to punish subjects who had fallen out of favor.

A distinctive characteristic of Ni Zan's work is a kind of pictorial composition new to Chinese art, showing an empty, desolate view (see left). In such compositions, which are very sparing with narrative elements, the often leafless trees in the foreground are the only visual link between the foreground itself, usually an embankment or sandbank, and the background showing mountains overgrown with vaguely depicted vegetation beyond a wide expanse of water. Strongly accentuated touches of ink, "moss dots," put the finishing touch to the composition. Ni did not cover large surfaces with dark ink and almost always used a dry brush. The dry brush technique earned him a reputation as a painter of particularly economical style, and it lends his works a light, bright appearance. The swirling vapor and banks of mist that are typical atmospheric features of Song painting do not appear in the work of Ni Zan and the other literati of the Yuan period.

Left

The Rongxi Studio

Ni Zan (1301–1374)

Ink on paper, hanging scroll, 73 x 34.9 cm, Taipeh Palace Museum

The composition, with its wide, empty expanses of landscape, is held together by the trees in the foreground.

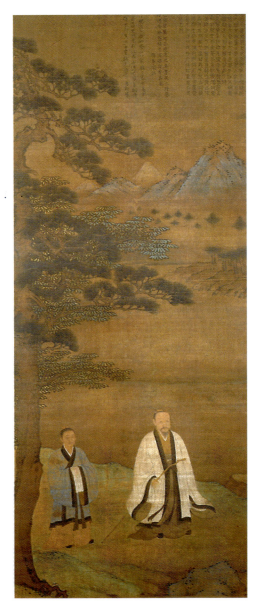

Portrait of Xia Zhenyi

Chen Yuan (mid-14th century)

Ink and paint on silk, hanging scroll, 122 x 44 cm, British Museum, London

The last of the Four Masters, Wang Meng (1308–1385), looked back to the art of the Northern Song period for his inspiration, painting landscapes with mighty mountain ranges centrally placed in the compositions. In view of his artistic work and his place among the scholar-painters, Wang Meng's origins seem rather unusual, since he was a grandson of Zhao Mengfu. Among other artist's names he bore was that of Huangheshan Qiao, "Gatherer of Brushwood from the Yellow Crane Mountains." After a brief career in the administration he lived in seclusion for many years, and took up an official position again only when the Chinese Ming dynasty had replaced foreign rule. However, his life ended tragically in prison, under suspicion of conspiring against the new rulers. During the fall of the Yuan dynasty in the 1360s he experienced a period of particularly rich creativity, producing works of very fine quality. His life differs in yet another point from that of the other three artists, for he was "only" a painter, not a calligrapher or a poet as well. His compositions are often dominated by a sense that nature abhors a vacuum, and he constructed his landscapes to be viewed at several levels. His most original contribution to pictorial composition is the ranging of many "layers" of landscape behind each other in the background, conveying an impression of unusual spatial depth. He also painted elements such as rocks and even the trees of the foreground in very precisely structured detail. In many of his mountain compositions scarcely a scrap of paper is left vacant, although in scenes including stretches of water a free area was imperative to depict the surface of the water. The characteristics of his style are his many tones of ink, muted shades of color, and extremely inventive and varied brushstrokes (curving, straight, short, horizontal, vertical), his use of fine lines and dots, and the "hemp fiber" textural stroke, all of them providing the dynamic element in his work. He painted a wide range of subjects, however, and to group him with the other three masters does not entirely do him justice. Ni Zan thought he had the finest and richest style of his time and considered him one of the major painters – the other artists whom Ni Zan particularly admired were the bamboo painter Gao Kegong for the soul (qiyun) of his pictures, Zhao Mengfu for his facility and the precision of his brushwork, and Huang Gongwang for his freedom.

The picture *Thatched Halls on Mount Tai* is a good example of Wang's command of wide variation and the changing directions of his lines (see right). His view of the thatched halls shows an extensive estate in rugged mountain landscape. From the Tang period at the latest the thatched hut, *cao tang*, was a poetic symbol of life in seclusion, but with positive and life-affirming rather than negative connotations. Even if only temporarily, the scholar exists in harmony with nature like any man of the common people, and can pursue his own pleasures freely.

Particularly interesting is Wang Meng's interpretation of the contrast between mountain and

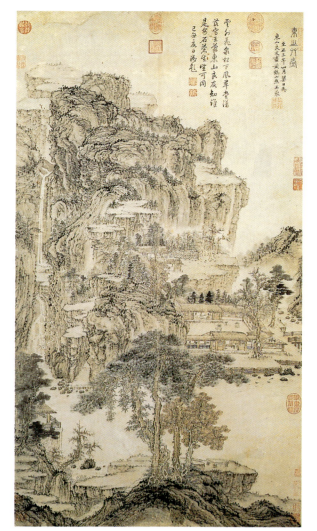

Thatched Halls on Mount Tai
Wang Meng

*Ink and paint on paper, hanging scroll,
111.4 x 34.8 cm, Taipeh Palace Museum*

valley, wild and "domesticated" nature (a reinforced bank, huts, and fences), and the group of pines in the middle of the foreground emphasizes the division between them. The buildings are rather sketchlike and are not depicted in detail. The pavilion with its view of the waterfall on the lower left edge of the picture is a favorite pictorial element, defining a landscape as an extensive piece of landscape gardening in the widest sense: pavilions prominently placed to attract the eye or give a view are typical of the buildings to be found in a natural setting redesigned by man.

Four masters and their four different concepts of landscape painting show us how they experienced landscape. It is still true to say, as Sirén cogently wrote, that while they were all "romantics" from the aesthetic viewpoint and "expressionists" or "idea-writers" (*xie yi*) from the technical viewpoint, they were all individualists in their use of brushes and ink.[1] The "eternal search for the soul of nature,"[2] reflecting the temperament of the artists – all of them eccentric in their views of life – became the subject of their painting. The life of each was reflected in his art. They walked in the mountains, traveled along the rivers, observed the clouds, the changes in the atmosphere, listened to the wind and water, and recorded them as pictorial

symbols of nature poetry. The economical pictures of the first three show that the general tendency was toward simplification; Wang Meng, with his dislike of emptiness, was the exception.

However, Wang stood on the threshold of the next dynasty, in loose connection with a group of painters who composed mighty, dynamic mountain views deriving from originals of the 10th and 11th centuries. As an exponent of this style, Wang was copied until well into the Qing dynasty.

The scholar-painters could have probably made a living from their art, for both Mongol aristocracy and the new middle class of prosperous merchants were anxious to acquire objects that would bestow prestige. However, few pictures ever came on the market. As the inscriptions make clear, they were given as presents to friends, or sometimes to a patron. The *nouveaux riches* had to look elsewhere to satisfy their artistic desires, and turned to applied art, including craft works with painted decoration. Such items were easily commissioned and acquired. They usually had a didactic content, and being made by craftsmen rather than artists were not of the very first quality. This category included portraits. It was still unusual to paint a person from life; instead, the portrait metaphorically conveyed the moral qualities of its subject, and the chosen background emphasized that point (see page 186, right). It is impossible to say how far this portrait really resembled its subject, but the artist has given us the picture of a strong, virtuous scholar (also symbolized by the pine), incorporating the moral values of wise men of the past (as suggested by the archaic blue-and-green style).

The readiness of potential purchasers to buy such works of art influenced the market, particularly the market in craft items, which flourished.

All kinds of filigree metalwork for personal adornment and everyday use (in the form of utensils) were made for an upper class that liked ostentation. They ranged from jade items in the style of the bronzes of the past to lacquer ware ornamented by all the possible technical procedures (lacquer painting, incised lacquer, carved lacquer, incised lacquer with gold inlay, and intarsia work of precious metals and gemstones). Decorative objects clearly enjoyed great popularity, and not only among the Chinese subjects of the Yuan. Craftsmen slowly emerged from anonymity. It is even possible to ascribe certain pieces to lacquer artists known by name, such as Zhang Cheng and Yang Mao, and obviously there was an awakening pride in this form of art. Craft work was to contribute the last of the great inventions to the applied arts in China.

The porcelain market could already supply vessels with incised or stamped ornamentation, transparent or monochrome glaze, with lead glazes in more than one color, or with colored ornamentation on white, red-brown, creamy yellow, or black bodies, all painted on the glaze and then fired. Some grave goods of the Tang period were already glazed in deep blue; at that time cobalt (Chinese, *sumali*) was being imported to color lead glazes. The pioneering achievement of the Yuan period,

Hairpin in the shape of a dragonfly

Anonymous, Yuan dynasty, gold, W 7.7 cm, Linqiu Department of Cultural Assets

however, was to use cobalt as a pigment for painting on porcelain underneath the glaze.

The fact that white porcelain was manufactured in the city of Jingdezhen during the Song period made it a center of blue-and-white ware. Other bodies were not so suitable for underglaze decoration in cobalt shades because of their constitution and because they did not offer sufficient contrast. In Jingdezhen, however, the raw materials for porcelain – kaolin and petuntse – were to hand in the nearby mountains, and there were good routes down the river to harbors for export. These technical prerequisites apart, how did this revolutionary stylistic change in the decoration of ceramics come about? The Song elite had preferred monochrome surfaces. Longquan ware was still being produced, and so was Jun ware. However, there were now merchants from the distant west living among the middle and upper classes of the Chinese, and they wanted to feel at home. That meant not just carpets and silverware but blue-and-white pottery, not dissimilar to Cizhou ware with its dark brown decoration on a white body. Perhaps they simply did not like the incised and stamped decorations of the Lonquan pieces. In any case, demand from a "foreign" market seems to have played a part for the first time in the development of Chinese porcelain. Cobalt was probably imported to China from the area around Kashan in contemporary Persia, where it had been used for since the 13th century; it was easier to transport the raw materials than the finished ceramics along the camel routes. The Chinese potters now had to change the colors they used. Their wide-ranging knowledge of native glazing and firing techniques had already familiarized them with the problems, the greatest of which turned out to be the difficulty of grinding cobalt fine enough to apply it in solution. A feature of early ceramics with underglaze decoration is the presence of tiny grains resulting from coarsely ground cobalt left behind when the painter lifted his brush. After firing there were ugly little holes, almost black, where the cobalt grains had broken through the glaze.

Porcelain with underglaze decoration

Jingdezhen, founded in 1004 and later where porcelain for the court was made, now became a center of blue-and-white porcelain with underglaze decoration. Decoration of this type was painted on the dried body – no corrections could be made – and the object was then dipped in a bath of clear glaze. The porcelain itself and the glaze were made of the same raw materials, but different compositions, and when the glazed piece was fired the glaze merged into the body. The decoration was thus enclosed between body and glaze.

All the blue-and-white porcelain of the Yuan period is dated from the basic information available and by comparing the various pieces. Until the scientifically studied finds of the 1980s and 1990s, the most important of these pieces were the so-called David Vases, a pair that have been dated

to 1351 from the cyclical information on the year given in the donor's inscription[3] (see below).

For many decades these vases were the only pieces of blue-and-white porcelain that could be definitely dated to the Yuan period. They were obviously not made for export or for a non-Chinese patron. They are fine examples of a genuinely Chinese type of blue-and-white porcelain, and pieces for export are not so meticulously painted. The David Vases show various original Chinese motifs on the surface, which is divided into different areas by thin lines running round their bodies. If we study the vases from the bottom upward, the areas divide into a first zone showing good luck symbols, with a band of peonies running round the foot above it. The transitional area between the foot and the body shows stylized waves, and the main decorative area is adorned by a scaly dragon among the waves. The shoulder bears another band of stylized flowers and tendrils (of the lotus) and the lower part of the neck has a phoenix among ornamental clouds, while the upper part bears ornamentation of lanceolate leaves (banana leaves) interrupted only by the inscription. The handles are worked in the form of realistic elephant heads. Finally, there is a band of leafy tendrils and chrysanthemums around the mouth, which thus shows three of the four flowers symbolizing the seasons. The two vases are not completely identical: the dragons in particular are different. They may be taken to represent the painted decoration of the Yuan period and clearly show that their inspiration derives from painting, from Cizhou and Longquan ware, and from the *qingbai* of early Jingdezhen ware. Pieces such as these ushered in the great age of blue-and-white porcelain.

The David Vases

Datable from the inscription to 1351, porcelain, underglaze decoration in cobalt blue, H 63.5 cm, by kind permission of the Percival David Foundation of Chinese Art, London

The David Vases are notable for the many motifs of their decoration and the division of the surface into several separate areas.

Europe Looks at the Dragon

Europe had already taken a timid peek over the Great Wall of China during the Mongol rule, though without ever really wanting to get too close to the Dragon. As a consequence, many aspects of Chinese life, including Chinese art, were completely misjudged.

From the 17th century onwards the Old World continued to look eastwards, but interpreted what little it saw in terms of its own growing self-confidence and power; it was not prepared to see anything that could challenge its new self-image, and the few facts and rumors that reached the West were largely devalued. It was of course both annoying and costly that Europe was not able to produce porcelain, but intensive research was being carried out and it was only a matter of time...

In the 18th century the English architect William Chambers, who had seen China with his own eyes, wrote that the architecture of the Chinese was only worth taking note of because of its uniqueness in size and simplicity, and sometimes even its beauty.

But even he considered its painting "imperfect."

In the 19th century the West looked with pity on the vast country of China as it sank, so it seemed, further and further into backwardness. The view from the West has changed little in the 20th century. Yet in terms of Chinese art of the last 500 years, there is not the slightest justification for this view.

Porcelain from a ship's cargo
recovered from the sea

17th century

The cargo was intended for European
buyers. Many transport ships left
China's ports with porcelain goods for
European orders.

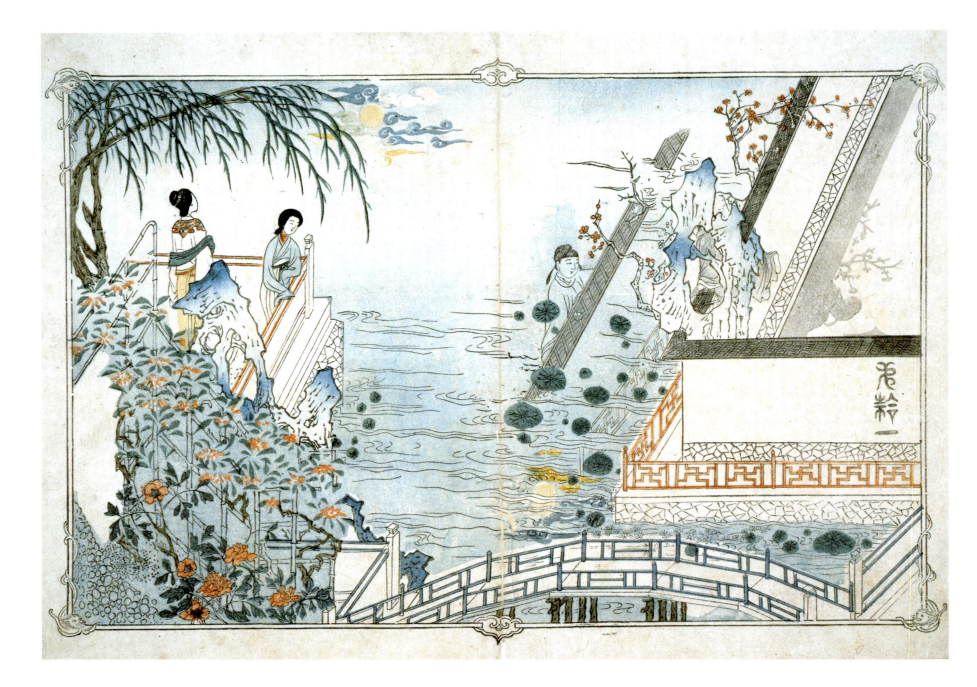

Chang meets Yingying at Night in the Garden

Min Qiji

1640, leaf 11 from an album wih 21 leaves, colored woodcut, 25 x 32.2 cm, Museum for East Asian Art, Cologne

A scene of the lyrical drama *The West Room* (Xixiang ji) by Wang Shifu of the Yuan era. The scholar Chang and Miss Yingying are a couple in love who cannot be together. The finely dressed figure of Yingying, to the left on the terrace, is looking at the Moon in the clouds. The reflection on the water in the bottom center of the picture steers us toward the scholar climbing the wall, seen as a reflection in the water and as a shadow in the garden on the right. His action is hidden behind a rock in the garden; only his outstretched foot peeps out from behind it. The servant who watches the water from the terrace, looks directly at the reflection of the Moon; even she is intended to attract the observer's gaze.

Ming: Traditions and Innovations

(1368–1644)

Zhu Yuanzhang, Buddhist monk and peasant's son, became the first Emperor of the Ming dynasty as a result of his leadership of the White Lotus Sect. He reigned from 1368 to 1398 and initially, to consolidate his power, he adopted the government structures used by Mongol emperors. Gradually, however, he introduced fundamental innovations. They included: a court ceremonial to clarify the different ranks of emperor, court, and people; six new ministries and the Council of the Interior; a presidential minister to govern alongside the emperor, which was an attempt to prevent one person gaining too much power; a subdivision of the Empire into 16 provinces; the removal of all non-Chinese from government offices; the reintroduction of tests for officials; and the estab-

lishment of the Supreme Court of Justice. He also had land newly divided up, had restrictions put on the property and possessions of Buddhist monasteries, and restored the five-family neighborhood groups for jointly implementing social services. Finally, he banned all foreign religious communities, and declared Nanjing the capital of the Ming (the "bright") dynasty. The Ming empire extended over almost the same area as at the time of the Three Kingdoms; in the southwest, however, it now extended as far as the Mekong. In the north the empire lay hidden behind the Great Wall, which the second emperor had renewed along the old fortifications (see pages 196–197).

The second emperor, whose reign was known by the governmental name of Yongle (ruled

1398–1424), moved the capital back to Beijing, again as a better defense against the renewed threat from the Mongols. The extension to the Forbidden City as well as the installation of imperial workshops in the immediate vicinity of the imperial household, the publication of the *Yongle da dian* encyclopedia, and the building up of the navy, are just four of the important events of his reign. The fact that China was a sea power seems to have been a secret among Sinologists for decades; certainly it is not widely known. Yet the competence of the fleet can be deduced from the furthest destination they reached safely: the east coast of Africa.

Under the Chengtong emperors (1436–1464) the power of eunuchs at court spread enormously, a problem never to be solved; the system of corrupt practices and nepotism this introduced was severely to undermine the power of the emperors.

During the Ming period new genres of literature emerged, such as the novel written in colloquial Chinese, books that were also vividly illustrated. The theater began to flourish again.

In commerce at that time there arose large businesses which adopted the practice of the division of labor; factories had to meet a keen demand from both home and export markets.

Many important Europeans were active at the court of the later Ming emperors as missionaries; seen as advisers and scientists, they were allowed to carry out their research unimpeded and report to Europe on China's achievements. The Chinese themselves "officially" declined all knowledge that came from Europe; nevertheless, with the aid of the Dutchman Ferdinand Verbiest (1623–1688), they were able to produce military equipment, for example a heavy 4.5 tonne cannon.

Every imperial era found an expression of its own in the art and *objets d'art* of the time. Along with Ming painting, it is above all the decorative arts which have come down to us (both the objects and texts about them). First of all we have the vast quantities of elegant porcelain made by the most varied production techniques. Their decorations, also found on carved lacquered objects, range from noble literary motifs such as the Eastern Fence motif of Tao Yuanming to the pictorial representation of proverbs, legendary figures, emblematic objects regarded as bringing good fortune, and motifs taken both from illustrated encyclopedias and from the first "pattern books" of painting. Extremely significant was the 16-volume book *Shizhuzhai shu hua pu* (Painting and Handwriting Patterns of the Ten-Bamboo-Hall), published between 1619 and 1633. These pattern books, illustrated with woodcuts, showed the ambitious amateur, in easy steps, how to paint every kind of picture (landscape, genre, portrait), as well as how to paint the same subject in different styles. Because of their circulation, they became influential works that set the standard for artists and craftsmen. Even the countless woodcut illustrations of plays and novels contributed to the spread of motifs and designs (see opposite). In spite of the close connection at this time in China between painting, the graphic arts, crafts, architecture, sculpture, and calligraphy, it is necessary to separate these forms of artistic expression into categories: "Art by and for the elite," "Architecture and sculpture for the living and the dead," "Beautiful, superfluous things," and "Commercial art."

Art by and for the elite

Painting and calligraphy are the undisputed leaders in the various Chinese art forms, and as much with experts and critics as in the eyes of the educated and moneyed elite. In the Ming period painting and calligraphy also took the format of the folding fan, a development that had come to China from Japan (see below). And again we must distinguish between the literati painters, who cultivated art as a form of relaxation for the elite, and the art of the court, done by court painters of the Academy – even the emperors themselves, or official artists who were originally in administrative jobs, as well as professional painters. The Academy of the Ming period, however, was not like that of the Song, a hierarchically-structured institution with "uniformed" officials; it was, to put it simply, a form of imperial patronage, with a workshop in the palace being placed at the disposal of the painters. This court art went back to the Song style, creating vivid landscapes or narrative figure scenes, as well as flowers and birds such as *xiaojing hua* in the style of the Northern Song era. Their compositions were symmetrical, which produced a decorative effect, but they no longer achieved the effect of depth of the Song painters.

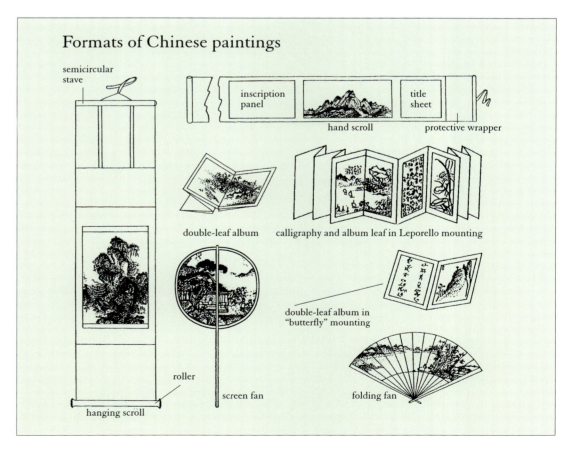

Formats of Chinese paintings

semicircular stave

inscription panel

title sheet

hand scroll

protective wrapper

double-leaf album

calligraphy and album leaf in Leporello mounting

double-leaf album in "butterfly" mounting

roller

hanging scroll

screen fan

folding fan

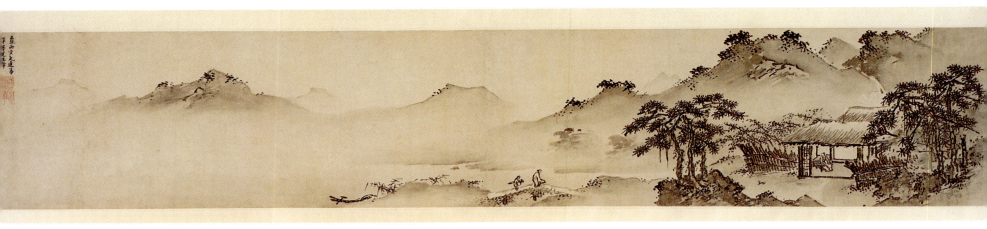

Painting from the Ming period looks flat; hidden depths are almost completely lacking. Colorful gradations of ink and color washes take over the space. One can see roughly three trends: the court Academy, conservative in style and technique and referring back to the painters of the Song Academy; the literati painting of the educated people concerned with art for pleasure and free stylistic development; and the professional non-court artists of the Zhe school.

The new era brought new schools, now called after the places where the development mainly occurred, or from which received its stimulus. They worked in one Song tradition or another, or in that of the Wudai, or rather Yuan painters, who in the meantime had become greatly admired.

Among the painters not active at court were thoroughly professional artists like Dai Jin (also called Dai Wenjin, 1388–1462), who dominated the artistic scene in Hangzhou in the first half of the 15th century.

Dai Jin, whose pseudonyms were "Silent Hut" (Jing an), and the "Hermit of the Jade Spring" (Yuquan shanren), and who came from the town of Hangzhou, is regarded as the founders of the Zhe school (zhe pai, a term used since the 17th century), painters who took their names from its main area of activity, the Zhejiang province. In general, professional painters of this stylistic leaning continued the tradition of the Southern Song painting. In the same way as at the courts, many painters belonged to the Zhe school circle and were also members of the Academy; ink techniques with sharp contrasts between light and dark, broad color-washed surfaces, or framing elements such as tree trunks or cliffs were used. The asymmetrical compositions of Ma Yuan were clearly in evidence again. Steep mountains stand out in contrast to broad expanses of water, the vertical being stressed on one side of a hand scroll or hanging scroll against an emphasis on the horizontal on the other. With the establishment of Southern Song painting, lyrical compositions were also revived.

The favorite pictorial motifs are closely connected to the commissioners of the art. Anyone rich enough – businessmen, low and high-ranking government officials, even the emperor – ordered a picture to hang in his reception room or office. Favorites were hanging scrolls that were also hung on screens. In their content they presented symbolically the values of the scholars' ideal society or gave some information about the owner.

Thus the repertory of the Zhe school primarily includes the illustration of historical events or people from Confucianist, Daoist, and historical literature, first and foremost famous hermits or respected officials; then fishermen or wood collectors as a symbol for the life of a simple man for which the soul of the official was really striving; or wandering scholars in a rough landscape, who, with servant and zither, are seeking time for contemplation, cut off from the world – if only for a little while. Every one is the picture of an ideal way of life that the officials could not live, since they had to perform official duties (see opposite).

Dai Jin's hand scroll with the depiction of the Linggu mountains (see opposite, bottom) is a commissioned work which Nie Danian (1402–1456) saw as an incentive to his son to travel… that at least is what the first colophon written by the commissioner tells us. Dai worked at this expressive scroll, with its rich contrasts, less with textured strokes than with washes. On the right he constructs a powerful landscape behind two groups of tall soaring pine-trees and an enclosed estate; a veil of mist produces the effect of three-dimensional depth. On the left a broad expanse of water stretches out, and in the distance color-washed partly outlined mountains rise up out of the mist. The fine shading of the inks and colors, the clear outlines and detail is characteristic of Dai Jin. With such examples of his work Dai Jin even went to the court in Beijing in the hope of finding praise and honor. His skills provoked rivalry with the court artists and led to some backbiting, with the result that he was forced to flee back south. In a renewed appearance at court two decades later, he achieved success and the highest officials became his patrons and commissioners.

Flowers and birds were of course also part of a Zhe artist's repertory, in the *xieyi*-style, without any outline *mogu*, and monochrome in the case of Dai Jin and Lin Liang.

Above
Visiting a Friend with a Zither
Dai Jin

Dated 1446, ink on paper, handscroll, 25.5 x 137 cm, Museum für Ostasiatische Kunst, SMBPK, Berlin

Opposite, top
The Return of Mr Five-Willows
Anonymous

In the style of the Song-painter Ma Hezhi, hanging-scroll, 48.4 x 43.9 cm, Staatliches Museum für Volkerkunde, Munich

The picture shows a scholar approaching in a boat over water; he is already expected before his arrival. "Lightly and gently sways my boat in the wind; my clothes flutter as it plays with them." The motif is derived from the cited line of the rhapsody "Return Home" of Tao Yuanming (A.D. 365–427), who gave up his unfulfilling magistrate's post in favor of life in his home village, where he devoted himself to poetry, wine, and his chrysanthemums. He exchanged the tedious regulated life of an official for a tiring but free life as his own master. "Mr Five-Willows" was a pseudonym of the poet (note trees on the embankment).

Opposite, bottom
Spring Clouds in the Linggu Mountains
Dai Jin

Four colophons, ink, color on silk, handscroll, 31.6 x 124.2 cm, Museum für Ostasiatische Kunst, SMBPK, Berlin

The numerous Zhe artists – Zhou Wenjing, Lin Liang, Lü Ji, Wang E, Zhong Li, Zhu Duan, Zhang Lu, Jiang Song – were craftsmen and professional painters who by constantly varying their themes, but without creating anything basically new, finally came to a standstill stylistically towards the middle of the 16th century, and this spelt the decline of the Zhe school.

A time of revival at the beginning of the 16th century was begun by Wu Wei (1459–1509), an expert in the *baimiao* technique, which is attributed to the circle of Zhe artists, but he was distinguished from the craftsmen by his educational background. He was cultured and educated, but made his living by painting; in so doing he was far from the ideal of a scholar-painter who would never have painted for money. He encouraged Zhe painting to improvize more and to use a looser brush stroke, and here he is moving over from a craft to a hobby.

Amateurs, dilettantes, "leisure painters," to put it in modern terminology, these concepts have no negative connotations in the history of Chinese painting; quite the opposite. Elite art arises from free time, from education, and from not being compelled to paint. The gentleman-painting of the Wu school *wumen pai* is representative of the elite art of the Ming period; the "gentlemen," scholars from the area around the town of Suzhou, followed the scholar-painters of the Yuan dynasty in their style of art. In their concept of life, too, they were close to the Yuan scholars: they retired (but now willingly) from official posts and lived with and in nature, as wanderers in the mountains or in their stylish gardens, men who had felt a relationship to nature. Their tools of the trade became the styles of the four masters of the Yuan period and therefore, through the "mediation" of the latter, the painters of the 10th and 11th centuries. Shen Zhou (also Shen Shitian, 1427–1509), a leader of the Wu school, like Wu Zhen, painted with broad ink strokes; according to his mood he took Huang Gongwang or Wang Meng as his model. He was considered to be one of the true scholars, *wenren*.

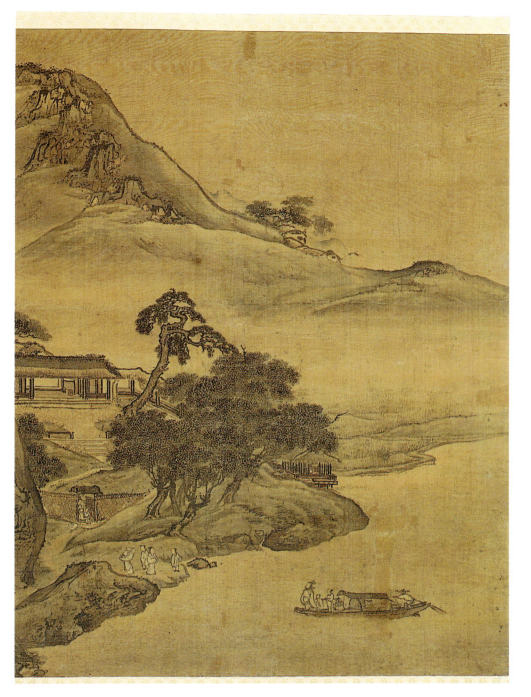

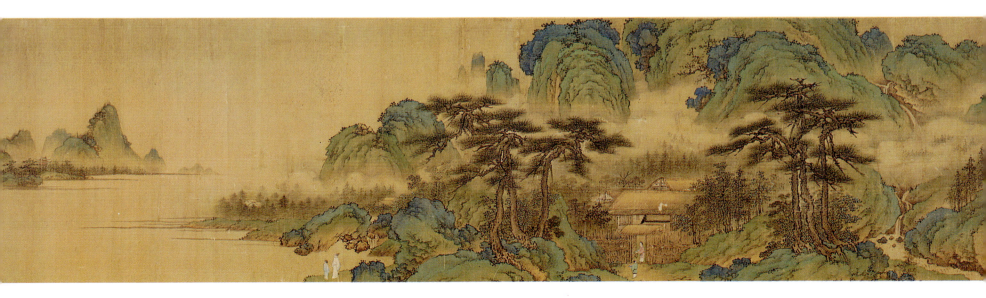

Bathing One's Feet

Ascribed to Wen Zhengming

Ink on gold paper, fan leaf 18.3 x 55.5 cm,
Museum für Ostasiatische Kunst, Cologne

This is a pictorial variation on a line of
poetry from the *Elegies of Chu Chuci* by the
poet Qu Yuan (about 332 to 296 B.C.), who
writes about withdrawal from the life of an
official during troubled times.

Preceding pages
Great Wall

The Ming rulers arranged extensive repair
work on the wall as defence against
intruders from the north.

His painting shows a new aspect of landscape painting: the person who admires the landscape, who is familiar with nature and absorbed in it. The results of Shen Zhou's occupation both with his own experiences of nature and also with the Yuan artists were these two ways of expression: painting with a fine brush stroke, and painting using a rough sort of brush in a free style. He left many flower paintings to posterity, garden landscapes in the broadest sense. That basically distinguished him and his successors from the literati painters of the Yuan period, and the initial use of more flowers (over and above the four precious ones), namely the peony, mallow, gardenia, hibiscus, magnolia, in the Suzhou scholars' range of motifs can possibly be explained by their presence in the gardens of their homeland.

His successor Wen Zhengming (1470–1559), a vigorous scholar, painter, poet, and garden-lover, was also inspired by the great masters of the Song and Yuan, especially Wu Zhen and Wang Meng.

During the different phases of his life he created works of art in a variety of styles. The first datable stem from the early years of the 16th century, and from 1520 he dedicated himself to a systematic study of painting which in his late works produced strongly individualistic features. Amongst other things, he broke with the convention of reading the hanging scrolls from bottom to top. Moreover, his painting are full not of direct statements of a theme or subject, but of hints and implications.

Wen's painting was subtle and clear in equal measure. His landscapes often refer to locations in their title yet many can be interpreted as homage to a patron or friend. A substantial amount of Wen's work, including written work, has survived today. His pictures show traces of descriptive painting using the stylistic methods of Mi Fei and the compositional features of Yuan painting. With Wen Zhengming, inscriptions and pictorial themes finally merge into one whole. He combined methods of expression such as ink texture and color wash in one picture, and often completed his ink landscapes with shades of blue-green and ocher.

One of his numerous pupils was Lu Zhi (1496–1576). Like Wen, Lu Zhi came from Suzhou. He seems to have been extremely mean when it came to giving away and exchanging pictures. In spite of poverty towards the end of his life he did not paint on a grand scale to support himself. In doing this he would no longer have set himself apart from professional painters. For the scholars this unique feeling of "detachment" was regarded as their most prized possession alongside the different quality of the way they painted, and so it was frowned upon to sell paintings. Lu lived off his chrysanthemums. Although this suggestion in literature may seem like a legend that has gathered around the man, it was widespread practice to succeed in supporting oneself from the garden or at least in gaining some extra income from it. This aspect of horticulture – a garden's usefulness being put before aesthetics – has gone unnoticed in the majority of monographs about Chinese horticulture. Literati texts, however, give clear indications that they knew how to make use of this preferred tax-free income. Lu painted landscapes and birds as well as flowers; in his bird paintings he followed the *gongbi* style, for his landscapes the style of Wen Zhengming (see opposite).

Lu also stands in the tradition of the literati painters who were inspired by their contacts with the past. In copying Song or Yuan painting, they introduced the use of well-ordered albums: the leaves are no longer laid out only for their individual effect, but for group effect, bringing together eight or more leaves; these might give examples of a range of styles and compositions of famous painters of the past, or be dedicated solely to a certain painter and his various compositions.

Dong Qichang (1555–1636, signed himself in various ways, including his first name *zi* Xuanzai and also various "artist's names" such as Siweng, Xiangguang or Xiangguang jushi, Wenming), a high-ranking minister, collector, painting and calligraphy artist, mentioned several times already, worked in an age when the Ming dynasty was coming to an end. His artistic oeuvre stands in the tradition of the Wu school, which, however, had split into numerous regional groups towards the end of the Ming dynasty (see page 200, bottom).

His theoretical approach (to study and transform the works of old masters) is clearly visible in his own work. His task found a successor in the oldest of the Four Wang, *si wang*, Wang Shimin (1592–1680), at the beginning of the Qing period. Unfortunately Dong left his ideas behind, not in the form of a long cohesive text, but in short "paintbrush notes," in essays, letters, scattered throughout his collected written work including the colophon *ba* and pictorial inscriptions *ti*. Dong derived his ideas from the expressions of the painter-princes of the Yuan period and thus he became a sort of mediator of an orthodox body of thought to the orthodox school of the Qing period: the Four Wang, along with Wu Li and Yun Shouping (see page 226). The belief that an artist could only create something new out of a knowledge of the past was of fundamental importance in

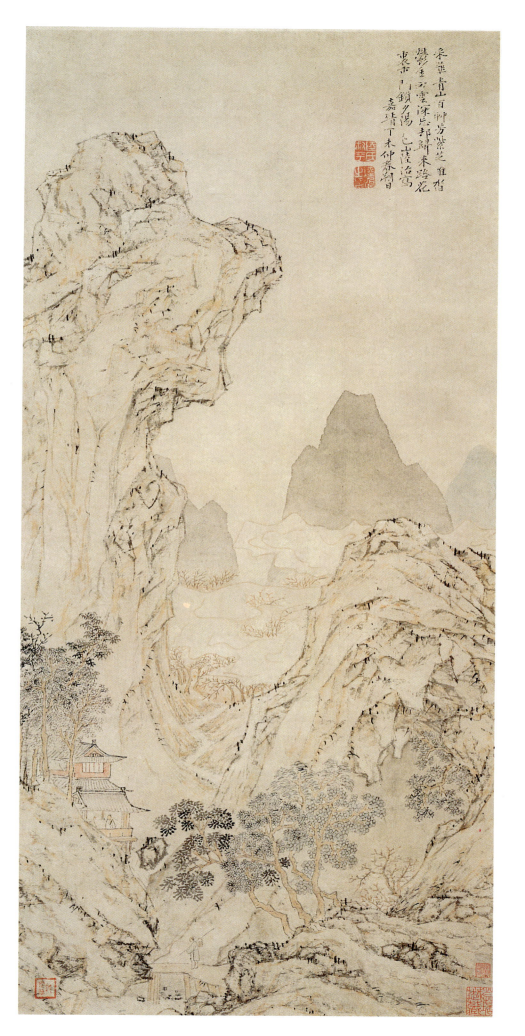

*In the Mountains
Gathering Medicinal Herbs*

Lu Zhi

Dated 1547, ink, color on paper,
hanging scroll, 70.5 x 32.7 cm, Museum für
Ostasiatische Kunst, SMBPK, Berlin

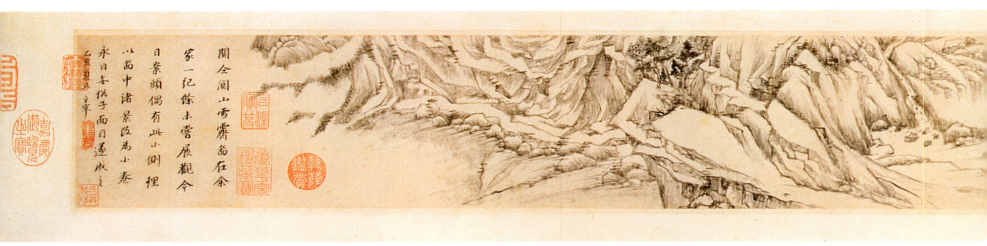

Chinese art: it was essential to take the best from every source and to combine it to make a new whole. Dong attempted to put this requirement into practice not only in painting but also in calligraphy. At the beginning of his artistic career he worked on calligraphy of the Tang period, especially Yan Zhenqing's scripts, then also with scripts from the Han period and finally the great Wang Xizhi. The collection of paintings from the Yuan period by the painter Gu Zhengyi (active from 1575–1596) became his first model in painting.

Dong's first pictures date from the late 1570s, yet none has survived. As a result of his admission to the Hanlin Academy in Beijing, he gained access to Han Shineng's extensive collection, famous among contemporaries for its quality; Han Shineng was one of Dong's teachers at the Academy. As a result he became acquainted with the work of the great painters of the past: Jing Hao, Guan Tong, Dong Yuan, Juran, and even Li Cheng.

For his scrolls, Dong borrowed ideas of technique and composition from numerous artists; his art consisted above all in uniting the various styles into one organic whole, without his creations appearing fragmentary as a result. His "quotations" produce a new poem convincing in itself. Artistic writing often made use of the comparison of verse and picture, whereby pictures were described metaphorically as poems without words and poems as verbalized pictures.

With the late work of *Clear Weather after the Snowfall in the Pass*, painted a good year before his death at the age of 89, he provides clear evidence of this ability. He shows the mood and variety of the concept of "100 miles into a single foot," as Zong Bing had demanded. At the same time his rhythm varies in the composition between flat and steep, abrupt and flowing, foreground, middleground, and background, and in his brush technique he borrows ideas from Ni Zan, Jing Hao, Guan Tong, Dong Juan, and also Huang Gongwang (see page 184). He uses the "colors of the ink" to the full, as well as the full range of possible textural strokes. Dong was more famous for this than for his polychrome works. His progressive spirit, however, created some expressive, colorful album

leaves, though the art experts of the day always dismissed them as being of minor importance. His speciality was the use of paper for these large colorfully produced leaves. The landscapes are not only kept to the muted colors of a Wen Zhengming but clear colors like green, brown, light blue, pale pink, ocher, orange, and bright red make the mountains and rivers gleam.

Other artists also tended to complete the ink painting with colors. The middle of the Ming period (16th century) had seen a group of painters who could not be consistently assigned to one school since they developed very individual stylistic forms, but yet were professional painters. One of the group was Tang Yin (1470–1523), also called Tang Pohu. To mention that he had been one of the Four Talents of Wu (*wuzhong si cai*) betrays his origins: he too came from Suzhou. He came from a simple background (his father was an innkeeper) and after a scandal he had to end his career as an official, after which he turned to painting for his living. Since he was master of a wide repertory, both monochrome and polychrome landscapes in the "one-corner" style (see page 167) by him have been preserved, as well as genre painting, including erotic scenes in glowing colors, and figure scenes illustrating histor-

ical events, flower pictures and architecture painting. He moved the people into the middle-ground again, the landscape served as a staffage for him. In his pictures in the flower-painting category which make up the smallest part of his work, he created a synthesis of monochrome and polychrome painting, although he was not considered one of the real leaders in innovation (see page 202, bottom).

To what extent the chrysanthemums and bamboo of the fan leaf could be regarded as symbolic of Tang Yin's way of life is purely speculative. Possibly in the bamboo (an embodiment of the ideal of the noble) and in the chrysanthemum (a symbol for the secluded life of the poet Tao Yuanming) he saw a metaphor for his failure as a noble-minded official. In this picture the characteristic style of calligraphy is noticeable in writing near the bamboo, just as it strikes one that the blooms are filled in with color inside an outline, but the chrysanthemum leaves were done without drawing an outline. Strong contrasts are produced by the shape of the dark bamboo, the climbing blossoms, and the soft silhouettes of further bamboo shoots. Zhao Mengfu was his model for calligraphy; in painting he followed the contemporaries of Ming, Zhou Chen from Suzhou, and

Way Through a Landscape of Lakes
Wang Jian (1598–1677)

Ink, color on paper, handscroll, 29 x 255 cm, National Gallery, Prague

Wang Jian was the second of the Four Wang, inheritor of the great art-collection of Wang Shizhen. He experienced the typical fate of a scholar-artist of the transitional period between the Ming and Qing dynasties: when the rule of the Qing was established he withdrew into private life. For this picture of a peaceful, broad water landscape he mixed ink with a brown clay, a technique for which he gives Dong Qichang as a model. Stylistically, models from the Yuan era can be clearly recognized in this scroll.

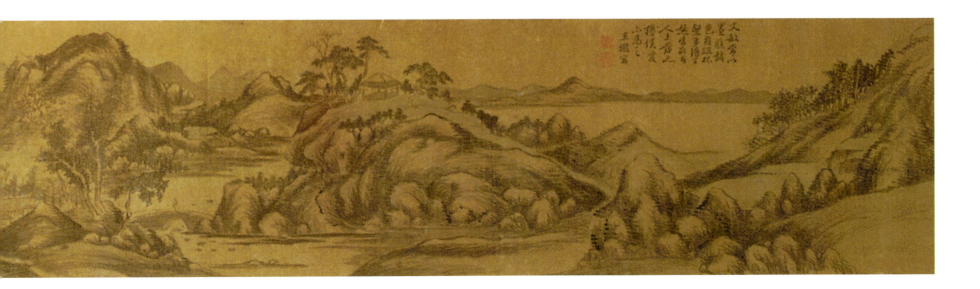

Evening visit in the Bamboo Courtyard

Qiu Ying, inscription poem of Wang Chong (1494–1533)

Ink, color on gold paper, 18.8 x 52.6 cm, in the summer of 1635, Museum für Ostasiatische Kunst, SMBPK, Berlin

Chrysanthemums and bamboo

Tang Yin

Ink, light color on gold paper, fan leaf, 17 x 47.5 cm, Museum für Ostasiatische Kunst, SMBPK, Berlin

Li Tang or Liu Songnian from the Song period. We hear that he was considered elegant but also suspect by his contemporaries. Even today he is regarded as one of the four great masters of the Ming era, together with Shen Zhou, Wen Zhengming, and Qiu Ying.

The quality of Qiu Ying, a very popular painter of his time (1494–1560) who earned his living as an illustrator and lacquer artist as well as a painter of commissions, is also to be measured by his imitations of Tang and Song paintings (which in some cases have survived only through his works), as well as by his portraits, depictions of historical figures, genre scenes, and landscapes. He enriched his landscape painting by a combination of monochrome ink paintings in the blue-and-green style. He thus united Academy and scholar styles on one scroll or on one leaf. Qiu executed his work finely with precise detail, and his vivid and light colors were carefully graded. Almost without exception, his landscapes include figures, making the transition between landscape and historical painting smooth-flowing.

Some famous historical gardens were interpreted by Qiu, for example, the Garden of Solitary Joy by Sima Guang the Song scholar or even the Golden Valley by Shi Chong (4th century A.D.). But he also painted real gardens. A large number of these pictures go to make up a new original genre of the Ming period: the garden picture, that picture of a model of nature that had become increasingly important in the life of the citizens and which was no longer so easily available.[1] Qiu Ying and Tang Yin, by their painting of elegant houses and figure scenes, possibly had a great influence on Europe's image of China, since their pictures were known by Europeans active in China both at the courts and in business, and their motifs were also used on porcelain and lacquer.

The life story of the painter Xu Wei from Zhejiang (1521–1593) seems particularly exotic; because of the effect he had on some painters of the Qing period, the individualists and so-called eccentrics of Yangzhou, he must be mentioned briefly. His way of life led him from a career at court to a life as a notorious drinker, to mental confusion and to a prison sentence for murdering his second wife. He favored the *xieyi* style and monochrome painting. Contrary to all the rules of composition he chose for his themes the smallest details of nature: plants, insects, small animals, leaves, details of landscapes. Above all in his use of the *xieyi* style, Xu was the equal of later eccentrics in every way, especially when he attempted to capture the mood of the moment by spilling ink on the paper or by daubing and making blots.

In stark contrast to every freely-composed landscape stood the documentary landscape scrolls, travel pictures of the Ming period, which were directly derived from types of pictures such as the Song period scroll *Life Along the River on the Eve of the Qingming Spring Festival* (see pages 168–169, top). Many painters, the four great masters

included, created scrolls which portrayed in topographical sequence and in panorama style a journey or round trip such as the views of a landscape around a lake. In a 17-meter (56-feet) long panorama, Shen Zhou painted 22 scenes from the area around Suzhou. It was not important whether the views portrayed were reflected in a topographically correct manner, or indeed were placed alongside each other. This kind of painting was to play an important role well into the next dynasty. During the transitional period between the Ming and Qing dynasties, a painter by the name of Xiao Yuncong (1596–1673) already well-known in his own time painted numerous such panoramas and illustrative figure paintings, which, partly also carved in wood, were extremely widespread. Ziao was one of the Individualists; together with the monk Hongren (1610–1663) he is regarded as the most significant painter of the Xin'an school from Anhui. The scholar Jiang Liuqi became a Buddhist monk after the fall of the Ming dynasty and called himself Hongren. He is one of the four masters of Haiyang (*haiyang si jia*); the landscape of the Huangshan was one of his favorite motifs.

Both quote in their works the Yuan painter Ni Zan. Xiao Yuncong's scroll with views of the present-day province of Anhui represents an outstanding work on account of the link between the pictorial representation of landscape and the written poems. It is about the life journey of the monk Jingru whom he knew personally (see above).

In the course of the 300-year Ming rule, paintings gradually saw a shift towards the decorative. The scholars painted landscape; but genre pictures, ancestral portraits, and the realistic flower and bird painting became more popular with the people, as if daily life and the environment were now of higher value than the ideals of the past.

Painting was a hobby of the members of the upper classes, accessible through block-printed books which contained step-by-step illustrations of brush strokes, of picture composition, and forms of expression for the amateurs to copy, which led to a glut of average pictures in a lifeless style. Set pieces were strung together. The amateurs fell into two categories: those who "pushed open the garden gate" in terms of original and soulful painting – and those who did not.

Architecture and sculpture for the living and the dead

Our present-day picture of Chinese architecture is on the whole based on buildings constructed under the Ming emperors which still exist today, such as the Imperial Palace (built between 1417 and 1420), the Temple of Heaven, the Temple of Ancestors, the Great Wall, and the official seats of government officials or even town fortifications. The wooden-frame building predominates, but huge constructions of fired bricks or stone were used in places where it was unavoidable: for bridges, walls, fortifications, and underground tombs. Like all rulers, the Ming emperors also did not think only of this life. Their palaces for the life hereafter, of which there is only a well-documented excavation of one site – Dingling, the tomb of the Wanli emperor Shenzong (reigned

Living Abroad or Returning Home are After All the Same Thing

Xian Yuncong

Section from shortly before the end of the scroll Monastery of the White Cloud, 1656, handscroll, 23.5 x 1202 cm, Drenowatz Collection, Rietburg Museum, Zurich

The topographical character of the picture is clear above all through the inscriptions. The scroll is consistent in its use of the brush stroke and coloring, only referring thematically to the landscape described in the poems, but not to the moods, times of day, or seasons of the poems. The inscription shows the monastery where the monk Jingru, the subject of the hand scroll, lived.

**Ground plan of the Imperial Palace,
The Forbidden City** *zijincheng*

*Rectangular, about 1000 x 786 meters,
constructed after the Ming period,
Forbidden City, zijincheng, Beijing*

In comparison, the ground plan of a north
Chinese enclosed estate *siheyuan* (below)

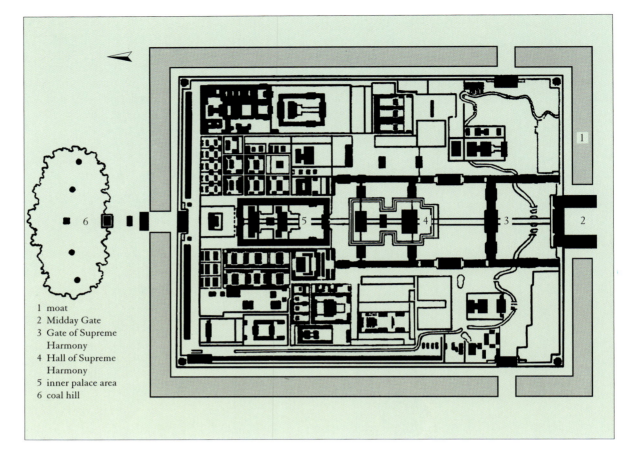

1 moat
2 Midday Gate
3 Gate of Supreme
 Harmony
4 Hall of Supreme
 Harmony
5 inner palace area
6 coal hill

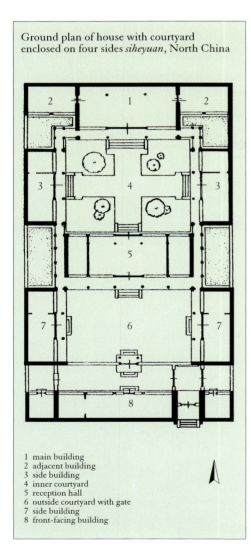

**Ground plan of house with courtyard
enclosed on four sides** *siheyuan*, North China

1 main building
2 adjacent building
3 side building
4 inner courtyard
5 reception hall
6 outside courtyard with gate
7 side building
8 front-facing building

1573–1620) – are not inferior to those of this life with regard to their huge size, and yet they are different in character.

Our knowledge of architectural sites is made wider by written descriptions by Chinese contemporaries and by the first Europeans, who praised these gleaming, colorfully decorated constructions. The Europeans of the 17th and 18th centuries were moved and fascinated by the strangeness of Chinese architecture, an architecture which they discovered secondhand through illustrated texts. They saw everything embodied in Chinese architecture (as an expression of a philosophy and a way of life) from the legendary rich country of Cathay to idyllic Arcadia. Even the German poet Goethe, inspired by such texts, wrote a poem which contrasted Chinese architecture with that of classical antiquity and the Renaissance.

> *In Rome I met a Chinese; all of its buildings,*
> *The old and the new, seemed to him heavy and drear.*
> *"Poor people!" he sighed, "I hope they can come to see,*
> *It's only pillars of wood which hold up the roof,*
> *Only battens and board, bright gilding and carvings*
> *Are charming the finer sense of a cultured eye…"*

"The Chinaman in Rome," Johann Wolfgang Goethe [2]

The general idea of the last four lines of the poem (not quoted here) is, however, that Goethe considers the Chinaman blind, sick even, since he prefers the transitory light construction. Apart from that almost every famous oriental museum in the Western world possesses parts of buildings from Chinese architecture, especially bronze fittings or porcelain roof tiles and turrets.

What the museum visitor does not see is that beneath the roof stands a framework of pillars, on a raised and multitiered terrace.

In comparison with the conventions formulated in the building manual of the Song period, *Yingzao fashi*, there was no basic change at the time of the Ming dynasty.

On rectangular platforms of compressed earth, which are covered with stone slabs, wooden constructions rise up whose walls are only infilling and have no structural function (this is provided by the frame). One approaches the visible side up steps and this side lets the light into the inside through wide doors and slatted windows.

Palaces and temples

A strict convention was also adhered to in the construction of complexes built on a rigid rectangular, axially symmetrical ground plan. In fact symmetry is visible not only in the ground plan but also in the elevation of a building complex. The size of the individual buildings, their height, the shape of their roofs, and the height of the roof ridge all fit in with each other. Thus the central axis can clearly be seen to be the center, the backbone of the construction. The higher the building towers up beyond the basic level, the greater

its standing within the complex. This three-dimensional interaction of height and distance produces the greatest effect in the case of the Imperial Palace (see below).

That was always the aim of this dominating architecture. Through its wide-open spaces it makes people appear small in front of the high buildings or at the foot of the terraces, and so makes them conscious of their lower status. The buildings symbolize superiority both by their height and by the fact that they are situated on terraces. The only building which reaches the same height on the longitudinal section of the whole precinct – but which does not stand out when on the spot – like the audience chamber, the Hall of Supreme Harmony (Taihedian), is the main gate, the Midday Gate (Wumen). It prepared the subject who had been admitted for an audience for what was to come: he stands like a little worm before this high three-winged gateway. When he had passed the Midday Gate, he would approach, across a winding moat and gold water, the next transit gateway, the Gate for the Worship of Heaven (Fengtianmen, today the Gate of Supreme Harmony, Taihemen).

Every morning civil and military mandarins in the Ming period had to gather before the gate. The officials of the imperial secretariat, representing the Son of Heaven, stood on the marble terrace in front of the gate which was almost 24 meters (79 feet) high. The offices were also here on the "outside." The civil and military mandarins of the following dynasty were allowed to go somewhat further into the palace. Three passages, under a

double hipped roof (the middle one, however, was reserved solely for the emperor), led the way to the audience square. The white marble from the balustrades and the radiant red from the columns and walls streamed towards the official, the roofs rose up brightly in their imperial yellow, as if the emperor was looking directly down onto his little subject below. The path for the normal mortal ended on the huge square, roughly 30,000 square meters (36,000 square yards) in size, in front of the Hall for the Worship of Heaven, which was renamed the Hall of Supreme Harmony under the Qing dynasty (Taihedian). Up above, the emperor sat enthroned in the Hall on the three-tiered terrace. The subject stood in front of a powerful building with a double-hipped roof. It has remained until today classical architecture's greatest preserved wooden building, first built in 1420 and, after several fires, reconstructed in the same form faithful to an existing model. In total, the Hall is constructed to a width of eleven "column distances" (eleven *jian*) and so is just 27 meters (89 feet) wide; it is 37.17 meters (122 feet) deep. The impression of height is further strengthened by the three-tiered terrace, which rises up by 8.1 meters (26 feet) from the courtyard. The whole Hall is a wonderful technical achievement that provides some amazing statistics. The roof covered in colored ceramic tiles, together with its intricate wooden balcony construction, a variety of the *dougong* system, weighs around 2,000 tons. In addition, the roof bears on its main ridge two ceramic decorations each over 3 meters (10 feet) high – *daen*, dragon-fish creatures with wide-open

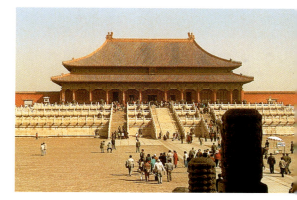

Top
Midday Gate of the Imperial Palace
Woodcut, 15.2 x 10.6 cm, Sinologisches Institut der Universität, Frankfurt

This woodcut appeared in the 1886 edition of the book *Hongxue yinyuan tu ji* (first edition 1847).

Above
Hall of Supreme Harmony
Imperial Palace, Beijing

Left and above
View over the roofs of the Imperial Palace, Beijing

Decoration of the ridges of two lower-ranking buildings of the palace, Beijing

Imperial Palace, Beijing

At the front the dragon is missing between the badly damaged Immortal and the *chiwei*.

Gargoyle

Marble, Temple of Heaven, Beijing

This gargoyle in the form of a dragon stems from a later period of reconstruction, but is identical to the classical pieces in the Imperial Palace and at the Temple of Heaven.

Immortal

Light ceramic, yellow and black glaze, H 27 cm, Staatliches für Völkerkunde, Munich

mouths and glaring eyes – that weigh over 4 tons. On the same terrace, but invisible to the normal mortal because of the mighty throne room, are also the square Hall of Central Harmony and a rectangular hall designed, like the Hall of Supreme Harmony, for the preservation of universal harmony. Behind this complex the inner palace began, home of the emperor and his extensive entourage: this included the walled-in residential palaces of the crown princes, concubines and empresses; libraries and gardens; and halls the royal family used for holding religious ceremonies.

Everything was predetermined, from the color of the bricks to the number of decorative roof turrets, the decoration of the beams, and the ornamentation of the decorative bricks on the subdividing walls. Important buildings were painted in the *hexi*-style: gold-colored dragons or phoenixes on a green or blue background bore the greatest number of roof turrets (a maximum of twelve), and curved tiles, *tongwa* (one of two types of bricks used for the buildings of the palace). The columns of the balustrades surrounding them displayed the richest decoration, and the gargoyles of their terraces were in the shape of dragons.

Some decorative forms were both ornamental and functional, for example the decorative figures on the ridge, which were to protect the halls from evil influences. One could imagine the dragon creatures consuming fire and helping the building to beat the bad weather. On the main ridge were *dawen* or *chiwei* (dragon creatures with bushy tails) in various sizes, the ridges running downwards (hips) bore on the end, in a firmly fixed sequence from bottom to top, an immortal riding on a hen-like bird, a dragon, a phoenix, a lion, a unicorn or heavenly steed, a sea-horse, a walrus,

suanni, a *yayu* (a creature who was one third fish, lion, and tortoise), a *xiezhai* (a fire-eating mythical creature in the shape of cow), a bull with scales, *douniu*, a winged ape-like creature, *xingshen*, and a dragon creature with a bushy tail, *chiwei*.

The size of a building depended on its position, and some featured few figures. The ridges of a well, for example, carry only the immortal on his hen, the dragon, and the final figure on top, the *chiwei*. The emperor's residential palace has ten figures; on every corner of the roofs of the empress's living chambers sat a row of eight figures. Only the Hall of Supreme Harmony has all the figures on its ridges. The program is hierarchical, which also applies to the use of roof tiles: important buildings had curved tiles, which meant that when seen from below they look even higher, while less important buildings had only flat tiles. The decorative panels of the end tiles, too, which in the period of the Han dynasty already displayed complex decorative designs, reflected the status of the building. The importance of a building can be seen inside as well as out: the splendid construction of the ceilings and the paintings inside, and the elaborate carving outside.

The painted decoration on the beams was also there for a more mundane purpose: it helped to prevent woodworm and other infestation. Three styles of decoration were used during the Ming and Qing periods, the *hexi* decorative painting being regarded as the most valuable. In the middle of the beams there was also a rectangular picture area with dragons or phoenixes, and nearby at the side of each a zigzag area (with either a pictorial decoration or a single color) and on both edges of the beam another area of pictures with spaces. Everything was separated by lines. The "simpler

variety" of decoration was the *xuanzi* style, in which floral ornaments and depictions of flowers in the border and zigzag areas made a great show, but the middle was an undecorated colored area. Deriving from this type was the Suzhou style, in which the empty colored areas or even the borders at the edge were filled in with landscape or flower paintings. This kind of decoration was to become particularly widespread in the imperial garden buildings of the Qing period (see page 238).

The interior walls (which made the separation and hierarchy within the walls particularly clear to see, and which separated the whole palace complex into clear compartments) along with the protective walls and walls for shade (which were to make it impossible for spirits to enter) also had decorative ornamentation. For that, colorfully glazed ceramic was used. The ceramics line the whole walls (the walls giving shade) and imitate woodcuts or even decorated beams and purely decorative false roofs (mostly half ceramic roofs without a substructure, which are set into the walls). Often there are walls, and terrace coverings of less important court complexes too, which are brightly decorated with ceramic flower reliefs.

At this point one would expect a mention of the famous Wall of the Nine Dragons. But it was not there in those days, not being constructed until 1771 during the Qing period. Incidentally it was not the only one, one actually dating from the Ming period is to be found in Datong, and another one, also from the Qianlong period, in Beihai Park. However the wall in the Imperial Palace may serve as an illustration of the above-mentioned abstract notes, since it shows the imitation of the beams (see page 208, bottom).

These treasures, however, were invisible to the subjects. The rich, colorful ceramic decorations mark the private domain; the emperor wandered past to his gardens or to his concubines.

The subject only saw the marble balustrades with the dragon and phoenix decoration in front of the Hall of Supreme Harmony, the red walls and pillars, and the gold painting of the beams and coffered ceilings – insofar as he dared to raise his eyes. During the audience ceremony, highly ritualized in the period of the Qing dynasty, one has to imagine the Hall being fanned by the scent of incense, and enshrouded in its haze. The fragrant mists rose from the throats of bronze tortoises, the beaks of cranes, and from round incense burners. This display went to further strengthen the effect of the enormity of the architecture; it charmed and impressed equally. Even the mandarin standing halfway up the social scale was conscious of his lack of worth. He came and went through little

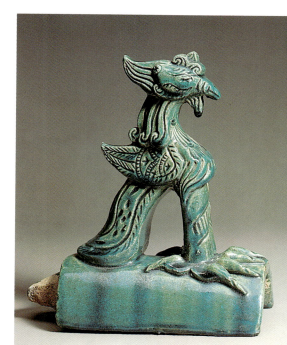

Phoenix

Ceramic, turquoise blue glaze, H 19.5 cm, L 17.5 cm, Staatliches Museum für Völkerkunde, Munich

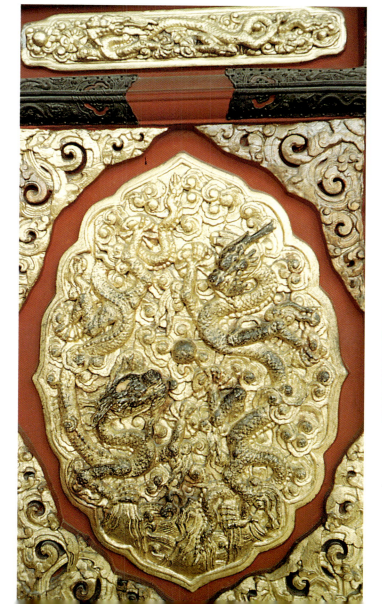

Left
Two dragons and fiery pearl

Gilded carving on the lower part of a folding door (exterior side), Imperial Palace, Beijing

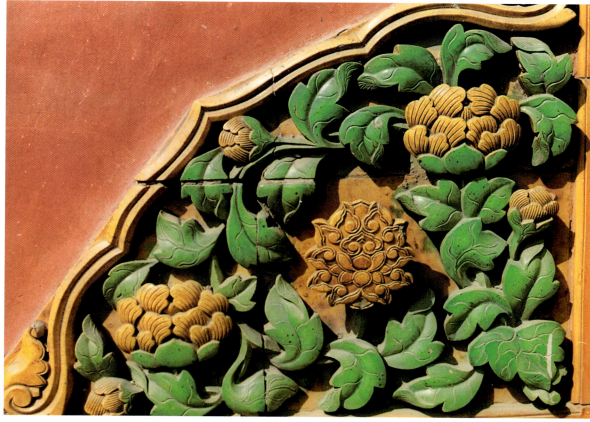

Relief in the corner of a wall area

Glazed ceramic, yellow lotus flower, two peony blooms and buds in a branch, W 40 cm, Imperial Palace, Beijing

The relief has a strong sculptural effect.

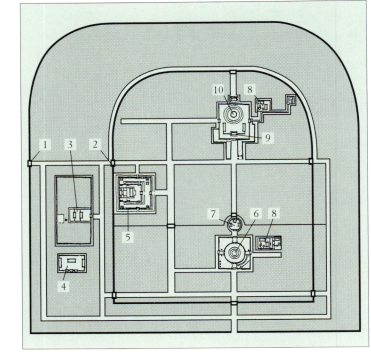

Below

Wall of the Nine Dragons

(Detail), central dragon relief, constructed 1771, colored glazed ceramic and relief tiles, total length of the wall 29.4 m, Imperial Palace, Beijing

Above the front view of the dragon the ceramic image of the *dougong* roof construction can be seen.

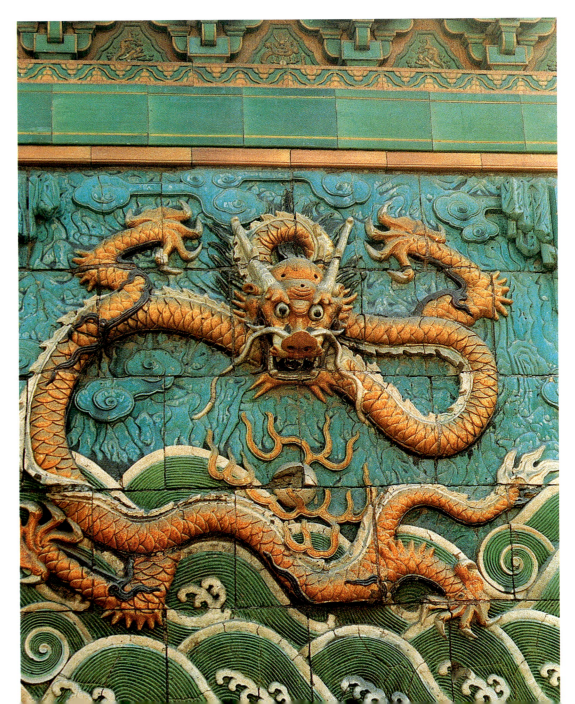

doors of the mighty gateway building. The emperor himself, the center of the Empire, took the largest passageway in the middle. He walked, for example, in solemn procession through the Midday Gate to perform the grand, middling, or minor sacrificial ceremonies in the places appointed for them.

The unapproachable emperor, the Son of Heaven, was father of the people. He had countless rituals to perform for the good of the kingdom and its subjects. Especially important were the Sacrifice to Heaven and the Harvest Prayer, two of the grandest sacrificial ceremonies. The emperor as spokesman for his subjects addressed his plea for protection directly to heaven. The solemnities took place at the winter solstice. Before the emperor could carry out the sacrificial ceremony, he had to purify both body and soul, and this was executed by several days of solitary preparation and fasting.

The whole of the Temple of Heaven precinct (as with imperial temples in general) consists not only of places for sacrifice and temple halls, but also of a small palace and numerous warehouses, kitchens, and stables. The grounds surrounded by a wall were never accessible to the people, not even at the ceremony. Even the emperor's processional path from the palace to the altar was covered over. Only the closest relations of the emperor (princes) and officials performing the rites were present, when incense, jade, silk, bullocks (slaughtered as burnt offerings), and sacrificial drinks were brought, and the emperor threw himself to the ground before Heaven.

A second great sacrifice, performed in the same palace at the beginning of spring, was the intercessionary prayer for a plentiful harvest, and the driving away of any evil relating to this. In a somewhat less splendid manner the royal household came with a plea for rain in the fourth month of the traditional calendar (May); here the slaughtering was done with less ritual. The consecrated building complex also played a fundamental role following the enthronement of a new emperor.

The iconographic program of the building complex fits in with its use as a place of sacrifice. Heaven is considered to be yang power, hence the temple lies to the south of the town (in those days outside the town); people traditionally imagined heaven to be round, hence the sacrificial altar was round like the halls. Its cobalt-blue roofs have curved tiles, like the other important buildings of the Forbidden City.

The Hall of the Harvest Prayer, which stands on a three-tiered circular terrace can, with regard to its arrangement of pillars, be interpreted as symbolic (see opposite). In China they imagined the earth as a square plate and heaven as a round bell above it; so the main supports of the hall form a square, above which is a clear view into the round conical roof. The exterior of the Hall of the Harvest Prayer has changed somewhat over the centuries. During the Ming period only the upper roof must have been blue, the one under it yellow, and the lowest one green. Thus the roof would

have symbolized, by its colors, water, earth, and sky. The colors of the roof tiles of the temples (there was not only the Temple of Heaven) were predetermined: the Earth temple had a yellow ceramic covering, the Moon temple white, and the Sun temple red.

What, in view of these guidelines, was permitted for the roofs of residential and Buddhist monastery architecture? The subject had to take simple, unglazed tiles, gray or gray-black, and was not allowed any decoration. It was the same with the monasteries; they were prescribed green tiles, thus the emperor, by using yellow glazed tiles, had equipped his buildings using his privileged position. Therefore the tiles, seen from right beyond the city's boundaries, were indicative of imperial favor, and of the status of a building and its occupant.

In the Jiangnan region, far away from the capital city, patrons discovered the best ways of getting round the imperial ban. The shape of the roofs was their decoration: the complex construction made possible a wide projection over the pillars and a steep curve at the corners of the roof. These bore decorations in the form of dragons with gaping mouths or "simply" steeply climbing roof ridges.

Tombs

The tombs of the emperors were planned during their lifetime; that was the custom and was laid down by the book of rites. The basic concept of imperial tombs is identical; the fittings and size, however, vary according to convention and taste, and to the fame and importance of the emperor.

In its construction, the tomb of the first Ming emperor in Nanjing, Xiaoling, corresponds to the 13 tombs near to Beijing. Taizu's tomb structure consists of a "Way of the Soul" lined with figures, which runs up to a construction of staggered buildings on a symmetrical axis, and halls placed one behind the other. Behind the last multistoried hall lies a large circular burial mound. The 13 emperors' tombs near Beijing, however, share a Way of the Soul that does not lead to the holy place in a straight line, as, for example, the Tang-period paths did, but in numerous curves and bends. One presumes that here, according to geomantic points of view, the changes of direction, just like the

Above left

Hall of the Harvest Prayer (Qiniandian)

Built in 1420, newly roofed in 1751, destroyed by lightning in 1889 and rebuilt, circular wooden frame building with three-tiered conical roof, H 37 m, surface area 26 sq m, Temple of Heaven, Beijing

Above right

Hall of the Harvest Prayer

View into the decorated roof beams, Temple of Heaven, Beijing

The painting is executed in the *hexi*-style, reserved for important buildings. The arrangement of the 19.2 m-high main pillars in a square can be clearly seen, and above them the dome of the roof.

Left

Ground plan of the Hall of the Harvest Prayer

The ground plan shows the four central pillars arranged in a square and the twelve outer pillars in a circle.

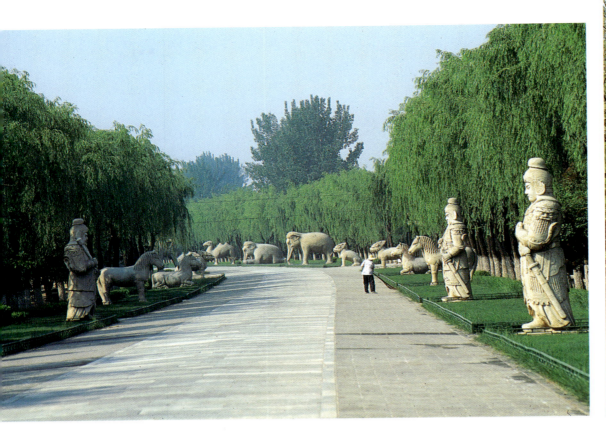

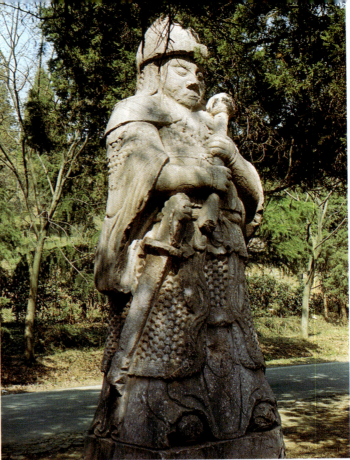

Above left
Way of the Soul to the Ming tombs

Constructed 1435

The Way of the Soul is lined by pairs of huge sculptures.

Above right
Military mandarin

Early Ming period, early-15th century larger-than-life sculpture in stone, on the Way of the Soul to the imperial tomb Xiaoling of the first Ming emperor, Nanjing in situ

Below
Plan of the imperial tomb at Dingling

Grave of the Wanli emperor (died 1620), Beijing

Imperial tomb, Dingling

breaking away from the north-south axis, appeared necessary.

The beginning of the path is marked by a gate of honor, *pailou* or *paifang*, then two interconnected buildings, the so-called Great Red Gate, which could shut off the entrance to the valley of tombs, and a Hall of Stelae, the alleyway of stone figures in which there are twelve pairs of animals and six pairs of people (civil and military mandarins) and one further gate. The figures still display the stiff robustness of those of the Tang period, yet the design of the garments and weapons shows an attempt at realism, the various types being depicted in contemporary clothing. At this point the paths fork off to the individual tombs. Each tomb of the necropolis consists of a site with several courtyards in front of a raised tumulus within which there is a walled tomb. People say that the Wanli emperor, after the completion of his mausoleum of Dingling, held a sumptuous feast inside.

The underground vaults of the Dingling site are placed along an axis with five rooms; three form the central axis, two the adjoining rooms. Twenty-seven meters (88 feet) under the surface of the mound of earth lies a palace of the dead with a surface area of more than 1,000 square meters (10,760 square feet). The vaults are fitted out as an anteroom, a "throne room," and a "ruler's chamber" – over 250 square meters (2,690 square feet) in area and nine meters (30 feet) high – in which are situated the coffins of the emperor, his main wife, and a concubine.

The burial gifts were discovered preserved in wooden chests; the discovery involved about 3,000 pieces ranging from the emperor's crown to porcelain, gold and silver ingots, and finally some garments. The pieces of porcelain taken out of the emperor's grave are being used to help to establish the date of Ming porcelain.

Amongst the decorations on the Wanli porcelain, flower patterns are the most prevalent, and densely woven branches and blossoms in extremely stylized forms, just as if a garden were spread out over the porcelain.

Gardens

The Ming period was the second great era of gardens, the gardens of the literati taking first place. The literati garden was presented visually as an illustration of nature, but technically was a meticu-

lously planned series of apparent coincidences. Literary depictions of gardens experienced a sort of boom, which lasted on into the Qing dynasty. For this period one can almost describe the art form of garden portrayal as obligatory in the legacy of a good scholar. In addition, the garden became one of the great motifs of Ming painting, whereby the visionary ideal of gardening, which the painter Qiu Ying magically put onto the pictorial scroll, virtually became a dream of the owner of a private garden. Alongside the descriptions of gardens which actually existed there also arose around 1634 the first theoretical work about the concept of gardens, the *Yuan Ye* of Ji Cheng (1582–?). This three-volume essay about making gardens treats all the important areas of building a garden: construction, choice of site, artificial hills (with hollows), *jiashan*; artificially built lakes and water channels (if not available naturally); decorative forms such as trelliswork, windows, gates, passages through walls, balustrades, and paving; the selection of stones as single pieces, and the wise choice of outlook (*jie jing*, the "borrowed landscapes"). The most important rule of construction was to create a copy of nature containing even more than the "original." Nothing, in fact, was left to nature. In addition it was important to have variety in the construction (an example set by nature) and in the range of living and inanimate elements. That explains the wide variety of buildings in the garden, which could be reached from the triangular open pavilion above the path up to the little two-storied palace, *lou*. The symmetry the buildings displayed was frowned upon in the garden. With the unruliness of nature as a model, it was necessary to spread out the buildings every bit as irregularly, and to present a surprise. The construction was not complete until the scenes within the arrangement had a name. Ji Cheng's work was regarded as inspirational and not as a collection of rigid rules which had to be adhered to.

For Ji Cheng, garden art is based on the creation of the total illusion of a natural landscape; the spirit (*qi*) of nature is to be captured in the garden by artificial means; the garden must in effect be an improvement on nature. The garden owner lives in the town but his garden creates a refuge. The literati gardens of the Jiangnan region, because of their situation either close to the town or in it, were of extremely different sizes, yet they were all places of peace. Even in the smallest space an appearance of chance and naturalness was planned. One gem

of a garden for example is the roughly 5,000 square meter (53,820 square foot) garden of the Master of Nets in Suzhou, where there was a pond, artificial cliffs, *jiashan*, the widest variety of pavilions, dry-gardens with single stones, and bamboo thickets – and so a rich variety of different views (see below).

If we look at the ground plan of the site, we can recognize three buildings lined up behind each other in the eastern section of the garden; the two frontmost ones previously formed the public room of the estate; all the other buildings were kept just for the family or the closest literati friends. The names indicate the private aspect of these halls and pavilions. One room for playing the zither, one for contemplation before an ancient tree, one room for the study of books… these will have been the favorite for the scholar.

Beautiful, superfluous things

Zhang wu zhi (Discourse on Superfluous Things), the title of an expert's manual from 1615–1620 by Wen Zhenheng (1585–1645), great-great uncle of the painter Wen Zhengming, gave its name to the products of the crafts in the Ming period.

The craft trade experienced a marked upturn as a reaction to two different developments at the end of the Ming period. It had always been the Cinderella of the art family but from time to time the craft trade moved into the foreground some-what when scholars gave themselves over to a preoccupation with and contemplation of classical *objets d'art*, such as bronzes or celadons, or one had a literary portrait painted of himself which portrayed his exquisitely fitted-out studio or art collection. In both cases, the articles made by a craftsman of low social status were also classified alongside painting and calligraphy. The material world of the upper echelons in the Ming period is shown by the connoisseurs' manuals. The end of the Ming period saw countless collections of texts come into circulation, which were seen as instructions in collecting; they also provided, into the bargain, lists of the criteria of good taste and ways of recognizing forgeries.

Good taste could be seen everywhere. The twelve chapters of the *Zhang wu zhi*, for example, explained such diverse things as scholars' studios, garden stones and plants, vases, clothes, interior furnishings, and food. Interiors in the Ming period did not remain the same; a lasting décor was not desired other than for the actual structural parts of the building. Thus Wen Zhenheng also wrote a calendar for the hanging of pictures that gives suggestions for a seasonal change of decoration. The choice of pictures had to vary according to the feast and time of year. At New Year he recommended hanging up representations of gods who brought luck; at the Qingming (spring) festival, peony blooms; on the fifth day of the fifth month (mid-June), representations of the dragon boat race; in summer (July) architectural pictures of summer residences and mountains; in fall, fall plants; in the eleventh month (December), snow scenes and winter plums… and for birthdays he recommended decorating the house with paintings of the gods of longevity and other lucky objects. From this change of wall decoration one can also deduce how decorative articles would be brought out in the course of the year and put away again. In winter Wen recommended bronze vases, in summer porcelain. The elite could suit the wall paintings and decorative objects to these conventions; the middle classes possibly treated themselves to colored woodcuts and

Opposite, top left
God of riches

Late Ming period, bronze with remains of colored paint, Völkerkundemuseum, SMBPK, Berlin

This figure of folk religion from the Daoist pantheon of gods wears the clothes and head covering of a Chinese official, and is holding a gold bar to his chest.

Opposite, top right
Writing set: paintbrush stand, little vase, stand for the ink stone, and water jug with the stamp of the manufacturer, Shi sou.

Ming period, bronze with inlaid decoration of silver threads, Victoria and Albert Museum, London

The fine decorative technique derives from the Song bronzes.

Below left
Inner courtyard between the library and the Chamber of the Ascent to the Clouds

Dry garden with various trees (color effects), bamboo, and a "sprig of bamboo" stone, garden of Master of the Nets, Wang shi yuan, Suzhou

The first construction dates from the Song period, the present view follows the shape after the reconstruction around 1700.

Below right
View across the pond towards the open hexagonal Pavilion of the Moonrise and Evening Breeze

Garden of the Master of the Nets, Wang shi yuan, Suzhou

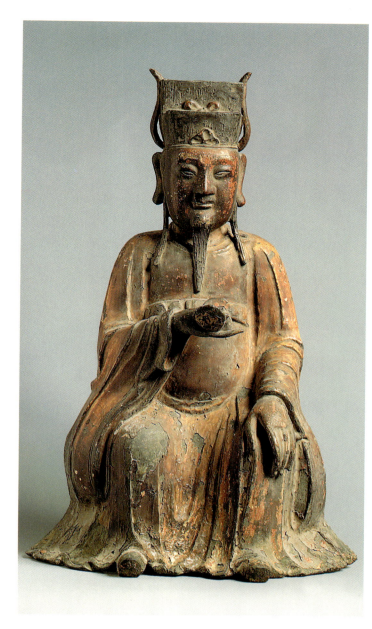

porcelain and for solemn occasions maybe even a little statue as well (see page 213). On the whole there was an increasing demand for ceramics, bronzes, and lacquers for both functional and decorative purposes.

As the elite turned to crafts, so these became increasingly popular and more valuable. On the late bronzes, for example, inscriptions of the manufacturer can be seen, lacquer artists left their names behind and ceramics, too, do not bear the imperial motto but the artist's name.

A room given special attention with regard to furnishings was the completely private workroom and library of the scholar, a gentleman's room in which the scholar (art expert, amateur painter, or calligrapher) kept his treasures, and to which he retired to study. It was an equally important part of his property as his garden in the town: a refuge. It was here that he kept his pictures and writings, his old books, his writing tools. Amongst them were fine paper, pressed, decorated pieces of ink, grinding stones for grinding the ink, water

containers, paintbrush holders, table screens and brushes, whose holders were artistically decorated. Except for the paper and ink, these objects were made of bronze, porcelain, lacquer, or carved stone.

Paintbrush, ink, grinding stone, and paper were described as four treasures of the study. As such they were used in a stylized way as decorations on porcelain and lacquer (see page 241, bottom left). The small table screen not only served as decoration, it was necessary to protect the scholar's work table from being splattered with ink. And besides the actual implements, lacquered boxes, dishes, and tins which were of less use to the scholar's life also adorned the study. Bronzes, for which the age had no real use, decorative vases or dishes, ceramics, preferably celadons of the Song period, were collected here if a person was wealthy enough to buy them (see page 214).

To name an example, bronze incense burners decorated with flecks of gold were regarded as valuable furnishings for the scholar's studio, marking out the real connoisseur.

Grinding stone, slate, and slab of ink

20th century with gold-colored inlaid inscription, China

Right

Fish-shaped vessel of the *zun* type

16th century grooved glaze (French champlevé) in bronze, H 19.3 cm, Museum für Völkerkunde, Dresden

Cloisonné-products primarily served as decoration for government buildings and temple halls. A pair of fish is considered to be a symbol of married happiness.

Far right

Plate decorated with blossoming twigs

Xuande period (1426–1435), underglaze cobalt blue with yellow overglaze, dia 29.4 cm, by kind permission of the Percival David Foundation, London

In the center of the plate is a twig with the blossom of an unknown type of plant; in each border section a twig bearing the fruit of a peach, lychee, cherry, and crab apple is illustrated.

Opposite, clockwise

Paintbrush with porcelain handle

Wanli period (1573–1619), L 30.5 cm, by kind permission of the Percival David Foundation, London

In each of the two fields, the paintbrush shows the picture of a five-clawed dragon in clouds. Covering the surface, the thinner part of the holder bears a stem of a plant and flowers; the end shows a continuous pattern of lancet-shaped leaves.

Incense burner

16th/17th century bronze with gold spots, H 10.1 cm, J. de Lopes bequest, Victoria and Albert Museum, London, M. 268-1929

Octagonal jar

Jiajing period (1522–1566), red and green carved lacquer on yellow ocher background, H 21.4 cm, dia 27.7 cm, Linden-Museum, Stuttgart

The decorated surface is divided into 33 pictorial fields, each one showing a scene from literature. On the lid the illustration of the tower of Yuenyang at the lake of Dongting is displayed.

Table screen with a motif of scholars and servants in a garden

Xuande period (1426–1435), red carved lacquer (tihong), picture area 32 x 31.7 cm, Linden-Museum, Stuttgart

The composition shows a few elements typical of scenic carved lacquer decoration: earth patterns (little stars or stylized blossoms in a diagonally set square), water pattern (waves) and sky pattern (parallel right angles), architecture in one of the styles like the *jiheua* painting, and in the garden scene numerous Taihu rocks, varied vegetation, a miniature garden in the flowerpot (*penjing*) and the preparations for a social gathering.

Like the private gentleman's room, the ladies' rooms were also exquisitely decorated. It can be deduced from the decoration whether the lady or the man of the house had been the recipient of the gift: phoenix, flower decorations, figure scenes from popular literature for the lady, dragons, tigers, bamboo, and landscapes for the men.

For the manufacturers and craft guilds the imperial court was every bit as good a purchaser as the rich tradesmen and scholars. And once again we have to correct some ideas about Chinese porcelain. The Ming vase, which is constantly mentioned in the West, was not unreservedly blue and white, least of all the plate. Underglaze decoration with the cobalt blue pigment of course made up the lion's share of Ming porcelain, but other techniques were also widespread (see above, right). Porcelain alone can fill volumes, therefore here are some representative pieces, especially of the decorative techniques, which have brought color into everyday life. The primary aids to dating porcelain are pieces from a known time of origin, with which all further ones are compared in their colors, pattern, strength, and quality of glaze.

Monochrome pieces were often more lavish in their production than for example the porcelain with underglaze color. All, however, fulfilled the same practical purpose. The shape, even if it were based on thousand-year old shapes, was suited to its purpose: *guan*, with a little opening, was useful for storing wine; *lei*, with a sweeping broad opening and round body, had established itself as a spittoon; high round containers were used for keeping ornamental fish, and their decorative design of water plants, fish, and ducks was appropriate (see page 216, bottom); little round boxes with a grooved top served as containers for crickets; what in Europe serves today as a typical shape for a tea caddy (the bulbous tall container

with a little semicircular lid) was already being used in the Ming period; and along with these were plates, cups, little bowls and pots with a partly fragile or even compact-looking outline (see page 217).

The picture of the elite interior concludes with the decoration of lavishly made miniature porcelain pieces placed in bird-cages as food bowls: they often kept little song birds, and large parrots, too.

Flower vases were already very important in the interiors in the Ming period, since the pleasure of having flowers in the house was seen as a substitute for the pleasure of seeing them in nature. Flower arrangement was regarded as an occupation of the spiritual person who carries out this task peacefully and takes pleasure in it. A small volume entitled *Oing shi* (The Story of Vases) by Yan Hongdao gave some suggestions for flower-arrangement: not too many types of flower, fine stems, different vases for summer and winter, large or small ones according to the space (see page 218). The arrangement was to be composed like a fine picture. And Yuan suggested placing a precious flower alongside a simple one, to complement one another. According to Yuan, flowers were to be enjoyed most of all when taking tea, then during conversation, and with wine, in other words in appropriate circumstances; for flowers are sensitive and idle gossip offends them. The book became a classic in Japan.

How far one should investigate the various individual motifs of a piece for their meaning is just as problematic as in the Dutch still lifes. If, for example, one interprets every motif on a plate for its symbolic content, the result can be overwhelming or possibly contradictory. In the 1930s (the heyday of iconography) Ferdinand Lessing, for example, compiled whole lists of congratulatory messages from the individual motifs. Such

Left
Wine jar of the *guan* type

15th century turquoise glaze, strengthened by copper at the opening, probably glazed color on unglazed fired pieces (émail sur biscuit). H 33.5 cm, by kind permission of the Percival David Foundation, London

The relief inscription on the shoulder reads as *nei fu gong yong*, "for use in the inner palace."

Far right
Wine jar of the *guan* type

About 1500, fahua decoration, H 34.5 cm, by kind permission of the Percival David Foundation, London

The jar shows the typical cobalt-blue background color for *fahua* decoration; the motifs are in yellow, white, and turquoise. At the neck, two-tone stylized clouds can be seen, and on the shoulder is a narrow band of *ruyi* decoration. Around the whole jug runs a border with twigs in blossom and jewels. The main motifs are garden stones, peacocks, and peonies, and underneath stylized lotus leaves.

Foot bowl

Xuande period (1426–1435), cobalt blue underglaze, H 8.3 cm, dia 15 cm, from a Ming tomb, discovered in 1993, Archaeological Institute, Beijing

The bowl shows the so-called eight Buddhist emblems: wheel, umbrella, fish, mussel, knot, vase, lotus, and canopy.

readings are easy enough to make, but they should be employed with caution.

Nevertheless, in some case the decoration can point to the user or commissioner, or even reveal its purpose, as for example certain wedding or birthday presents. In general it seems that the Chinese surrounded themselves with decorative motifs which brought happiness and were lucky. Among these are flowers, ornaments, animals, figure scenes, and symbols. Alongside Daoist symbols, traditional decoration (pictures of proverbial idioms) found its way onto porcelain, especially onto that not ordered by the emperor. The drawings were comparable to ink painting, in other words different shades of blue were used. The decorations of the Wanli period were ornaments that afforded the eye no free space.

Commercial art

During the Ming period, and also in the transitional period up until the firm establishment of the Qing emperor of the Kangxi era, porcelain products were the works of art which were manufactured specifically for trade. Previous luxury goods of Chinese provenance had been the silk materials and celadons that made their way into the outside world overland; the things the scholars most valued seldom found their way over the borders of the empire. The "beautiful superfluous things" that were inherent in the long tradition of culture, and which one treasured because one was a connoisseur, were not of any commercial value. For those not acquainted with such things, everyday objects such as household porcelain became luxury goods. China was an important sea power, a trading partner for Southwest Asia,

Japan, and the Middle East, and Europe also joined the queue of willing traders bringing back the "white gold" to Cathay piece by piece. European trade companies sent ships into China to buy the expensive luxury items which could not be manufactured in Europe. At that time China was producing various types of ceramic in different centers, amongst them the pure-white figured porcelain from Dehua; superficially and carelessly produced thick porcelain items for export to Southeast Asia from Shantou (Swatow); and the famous porcelain with the blue underglaze decoration, for which the town of Jingdezhen was considered to be a hallmark of quality, as it is today. The porcelain pieces from Shantou, after their southern Chinese shipping port, come from private kilns and hardly measure up to the products of the imperial factories in Jingdezhen.

Jingdezhen stood under imperial supervision, which meant that the raw materials as well as the finished goods were quality controlled. Anything other than porcelain with underglaze decorative techniques such as the *fahua* technique, or the *doucai* porcelain, which produced very colorful pieces, raised very little interest in Europe.

Monkscap pot

Yongle period (1403–1424), tianbai-glaze with concealed decoration (anhua), H 17.8 cm, by kind permission of the Percival David Foundation, London

The decoration on this container is appropriate for Buddhist liturgical use: a band of lotus leaves is almost invisibly carved in the piece, together with the eight Buddhist emblems.

Fish container

Longqing trademark (1567–1572), wucai-decoration, dia 55.2 cm, by kind permission of the Percival David Foundation, London

The motifs of the container – ducks, herons, and water plants – are partly as underglaze painting and partly in the overglaze colors of green, red, yellow, and brown, with fine black outlines.

If one examines the paintings of Rembrandt van Rijn or Dutch still-life artists, the familiar blue-and-white decoration of the dishes is striking if one looks closely. One might think it was Delft faïence, but the style is too original – they were real Chinese pieces. The cargoes from sunken ships which were recovered in the 1980s and 1990s allow us to gauge the huge amounts of porcelain which sailed across the South China Sea in all directions during the Ming period.

The manufacturers at the various firing centers knew how to adapt to the buyers' taste. And they also matched the quality of production to the purse of the respective recipient. For example, containers with Daoist symbols and a Japanese-style of painting went predominantly to Japan and pieces decorated with floral patterns to the Middle East. But not all the porcelain with inscriptions from the Koran were made for abroad. Particularly during the Zhengde era in Jingdezhen countless pieces of porcelain with Arabic and Persian inscriptions were produced for Moslem eunuchs at the court (see page 220). Even in the middle of the 16th century, porcelain with gold-leaf plating on a multicolored pattern went to Japan.

Towards the end of the Ming dynasty under the Wanli emperor, the amount of porcelain exported escalated, and Europe also began to be a trading partner. The Europeans preferred blue-and-white patterned porcelain, which virtually became the quintessential Chinese porcelain. And for these clients, the Chinese ceramic workers relinquished some of their skills where artistic decoration was concerned. In many cases it could not be spoken of as art: it was mass production.

A class of blue-and-white porcelain made for export makes up the so-called Karaken, Kraak porcelain. The name is derived from the Portuguese cargo ships which transported these goods and the Dutch translation of their name, Kraak; they spoke of "Kraak porselein." Kraak porcelain was produced in Jingdezhen from the early Wanli period to the fourth decade of the 17th century.

The shapes mainly cover plates, wine jars, bottles, bowls, and Kendis (strangely shaped oriental drinking bottles) which are decorated with cobalt-blue underglaze (see opposite).

The porcelain is fine, the glaze transparent and thin and tends to flake off at the curved edges; this is often described as "insect nibbled." The curved areas were shaped in molds. Kraak porcelain can be recognized by a special division of the decorated areas and a fixed use of decorative motifs. Eight large areas are arranged on the border round a central motif on the flat part of the plate; in plates and dishes, the central motif is framed by an eight-part pattern. Even on late pieces of Kraak the decorative division has remained unchanged but the pattern has been far more carelessly executed. This could be the result of mass production, or the lack of imperial control through the chaos of war.

The decoration of the visible side may be rich but the underside of Kraak plates looks bare: the different fields are quite spartan-looking and are only sketchily painted with a few strokes in light cobalt-blue.

Tea caddies with the decoration known as "Treasures of the Scholar"

Transitional period, 2nd quarter 17th century cobalt-blue underglaze in combination with anhua-technique, H 21 and 22 cm, Landesmuseum, Kassel

These discreetly decorated caddies illustrate the values of the literati: various flower vases, along with the four treasures, decorate the writing desk of the scholar, and every vase holds a different flower arrangement. Many texts of Ming period connoisseurship have been turned into pictures with that kind of decoration.

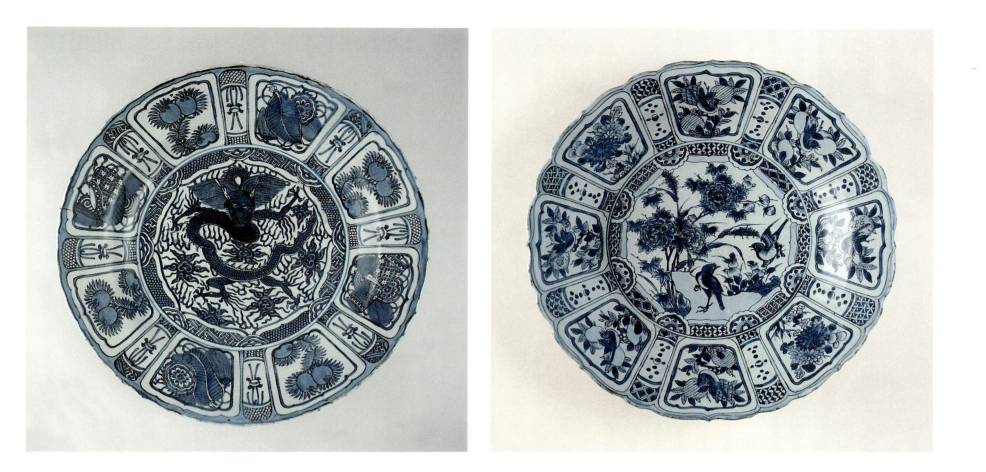

Kraak porcelain can be divided into four main groups of motifs: birds amongst flowers; cups and vases arranged as a "still life;" water birds in a river landscape; deer. Alongside these there were a large number of individual motifs or of motifs that appeared only occasionally. In the border areas every emblem imaginable can appear, often resulting in symbols from different sources being combined (see above, right).

The extent to which the Chinese potters were able to gear themselves to European demands can be seen from the completely non-Chinese shapes which paved the way for the development of the *Chine de commande* (commissioned porcelain) of the 18th century. The *Chine de commande* in its purest form portrays decorative motifs such as coats of arms or Christian iconography. The Kraak plates had an average size of 50 centimeters (20 inches), a size not used in China. The beer mugs or cups with handles must also have seemed exotic to the Chinese producers. The desired shapes and decoration were brought to China as patterns; the first dispatch of wooden models from Europe to Jingdezhen has been verified as being in 1635. Agreement was reached on the eating and drinking habits of the Europeans, which the mugs made in China clearly indicate. This export porcelain with the blue-and-white decoration dating from the transitional period shows pictures of Chinese literati on un-Chinese shaped containers, which were also pictured on items for the home market or carved lacquer work: a scholar and his servant in a landscape. Alongside European

shapes, whose patterns had been sent over, European motifs such as houses or even tulips slowly find their way into the range of motifs for goods destined for Europe, which was to further confuse the European image of China.

Commercial art extends from the Ming into the Qing dynasty, since during the first 50 years under new rulers the decorative style which we now call the traditional style continued to be produced in Jingdezhen. After 1655, however, there were no more deliveries from China since the chaos of war connected with the change of dynasty had brought production in Jingdezhen almost completely to a standstill. Japan filled the breach for the European market and imitated Kraak ware in order to deliver it to the United Dutch East India Company. From 1657 European shapes and motifs disappeared from Chinese manufacture. These two dates mark the middle of the transitional period, the time from the end of the Wanli period up until the installation of a new chief supervisor of the imperial factories in Jingdezhen in the year 1683, in the era of the Kangxi emperor (reigned 1662–1722).

During the first half of the transitional period the Japanese and Dutch, as the new commissioners, had partly offset the loss of the emperor's orders. In the middle of the 17th century the imperial factories in Jingdezhen had neither commissioners nor purchasers and certainly only poor quality raw materials. What was also important was that for over 30 years no imperial supervisor established a norm for Jingdezhen. Because of the lack of imperial guidelines, potters now had more freedom.

Left
Plate with dragon

1590–1610, cobalt-blue underglaze, Kraak porcelain, dia 51 cm, Landesmuseum, Kassel

The piece shows the division into decorative fields on the border and the center typical of Kraak porcelain. In the center, framed by an octofoil pattern, a four-clawed dragon can be seen in front of a background of stylized flames. On the border is an arrangement of eight wide and eight narrow decorated fields. Four of the broad fields show the peach branch rather like a sunflower; the others are four lucky symbols.

Right
Plate with birds and peonies

2nd quarter of 17th century, cobalt-blue underglaze, dia 47 cm, Landesmuseum, Kassel

The center of this Kraak plate is decorated with magpies and peonies. The typical eight broad and narrow fields are arranged around the border, with identical decorative motifs standing opposite one another. Peach (symbol of longevity), chrysanthemums (symbol of the simple life), pomegranates and lychees (symbol of fertility) decorate the border.

Table screen

Zhengde period (1506–1521), underglaze decoration, H 45.8 cm, by kind permission of the Percival David Foundation, London

This piece bears an inscription in Arabic, a sura from the Koran (from LXXII 18–20) in a square border, surrounded by stylized branches in blossom. These pieces are usually still stubbornly interpreted as articles for export. It is known for certain, however, that Muslim eunuchs, for whom such pieces could have been meant, were active at the imperial court. Such an interpretation is supported by the type of ceramic, the table screen being so clearly of native Chinese origin.

Opposite
Shoulder vase of the *guan* type

Mid-17th century, decorated with figures, wucai-painting with cobalt-blue underglaze and overglaze colors of green, yellow, aubergine and rust, H 39 cm, Landesmuseum, Kassel

The scene shows Chang'e, the Moon goddess, with numerous servants and visitors, who are approaching her palace. Two men with a servant hover on a cloud.

New forms of decoration emerged. The world of literature was discovered, and the ink painting of the literati appears to have been used more and more often as patterns for the composition of designs. The typical porcelain from the transitional period is still of the familiar blue-and-white variety. The decorations are now generally figure scenes in landscapes with cliffs, clouds, and specific vegetation: the "V-shaped"[3] pattern, as Jenyns says, borders with leaves, foliage designs and formal plant decoration, possibly a tulip, characterize the transitional goods as well. It was not the Dutch who introduced the portrayal of tulips but the oriental trade partners, for the tulip is an oriental decorative motif. However it fitted in very well with the Dutch in the age of the tulip craze that such a motif belonged to the repertory of decorations used by Chinese porcelain manufacturers. The potters, no longer restricted, took great pleasure in experimentation and this brought, amongst other things, a combination of the blue-and-white decoration and the so-called *anhua* decoration (the "borrowed" decoration). The containers made in this way look elegant and fragile, most suitable for adorning the studio of the reserved scholar, since they were not ostentatious. The observer has to take a close look in order to be able to enjoy the various aspects of the representation. The glazed surface is brought to life by the relief and the light breaks onto it in various

ways (see page 218). The world of literature, of myths and legends was colorfully portrayed on the pieces from the transitional age. An example of the decoration from this source may be a version of the story of Chang'e, the wife of the legendary archer Houyi, who possessed the elixir of eternal life, a story which had been going around since the time of the Warring Kingdoms in numerous extremely different versions. While her husband was away, Chang'e drank the elixir, which made her so light that she rose up in the air and floated up to the Moon palace, where she ruled as Mood goddess from then on.

The motif was later told in various forms by writers; it was put on stage, then artists adopted it, and also the craft industry. A change in the type of client may have been a decisive factor in this. The former imperial workshops manufactured for the free market on a larger scale (see opposite).

The customers could have found pleasure in the patterns which were familiar to them: the wife of a scholar perhaps thought highly of the motif borrowed from folklore about the Moon goddess, while the merchant's family simply took pleasure in the fresh colors.

That brings us back to the officials, scholars, and the moneyed elite. What became of them and the arts in their lives when the Manchurians first came to power?

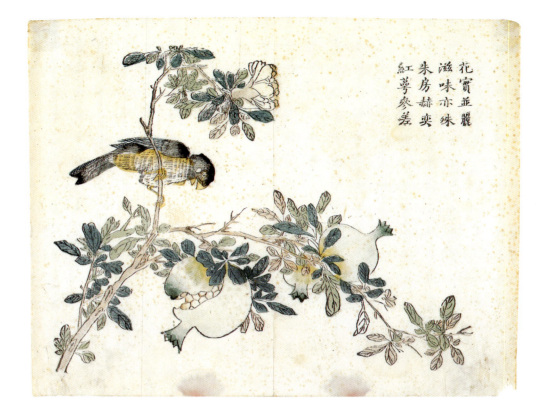

The Qing Dynasty

What could art still create?

"C'est le pays le plus peuplé et le mieux cultivé qu'il y ait au monde..."

Denis Diderot, 1752

The Qing dynasty (1644–1912) is often belittled, for after the glories of the past, whether in painting, calligraphy, or the crafts, the arts now seemed merely imitative. But there were in fact real artistic achievements during the Qing dynasty, notably refined monochrome porcelain glazes, and also large, brilliantly produced lacquers; there were also innovatory developments in painting, especially by the Individualists in the late 17th and 18th centuries, as well as by artists of the Shanghai school from the middle of the 19th century; and

there were, finally, new subtleties in the use of colored woodcuts.

All these innovations are worthy of admiration, though of course with a realistic sense of their place in China's long cultural history. After all, if we consider what superb works of art had emerged in the previous 2,500 years in China, then the Qing heirs to that tradition were not in an easy position. But a realistic assessment of their achievements is sometimes made more difficult by the fact that some politically-oriented Chinese historians may still believe that nothing good could emerge during this period because China was once again under foreign rule. The great empire had been conquered by the Manchurians, from the north, and from now on the Chinese had to wear pigtails as a sign of their subjugation. Yet the new rulers quickly accepted the Chinese system of government, as well as Chinese customs, language, names, and even the principles of Confucianism, though the state religion was Lamaism.

The first four emperors of the Qing dynasty led China to its greatest territorial expansion, created a high degree of prosperity, and brought the empire internal peace. The powerful Manchurian tribal leader Nurhaci laid the foundations for the take-over of the Ming empire, which was in terminal decline. In 1644 a minor came to power, his reign lasting until 1661; in other words his reign extended from the fall of the Ming dynasty to

the final reconsolidation of the empire. So the Shunzhi era began with the rule of a child emperor, who worked hard at learning the language of his subjects and, in questions of government, trusted in the knowledge of a few powerful men from the Manchurian aristocracy. The choice of his successor was to prove extremely favorable, for Xuanye (1654–1722), known under the governmental name of Kangxi, was able to unite the Chinese under Manchurian rule by his forward-looking policies and his tolerance. The emperors of the periods known as Kangxi (1662–1722), Yongzheng (1722–1735), and Qianlong (1736–1795) are regarded as the Three Wise Men under whom the rule was greatly strengthened. The Kangxi emperor, incidentally, was the first emperor under whose rule China concluded a treaty with a European power: Russia made a commitment to recognize the West Amur region as Chinese; the signing of the treaty was executed in Chinese, Manchurian, Russian, and Latin. The Manchurian administration was bilingual: it used Chinese and Manchurian. Evidence of this can be found even today on the signs inside the Imperial Palace buildings (see opposite, bottom).

The Kangxi emperor did not repeat the crucial political mistake of his "predecessor" Kublai Khan, but filled the highest offices equally with Manchurian and Chinese officials. Each official took an examination in his nonnative language, and failure led to the end of even the most promising careers. This meant that an old grievance of the Chinese was removed. The emperor adopted the Chinese system of administration, confirmed Confucianism as an official state doctrine, and mostly won over to his side that stratum of society to which the Ming officials and scholars belonged.

Nevertheless, in protest against foreign rule many retreated to exile in the country. Among them were a few talented, extremely nonconformist painters, and as a result, the number of literati artists fell in comparison with number of Academy artists, and the philosophical and stylistic differences between the two groups grew wider. The independent painter-scholars, who allowed the world to take its own course, developed motifs which were different from those of their "serving" colleagues. At court, by contrast, a documentary style of painting arose as a first priority, embracing portraiture as well as landscapes and history painting. This development was encouraged by an energetic editing and publishing program for which tens of thousands of scripts were examined, the results being extensive anthologies of all literary genres, and huge illustrated encyclopedias. For these the court painters were kept busy creating designs for the illustrated woodcuts (see right). Apart from the documentary quality a specialist might still discover in these illustrations, for the art historian these works represent a totally new development in woodcut technique. Since they were not always worked with outlines, colored woodcuts attained the quality of a flower picture done with ink and a wash (see below). In terms of style and subject, the literati painters, by comparison, continued to work as their Ming-period predecessors.

The Yongzheng emperor (Yin Zhen, 1678–1735) continued the Kangxi policies during his rule from 1722 until 1735, but in a modified way: he banned Christian missions, introduced checks on bureaucrats by employing anonymous informers, banned political gatherings in order to avoid anti-Manchurian secret societies, and formed the Grand Council of State to carry out imperial edicts speedily. He set up a modern, well-organized form of state budget, which became the basis for the flourishing period under the rule of his son.

Below left
Lily blossom

Colored woodcut from the Mustard-seed Garden, edited by Wang Anjie and his brothers, 1679–1701, 25 x 31 cm, Staatliches Museum für Volkerkunde, Munich

Here the blossoms are "drawn" with outlines, only the ridges on the leaf have lines drawn in an ink outline.

Below right
Peach branch in an antique vase

Colored woodcut from Painting Textbook from the Mustard-seed Garden, edited by Wang Anjie and his brothers, 1679–1701, 25 x 31 cm, Staatliches Museum für Volkerkunde, Munich

The woodcut shows on the one hand the arrangement of a branch, on the other a combination of objects "painted" with and without outlines.

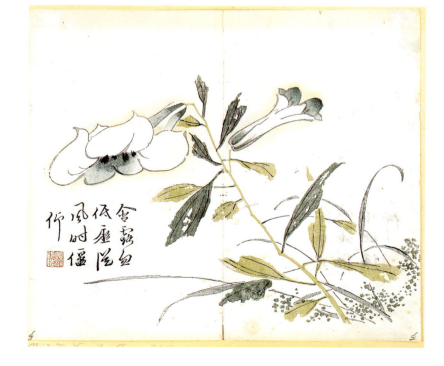

The Quianlong emperor (Hong Li, 1711–1799), on taking over the government in 1736, ruled over 150 million people; a number which, by the end of his rule, had risen to 275 million. At the beginning of 1796 he abdicated voluntarily (he did not wish to rule for longer than his grandfather, the Kangxi emperor) and spent the last three years of his life in seclusion in his palace, enjoying art. In cultural as well as political matters his period of rule was one of the most magnificent of the Qing dynasty. Admittedly, the huge empire, which had to combat tendencies to break away at its distant boundaries needed his full attention and a series of effective political and military responses. But he also attempted to use cultural traditions as a means of unifying his vast empire. He was a patron of the arts, wrote poetry himself, possessed collections of various objets d'art, and was the patron of countless scholarly works, including a catalog of bronzes and a celebrated catalog of the imperial collection of manuscripts and paintings. This catalog is an inventory of the paintings and calligraphic works the emperor and his predecessors had collected. The emperor himself, though only a moderately talented painter, was a gifted calligrapher, as we can see in his painting and calligraphy on the Letter to Bo Yuan (see page 126). He favored the script of Dong Qichang, and so it became the norm at court. As a follower of Confucianism, he

had little interest in Western ideas about science and progress, though he did have a passion for European art.

Under his rule China remained an agrarian state and modern technologies were not introduced. The luxury at the imperial court became increasingly decadent during the Qianlong rule, though the court environment also remained supportive of the free scholar-artists, many of whom were nonconformists and eccentrics.

The later rulers of the Qing dynasty pale into insignificance beside the three already named, although admittedly they hardly had a chance to bring the empire into the modern world – they would have had to combat the deeply entrenched state ethos, the rigid and cumbrous bureaucracy, and the increasing backwardness of China vis-à-vis Europe, now developing very quickly. The Opium Wars, unequal treaties, the emergence of secret societies, and the modernization proposals of various political factions led, at the end of the 19th century, to a desperate situation that would not be ended even by the Revolution of 1912.

As we have seen, painting during the Qing period can be divided into two main types: the painting of the literati who flourished independently of the court; and the painting of the court artist, which showed a predominantly documentary, and in architecture, decorative, character.

The so-called Academy painters worked in the imperial workshops. They were engaged in portraying whatever pleased the emperor, as accurately and as true to nature as possible. To a lesser extent this was also true of the portraits of the imperial concubines, even though the artists were not allowed to see them face to face; Western painters at the Chinese court particularly bemoaned this situation as it ran totally counter to their concept of a portrait. In addition, genre scenes (*fengsu hua*) were painted. These can be divided into three main groups: pictures of important state events, among them court ceremonies, imperial journeys, birthdays, and weddings; scenes of everyday life as documents of the world outside the palace walls; representations of an ethnographic kind – of foreigners, ethnic or cultural minorities, and peoples on the periphery of the empire.

Capturing the cultural, social, and political life of the era, these genre pictures now seem like souvenir photographs. The documentary character of these scenes may have its origins in the Manchurians' lack of a strong written tradition. Since they adhered to Lamaism (a Buddhist sect that communicates more by pictures than by texts), the Manchurians were accustomed to an illustrative or documentary style that generally took the form of simple religious paintings. Another possible influence is that of the Christian missionaries active at the Chinese court. Certainly European artists helped to acquaint the Chinese with the "painting of events," though their influence may have been slight.

The formats of the documentary painting were mostly hand scrolls, but albums were also widely

Below left
Mountain landscape

Ascribed to Wang Shizhen (1634–1711)
Ink on silk, hanging scroll, Staatliches Museum für Völkerkunde, Munich

In front of high mountains, a guest comes up the mountain with his servant, where he is awaited by his host on a terrace. The painting in orthodox style shows countless seals, the prominently placed large seal is one of the collectors' seals of the Qianlong emperor. Wang Shizhen who signed the work was in his time a well-known poet and literary critic.

Below right
Colonel Canling Badai

1760, Qing Academy, possibly the Lang Shining school, color on silk, hanging scroll, 295 x 95 cm, Museum für Ostasiatische Kunst, SMBPK, Berlin

used. The twelve scrolls of the Kangxi emperor's journey to the south, with a total length of more than 200 meters (656 feet), together form the largest painting in the world.

The Qianlong emperor who, in the footsteps of his grandfather, also undertook inspection journeys to the south, the heartland of support for the ousted Ming, in order to consolidate the empire and advertise his claim to power, also had twelve such scrolls made, though they were shorter ones. Parts of these were edited in the form of a travel manual with the title *Nanxun shengdian* (Ceremonial of the Journey to the South). The paintings and woodcuts in this are topographically correct, and can therefore be interpreted in the broadest sense as real views. This distinguishes them fundamentally from the traditional landscape painting of the literati, for whom accurate representation was not the main concern. The subjects depicted in the *Nanxun shengdian* include attractive landscapes, and also views and plans of the palaces on the journey where the imperial entourage stopped (see right). The finely executed woodcuts follow the compositions of the scroll pictures, and the coloring, though light and soft, is always realistic.

A similarly documentary effect was also produced by the Academy versions of everyday life, though these were in effect a throwback to the genre scenes of the late Song and Yuan era: depicting "everyday life" meant representing various "types" engaged in their customary activities. Such depictions (known as *shehui fangqing*) took two forms: panoramas and smaller studies. The models for panoramas were probably works such as the long hand scroll *Life Along the River on the Eve of the Qingming Spring Festival* (see page 169, top), but also works in smaller formats, principally the albums. Even the latter have their origin in the painting of the Song period. Like their precursors, the creators of the small leaves tended to concentrate on the representation of an individual event or of a person of a certain function or standing; from doctor to fortune-teller, they are shown engaged in their profession or craft, the colors strong, the details precise.

The last form of Academy painting (a particularly interesting one in terms of Chinese history and culture) was the documentation of the customs and festivals of the many ethnic peoples of the state of Qing. On these scrolls or leaves, which throughout are in bright, striking colors, there can often be found accompanying texts in Chinese and Manchurian (see opposite, right).

The style of this painting is paraphrased as *gongbi-zhongcai*: "precise brushwork, many colors." The spirit and purpose seem to be essentially didactic, and the artists clearly set great store by closely observed details that attempt to capture the uniqueness, the "something quite different," of the unusual subjects.

This type of court painting was only one (and the most restricted) facet of the painting of the Qing era. The works of the painters and

Top

Cliff of the Swallows (Yanziji) near Nanjing

Southern travel album of 1765, colored woodcut, 23.5 x 30.5 cm, Museum für Kunsthandwerk, Frankfurt

High above the Changjiang River we can see a pavilion with a view.

Above

Tiger Hill (Huqiu) by Suzhou

Southern travel album of 1765, colored woodcut, 23.5 x 30.5 cm, Museum für Kunsthandwerk, Frankfurt

The site of the Yunyan monastery and a 10th-century pagoda can be seen.

calligraphers found in the imperial collection are known under the title *Shiqu baoji* after the three-volume catalog of imperial art works (in 1744 the Qianlong emperor had ordered an inventory of all the paintings, calligraphy, and prints of the imperial collection; the second volume followed in 1791, the third in 1815). It is striking that those painters based a long way from the court, who are today described as the Individualists, are almost totally absent from this collection, though they were in fact much admired by the emperors of the Kangxi and Qianlong eras. The independent artists and the artist attached to the court worked according to completely different principles. The orthodox court artists, with their traditional realistic paintings, were closer to the taste of the great lords than the boldly abstract painters with their innovative, individualistic styles. Moreover, the latter were ideologically among the declared opponents of the Qing dynasty.

Common to all the artists of this period, however, was the preference for arranging the pictures into an album, making the album leaf the most widely used format of painting. Irrespective of the number of leaves the album had, artists could display the full range of their techniques in this small format, which were from 20 to 30 centimeters (8 to 12 inches) in height and 30 or 60 centimeters (12 or 24 inches) in width. The other formats were not obsolete as a result, but the albums were by far the most popular, for they made it possible for artists to arrange their works in terms of theme or technique.

Orthodox, individualistic, and eccentric

Among the most famous painters of the orthodox school were the Four Wangs: Wang Shimin (1592–1680); Wang Jian (1598–1677; see page 201); Wang Hui (1632–1717); and Wang Yuangi (1642–1715), a grandson of Wang Shimin. There was also the flower and bird painters Yun Shouping (1633–1690) and Wu Li (1632–1718), a pupil of Wang Shimin; and Wang Jian, who was known for his landscape paintings in the style of Wu Zhen and Wang Meng.

Seeing themselves as part of a long tradition, they all continued to use the style of ink painting typical of the Ming literati painters; they were attempting to convey to their own age and beyond the spirit of the Song and Yuan paintings they all valued so highly. The two earlier Wangs in particular were traditionalists, and clung to the ideal of the universally educated and creative scholar-artist who devoted himself to painting and calligraphy as a noble pastime. Living at the end of the Ming era, they still earned their living as officials.

Because of his high social standing, Wang Shimin had been able to meet the great artist Dong Qichang, who became his mentor. This, and the fact that in the scholarly Wang family large numbers of paintings were available for close study, explains why Wang Shimin was so deeply rooted in the traditionalist style. At the same time,

another of Wang's main sources of inspiration was
Huang Gongwang, whose typical elements, such
as the layers and folds in mountain peaks, he used
in a new way. And there were other masters whose
influence on him can be recognized, including
Dong Yuan, Juran, and Ni Zan. Wang used a
variety of light and dark ink tones, applied with a
range of brushstrokes, creating towering, tightly
packed landscapes of great charm.

The painter Wang Hui, the son of an art-dealer,
acquired a deep knowledge of painting from
Wang Shimin and Wang Jian, who had "discov-
ered" him as a promising talent. Moreover, three
generations of his family had been artists, and his
father's wealth and status had opened the door to
many private collections of the highest quality.
Becoming known for a style characterized in
particular by a wide range of thin and elegant
brushstrokes, he began working at the court in
Beijing in 1691 on commissions of the Kangxi
emperor, painting pictures documenting the
second imperial inspection journey to the south in
1689. Though he refused a permanent position at
court (and left after seven years), he nevertheless
directed the work on the painting of the Kangxi
emperor's southern journey, which resulted in the
longest picture in the world. Wang taught the
various court painters and his own pupils how to
portray on silk with ink and color detailed and
skillfully executed landscapes, people in distinctive
costumes, and important events from the various
stages of the journey. His invaluable contribution
was to give the work by different painters a unified
appearance by painting most of the landscape
himself. Figures, buildings, and "routine work,"[2]
as Fong called it, he left to his assistants, so the
scrolls are not wholly representative of his talent.

His abilities, especially his style in old age, are
seen more clearly on hanging scrolls with typical
literati motifs, works which refer to the old masters.
In these he exhibited his range of brushstrokes,
horizontal, vertical, and diagonal; the diagonal
strokes he used to suggest the texture of stones,
mountains, and vegetation, a technique that
creates the impression of countless plants and
rocks. He depicted expanses of water with the same
strokes, small and curved (see right). His own style
developed through study of the works of the Yuan

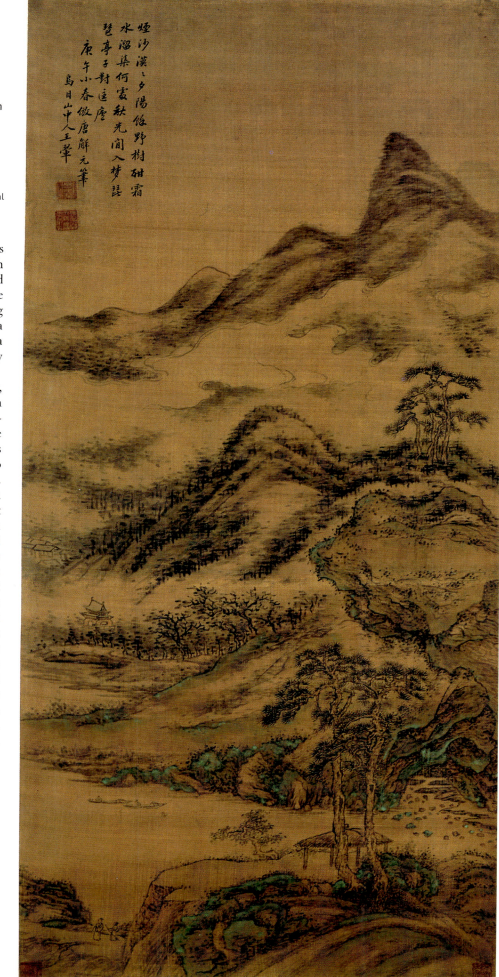

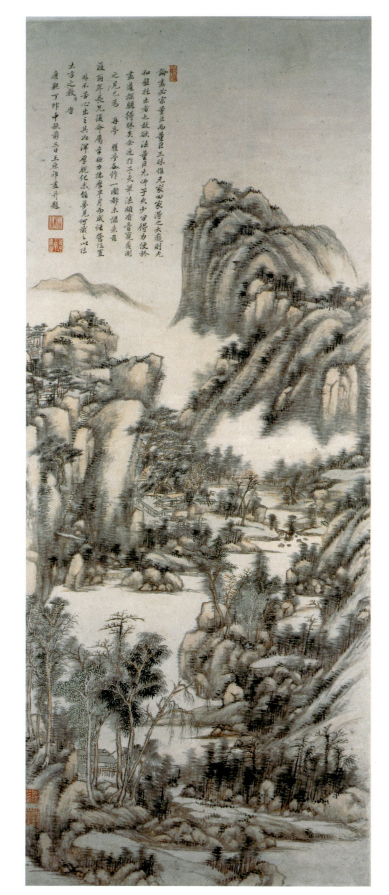

Japanese quince

Yun Shouping (1633–1690)

Dated 1685, ink, color on paper, fan leaf 16.9 x 52.1 cm, Museum für Ostasiatische Kunst, SMBPK, Berlin

Yun's pictorial representation in the "boneless style" shows a blossoming branch of the thorny Japanese flowering quince (*Chaenomeles speciosa*) in a very realistic and lively manner, but at the same time with a light and sketch-like effect. The composition of the picture and the inscription have a complementary effect, especially through the fine, calligraphic use of the brush for the branches with thorns and the delicate script in the *xingshu* style.

Left

Landscape in the style of Huang Gongwang

Wang Yuanqi (1642–1715)

1687, ink, color on paper, hanging scroll, 132 x 51.4 cm, British Museum, London

Wang uses predominantly horizontal texture strokes, like his model Huang Gongwang, apart from the wash for the distant mountain peaks. The cloudy mist creates a sense of distance. The prose inscription of the artist describes how orthodox artists of the Qing era acquired the models of the past. At the same time it creates a balance between pictorial composition and empty space, placed at the end of a zigzag compositional line which begins at the bottom right with the emptiness of the cut-in surface of the water, continuing on the left with a larger area of water, and finally being taken up on the right by the wisps of cloud from the mountains, coming to a halt towards the left. This compositional line ends with the inscription.

painters, and culminated in his discovery of the monumental landscapes of early Song painting.

His work is in effect a synthesis of Song and Yuan painting, combined with the literati painting of the Ming era. Wang Shimin saw in Wang Hui an "enlightened one," a Chan painter, a congenial spirit whose artistic vision brought to life the great painters of the past. And even though his influences and techniques were many – he mastered Fan Kuan's "raindrop" texture as well as Juran's "hemp fiber" texture perfectly – in his finest work he did not simply copy older works but created new compositions that harmoniously combined styles that had been considered incompatible. Nevertheless, his role as a "forger" ("copyist" is more accurate) became clear only in recent years, when his brushwork technique was examined very closely. It now seems that works hitherto attributed to painters of the Song, Yuan, or Ming era were painted in his studio. He was, apparently, able to deliver whole collections of "historical" Song and Yuan paintings to order.

Wang Yuanqi, the youngest member of the Wang group, was a grandson of Wang Shimin. He held a high-ranking position at court and was director of the imperial painting and manuscript collections, a situation that clearly suited his tastes. Of all the traditionalists, he was the most inventive. His landscapes communicate space and depth by subtly breaking up the surface of the picture, a mountain slope becoming a collection of blocks executed in an almost Cubist manner (see left).

With Yun Shouping (originally Yun Ge, he changed his name several times; 1633–1690) an innovative genius of flower and bird painting appears amid the general conformity of the orthodox masters. Born into a respected family, he became famous for lyric poetry and calligraphy as well as for painting. After the fall of the Ming dynasty, his family, staunch Ming supporters, went to Fujian, a last bastion of those loyal to the Ming. Although never a court painter himself, his style of flowers became a model for orthodox court painters. He developed two styles of flower painting: painting in the strictly naturalistic sense with outlines (*xiesheng*); and painting in a free,

sketch-like manner (*xieyi*) without outlines, form being indicated simply by areas of color (*mogu*). Yun favored the latter style because it allowed him to capture the fleeting impressions of nature more effectively (see opposite, above). His innovations in flower and bird painting were in technique: in the use of washes, textured strokes, and color harmonies.

As a man of refined and discriminating tastes, he was even very choosy about the people he mixed with, and consequently refused to let his pictures go to just anyone; only people whom he considered worthy were allowed to enjoy his art. When he died he was very poor and his friend Wang Hui assumed both the costs of his coffin and the performance of the funeral ceremonies.

The main contrast to the orthodox painters is provided by the so-called Individualists. The term in fact embraces several very different painters that the critics could not assign to any specific school; they were both the last of a long line of Chan painters, and also the inspiration of many later nonconformists. Among the Individualists were two artists known as the "Two Stones," Shitao (about 1642–about 1707) and Shixi (better known by the name of Kuncan, 1612–1673?). Both were monks. To these two can be added Zhu Da (1626–1705), better known under his artist's name of Bada shanren, and the monk Hongren. All four artists lived through the fall of the Ming dynasty and the invasion of the Manchu. During those years of dramatic change they, as convinced Ming loyalists (Chinese *yimin*), withdrew into the solitude of exile. Zhu Da came from the Ming imperial family and after the fall of the dynasty fled in order to escape persecution; he became a monk, first of the Buddhist, and later of the Daoist, faith. He fled because when dynasties changed, it was not uncommon for members of the previous ruling house to be executed.

In his painting, Zhu Da transferred the flowing brushstroke of calligraphy to the painting of landscapes, animals, flowers, and birds. Whether painting cats or birds, near or distant landscapes, he painted them with just a few simple strokes – or, it sometimes seems, a single brushstroke, his style at once abstract and powerfully expressive. In calligraphy, he was decisively influenced by his study of the masters Ouyang Xun, Huang Tingjian, and finally Dong Qichang; in painting, he was inspired by the works of Dong, Ni Zan, and Mugi. He seemed to distance himself firmly from representations which were true to nature: the majority of his works are characterized by generously brushed lines, dots or strokes running in all directions alongside and across each other, and also by a lack of scale and perspective (see right). According to the art historian Craig Clunas, Zhu Da's paintings do not resemble anything produced by his predecessors.[3] He found many imitators, however, particularly in the modern period. His works can often be interpreted as a silent protest against foreign rule; this can be seen, for example, in the recurring image of a lotus flower with a

Fish, bird, rock

Zhu Da (Bada shanren)
1694, ink on paper, hanging scroll,
Drenowatz Collection, Rietberg Museum,
Zurich

The picture shows the high degree of abstraction which Zhu Da was able to attain. The three pictorial building bricks step directly out of the surface. With a few simple strokes and the application of a brush dripping with ink, the artist created a picture simultaneously in the spirit of the Chan painting and of the literati. The "hovering" fish shows a characteristic of traditional painting: water is not represented.

Waterfall on the Han River

Shitao

Dated 1694, ink, color on paper, hanging scroll, 54.3 x 41.5 cm, National Gallery, Prague

According to the inscription the picture is the impression of a journey: "On the 21st day of the seventh month of the year 1694, Shitao passed by the Ping mountain here." Reduced composition, powerful but concentrated strokes and economical, accentuated colors show a scholar in front of a waterfall. Tension is created through the empty space and through the contrast of the high cascading waterfall and the horizontally composed pine-trees. The pines and the waterfall oppose one another on one diagonal, the painter and the poem in another.

broken stem. His attitude to the new dynasty is even more evident in the somber poems he wrote on some of his flower pictures.

Another important Individualist was also a relic of the old dynasty. The great nonconformist artist Shitao (also known as Daoji and Yuanji) was born Zhu Ruoji. He was a direct member of the Ming clan and his family were deeply involved in an attempt to re-establish the Ming dynasty; in the course of these events his father was killed and the young Zhu saved by a faithful servant, who took him to the safety of a monastery. Here "Zhu Ruoji" became "Yuanji" and "Shitao." In his early years he traveled with that same guardian through various southern provinces, finally becoming the pupil of a Chan monk. He painted his first pictures in the 1650s; orchids, as he tells us

himself. During the 1660s he developed a style of his own, based on works of artists from Anhui, including Hongren. He was influenced in particular by the dry ink technique of Ni Zan and the "outline style" (*baimiao*) of Li Longmian. In comparison to the orthodox literati artists, however, he never had the opportunity of seeing originals of the Yuan or Song era. Probably works from the Ming period and their transformation into woodcuts were the examples from which, as a self-taught artist, he learned his trade. The extreme poverty of his youth was reflected again in later years in countless pictures of a melancholy nature. Until 1696 he traveled around more or less permanently; they were years in which, among other things, he became acquainted with the Kangxi emperor, collected many impressions of places and people, and sold his first paintings (from 1680). Although Shitao's concept of painting ran counter to that of the orthodox painters, he collaborated with Wang Hui and also with Wang Yuanqi, the commercially oriented member of the literati. In his highly original calligraphy, which in brush technique is closely related to his paintings, Shitao is at pains to show that nothing genuine or original could be expected from the traditionalists. Some of his pictures are in fact declarations of war on tradition; his *Ten Thousand Ugly Pink Dots*, to be found in Suzhou, was by his own admission an attempt to shock those who praised only the old masters. Not to belong to any school was his artistic creed, abstraction his aim, and *yihua* line his means. This priority of the line, a stroke of which can denote the infinity of creation, may have arisen from his knowledge of Chan Buddhism. But Daoism might also be a possible inspiration in this matter: his art is implicit with the sense of "the One from which everything originated." Around 1700 Shitao's text *Huayu lu* (Conversation about Painting) appeared. The mere method of painting, he writes, must not constrict the artist; he must not become the slave of technique. The transformation of tradition is the only way for the painter to find a genuine style, since he cannot feel exactly like the ancients, he can only be himself; he must listen to his own inner voice. Alongside the theoretical background to painting, in *Huayu lu* Shitao also gives instruction in how to paint various subjects. He sets out 13 different textural techniques, explains a form of landscape that requires three levels (earth, trees, mountains), and recommends the following six topics of composition: spring-like plain with wintry mountains; wintry trees in front of spring-like mountains; towering mountains and hanging branches or vice versa; the enclosed view (in the same sense as an enclosed garden; Shitao was also known for bold stone compositions in gardens); "cut-out" scenery; and finally, high, steep mountains like those which one could imagine on the islands of the Immortals (see left).

It was not physical similarity, nor the mere reproduction of nature, nor brush technique that were the aim of his artistic creations, but "self-

presentation." His works, though they contain many motifs from literati painting, are far from being conventional images (see above).

The same thing could be said about the painter Kuncan. There is no doubt about the individuality of the painting of this famous monk, though only a few works by him have survived. And despite a great deal of research, little is known for certain about Kuncan himself, though as one of the monk painters he has had countless anecdotes attached to his works and his name. His family name was Liu; he came from Wuling (today Changde in the province of Hunan) and lived in Nanjing. His monk's name was Kuncan; alongside this he used other names, of which Shixi is generally the best known. He was a fine landscape painter, but also produced figure studies and plant paintings. His sources of inspiration were primarily the four masters of the Wang era, especially Wang Meng and Huang Gongwang. Kuncan's pictures are the expression of an intense experience of nature, not the mere presentation of the technical possibilities of the brush, the ink, or the colors, though he mastered all of these to perfection. Kuncan portrays landscapes atmospherically and in detail. On the basis of a sequence of seasons (still preserved complete, even if scattered around three museums), Kuncan's ability to represent the mood of a landscape becomes clear. Summer, Autumn, and winter, the latter dating from the year 1666, are shown here together for comparison (see right). Spring, the fourth landscape (not shown here), is to be found in the Cleveland Museum of Art, USA. These four small landscapes, dedicated to a friend, were originally conceived as album leaves but are now mounted onto small hand scrolls. For each season Kuncan depicts different weather conditions (a clear winter's day contrasts with a hazy and sultry summer's day, for example) by varying both the coloring and also the contrast between clear line and misty washes. All his landscapes are dense and unsettled.

The Individualist direction in painting culminated in the disappearance both of the ideal of the amateur painter and also the strict imitation of

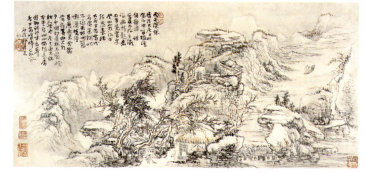

Above

Peach-blossom spring

Shitao (about 1642–about 1707)

Ink, color on paper, handscroll, 25 x 157.8 cm, Freer Gallery of Art, USA

With the theme of the peach-blossom spring, Shitao varied a standard motif of literati painting. The Ming literati immortalized the motif, especially Qiu Ying. Tao Yuanming's (A.D. 365–427) prose poem "Peach-blossom Spring" tells the story of a fisherman who passes through a gap in the rocks into another, heavenly world, after traveling along a riverbank with only peach-trees growing on it. The inhabitants of that world live in peace and prosperity, never returning to the world on the other side of the mountain. They look after the fisherman well and ask him to keep their existence a secret. When the fisherman returns to his own world he marks the way to the gap in the rock exactly, but when the Prefect, on the basis of his report, sends out a search party, there is no trace of a path to that heavenly world.

Summer

Kuncan (1612–1673?)

Ink, color on paper, album leaf, 31.4 x 64.3 cm, Museum für Ostasiatische Kunst, SMBPK, Berlin

This picture, like the others in the series, is provided with the inscription by the artist and bears three seals with the names Jie qiu, Shixi, and Canzhe, three names regularly used by Kuncan.

Autumn

Kuncan (1612–1673?)

Ink, color on paper, album leaf, 31.4 x 64.9 cm, British Museum, London

Winter

Kuncan (1612–1673?)

Ink, color on paper, album leaf, 31.4 x 64.9 cm, British Museum, London

In all four landscapes the painter shows a gentle landscape of hills, old trees, and a simple hut in which a scholar is sitting.

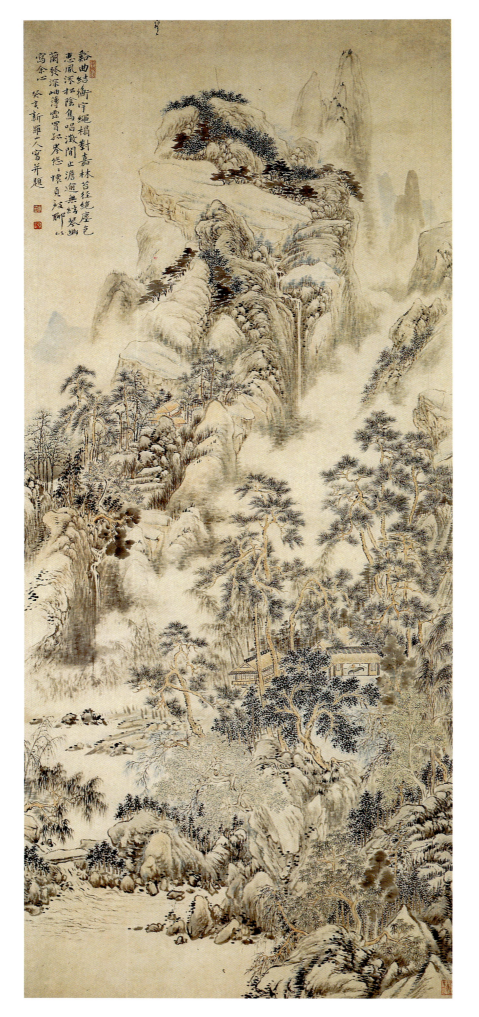

classical models. It was from this position that the so-called Outsiders or Eccentrics, the *guai*, started.

The "Eight Eccentrics of Yangzhou"

During the 18th century the cultural and social life of Yangzhou, which had grown wealthy on the salt trade, attracted countless artists; it offered not only beautiful gardens and landscapes, winehouses, inns, brothels, and pleasure-boats, but also all-important patronage. Many wealthy travelers came to the town, and some were keen on buying works of art; and the rich merchants who lived there prided themselves on patronizing "their" painters, whether the artists were locals or newcomers. As a result of being generally less cultured than other patrons of the arts, these new buyers were less firmly tied to traditional forms, that had a very positive effect on painting: painters could now experiment with new themes and techniques, and yet still find enthusiastic customers.

The label the "Eight Eccentrics of Yangzhou" (*yangzhou baguai*; they were also called the "Outsiders") was coined in the 19th century and encompasses very different artists. In what is probably the first Chinese text to use the expression (in the second half of the 19th century) the following names are given: Luo Ping (1733–1799), Li Fangying (1695–1754), Li Shan (1686–about 1760), Jin Nong (1687–1763), Huang Shen (1687–1772), Zheng Xie (1693–1765), Gao Xiang (1688–1753/54), and Wang Shishen (1686–1759). Occasionally, however, Gao Feng-han (1683–1748), Bian Shoumin (1684–1752), and Yang Fa (working in the second quarter of the 19th century) are added, as are Min Zhen (1730–about 1788) and Hua Yan (1682–1756). Grouping these names together does not mean that the artists followed a common program, either in style or theme. What was new was that the painters were literati but "lowered" themselves to selling their art – the age demanded a change of traditional values. In the eyes of the literati painters of the Ming era, this would have meant prostituting the ideals of the scholar-painter. But the newly emancipated artists had a different view of their situation, one that can be summarized as "a little vulgarity does no harm, because after all even the distinguished scholar has to live off something" – a very pragmatic view. All the same, they did not always feel at ease with this development, as becomes clear, for example, in one of Zheng Xie's private letters.

These artists demonstrated their artistic independence and individuality through intense styles of painting that verge on the abstract or the expressionist. Using thin brushstrokes paired with extensive washes, or bold calligraphic strokes that produce a sketch-like effect, these artists created works that were to have an influence lasting well into the 20th century. Some employed rough-bristled brushes or worn brushes to create distinctive effects – an example is Jin Nong, originally a calligrapher, who is now considered to have been the "leader" of the Yangzhou group. He looked for

his models not among the Song or Yuan painters, but in the art of the pre-Tang and Tang era, and in doing so acted as an important link between earlier artists and the Yangzhou group. The subjects of the Eccentrics were the traditional Four Noble Ones, and the Three Friends of Winter, but they also developed themes new to literati painting, such as spirits and personal and narrative landscapes, themes that permitted greater self-expression and the use of free and dynamic brushwork. In principle, then, the Eccentrics did not break totally with tradition but actually lived the ideal of the literati painters, and especially those of the Yuan era. They differed in technique: Wang Yuanqi, one of the orthodox painters, criticized them for "not using brush and ink correctly," a charge that amounted to total condemnation.

If examined closely, the works of the Eccentrics show marked differences in expressiveness and in degree of abstraction. In the early days there were artists like Hua Yan, who, despite his versatility, was regarded as one of the conservatives among the Eccentrics (see opposite). Nevertheless, the characteristic elements of the Eccentrics can be recognized: abstract, calligraphic brushstrokes, ink dots, and warm colors.

Zheng Xie, better known as Zheng Banqiao, was the most complex of the Eccentrics. Famous as a poet, essayist, and calligrapher, he became known for his exceptional talent in painting ink bamboos, a traditional motif that gave him the opportunity of subordinating illustration to calligraphic brush-work. Other traditional motifs of ink painting, such as stones, orchids, and chrysanthemums, were also in his repertory. Zheng acknowledged his masters to be Xu Wei, Daoji, and even his contemporary Gao Qipei, and it was through them that he evolved his own simplified style. The calligraphic strokes communicate the dance of the brush in Zheng's hand, quick, concentrated, and rhythmic, the black or gray bamboo leaves creating a subtle illusion of near and far, clear and hazy. After his (not entirely voluntary) withdrawal from public office in 1753, Zheng spent a good life on his property in Xinghua

Above

The poet Tao Yuanming with chrysanthemums in a boat

Ren Bonian

Dated 1887, ink, color on paper, album leaf, 27.7 x 34.1 cm, Museum für Ostasiatische Kunst, Cologne

Ren illustrates the poet's homecoming by by showing him sitting in a boat; the chrysanthemums are a symbol of a poet's life of seclusion. In the poem they are mentioned after the poet has arrived at his estate – the picture condenses the key scenes of the literary model in one scene.

Right

Hermit

Gao Qipei (1660–1734) or a pupil

Finger painting, ink on paper, hanging scroll, Oriental Museum, Budapest

near Yangzhou, painting his famous bamboos and other subjects. His bamboos enjoyed a vogue, and to the horror of his patrons he even drew up a price list geared to the size of the pictures, which put a stop to bargaining prior to or after purchase. It is often said that the term "eccentric" applies solely to paintings of this group, but in Zheng's case it applies equally to the man himself, for he maintained a lifestyle unusual for a Confucian man of letters, what at heart he always remained. His fame continued long after his death, for the possession of a Zheng, whether painting or calligraphy, provided an entrée to the higher levels of the literati.

Luo Ping, a pupil of Jin Nong, was the youngest of the Yangzhou painters. His choice of motifs caused a furore in 18th-century Yangzhou: he specialized in the painting of spirits – he reproduced them, he maintained, exactly as they appeared to him. Like other artists, Luo felt the effect of the decline of Yangzhou from the middle of the 18th century, when painting and calligraphy were to some extent replaced by opera and theater as the favorites of patrons. The Yangzhou painters, however, though they flourished only briefly, were widely influential, and in particular formed a point of departure for the development of the Shanghai school in the 19th century, though they were also inspired by the Individualists.

Though the finger-painter Gao Qipei (1660–1734) was eccentric in his choice of technique, he was not one of the Eight Eccentrics. This senior official of the Kangxi set his interpretations of figures, landscapes, and animals onto paper with his fingernails as well as a brush. Gao came from the northeast of China, the present-day province of Liaoning. He originally worked in the traditional style; but wanted to distinguish himself by something particularly original, and achieved this through his extraordinary technique. Though finger-painting had been known in the Tang era, in the course of almost a thousand years it had not produced a well-known master.

It is possible that this Manchurian official was trying to emulate the first emperor of the dynasty

(Shunzhi), who is supposed to have mastered the technique. Finger-painting was popular among the Manchurian officials and Gao's works were received enthusiastically. He painted mainly landscapes and figures, also flowers and birds, and was as adept with monochrome as with color.

To sum up, the development of Chinese painting during this period appears to quicken. The orthodox painters kept to tradition and aimed at perfection; the Individualists threw off some of the deadweight of tradition and created their own distinctive styles; the Eccentrics, finally, going beyond the achievements of the Individualists, developed a range of idiosyncratic styles that brought new potential to calligraphy and painting.

The legacy of the Individualists and the Eccentrics was inherited principally by the Shanghai school. Like the merchants of Yangzhou a century before, the merchants in Shanghai had recently grown wealthy and many developed a keen interest in painting and calligraphy; possessing fine works was, after all, an effective way of displaying one's success. And here, too, painters were free to develop a wide range of subjects and technique. Among the most important painters of the Shanghai school is Ren Xiong (1823–1857), whose famous self-portrait with shaven head, half-naked upper body, and jacket falling from his shoulders, can be seen as a symbol of China's move into the modern era. Also in the Shanghai school are Xu Gu (1823–1896), Zhao Zhiqian (1829–

1884), the famous Ren Yi (1839/40–1895), and his pupil Wu Changshuo (1844–1927).

Ren Yi, also known as Ren Bonian, was the leading artist of Shanghai. Traditionalists were suspicious of his success, especially as he was extremely proud of the wealth he had accumulated through painting – an attitude that clearly broke with the venerable traditions of the literati. Ren's repertory included, alongside flower and bird pictures, new motifs he took from popular literature, novels and stories which, based on classics, were written in colloquial rather than formal Chinese. And he painted their heroes in a way that could be understood by anyone. This subject matter and style allowed Ren to widen his circle of clients to include the urban bourgeoisie, who preferred this literature. In fact, because he presented classical themes and subjects in a way that was clear and expressive, even those with little education could understand his works.

The Emperor's new gardens

The architecture of the Qing period continued the traditional Ming style. Because of increasing restrictions in the capital, the Qing emperors were no longer able to embark on new building projects at the Imperial Palace, and had to be content with improvements. Nevertheless, some interesting complexes were newly created. Among them were extensive temple sites, new residences at existing

Right

White Dagoba (Bai ta) in the Northern Lake Park

Built about 1651, Beijing

Far right

Diamond Throne Pagoda (Jin'gang baozuo ta)

Built after 1748, white marble, Western Mountains, Beijing

The Qianlong emperor had the Diamond Throne Pagoda, which was modeled of a temple in Hangzhou, in the Western Mountains.

Yihe juan, Summer Palace, site north of the Kunming Lake

1 Eastern palace gate
2 Hall of Justice and Longevity
3 Pavilion Announcing Spring
4 Hall of the Jade Waves (with Little Castle of the Wonderful Sunset)
5 Garden of Virtue and Harmony
6 Hall of a Joyful, Long Life
7 Garden of Harmonious Joys
8 Pavilion of Happiness in the Landscape
9 Gate of Honor "Arch of the Shining Clouds and Jade Channels"
10 Hall Which Disperses the Clouds
11 Tower of the Scent of Buddha
12 Complex of a former Lama temple
13 Long Promenade
14 Boat of Purity and Peace, also "marble ship"
15 Far Lake
16 West dike

Below

Maze in the European style

2nd half of the 18th century, destroyed in 1860 by English and French troops, part of the European Garden in the Yuanming Garden, Beijing

In the garden of the Long Spring, Changchun yuan, part of the Yuanming yuan, there were several buildings *à l'européen*. Three-dimensional, they could not be entered: behind the façades was just earth.

Ruins with rocailles

2nd half of the 18th century, destroyed in 1860 by English and French troops, part of the European Garden in the Yuanming Garden, Beijing

Little Castle of the Wonderful Sunset (Xijia lou)

First building under Qianlong, Summer Palace, Beijing

Right

Tower of the Scent of Buddha (Foxiang ge)

Octagonal four-storied building with wooden frame, tower about 40 m in height, without the supporting foundation of about 20 m in height, on the Hill of Longevity (Wan shou shan), Summer Palace, Beijing

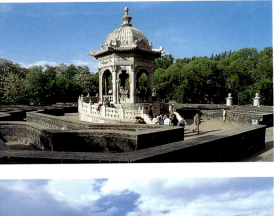

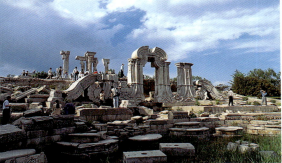

palace complexes, and above all gardens, both on the perimeter of the city and at summer seats away from the capital. The first garden developments took place in the present-day Northern Lake Park, where, as a result of Lamaist influence, a remarkable bottle-shaped stupa was constructed on an exposed site: the White Dagoba (Bai ta).

When looked at retrospectively, these building works can be seen as the final imperial developments in the capital city, and therefore of the empire. Like their predecessors the Yuan, the Qing rulers built a temple in a prominent site in the capital; and in their two main residences, in Beijing and Chengde, they also built copies of buildings and gardens from all around the empire, a "collection" that was in effect a symbolic appropriation of the empire.

Garden art experienced an unexpected upturn during the Qing dynasty; new sites and reconstructions were a source of pleasure for the educated – and those who considered themselves educated, or wanting to show off their newly acquired wealth. In addition, the change of dynasty brought the removal of countless officials who were Ming loyalists, who now retired to their country estates and cultivated their gardens. Likewise, during the so-called Qing Inquisition, countless intellectuals sought a quiet life in the country. In this enforced retirement we can see a contrast between otium (retirement from active public life) and negotium (work and civic responsibilities) reminiscent of the days of Roman emperors. The people owning private gardens mostly reconstructed sites from the Ming period, and in doing so were bound to the existing plot of land; there was in fact a preference for gardens with a history. When renovated and newly named, they served as a place of peaceful recreation during long years of (often enforced) retirement. The Qing period, however, can also be seen as the era of gardens, for the great imperial gardens, which almost entirely fashioned the Western concept of a "Chinese" garden, date without exception from then. Ming period imperial gardens, which extended out from the south side of Beijing, have not survived. But the Qing designs did follow the suggestion made in the classic study of gardens Yuan Ye by Ji Chang of the Ming dynasty, and precisely because the models for the Ming imperial gardens had been based on them. There were no real landscape designers; it was the land-owning merchants, scholar-officials, and even the emperor himself who found fulfillment in reconstructing a small piece of nature according to their own desires. They provided the basic "spiritual" concept, which geomancers, carpenters, laborers, gardeners, and "stone masons" ("masters of artificial mountains") then made a reality. This spiritual concept was based on a knowledge of other gardens, descriptive literature, documentary painting, lyric poetry, geomantic lore, and the advice proffered by the Yuan Ye. According to the wishes of the owner, paintings and lines of poetry were turned into gardens; celebrated gardens were imitated, closely or freely, and famous natural landscapes were reproduced in miniature. The main aim of the garden, whether large or small, was to create natural-seeming scenes full of variety.

The Qianlong emperor can be considered the inventor of the theme park. He encouraged the

copying of real landscapes, of imitating famous gardens, and of transforming paintings into water, earth, plants, and stones... and all this in truly majestic dimensions. A picture by Zhang Zeduan was especially dear to him in this connection. First he had a pocket version of the picture *Life Along the River on the Eve of the Qingming Spring Festival* (see page 169, top) prepared by the court painters, and then he built up the various scenes as a garden. Unfortunately, nothing of his garden has been preserved. Other gardens, however, are amazingly well documented. They reveal that at a time when Europe was enjoying a vogue for chinoiserie, the Chinese imperial court was indulging in a fashion for things European. Just like his contemporaries in the West, the emperor was accustomed to giving masked balls, and there is a painting showing him in the "fancy dress" of European clothes. Similarly there are trompe-l'oeil effects on the walls of his palace and late Baroque buildings in one of his parks (see opposite, above left).

Officially, the Qianlong emperor had had the Christian mission banned, but he had not in fact removed the missionaries from the court: they could keep him abreast of developments in science, technology, and the arts. A fountain by the French physicist Benoist owes its existence to the caprice of the emperor in wanting to have a European garden. In 1749 the emperor ordered the Italian painter Giuseppe Castiglione (1688–1766?), who had been

working at the court since 1715 under the name Lang Shining, to lay out a pleasure garden. The Qianlong emperor had discovered a love of fountains and the painter-architect was now put to work designing a garden, to be completed in three phases, that would incorporate European features, including fountains. And so through the patronage of the Qianlong emperor the site of a palace and gardens built by the Kangxi emperor at the beginning of the 18th century was now carefully redesigned. Nor was this Europeanization the most eccentric expression of the imperial mania for gardens. The Yuanming yuan, the residence of the emperor's father, begun as a palace-garden complex under the Kangxi emperor and completed during the Yongzheng period, was also altered, with copies of gardens of the Jingzhen region being constructed. That was only a foretaste of the projects the emperor pursued with a real passion. The present-day Summer Palace, originally the Park of the Clear Waves, renamed Yihe yuan by the empress-widow Cixi (1835–1908), is the best example of his obsession with building. He justified his building activities to his ministers by arguing that in order to maintain the emperor's health and efficiency in performing his sacred duties towards his people, he needed a "refuge" in which his mind and body could draw new strength. In the beginning he insisted on thrift; an attractive spot and simple buildings, like those of his great-grandfather and father, would suffice. But things soon changed.

Jichang-garden (Jichang yuan)
Woodcut illustration from the Hongxue yinyuan tuji of 1847, Shanghai edition of 1886

Lotos pool in the Xiequ yuan with open pavilions on the bank
First building from 1751

Around an L-shaped pool surrounded by willows, open pavilions are grouped with a view to the water, halls, terraces, bridges, and promenades, which provide a path around and over the pool. One bridge is called Recognize the Fish, adapted from philosopher Zhuang Zi's discussion about whether fish know feelings of happiness.

Temple in the style of the Potala (Putuo zongsheng miao)

Built between 1767 and 1771, Summer Residence, Chengde

The temple is a copy of the Potala palace in Lhasa. If Tibetan clerics visited the residence of the emperor during the summer, then they were lodged, for example, in the temple in the style of the Potala. If Panchen Lama or other high-ranking religious leaders visited the summer residence, then there was also the temple of happiness of the Sumeru-mountain Xumi fushou miao, an imitation of the monastery of Tashil-hunpo in Shigatse for their use.

The Long Promenade

First building 1750, wood with roof tiling, pillars and beams colorfully painted in the Suzhou style, Summer Palace, Beijing

Painted beams in the Suzhou style

Summer Palace, Beijing

This painted panel showing a river landscape is badly in need of renovation.

Countless lakes (including the vast Kunming Lake) were dug, the excavated material being used to landscape the garden with hills; small buildings and whole palaces were constructed, and historically important garden furnishings were brought from all over the country, including famous natural stones steeped in legend. Between 1749 and 1764, the emperor spent the enormous sum of 4.5 million liangs of silver from the treasury.

Almost 300 hectares (750 acres) in area, the site incorporated recreations of the gardens and landscapes of the Jiangnan region: Hangzhou and the Western Lake, Suzhou and its gardens, and even the gardens on Lake Tai.

Four different major elements make up the Summer Palace site: the residence with imperial halls and rooms, in which there were single courtyards with planted gardens; the southern lakes with their cultivated banks; the Hill of Longevity and the lake behind; and the gardens within the garden to the east of the site. In the private gardens, as in the gardens of Changchun yuan and Yuanming yuan, walls marked the separation into individual sections. But at the Summer Palace the emperor was able to dispense with walls; here miniature "hills" fulfill this function, and only one garden within the huge complex, the garden of the Hui mountain, is enclosed within walls. One of the finest recreated gardens at the Summer Palace is a copy of the Garden of Relaxation (Jichang yuan) in Wuxi, one of the many sites with which the emperor had become acquainted on his inspection journeys to the south (see page 237, top right). Another garden, called the Garden of Harmonious Joys (Xiequ yuan) after 1811, is a replica of the garden of the Hui Mountain that follows its original in every particular: the emperor had had a detailed map made of the original on the spot in order to be able to create his own version in Beijing (see page 237, below). It was in the tranquil solitude of this garden that the later Qing emperors sought relaxation by fishing in the lake.

And it is on the shore of the lake that the Summer Palace unfolds its greatest architectural splendor. From a two-storied building on the east bank, the emperor could watch the sunset and look out towards the replica of the Western Mountains that had been created in the garden. He could walk along the lake thanks to the longest covered walkway in Chinese garden art, the famous Long Promenade; the Qianlong emperor had had it built in 1750. A covered walkway was a standard feature of a Chinese garden, and they were usually set close to a wall. This promenade, which is open on both sides and roughly 800 meters (2,625 feet) long, is exceptional. Running parallel with the shore of the lake and also with the slope of the Mountain of Longevity, it links the eastern area of the park to the west like a richly decorated chain. As it is open on both sides, it afforded the emperor and his family an unimpeded view of the entire scene. The beams and panels were richly ornamented with *sushi* (Suzhou style) decoration, the decorative form used in gardens as well as living quarters, in which there is a combination of graphic patterns, floral motifs, and pictorial insets. In the insets the emperor had painted views from his journeys to the south, flowers and birds, and illustrations of classical novels (see below).

In the Summer Palace complex the emperor pursued the concept of "order and variation." In the lakeside promenade area, as part of the main complex in the garden, order predominates. Exactly halfway along the promenade is the Tower of the Scent of Buddha; on the shore, exactly opposite, is a gate of honor, *pailou*. This spot marks the landing stage for the imperial boat used on festive occasions when the royal household traveled by boat from here to the Kunming Lake.

On the western end of the Long Promenade, a viewing pavilion of unusual design awaited the visitor, modeled on a boat, as is one in the West Garden in Nanjing. But no private garden could boast a pavilion with the dimensions of this "marble ship" at the Summer Palace, a two-storied construction 36 meters (150 feet) long. Like the whole site, it is garden architecture taken to excess. Originally the Qianlong emperor had the boat built as a viewing pavilion, but today we see the construction the empress-widow Cixi ordered in 1893 to a new plan (see top left), which recalls a Mississippi paddle-

steamer. West of the "paddle-steamer" stretches a dike covered with willows, the West Dike. This dike on the Kunming Lake is breached six times and so, with its six bridges, is a close copy of the Su Dike in the West Lake in Hangzhou. Even in their shape, the bridges are copies of Hangzhu.

Original buildings dating from the Qianlong period are rare at the Summer Palace which was badly damaged by fire in 1860. Among the things to survive were a few works in bronze, notably the Zhong arcade at the back of the slope of the Hill of Longevity, the bronze pavilion, and a bronze ox. The park was badly damaged a second time by European troops during the Boxer Rebellion (1900). This time noninflammable buildings like the Pagoda of the Countless Precious Objects and the Temple of the Sea of Wisdom were less badly affected than the wooden ones. Decorated all over with tiny lead-glazed relief tiles that show hand-sized figures of Buddha, these buildings are jewels of ceramic-decorated architecture.

Even these two buildings had their models in the empire, notably the porcelain pagoda in Nanjing, and the "beamless halls," huge buildings that displayed their builders' remarkable skill in constructing stone vaults. By bringing together elements from the empire, the emperor was again demonstrating his legitimate claim to power. He surrounded himself with the wealth of his empire displayed in microcosm; he even created a micro-cosm of his world for his summer holidays – the summer residence in Jehol (Chinese, Chengde), 250 kilometers (185 miles) from the capital, which became his most extensive imperial park. Dotted around the landscape were palaces, gardens, and temples, most of them, as usual, copies of originals from all parts of his domain. His grandfather had started work on the site in 1703; the Qianlong emperor now built numerous extensions and

Top left
Boat of Purity and Peace

Built in 1755, after a fire in 1860 rebuilt in 1893 by Cixi with changes; natural stone and brick, painted in color with trompe l'oeil effect, length 36 m, Summer Palace, Beijing

Above right
Pot

Yixing Ceramic, H 10 cm, L 9 cm, Staatliches Museum für Volkerkunde, Munich

This small pot is decorated with a stylistic variant of the character for long life, *shou*.

Gate of honor, *paifang*, in front of the building complex on the Hill of Longevity

Summer Palace, first building under Qianlong, rebuilt by Cixi after a fire

The painting shows a rare style, a variant of the *xuanhe* style, with graphic decorations.

Above left
Statuette of the Buddha

Statue typical of the early Qing era, sancai lead-glazed in the colors yellow, brown, and green, H 17 cm, Staatliches Museum für Volkerkunde, Munich

The relief tiles of the Temple of the Sea of Wisdom in the Summer Palace show comparable depictions of Buddha on a throne of lotus flowers. Differences in the little high-relief figures of the ceramic tiles are detectable mainly in the head covering and the richer clothing.

Famille rose porcelain, 2nd quarter of the 18th century, overglaze colors in pink, green, blue, aubergine, black, rust, and gold, H 41.5 cm, dia 47.5 cm, Landesmuseum, Kassel

The pieces are decorated with a glazed color design of pheasants amid magnolia and peony blossoms.

Opposite
Rouleau vase portraying a gathering of literati

(Detail), porcelain, cobalt-blue underglaze, H 67 cm, Staatliches Museum für Völkerkunde, Munich

The typical gathering of literati in the studio of the host shows the scholars looking at a scroll; a second group is playing chess, surrounded by all kinds of precious objects. Meetings of literati of this kind took place regularly, for example, in 18th-century Yangzhou.

embarked on a series of major alterations. The park around the main palace, which had been built in the mountains to escape the summer heat, became the classic park of a Chinese emperor. Surrounded by a wall, the site encompasses a large expanse of water, more than 110 buildings, rocky landscapes, and large areas of parkland that betray the fact that the site was originally the imperial hunting ground. Eleven temples were built, of which eight still exist. The result was a park that contained a range of distinct, individual land-scapes (*jiejïng*), mainly copies of specific Tibetan or Chinese locations.

Traces of a cultural exchange: *famille rose, famille verte, Chine de commande, email sur biscuit, blanc de Chine* and snuff

The porcelain products of the Qing period bear exceptionally aristocratic names, at least in Europe. In 1708 the alchemist Johann Friedrich Böttger and the scientist Ehrenfried Walther von Tschirnhaus succeeded in making porcelain at the court of Augustus the Strong, who was one of the keenest collectors of the "white gold" from China. But before the coveted white porcelain could be held for the first time, a reddish-brown product known as "Böttger's stoneware" was the result of his experiments. It is very like a porcelain product, Yixing Ceramic, which was used widely in China at that time, and which, on account of its quality

Far right
Plate

Overglaze decoration in famille noire, dia 34.7 cm, late 17th century, by kind permission of the Percival David Foundation, London

The Daoist Trinity decorate the center: the star deities for happiness, success, and longevity (from right to left). They are accompanied by symbols which underline their iconographic significance: stag, child, crane, and old pines. In the leaf-shaped insets on the rim are alternate pictures of the stag and crane, these are predominantly in shades of green, the areas between are glazed in black (hence *famille noire*).

Right
Vase with floral decoration and pictorial insets

Kangxi era, porcelain, cobalt-blue underglaze, H 28.5 cm, Landesmuseum, Kassel

The pot is decorated with pictorial insets of overlapping fan leaves painted with literati scenes.

Table screen

1st half of the 18th century, gleaming gold glaze jiao-huang on a panel decorated in bas-relief, H 23.5 cm, by kind permission of the Percival David Foundation, London

The motif on the screen shows a cock with a *Celosia cristata*, cockscomb plant, a symbolic reminder to the scholar not to give up his ambitions to do well in office.

Plate with garden arbor

2nd quarter of the 18th-century, porcelain, cobalt-blue underglaze, Ohlmer Collection, Hildesheim

The pattern for the decoration stems from a Dutch artist by the name of Cornelius Pronk (1691–1759). A polychrome matching piece with identical decoration can be found in Kassel. In the center of the plate an arbor can be seen, clipped into shape as if from a French Baroque garden, beneath which figures in Chinese clothing are amusing themselves. In the pictorial insets on the rim are illustrations of butterflies and plants in flower.

for improving the taste of tea, could always hold its own alongside porcelain (see page 239, lower right). The porcelain of the Qing period was without exception colorful, unlike the earlier blue-and-white porcelain, and its glazes were perfect, having great purity and a fine sheen. The influence of the blue-and-white wares of the traditional era lasted into the Kangxi period, but under the third and fourth emperor of the dynasty the amount of porcelain produced began to decline. As before, the decorations include floral motifs, well-known scenes from literature, mythology, and the life of the literati. The decorated polychrome pieces became best-sellers not only on the home market, but also in 18th-century Europe, where they perfectly matched the prevailing rococo taste. In the 19th century the porcelain pieces with the overglaze colors were given the aristocratic names of *famille rose*, *verte*, *noire*, *jaune* (see page 241, below right). Their motifs were usually deities

who brought good fortune and figure scenes. Their characteristic combination of strong and pale colors had been made possible, especially in the case of the *famille rose*, by an exchange of knowledge between East and West (see page 241, above). Of course Chinese ceramic makers, like all other craftsmen of their time, created goods "from the whole wealth of the classical tradition;"[4] but pink, a new overglaze color on a gold background, made their palette even richer. This color was introduced into China at the beginning of the 18th century by the Jesuits at the Imperial Court and was named "foreign color," *yangcai*. The decorations on such ceramics are distinguished by a marked affinity with the composition and coloring of contemporary flower and bird painting. Although the lion's share of these ceramics was for export, the Qianlong emperor is known to have liked these decorated pieces. It is interesting that he also thought very highly of a literati painter by

the name of Zou Yigui (1686–1772), in whose flower pictures the forms are created by areas of solid color rather than by outlines – the relationship between painting and porcelain decorations painted with enamel colors became even closer. Zou Yigui was also the most important theoretician of his day, writing almost exclusively on flower painting. The approach he advocated was "natural painting:" painting based on close observation of a flower, capturing its exact colors and shape – not the imitation of an earlier master.

The Qianlong emperor had preferences not only in the decorative technique of porcelain, but also in motifs, one being the cock and hen. Cocks and hens had been used as decoration on polychrome porcelain since the Ming period; they conveyed both a pleasant sense of rural life and also precise symbolic meanings. The cock was an important symbol of the five virtues (according to the Han period comment of Han Ying to Shijing). His comb stands for literary culture (*wen*), in the same way as an official's cap does, and his spurs for the warlike fighting spirit (*wu*); since cocks are always ready to challenge intruders, they are also thought to display courage (*yong*); their call when looking for food indicates unselfishness (*ren*); and the punctuality with which they raise their voices every morning shows their trustworthiness (*xin*) (see opposite, right).

As can be clearly seen in this example, the finest monochrome glaze over shallow relief decorations lends a velvety sheen to pieces. In the

Yongzheng period (1723–1735) the Chinese produced numerous new glazes, and in the following Qianlong era (1736–1795), there was a creative return to a wide range of classical forms. The colors, however, were garishly bright, with ceramics spanning the whole gaudy spectrum being produced alongside the traditional blue-and-white ware. Even the simple and elegant shapes of the Song period experienced a revival, but now in glowing colors. The edges of the vases and dishes often formed a vivid contrast, gleaming snow white above the color of the glaze (see below).

Any review of the porcelain of the Qing period also needs to mention the *Chine de commande* and the *blanc de Chine*. The former was porcelain prepared for trading companies who sold to Europe, and so in shape and decoration met European requirements. The results often look incongruous, featuring Chinese elements along with Christian motifs, European coats of arms, landscapes, and even figures; often the setting is European, though the figures clearly have Chinese features (see opposite, left). Nevertheless, the European traders had to satisfy a huge demand for such wares and ordered not just vases and dishes, but also small figures. Particular favorites were the pure white pieces from Dehua, described in Europe as *blanc de Chine* (see page 244).

The factories of Dehua had presumably been producing ceramic products since the Song period, and from roughly the 16th century into the 19th

had specialized in monochrome white porcelain. Much of this was for religious use, and included Buddhist sculptures. The Dehua productions, therefore, also represent the sculpture of the period (see page 245). The influences of Europe were often subtle, indirect, and of short duration, but in at least two cases the impact was unmistakable. The first is the change in the image of Guanyin, which show the influence of the Madonna and Child (see opposite, right). The second can be seen in the new habit of snuff-taking, which emerged at the end of the Kangxi period and was thought very beneficial. The snuff bottles produced are a wonderful example for the modern design concept of form following function. On account of climate and the perishableness of snuff when damp, a container had to be designed which had the smallest possible opening as well as a small capacity. Snuff takers also wanted to carry with them the blocks of snuff from which snuff powder is made. What was more obvious than using traditional forms, but making them very small – from five to ten centimeters (two to four inches) tall? A cork made in the same material as that of the bottle serves as a stopper, with a small matching spoon made of horn, bone, or ivory. With a good bottle

Left
European family

1st half of the 18th century, blanc de Chine, Dehua, Museum für Kunsthandwerk, Frankfurt

Especially striking in this family of four in white porcelain are the Dutch costumes of the male figures and the Chinese costume of the female figures. The father sits cross-legged on a stool and holds a pipe in his hand. The figures are grouped around a Chinese table, in front of which is a miniature garden (penjing) and a little monkey.

Snuff bottles

(From left to right), glass, painted from the inside with a polychrome landscape motif. Flashed glass, clear glass, and burgundy-colored glass, carved, decorative motif of ancient vessels, on the neck the stopper and the shadow of the little spoon can be seen. Hair crystal, black tourmaline needles, the decoration is produced by the texture of the stone, max H 7.5 cm, Staatliches Museum für Volkerkunde, Munich

Guanyin giving presents to children

18th century, blanc de Chine, Völkerkundemuseum, SMBPK, Berlin

Here the goddess Guanyin is shown holding a small child on her knees, and on the plinth of the statue stand her familiar companions, Shancai and Longnü. The influence of Christian Marian iconography can be seen. Comparisons with representations of Guanyin from the period before contact with the Christian missions show clearly the Christianization of the motif.

Li Tieguai

19th century, New Year lamp of ox-horn, H 56 cm, Völkerkundemuseum, SMBPK, Berlin

On the 15th day of the first month, at the concluding festival of the New Year celebrations, which were drawn out over more than five weeks, a magnificent lantern festival took place. Li Tieguai is one of the eight Immortals of Daoism, a lucky symbol for a long life, and the guardian and patron of the sick and apothecaries. He is represented with a crutch and calabash (in which there are magic medicines). According to legend he was a pitiable victim of the negligence of his pupil, whom he ordered to watch over his mortal body during a sea voyage (his soul had left his body). For several days Li did not come back into his body, so his pupil had him cremated. When Li wanted to return to human form, only the body of a recently dead crippled beggar was available. And so this is the form he took.

there was also a little plate of the same material on which to crush the lumps of snuff, a stand for holding it securely, a bag for carrying it, and a little box in which to store it. The decorative techniques and motifs were as many and varied as the materials out of which the little bottles were made – jade, precious and semiprecious stones, coral, ivory, wood, fruit kernels, coconut shell, bamboo, ceramic, metal, and glass (see opposite, bottom). Whatever material they started with, the craftsmen exhausted every technique: underglaze and overglaze painted porcelain; cloisonné enamels; carved reliefs in wood, lacquer, or ivory; cut glass; glass painted from the inside – almost nothing was impossible. Precious and semi-precious stones acquired their decorative effect from the natural color variations, their grains, and inclusions.

Because of their small size, the snuff containers made suitable little gifts and became real currency, often as bribes; in fact, the decoration started to reflect their role as gifts. The motifs and colors nearly always have a meaning; like on other craft products, they are traditional symbols of health, wealth, happiness, and a long life.

Occasionally the pieces are decorated with calligraphy, the craftsmen drawing upon well-known themes from myths or legends. There were also snuff containers made to resemble animals or plants in order to conceal their real function; they are in effect tiny pieces of sculpture, and now very rare. They also represent symbols of good fortune, popular subjects being the lotus and the bamboo. There are even containers in the shape of the Daoist Immortals.

The need to ensure the protection or good will of the gods, which usually took the form of prayer and regular sacrifices, was also expressed through statues of Buddhist or Daoist figures. Working in bronze, porcelain, ceramic and the more modestly priced materials such as wood and horn, artists found rich opportunities in the realm of this religious art (see above, left). The demand for them was greatly increased by the fact that during the course of the year it was necessary to set up

Town god Cheng huang

17th century, bronze,
Völkerkundemuseum, SMBPK, Berlin

Sculptures of male deities of popular religion, by contrast with Buddhist sculpture, are frequently represented as bearded seated figures with broad officials' or priests' robes from the pre-Qing period. The town god is an important mediator between man and the pantheon of the gods, as he keeps the book of life and death, in which the fate of a person is entered irrevocably. In the figure of this well proportioned statue he radiates dignified peace of mind through his upright attitude and his faraway smile.

Below
Statues of the yearly cycle

19th century, ceramic, underglaze decoration, Völkerkundemuseum, SMBPK, Berlin

The 12 figures are sculpted as statues clothed as high officials. The heads clearly show their identity but the long garments, which have borders with a continuous pattern are also decorated with the appropriate calligraphy characters. From left to right can be seen a cock, sheep, snake, dog, tiger, cow, rat, pig, dragon, monkey, hare, and horse.

different statues. As the examples shown here reveal, these small statues brought out at religious festivals display not only a high degree of craftsmanship but also a sophisticated realism and a delightful humor. The technique of making ox horn into transparent sheets was certainly not widely known in imperial China, and yet craftsmen who made Chinese lanterns created remarkable objets d'art out of just wire and thin slices of horn – usually figures from mythology and folk lore drawn from literature, popular theater, and shadow plays. A popular character was Li Tieguai, who is always portrayed with a crutch, calabash, and wearing ragged clothes (see page 245, left). Also very popular were the animals of the Chinese zodiac; there are 12 animals (one for each year of a 12-year cycle), and carved images of these 12 (lanterns or statuettes) would traditionally be set up to welcome in the new year (see below).

On the occasion of very important events in the family, such as birth, marriage, sickness, or death, it was likewise necessary to bring food, wine or a burnt offering (incense and finally a funeral offering) to the appropriate deities, divine helpers, and ancestors, all of whom were represented by religious pictures or statues. Such simple rituals were widely observed, and in this at least there was little difference between the peasant, the magistrate, and the emperor himself.

Statues of local gods were carried around in processions so that through their "tour of inspection" they would protect the territory and ward off evil such as plagues (see left). Guilds had certain guardians or tutelary gods, the original Daoist Immortals being called upon; there were, for example, well-known tutelary deities of silkworm

breeders and farmers. A candidate on his way to a career at court directed his pleas to the "god of literature" or the "god of the red gown," deities considered appropriate for those seeking official posts. Often contact with a deity could not be made directly; it had to be through mediums – in stories written in colloquial Chinese during the Ming and Qing periods, there are hundreds of stories that involve the use of mediums.

In the villages the earth god, as the highest village god was the recipient of prayers, petitions and sacrifices for the wellbeing of the community; his status corresponded more or less to that of the town god. These deities came either from folklore, mythology, and classical literature – some were even real people whom the emperor, because of their upright behaviour or their services to the community, had deified (see above, right).

The fame of many of these historical figures sometimes led to the creation of cults. An example is the war god Guan Di, based on the historical figure Guan Yu (died A.D. 220). Guan Yu was a famous hero whose courage, cunning, and loyalty attracted so much admiration that he was eventually turned into a god. As early as the Song dynasty he was being honored in his own temple. Guan Di's attributes are the color red and a halberd whose blade has the shape of a quarter-moon, a weapon also carried by his faithful companion, Zhou Cang (see above, left). With such statues the craftsmen were clearly trying to capture, even if in caricature, the real world of warriors and officials. With imaginary creatures like the animal of the zodiac they allowed their creativity a free hand; with legendary figures they stayed very close to the descriptions provided by literature or folklore.

In the 19th century Guan Di became one of the busiest gods of the pantheon, as external attacks and internal wars led to political chaos. One result was the wholesale looting and destruction of works of art. What was left at the beginning of the Republic?

Above left
Zhou Cang

18th century, bronze,
Völkerkundemuseum, SMBPK, Berlin

As a statue in armor, a many-cornered hat and the quarter-moon halberd in his hand, the war god Zhou Cang stares around gloomily. The figure of the old warrior is presented in a humorous manner; because of his fat belly much of the wildness which is supposed to be expressed in his button eyes is toned down.

Above right
Earth-god temple with sitting figure of an earth-god Tudi

18th century, ceramic, turquoise glaze, can be dismantled, Völkerkundemuseum, SMBPK, Berlin

The earth-god Tudi, shown here as a sitting figure, is comparable in his function with the town god shown on the opposite page.

The Republic

Shanghai 1930

After the end of the Qing dynasty, China faced a desperate and seemingly hopeless political situation. Internal decline as well as external interference and threats characterize the years between 1912 and 1949. So it is all the more amazing that art did not come to a standstill – and that in fact important developments, including the revival of ink painting, date from those years.

In order to be able to understand the difficulties under which art was produced during these turbulent years, we will look briefly at the main political events of the period.

The first republic was a "republic of generals." So-called warlords, without any real desire for social and political change, tried to gain power over as large an area as possible and to make a profit out of the greatest possible number of people. Interested parties from abroad became involved in the chaos, actively supporting one warlord or another. This "support" resulted in the further destabilization of the Chinese empire; only the strengthening of the existing Concessions on Chinese territory (the result of treaties negotiated under the Qing dynasty) lay at the heart of any foreign interest. Japan was able to forge ahead with aggressive campaigns of conquest against the Western powers, since the latter were tied up in World War I. China entered shortly before the end of the war on the side of the Western alliance, and so belonged *de facto* to the victors.

With the Treaty of Versailles, however, the situation became more confusing. German concessions in China were signed over to Japan on the spot. Japan, however, had already pushed through its Twenty-one Demands (1915), and with that achieved territorial rights in Manchuria, and the control of ports and important Chinese industries. This transfer of German-held territory to Japan allowed the political powder keg to explode.

The anger of the people turned against the USA and towards the new Russia, whose new political structure set China an example of revolutionary action; Russia had annulled all treaties made by the Tsarist regime with China. In spite of this, the Chinese intellectual world at that time was drawn to an extremely wide variety of ideas, though the young intellectuals wanted only one thing: to do away with the political and philosophical thinking of Old China, with its outdated values and moribund traditions. Their approach was Friedrich Nietzsche's "revaluation of all previous values." So the main target of the 4th of May Movement (1919) was Confucianism, in which reformers saw the principal stumbling block to development. The two main political forces that emerged had identical political aims: independence, the reunification of China, social reform, the abolition of racial discrimination, and the liberation of China from the yoke of Japanese tyranny. From the early 1920s, and despite their differences in political philosophy, these two forces – the Kuomintang founded in 1912, and the Chinese Communist Party founded in 1921 – were unlikely allies in the struggle to free China from the occupation. In 1921 Sun Yatsen (Sun Zhongshan) became President of the Republic. A western-style parliamentary democracy, which was Sun's main aim, seemed to have been established, at least in one part of China. One of Sun's most devoted officers was later to turn fiercely against the communists, although he himself was educated in the Soviet Union: Chiang Kai-shek (Jiang Jieshi). His rise to power had begun after Sun's death in 1925. From 1927 his national government, which finally brought about relatively stable government throughout all China, sat in Nanjing. When the Communist-oriented intellectuals saw Confucianism starting to make a comeback within the Kuomintang, there were rifts and finally a civil war. Chiang Kai-shek pursued the Red Army, which set out on its fabled Long March (1934/35) under the leadership of Mao Zedong. But then a common enemy was able to reunite both groups again for the good of China: Japan had occupied

Journey to the Yellow Mountains

Huang Binhong

1943, ink, colors on paper, hanging scroll 59.3 x 24.8 cm, signed with the name Binhong and sealed, Museum für Ostasiatische Kunst, Cologne

Here with the Yellow Mountains (Huangshan) Huang varies a motif which already had moved generations of painters, especially the Anhui school of the 17th century. His dense painting style is, however, clearly distinguishable from the sparse works of, for example, Hongren.

Manchuria, put the last emperor on the throne again and set their sights on the south. During the Sino-Japanese War between 1937 and 1945 three governments ruled in China: Chiang Kai-shek sat in Chongqing, the province to which so many artists were to flee; Mao Zedong in Yan'an; and Wang Jingwei in Nanjing. They jointly formed the defence forces, though the success of the communist style of guerrilla warfare led most of the population to see the Communist Party as the most effective agent against the Japanese.

In fact, many believed they had the Communist Party to thank for a double liberation: from Japanese domination, and from the government of Chiang Kai-shek, who, after Mao's proclamation of the People's Republic in October 1949, withdrew with his supporters to Taiwan.

So what effect did these years of violence, instability, and confusion have on the arts? Amid the general turmoil, the painters at first continued in the traditional Chinese styles, particularly those of the second half of the 19th century; this kind of painting was called *guohua*, which can be roughly translated as "painting of the nation" (as opposed to painting in foreign styles). Once again painting divided along regional lines. In Beijing painters like Yao Hua or Pu Ru, a brother of the deposed emperor, painted landscapes in the Academy style, which referred back to the Four Wang. In Shanghai, the city of economic upturn and *joie-de-vivre*, there were countless patrons of the magnificently colored flower pictures; landscapes were less in vogue. Here they took the Individualists and the painters of the Shanghai school like Ren Bonian or Wu Changshi as models. The painters of the Lingnan school in Canton, who had at first adopted Western influences, depicted contemporary themes, but returned to traditional modes of painting, and were among the first to do so.

After the end of World War I many young painters, like the intellectuals of the period, went abroad to study. Among them were Liu Haisu, Xu Beihong, and Lin Fengmian. France was the first choice, but surprisingly Japan also played the role of a mediator of Western art. European art was at that time a hothouse of new styles: Impressionism was now well established, Realism likewise; Expressionism, Cubism, and Surrealism in sculpture and in painting were struggling for recognition. In the USA, pioneering forms of modern architecture were emerging, the most conspicuous being the skyscraper. So young Chinese artists returned to their homelands with a wide range of new ideas, "importing" modernist styles of painting, sculpture, and Western architecture. Among the most important were the new functionalism in architecture, and a range of artistic styles, including those of Corot, van Gogh, and Matisse; in particular, artists were encouraged to leave the studio and study the world around them, painting in the open.

Nevertheless, the towering figure of modern ink painting, the great artist Qi Huang, known as Qi Baishi (1863–1957), appears to have been

untouched by such outside influences, and perhaps as a consequence his landscape paintings were little admired by his contemporaries. He painted a large number of landscapes during the 1920s and 1930s using the impressions gained from his five lengthy journeys through his homeland. The two most important influences on him were Shitao and Bada Shanren, in whose spirit he fostered the *xieyi* style, in which he placed sketches of real scenes he had drawn on the spot into ideal landscapes. However, he also painted specific places, sometimes because they were famous for the events enacted there, sometimes just because they provided particularly striking views. The objects portrayed in his landscapes are often radically simplified, so that a simple cone, for example,

Magnolia branch

Qi Baishi (Qi Huang, 1863–1957)

About 1934, ink, color on paper, hanging scroll, 46 x 29 cm, Museum für Ostasiatische Kunst, SMBPK, Berlin

Galloping horse

Xu Beihong (1895–1953)

Ink on paper, hanging scroll, Palace Museum, Taipeh

The galloping horse is realistically proportioned and lively, and yet the work has a spontaneous and almost abstract character.

represents a mountain; his almost naive houses and boats are similar to those seen in children's drawings. In fact, in his bold use of paint – indicating the sky simply with broad ink strokes, or representing forms by areas of tone without outlines – Qi Huang belonged to the avant-garde of Chinese landscape painting. This simplicity, almost a form of primitivism, grew out of the need for a direct and immediately expressive style. Whether he was painting on a fan, on album leaves, or on great hanging scrolls, his subjects were landscapes; and though he himself prized his landscapes highly, it was his flower pictures that established his reputation, his views winning hardly any acceptance. His numerous depictions of insects and lobsters also enjoyed great success, some of them internationally. A famous painting late in his life is the hanging scroll of the magnolia branch, dating from the early 1930s (see page 249).

In this picture Qi Baishi refers to himself in the seal as *baishi weng* (old Baishi); in later inscriptions he signs himself *shan weng* (old man of the mountain). This painting of magnolias, which is based on a firm diagonal, is characteristic of his flower paintings, the petals painted in light, delicate tones, the black stems painted with swift, firm strokes. An influential model for this type of flower painting was an artist of the Shanghai school of art, Wu Changshi. In its concentration on the characteristic features of the magnolia blossom, Qi's painting is typical of flower painting in the *xieyi* (quick sketch) style: the light petals, formed by transparent outlines, with a dab of color at the center, and the tight, unopened buds, capture the very essence of these delicate, transitory blooms.

Xu Beihong (1895–1953), who belonged to the next-but-one generation of painters after Qi, painted in a completely different style. Xu was one of the young painters who had traveled to Europe and he may be regarded as one of the leaders of those who introduced Western art into China. In 1919 he went to France for the first time, on a scholarship, and stayed in Europe for nine years, interrupted only by a short vacation to his homeland. As a student of the École des Beaux-Arts in Paris, he received sound training in all the aspects of art which were normal in Europe but totally new to him. On his return to China he painted in oils, still unfamiliar in China, his works noted for such European characteristics as anatomical precision, and the use of central perspective and *chiaroscuro*. Throughout the 1930s he concentrated on the painting of historical events according to European forms. Nowadays, however, he is best remembered for his ink paintings of galloping horses, which became world-famous. He painted them at the same time as his historical paintings, for he seems to have recognized that something was lacking in his oil painting; though he had thoroughly mastered the technique, oils appeared to him an inappropriate medium for traditional Chinese subjects. Perhaps, despite his years in Europe, he was still deeply rooted in the Chinese tradition. His works, nonetheless, are the climax of the synthesis of European and Chinese painting traditions during this period.

Although Fu Baoshi (1904–1965) is included among the traditional painters, his paintings in fact look forward into the new era. He was from a poor home, and at age 11 he started carving seals, painting, and practicing calligraphy. At 21 he wrote his first book, and one year later completed his studies at art college. In 1933, through the recommendation of Xu Beihong, he went to Japan on a scholarship and studied art in Tokyo. It was largely theory he studied, however; like the literati of the past, as a painter he was essentially self-taught. His works fall into three main creative periods, each marked by different sources of inspiration. The first period, until around his thirtieth year, was marked by the study of the old masters; of particular interest was Shitao, the great Individualist, so it is not surprising that Fu Baoshi's style is also characterized by fine lines, a dry brush, and the interaction of ink and color.

Like other painters, he spent the time of the Japanese occupation (from 1937) far away in Sichuan. This meant experiencing new landscapes, and the works of many of these artists were enriched by new subjects, notably the mountains and lakes of Gansu, Xinjiang, and Qinghai. During this, his second period, Fu mainly painted rainy landscapes and also historical figures.

The third phase began with the founding of the new China in 1949. He continued painting landscapes, but adopted Western and Japanese elements in his compositions. In 1950, as a highly esteemed painter of the traditional style and a professor of art, he was granted the honor, along with Guan Shanyue (born 1912), of working on an important 5.5 by 9 meter (18 by 29.5 foot) landscape in the People's Hall of Congress in Beijing.

Chinese artists were now able to draw upon a range of different traditions. Xiao Sun (1883–1944), for example, made no secret of his admiration of the Yuan painter Ni Zan, whose influence can be seen in many works. Various influences can also be seen in one of the most important artists of the period, Huang Binhong (1864–1955).

At the start of his career, Huang Binhong, who came from Anhui, concentrated on the landscapes of the Anhui school. However, an element of stiffness, lifelessness, and conservatism is present in the paintings of such Anhui artists as Xiao Yuncong and Hongren, which is why in time Huang turned to other models, notably Kuncan. Huang's early work was painted out of the glare of publicity, for he believed that an ability to truly understand nature, an understanding indispensable for painting good landscapes, came with maturity, namely after 40. His mature landscapes are lyrical and monumental, his style characterized by wavy brushstrokes (see page 248).

Huang, often described as the second major figure of modern Chinese painting (the first being Qi Baishi), was one of the greatest painters in the *xieyi* style. His works can be divided into four groups over three main periods. The three periods

Mausoleum of Sun Yatsen

*Built during 1926–1929 from plans by
Lü Yanzhi, steps and tomb, Nanjing*

The mausoleum, built in the classical
Chinese style, is the expression of the
proud nationalism of the political group
around Chiang Kai-shek, in whose territory
the site was built.

are: the imitative period, from youth until 50; the travel and painting phase, from 50 through 80; and the late phase, the 12 years until death at 92, during which he was losing his sight but continued to paint. Two styles mark this late phase: that during which, sight impaired, he visualized scenes in his mind's eye and painted them without really being able to see them clearly; and the style of his final years, when, after a successful operation, he was able to see again and began painting the wild, almost abstract landscapes of his purblind years again in his earlier style.

Many of his works are dramatic, gloomy landscapes that reflect the contemporary mood of despair at the sad fate of a once great China.

Architecture

In terms of architecture, the mausoleum of the statesman Sun Yatsen (1866–1925) is indisputably the most important building of the Republic.

The Zongshan ling mausoleum was erected in Nanjing between 1926 and 1929 at Sun Yatsen's own request; the plans were by Lü Yanzhi. The body of the great politician was moved into the mausoleum after he had been provisionally buried in a monastery for the first years after his death in 1925. The mausoleum is planned in the style of a traditional burial place for the most senior servants of the empire: with a gate of honor, a "Soul's Way" (in this case an alleyway of pines), several halls placed behind the other, a memorial stone celebrating his achievements, and a statue of him. The text of the memorial stone, set half way up the steep climb to the mausoleum, proclaims the essence of Sun's political creed: "The world belongs to everyone." At the highest point of the site, on a strict north-south axis, is the Hall of the Tomb, reached by 299 broad steps. In the Mourning Hall,

which likewise bears inscriptions expressing Sun's political testament, is the sarcophagus, set in a sunken white circle. Europeans may feel strangely moved here, for there is a similar mausoleum in Europe: Napoleon's tomb in Paris.

In fact it was a French sculptor who created the seated statue of the great democrat. Seen from the front, sitting upright, an open scroll in his hand, the figure of Sun Yatsen, dressed in traditional long gown, is meant to remind the visitor not only of Sun himself but his achievements and ideals. On the whole site, the juxtaposition of Western and Chinese elements is a visual expression of Sun's political views, which blended traditional Chinese values and Western ideas of reform.

This juxtaposition of East and West also characterized town development in those years. Canton, for example, got an "iron-frame house," somewhat smaller than its famous model in New York. The face of the colonial towns showed irreversibly the influence of the European or Japanese architecture, with Shanghai's new architecture consisting predominantly of high-rise buildings of up to 15 stories. As the population increased rapidly, the traditional two-storied house had to give way to the Western-style apartment block.

In all areas of art and life, however, nationalistic feelings led to rejection of Western and Japanese influences that had grown more pronounced since the capture of the country in the 19th century, and that represented a progressive and relentless internationalization of the country.

These external influences were at their weakest during the years of the war against Japan and then the Civil War. With the flight of Chiang Kai-shek and the declaration of the People's Republic by Mao in 1949, a different sort of cultural program emerged, and architecture, along with fine art, was exploited for the glorification of the regime.

Bare trees in the Autumn

Fu Baoshi (1904–1965)

*2nd quarter of the 20th century, inscription
in the style of an artistically modified lishu,
hanging scroll, 108 x 53.2 cm, Museum für
Ostasiatische Kunst, SMBPK, Berlin*

(from 1949)

In recent international exhibitions much space has been dedicated to the contemporary art scene in China, and around the world the number of specialist studies of individual media and art forms is increasing rapidly – China is now known not only for traditional ink and oil painting, but also for avant-garde developments in performance art, installation, photography, and video art.

In China, the arts of the past 50 years, whether painting, sculpture, or architecture, can be divided into three main periods; and in all three periods the directions taken by the arts have been closely linked to the political direction taken by the Communist Party. In other words, art has been seen as an instrument of the state. Mao Zedong had already said at the beginning of the 1940s that art must "serve the state" and "must please the worker and peasant masses." It could make use of tradition, of course, but the content should be new and appropriate to the contemporary world. In the period 1949 through 1979, the predominant trend, Revolutionary Realism, combined the Socialist Realism of the Soviet Union, which acted as a

decisive model, and elements of Chinese folk art: the stated aim was the glorification of the workers, the peasants, and technology. Which theme predominated at any one time depended on the campaigns prescribed by the state.

The second major period extends from 1979 until 1989, when China was opened up increasingly to the Western world, and so to the world of contemporary art. Artists slowly began to experiment with Western styles of the 19th and 20th century again. For the artistic creativity of those years, a concept of classical ink painting was used: *lin*, which roughly means "free copy."

The third period began with the collapse of the democratic movement in 1989, since when more and more Chinese artists have been drawing their inspiration from the contemporary West; and in doing so have been attempting to create a form of modernism that is genuinely Chinese.

To form a completely representative view of modern Chinese art we would also have to consider the artists who had worked in exile: those who left just after 1949 (when the communist state was established), after 1966 (during the Cultural Revolution), and 1989. Many remained closely attached to their cultural roots, while some chose to engage creatively with their new environment and hardly glanced back at their Chinese origins. Finally, there were Chinese artists who lived abroad on scholarships or by invitation. For reasons of space, the focus of this section has to be limited to artists living in China.

Nowadays, a large majority of the recognized and established modern artists in China are teaching in art colleges. But there are also independent artists who are creating antistate art using Western styles and methods, artists who are in effect settling a score with the present or the recent past. Other contemporary artists, by contrast, are searching for new forms of expression using traditional means: ink and rice paper.

The ten-year Cultural Revolution, a time during which all aspects of Chinese life were in complete disarray, was a major disruption in the development of Chinese art. It was not only that artists were sent into the fields to work and peasants were sent to academies to create a new style of art; the period also saw the deliberate and willful destruction of cultural traditions and legacies. There are many well-known cases in history of politically and religiously motivated censorship, stretching from the medieval iconoclasm to the book burning of the National Socialists, to name just two better-known examples. Sadly, the state-sponsored vandalism of the Cultural Revolution was just another in a long sequence of examples, and by no means an isolated event in a communist dictatorship. At the heart of such campaigns of political censorship and iconoclasm is the often uneasy relationship between artists and patrons.

Black Visa No. 1

Wang Guangyi (born 1956)

1995, oil on canvas, 100 x 100 cm

But what happened immediately after the Cultural Revolution, and what is happening today? As sculpture and architecture in modern China have for many years been closely related, we will begin our survey by looking at these together. We will then consider another closely related pair, painting and calligraphy (or rather, what developed from them). Then, after looking very briefly at crafts, we will glance at contemporary Chinese art – at new media such as video art or installations, action painting, and "happenings."

Architecture

One sentence suffices to outline the characteristic new element of architecture: China was breaking out into a new dimension – height.

In the classical period, the highest buildings were those whose height had a symbolic function: the pagodas of monastic institutions, monumental gateways, towers, and imperial palaces. Traditionally, domestic buildings, with the usual enclosed courtyard, were only one or two stories high. During the Republic, multistoried stone buildings began to appear, and the image of towns was transformed as clusters of high-rise buildings started to dominate the urban skyline.

Modern architectural forms flourished with the establishment of the communist People's Republic, for the state inaugurated a building program that included hospitals, kindergartens, schools, and universities. Ideologically important, such buildings were purely functional in form: the form was itself the message, and there was no need for a more explicit use of style. This approach to architecture, at least with important state buildings, changed with the first five-year plan. For now there was a greater emphasis on the emphatic display of power through architecture; like the Gothic cathedral of medieval Europe, state buildings in communist China became the clear and unmistakable expressions of the power of the state.

As a consequence, the gradual shift towards height is best seen in state buildings. During the 1950s the building program for the capital included the People's Congress Hall (the seat of govern-

ment), various ministries, museums, monuments and memorials, theaters, and large hotels. And in the provinces, too, there was a visible shift to modernity in architecture. And in all this two stylistic trends predominated, which can be referred to as Historical Monumentalism, and Socialist Monumentalism. An example of the first is the People's Congress Hall built in 1952 in Chongqing and designed by the architect Zhang Jiade. This monumental style drew upon the classical architecture of imperial China, including the familiar hipped-roofs, pillars, bright colors, and decoration. The front of the building is still the side with the eaves; the body of the building is strongly constructed, and the pillars lining the façades of the wings are symmetrical in number and constructed according to the traditional system of *jian*. It could be argued that the design of the People's Congress Hall had its origins in the days of the Republic; but Historical Monumentalism is also found in later buildings elsewhere, including the theater of Qi'nan (in the province of Shandong, 1954, architect Ni Yinmu), the Youyi hotel in Beijing (Youyi binguan, 1956, architects Zhang Bo, Sun Tarao, and Zhang Depei), and the Academy of Art in Beijing (Zhongguo meishu guan, 1960, architect Dai Niancui).

This style of civic architecture was also seen as a way of helping to integrate minority groups. The memorial of the Mongol ruler Genghis Khan in the Autonomous Region of Inner Mongolia, for example, can be seen as a regional and "ethnic" variant of Historical Monumentalism.

This memorial is a symmetrical construction consisting of a main building and two side wings

Above
Genghis Khan Mausoleum
1956, Autonomous Region of Inner Mongolia

Aerial photograph of the symmetrically planned site with the Gate of Honor, from plans of the architects Guo Yuncheng and Liu Tierong.

Below left
Skyline of Beijing
1991

View from the Summer Palace towards the southern part of the town.

In Beijing the Square of Heavenly Peace (Tiananmen guangchang) became a complex symbol of communist China. The new Museum of History stands to the east, the People's Congress Hall to the west (see opposite). So on both sides of the parade huge square buildings tower up, creating a combination of wide open spaces and high buildings clearly meant to inspire an intimidating sense of overwhelming power.

The construction of the façades on these two new buildings is similar, and so they maintain a symmetry that has its origins in the Imperial Palace. In the center of the square is a monument dedicated to the "heroes of the people," consisting of a huge pillar on a square base; it was planned and built at the beginning of the 1950s (see below).

This monument, which was aligned with three (and since 1977 four) buildings, brings us to the subject of monumental sculpture. In modern China, monuments and memorials have an important function to play in a building complex. As in Europe, they are used to create a focal point for large open spaces, and to give emphasis to the central axis of architectural complexes. In the architectural sites of imperial China, the design of public spaces was quite different: they were kept free so that the imposing building would dominate the site all the more effectively; and also so that the people on their way to prayer in a monastery or palace could move freely. The monuments now standing in these open spaces have in effect become the pilgrims' destination, have become "holy places."

The importance of a monument is emphasized by its position. The monument to the Heroes of the People, on the central axis of the Square of

Top

**Great Hall of the People
(Renmin da huitang)**

Central building, 1959, plan by Zhang Bo and Zhao Dongri

Above

Monument to the Victims of Chiang Kai-shek

Photo after the Feast of Souls in April, Terrace of the Rainflowers, Yuhua tai, Nanjing

Right

Monument to the Heroes of the People (Renmin yingxiong jinianbei)

1958, gilt inscriptions, Beijing

The monument was built to a plan by Liang Sicheng (1901–1972) and Liu Kairan. The italic script is written in the style of Zhou Enlai and Mao Zedong. On the plinth are reliefs depicting scenes from recent Chinese history.

(see page 253, top). These three parts have roofs that combine traditional Chinese forms with large domes similar to those found in the Islamic architecture of the Middle East. These domes are symbols both of the traditional home of the nomadic Mongols, the yurt, and also of their religion (a large part of the Mongolian population is Muslim). The building actually serves as a memorial, since a mausoleum needs a dead person or his remains, which in this case do not exist. This monument to a great historical leader of a national minority may seem an unwise concession by a central government. But the architecture is in fact a linking of the two cultures: Genghis Khan was after all the grandfather of the founder of the Yuan Dynasty. The message the building proclaims is clear: the Mongolian minority may celebrate their cultural independence... but only as an integral part of a larger whole.

A completely different form of architecture is represented by the second stylistic trend in modern Chinese architecture. Socialist Monumentalism is schooled in the architecture of the Soviet Union. Its characteristic features are massive pillars dominating the main façade, and windowed fronts constructed like a grid; the roofs are flat, the entrances often emphasized by projections.

Most official buildings constructed between 1949 and 1979 conform to this style, which seems the direct expression of an ideology. It can be seen in the capital's theater (designed by Lin Leyi, 1955), and the offices of the consultative conference of 1956; the People's Congress (Renmin da huitang) and Museum of History (Zhongguo lishi bowuguan), both completed in 1959; and the Mao Zedong Mausoleum, officially opened in 1977.

Heavenly Peace, is a memorial to a new age that clearly refers to a long-established cultural tradition. Huge square pillars like this were already an integral part of the "Soul's Way" (the pathway leading to an emperor's tomb), and the design of modern Chinese monuments reveals countless elements of classical architecture. The design of the Heroes of the People monument looks both to the past and the future. This was also true of one of its designers, the architecture historian Liang Sicheng (1901–1972). During the 1930s and into the 1940s, along with his wife Lin Huiyin and his colleagues from the Chinese Architectural Society, he studied 2,000 classical buildings, documenting them with the help of detailed photographs. Together with his design for the Heroes of the People monument, this vast project on Chinese architecture can be seen as his own monument to both the old and the new China.

The three-part Heroes of the People monument stands on a platform with two steps. At the base of the monument there are reliefs depicting the battles fought by the heroes of the people in their struggle for freedom. These reliefs were carved by different artists, the most notable being Wang Linyi, who had studied in Paris; he carved the relief portraying the 4th of May Movement. Above this base towers the decorated pillar. On the two main sides there are inscriptions inlaid with gold; on the other two sides there are bas-reliefs showing a star in a laurel wreath, and "fanfares" of long flags. The top of the pillar provides the link with classical architecture. Here there is a frieze in bas-relief and a pediment suggesting the roofing tiles, and the top is a tent-like construction which, with its deeply curved ridges, is strongly reminiscent of the traditional Chinese roof.

The square and its monuments allows an interesting parallel to be drawn with the Capitol, the Obelisk, and Lincoln Memorial in Washington, which, like the Imperial Palace, the Heroes of the People monument, and the Mao Mausoleum, are arranged along a single axis. Furthermore, the Lincoln Memorial and the Mao Mausoleum each have a façade of 12 columns, and flights of steps to the north and south.

Between the Heroes of the People monument and the Mao Mausoleum, two sculpted groups of figures recall the mood of a new beginning in the country. Bent over, heavily burdened but eyes fixed

View southwards over Tiananmen Square

Beijing

In the center is the monument to the Heroes of the People, and behind it the Mausoleum of Mao Zedong.

The new railway station, Beijing

Dancers with silk scarves and musicians with pipes decorating a fountain

Academy of Art, Hangzhou

on a goal, peasants and workers make their way forwards, the path having been cleared by the army (see opposite). In all such compositions there is a strong diagonal emphasis on ascent: all the figures are lined up in such a way that it is easy to see that they are striving to attain the high ground, which is to be interpreted as freedom from oppression. The statement is not in the least subtle: it is meant to be direct and easily understood. Members of different ethnic groups, social levels, trades, and professions follow a flag which, blowing defiantly in the wind, is borne aloft by someone who looks very like Chairman Mao. Even here, however, there are signs that the new socialism mingles with elements of traditional folklore.

The 1970s was the era of glass and steel. Buildings that needed plenty of light were built as steel frames with glass façades, and sports halls and stadiums appear as a trial run for the high-rise buildings that were built from 1979. The years since 1989 have seen the rapid disappearance of the old building materials in the large cities, for demolition is much cheaper than renovation. Cities are changing beyond recognition as areas of narrow streets of low, traditional houses (*hutong*) with their own courtyards are falling victim to the excavator and bulldozer.

In some public buildings contemporary architecture strives for a remarkable synthesis of the monumental style, glass and steel, and traditional architecture. A striking example of this is the new main station in Beijing, begun in 1996.

Above the winding, tube-like entrance to the station rises a building in the shape of a gateway, the front of which is built true to the early socialist style, with a façade of regularly spaced windows. It also, however, shows noticeable parallels with the massive buildings of the fortified sites of imperial China. Strangest of all, on the arch of the gate and at the corners groups of traditional buildings sit enthroned; they appear to be made by the age-old timber-frame method of construction. Over the gate a three-storied building rises up that demonstrates all the standard features of traditional architecture: façades divided into an odd number of bays, and stories which become smaller and lower as they ascend and are separated by sweeping roofs, a pyramid roof topping off the building. This strange building marked a renaissance in the combination of old and new architectural forms in China.

Painting

A survey of the last 50 years of Chinese painting really amounts to a history of exactly what was permitted, tolerated, acclaimed, regarded with disapproval, or banned.

Chinese artists had been in touch with the West before the Revolution, and became acquainted with Western art – with Realism, Impressionism, and Surrealism as well as traditional painting in oils and tempera. Oil painting became the favorite medium of painters working in the spirit of

Socialist Realism. They took as their subjects heroes of the liberation, soldiers, ordinary poor folk, and workers, all of them involved in the struggle to liberate the new China from imperialism. Their approach was realistic, almost photographic. In color, the emphasis is always on strong red tones, red being the traditional symbol of strength, courage, intelligence, and warmth. In such pictures soldiers and workers clad in olive green strive toward this color, and only the movement they are depicted as making breathes life into such pictures; otherwise all the figures are interchangeable, mere types. This kind of simplification was intentional, since the paintings were meant to offer opportunities for identification. They glorify the groups of workers or soldiers that form their subjects. These workers and peasants, painted in strong primary colors and the "silhouette style" of popular New Year pictures, are not just dominant themes in oil paintings of the 1950s but also appear on factory walls and in posters and banners of the 1960s. Their features are powerful and strong, the burden of their labor has left them unbowed. Metaphorically, such paintings show "work leading the people out of subjection and into a modern industrial age." The propaganda is emphasized by slogans blaring out their message to the viewer from blank areas of the picture, in the simplified form of "official script" calligraphy. Such poster art of the 1960s retained a naive character reminiscent of painted postcards.

In general, oil painting of the Maoist period is a play of bright colors, its aim being a romantic celebration of political enthusiasm; yet it remains a standardized product. However, the genuine art of China, traditional ink painting, continuing to show flexibility and variety, struck out along new paths. At this time the subjects, colors, and compositions of ink painting came partly from the past, partly from the present – for instance in the use of Western perspective, open-air themes, and political messages. Artists fell into two camps in their choice of subjects: those who obeyed the dictates of socialist art; and those who, like the scholar-painters of the past, practiced traditional landscape or flower painting. Historically, their themes divide clearly into three periods: before the Cultural Revolution; the Cultural Revolution itself; and the period when China opened up to the West.

This section, therefore, begins with those artists who were painting in the 1950s. The great master of the Shanghai school, Qi Baishi (see page 249), lived for almost 100 years. He had known the imperial period, the Republic, and finally the radical upheavals of a socialist state. His late work was done in the years when China was becoming an industrial society, and there is a touch of defiance about his flowers, birds, and lobsters painted in the manner of the Shanghai school, with his own characteristically varied style, his continuing development of light but expressively curving strokes, and his ability to indicate meaning through brushwork alone. Lobsters were a symbol of resistance, but in Qi's late works any defiance they may express is subtle and indirect.

In his bird and flower pictures, Qi often combined brush techniques of the precise *gonghi* style with expressive ink strokes derived from the *xieyi* technique. His use of both outlines and the

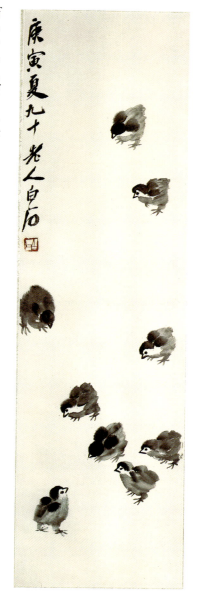

Above

Chickens

Qi Baishi (1863–1957)

1950, Museum für Ostasiatische Kunst, SMBPK, Berlin

Inscription: "Painted in the summer of 1950 by the 90-year-old Baishi."

Far left

Monument to the People's Liberation Army (Renmin jiefangjun jinianbei)

Sculpture, Tiananmen Square, Beijing

Left

Branch with winter plum blossoms

Qi Baishi (1863–1957)

Museum für Ostasiatische Kunst, SMBPK, Berlin

Inscription: "Painted by the old man Qi Baishi in the Hall of Jiping [floating water plant] in Beijing, signed Baishi."

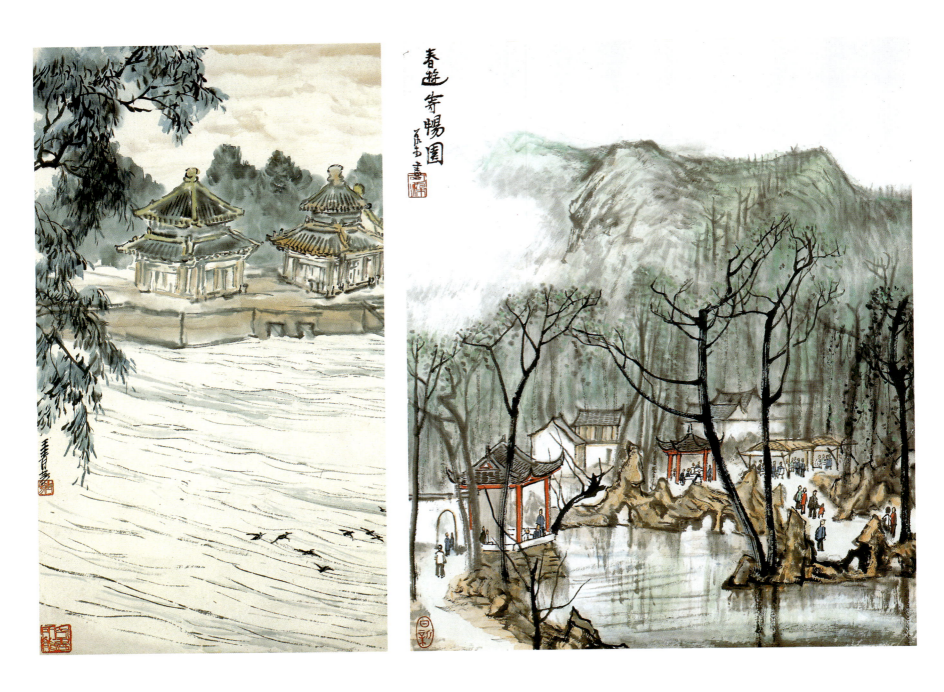

"boneless" technique (in which forms are created by areas of ink) can complement each other in the same picture. In works he painted at the advanced age of over 90, he depicted the classic subjects of the scholar-painters, such as the Four Noble Friends (plum blossom, chrysanthemums, lotus, and bamboo) — leaf by leaf or petal by petal in single brushstrokes, using generously applied wash or the side rather than the tip of the brush. Qi's late work contains variations on themes that he had painted throughout his artistic life. He renders a subject in the *xieyi* style, conveying the notion of a stem, a flower, or a leaf with a single calligraphic brushstroke. His use of color embraces every shade of ink, and only his flowers are painted in the natural colors of the plant itself. In the works of Qi's old age, plants and animals predominate — as if he had given up painting his beloved landscapes now no one could appreciate them, they lived on, however, in the work of some who came after him, his "children in the spirit."

Wang Qingfang (1900–1957), a pupil of the great masters Qi Baishi and Xu Beihong, chose to paint landscape, or more precisely urban scenes, in all their different aspects and rich variety of interest. The fact that he studied with Qi Baishi indicates that Wang was an artist in the tradition of the Shanghai school. His contemporaries, however, saw him as one of a group established in Peking and sometimes described as the Peking school, noted for their faithful depictions of specific views. Wang too produced open-air studies, combining both what he saw and also what he felt into a style precisely reflecting the place he depicted; his style was characterized by light colors, sketchy brushstrokes, and the ample use of color washes. In the painting reproduced here (see above, left), his eye focused on two pavilions seen across the water of the Beihai park; and despite its pale colors, the picture is full of the tension created by the contrast between solid land and the flowing surface of the water. The subject

of this hanging scroll is one deeply rooted in the history of Chinese landscape painting: the garden.

An outing in a garden is handled very differently by Li Keran (1907–1989). He was born into an illiterate family of peasants in Jiangsu, and began studying at the Academy of Arts in Shanghai in 1923, where he learned oil painting as well as traditional Chinese art. He was politically active during the period of resistance to the Japanese, and later became a teacher. Although he had thoroughly mastered the technique of oil painting, he preferred ink as his medium, particularly after the early 1950s, painting both polychrome and monochrome landscapes and figures in the *xieyi* style. Figure and landscape paintings were his chief contribution to an exhibition held in 1945, which also featured works by four other major artists of the period, including his teacher, Lin Fengmian. Like the works of his great predecessors and examples Zhu Da and Dong Qichang, Li's landscapes convey the atmosphere of the seasons, the times of day, and the weather. In his works buildings, ships, and figures are often rendered with a few, quick strokes in what seems a rather naive style. His landscapes sometimes combine both realistic and imagined elements, combining the actual locality and the products of his own mind. Li sketched out of doors, and his lively *Walking in Spring in the Jichang Garden* is a typical example of his work (see opposite, right). This garden in Wuxi, a town in the classic garden region of the Jiangnan district, was frequently painted, and Li interprets it as a scene of contemporary, everyday life. Visitors in blue jackets move through the spring landscape of the garden, which is just breaking into green leaf.

The painter skillfully guides the viewer's eye to the main subject, the people walking in the garden, by his use of light and color, particularly the red of the columns. Stylistically, it is obvious Li has mastered Western techniques, with his clear depiction of light and shade, the reflection of the trees and rocks in the water, and the construction of perspective. His brushwork, however, owes much to traditional ink painting, particularly clear in his representation of the tree trunks and the slope of the mountainside. Like his great predecessors, Li traveled his native land painting from life, and in old age was still visiting the mountains that had been sacred to the scholar-painters.

A characteristic of his late work of the 1980s is his use of dark, wet ink in large areas of his pictures, hardly letting the ground of the painting show through at all. It may be that his own history led him to immerse himself in black, for he was one of the artists persecuted during the Cultural Revolution. A retrospective exhibition of some 200 examples of his work in 1986 shows that Li was one of the first and most significant Chinese artists to introduce Western influences into ink painting.

Ink painting was the medium of traditionalists and of artists forced into internal exile by the new political and social conditions. In the middle of the 1950s, when the pictures described above were painted, most younger artists were state employees by virtue of being members of the academies, and were thus bound to the official political and cultural line. Before the antirightist campaign of 1958, ink painting was regarded as a recognized artistic medium maintaining the traditional language of form and color much as it had always been. Ink painting was acceptable so long as it did not move toward Surrealism or abstract art. But the political situation brought about changes. It was because artists were afraid of being branded "right-wing intellectuals" that they changed the traditional color language of ink painting to make red the dominant color; wet black ink fell into disuse, only shades of gray were used. Subjects themselves became political, a category that could hardly include landscape or flower painting. Moreover many painters of the 1950s had already embraced the cause enthusiastically and had put their art at the service of socialism.

This development is well illustrated by the industrial subjects painted by Li Hu (1919–1975), in which expressive ink-painting techniques are used with a totally new kind of subject. Becoming convinced in his mid-30s that a new age was dawning for China, he devoted himself to Socialist Realist subjects, using traditional media combined with a Western style (see below).

In this work Li, who was a pupil of Xu Beihong, clearly employs European techniques of composition and of contrasting light and shade to depict a broad river beneath a sky streaked with dark clouds. It is precisely an effective use of light that indicates both the central subject (and the theme), the building site of a bridge, on the right of the picture in the far distance. The pontoon cranes used in building the Wuhan bridge rise into the air at the point of transition from darkness to light;

Bridge-building in Hankou
Li Hu (1919–1975)

Dated early summer 1955, ink, color on paper, leaf 52 x 67 cm, National Gallery, Prague

This picture is an example of a combination of the traditional Chinese ink style and European elements, such as perspective and the use of light and shade.

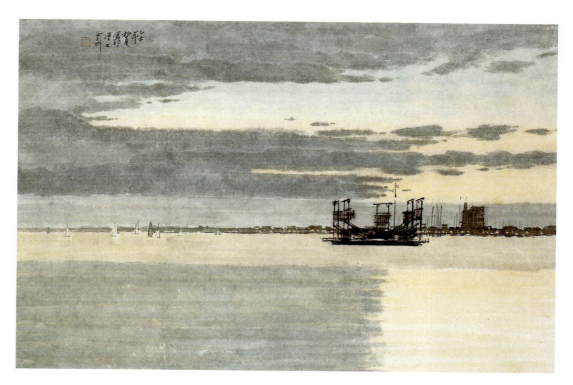

Right

The self-being of Master Zhuang

Lü Shoukun (1919–1975)

Dated 1974, ink, color on paper, hanging scroll, 138 x 69.3 cm, Hong Kong Museum of Art

"The observer reacts with an understanding smile to the expressiveness of the picture" (Katzenberg 1996). For anyone educated in China, the motif of a butterfly in flight over a dense piece of earth is immediately recognizable; here the motif is portrayed in a vivid red familiar in modern China and broad black strokes that have a calligraphic quality. This abstraction also displays a character typical of Chan (Zen) painting. Chan-Buddhist paintings do not make explicit statements; they hint. In this spirit, Lü Shoukun too is hinting, though he has also provided an inscription on how to interpret the image.

Below

Hymn to the Red Flag (Hongqi song)

He Tianjian (1891–1977)

Dated 1961, ink, color on paper, 68.5 x 31 cm, private collection

In this work the artist combines traditional Chinese elements and communist principles. The inscription makes the artist's political creed explicit.

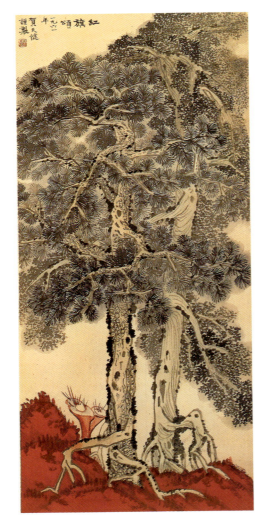

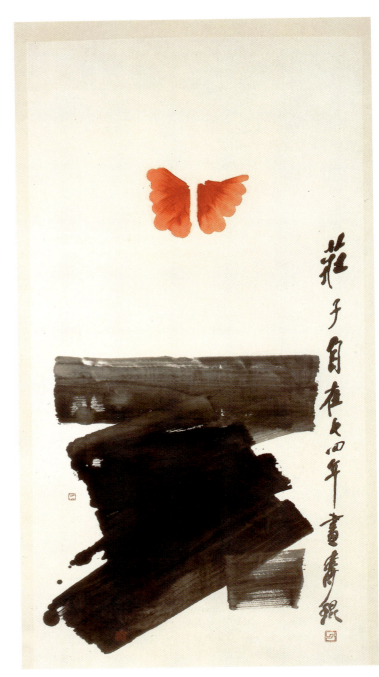

metaphorically, from the old and the new order. Political propaganda made regular and explicit use of bridge-building on the Changjiang River as a symbol of modernity and unity, for the bridge was an important link between north and south. Here the ancient ferry, symbolizing the backward China of the past, is being replaced by the bridges whose architecture stands for progress; the light even spills over slightly into the "backward" area of the picture, where boats are sailing in the wind.

Another unifying symbol was the Red Flag, now flying ubiquitously over China. The symbolism inherent in the subject and the artistic trick of using red, often as the only bright color, served an explicitly political purpose. Red in ink paintings stood for life, warmth, courage, and strength. He Tianjian (1891–1977), a self-taught painter and college lecturer, created work typical of the late 1950s and early 1960s, combining the new symbolism of color with a traditional style.

But the Cultural Revolution destroyed more art than it produced. Most of the works of the time were series of small pictures (comparable to strip cartoons), political posters, and paintings glorifying heroic workers and peasants. Life in the People's Commune, full of privations but idealistically looking forward to a new future, was the subject of both literature and art, and the heroic past of the Communist Party was represented in paintings for purposes of popular education. In retrospect, it may well seem that the symbolism of the color red had acquired a new meaning: the millions who fell victim to civil war, political persecution, and famine.

The artist Lü Shoukun (1919–1975) seems to be from an entirely different world, remote from the Cultural Revolution and in stark contrast to it. At that time he was in fact living in Hong Kong, outside the sphere of influence of the Communist Party and quite unaffected by the political demands made on artists. His work shows how, in other circumstances, ink painting might have developed on mainland China. Lü, who did not devote himself to art until nearly 30, has entered art history as the pioneer, theorist, and leading practitioner of what has been dubbed the New Ink Painting. The movement is notable for its simplified compositions and its abstract motifs, though there is also a close link with traditional Chinese culture. In fact, this link is often so close that Westerners may need an explicit guide to a theme. The painting shown here (see right) can be deciphered in terms of the following meditation:

"Zhuang Zhou once dreamed that he was a fluttering butterfly. The butterfly felt well and happy and knew nothing of Zhuang Zhou. Suddenly he awoke, and he was Zhuang Zhou. I do not know whether Zhuang Zhou dreamed he was a butterfly, or whether the butterfly dreamed it was Zhuang Zhou. There is surely a difference between the butterfly and Zhuang Zhou. And so it is with the transformation of things."[1]

Ink painting of this kind could perhaps have developed on mainland China, on the ground already prepared by Qi Baishi, Xu Beihong, and Fu Baoshi, had it not been for the drastic break brought about by the Cultural Revolution.

So what was Chinese painting like at the end of the 1970s? Once the state had to some extent slackened its cultural hold, young artists in particular, who had been children during the Cultural Revolution, felt at liberty to enter into a free intellectual exchange with the West. Most older artists, by contrast, reverted to the nonpolitical style of their youthful works with a sense of renewal. In the works of many of these painters, the intervening period might never have been (see opposite, top right).

Cui Zifan (born 1915), a graduate of the Party College in Yan'an, painted in what had always been the comparatively nonpolitical bird and flower genres. He was a pupil of Qi Baishi, and in the painting we have chosen he produces, using a

very free style, a variation on Qi's manner of combining red flowers with black leaves. Here the classic chrysanthemum theme appears in a new aspect, growing beside a fence – Tao Yuanming's traditional "eastern fence" motif. For younger Chinese artists, however, pictures of this kind were echoes of the past – if not technically, at least in the choice of subject.

In the years from 1979 to 1989 exhibitions of modern Chinese art took place annually in major Chinese cities, with groups of like-minded artists, most of them young, coming to wide public attention. In 1990 a large-scale exhibition went to Paris, and since then the new art from China has regularly appeared at international exhibitions, becoming increasingly well-known and sought-after.

Art after 1989

The young graduates of Chinese art academies or colleges do not lag behind their Western contemporaries in the use of such new media as photography, video, and computer art. They film, cut, distort; produce installations and employ various "alienation techniques"; make collages and fling paint on canvas without regard for convention... and get their exhibitions closed down (if they were officially sponsored) by staging daring "happenings."

In painting, a style of political satire known as Cynical Realism has developed in both traditional ink painting and oil painting.[2] Many artists work on a series with a unique subject or content, or in a unique style. A glance at the careers of younger artists shows that those born in the 1950s tend to go in for political parody. They saw the Cultural Revolution for themselves, they had its posters and banners before their eyes daily; perhaps they too once wore the red scarves of the Red Guard while

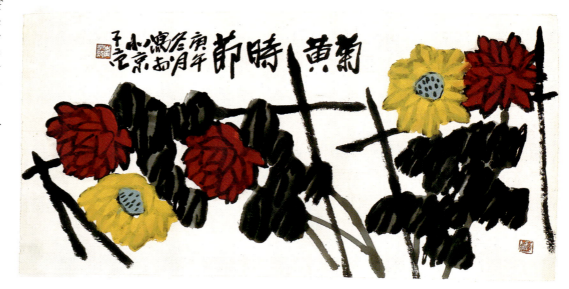

the schools that might have educated them were closed. Artists born in the middle of the 1960s are more likely to adopt the style of Cynical Realism. As children, they had access to relatively regular schooling, and if they had talent they could qualify to study art in state institutions, graduating in the 1980s. "They represent themselves and ordinary fragments of their environment – tedious, accidental, even absurd – without shame: with self-contempt, indifference, and cynicism."[3] Satire on the painting of the Mao period, especially when it showed the Chairman himself, shrieks for our attention in bright oil paints.

In China there are conflicting views of this kind of art: to some Mao was an unimpeachable hero and leader, to others a bloodthirsty tyrant. Consequently, neither camp reacts enthusiastically to works satirizing the classic depiction of Mao, such as Yu Youhan's *Chairman Mao Visiting a Peasant Family*. Not only is Mao's stature diminished, but poster art itself is satirized.

Wang Guangyi (born 1956), whose three depictions of Mao behind bars attracted more notice at the first big avant-garde exhibition in Beijing in 1989 than he had ever gained for his variations on "icons" of European art and his publications, satirized popular propaganda posters in a series entitled "The Great Criticism" (1990). His workers and peasants do not carry banners protesting against imperialism; they hold aloft such symbols of Western consumerism as Marlboro cigarette packets, and salute in front of the Coca-Cola logo. Everything is seen behind a loosely constructed pattern of small numbers, a variation on his earlier barred grid. Still using such alienation techniques, Wang has devoted other series to press photographs (1991/92), and most recently to the passport (1994) and the visa (1995; see left). "Of all documents in the possession of the member of a civilized society today," the artist comments, "the visa probably has the strongest ideological character."[4] Wang Guangyi considers that there can be no further development of the problems inherent

Above
Chrysanthemum time
Cui Zifan (born 1915)
1990, ink and color on paper, hanging scroll, 54 x 104 cm, Hong Kong Museum of Art

Left
Red Visa No. 1
Wang Guangyi (born 1956)
1995, oil on canvas, 100 x 100 cm

In China a visa, which provides a person with the opportunity to come into contact with the outside world, is of great symbolic significance. Obtaining one involves being interviewed by a government official, and here the artist has used some of the facts that have to be given on the application form. The dog is a symbol of China.

山頭白雲 林中小草

工欲善其事 必先利其器

春風江上路 不覺到君家

Calligraphy by pupils of a secondary school in an official showcase

Early 1989, Nanjing

in art itself, and so turns instead to the subjects outside art that he thinks suitable for a contemporary artist. From his own viewpoint, he is commenting on the state of the world as a collection of national identities, not of individuals.

All these young artists are critical observers of their environment, from which Cynical Realism in particular derives its ideas. Many artists, including Lu Lin, Zhang Gong, and Yue Minjun, confront the viewer with bright colors such as sugary pink or sky-blue in oils or acrylics, and ink painters choose colors never used in the genre before, for instance orange or mauve (Zhu Wei). Their themes are concrete, but sometimes the treatment is surreal. Other artists such as Wei Dong (born 1968) make deliberate use of the dichotomy between the classical and the modern, setting contemporary figures in a landscape painted in the traditional Ming style.[5] The painted collages of Wang Cheng reflect the present and its environment in a very different way. Wang Cheng, born in 1965, creates collages of themes taken from newspapers, painting over them in a reduced color spectrum to black, white, and tones of brown or gray in his analysis of what newspapers say and what they show. In his studio, the newspaper pictures and text become new statements that reflect on an environment that must be viewed in the context of a press freedom that exists only on paper.

His work allows photographs and painting to enter into a new dialog that makes the viewer stop and think, in which, largely because black does not predominate over white but vice-versa, it is the void, what is not there, that acquires a special significance. Script – the "standard script" of modern printing – is an important part of his statement.

The calligraphy of modern times itself employs very different styles, some a continuation of old traditions, some new. In the post-Maoist educational system, pupils are taught the elements of fine calligraphy, acquiring a substantial knowledge of the characters of official script. This form of teaching brings pupils into contact with the long versions of the characters, not otherwise in general use, and they have to practice the concentration and composure necessary for calligraphy. So after a period when it was banned the foundations are again being laid for personal calligraphy (see left). Pupils whose talents are recognized can expect encouragement, and the best of them will then be recommended for acceptance as art students, so that they can continue working in calligraphy on the basis of both traditional and new trends. One of these new trends draws inspiration from early forms of writing, and so is closely linked to historical research on the development of inscriptions on oracle bones and seal inscriptions. These modern works use distorted characters that have recovered some of their original pictographic nature, and so place particular emphasis on the graphic quality of a script (for instance in the work of the artists Gu Gan and Huang Miaozi).

The artist Xu Bing, born in 1955 and resident in the USA since 1990, has another way of working with script: he uses printed characters as his medium. His criticism of outdated forms of communication takes the form of an installation consisting of meter-long sheets of rice paper covered with characters that are impeccably printed but convey no meaning, since all his characters are his own inventions (*Mirror of the World*, 1988).

The best-known piece of Chinese calligraphy of our time probably consists of four characters in Mao's hand: the title of the daily paper *Renmin ribao* (see opposite, bottom right). The major impact on modern calligraphy, however, comes from advertising, which now provides a significant market for calligraphy. The various scripts used are selected on the basis of the appropriate connotations they bring to the product or store being promoted (see opposite, top right).

Contemporary works should not mislead us into thinking that all modern Chinese art has remained representational; there are a number of different movements tending toward abstraction, and the 1980s saw a vigorous debate between artists and critics on the path art should take, abstract or figurative. Today abstract styles are being developed by many artists, among them Qiu Shihua (born 1940), Shen Fan (born 1952), and Zhou Chunya (born 1955); and artists no longer living in China, who include Ma Kelu (born 1952), Ma Desheng (born 1952), and Ding Yi (born 1962). Compared with the politically motivated works of much contemporary art, theirs is a

Reports from the Madhouse

Wang Cheng (born 1965)

1995, oil on canvas, 153 x 180 cm

Above

Chinese calligraphy on shop signs

Dazhalan, Beijing

The scripts used in advertising attempt to give an appropriate aura to the products: the sign for a tea house (foreground, right, vertical) uses the classical type of script; the sign for a department store is in classical long signs (left, horizontal).

Left

Ding Yi (born 1962)

OT, 1994–1921, charcoal and chalk on canvas, 140 x 160 cm

quiet and meditative art. Ding Yi completed his study of traditional Chinese painting in 1990; he has exhibited regularly since 1985, and may therefore be regarded as an established artist. His path to abstraction was by way of reduction to the brushstroke itself, a path that led him (since 1988) to several series of abstract paintings based on repeated motifs. Working with oils, acrylics, felt pen, and gouache he creates surfaces with an almost relief-like quality (see above, left).

There is no market in China for the paintings of Zhou Chunya, whose abstractions – landscapes in black on white – seem to draw on the tradition of ink painting. The pictures of this famous artist, who teaches at the Chengdu Academy, reach the international market by way of Taipeh. The influence of the international art market on modern works should not be underestimated. When the avant-garde exhibition in Beijing in 1989, intended to be a retrospective of the 1980s, was closed after an incident, the publicity spread far beyond Hong Kong. Most buyers of recent Chinese art were living in Hong Kong at the time, and the city was a center for foreign distribution of the modern art of the mainland. With economic

development in China, the emphasis has now shifted to Shanghai and Beijing, and there are buyers on the mainland, while demand in the West has not slackened. There is a risk, however, that art will continue in the same old ways simply for the sake of profit. Foreign collectors want art that expresses a spirit of revolt and dissidence, art that cannot be exhibited in China, at least officially, and will pay high prices for it; art is a commercial business, and artists can hardly be blamed for producing works that will sell. For some time ideology has for many artists taken a back seat to a new value: money. The inevitable result, sadly, will be artistic sterility.

The problem is not so acute with performance art and installations: performances cannot be identically reproduced, and installations may make a different effect when reinstalled in other surroundings. Lin Yilin (born 1964), a sculptor from Canton and member of a group that strives for an independent direction for modern Chinese art (The Large Tailed Elephant Group), works serially with installations using bricks (see page 264, bottom). He sees them as architectural fragments, symbolically representing a residential

Mao Zedong's script

Title of the daily newspaper *Renmin ribao*, written in a powerful style that has a marked slant towards the top right.

which are to be found in every previous era, were manufactured in large numbers and according to modern standards; the craft industry became "airport art." Lacquer ware is an illustration of the phenomenon, for no new forms of expression have developed from the old handicraft, as they have in Japan. However, ceramics have freed themselves from the straightjacket of market-oriented reproduction, and in this field at least young artists are pursuing new directions using old techniques.

Artists like the potter Liu Jianhua are making porcelain with surface designs taken from ancient techniques, but transferring them from utilitarian ceramics to sculpture. Conversely, artists are also rediscovering the creative potential of everyday items (see left).

A glance at Taiwan

On the island of Taiwan the development of modern art and architecture followed a course parallel with that of mainland China; only the ideology was different. The general appearance of towns has moved away from the Japanese colonial style of 1895–1945 (little square houses with sliding doors), and the immigrant-style (after 1949) of the southern provinces has had to give way to modern boxes of glass, steel, and concrete. Traditional ink painting and calligraphy have been cultivated during the past 50 years, with many immigrant artists from mainland China continuing to work in their own traditions (see opposite, right).

After the founding of the Republic the teaching in art colleges began introducing increasingly

Grinding stone

Ye Lianpin (born 1940)

1988, Jinxing stone, banana leaf decoration, Museum für Ostasiatische Kunst, SMBPK, Berlin

atmosphere, while the observer will also see in them old and modern China, yin and yang, rigidity and movement (*Wall Installation with Water-bags*, Avant-Garde Exhibition, Berlin 1993).

Crafts

Are there still genuine crafts being produced in China? This question has to be asked because Chinese crafts have declined into a stagnant industry that merely reproduces countless copies of traditional items. Typical craft items, models of

Right
The result of 1000 (bricks or 10 yuan notes)

Lin Yilin (born 1964)

1994, installation of bricks and banknotes, with the artist

Shown on the handover of the crown colony of Hong Kong to China on 1 July 1997, this work was clearly open to several topical interpretations: the wall (China) is seen devouring money (Hong Kong).

Opposite, top left
Panda on a rectangular ceramic container

Height about 100 cm

The panda is intended to be placed outside where large numbers of people pass by.

Opposite, right
Calligraphy in the style of oracle bone inscription

Chen Qiquan (born 1917)

1977, ink on paper, hanging scroll, 129.9 x 58.4 cm, Museum für Ostasiatische Kunst, SMBPK, Berlin

The artist is continuing the ancient tradition of Chinese calligraphy.

more avant-garde styles and movements, such as kinetic art, together with both Western oil painting and eastern ink painting. Courageous craftspeople have struck out along new paths as well, acting on the principle of "No tradition? No matter!" During the 1980s, for example, glasswork that is classic in form but innovative in color was made. Likewise, potters were busy making replicas until the middle of the 1980s, but since then more and more of them have sought creative paths of their own as far away as possible from those represented by mass-produced factory items.

Since 1988, and now that there is freedom to travel (at least in one direction), artists have been able to meet and exchange ideas, and as a result there are signs of a rapprochement between the creative artists of the two Chinas.

In both Taiwan and mainland China a wide range of modern art has been produced, and it is difficult to make a representative selection. The works selected for this section of the book imply no judgement of quality – and more particularly, no disparagement of any artists who are not mentioned.

Finally, looking back over this entire section of the book, it becomes clear just how difficult it is to encompass the diversity of works we are classifying under the term "Chinese art." This historical survey opened with works which, though they now have a timeless value for us, were everyday objects for the people of the neolithic era. The expression of the daily world of a time now long past, they are unanimously agreed to be "art." And other epochs, similarly, have produced their own works of art; time alone will show what posterity will consider to be the art of our age.

It is possible that their ideas of it may derive from objects like the item shown above, an elaborately decorated piece of utilitarian pottery, mass-produced, that expresses one of the dominant themes of the 20th century: the protection of the natural environment. Let us hope that all forms of art, irrespective of likes or dislikes, will continue to be recognized and admired for what they are.

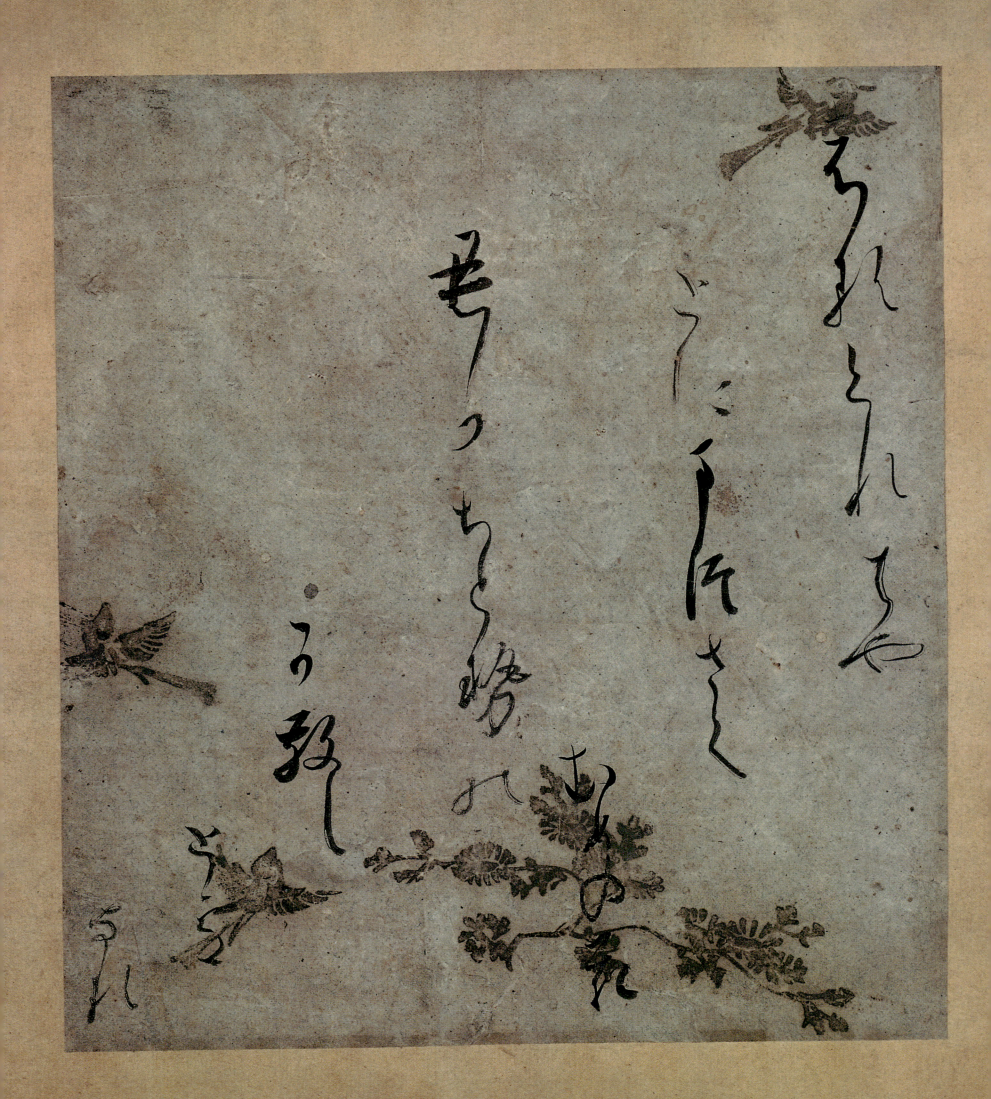

Calligraphy

In a quiet room in a mountain temple, an old priest is making preparations to write. He puts down a piece of felt cloth to protect the tatami mats, then he carefully places on top of this a sheet of fine, white paper, with weights in the shape of jade dragons placed at the top and bottom to prevent it curling. To the right he places an antique ink stone, a small water dropper, a favorite brush on a porcelain rest shaped like a miniature range of mountains, and a stick of dense, black ink scented lightly with incense. He puts a few drops of water in the indentation on the stone and then grinds the ink stick to make the precious liquid. It takes a little time, itself a meditative preliminary, in order to make sure that the ink is of the deepest black, suitable for writing. When ready, the old man kneels before the paper, gazing at the pure, white surface for a few moments. He then picks up the brush and dips it in the prepared ink — not too much, otherwise the paper will get soaked. Holding the brush above the paper, he takes a deep breath, and then makes the first masterly stroke: thick black strokes, light ones as fine as a hair, some streaking as the brush relinquishes its load of ink; and, dancing on the paper, the characters are formed. Ahh… ecstasy!

Segment of the *Kokin Wakashū*

Attributed to Fujiwara-no-Kintō
(A.D. 966–1041)

21.9 cm x 18.5 cm, Hatakeyama Collection, Tokyo

This segment, known as Sakai-jikishi, is part of the famous *Kokin Wakashū* scroll of poems, and is written in flowing "grass-style" calligraphy. The paper is exquisitely decorated with a design of chrysanthemums and mythological flying phoenixes in silver, which has tarnished with age to an attractive gray.

Introduction

Words such as those on the previous page give an indication of how close calligraphy is to the heart and soul of those Asians – nearly a quarter of mankind – who use Chinese characters that were invented and developed over 3,000 years ago, and which became an integral part of the country's rich culture. In turn, Chinese characters were adopted by Korea and Japan, and to some extent Annam (Vietnam) in the south, where they became modified for local conditions, and are still being used to the present day. For most people in Western countries these signs are completely mystifying as there is no point of reference whatsoever to any familiar phonetic alphabets; however the importance of calligraphy in Asian art cannot be over-emphasized, and so perhaps it is a subject worth looking at more closely.

Calligraphy is the art of writing and in the Far East it has long been a skill that every cultivated person has been expected to learn. Along with music, painting, and an adeptness at the board game of chequers, calligraphy is one of the famous "four gentlemanly pursuits," a subject often depicted in eastern painting. Esteemed even more than painting (although they are often associated), calligraphy is considered by many connoisseurs in the Far East to rank as the noblest of all the arts.

In Western countries, where phonetic scripts are used, a fair writing hand has also been required of the educated classes until very recently. However, in the writing of Chinese ideographs it is not simply a matter of using lines to form the characters, and of arranging them in an interesting way; it is also necessary to express meaning in a way that is in fact abstract. Characters can be written slowly and carefully, roughly or delicately, depending on the mood and technique of the writer; but in addition there is something much more important that is revealed in calligraphy: the writer's soul. No matter what meaning the characters may have, the way in which they are written will yield unmistakable clues as to the writer's sincerity. It has been said of calligraphy that it is impossible to deceive – there will always be some hesitancy, some wavering of the brush stroke that will reveal the true spirit or intention of the writer – and so it is no wonder that in the Orient handwritten letters of any importance are always studied with the greatest of care.

Apart from inscriptions engraved on rock or bone, most calligraphy throughout history has been written on paper or silk using a brush made of animal hair, and ink which is made mainly of soot blended with small amounts of other materials, such as incense and a bonding agent. The soot is made by burning vegetable oil or wood (preferably pine), which is then mixed with a glue rendered by the boiling of ox-hides. Sometimes incense, camphor, herbs, or powdered pearl or gold is added for exotic effect before the mixture is molded into sticks or cakes. These are then often embossed with various designs and it is thought that they "mature" with age, like certain wines. (And, as with wine, this is true only up to a point; after a couple of centuries, the glue component degenerates to such an extent that the ink is no longer usable.) All writing materials were, and still are, produced in a wide range of quality, and many of the finest writing implements, and even sticks of embossed ink, are highly valued as works of art in themselves. The very fact that using a valuable stick of ink causes its diminution as it is slowly ground away, implies that the calligrapher or artist entrusted with such a material has a commitment to take his work seriously.

In China, the practice of calligraphy was central to the idea of the scholar-gentleman – that idealized mandarin posted to some peaceful and scenic part of the empire, with no duties so heavy as to interfere with a round of poetry parties, philosophical discourse, the appreciation of nature, and the cycle of the seasons. The accoutrements for his table were carefully chosen with the calculated aim of nurturing his muse, or of raising his spirit to those lofty heights where inspiration is born, and used to include finely made brush pots, paperweights, water droppers, wrist rests, brush rests, flower vases, and seals, together with rare ornaments of jade and a few strangely shaped rocks.

By using a brush instead of the quill or pen used in the West, the skilled calligrapher is able to make marks that can convey countless nuances of expression. Beauty and expressiveness have often had priority over legibility; it was said of one famous calligrapher that of all his writings the only ones that were readable were his letters requesting payment. Brush strokes may be thick and bold, or fine and delicate; densely black if executed with a brush heavily laden with ink, or light and scratchy if the brush is nearly dry. A piece of calligraphy written by a master is not merely a form of communication, but is also a work of art that can be savored long afterwards and used as an example to inspire future writers. To give one instance, in Japan many old letters of quite mundane content (a request by a noted potter for some supplies of clay, for example), are now valued treasures because of their calligraphic quality and the historical prestige of the writer. Particularly fine examples are often mounted as hanging scrolls and hung in the *tokonoma* of a room to become a spiritual focus during a tea ceremony.

Chinese writing: ideographs

Most cultures that have developed beyond the Bronze Age have developed ways of inscribing their own languages. But in almost all cases these are based on phonetic systems, in which a sign represents a sound. As such, a reader would in theory be able to pronounce the written word, but not necessarily know its meaning. By way of contrast, Chinese ideographs or characters convey a meaning independent of sound, and in a direct way that conveys a very powerful impression to the

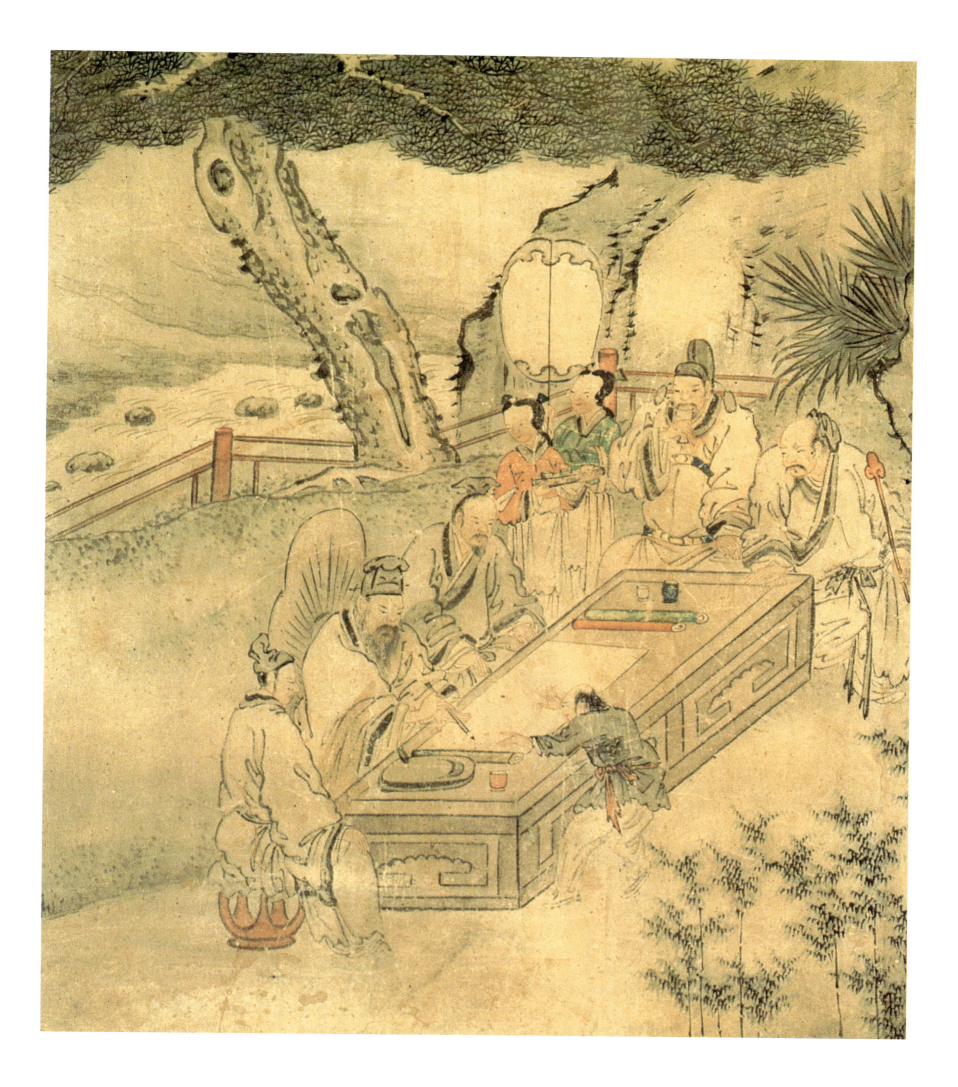

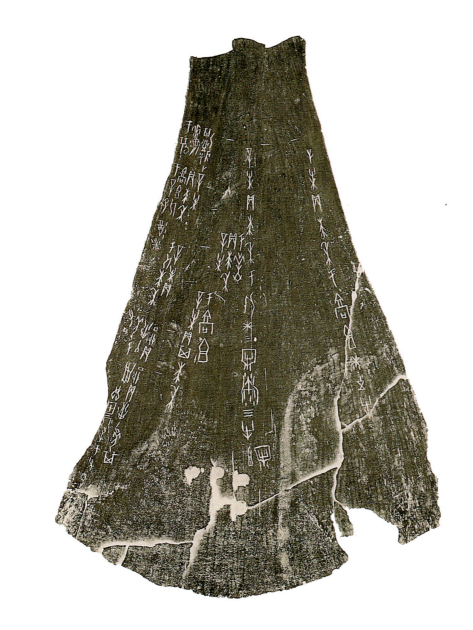

Oracle bone with inscription

Chinese Shang dynasty, 16th century B.C.–1028 B.C., L 32 cm, W 21 cm, Collection of the Shanghai Museum

The earliest Chinese pictographs are seen on the shoulder-bones of cattle. These were heated to cause cracks, which were studied for divination, and then the results were inscribed in vertical rows of characters. The inscription on this piece expresses hope for a bountiful harvest.

reader. Officially, in standard Mandarin Chinese, each character represents a one-syllable word, but pronunciation of the character can differ widely depending on geographical location; it is not uncommon to see two Chinese people, or even a Japanese and a Chinese, exchanging written notes and understanding each other perfectly well, even though originating from areas with different spoken languages.

Simple marks have been found inscribed on excavated pottery from various Chinese neolithic cultures dating back to 5000 B.C., but so far there is no evidence that these were related to a spoken word and therefore cannot be considered as a written language. The first appearance of a developed writing system was during the Anyang phase of the late Shang dynasty, just over 3000 years ago. Chinese Tang dynasty records indicate that "in ancient times" there was no written language, and events were remembered by a complex system of tying knots in a rope, or by cutting notches and symbols on strips of wood. Gradually there was an evolution into rudimentary pictures or diagrams of familiar subjects such as fish, animals, houses, tools, and human figures, which in turn became simplified into the early pictographs, a stylized form of picture-writing. In China these were refined into a repertoire of abstract ideographs that have continued in use, with few modifications, until the present day.

Gradually the written language evolved to the stage where there were tens of thousands of characters. To the Western mind it may seem intellectually daunting, if not impossible, to have to cope with such a complex written language, but it should be remembered that many characters have a strong intuitive effect and their meaning can often be understood by context and the composite elements of the character. By using these characters to record and express every aspect of life from complex philosophical concepts to subtle poetic nuances, the Chinese have created an extraordinarily rich literary heritage that has spread to their neighboring countries, just as Greek and Roman classicism spread through the Western world.

Early Pictographs

⛰ stands for **mountain** and ≋ for **water**

Early pictograms developed in various stages starting with simple pictures seen engraved on bones excavated from sites dating from the Shang dynasty. For example,
Simple ideas were expressed by a symbol that hinted at the appropriate meaning:

上 for **over** or **above** and 下 for **under** or **below**

More complex ideas were expressed by joining two symbols together to make an associated meaning:

人 han combined with 木 **tree** makes 休 = **rest**

To give another example:

日 **sun** combined with 月 = **moon** produces 明 **bright, shining**

Some ideographs called pictophonetics combine one element with a meaning, and the other with a sound from the spoken language. For example:

The Chinese for **cypress tree** is pronounced *bai* and written with the symbol 木 for **tree** combined with 白 meaning **white**, but with the pronunciation *bai*, to make the character 柏.

Calligraphy in China

Inscription of the lid of a bronze vessel

Chinese Western Zhou dynasty, 1027–771 B.C., Collection of the Shanghai Museum

The earliest appearance of a clear defined script with a standardized structure, and known as big seal script, is seen on bronze vessels of the Zhou dynasty. In this example, even though the characters have component parts of random shape and length, they are beautifully expressive and carefully spaced.

While some signs and symbols are found on early neolithic pottery, the first evidence of systematized writing is seen on tortoise-shells and the shoulder-blades of cattle, known as "oracle bones," that date from the Shang dynasty (about 1600–1028 B.C.). Hot branding-irons were applied, causing the bone or shell to crack, and the resulting pattern was interpreted to foretell the future. Such divination was a major preoccupation in the household of the ruling family of the king, who had a god-like status, and with it great power and responsibility. Ancestor spirits were invoked before any important undertaking where the result was uncertain, such as a hunt or a battle, and the interpreted divination was then engraved on the bone or shell in vertical rows of characters (see opposite, top).

During the same period there was a rapid development of bronze-casting technology. Many examples of early writing can be seen on the splendid vessels dating from the Shang dynasty and the following Zhou dynasty (about 1100–256 B.C.). This early calligraphy is known as the "big seal script" (see above). Throughout the long and tumultuous Zhou dynasty different styles of Chinese script proliferated among the regional duchies until the time of the first Emperor of Qin, who unified the country in 221 B.C. During his brief but momentous reign he destroyed the writings of his adversaries (and in doing so, consigned to oblivion some hundreds of years of recorded history, philosophy, and science); but he also brought about a standardization of writing, the script being known as "small seal script." Apart from being used for official records throughout the empire, this classical style was employed also for formal inscriptions on stone tablets and tombstones. It is still used today in more-or-less the same form, particularly for the engraving of personal seals, which are commonly used in the East on documents and letters, just as personal signatures are used in the West.

In addition to this small seal script, four more basic scripts were standardized during the Han dynasty (206 B.C.–220 A.D.), that with relatively few changes have been used since that time until the present day.

The four are as follows:

Clerical script (Chinese *li shu*; Japanese *reisho*) was developed as the official script used by bureaucrats for recording on strips of bamboo or on stone stelae. At first written in ink, the thick and thin ends of the brushstrokes are somewhat exaggerated but with powerful graphic effect (see left). Together with the seal script, this is used at the present time largely for ceremonial purposes.

Normal script (Chinese *kai shu*; Japanese *kaisho*) is the commonly used "squared off" script of graphically edited characters that was widely used throughout history and is now the standard form used in books and newspapers (see pages 274–275). Running script is a form of normal script that is written quickly so that characters are kept separate, but the individual strokes may be abbreviated.

Cursive script (Chinese *xing shu*; Japanese *gyōsho*), is the personal, freehand style that evolved from writing quickly, the equivalent of cursive handwriting in the West. Brush strokes forming the characters are often run together and in many cases legibility is sacrificed. However there can be a limitless scope for personal expression and, as is often the case with Western handwriting, the cursive script can be maddeningly difficult to read or even decipher (see opposite, top).

Draft script (Chinese *caoshu*; Japanese: *sōhsho*), is an abbreviated shorthand of simplified characters in which multi-stroke components of a character can be abbreviated to a mere squiggle. At first it was developed for the use of lower-ranking officials of limited education, such as prison warders, but later became a free, cursive script much favored by poets and similar in appearance to the *xing shu* script above (see opposite, bottom).

Though considerable freedom was allowed in writing any of these scripts, the order in which the strokes of a character were written was strictly prescribed, and still is. Every schoolchild in China, Japan, or Korea learns how to write by order of brushstrokes. For example the character meaning "tree" is written as illustrated in the box at the foot of the page.

Anyone having survived the time-consuming discipline of learning enough characters to be considered literate is also able to look at someone else's calligraphy and feel the way in which it is written. By mentally tracing the same character in the mind's eye, the reader can intuitively sense how the writer used his brush – the pressure applied on the paper, and the speed with which the brush was used.

Left
Poem dedicated to painting
Jin Nong (1687–1763)
96.8 cm x 35 cm, Collection of the Shanghai Museum

Despite a life of financial insecurity, Jin Nong was a noted student of ancient scripts and paintings, who espoused the notion of the hermit-scholar. He used a specially prepared brush to achieve this individual rendering of the official, or clerical script.

Opposite, top
Shang Yu Tie in cursive script
Wang Xizhi (A.D. 303?–361)
H 23.5 cm, W 26 cm, Collection of the Shanghai Museum

Wang Xizhi was one of the legendary early calligraphers. He was skilled in writing all varieties of scripts, and his work has served as a model for students ever since. This extremely rare example shows the rapidly written cursive script, in which many of the components of each character have been abbreviated, and joined together with a single brush stroke.

Opposite, bottom
Ku Sun Tie in wild cursive script
Monk Huai Su (born A.D. 725)
L 25.1 cm, W 12 cm, Collection of the Shanghai Museum

The monk Huai Su saw the merit of releasing all inhibitions in order to achieve outstanding calligraphy, and achieved this by getting drunk before picking up his brush. This example is typical of the wild cursive script that appeared during the Tang dynasty, which liberates the cursive script to an even more extreme level that is exciting, even if sometimes illegible.

1st stroke	+ 2nd stroke	+ 3rd stroke	+ 4th stroke
一	十	才	木

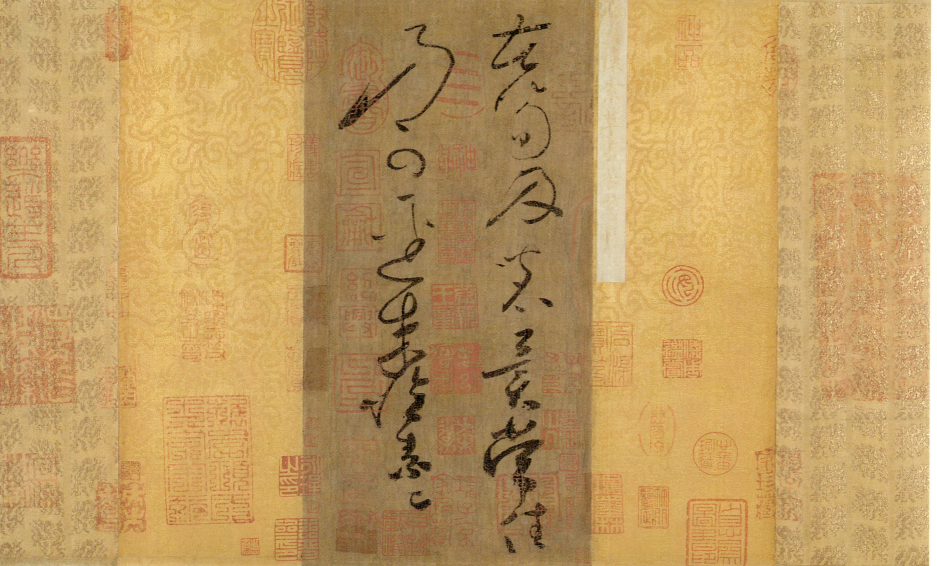

帝亦知之因事屢稱謀之左右有間

莫應

君聞不悛與義降外吾豈羽毛為

人所鷹抱默以老含章不矜環堵

蕭然大市疎繒

妻子脫粟玉食友朋軾遷于南秋

穀五登坐閱百吏錐刀相仍

有斐君子傳車是乘穆如春風解

此陰凌尚有

典刑紫歸垂膺魯無

君子斯人安承納幣請醫義均股

眩別我而東衣祓僅膝

一臥永已吾將安憑壽命在天維聖

莫增

君趙魏老二子薛滕天亦愧之其

世必興

舉我一觴

歸安丘陵

尚饗

Essay in memory of Huang Jidao

Su Shi (1036–1101)

H 31.6 cm, L 121.7 cm, Collection of the Shanghai Museum

An example of normal, or regular script, in which all the characters are clearly formed and separate, by one of the celebrated calligraphers of the Song dynasty (see detail below).

Calligraphy that was considered an art form rather than just a medium for recording developed during the Han dynasty; most surviving examples are engraved in stone, but some are on wooden tablets and strips of bamboo, and a rare few are to be found on fragments of silk. Until paper became widely used at the end of the Han dynasty, the standard method of keeping records was by writing on strips of bamboo, which were bound together side-by-side, and could then be rolled up for storage. Bamboo was cheap and widely available, whereas silk was considered to be too precious to be used for the prosaic purpose of bookkeeping, and wooden tablets took up too much storage room.

From the Qin dynasty onwards, and throughout the eventful course of Chinese history, there has been a fondness for stone stelae engraved with calligraphy, the permanence of the material seemingly adding to the weighty importance of the words. Being cut with a hammer and chisel, the characters are usually in one of the official scripts, as the cursive script required the freedom of a brush and ink. Many stone examples are still to be seen today, but apart from a few fragments, the only records that we have of early brush writing are in the form of traced copies, as the originals have long since perished.

The invention at the beginning of the 2nd century A.D. of paper made from vegetable fibers caused a tremendous flowering of calligraphy, which now came to be appreciated as art rather than as merely a means of communication and record-keeping. Composition of poetry went hand-in-hand with the complete freedom of expression that was available to anyone with some ink, a brush, and a sheet of paper. With the recognition of the aesthetic qualities of writing, master calligraphers came to be recognized as artists in their own right. Calligraphy became a pastime of the educated bureaucrats who were steeped in Confucian ideology and the Chinese classics, and it is during this period that we begin to see the appearance of that most respected figure in the East: the gentleman-scholar. Having in the course of his education memorized up to 40,000–50,000 characters, the respect he was accorded was perhaps well deserved.

Early masters of calligraphy in China

The first calligrapher whose writings were widely regarded as art works in their own right was reputed to be Zhang Zhi, who wrote in the free-hand cursive script at the end of the Han dynasty. However the most celebrated and exalted star of calligraphy history was Wang Xizhi (A.D. 303–361; see page 273, top), who was born into a high-ranking noble family during the Eastern Jin dynasty and who is famous for his work the *Lanting Xu*. This is a widely celebrated preface for a collection of poems known as the *Meeting at the Orchid Pavilion*, and is composed of 324 characters in 28 columns. The story behind this masterpiece is that of a party that Wang Xizhi held in springtime with some of his literati friends at a place called the Orchid Pavilion. The now-classical theme of the gathering is one that is often seen

維元祐二年歲次丁卯八月庚辰朔
越四日癸未翰林學士朝奉郎知
制誥蘇軾朝奉郎試中書舍
人蘇轍謹以清酌庶羞之奠
昭告于
故穎州使君同年黃兄幾道之靈
嗚呼
幾道孝友忝二人無間言如閨與
曾天若成之付以百能超然驥德
風鶩雲騰入為御史以直自繩終
然玉雪不汙青蠅出挨百城不緩不
摧姦民情吏實畏廉憎
帝承知之因事屢稱謀之左右有問
莫應
君聞不悛與義降外吾豈羽毛為
人所鷹抱黙以老含章不衿環堵
蕭然大布疏繒
妻子脫粟玉食友明賦還于南秋
穀五登坐閱百吏錐刀相仍
有斐君子傳車是乘穆如春風解
此陰爰尚有

depicted in Chinese and Japanese painting and involves the floating of wine-cups in a stream, with the guests seated on the bank. Wherever a cup stopped, the person sitting closest was obliged to compose a poem. (In a variation of the game, the guest is required to either compose a poem on the spot and (or) drink the wine in front of him, and one suspects that even this rule got muddled from time to time.) At the end of the Orchid Pavilion party the literary efforts of the guests were collected and Wang Xizhi wrote his own, legendary preface in semi-cursive script (see page 124).

It seems to have been an especially magical moment, when all of Wang Xizhi's skill and inspiration united to create this lively and graceful calligraphy. It is said that even Wang Xizhi himself was so delighted with his own work that he tried to replicate it on numerous occasions but could never again quite capture the spontaneity and flow of the original. We can only imagine what this looked like from the many later copies that are extant, as the original was entombed with the later Emperor Taizong, who reigned from A.D. 627 to 649. During his lifetime the emperor was an ardent admirer and collector of the works of Wang Xizhi, and realizing that he could not bear to part with this treasured calligraphy when his time came to ascend to Heaven, gave orders for it to accompany him on the final journey.

Being highly educated and much influenced by earlier calligraphers, Wang Xizhi excelled in writing in all of the established script forms; but unfortunately none of his original work remains. We are only left with copies (and in many cases, copies of copies), that were made by various methods such as tracing or ink-rubbing; and as the subtle nuances of brush-written calligraphy can never be precisely recaptured, the true hand of the master can only be guessed at. Out of a whole family of gifted calligraphers, his youngest son Wang Xianzhi, inherited the genius of his father and in turn became a celebrated writer of almost equal status, particularly noted for his work in cursive and semi-cursive script. Father and son are known as "the two Wangs," and their works, which set the highest standard for the ideals of beauty in writing, have been copied and recopied by generations of calligraphers ever since.

Emperor Taizong, the admirer of Wang Xizhi, was instrumental in the establishment of the high status that calligraphy had in Chinese cultural life. During his lifetime he avidly collected some hundreds of extant works of the two Wangs, including the famous *Orchid Pavilion* preface, and ordered numerous copies to be made of these masterpieces, which he gave from time to time as gifts to his favored nobles. In addition, he established an official government department for the propagation of literacy, charged with the duties of teaching calligraphy to the children of high-ranking families, and using the works of the two Wangs as examples of excellence to be emulated. From this time onward, an exceptional talent for refined calligraphy was *de rigueur* in the formidable civil service examination process, which, for the few who passed, served to open the doors to power and wealth, and to the glittering imperial court.

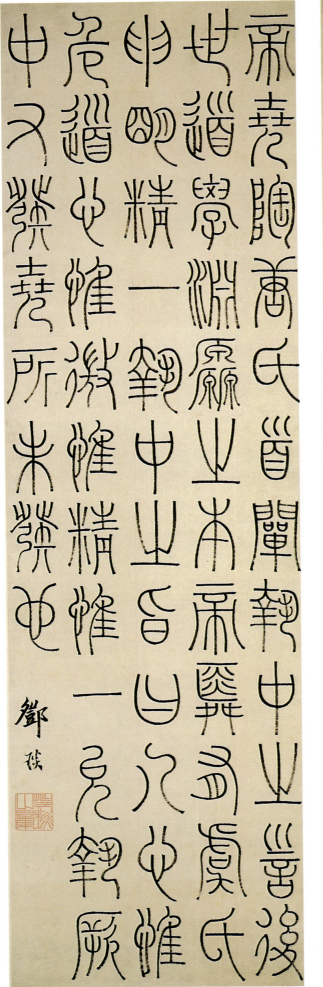

Left

Scroll of seal script

Deng Yan (Qing dynasty)

L 114.7 cm, W 33.4 cm, Collection of the Shanghai Museum

During frequent waves of interest in classical studies, many calligraphers used archaic scripts for artistic purposes rather than for general writing. The seal script shown here is normally used these days for personal seals or commemorative tablets. (Detail shown opposite, top.)

Right

Du Fu's pentasyllabic regulated verse in running script

Zhang Ruitu (1570–1641)

L 193.3 cm, W 60.8 cm, Collection of the Shanghai Museum

After a career setback, Zhang Ruitu became interested in Chan Buddhism and developed his own particular style of calligraphy which is here seen in running script – a form of regular script, but written more freely and with expressive, abbreviated strokes. His work was much admired by members of the Obaku Zen sect who brought examples with them to Japan. (Detail shown opposite, bottom.)

Two calligraphers from later in the dynasty, during the 8th century A.D., are Zhang Xu and Huai Su, who are celebrated for their more rapidly written, cursive style. In a society that was noted for its elaborate punctilio, they were both highly eccentric, and were famed for getting drunk in order to shed any lurking inhibitions, before expressing themselves in a flurry of active writing (see page 273, bottom). The practice of this style (particularly the drinking part) was taken up by monks of the Chan sect of Buddhism (later Zen in Japan) to produce calligraphy that, being unfettered, can be appreciated intuitively for its wild freedom – even if to some extent legibility may have been sacrificed.

The Chan influence on calligraphy

The subject of Zen will be discussed elsewhere in the context of Japan, but at this stage it is worth saying a little about its early inspiration, the Chan sect in China, which had a tremendous influence on calligraphy and painting, and, later, on just about everything in Japan. Simply put, Chan Buddhism is the practice of meditation with the aim of reaching a state of enlightenment such as that achieved by the Buddha. Buddhism had originally come from India and had gradually infiltrated China in the first century A.D., where it lived side by side with native Taoist and Confucian beliefs. Chan lays great stress on the intuitive seeing of one's own consciousness, insisting that everything else (even language) is unnecessary if it gets in the way. The practice began to spread rapidly early in the 8th century, and quickly split into various sects, each claiming a monopoly on the truth. Within a couple of centuries, Chan was being accepted in the capital, gaining imperial patronage; there was also a strong following among the new class of officials, the clever meritocracy that was gradually replacing the old hereditary nobility.

During the Song dynasty these new officials, having succeeded in passing the demanding civil service examinations, ranked as the highly educated elite of the empire, and many were attracted by the intellectual appeal of the Chan sect. Even though one of the central ideas of Chan philosophy was that words and reason were impediments to enlightenment, it seems that a lot of words were needed to explain the concept. One of the effects of the spread of Chan, especially under the patronage of the officials, was the dramatic change in literature and the arts. From the old, formalized systems and schools, there was a move to a more personal and contemplative form of expression, and this is clearly reflected in the art of the period (especially in ink paintings of misty, dream-like landscapes) and, of course, in calligraphy.

However, too much official attention led predictably to the regulation of the Chan sect to such extent that the temples became bureaucracies themselves, with abbots appointed by the court and the monks employed in writing government

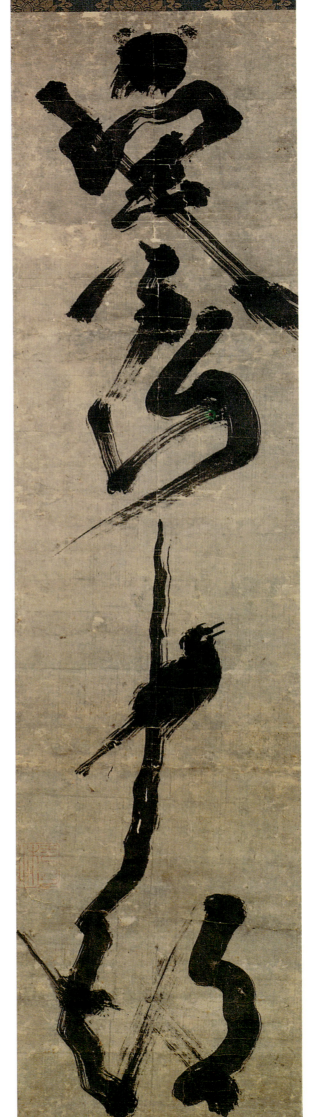

Hanging scroll

Ink on paper, 104 cm x 26 cm, Jeffrey Montgomery Collection, Lugano, Switzerland

This unusual scroll of kanji characters blending with quickly brushed blackbirds demonstrates how closely painting and calligraphy are associated in the Far East. The writer-painter is unidentified but was probably a Zen priest living sometime during the 16th–17th centuries.

Opposite
Calligraphy

Nukina Kaioku (1778–1863)

Ink on paper, Collection of J. E. V. M. Kingadō, USA

One of the greatest calligraphers of the late Edo period, Kaioku, like many of the literati, was skilled in a variety of disciplines. Born into a samurai family, he traveled around Japan and studied Buddhism, Confucianism, and Nanga-style painting. This example was written at speed, but even so it shows great expression and perfect control.

documents and recording religious sermons. Many examples of this Song dynasty calligraphy were taken back to Japan by the first Zen monks who had studied in China, and they have been treasured in the great Zen temples ever since. Treasured, however, not so much for the beauty of the calligraphy, but for their religious value, as many were brought back as records of the actual words of the Chan masters.

Calligraphy from the Song dynasty to the present day

The Song dynasty marked a turning-point in the history of Chinese calligraphy, for this period saw the development of printing; new and improved writing materials; the academic study and compilation of ancient inscriptions; and, above all, the challenge to established beliefs and practices posed by the intellectual freedom of Chan Buddhism. The philosophy can be summarized in the words of one of the master calligraphers of the period, Su Shi (1036–1101), who asserted that, "just because calligraphy has been made by a so-called professional, this is no reason for it to survive. Only work that also conveys an insight into human nature is worth handing down for later generations" (see pages 274–275). His teacher, Ouyang Xiu (1007–1072), was known for being one of the first literati: not only a gentleman-scholar, but also a high-ranking bureaucrat; it was this educated class that was most responsible for perpetuating high culture during the following centuries.

During the past 700 years or so, Chinese calligraphers have looked back to the great masters of antiquity for inspiration and models on which to base their own individual styles. Some have achieved a legendary status for their level of achievement, though the 4th-century Wang Xizhi and Wang Xianzhi were widely seen as having taken the art of calligraphy to the ultimate peak.

Zhao Mengfu (1254–1322) excelled in the gentlemanly pastimes of poetry, painting, music, the engraving of seals, and calligraphy; and in order to perfect his own writing he diligently studied ancient examples that remained on stone stelae and in old collections. Another Yüan dynasty calligrapher, Wu Rui, chose instead to perfect the ancient official and seal scripts rather than the more personal and expressive running script or cursive style that was favored by the poets and literati.

Until the modern period, the finest calligraphers came from these ranks of the gentleman-scholars and, to a lesser extent, the followers of Chan Buddhism in temples around the country. Whereas the Japanese *bunjin* who followed mainland scholastic ideals after the early 18th century came from varied backgrounds, the Chinese literati were born only to the leisured classes. Freedom from having to earn a living was at first the province of sages and hermits who lived away from the centers of power, but later became the good fortune of the high-ranking bureaucrats who had succeeded in the civil service examinations. By

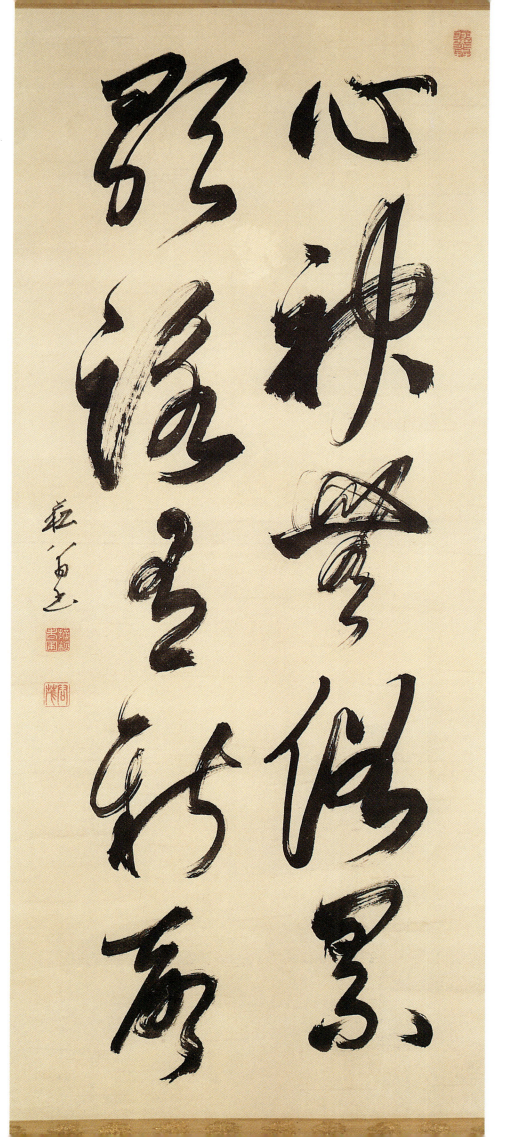

the very nature of the studies required, the Chinese literati were steeped in classical literature, poetry, and calligraphy, and if they were lucky enough to have been rewarded with a posting that was not too arduous, they could devote the rest of their lives to cultural pastimes.

Calligraphy in Japan

In Japan, until recently, it was widely understood that there was no form of writing until contact was made with China around the 3rd century A.D. or so, at the beginning of the Tumulus period. However, in January 1998 a story appeared in a Japanese newspaper announcing the discovery of a fragment of earthenware, excavated from a late Yayoi site in Mie Prefecture (on the coast between Nagoya and Osaka), that was carved with a Chinese character in the flowing, cursive style. The pottery has been dated to the mid-2nd century A.D., and therefore it can be assumed that by that time there were already well established contacts with the mainland. Maybe future archaeological finds will shed more light on the matter, but at the moment the exact date when writing first appeared in Japan remains unclear.

It is known that there was a considerable number of Koreans living in Japan during the Tumulus period, a large proportion of whom had comparatively more experience of China and its culture, and to some extent they handled the early correspondence and documentation that went along with those early diplomatic links. From the 6th century onwards, as more and more written material made its way over from the mainland, the native Japanese began to tackle the assignment of learning Chinese characters.

Adopting the ideographs was only the beginning; adapting the characters to write the Japanese spoken at that time was a different matter altogether, for the language was (and is) totally different to Chinese. Japanese is non-tonal and has a fairly complex grammatical structure, with tenses to indicate past, present, future, and so on; whereas Chinese is grammatically rather simple but with a subtle, tonal pronunciation. An accommodation took some three centuries to accomplish, and with considerable ingenuity, if not perversity, a system of writing was developed using Chinese ideographs together with two phonetic "alphabets" that had been simplified from Chinese characters, the pronunciation of which more-or-less approximated the sounds of spoken Japanese.

During these early centuries, formal state and religious documents were written in classical Chinese, but by the 9th century poetry, literature, and correspondence were written with a combination of Chinese ideographs and phonetic symbols. The two "alphabets" of phonetic symbols are katakana, which has characters that are rather angular in form, and hiragana, in which characters are more rounded and have been adapted from the free-flowing cursive style of writing. The invention of the two scripts is attributed to Kobo Daishi (A.D. 774–835), a saintly historic figure in Japan, revered for having founded the Shingon sect of Buddhism and its mysterious, reclusive temples on Mount Koya, not far from Osaka. Each system has 36 symbols corresponding to the same sounds and indicate the Japanese vowels (a, i, u, e, o) as well as

Left

Hand-scroll of waka poems

Painting by Tawaraya Sōtatsu (?–1643), calligraphy by Hon'ami Kōetsu (1558–1637)

Ink and colors on paper, complete scroll 462.9 cm x 32.3 cm, Hatakeyama Collection, Tokyo

The painting shows the graceful lines of Japanese susuki grass, which is highly evocative of the early fall season, and here is teamed with 31-syllable waka poems written in the peerless calligraphy of Hon'ami Kōetsu.

Below

Scroll of waka poems by Fujiwara-no-Kanesuke (A.D. 877–933)

Attributed to Ki-No-Tsurayuki (AD 868–945)

Ink on paper, 27 cm x 45 cm, Hatakeyama Collection, Tokyo

An example of the elegant, free-flowing "grass" writing favored by the cultured Heian nobility, with more emphasis on the native Japanese hiragana phonetic characters than on Chinese kanji.

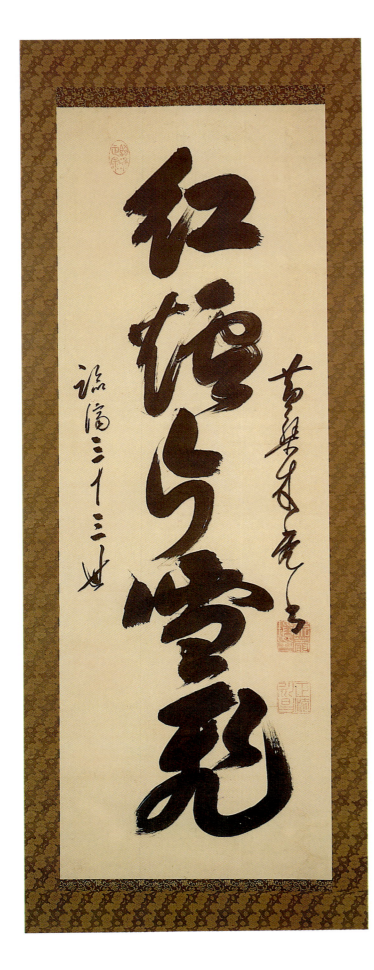

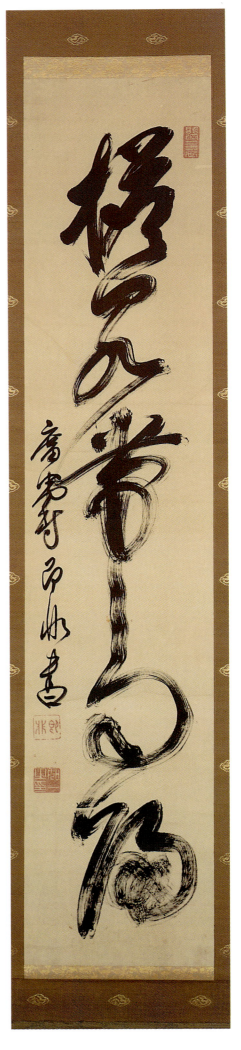

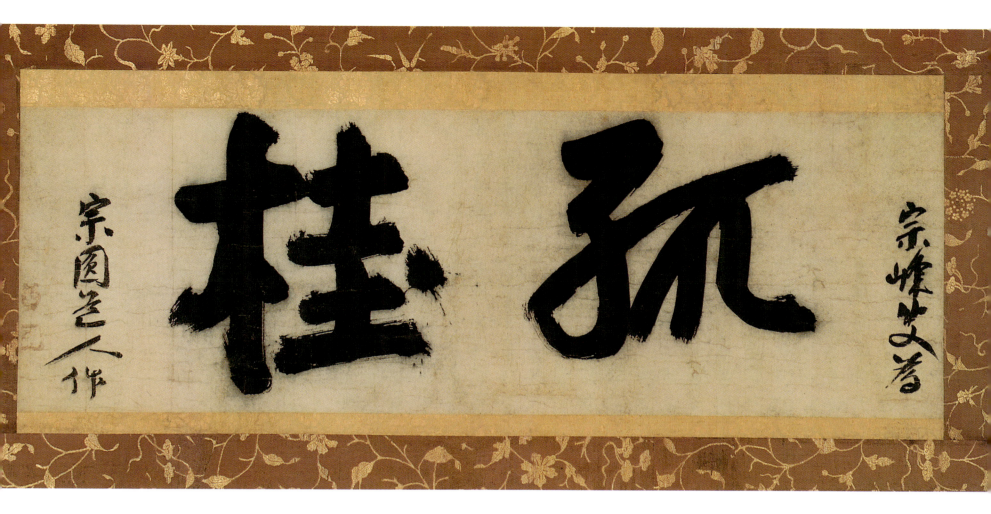

Above
Calligraphy

Shūhō Myōchō (1282–1337)

*Ink on paper, 31.6 cm x 94.4 cm,
Hatakeyama Collection, Tokyo*

Shūhō Myōchō's calligraphy is similar to that
of the Chinese teacher Huang T'ing-chien.

Opposite, far left
Buddhist maxim

Obaku Mokuan (1611–1684)

*Ink on paper, Collection of J. E. V. M.
Kingadō, USA*

Mokuan's forceful and rounded calligraphy
is usually written with large characters.

Opposite, center
Character "bamboo" and a poem

Obaku Kōsen (1633–1695)

*Ink on paper, 129.8 cm x 28.4 cm,
Collection of J. E. V. M. Kingadō, USA*

The large character at the top is that with
the meaning "bamboo."

Opposite, right
Buddhist maxim

Obaku Sokuhi (1616–1671)

*Ink on paper, Collection of J. E. V. M.
Kingadō, USA*

Sokuhi's calligraphy is perfectly balanced
around a central vertical line.

consonant-and-vowel sounds such as ka, ki, ku, ke, ko, ma, mi, mu, me, mo, and so on. Anything uttered in Japanese can be written in either *hiragana* or *katakana*, but in normal usage *hiragana* is used for indicating native sounds, and *katakana* is used for writing the now-numerous words which have been imported from other languages, especially English.

These days some 1,945 Chinese characters, called *Jōyō kanji* are prescribed in the syllabus of the Education Ministry as being essential for daily use, and they are learned by every child at school. These characters are supplemented by the two phonetic scripts, *hiragana* and *katakana* (together called *kana*). To give an example of how these are used: *Ashita watakushi wa Rondon e ikimasu* (Tomorrow I go to London). In this sentence, the only Chinese characters are the fourth from the beginning, and the fourth from the end (see the box on page 285) and they give the core meanings: "I" and "go." *Rondon* (London) is a foreign word and written in phonetic *katakana*. The other characters: *Ashita ... e ... (i)kimasu* are all phonetic *hiragana*. Just to confuse matters further, *e* and *wa* are written with the *hiragana* characters *he* and *ha* when used grammatically, as in this case. The signs of Japanese train stations always have the place-name written in *kana* above the name in *kanji* for the benefit of children who can easily pronounce the name but may not yet be able to

read it. Similarly, books and comics aimed at a young readership may have *kana* alongside the *kanji* (called *furigana*), as do newspapers when particularly obscure *kanji* are used.

In historic times, just as in China, a large number of *kanji* had to be memorized for one to be considered literate, and under the feudal system, before 1868, such learning was limited mainly to the nobles, priests, and ranking samurai warriors. Most of the lower-ranking population had no access to any formal education but could usually manage to recognize enough *kanji* to understand shop-signs and the large number of regulations posted by authority.

The number of *kanji* that are required to be learned under the Education Ministry's edicts has been reduced considerably from the end of World War II to the present 1,945 *Jōyō kanji*, which theoretically would be sufficient for understanding newspapers and the majority of books that are currently in print. Most people with literary aspirations, however, have probably mastered up to double that number. It should be explained that, just as in China, a lot of *kanji* are specialized; for example, the hundreds of names for different trees or plants. As such, the particular *kanji* may not be memorized, but the reader would immediately recognize enough clues from the components (called "radicals") of the character to hazard a rough guess at the meaning. For example, an

花満層臺鶯乱啼
柳深淺處畫樓西
浮花十二闌春風不成眠

嶽山此日
秋亭

あ	し	た	私	は	ロ	ン	ド	ン	へ	行	き	ま	す
A	shi	ta	watakushi	wa	Ro	n	do	n	e	I	ki	ma	su.

ideogram with the component 氵 on the left-hand side would be assumed to be connected with the meaning of "water" (as would a European word with the suffix aqua-). Similarly, one with 木 on the left-hand side would have a meaning connected with "tree" or "wood," which would most probably become clearer in the context of a sentence.

Over the past few years, the proliferation of word processors has to some extent led to a decline in hand-writing skills among many young Japanese. All school-leavers can read at least the *Jōyō kanji*, and the level of literacy is 100 percent according to official statistics, which is the best in the world. However, many quickly lose the ability to write by hand with any fluency once the exams are over, and the nadir has now been reached where even the New Year cards, traditionally sent to demonstrate one's calligraphic skills, are often churned out on a computer and are even considered socially acceptable.

However, for most of history since writing was first introduced, the Japanese have been avid practitioners of the art of calligraphy and several styles have predominated. Most of the oldest that are still extant are Buddhist texts that were copied by professional scribes after the religion had been introduced to Japan, and are written in the clear *kaisho* script. Some are inscribed with characters in gold or silver on an indigo background and accompany Buddhist images that have been drawn in the same colors.

A completely Japanese style of aristocratic script appeared in the Heian period; this used the graceful flowing *hiragana* rather than Chinese *kanji* for writing letters and poetry. This was a style that was favored especially by women of the imperial and noble families, and was often inscribed on exquisitely made paper decorated with designs in gold and silver. The combination of calligraphy with painting shows how very closely the two arts are linked (see page 266; and page 281, top). This style reemerged again in a revised form during the Momoyama and early Edo period in the hands of the masters of the Rimpa school such as Hon'ami

Kōetsu, and members of the noble families (see page 281, top).

The powerful, expressive, often violent calligraphy of Zen was introduced to Japan during the Kamakura period by monks who had studied at the great Chan temples of China. The style was in complete contrast to the mannered and elegant writing of the Heian nobles, but it shows a strength that is calculated to underscore the spiritual meaning of the words (see page 282 and 283). Zen calligraphy enjoyed a renaissance in the Edo period when the establishment of the Obaku sect attracted a large following and great interest. Calligraphy was often teamed with painting to enhance the message as can be seen in a simple sketch of a gourd by Nantembo. To some extent inspired by Zen practice and teaching, the Bunjinga, or Nanga painters, were all proficient calligraphers and used writing by itself for poetry or to convey philosophical ideals, or to accompany and elaborate the literary meaning of their paintings.

In recent years, calligraphy has broken free of all rules and is now often used to further narrow the divide with painting. The concept is not new as can be seen in the extraordinary scroll that shows the transmogrification of *kanji* characters and a blackbird (page 278). There are plenty of calligraphers working in exciting directions and frequent exhibitions are held all over the country to display their work. Some have been inspired by classical styles, such as Sakai Hasetsu (born 1912), who writes poetry with a liquid line reminiscent of those of the Heian courtiers (see page 286); and Shiko Munakata (1903–1975), who shows a Zen force in his thick-stroked characters (see page 287). Others such as Kishi Reishu (see page 286), and Chikutai Osawa, lean more to abstraction and design rather than the meaning of the words. Western artists such as Mark Toby, Franz Kline, and Robert Motherwell have not been immune to the exciting graphic possibilities of Oriental calligraphy, and the influence is obvious in their work. Those who spend the large sums of money that these artists' work commands today might reflect on where the art came from in the first place.

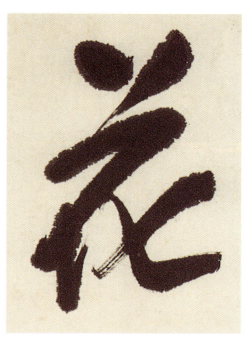

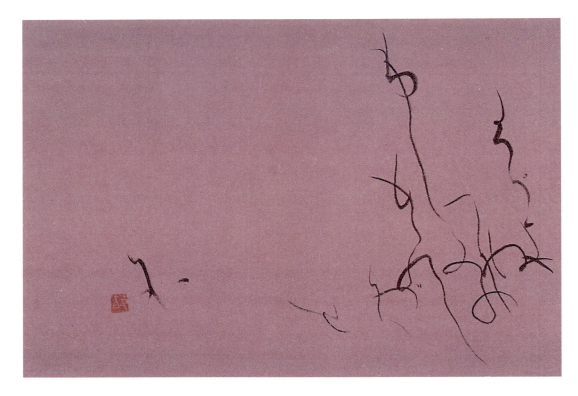

Poem by Matsuo Basho (1644–1694)

Sakai Hasetsu (born 1912)

Ink on colored paper, 15 cm x 21.5 cm, private collection

On my cloak
the peach of Fushimi,
a drop of dew

Right

"Iroha"

Kishi Reishu (modern)

Ink on paper, 38 cm x 43.5 cm, private collection, Tokyo

"Iroha" is the classic poem by which every school-child memorizes the *hiragana* phonetic script. In this modern example, the poem is written faintly as the background, and more forcefully in darker ink on top.

Opposite

Buddhist maxim

Shiko Munakata (1903–1975)

Ink on paper, 136 cm x 34 cm, Collection of J. E. V. M. Kingadō, USA

Munakata was one of the leaders of the mingei movement, which espoused the "artless" philosophy of folk-craft. He was famed for his prints and calligraphy executed with strong rough strokes, such as can be seen in this hanging scroll.

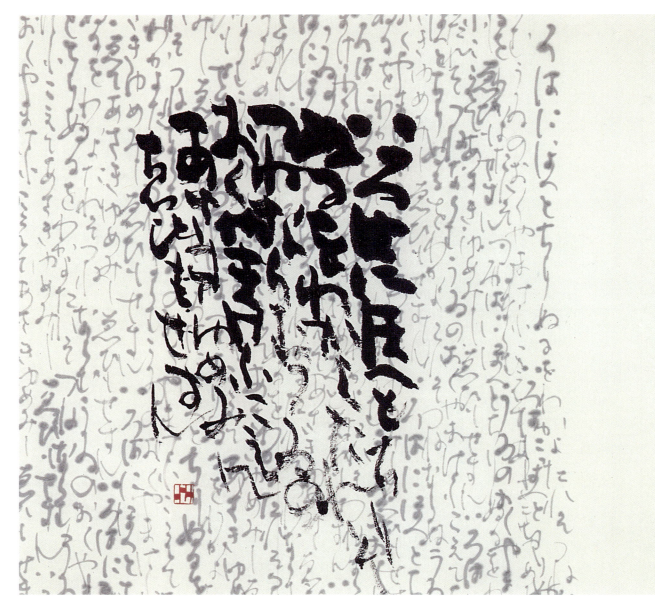

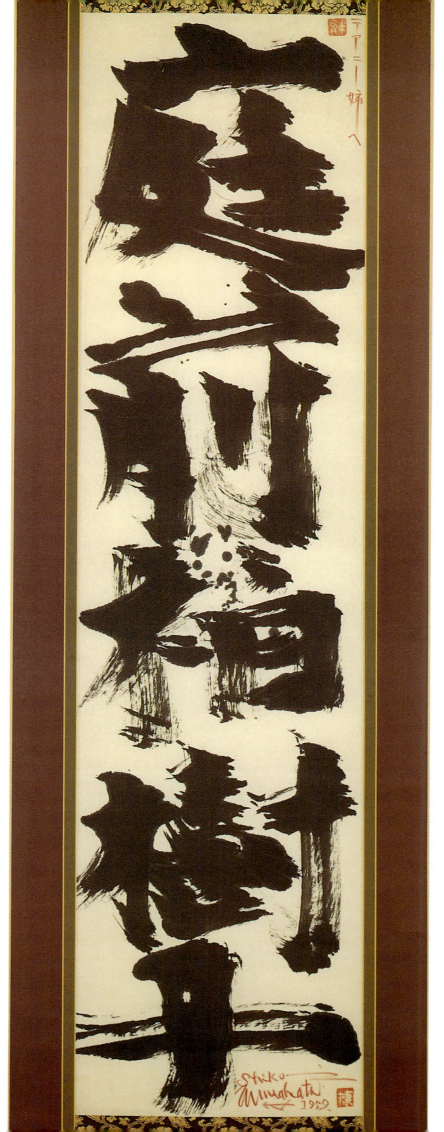

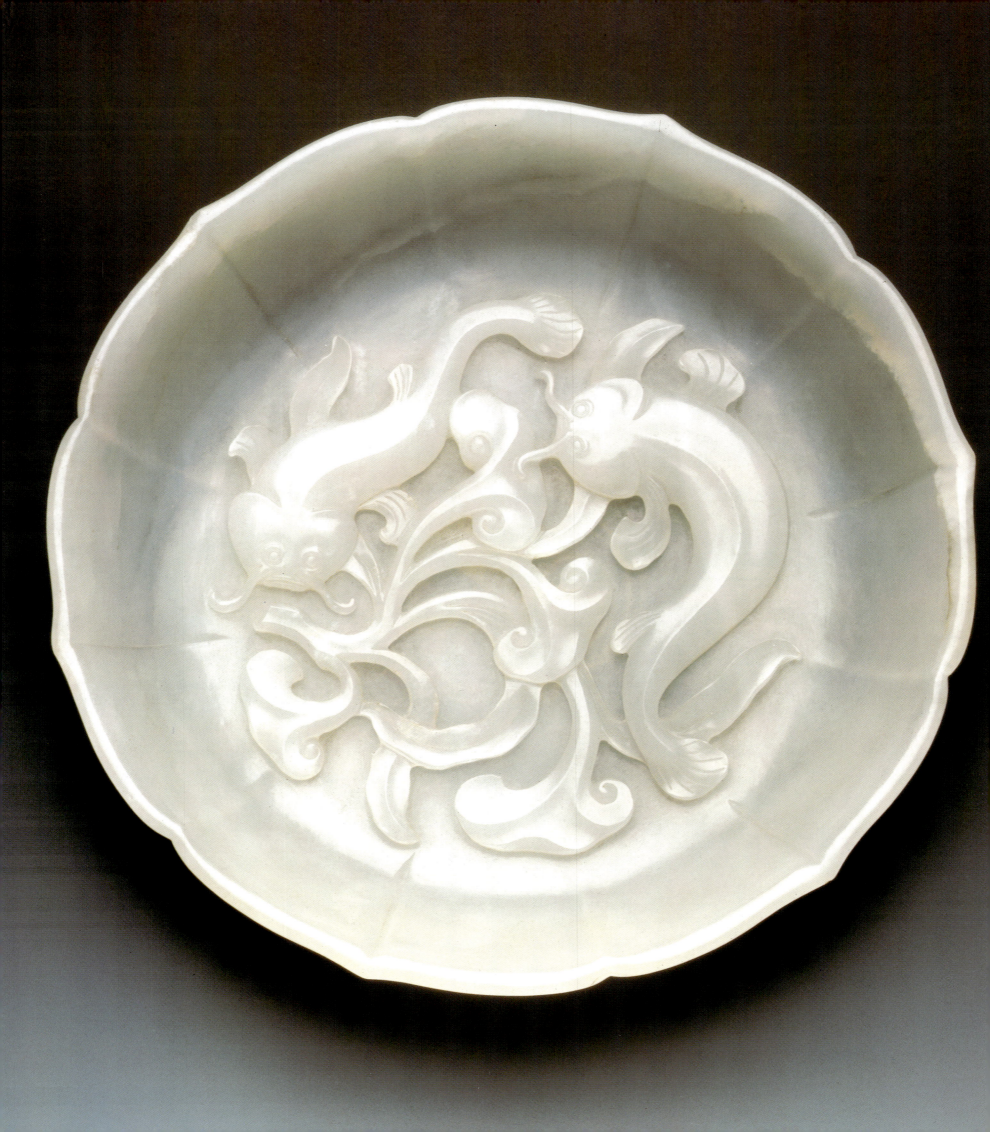

Jade

Although jade is found in various locations around the world, it is only in China where this stone,
valued even more than gold or silver, achieved a very special status and mystique that lasted for
thousands of years. It was especially prized not only because of its rarity and beauty, but also because it
was closely linked with the concept of immortality, and because it seemed to possess qualities that
reflect Confucian values much prized by the cultured Chinese:
Its surface luster represents purity,
its dense hardness represents clear intelligence,
its sharp edge, which does not cut, represents justice,
the resonant sound it makes when struck represents music,
its color represents loyalty,
its imperfections, visible through the translucent stone, reveal sincerity,
and its brightness represents heaven…

Shallow dish with the design of a
catfish and fungus

Qing dynasty (1644–1911), whitish
nephrite, H 2.5 cm, dia 13.5 cm,
Museum of Far Eastern Art, Bath,
England (Ref. BATEA 519)

The design shows a graceful composition
of the auspicious *linghzi* fungus with two
finely carved catfish. The base is inset and
similar to that found in enamel wares of
the same period.

The Material

Below

Historic depiction of jade working

(Detail), block book from the late Qing period, Tokyo National Museum, Tokyo

This 19th-century picture illustrates the drilling stage of the work.

Bottom

Cut jade blanks

Only when it is cut does the quality of the jade become apparent.

This extraordinary veneration for jade has continued throughout Chinese history from the beginning of the neolithic period over 7,000 years ago until the present day. In fact it would be almost impossible to discuss China and its rich cultural heritage without addressing the very high regard the Chinese have for jade, and its importance in the country's artistic history. And for the first three or four thousand years or so, its dominance so eclipsed that of any other material, that this early era is now becoming known as "the age of jade."

Archaeological excavations over the past 25 years or so have shown that early neolithic jades were made from stone found within China, at sources long ago depleted. However, since ancient times most of the material has been transported, often with great difficulty, from the area of Khotan and Yarkand in the K'unlun Mountains of central Asia, about 800 kilometers (500 miles) north of Delhi. In the 18th century (very recent by Chinese standards), these supplies were supplemented by imports of jadeite from Burma, and a characteristically flecked, dark-green jade from Siberia called "spinach jade."

Firstly, by way of definition, the word "jade" in the West is commonly used to describe two totally different kinds of stone: nephrite and jadeite. Both are hard, decorative stones, chemically related but having different properties. Nephrite, which has a dense, fibrous structure, is found in a range of colors from black, through shades of green, to almost white. The surface can be polished, but never to a high gloss, and has a characteristic waxy or oily finish. Jadeite, in contrast, is found in a more brilliant palette of colors, and can be polished to such a lustrous, glassy finish that in its purest green variety it is a highly prized gemstone. In addition to the natural tones, the Chinese have developed techniques to alter the colors of both nephrite and jadeite by artificial means involving heat or staining chemicals, especially after the 8th century AD. "Calcification" is a term used to describe the whitened areas of burial jades, an effect caused by natural chemical changes whilst in the ground. Heating jade to a very high temperature causes a different whitening effect known as "chicken bone."

Jadeite was mainly imported from Burma during the past 250 years, and so the bulk of works in this material can be considered fairly recent. In this brief look at the history of the stone in China the word "jade" will refer to nephrite unless otherwise stated.

Mention should be made of the fact that jadeite occurs in small quantities in the Nagano area of Central Japan and until the 7th century AD was

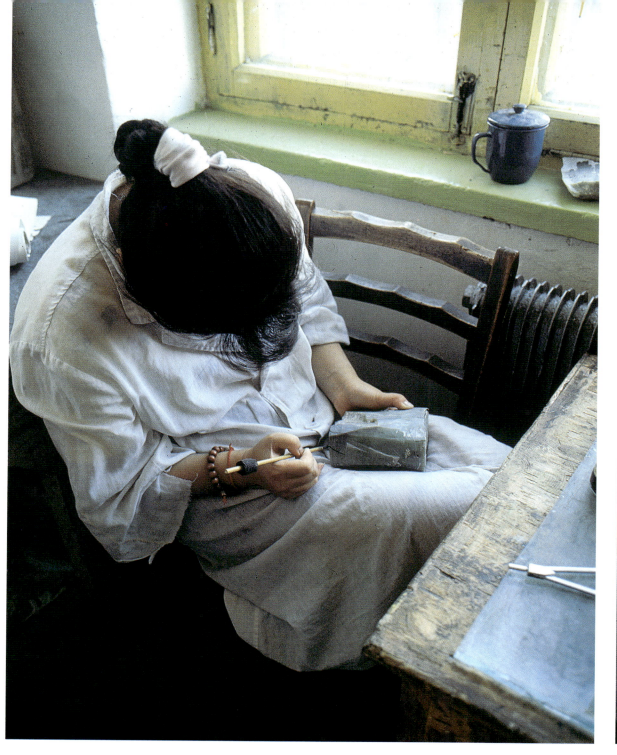

used to make small beads and pendants similar to objects found in neighboring Korea. Also neolithic nephrite objects have recently been found in excavations in the southeast of the island of Taiwan, giving evidence of a previously unknown jade culture that is still in the process of being researched.

Nephrite is an amphibole rock of a complex, fibrous structure, and is composed of calcium, magnesium, and silicate. Jadeite is a crystalline gemstone of a completely different structure – a pyroxene composed of sodium, aluminum, and silicate. Both types of stone are rather rare and, as they are igneous, there can be chemical and structural variations.

On the Moh's hardness scale, nephrite is around 6.5 and jadeite is a little harder, just under 7. For comparison, diamond is 10. Hardness, color, and surface lustre can be affected by heat and chemical action.

Jade has a very special tactile quality and the Chinese were fond of carrying or wearing small pieces of the stone (such as pendants, beads, or snuff bottles), purely for the satisfaction of frequently touching the material, much as "worry beads" are used in the Eastern Mediterranean. At first touch it is cold but it immediately warms to body heat. It is tough, and does not shatter when dropped on to a hard surface, and although it can be ground to a fine edge, it will never be sharp enough to cut, as will flint or obsidian. Jade is so hard that it will easily scratch glass and steel, and so the working of the stone into shapes is, to say the least, extremely difficult and time-consuming.

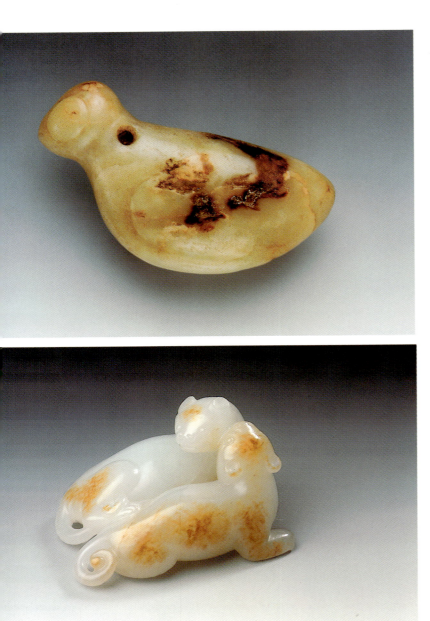

Techniques of "Jade Carving"

How, then, is jade fashioned? The term "jade carving" is widely used, but to be exact, it is impossible to carve jade in the sense that wood can be carved with a knife, although the verb is used for convenience. In fact, the only way to work the stone is by abrasion with a harder material, and in the early neolithic period this was done by rubbing, scratching, or drilling the jade with another harder piece of rock, or abrasive sand used in conjunction with leather or bamboo. Over the course of history, and with characteristic inventiveness, the Chinese developed and refined techniques to the point where they were able to work jade with great skill and sophistication.

Jade was typically found in the form of river pebbles or boulders from the Khotan region, and transported to the centers of civilization in China. It is not clear just when this trade developed, but it must have been around 2000 BC – after the end of the neolithic period when supplies within China

had become exhausted and communications were established with the nomadic (and to Chinese eyes, barbarian) tribes to the West. For a brief period during the Han dynasty (and much later during the reign of the emperor Qianlong in the 18th century) the territory was under the control of the central government. Since that time, and often for long periods, supplies have been frequently disrupted by the chaotic history of the area.

The pebbles found in riverbeds usually had a "skin," a surface of weathering or chemical change caused by eons of exposure to the elements. As such, the beauty of the jade within was invisible, and much guesswork went into the selection of pebbles to be used for working into objects. Sometimes, the pebble had a shape that was already inspiring or that lent itself to revealing some form (of an animal perhaps) with only a little workmanship required. Such *objets trouvés* were particularly prized in the 18th century as paperweights or, drilled out, as snuff bottles.

In working the stone, the first step was to make it into smaller pieces, or slices, and this was achieved by laboriously sawing through the pebble or boulder with a bow-string, a helper continuing to pour water and fine, abrasive sand on the cut. By experimenting with different varieties and grades of sand, the Chinese discovered in later times that harder materials, such as garnet or corundum, worked more effectively in this grinding process than the more commonly available quartz.

It could take several months to cut through a small boulder using this method. Then, having finally cut a shape suitable for working, a form could be fashioned by grinding the piece of jade with coarse, abrasive sand to delineate the main features of the desired shape; and then with sands of varying degrees of fineness to indicate smaller details, and eventually achieve an overall polish. Various sizes of rotating wheels and drills, driven by a treadle, were invented to take some of the drudgery out of the grinding process, but the work was still time-consuming and laborious. These techniques of working jade reached their highest level of sophistication during the Warring States period (475–221 BC) and were to remain constant until the advent of electric lapidary tools in the 20th century.

Perhaps it is the sheer difficulty of working jade that contributed to the mystery and talismanic aura of the stone; certainly the earliest jade objects were closely connected with magic, ritual, and burial customs. The very fact that so much effort and time were needed would automatically have invoked respect and veneration for finished objects of the material. However, despite the primitive facilities available, techniques of working jade were refined to a very advanced level early in the neolithic period, and it is surprising to find that some of the oldest pieces found in burial sites are of a high artistic order, with an almost modern sense of inspired design and superb workmanship – five or six thousand years before the works of Brancusi, Henry Moore, and Isamu Noguchi.

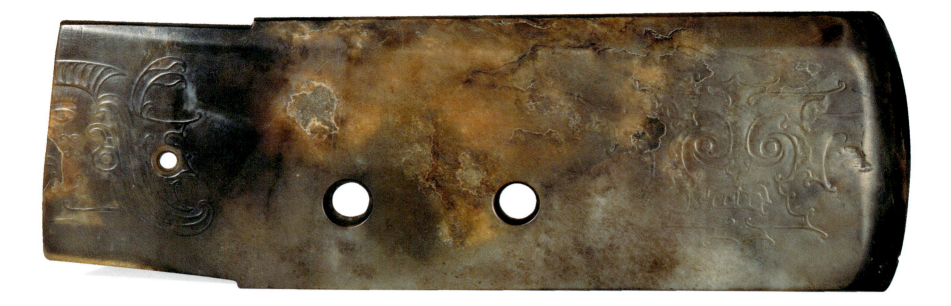

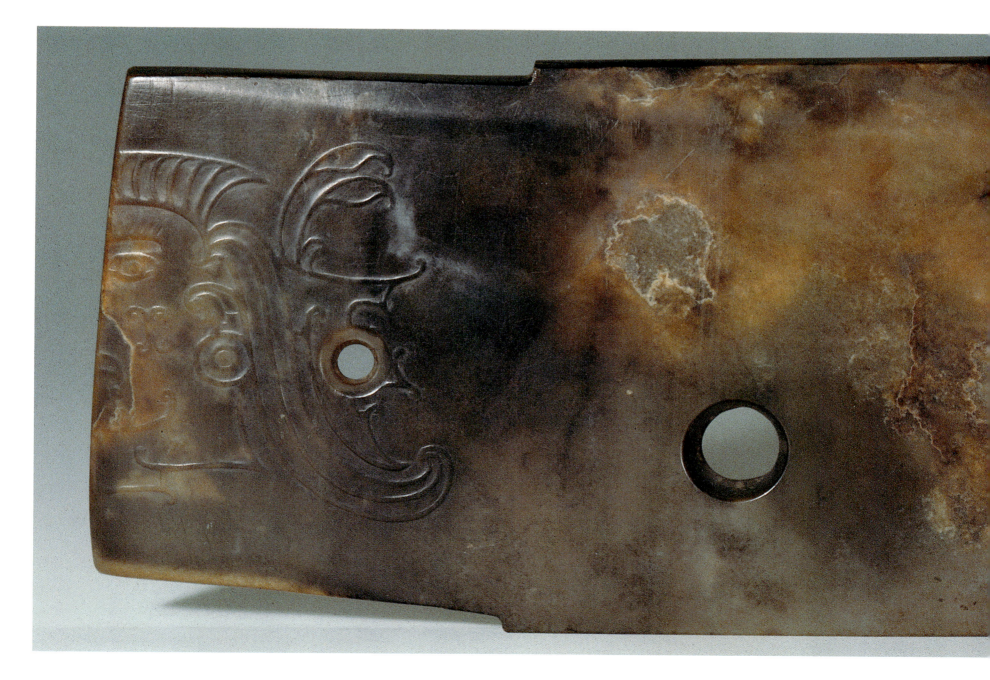

Top, left

Seated humanoid figure

Chinese neolithic (about 4800–4000 BC), gray-green nephrite with black inclusions, H 7.2 cm, W 3.9 cm, Museum of Far Eastern Art, Bath, England (Ref. PE 512)

This small, seated figure with his hands resting on his knees shows a face with no salient features. It probably dates from the very earliest jade-working cultures of the Liao River area of Manchuria in north China. The strange features of the head could be suggesting the horns or ears of an animal. This piece is much worn and smoothed, indicating that it was handled for a long time before being buried, and it has a hole perforated horizontally through the neck so that it could be worn as a pendant.

Top, center

Circular crested dragon

Hongshan type, north China neolithic (about 3500–2200 BC), H 4.5 cm, W 4.3 cm, D 0.7 cm, opaque black-green nephrite, Museum of Far Eastern Art, Bath, England (Ref. PE 58)

This is perhaps a prototype of the dragon that features so much in later Chinese iconography, but with the blunt snout of a pig. The mane, turned up at the end, adds a graceful balance to the design, and the piece is drilled from both sides to form a perforation. It was probably worn on a cord as a pendant.

top, right

Balloon-bodied animal

Hongshan type, north China neolithic (about 3500–2200 BC), H 7 cm, W 6.1 cm, D 4.7 cm, yellow-green nephrite with rust-colored areas, Museum of Far Eastern Art, Bath, England (Ref. PE 610)

This strange creature with a round, legless body, the snout of a pig, and large, protruding eyes, has been drilled for a carrying cord. Along with most Hongshan-type jades, it has been smoothed and well-worn by handling.

Above

Lotus-shaped brush washer with frog, snail, and ducks

Ming dynasty (1368–1644), gray-green nephrite with brown inclusions, H 5.5 cm, L 12.4 cm, W 6.4 cm, Museum of Far Eastern Art, Bath, England (Ref. BATEA 448)

A brush washer such as this would have been used on a scholar's desk for rinsing the ink off brushes after painting or calligraphy. In this case, the leaf is shaped to hold the water, and the lotus bud is hollowed out to serve as a brush holder. The grouping of the duck, frog, and snail form a rebus with the meaning: "May you have many sons, year after year." The carving is superb and shows careful attention to detail such as the veins on the leaf.

Neolithic Jades

(before 5500–1600 BC)

As much archaeological research has been carried out in China over the past 20 years or so, a stream of new discoveries has led to a continual re-appraisal of early neolithic culture (or cultures, to be more accurate, as there are wide differences depending on geographic location). Leaving aside the question of exactly when and where the first jades were worked, it is clear that the development of jade working coincided with the transition from the lifestyle of the nomadic hunter gatherers to that of the settled farmers and villagers. In China as elsewhere, such settlement provided the cradle in which civilization could grow, and, for the fortunate few, the leisure time to ponder on the mysteries of fertility and harvest, the cycle of the seasons, life and death, and the nature of the gods.

As in any society, settlement also gives rise to the development of customs for handling the bodies of the dead, and their accompanying rituals and artifacts. In early China this involved burial, and the creation of objects that were not purely utilitarian to be incarcerated in the tomb. It is significant that of all of the objects of gold, silver, ceramic, bronze, and so on found in Chinese tombs, only objects of jade were buried close to, or adorning the corpse in the coffin. In fact, virtually all early jades have been found in tombs, not residential sites, and it was only later in the historic period that the precious stone was used to make objects for use by the living, and not by those lying in their graves.

Considering the difficulties of daily life in the neolithic period, together with the time-consuming difficulty of working jade, it is surprising to realize that whole communities of workers must have been sustained purely to make ritual objects for burial. Societies that could afford to maintain such workers would already have become organized into settled communities with stable food supplies, and have generated an elite with the economic and political power to warrant such attention to burial.

Jades from various neolithic cultures have been found at burial sites throughout the river valleys and plains of China under an altitude of 180 meters (570 feet) or so, where agriculture could be supported; the detailed geographical and chronological classification of these cultures is complex and still being researched by Chinese archaeologists. However, three of these cultures are notable for burial jades of a far superior quality to those from elsewhere: they are the Hongshan of the Liao River, far north of Peking, the Longshan of the Yellow River area, and the Liangzhu of the Yangtze River delta.

The earliest excavated jade objects have been found in tombs around the Liao River area of north China (broadly, the Hongshan culture). They date from over 4000 BC and take the form of small humanoid figures with haunting expressions, masks, birds, insects, ritual objects, and strange beasts that might be prototype dragons though they have the familiar snout of a pig.

("Tout est bon dans le cochon" was an observation not lost on the Chinese, for whom the pig has always been a cherished food supply.)

An extraordinary characteristic of these Hongshan jades is that they are nearly all worn and smooth. To some extent this effect was purposely achieved by laborious grinding and polishing in order to bring out the beauty of the stone. However, it seems that many pieces buried at that time must have already been very ancient heirlooms inherited from a far more ancient tradition of jade working, about which almost nothing at present is known. It is startling to consider that if these jades were considered ancient by the peoples of the Northern neolithic era, then it is most likely that the material was being skillfully worked over 7,000 years ago.

The Longshan culture developed later in the neolithic period (about 2800–1900 BC), and was located in the fertile area of the Yellow River. Finely executed jades have been excavated in the forms of *bi* disks, axes, scepter-blades, strange masks of demons or gods, and various forms depicting birds, which may have been central to religious beliefs.

One of the features seen for the first time on some Longshan jades is the appearance of detail in the form of raised lines (see page 293). As this

Right
Cong

Chinese neolithic, Longshan culture (about 2500–1700 BC), H 8.6 cm, dia 6.5 cm, green nephrite, Museum of Far Eastern Art, Bath, England (Ref. PE 370)

The opening in this *cong* has been squared out from the original round bore-hole, leaving very thin walls, on which two vertical lines have been incised. Long burial has caused chemical alteration and a change of color over a large area.

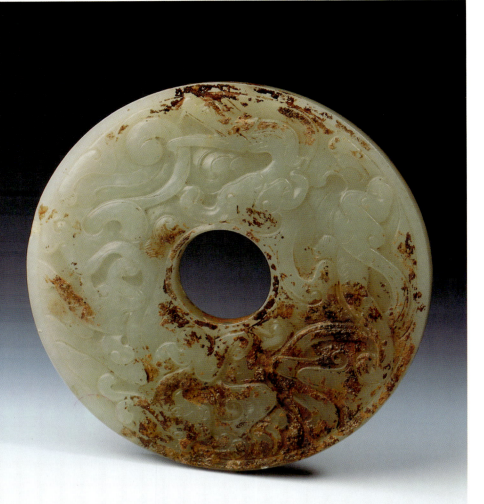

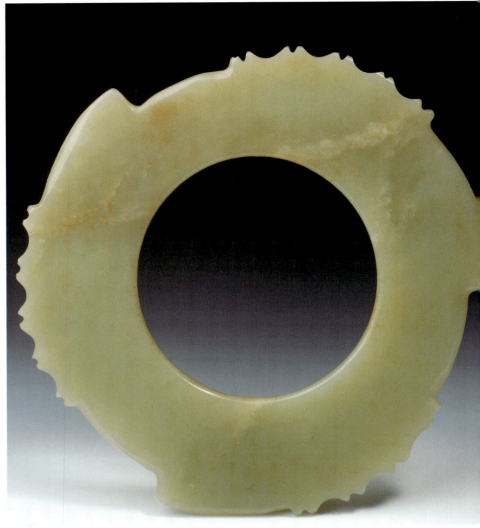

could only be achieved with great difficulty by the removal of a layer of jade on each side of the raised line, it is clear that technical skills had already become highly developed by this time.

Burial jades, which were used to adorn a corpse, can be classified according to shape, although there are many variations to be seen. Conjectures have been made that the forms represent Heaven, Earth, and the cardinal points. However, apart from some obscure references in later texts, there seems to be no evidence to prove this. Although the nature of ancient ritual has been lost to history, it can be surmised that there were similarities with the practices of neighboring Siberia, Korea, and Japan. Magic must have been practiced, and shamans employed to invoke the benevolence of the gods in guiding the afterlife of the dead, and to manage the orderly process of the seasons, so vital for the growing of food. These objects may then have been used in a ceremonial ritual, and could have represented some abstract idea or belief. As none of the objects resemble anything that could be considered of practical use, and presuming that they do indeed represent abstract concepts, it is intriguing to wonder just what those ideas were.

As sculptures the forms of ritual jades can stand easily alongside any masterpieces of our modern

period – though of course it is certain that what was in the minds of their creators was surely completely different from what goes through the minds of our artists today. Interestingly, almost all of these jades are small enough to be held comfortably in the hand, and perhaps our best hope of gaining a sense of what these pieces may have meant for their creators, even if we can never fully understand their function, would be to actually handle them.

Ritual jades

Ritual jades were used for burial through the neolithic and on until the latter part of the Han dynasty, and are found in the following forms:

1. *Bi* discs are thin disks of jade with a central hole whose proportionate size varies from one disk to the next; they may be symbolic of the Sun. They first appeared in early neolithic times in a plain, simple form, though in later dynasties they are decorated with carving. Some of the early *bi* disks from Liangzhu burial sites are of impressive size and have splendid color-tones, showing the care with which the original jade stone was selected (see page 297). One variant of the *bi* disk, first seen in the Longshan culture, is found with an irregular

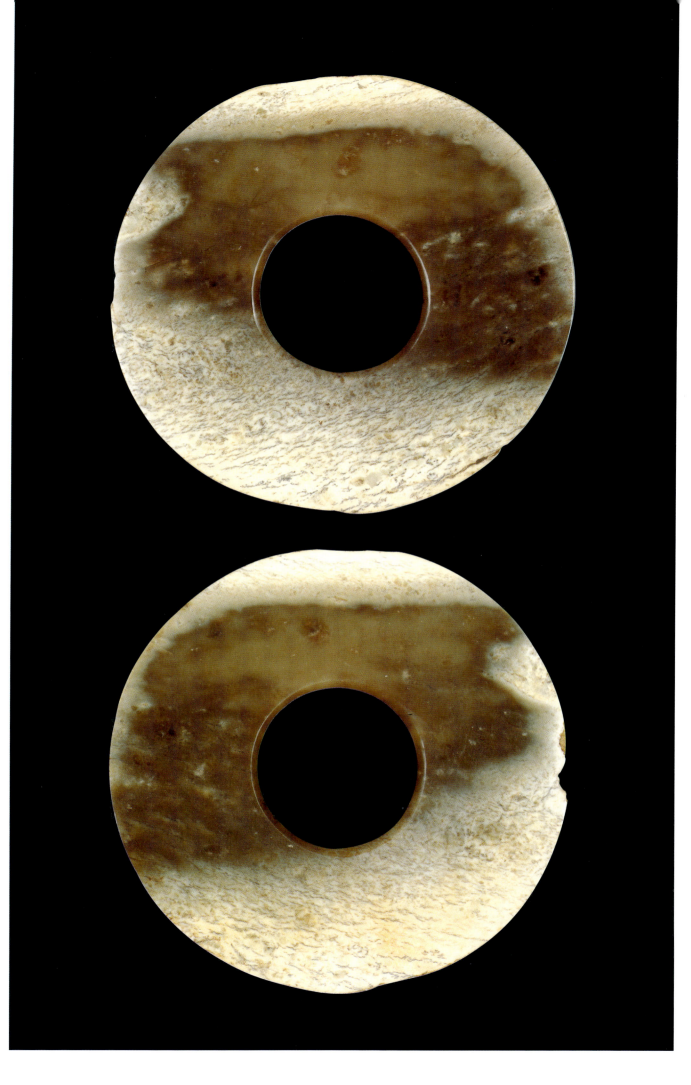

Pair of *bi* disks

Chinese neolithic, dia 16.3 cm, green nephrite with dark inclusions and extensive calcification caused by chemical changes while buried, private collection

This pair is unusual in having been cut back to back from the same boulder. The central hole is drilled from one side only.

"Knuckle-duster"

Hongshan culture (about 3500–2200 BC), H 5.0 cm, W 10.2 cm, D 1.3 cm, dark green nephrite, Museum of Far Eastern Art, Bath, England (Ref. PE 750)

This bizarre object is described as a "knuckle-duster" in the absence of any other suitable designation. With the large, "eye holes" with slightly raised ridges on the inside, and four "teeth" below, the shape also suggests a skull without the jawbone. At each end of the object there are long, pig-like masks with eyes and flap ears.

Hand implement

Majiaban culture, Yangtse River estuary area, Chinese neolithic (about 5000–3900 BC), pale green nephrite with whitish alteration, L 12.5 cm, W 6.2 cm, D 0.7 cm, Museum of Far Eastern Art, Bath, England (Ref. PE 405)

Even though this implement, which in the absence of other terms is sometimes referred to as "knuckle-duster," looks as though it is capable of inflicting frightful injury, it is highly unlikely that it was ever used as such a weapon, for it is rather thin and liable to fracture. The piece is drilled with a hole that could have been used for hanging, but just what this object represents is a mystery.

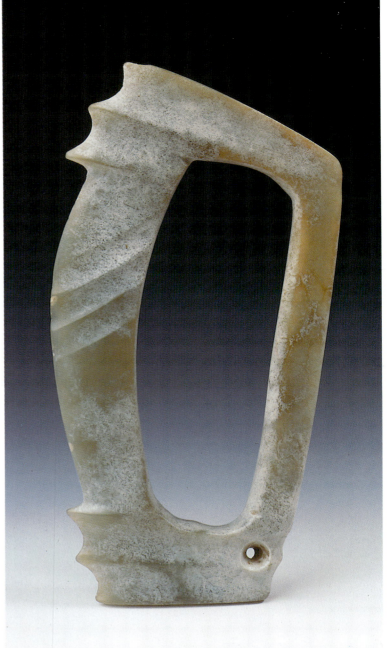

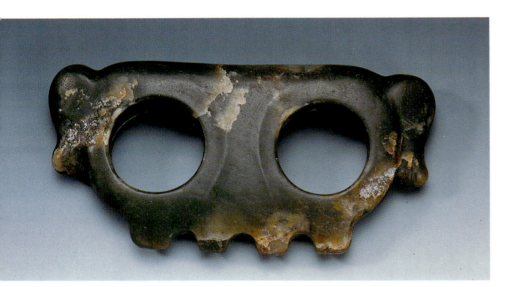

Cong with bas-relief masks

Liangzhu culture, Chinese neolithic (3300–2300 BC), light calcified nephrite with black stains, H 8 cm, the Shanghai Museum

This *cong* is a tour de force of Lianzhu jade workmanship. It is decorated with stylized masks, one above the other, and meticulously finished. At the top of each design are two bands of fine incised grooves containing another band with a pattern of coils the same as those on the masks. It is still a mystery how such pieces could be so perfectly made considering the tools that must have been available over 4000 years ago.

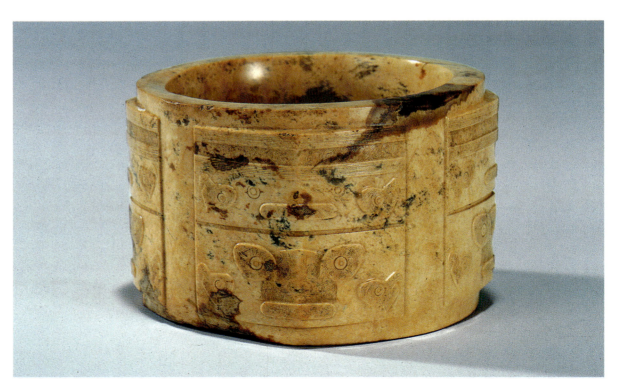

Left
Adze

Dawenkou culture, Chinese neolithic, Yellow River estuary area (about 4500–2300 BC), gray-green nephrite with black flecks, L 21.5 cm, W 10.0 cm, D 0.5 cm, Museum of Far Eastern Art, Bath, England (Ref. PE 407)

This thin slab of jade has been fashioned into the shape of an adze with a slightly curved beveled edge. Two holes have been drilled from either side to meet in the middle; the larger one almost perfectly, but the smaller one off-center.

Center
Dao blade

Shandong-Longshan culture, Chinese neolithic (about 2300–1700 BC), opaque green nephrite with lighter markings, L 29.7 cm, max W 5.9 cm, D 0.5 cm, Museum of Far Eastern Art, Bath, England (Ref. PE 539)

With a subtle change in width, and with a beveled edge along one side and end, this blade is superbly designed and crafted. Three holes have been drilled from each side to meet accurately in the middle.

Far right
Chang scepter

Shandong-Longshan culture, Chinese neolithic, (about 2300–1700 BC), L 28.8 cm, W 5.3 cm, D 0.7 cm, greenish-black nephrite with whitish areas, Museum of Far Eastern Art, Bath, England (Ref. BATEA 532)

This *chang* has slightly curved edges, with the "handle" having a rough, broken finish at the end.

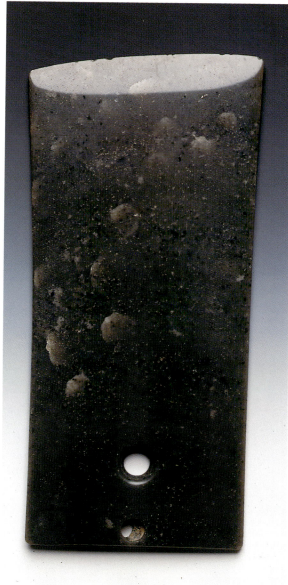

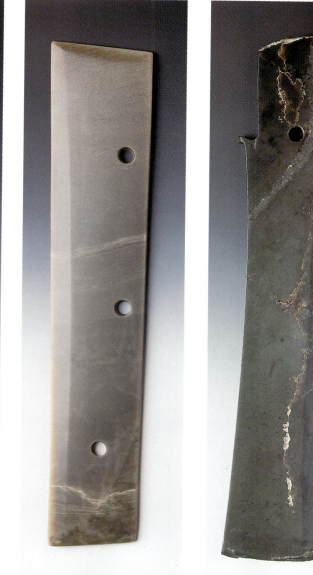

outline, and it is suggested that this may have some astrological connection.

2. The *cong* is square-sided cylinder, thought to be a symbol of the Earth, and found only in the tombs of males. The hollow center was created by drilling from each end in order to meet in the middle, and despite accurate aim there is usually some irregularity in the cylinder to mark the meeting of the bore holes.

Throughout most of the neolithic period they are usually plain (see page 295, but recent excavations of rich tombs of the Liangzhu culture (around the Shanghai area south of the estuary of the Yangtse River, 3400–2250 BC) have revealed *cong* that rank among the masterpieces of jade art. Some have beautifully finished, stylized masks on each corner in low relief, a staggering achievement when one realizes that to make such a design, everything *else* had to be painstakingly ground away (see opposite, bottom). Others are extremely long, and illustrate such mastery of drilling that the cylindrical bore meets in the middle with almost perfect accuracy.

3. Symbolic weapons and tools appear in the form of axes (*yue*); adzes with a beveled edge; long blades; scepter-like objects (*chang*), often with drilled holes (see above); and strange, savagely beautiful objects that look like "knuckle dusters" (see opposite, top)… they seem capable of inflicting horrendous injury, but, like the other objects, they were probably used only for burial rituals.

Other items found in neolithic tombs may have been used more for the simple adornment of the corpse than for actual ritual. These include slit disks (which may have been earrings), plaques, beads, and pendants of various shapes (see page 301).

In contrast to the Hongshan jades, those excavated from Liangzhu sites show no signs of wear, and are, apart from the stains and effects of burial, as perfect as when they were first made. The techniques of this culture were by far the most advanced of the neolithic period, and almost all jade items are superbly made and exquisitely finished. Just how this was accomplished, considering the available materials and tools, remains a mystery yet to be solved – it is all the more unfath-

Above

Spearhead

Shang dynasty (1600–1100 BC), L 9.8 cm, green nephrite with gray and brown markings, private collection

Superbly formed and finished, this piece is almost identical to a perforated spearhead that was found in the tomb of Fu Hao (about 122 BC), consort of King Wu Ding.

Right

***Ge** dagger blade*

Xia dynasty, Erlitou period (about 1900–1600 BC), white nephrite, L 37 cm, W 6.5 cm, D 0.7 cm, Museum of Far Eastern Art, Bath, England (Ref. PE 243)

This carefully made blade was possibly modeled after a weapon made of metal. Below the two drilled holes is a band of crosshatched lines and the "handle" has seven grooved channels ending in small teeth that project slightly. Both front and back are more or less identical in design.

omable as this was the "Stone Age," when no metals were being used.

However, we have here an object lesson in an important historical truth: that an ancient culture is not necessarily primitive. This is put into clear perspective when one realizes that even with modern electric tools and diamond wheels, jade objects made today are largely kitsch, and not one recently manufactured item could even begin to compare artistically with those of ancient China. Sadly, that is except for the fakes, which these days are so well made and artificially aged that they deceive the experts and present a mine-field for the novice collector!

The Early Historical Period

From the Xia dynasty to the Han dynasty

The early historic period extends over 2,000 years, during which we see different waves of jade production and an enormous proliferation of shapes. The Xia dynasty, at the end of the long neolithic period, is marked more than anything by the development of metal-casting, a development whose impact cannot be overestimated as now tools and weapons could be made easily and quickly, instead of being laboriously chipped out of stone. Those societies that were fortunate enough to master the new metal techniques were able to conquer and subjugate those which had not, and so there was a gradual concentration of economic and military power.

Jade carving did not diminish during the Xia dynasty, for the stone had a long-established role in burial, and in fact the new bronze technology was used to make rotary, treadle-powered tools that to some extent facilitated the working of jade. Excavations of tombs dating from this dynasty in the central Yellow River have yielded large, splendid blades of whitish jade with incised lines of decoration, most likely in imitation of the shapes of bronze weapons in use at the time.

The following Shang and Chou dynasties begin the era that can be called historic (in other words when records began to be kept). Central features of this period are the concept of a nation under a king and some form of centralized control, the development of communities living in cities, the rapid improvement in metalworking techniques, the use of money for commercial transactions, and above all – written language. The great difference between the neolithic period, stretching back through millennia, and the past 3,500 years or so, is that history has been recorded in considerable detail since the Chinese created a way of inscribing characters that could represent all aspects of life. Our only clues for understanding the neolithic period come from the artifacts found in archaeological digs, whereas understanding the historical period requires us simply to open a book, so well has the life of the historic period been recorded.

From this time on until the modern period, the working of jade became an integral part of Chinese

culture, not just limited to burial and ritual objects, but extending to all manner of items for personal decoration, ornaments, vessels, seals, and the accoutrements for the scholar's desk.

During the Shang period the art of bronze-working was developed with great ingenuity, and to some extent jades of the period echo the designs and patterns found on bronze vessels. On some occasions the materials were used together, for example a jade spearhead being set into a bronze handle. Considering the rapid evolution of society and technology in this period, it is rather surprising to find that despite a proliferation of forms (animals, human figures, fishes, insects, *bi* disks, and other ritual objects), the quality of many Shang jade carvings seems decidedly primitive when compared to the masterpieces of the earlier neolithic era, particularly those of the Liangzhu culture. While there is no shortage of imagination, shapes are often crudely cut and the apparently lazy carving seems to reflect a lack of interest in achieving perfection.

The reason for this is unclear, but maybe it is a natural cycle of conception, innovation, maturity, and decadence that seems to be the fate of most artistic endeavors. It should be remembered, too, that for thousands of years jades had been made as burial objects. In the Shang dynasty, burial rites became more complex (often involving human and animal sacrifice) and the jade objects were perhaps considered less deserving of time and effort.

This situation was reversed in the subsequent Zhou dynasty, a period during which jade working yields a proliferation of forms and bravura – technical accomplishments that reach perfection in the time of the Warring States (475–221 BC).

Despite numerous power struggles between regional warlords, the Zhou is noted for being the time when China became more organized, with a king who was required to have "the mandate of Heaven." There was an emphasis on the family system and on a devotion to ancestors that continues in Chinese society today, despite the depredations of the Cultural Revolution in the 1960s. Settlement and skilled agriculture led to wealth generated by commerce rather than military seizure. A system of roads, connecting already large cities, led to a cross-pollination of ideas. In other words, civilization. China was evolving a coherent identity.

Above, left
Bird pendant

North China neolithic, Hongshan type (about 3500–2200 BC), H 4 cm, yellow-green nephrite, Museum of Far Eastern Art, Bath, England (Ref. PE 598)

This bird pendant shows an inspired sense of design. The claws are delineated with a few simple cuts, but the "bone" down the center of each wing has been painstakingly delineated in relief. The eyes stand out from the surrounding surface and the whole piece is very well smoothed.

Above, right and below (detail)
Tiger pendant

Eastern Zhou dynasty (about 770–221 BC), green nephrite with blackish areas, L 8.3. cm, W 2.6. cm, D 2–3 mm, private collection

This very thin pendant must have been worked with great care to avoid breaking. The design of a tiger is very stylized and the surface is embellished with scrolling decoration.

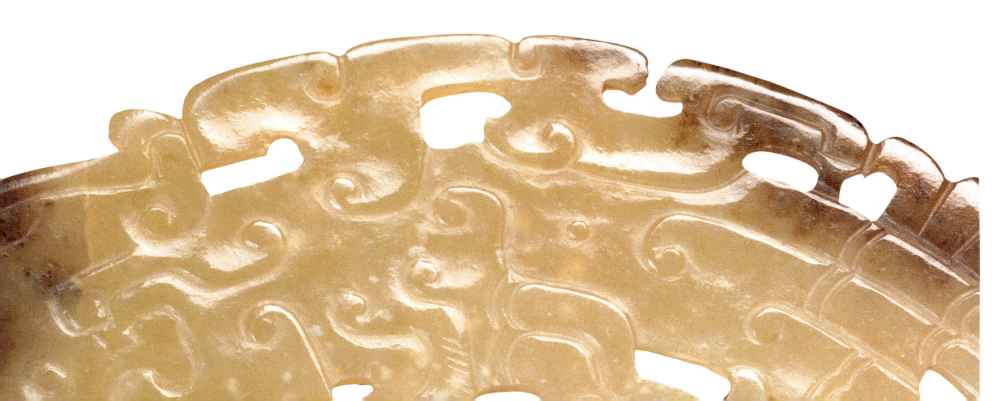

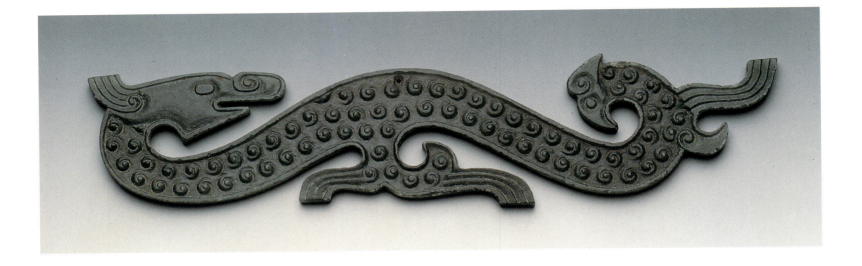

Plaque in the form of a dragon and phoenix

Warring States period, later Zhou dynasty (about 475–221 BC), green nephrite, L 16.5 cm, D 0.3 cm, Museum of Far Eastern Art, Bath, England (Ref. PE725)

This extremely thin plaque is carved with an identical design on both sides and shows the typical Zhou treatment, with the raised edge surrounding the object and detailed coiled whorls in relief on the surface.

Sword scabbard chape

Han dynasty (206 BC–220 AD), H 5.9 cm, pale green nephrite with black and reddish-brown markings, private collection

This chape is finely carved on both sides with a design of interlocking spirals and a *taotie* monster mask.

Early Zhou jades are often worked from remarkably thin flat plaques with designs of carefully incised lines that contrast markedly with the "hacked" look of so many earlier Shang pieces. Great care was taken over the finish of an object, and the achievement of a soft polish, a development that eventually resulted in the wonderful, silky surfaces of the jades of the Warring States. Moreover, through the dynasty much attention was given to the decoration of the surface of jade carvings, resulting in complex patterns from raised dots to coiled, tadpole-like motifs, C-scrolls, and stylized designs inspired by dragons and animals (to some extent trying to mimic the more-easily accomplished designs in bronze).

In other attempts to replicate bronze objects, the later Zhou made superb jade vessels, thinly-walled and often fitted with lids and elaborately decorated, and, in a masterly tour de force, hinged, moveable buckles, and chain-like linked objects all carved from one piece of the stone. Also, in the latter part of the dynasty, and accompanying the military preoccupations of the Warring States, we see the first jade furniture for the sword, consisting of the pommel at the end of the handle, the hilt or guard between the blade and the handle, perforated for the tang to go through, the chape at the end of the scabbard, and a scabbard slide to attach the weapon to the user's belt.

Despite continuous hostilities between independent territories, this later period of the Warring States was noted not only for exquisite design but also for the attention to detail and finish of jade objects, the finest pieces of which rank with the major masterpieces in the history of all Chinese art. The tensile power and ferocity of dangerous beasts such as dragons and tigers were favorite subjects for the jade carvers, and the strength of their works seem to reflect the military turbulence of the times. One characteristic of many of the flat, plaque carvings of the Warring States is the appearance of a raised border around all or part of the piece, an artistic device which gives the effect of framing the subject.

The era ended, during the brief reign of the Emperor Qin Shi Huang Di of the Qin dynasty, with a turning point in China's history. Regional warlords were subjugated by military force and their fiefs united. Then (as a precursor of the events in the 20th century under Mao Tzetung) all books whose texts were at odds with the philosophy of the central, imperial government were burned.

The jades of the following Han dynasty can still be dated with some accuracy from excavated grave sites, but this era marks the end of the culture of jades made purely to accompany the dead (notably the *bi* disk and the *cong*). However, dating from this period are the famous burial suits made of jade plaques sown together with wire, which have been found in burials dating up to the unsettled times at the end of the dynasty, along with stylized pigs, "plugs," and cicadas that were placed in the hands and orifices of the corpse. (In an odd departure from the usual Chinese pragmatism, and ignoring the evidence provided by simple observation, the Han believed that jade could prevent the decomposition of the body.)

For 150 years or so during the first part of the Han, the area of Khotan and Yarkand, the source of jade, was under direct Chinese control and so large supplies of the stone were available. An obscure supply of black jade seems to have been worked at this time, and many carvings of this unusual stone can also be dated to the period. Items for personal adornment were made of jade in a wide variety of forms: hooks for belts and robes, hair and hat ornaments, bracelets, and so on, as well as finely made sword accessories, often with the popular Han design of carved dragons.

Han animal carvings made a radical departure from those of earlier dynasties in that they are often in the round, as opposed to the flat, silhouette plaques of earlier periods. However, almost all are ground flat underneath, or more rarely, have the legs or feet tucked under the body, making the sculptures easy to handle, a treatment that was almost certainly dictated by the rounded shape of the jade pebble. It stands to reason that the carving of a standing animal would involve wasting an extravagant amount of time and material (grinding out the space between the legs), and such creatures are hardly seen until the much later Ming dynasty.

The human form is rarely depicted in the Han except for the wonderfully stylized figures known as the "Old Man with Beard" (see right). These are often carved with such simplification of the features as to have become almost abstract, with the face reduced to a triangular plane, and three small notches hinting at the eyes and mouth. They may have symbolized longevity and seem to have been worn as auspicious talismans. In most cases they were drilled from the top of the head to the ends of the sleeves in an inverted Y-shaped perforation meant for a suspension cord. The "Old Man with Beard" is unusual not only because of its large size, but also because it has a suspension-cord hole drilled horizontally through the head. These figures were much copied in later times, but incorrectly, since they are usually found drilled with a single perforation from the top of the head to the bottom of the feet.

From the Six Dynasties to the Yuan Dynasty

The use of ritual jades more or less died out during the Han period, and although some later jades went into the tomb along with other possessions, the dating of carvings after this time is largely conjectural and based on comparison with the forms taken by objects in other materials, such as bronze. This is complicated further by the fact that with a deep bow to their golden ages of the past, and along with the fashion of archaism that surfaced from time to time, the Chinese were very fond of copying earlier jades.

After the fall of the Han, China once again went through a period of civil strife when the country was divided up under competing warlords and kingdoms. Historically, the time of the Six

"Old Man with Beard"

Western Han dynasty (206 BC–8 AD), green nephrite with creamish areas, H 14.2 cm, W 5.7 cm, D 2.3 cm, Museum of Far Eastern Art, Bath, England (Ref. PE 748)

Pendants such as these were probably talismans symbolizing long life and good fortune. Han examples are rather rare but were much imitated in later centuries. This example is larger than usual, and has been drilled horizontally through the head for hanging purposes.

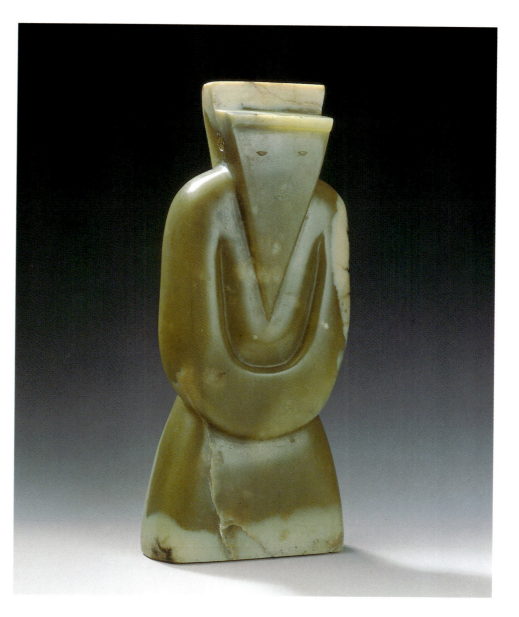

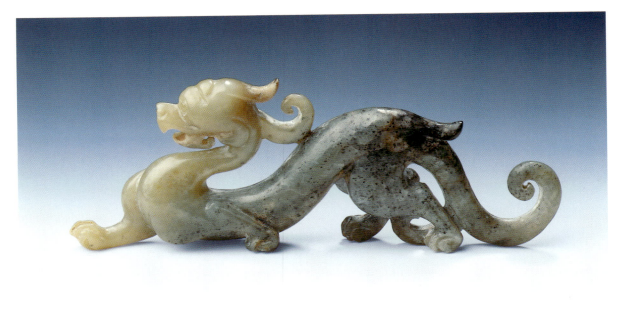

Strutting dragon

Early Six Dynasties (AD 220–420), green and black nephrite, H 4.7 cm, L 12.3 cm, D 0.9 cm, Museum of Far Eastern Art, Bath, England (Ref. PE 205)

Almost like a still from an animation film, this sinuous dragon is caught at a taut moment before its next sudden movement forward. Repeated curls of the mane and bifurcated tail, and the S-shaped body raised on stretched hind-legs exaggerate the feeling of tension. The carver has adroitly used the color variation in the stone to maximum advantage in crafting this proud animal.

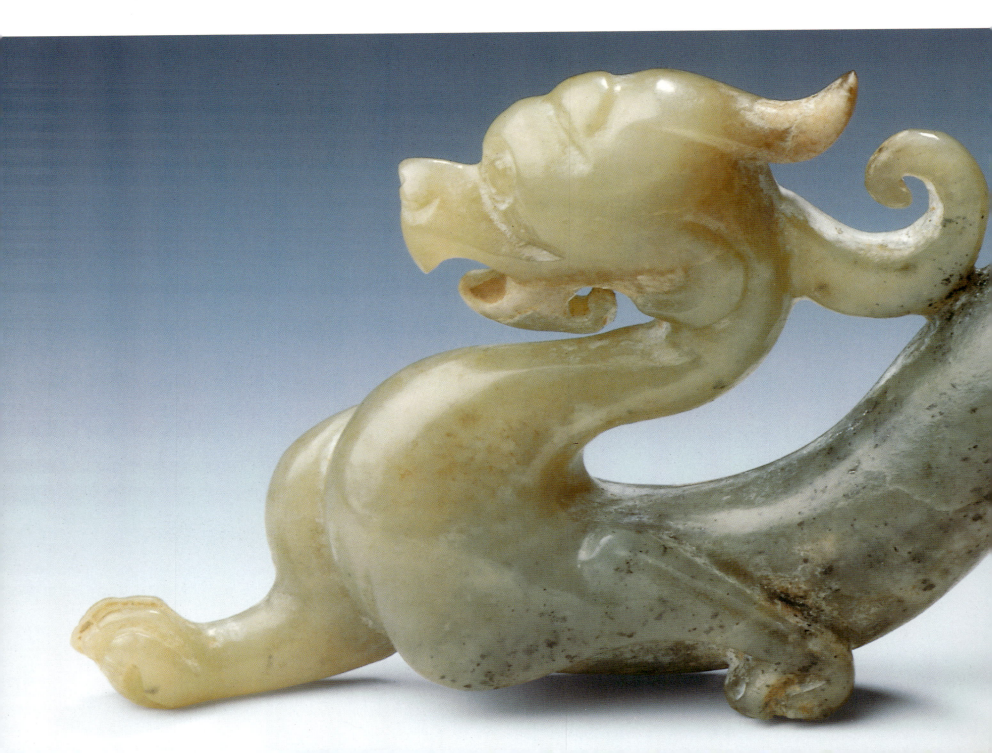

Dynasties is noted for the spread of Buddhism, which had arrived from India during the Han period, and its gradual acceptance and accommodation with the native Taoist and Confucian philosophies. The supply of raw jade was interrupted during this troubled time as the trade links fell victim to political instability, and jade carvings that can definitely be ascribed to this period are rather rare.

Of the jades that are considered to date from the Six Dynasties, the animal carvings are the most impressive, showing not only an attention to detail and realism, but also an "attitude" that makes them most appealing. The strutting dragon shown on the opposite page has been beautifully carved with careful attention paid to the claws, the tendons of the legs, and the head. In addition to this detail, with the inspired sinuous shape the carver has captured with impressive skill a sense of muscular tension and frozen movement in this splendid beast. As in a compressed steel spring, there is more than a hint of tremendous, contained power that could be triggered at any moment with the slightest provocation.

A Six Dynasties pig (see page 305, above) shows an example of the trend towards realism and a departure from the earlier, almost abstract style of burial pigs that had continued from the end of the Han dynasty. The carver has adroitly used the natural black and pale colors of the stone to fashion a very realistic piebald pig with a wavy back, a shape that could have been used on a scholar's desk as a brush rest.

The brief Sui dynasty saw China unified again, and ushered in the Tang dynasty and another three centuries of more-or-less stable conditions until the next wave of unrest in the middle of the 9th century AD. The Tang dynasty was a period when China opened up to free trade with countries along the celebrated Silk Road, and large numbers of foreigners from Central and West Asia came to live in the empire, and came in time to have considerable influence on the subjects and designs of jade and other materials.

With the open trade routes, jade remained plentiful until AD 845, when the supply was largely halted for about a century due to a Chinese religious backlash against the Turkic tribes of the Khotan and Yarkand area, who had previously been converted to Islam. The Tang is looked back on as a golden age during which enormous wealth was generated by merchants and the ruling classes. With the influence of foreign tastes, it seems that the particular *cachet* of jade in Chinese eyes was to some extent eclipsed by gold and silver, and subsequently jade objects dating from this dynasty are comparatively less common.

Tang jades are notable for having been made with personal adornment in mind, and include plaques for attachment to a belt, comb tops, and hair ornaments, a trend that was to continue through the following centuries. Apart from the

odd *bi* disk, ritual jades for burial and sword accoutrements were no longer seen. Subjects for jade carving include exotic animals (such as peacocks, Indian cattle, camels, West Asian fat-tailed sheep) introduced to China by the foreigners who in turn are seen depicted in bas-relief on rectangular plaques that decorated the belts of the mandarin and military ranks. Bull-headed rhytons (drinking horns) of Sassanian inspiration, and various other vessels, were also carved in jade and imitate objects more usually made of metal.

Occasionally, Tang jades depict objects or figures inspired by Buddhism, which by this time was well established in China. The dynasty is also noted for the use of jade combined with other precious stones and metals to make decorative accessories, and for the first appearance of flowers and plants as a motif, which became more and more popular towards the end of the dynasty.

After the hundred years or so when jade supplies were interrupted, trade routes were again opened to Khotan in the middle of the 10th century and once more there was a rich supply of fine quality jade flowing east into China. Again, the dating of jades to the Northern and Southern Song dynasties, and the contemporary Liao and Jin dynasties in the north, is conjectural due to the scarcity of documented excavations, and has to be made by comparison with objects fashioned from other materials.

Whereas the Liao dynasty continued to foster the cosmopolitan tastes of the Tang, the Southern Song seemed to have a more contemplative outlook, perhaps as an escape from the endless political troubles. This feeling is evident in the landscape paintings of the time, in the small ink masterpieces of mist-swathed mountains (the Arcadian idyll to which every scholar-bureaucrat wished to retire); and also in the serene, perfectly formed monotone ceramics with white, green celadon, or the palest blue glazes.

The Tang taste for personal adornment continued and we see hair-ornaments and plaques for attachment to belts or costume, sometimes carved from a fine quality white jade associated with this period. The previously rectangular belt plaques are now seen in different shapes and are often combined with decorations of either gold or gilt-bronze.

Small jade animals that can be dated to the Song seem, if anything, to be the most naturalistic, and carved with careful attention to the under-skin structure of bone and muscle. In particular, there was a taste in the Song for depicting small, race-hound-like dogs, captured in repose either curled up or with the front paws stretched out. The Song jade carvers seem to have taken great pains to capture a certain mood or gesture, rather than just to depict their chosen subject. This is seen in the dog licking its paw (see left) and also in the carving of a young acolyte carrying a fly whisk and a slipper, and kicking his too-long robe out of the way (see below).

In the latter part of the dynasty there was a strong interest in antiquity among the literati and a vogue for either copying or using ancient design motifs and forms in jade as well as metals. This has caused endless questions and misdatings in the

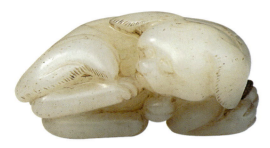

Above
Curled dog

*Probably Southern Song dynasty
(AD 1127–1279), white nephrite with
brown flecks, H 2.1 cm, L 4.3 cm,
W 3.0 cm, Museum of Far Eastern Art,
Bath, England (Ref. BATEA 447)*

Here a jade craftsman has carefully observed a dog and its habits in order to realistically capture this one which is licking its paw. Although very Song in feeling, the dating of this piece is tentative for such dogs also appeared during the early Ming period.

Buddhist monk

*Song dynasty (AD 960–1279), H 7.1 cm,
white and yellowish-brown nephrite,
private collection*

The young monk with a pleased expression is carrying a fly whisk and a slipper. In a very human touch, the jade carver has depicted the boy kicking his robe out of the way.

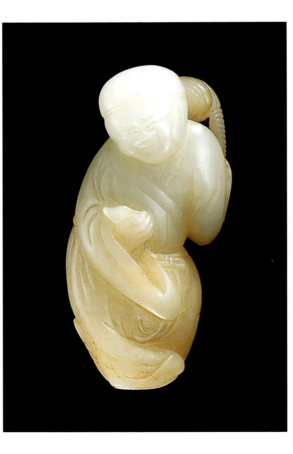

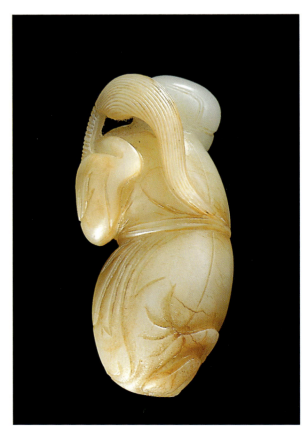

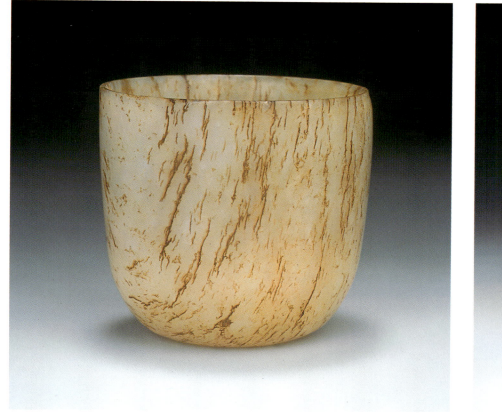

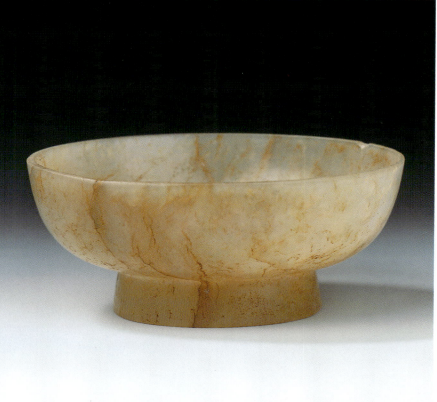

From the Ming Dynasty to the Qing Dynasty

20th century, though in many cases there is something that is "not quite right" about these pieces, at least to the observer familiar with archaeological research. The obvious giveaway, for example, is the fact that the carver has copied a Shang form, but decorated the surface with a motif from the Warring States period.

But most characteristic of the Song jades are those vessels that are inspired directly by the famous ceramic wares of the dynasty; pure, elegant forms with minimal, if any, decoration. Simply designed and superbly finished, they would have been a joy to use (see above).

The following Yuan dynasty was marked by the conquest of Song China by Mongol invaders from the north led by the tyrannical Kublai Khan, and the enslavement and exploitation of many of the native Chinese. The new rulers were familiar with jade and established workshops to cater for the Mongol court. It seems that there was no shortage of raw jade, though finished items that can definitely be ascribed to the Yuan are rather rare. Such jade pieces show a continuation of Song-style vessels and costume decorations, some of a yellow-brown coloration, which seems to have been a fashion of the time. Historically speaking, the Mongol rule was of fairly short duration, ending in 1368 when an uprising of militant peasants restored native Chinese control and established the Ming dynasty.

The previous 600 years or so had seen jade carving evolve giving both a technological peak (which had already been reached way before during the Warring States period of the Zhou dynasty), and also an unprecedented variety of forms and subjects. For most of the Ming dynasty, raw jade was abundantly available as peace and stability kept the trade routes open. No longer restricted for the use of those of high rank, jade items became available to anyone who could afford them. In consequence, a tremendous variation in quality can be seen in Ming jades, not only in the skill of workmanship, but also in the artistic quality of the object. If beauty lies in the eye of the beholder, then this may seem a debatable assertion, but in the Ming we begin to see the emergence of a certain vulgarity in items made for classes who were acquiring jades for the first time, with symbolic expression being given precedence over artistic qualities.

Most jades that we see from the Ming and the Qing dynasties are heirloom pieces that have been handed down in Chinese families, and it seems that with odd exceptions, very few were buried. The variety of subjects that inspired the jade carvers of these latter dynasties is much too vast to cover in these pages, but some typically Ming jades depict large-size animals, especially buffalo and horses, using a lavish quantity of the stone; groups of animals; human figures, and plants… in many cases with some rebus or symbolism of good fortune.

Left
Deep cup

Northern Song dynasty (AD 960–1127), yellowish nephrite with brown markings, H 6.5 cm, dia 7.2 cm, Museum of Far Eastern Art, Bath, England (Ref. BATEA 418)

This rather attractive, brown-flecked jade cup was considered poor quality by the Chinese, and is of a type that was commonly seen when raw jade became available once again in 1077. There is no foot, but the overall shape, and a circular, inset indentation in the base is similar to that found in ceramic wares.

Right
Bowl with high foot

Southern Song or Yuan dynasty (13th–14th century AD), pale green nephrite with brown markings, H 3.6 cm, dia 9.6 cm, Museum of Far Eastern Art, Bath, England (Ref. BATEA 422)

This bowl, thinly carved and with the high foot, is typical of the shape of Junyao ceramic wares.

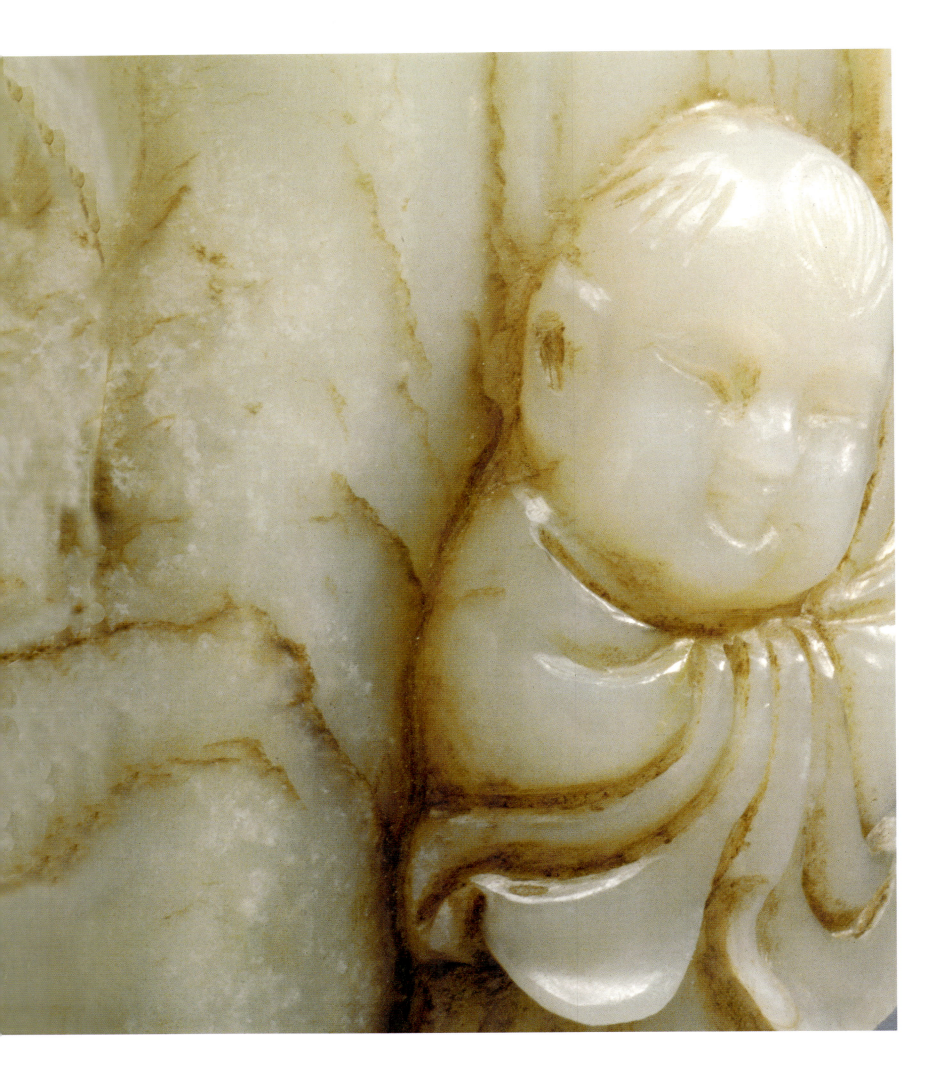

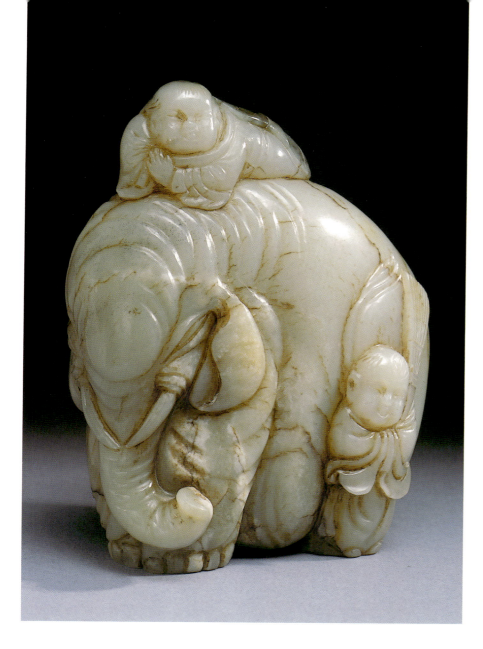

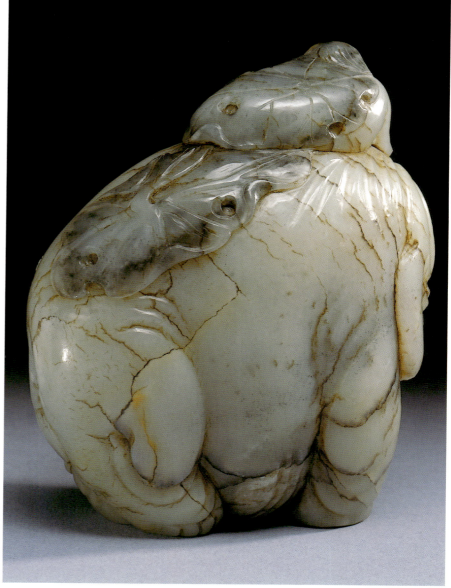

Elephant and boys

Ming dynasty (1368–1644), H 13.2 cm, light gray-green and blue nephrite, private collection

The elephant is a symbol of strength and wisdom, and also has associations with the Buddha. An auspicious double rebus can be seen in this carving involving homonyms in the Chinese language: washing an elephant means happiness and good luck; riding an elephant meant good fortune and luck. An area of rare blue jade on the back of the elephant has been cleverly used for the carving of two large lotus leaves.

There was much faking of ancient styles to cater for the antique collectors of the day, but without available scholarship the jade carvers were inevitably inconsistent with their details and these pieces are now readily identifiable. A wide repertory of objects for the scholar's desk includes brush stands, brush handles, brush rests, brush washers, small landscape screens, and boulders for inspiration of the muses. Finally, the tradition of making costume accessories and hair ornaments continued.

The Qing dynasty, which replaced the Ming dynasty with a Manchu court from the north, was the last before the modern century. In its early years supplies of jade were constricted yet again by political strife, but this situation was ameliorated in the mid-18th century during the reign of the scholar-emperor Qianlong, when peace and a renewal of jade imports led to a renaissance of the arts. A highly organized system of jade workshops under imperial patronage was established in the capital Beijing and around the country, and spectacular jade objects were made that are perfect examples of the genre.

The Qing jade carver was in no way limited in choice of subject, and borrowed freely from the forms and motifs of Chinese history to make fabulous objects imitating Shang bronze vessels, for example. Nor was he limited to nephrite jade, and freely used his talents to work with other decorative stones, including quartz crystal, lapis lazuli, malachite, and jadeite, which was imported from neighbouring Burma.

In addition to the masterpieces made for the court, the Qing jade carvers made delightful small objects, often cleverly using the "skin" of the jade pebble as part of the design of the finished item. In addition, the copying of ancient jades was refined to a fine art (far more accomplished than those of the Ming), even down to staining the finished object to give a "fresh from the tomb" look that was much prized by amateur antique-collectors.

But this last flowering of jade culture marked the beginning of the end, and in yet another turn of the natural cycle the quality of jade goods declined in the 19th century, in step with the crumbling of the empire and political decadence. There was a brief revival of the imperial workshops under the Dowager Empress at the end of the last century, but the standard of jade workmanship was in no way to be compared with that

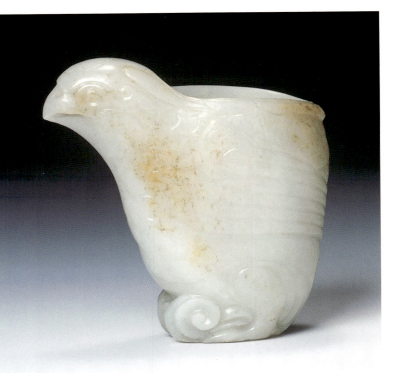

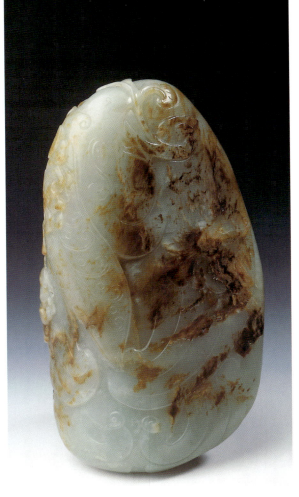

of the Qianlong period a century before, or even with the other high points of jade culture, all the way back to the neolithic era.

With the availability of electric tools, the working of jade has become a mere process (like making a television set) catering to the tourist shops; there is no artistic expression whatsoever. Jade does not reveal its beauty to speedy workmanship, and just as it is easy to cut the stone with electric power tools and diamond and carborundum abrasives, so it is just as easy to deface. It is not feasible to think of a world without electricity, or an economic system that would allow one man

to spend years of his life to produce a jade object that is, after all, useless, and so the future of jade art looks bleak indeed. The history of jade in China stretches back over 7,000 years, and as there have been many waves of achievement and decline in jade carving, as well as the other arts, it would be consoling to imagine that our present nadir would be followed by another golden age. I fear that this is an impossible dream. We can be thankful, however, that the stone is almost indestructible and so at least we can continue to enjoy the many jade artifacts that China's long history has bequeathed to us.

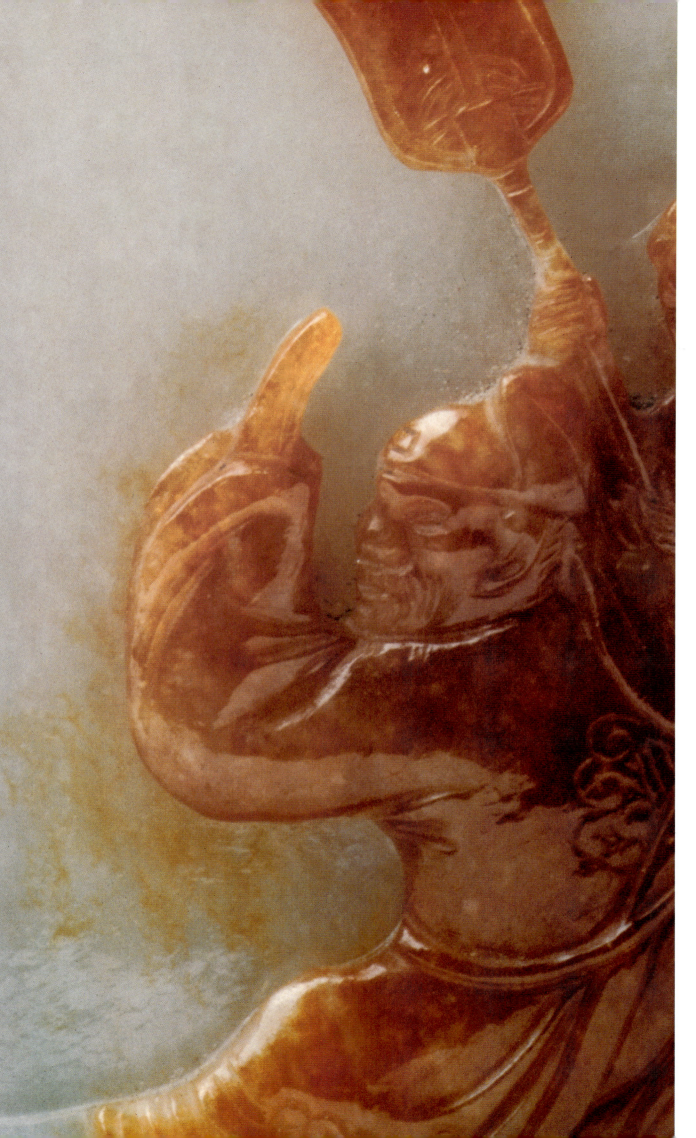

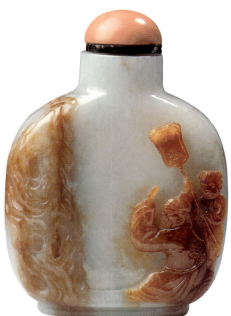

Snuff bottle with design

*Qing dynasty (1644–1911), white jadeite
with areas of lavendar and emerald green,
and orange-brown "skin," H 6.1 cm,
W 5.0 cm, D 2.0 cm, Museum of Far
Eastern Art, Bath, England*

Snuff taking became popular in the Qing
dynasty, giving rise to a vogue for snuff
bottles, which were made out of a variety
of materials including nephrite and (as in
this example) jadeite, which was being
imported from Burma. Apart from having a
glassy lustre when polished, jadeite shows
a different range of colors to those seen in
nephrite. As often seen in nephrite
objects, the carver has used the "skin"
as part of the design.

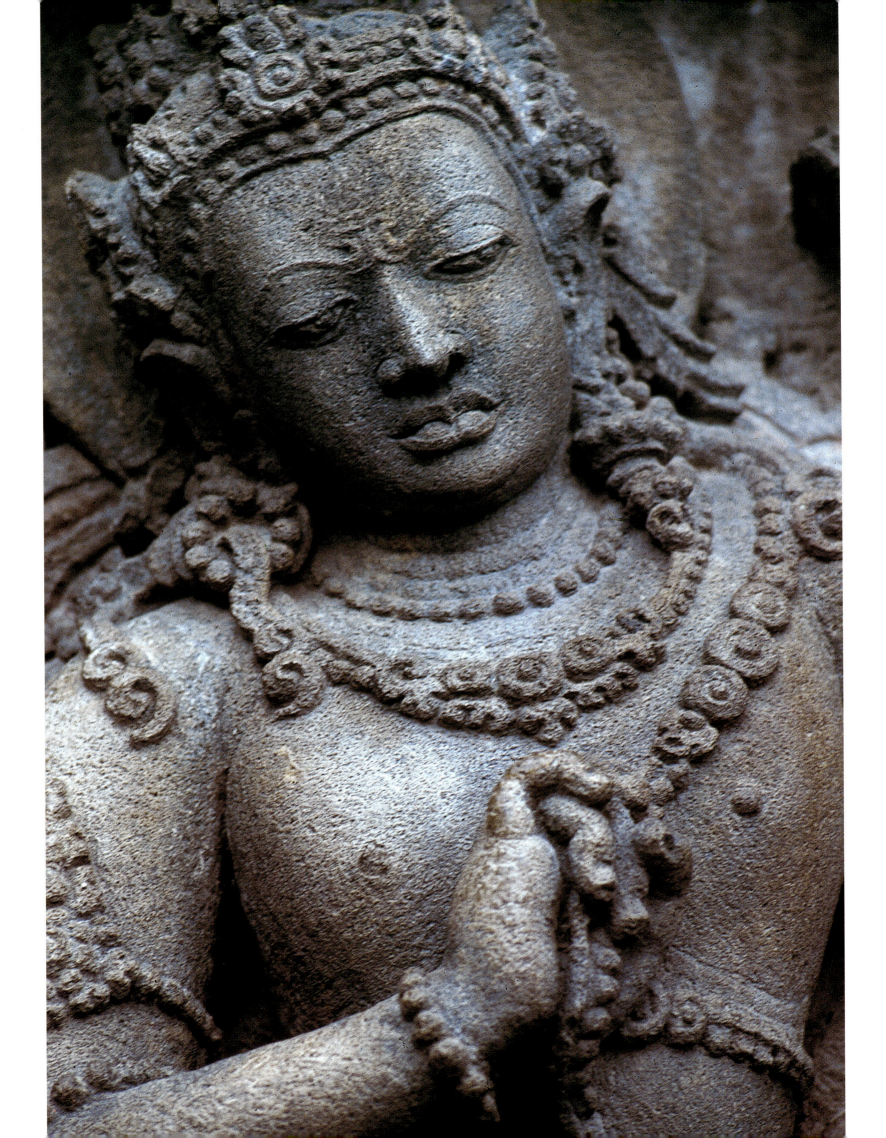

Indonesia

Bhineka tunggal ika — Is the motto of Indonesia to be interpreted as "unity in diversity" or "diversity in unity"? For no other state in the world unites so many people of different ethnic origin, languages, and religions as Indonesia. In the center of the capital, Jakarta, the main mosque is to be found directly by the Catholic and Protestant churches. In Central Java, Hindu and Buddhist temples stand alongside each other. The artistic diversity of the Indonesians is overwhelming, whether it is the long houses of Toraja, the carved ancestor figures of Borneo, the ikat textiles of Sumba, or the temple complex of Borobudur on Java, one of the most remarkable architectural monuments in the world. All these products reflect an island culture fashioned by a rich diversity of races and religions.

An *apsara* portrayed
on the exterior wall
of the Prambanan temple

*Central Javan period, 8th–10th century,
stone*

The facial expression is meditative,
reflecting a mind turned in on itself. The
hand position is probably inspired by
Javanese dance movements.

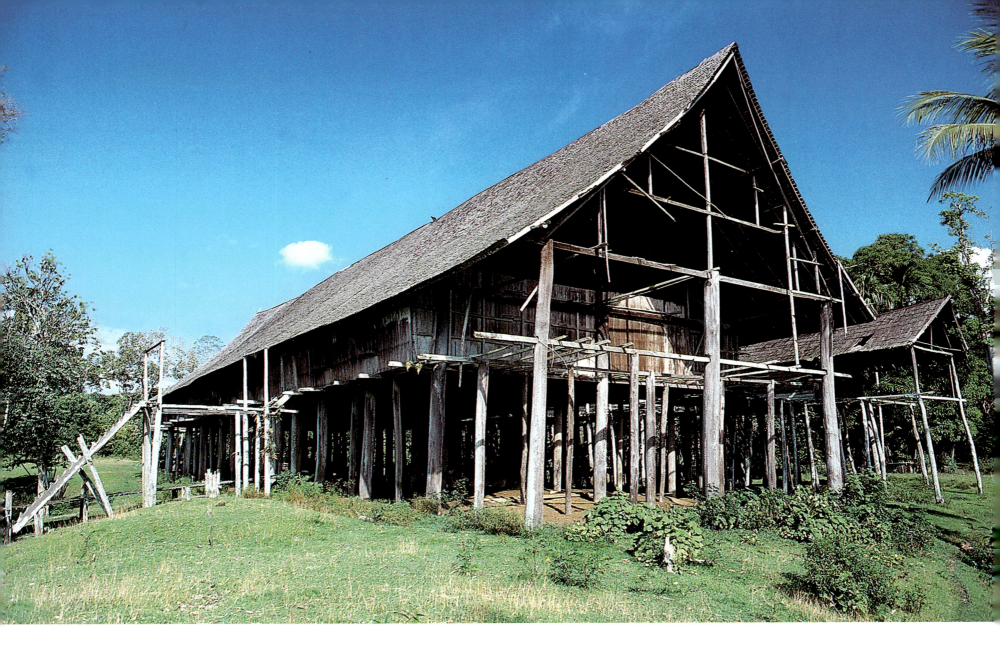

Architecture and Symbolism

Traditional houses

The house plays a very important role in our lives; it is as intimate as clothing, or even our skin, and we find protection and security in it. In modern societies the house clearly indicates the character of its occupants, their way of life, and even their political orientation. In many traditional societies, by contrast, the layout of the house is a reflection of a concept of the cosmos. In Indonesia, for example, the construction of the house symbolizes the division of the macrocosm into three regions: the upper world, the seat of deities and ancestors (the roof); this world, the world of people (the living areas); and the underworld, inhabited by demons and spirits (the space between the supporting posts of a stilt-house).

It is clear from this view that the house has a mystical meaning in traditional societies, a view confirmed by the fact that in such a society the ceremony to mark the start of the building of a house is one of the most important of all ceremonies. The essence of these ceremonies is the symbolic expression of cosmic law.

At the same time, the house can also reflect the structure of society; it can indicate both the social status of the inhabitants, and also their relationship to each other. There are usually very precise rules on the allocation of rooms and also on who should live in which rooms. In Indonesia, the living area is generally not separated by walls, except, for example, in the long houses of the Iban; if walls exist then they are built of a light material. Unfortunately, such houses have a relatively short life span in the tropical climate of west and central Indonesia, since they are mostly built of wood, tree bark, rattan, and palm leaves, and without nails.

The typical way of building in Southeast Asia is to build on stilts, an architectural form usually combined with a saddle roof. The early use of this type of house can be seen on the bronze drums of the Dongsong found in North Vietnam, which prove that stilt houses were already constructed in prehistoric times. Buildings on stilts are in fact very widespread in the region, and can be found in the Indonesian islands of Sumatra, Kalimantan,

Above
Long house of the Iban
Before 1920, Tumbang Gagu, Central Borneo

Opposite, bottom left
Long house of the Iban
Elevation and ground plan

Opposite, bottom right
Traditional houses with typical horns and saddleback roofs

East Indonesia (1–7), East Java (8), Sumatra (9–12), Vietnam (13), northeast India (16), Micronesia (15)

and Sulawesi, and also in such places as Thailand, Laos, and Vietnam on the mainland.

They are not, however, found in the Indianized areas of the region, like Java and Bali. It is possible that stilt houses were built here once, but this cannot be established for certain, though a depiction of a stilt house on a relief on the Borobudur temple allows us to assume that in the 9th century A.D. such houses were at least being built on Java.

Another characteristic of Southeast Asian houses, apart from stilts and the saddle roof, is the forked horn on the roof, which is considered to be a symbol of the buffalo, regarded throughout the region as a link between Heaven and this world.

The most famous stilt houses of Indonesia are those of the Dayak in Borneo, the Minangkabau and Batak on Sumatra, and the Toraja on Sulawesi (Celebes). We will look at all three.

The long houses of the Dayak

The Dayak, some of the original inhabitants of Borneo, build long houses on stilts, using ironwood for the structure and tree bark for the walls; the floors are simple planks of wood placed side by side. The length of these long houses varied from region to region. From the evidence we have, in the last century there was a long house of 110 meters (over 360 feet); today they generally range from 10 to 70 meters (33 to 230 feet).

A Dayak long house always stands on a river, so that the inhabitants always have ready access to the water. In earlier periods the Dayak built one single house, from which a small village of smaller houses would gradually develop (see page 316), and this is why in Central Borneo there is only one long house in every village. The long house offered

Bronze drum from the Dongson in Vietnam

Discovered 1982, dia 73.8 cm, Co Loa, Ha Noi

On the drum is an illustration of a stilt house.

Forked horns on the roof of a long house

Before 1920, Tumbang Gagu, Central Borneo

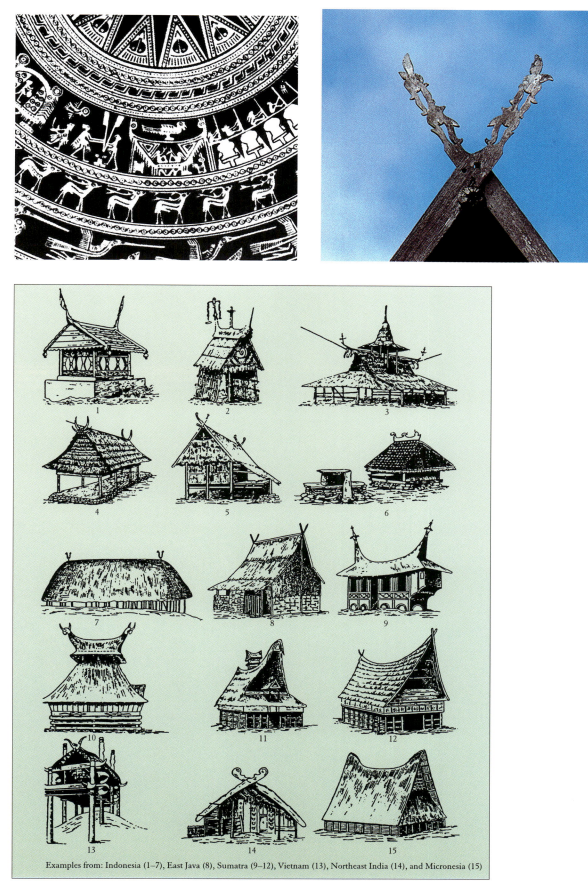

Examples from: Indonesia (1–7), East Java (8), Sumatra (9–12), Vietnam (13), Northeast India (14), and Micronesia (15)

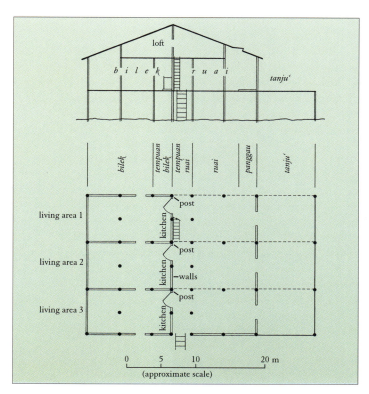

the inhabitants protection from wild animals, from neighboring enemies (at times of the headhunt), and from flood water, which in a very short time can rise by three meters (10 feet). Houses high on stilts also offered protection against malaria, since the malaria-carrying mosquitoes generally stay close to the ground. The Dayak no longer build long houses, preferring instead stilt buildings meant for small family groups.

On Borneo the long house forms a center for both social life and for rituals. Here people meet to talk after work, and it is here the central ceremonies and rituals of the group are performed. Life in a long house was closely governed by clear sets of rules, as we can see from the example of the Iban (one of the main tribes of Dayak) who live in west Borneo right up to Sarawak. The long house of the Iban is divided into various separate rooms (*bilik*). Two to three generations live in one *bilik*, from

grandparents to grandchildren, so the *bilik* forms one of the smallest social and economic units in Iban society. The households of the individual *bilik* families are completely separated from those of the other inhabitants of the long house. There is no common purse or common upkeep, and every *bilik* family possesses its own fields on which rice and vegetables are grown. Membership of a *bilik* is attained through birth, marriage, adoption, and, in rare cases, through admission. On marriage, a woman can either move into the *bilik* of her husband or the husband into the *bilik* of his wife. Generally a long house is founded by an entire group of relations, which means that the *bilik* inhabitants are relatives twice or three-times removed. When the long house becomes over-crowded, families can claim their inheritance and build a long house of their own (or, nowadays, a small house).

In front of the *bilik* is a roofed-over gallery or vestibule (*ruai*), which looks rather like a village street. The open space in front of this is assigned to an individual *bilik* (see page 315, bottom left). The *ruai* is a communal living area for the long house occupants; it is a public room belonging to the men's world, whilst the *bilik* is reserved for the private (female) world.

In each long house there is a central stilt or main post which is the first to be placed in position when the house is built. This post is associated with the ancestor who founded the house and has a sacred significance; it stands in the center of the house and is looked on as the link between the underworld and the upper world, and it is where the most important ceremonies are performed. Rituals within the family, such as healing a sick person or requesting protection for a traveler, take place in the *bilik*. Ceremonies that concern all the inhabitants of the long house, such as thanks-giving for a good harvest, and rituals concerned with birth, marriage, and death, take place in the *ruai*. All these rituals and ceremonies serve to create a sense of common identity and purpose among those who make up the long house community.

The ancestral founder, who decided to settle his family in a specific place, plays a very important role in every long house. His decision will have been based on an omen or sign that took animal form; in the case of the Ngaju, usually a lizard. This "originating myth" of the founding of the house is passed down orally from generation to generation, and is frequently immortalized through symbols placed at the entrance to the long house. The long houses were often decorated with representations of water snakes and rhinoceros birds. They were connected with the group's central creation myth, for the water snake is associated with the underworld, and the rhinoceros bird with the upper world of the good spirits.

Ossuaries usually stand next to a long house, and are always built downriver so that they do not bring bad luck to the inhabitants of the long houses. The upriver direction (the direction of sunrise) brings good luck, the downriver direction

Long house

(General view, below; and detail, bottom), before 1920, Tumbang Malahui, Central Borneo

Up to 20 small family groups live in a Borneo long house. In this long house the building on the left contains the kitchen. In front of the long house stands an ossuary (compare page 351). The carved tiger is a figure referring to the foundation myths of this long house.

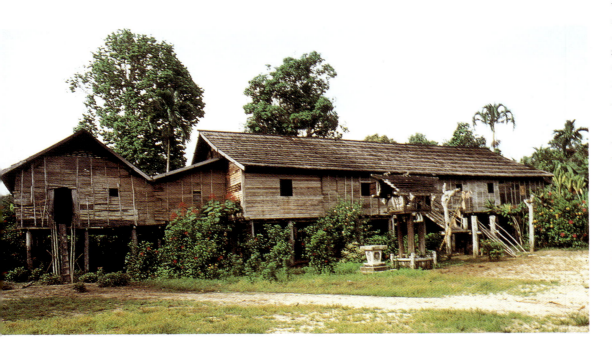

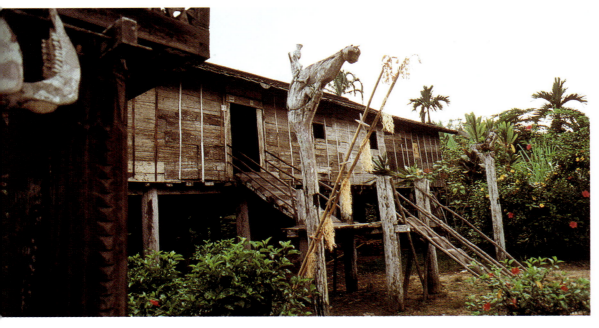

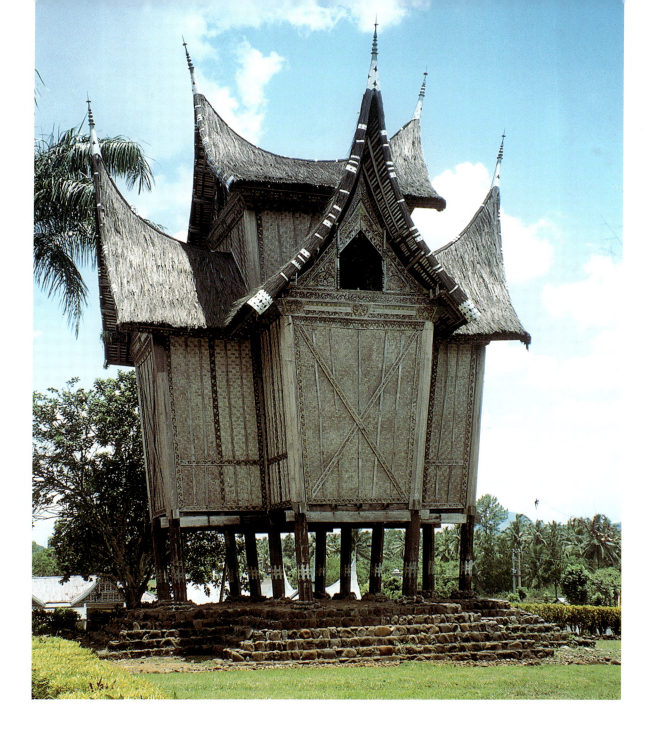

Rice store

Minangkabou architecture, Pagaruyung near Bukit Tinggi, Sumatra

The roof is reminiscent of buffalo horns and is thereby typical of the architecture of this area.

(the direction of the sunset) is the direction of death and therefore unlucky.

Although the Dayak today no longer build long houses they still strongly identify with a long house and believe that those who have never lived in a long house are not true Dayaks.

The houses of the Minangkabau (*rumah gadang*)

The Minangkabau are a Malaysian people who live in the Padang highlands of Sumatra. Typical of the houses of the Minangkabau are the distinctive roofs, which look like buffalo horns (see pages 318 and 319). The word "Minangkabau" can actually be interpreted as a compound of the words *menang* ("win") and *kerbau* ("buffalo"). This derives from a local legend that relates that a buffalo fight was arranged by the locals and the people of the influential kingdom of Majapahit

(eastern Java). The locals' buffalo was the winner and since that time they have called themselves the "buffalo winners," Minangkabau, as a proud testament to their strength and courage. The houses are called *rumah gadang* ("large house") and are not inhabited by different families, but by three to four generations who come from one ancestor and thus a *rumah gadang* is also a family unit, and each of the Minangkabau identifies completely with his or her own *rumah gadang*.

The Minangkabau live in west Sumatra and cultivate rice, and the majority are Muslims. The society is not structured hierarchically, though there are men who act as headman, guards, or clan chiefs. Unlike other ethnic races in Indonesia, the Minangkabaus have a matrilineal system of relationships – inheritance is handed down from mother to daughter. A consequence of this is that *rumah gadang* are mostly inhabited by women from the wife's side of the family. The

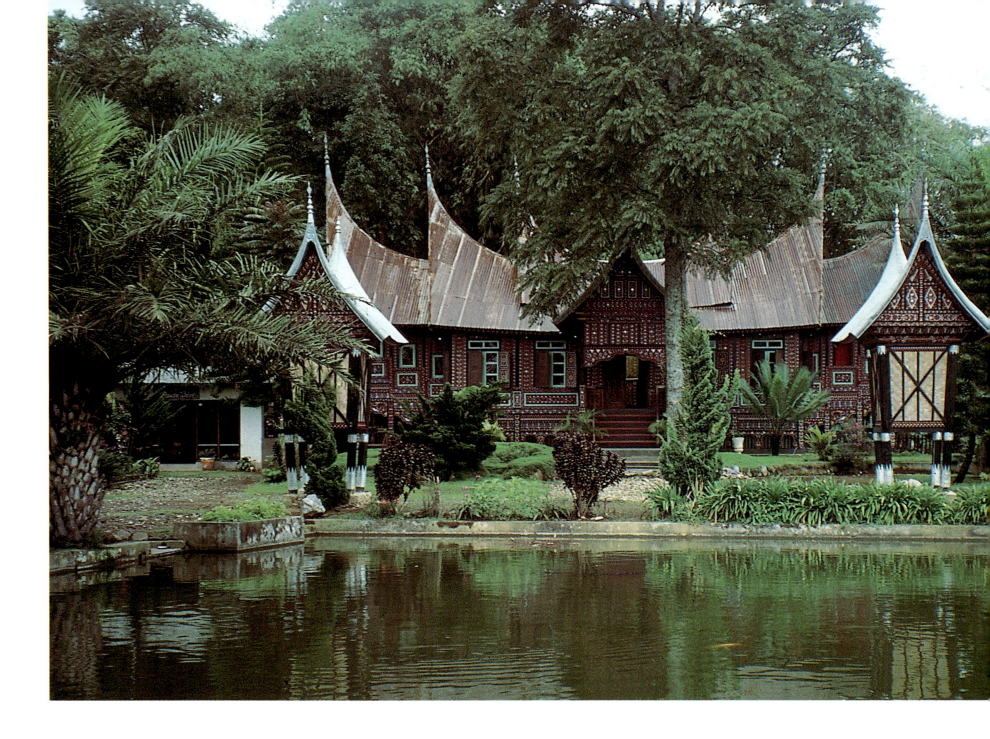

Minangkabau house, *rumah gadang*

Pagaruyung near Bukit Tinggi, Sumatra

Houses like these are inhabited by three to four generations of an extended family. The *rumah gadang* of Sumatra are unusual in that they are passed on by mothers to their daughters.

Minangkabaus therefore present an interesting combination of native common law, which is matrilineal, and Islamic law, which is patrilineal. The central feature of the matrilineal law of inheritance is the *harta pusako*, the property of the family, which includes land, the house, and the family cemetery. In 1960 in the Minangkabau region a law was introduced that made it possible for *harta pencaharian* (possessions acquired during the marriage) to be passed on to sons.

In the Minangkabau region the two strongest positions occupied by men are as an uncle (as a "mother's brother," *mamak*) and as leader of the family group (*penghulu*). As *mamak* they are entitled (indeed obliged) to take over the education of their sisters' children; in fact the children of their sisters have more claim to their keep than have their own children, whose maintenance and education are in turn borne by the wife's brother. The men maintain the tradition of the *merantau*,

that is, they leave their own area to gain experience of life and a profession. The women manage the *harta pusako* and have full authority to make decisions concerning it. The *penghulu*, the male heads of families, on the other hand, ensure that the common laws of the group are observed. With regard to the *rumah gadang*, the legal right of possession is given to the women, and the men are formally described as "homeless." As sons they live with their mother in the *rumah gadang* until school age, and after that they must stay overnight in the Islamic Koran school (*surau*). When a man marries he become a "visitor" in his wife's *rumah gadang*.

The *rumah gadang* has three main areas: immediately after the entrance comes a middle area (*runag tongah*), where there is normally a central post; adjoining this the *anjuang*, and the bedrooms (*biliak*). Opposite the *anjuang* is the kitchen and in front of that a large space (*pangkalan*), where visitors are received. While the long

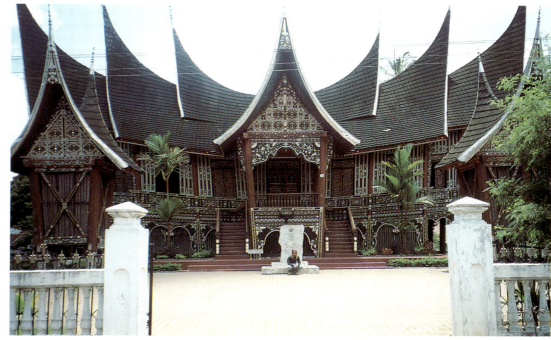

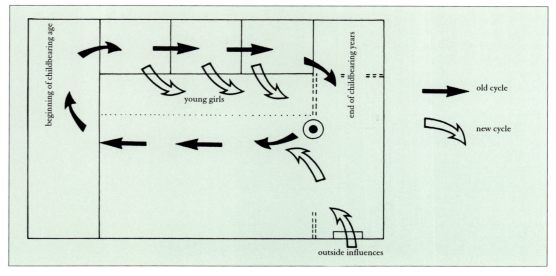

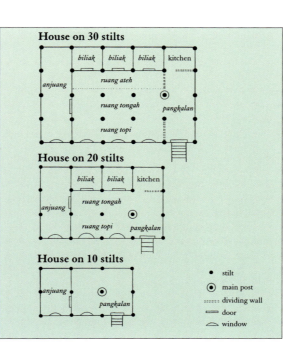

house is a meeting place for all, the *rumah gadang* is essentially a women's area; none of the men spends much time in the house with his mother or his wife, and the *biliak* (bedrooms) are seen as rooms for mother and child. In fact the arrangement of the house reflects a woman's life cycle, and forms a journey from the central post to the *anjuang*, then to the *biliak*, and lastly to the kitchen. Unmarried girls sleep in the *ruang tongah*, around the central post. Newly married couples must sleep in the *anjuang*. They in turn, when the wife's younger sister (or mother's sister) marries, must then move into one of the *biliak*, and in this way move nearer to the kitchen. Visitors are received in the room next to the kitchen, in the *pangkalan*; as this is where the old women sleep, this area is a symbol of the end of the life cycle.

This, it has to be admitted, is an interpretation based on Western academic research, and so it is not certain whether the inhabitants see things in

Minankabau house, *rumah gadang*

Top

View of a house in Batu Sangkar near Bukit Tinggi, Sumatra.

Above

The "life cycle" of women in the traditional house of the Minangkabau.

Left

Ground plan of typical stilt dwellings on 30, 20 and 12 posts.

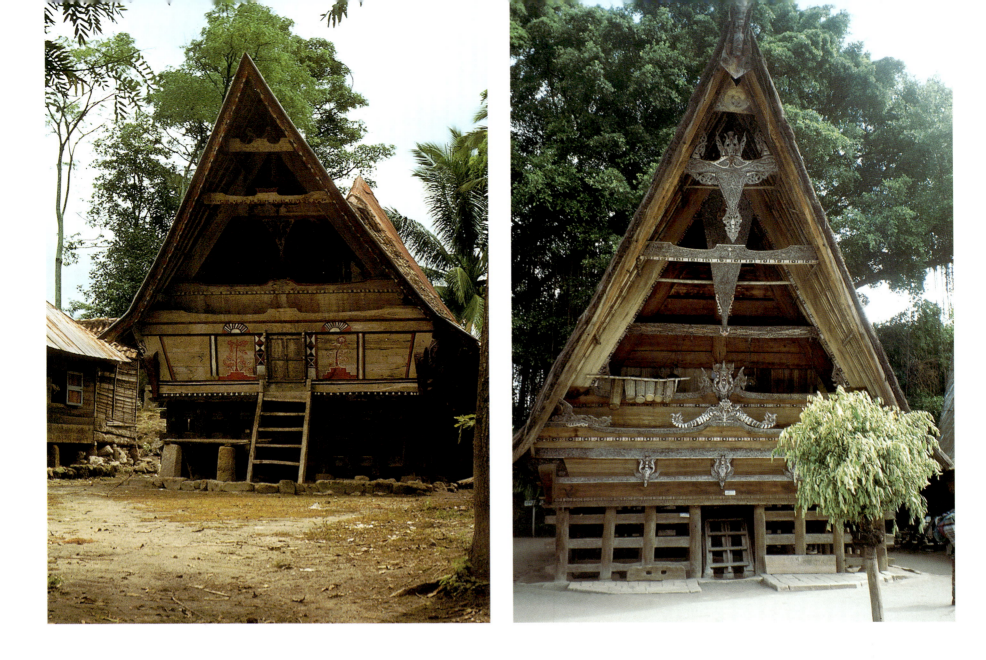

Two Batak houses, *rumah adat*
Lake Toba on the Island of Samosir

In contrast to other Batak houses, the *rumah adat* of the Toba Batak are very large on the main floor and have a high, pointed roof. The walls are richly decorated with colored carvings. The ornamentation is supposed to protect the inhabitants from disaster and illness. In contrast to their neighboring tribes, the Minangkabau, the Batak have patrilineal descent.

The houses of the Batak

The Batak, who live in north Sumatra, are divided into six ethnic groups that originally had little to do with each other. Their society is not hierarchically structured, and though there were once "princes" (*raja*), their area of influence was very small and did not extend over the whole Batak country. Moreover their function, which in fact was essentially that of a village headman, was not passed to their sons. Two Batak races, the Mandailing and the Angkola Batak, became Muslim in the middle of the 19th century, and the Toba Batak were converted to Christianity in 1864 by the German Rheinisch Missionary Society. The others kept their native religion, though there have been converts to Islam and Christianity more recently.

In a similar way to the Dayak, the Batak always fought against their reputation for cannibalism,

precisely the same way. It could be pointed out, for example, that when women reach the end of their childbearing age they receive a new status in society, by taking over religious duties.

which was banned by the Dutch colonial government at the end of the 19th century.

In a good deal of European literature the traditional houses of the Batak (*rumah adat*) were described as dirty, unhygienic, and dark. But there are others, more observant: "The houses of the Toba and Karo are recognizable by their massive style of building construction, which is suited to the way the inhabitants settled more or less permanently. The stilt house is an eminently practical form of architecture for life in the tropics. Unwelcome visits from strangers or domestic animals could easily be prevented by pulling up the steps. When swept up, the dirt that had accumulated in the unstructured inner room, with the open fireplaces, easily falls through the cracks in the wooden floor down into the area for the pigs, hens, dogs, cattle, and water buffalo. In this way organic rubbish finds an excellent biological use. Even the modest ventilation through the little window and door openings which, when the fire is burning, hardly draws the smoke away, has a positive side: the smoke drives away all the insects."[1]

Unfortunately, the Toba Batak houses (see above) are no longer being built.

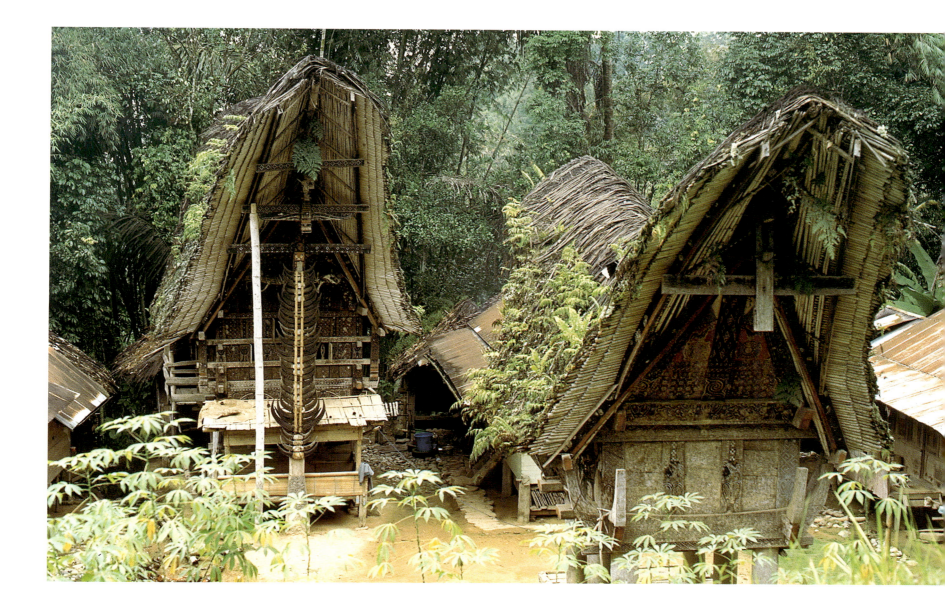

Toraja house, *tongkonan*, with a rice store *alang*

Toraja area, Sulawesi (Celebes)

The distinctive feature of such houses are the roofs, which make them look like boats. The rice store is a smaller form of the *tongkonan*. The roof of both usually consists of *ijuk*, dried branches of sugar palms.

Earlier, rice stores (*sopo*) were a part of the traditional house, the *rumah adat*. The *sopo*, like the *alang* of the Toraja (which we will look at below), were very important as status symbols. Apart from being places to store rice, they also functioned as meeting places, for the *raja* of the Toba Batak and the noblemen of the Toraja had nowhere else available to greet and entertain guests, or to hold village meetings.

Today the *sopo* still function as storage places for building materials or firewood, but rice supplies are now kept in the *rumah adat* itself.

The ornaments put onto the external walls of the house are meant to drive away evil influences such as illness and black magic. These ornaments consist of anthropomorphic and zoomorphic representations, carved decorative ornaments, and wall paintings. The colors used are natural colors, the most important being red (from red clay), white (from chalk), and black (from charcoal), which respectively represent the three spheres of the cosmos: the human world, the world of good spirits above, and the underworld. The Toba Batak (in contrast to the Dayak, the Minangkabau, and the Toraja) accord the lion's head (the *singa*) a

very important role in their culture. "He is found in countless representations, mostly, however, reduced to his face. He has two central meanings for the the Toba: they believe that he wards off diasaster, illnesses and other evil influences from the house and its occupants, and also that he can release beneficial positive energies for the welfare of the occupants."[2] According to another interpretation, the word *singa* comes from *si inga*, "protective figures in the corners."

The houses of the Toraja

The ethnic groups in the mountain regions of southwest and central Sulawesi (Celebes) are known by the name of Toraja, which has come to mean "those who live upstream" or "those who live in the mountains." Their name is in fact derived from *raja*, which in Sanskrit means "king."

Of the roughly 320,000 Toraja, approximately 80 percent are Christian, for the most part Protestant. The society is hierarchically structured: the noblemen are called *rengnge*, the ordinary people *to makaka*, and the slaves *to kaunan*; birth determines which rank a person will occupy.

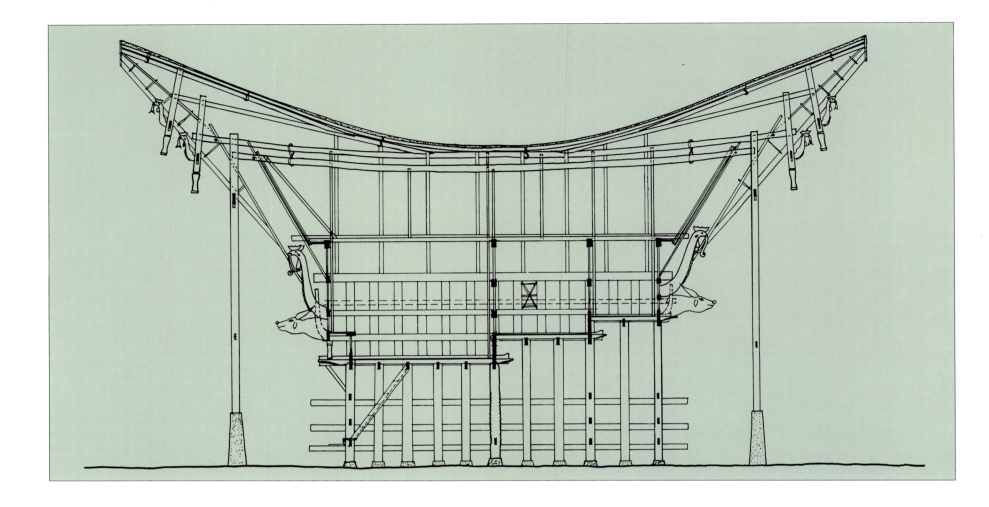

The distinctive features of the traditional houses (*tongkonan*) of the Toraja are the "buffalo horns," the roof design (which looks like a boat), and the rich decoration on the walls (see opposite). Every house has a link with a founder-ancestor, whose story is known to his descendants, in other words to all the inhabitants of the house. According to legend, the buffalo and the first man were both created out of gold by the highest deity of the upper world. As a consequence, the buffalo plays an important part in life; it is, for instance, killed at the festival of the dead to accompany the dead to the upper world. The buffalo is a symbol of status, courage, strength, and fighting spirit.

Designed as a representation of the universe, the *tongkonan* is constructed in three parts: the upper world (the roof), the world of humans (the middle of the building), and the underworld (the space under the floor). Furthermore, the separation of the building into north-south and east-west areas plays an important part in the basic plan. The north is associated with the life-giving since the river of life runs from north to south, and the river which brings the water for the production of wet rice (*sawah*) also flows north-south. As a result, the living must never sleep with their head pointing towards the south. The kitchen is in the east, as the east is associated with food and also (because the sun rises in the east) with life itself.

The important status of rice is reflected by the fact that near every house is a rice store (*alang*) built as a slightly smaller model of the house. Moreover, there are certain taboos which women must observe when they want to enter the rice store; for example, they must not enter with bare shoulders, or while menstruating. As the *alang* is a very important status symbol for the Toraja, it is always richly decorated (see page 321).

The highly distinctive roofs constructed by the Toraja have given rise to various ingenious interpretations. One of them centers on Toraja's creation myth, in which a child who lived in the upper world, who was called Manurun diLangi ("he who comes from Heaven"), opened the gates of Heaven and peered down at the world. Seeing beneath him a wide expanse of sea, he decided to visit it. The highest deity, whose help he had sought, created an island, which he called Pongko. Manurun diLangi sailed to Pongko on a raft, followed by a buffalo, a pig, a hen, and the plants that grew in Heaven. He lived contentedly on Pongko and the people of the island multiplied. One day war broke out, and some of the inhabitants of Pongko set sail with eight rafts; after a long journey they reached their present homeland, Sulawesi. The *tongkonan* is supposed to resemble the rafts the Toraya's ancestors used when they left Pongko.

Certainly the roof is something of deep significance for the Toraya, and even today they build "modern" houses (in other words houses built with cement) with such roofs. Unfortunately, the *tongkonan* is now built less and less.

Diagram of a *tongkonan*, a Toraja house

This diagram clearly reveals the structure of the *tongkonan*, which is supported on stilts and topped by a huge saddle roof. The significance of the buffalo is shown by the fact that a buffalo head is hung at both the front and back of the house.

Opposite
A *tongkonan*
Toraja area, Sulawesi (Celebes)

The walls are always richly decorated with symbols. The Toraja use yellow (the color of happiness and power), red (the color of blood, associated with life), white (symbolizing purity and the higher world), and black (the color of death and the underworld).

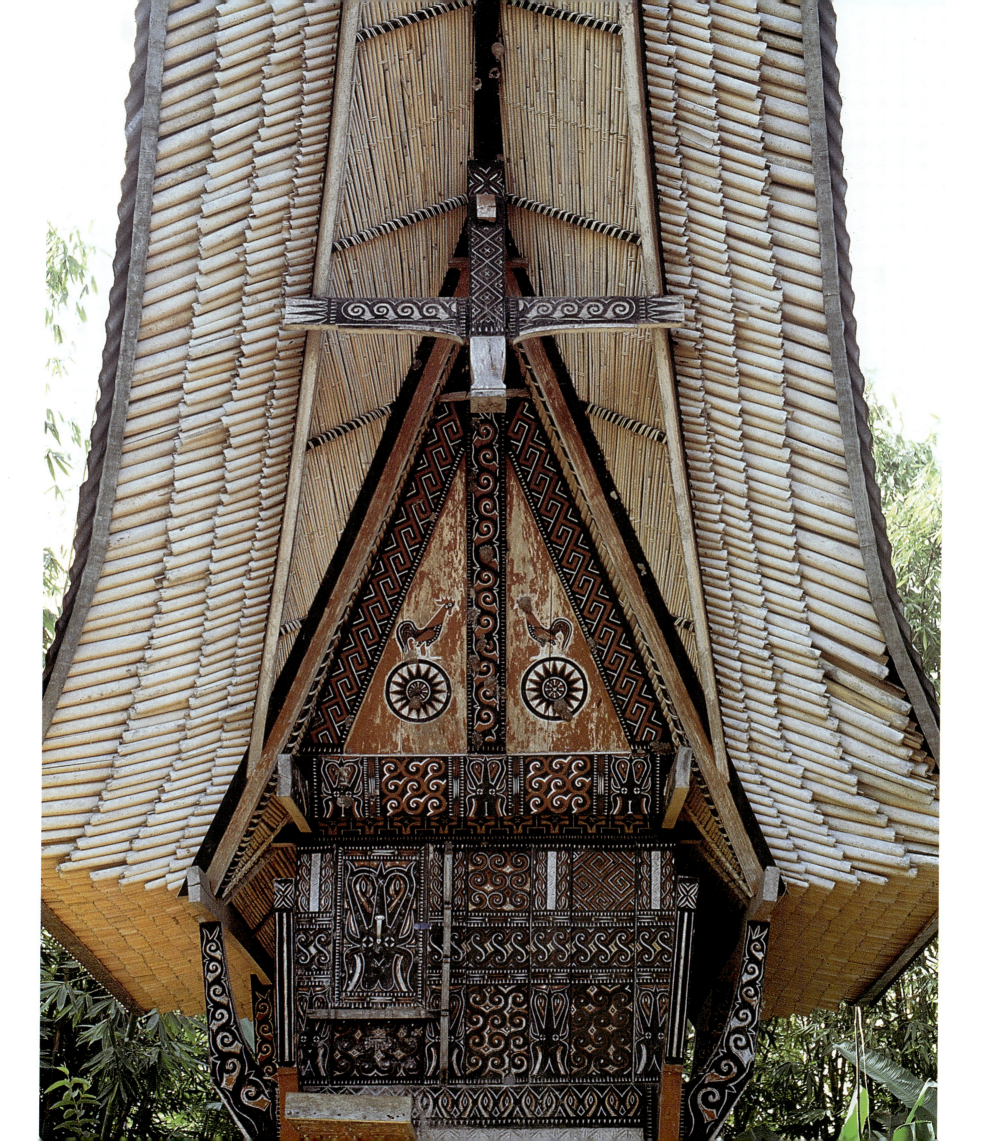

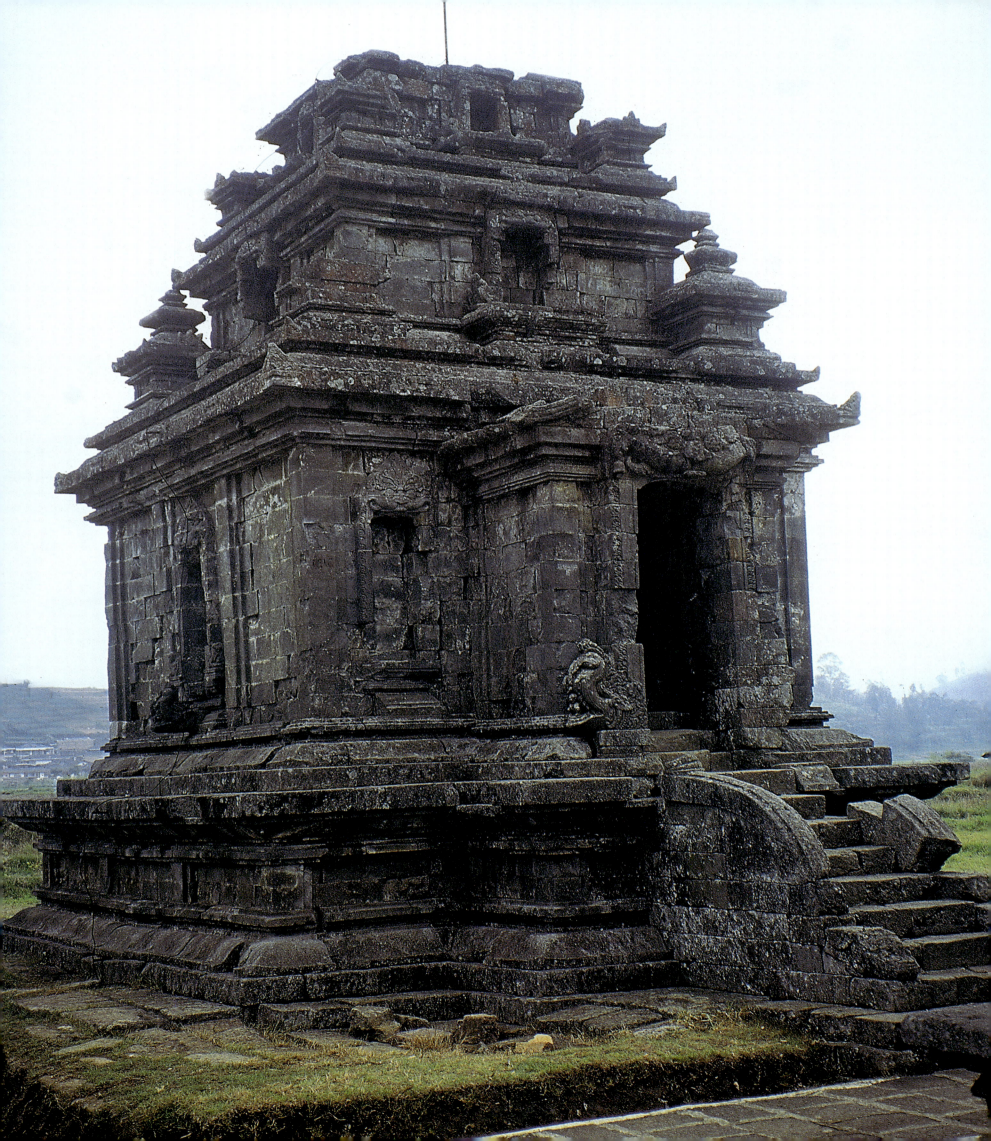

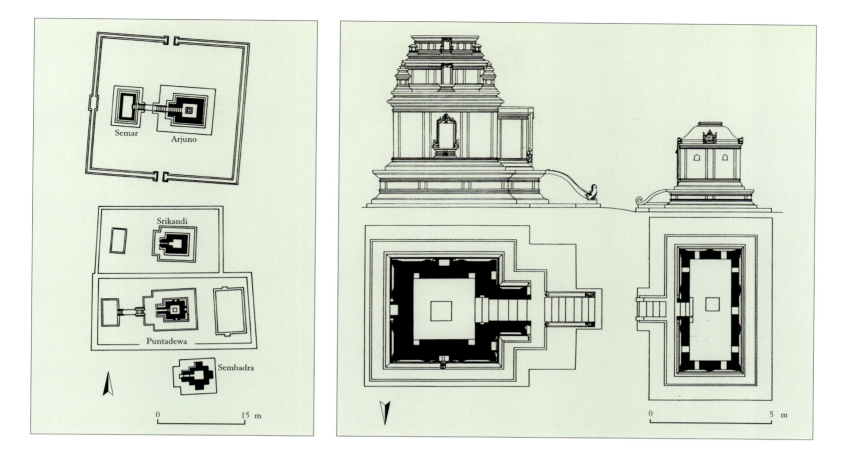

Indian Influences

Above

Temples on the Dieng plateau

On the left is the ground plan of the Arjuno group. On the right is the ground plan of the Candi Arjuno (left), with the subsidiary temple of Candi Semar.

Opposite

Candi Arjuno

A.D. 680–730, Dieng plateau, Central Java

The Hindu temples on the Dieng plateau in Central Java are among the very earliest on the island, and many of them, long abandoned, are in ruins. Opposite this temple stands a subsidiary building that probably served as a repository for the cult objects.

Indonesia forms one of the largest Islamic states in the world, with 87 percent of its population being Muslim. Islam came to the island along the sea trade routes from the 13th century onwards. The major step in the conversion of the Indonesian island came in the 16th century, when the Islamic kingdom Demak flourished on the north coast of Java and soon grew more powerful than the Hindu-Javan kingdom of Majapahit in eastern Java. Since the trade routes ran mainly across the Indian Ocean, Islam did not reach the mainland of Southeast Asia, where to this day Theravada Buddhism has the greatest number of followers.

Five hundred years ago the religious landscape of Southeast Asia was very different. Buddhist and Hindu influences from India spread and gained a foothold, but were intermingled with native religions. And so the forms of Buddhism and Hinduism that developed on mainland Southeast Asia were different from those in the Indonesian island kingdom. Nevertheless, it is still possible, despite this process of adaptation, to talk of a "philosophy stamped by India" visible in Southeast Asian art, particularly so with temple architecture.

This is confirmed by the celebrated thesis of the scholar Heine-Geldern, to whom the mythical Mount Meru is the central concept of Southeast Asian religious architecture: the temples are in effect models of Mount Meru, which in Hindu mythology is the seat of the gods, and in Buddhist philosophy the seat of the guardian of the world. In other words Southeast Asian temples, like Southeast Asian houses, are seen as reflecting a specific image of the universe; for those who built these temples, it is only when the relationship between the macrocosm and the microcosm is ordered can harmony rule in the world. In Southeast Asian architecture, the spiritual shines through everywhere, and access to this is provided by the countless symbols incorporated into the architecture and its decoration, though this is not always successful, for the symbols are open to many possible interpretations, and not even experts are united. "The Asian architect is never a philosopher, never a scholar. His works nevertheless always betray philosophical and religious speculation, and his creative works and his aesthetic sense spring from this. He has the overall design of his buildings to thank for it, which in turn are destined to have an effect on the development of religious thought. Religious thought, on the other hand, is a philosophy of life whereby man does not have to heed certain aspects or problems of life if they are deemed insignificant and therefore not of vital importance. In practice, in religion the individual is free (persecution hardly ever occurs), yet the development of his religious thought is activated by the competition of the various doctrines. [...] In this Asia stands between two realities: the mysticism of the religious world, and the material world of everyday life. This is not to say that the sacred is set against the secular: religious reality transcends and penetrates the reality of physical existence and they form a whole."[3]

Indian influences came to Indonesia through merchants who traveled to Indonesia and brought

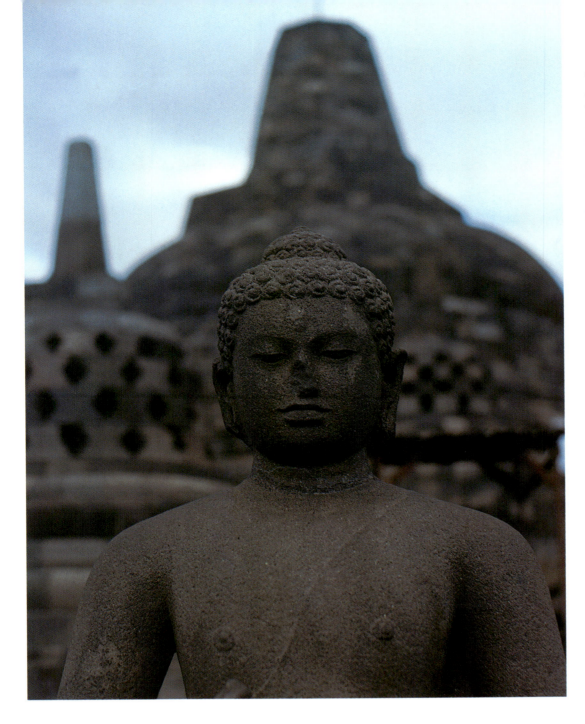

Statue of the Buddha

Central Javan period (A.D. 732–928), Borobudur, Magelang, Central Java

This statue of the Buddha, one of 72 images of the Buddha on the upper terraces of the Borobudur complex, was originally encased in a stupa built with diamond-shaped holes (like the one in the background). These statues of the Buddha are situated on the uppermost terrace, which symbolizes the spiritual level known as Arupadhatu.

religious objects with them, and through the Brahmans who were invited by Indonesian princes to dedicate temples and explain their beliefs. These seeds of religion were soon to take root. The "Indianization" of Indonesia had begun in the first post-Christian centuries and evolved gradually and peacefully; it was not driven by ideas of imperial power or conversion. Merchants from Gujarat, for example, brought figures of Hindu deities or Buddhas with them, sold them or gave them as gifts, and related the legends and wise sayings connected with them. Thus the Indonesians slowly but surely adopted these religions, previously unknown to them, together with the spiritual atmosphere that came with them. But they did not take Indian culture wholesale; they adopted only individual elements and these they adapted to local conditions. "The result is a harmonious integration of Indian culture. The process of the selection, redefinition and integration is called 'localization' from now on. In the course of the story of development it became increasingly clear that the old Indonesian culture was certainly inspired by the Indian, but remained Indonesian in substance."[4]

These Indian influences met a peasant culture in which ancestor worship and mythology had a profound impact on thought, and on social and political life. Until the coming of Indian ideas, life in the Indonesian islands had been determined by harvests, and people had lived alongside each other on an equal footing. With the arrival of Indian culture this form of social life was gradually replaced by one dominated by a godlike king and supported by the surplus yields produced by the peasants' harvest; palaces and temples were built to demonstrate and strengthen the power of the king. Nevertheless, during this process the Indonesians never lost their independence, for though they adopted a new religion they interwove it with their own ancient myths. And so the typical Hindi-Javan culture was born. When the Indian poet Rabindranath Tagore (1861–1941) visited Indonesia, he said: "I see India everywhere but I can't recognize it any more."

As early as the 7th century A.D. there had been a lively exchange between India, the Southeast Asian mainland, and the Indonesian islands. There is evidence of this in the writings of the Chinese pilgrim, I Tsing, who around this time stayed on Sumatra in the kingdom of Srivijaya, to wait for favorable winds that were to take him to India. I Tsing wrote that many monks from different countries met in Srivijaya, and that pupils from all over the world gathered at the Borobudur temple to receive instruction in Buddhism. In this period three dynasties played an important role in Indonesia: the Buddhist Srivijaya dynasty on southern Sumatra (roughly from 650 A.D. to the end of the 11th century); the Hindu Sanjaya dynasty; and the Buddhist Shailendra dynasty on Java (732 A.D.–929).

The Sanjaya dynasty, which established the first kingdom of Mataram, was founded around 730 A.D. by Sri Maharaja Sanjaya. This marks the beginning of the historical period of Central Javan, here the first Hindi-Javan temple site of Dieng ("mountain of the gods") was built, on the 2,000-meter (6,560-feet) high plateau, which is the basin of the surrounding volcanic region.

And so it is on the Dieng plateau that we can see the prototypes of all Hindu temples of Java, the simple models of later, larger richly decorated temples. Originally there were about forty—eight remain. A group of temples in the north of the plateau is named after the hero of the epic the *Mahabharata*, Arjuna, though this was probably a later addition. (The Javan version of the Indian epic the *Mahabharata* was the *Bharatayuddah*, which was probably written around 1200 at the court of the East Javan Kediri dynasty.) The epic describes the eternal struggle between good and evil, and the battle of the Pandawa brothers against the Korawa brothers, all descendants of the

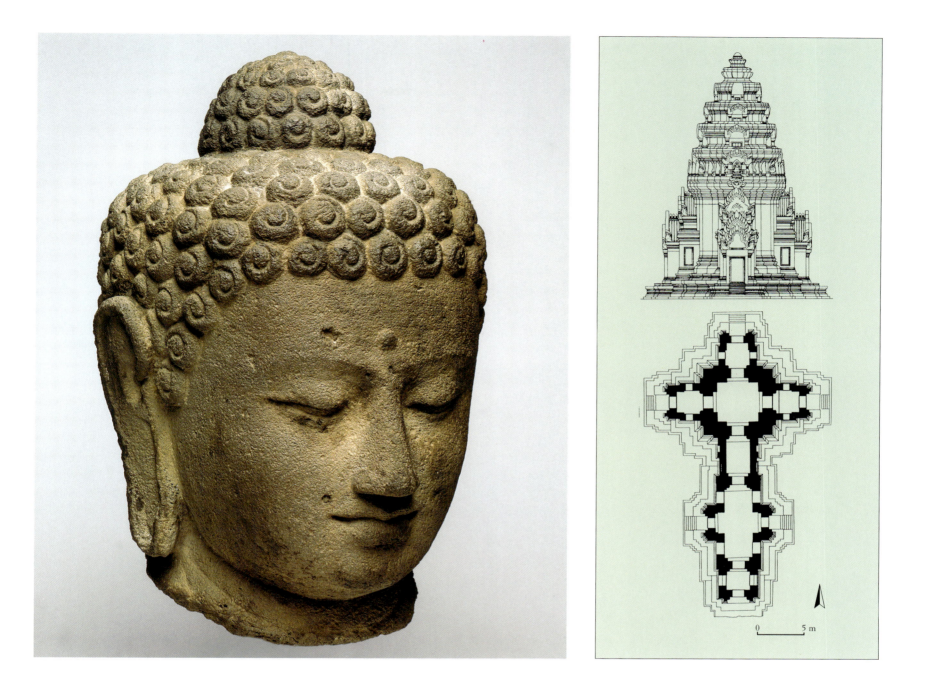

Bharata. The Arjuno group consists of the temples (*candi*) Semar, Puntadewa, Srikandi, and Sembadra (see pages 324 and 325). The relatively small buildings are constructed on marshy ground and all follow the same pattern: "From a square base rises a smaller cella (inner sanctum of the temple) that opens to the west (something which might suggest a temple of the dead); this cella has a stepped roof which repeats the shape of the cella with lingams and stupas". On a square base, a smaller cella (inner sanctum) is built in the middle of the inner courtyard of the temple. The cella is a hollow cube in which there is usually a lingam, and is covered by a hollow pyramid roof. The cella is open to the west, which suggests a like between temples and the dead.

Over this rises a stepped temple tower that repeats the shape of the cella. Above the entrance to the cella is a constantly recurring motif, the sculpted head of Kala, son of the Shiva. The head

of a demon, it is meant to ward off evil. Opposite the temples themselves is a subsidiary temple, the purpose of which is unclear. Maybe it served the priests as a living area or was a repository or objects used in rituals (see page 325).

All the temples were probably dedicated to the main deities of the Trimurti (Brahma, Vishnu, and Shiva), though the only temple which in fact has the Trimurti carved on the exterior walls of the cella is the Candi Srikandi: in the south, Brahma, the creator of the world; in the north Vishnu, the protector of the world; and in the east, Shiva, the destroyer and rebuilder of the world. Somewhat further away from the Arjuna group stands the Candi Gatotkaca, though it belongs to the group stylistically. The celebrated Candi Bima earns a place in its own right. It is larger, stylistically more mature, and perhaps in shape illustrates the transition to the most perfect Hindu-Javan Shiva temple complex, the Prambanan. Its pyramid-like tower

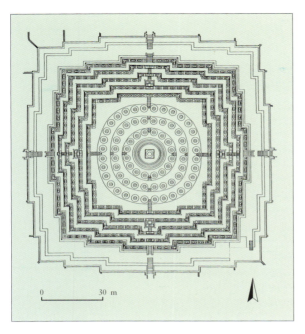

Borobudur

Central Javan period (A.D. 732–928),
Borobudur, Magelang, Central Java

Left
Ground plan of Borobudur

Below
Aerial view of Borobudur

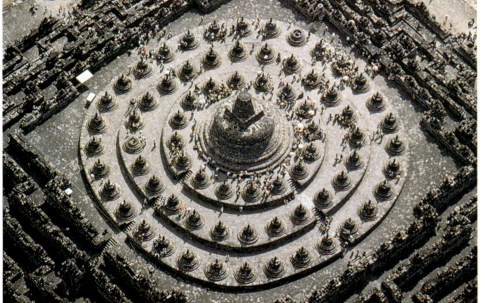

rises up steeply and the horseshoe-shaped niches, fitted with heads, busts, and symbols in high relief, are very striking. With the end of the Sanjaya dynasty, the first empire of Mataram, building activity on the high plateau moved to the Kedu plain around Yogyakarta, as it is called today. The new dynasty of the Shailendra Buddhists commissioned the building which in A.D. 830 came to a glorious conclusion with the completion of the Borobudur temple. From 778 to 870 Central Java was ruled by the Shailendras, who were related to the Srivijaya dynasty.

Borobudur

Around 1300 years after the life of the historical Buddha, the largest Buddhist building in the world was built in Central Java: the "world mountain," Borobudur. This architectural vision of a religion grew out of the tropical landscape; it is in essence a petrified illustration of the cosmos as seen in the Buddhist thought of Southeast Asia. Three central elements of Buddhism are expressed here in the architectural form of the stupa, the Meru, and the mandala.

The stupa developed historically from the stone-age burial mounds that in earlier times were reserved for important rulers. Later, stupas were generally built at a crossroads and contained the ashes or relics of holy men, which the people revered by walking round in a clockwise direction.

The Borobudur, which was erected on the side of a natural hill and so has no interior rooms, culminates in the largest stupa in the world.

The Meru is a representation of the mythical world mountain, Mount Meru, on whose summit the gods live. In order to be nearer to the gods, the builders constructed a pyramid whose steps are the

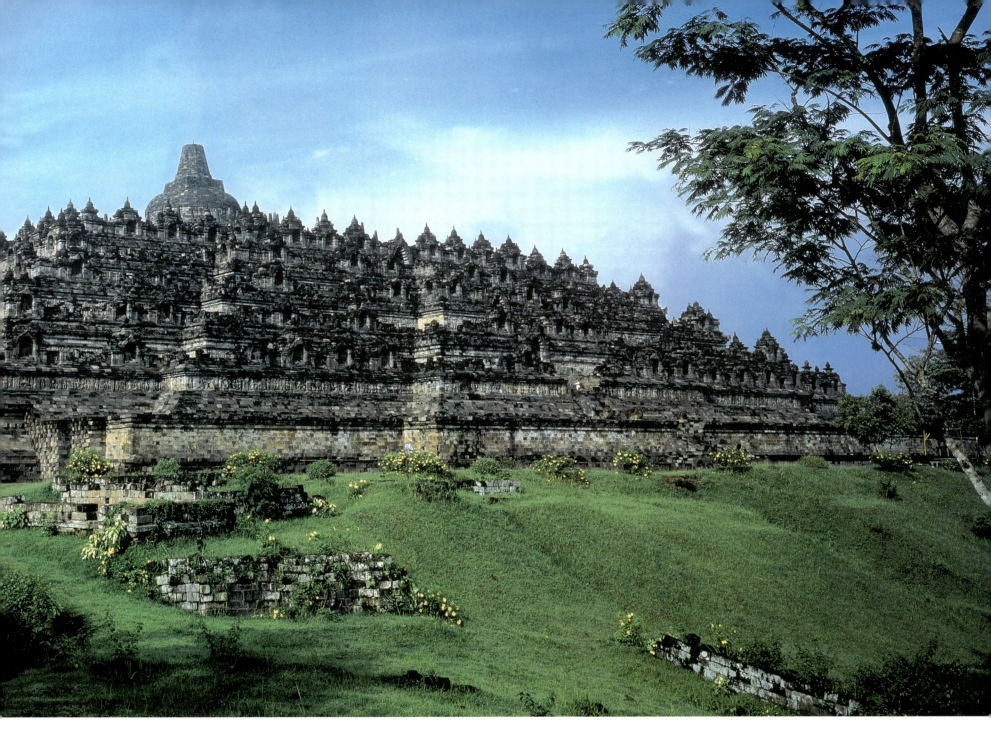

natural hill, a terraced holy shrine. With every step pilgrims climb they symbolically achieve one more step in their spiritual development and so reach a higher state of consciousness.

The architecture of the Borobudur reflects the philosophy of the three cosmic spheres of Buddhism: Kamadhatu, the sphere of desire; Rupadhatu, the sphere of form; and Arupadhatu, the sphere of formlessness (see page 330, bottom).

The mandala is the symbolic representation of the world and the spiritual creatures who go to make it up. A mandala serves as a pattern for meditation and as an aid (*yantra*) in achieving concentration and the state of meditation. The Borobudur is a three-dimensional mandala in which architecture and sculpture work in harmony; the Borobudur-mandala guides pilgrims along the stepped path that climbs through the three spiritual realms (see page 330, bottom). The mandala

symbolizes that process through which the soul is liberated from its earthly life in order to attain perfection at the highest stupa: a meditative pilgrim's way to Nirvana, the state of non-existence sought by the Buddhist.

The lowest level, Kamadhatu, reflects earthly pleasure and suffering; here the predominant elements are sin, vice, war, and suffering. This level merges almost imperceptibly into that of the Rupadhatu, the sphere that mediates between the lower and upper levels, between the physical and the spiritual. Pilgrims are still more or less tied to the lower level, but before them lies a vision of purification and reform. Perhaps this second level could also be described as a sphere of hope. As aids in this process of spiritual ascent there are the four galleries in which 1,300 elaborate bas-reliefs in basalt depict the life of the historic Buddha, Siddharta Gautama. It begins with his mother

Borobudur

Central Javan period (A.D. 732–928), Borobudur, Magelang, Central Java

A new dynasty, that of the Shellendra Buddhists, gave the commissions which came to a glorious conclusion in A.D. 830 with the completion of the Borobudur temple. The Shallendras ruled Central Java from about A.D. 778 until 870. They were related to the Srivijaya dynasty which ruled in southern Sumatra from their capital Palembang (from about A.D. 650).

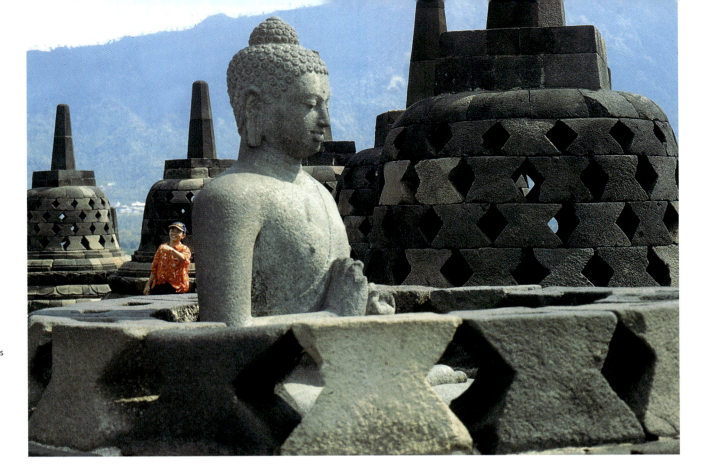

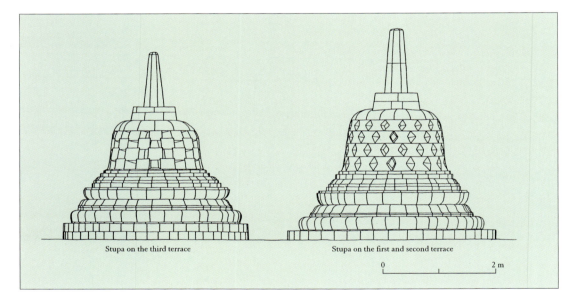

Stupa on the third terrace

Stupa on the first and second terrace

0 2 m

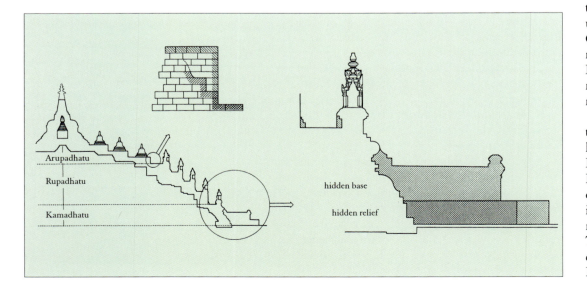

Arupadhatu

Rupadhatu

Kamadhatu

hidden base

hidden relief

Maja's prophetic dream about a white elephant, and then her death after his birth. Siddharta's youth in the royal palace is also depicted: he is to want for nothing; yet this life imprisons him in a golden cage, and the suffering and misery of the world are withheld from him. One day, however, Siddharta leaves and comes into contact with the harsh outside world. He has four central encounters. First he meets an old man and learns that there is no eternal youth. Then he meets a sick man, and learns that good health is not everlasting. When he comes face to face with a dead man he sees that life is transitory. Life, clearly, is not as wonderful as they had led him to believe. The last encounter is with a monk; from him he learns how one can transform one's life through meditation. Siddharta thinks long and hard and decides to seek spiritual emancipation from the pain and transience of life by living as a hermit and seeking spiritual wisdom. Enlightenment comes as he is sitting under the famous Bodhi tree, and out of Siddharta Gautama is born the Buddha. His life of teaching now begins. The succession of terraces portrays the Buddha's striving for enlightenment. There are no more dramatic scenes; the pictures are abstract and repetitive.

The next step leads to the Arupdhatu. This is the sphere of formlessness, the release from human suffering. Whereas the terraces of the Rupadhatu, with their many images of the Buddha, are square, the Arupadhatu is in the form of a circle, the "perfect" geometrical figure, an image of the absolute, where the statues of Buddha remain hidden under open stupas (see page 332). There are 72 stupas on the three upper circles. We do not know whether there was once a statue of the Buddha in the large uppermost stupa.

On their symbolic path to Nirvana, the devotees have been able to admire 432 Buddhas in high relief in the niches above the gallery passages. Each of these has a typical *mudra* (hand position). On the eastern side is the *bhūmisparshamudra*, indicating reasoning; on the south, the *waradramudra*, meaning granting wishes. On the west is the *dhyanamudra*, indicating meditation, and on the north the *abhayamudra*, representing fearlessness. With the 72 stupa Buddhas on the highest circle, we have a total of 504 statues of Buddha on this highest spiritual level.

504, 432, 72: the sum of each set of digits gives the number 9. The number of terraces including the highest circle likewise gives 9. The Borobudur is steeped in such number symbolism, though much of this is not understood.

A few kilometers east stands the second most important Buddhist temple in Java, Candi Mendut (see page 333), of which only the main temple still remains. Between Borobudur and Mendut stands a further temple, Candi Pawon. Possibly all three were originally connected by a covered walkway. What makes the temple of Mendut unique is the statue of the seated Buddha, flanked by two bodhisattvas; this is the only place where all three figures have survived *in situ*. A teaching Guatama Buddha, made from trachyte, sits not with crossed legs as is normal, but in a sitting position, his feet side by side on a lotus flower. His hands are positioned as the *dharmachakramudra* (a gesture indicating "turning the wheel of the teachings"). To his right and left sit two bodhisattvas in classical Buddhist pose. The different positions of the figures' legs make this group all the more remarkable.

The staircase that leads to the cella is decorated on its exterior walls with beautiful reliefs. On one is the representation of a tortoise, being flown to another land by two birds holding a stick the tortoise is grasping in its mouth. Below, archers are firing and injure the tortoise, with the result that it cannot keep its mouth shut; it calls out to the birds and in doing so falls to the ground and is dashed to pieces.

A second relief shows a sleeping Brahma and a crab, which has a snake and a bird caught in its claws: the snake and the bird are after the sleeping man's blood, but the crab had previously been rescued by the Brahma and so now protects him.

Below
Stone relief at the Borobudur
Central Javan period (A.D. 732–928), Borobudur, Magelang, Central Java

These men with full beards are presumably Indian Brahmans, since Javan men generally have a light beard growth.

Bottom
Stone relief at the Gandi Prambanan
9th century, Hindu, Central Java

Sitting deity with the hand position of *witarkamudra* (gesture of the teachers").

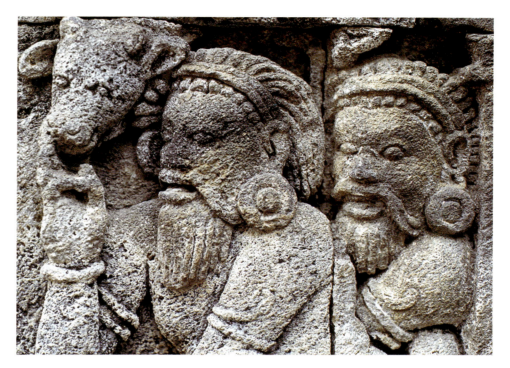

Once a year the greatest Buddhist festival, the Waisak, is held at Borobudur and attracts Buddhist monks and adherents from the whole of Indonesia. They fetch holy water from the source of the Progo River on Mount Sindoro, and fire from Mount Merapi. Two days later they all meet at the Gandi Mendut to perform the ceremony and walk in procession to the Borobudur past the Candi Pawon. Recently there have been fruitless attempts on the part of the Buddhists for permission to use the temple sites for daily rituals.

Towards the middle of the 9th century A.D. the Shailendras were expelled by the ambitious Sanjaya dynasty, who were Hindu. The Buddhist Shailendras were driven to Sumatra, where they merged into the Srivijaya kingdom. The rise of the Sanjaya dynasty in effect represented a renaissance of the first rulers of Mataram, who had built the temples on the Dieng plateau. The new temple site of Prambanan (see page 335) was built as a stone symbol of the victory over the Shailendras. Under the ruler Sri Maharaja Rakai Pikatan, the site was built with an original total of 232 shrines, and was completed around 915 A.D. under King Daksha. A devastating earthquake destroyed the whole complex in 1549.

Today we can once again admire the eight main temples, for they have been reconstructed. The three largest are arranged in a square courtyard on a north-south axis. They symbolize the Trimurti, the Hindu trinity. In the middle, the main temple, 56 meters (184 feet) high, is dedicated to Shiva; next to it, to the south, is the temple to Brahma and to the north the temple dedicated to Vishnu, both 37 meters (121 feet) high. Opposite these three temples are three more shrines, which contain the mythical animals which the Trimurti used for mounts: Shiva's bull, called Nandi; Brahma's gander, Hamsa; and Vishnu's sun-bird, Garuda. At the northern and southern entrance doorways stand two identical buildings which possibly served as places to keep cult objects. All the other 224 shrines lie in ruins today (see page 335).

The main temple dedicated to Shiva stands on a square base. High steep steps lead up to the main cella, which opens to the east, and also to adjacent cellas on the other three sides. Around the cella is space for the ritual procession, and above the cella the roof rises up as a multilayered pyramid. Thus, as so often in Southeast Asian art, we have a building symbolically divided into three parts: the square base; the cella, which repeats the ground plan of the base in a scaled-down form; and the pyramid roof. The so-called Prambanan motif is repeated on the base. This consists of the front view of a lion which is sitting in a niche between two trees hung with jewels; each tree is accompanied by a pair of birds that have the heads and

Stupas at Borobudur
Central Javan period (A.D. 732–928), Borobudur, Magelang, Central Java

A view from one of the uppermost terraces, showing the distinctive, bell-shaped stupas and the natural setting of the temple, which was seen as the focus of the region's spiritual energies.

breasts of women. At the top of the steps visitors come to the gates, over which Kala heads keep guard. When they go into the main cella they see three religious symbols, the middle one being Shiva's Mahadeva. In walking around the outside of the cella they come to the adjacent cella on the south side, with a religious symbol of the Shiva as Mahayogi. In the cella on the west side is the elephant-headed son of Shiva, Ganesha; and in the northern one is his wife Durga.

Around the processional path used in rituals runs a balustrade whose inside wall is decorated with 42 scenes from the Indian epic the *Ramayana*. The Shiva temple is also popularly called the Loro Jonggrang, and the legend of the origins of the Prambanan goes like this: the princess Loro Jonggrang, daughter of Kin Ratu Baka, spurned a prince who was destined to be her husband. In order to have a reason to reject him, she ordered him to construct a huge temple-palace with 1,000 statues. This he accomplished in one single day, for the prince had magic powers, and to her horror the princess saw that only one single statue was needed to complete the temple. She resorted to cunning and, with a wooden block in which rice is pounded, she beat so furiously that all the cocks flew up in fear and the sun became overcast. The prince was deceived and thought the day was already at an end. When he realized the deception,

he changed Loro Jonggrang, the "slim virgin," into the last statue.

In A.D. 930 the political, economic, and cultural center of Java moved to the east. This may have been brought about by the eruption of the volcano Merapi, but possibly by the Javan belief that capital cities must be changed after three generations. The 200 years of the Middle Javan period, one of the golden ages of Indonesian culture, came abruptly to an end and the East Javan period began, which lasted until the end of the 16th century.

Whilst the Middle Javan period was distinguished by great buildings, the kingdoms of the East Javan period concentrated on expansion and trade. By the time of the famous chancellor, Gaja Madah (1319–1364), the territory of the Majapahit kingdom embraced the whole of present-day Indonesia, and records state that a few kingdoms on the Southeast Asian mainland were paying tribute. This period is also known from 15th-century chronicles such as the *Negara Kertagama* and the *Serat Pararaton*, which serve as valuable written sources about events of that time.

The East Javan buildings are not such massive constructions as those of the Borobudur and Prambanan complexes; they are small, individual temples built by the rich as a substitute for tax, or by kings to ensure their deification after death.

Many are built out of andesite like those in

Candi Mendut

8th century, Buddhist, Central Java

In contrast to Borobudur, Candi Mendut has an interior, in which there are three statues, a seated Buddha and two boddhisattvas.

Candi Prambanan

9th century, Hindu, Central Java

The Prambanan style is considered to mark the transition from the Central to the East Javan style.

Opposite, top right

Candi Prambanan

9th century, Hindu, Central Java

A general view of the Candi Prambanan. Of the original 232 shrines, which were destroyed by an earthquake in 1549, the eight most important temples have been rebuilt. The highest temple in the center is dedicated to Shiva, the two slightly smaller ones next to it to Vishnu and Brahma. See the ground plan (opposite, bottom left).

Opposite, bottom right

Guardian figure with child

East Javan period (10th–15th century A.D.), Trowulan

Trowulan is the former capital of the large empire of Majapahit in East Java. Archaeological research carried out in 1991 by the Indonesian Field School of Archaeology demonstrated that the capital was not only an administrative and religious center, but also an economic center. The works of art also served secular purposes. Here one can see a guardian figure. Remarkably he is depicted with a child – children were very rarely depicted during this period. These figures probably date from the 14th century A.D.

Central Java, but many are also constructed of brick, as in the Champa kingdoms of a later age. Most of the temples are Hindu. According to scholar Marijke Klokke, they apparently used palm leaves for the roofs during the Majapahit period, since in most of the temples of this time no roofs have survived. "Whilst the temples of Central Java are constructed symmetrically, with the main temple being found more or less in the geometrical center, the main temple in East Java is placed at the back of the site. Instead of central inner courtyards that enclose each other, the courtyards here, as is still the case today in Bali, are arranged behind each other in a row."[5] A good example of this is the temple area of Candi Panataran, which was founded around the 14th century. In the 16th century the influence of the Majapahit kingdom weakened. The phase of Indian influence, marked by the rise of the Islamic Demak kingdom on the north coast of Java, was at an end. Today the abandoned Hindu and Buddhist buildings are evidence of a glorious past, though in the Islamic world of present-day Indonesia they are little more than cultural monuments.

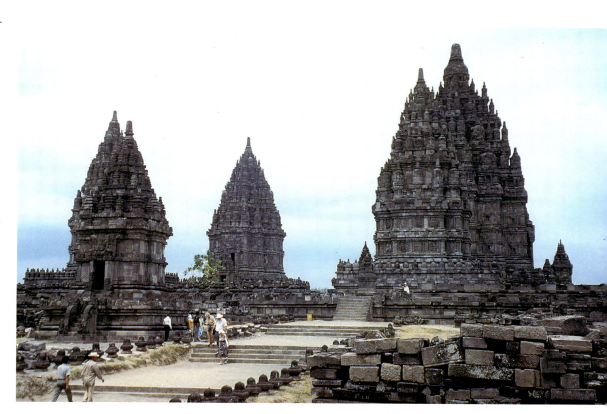

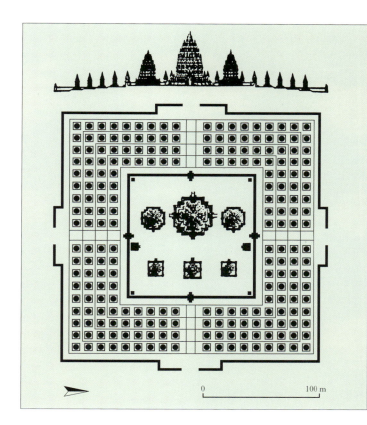

Candi Prambanan

9th century, Hindu, Central Java

The three main temples are depicted at the center of this ground plan. Facing them there are the temples dedicated to the mythological mounts of the three principal Hindu deities. All 224 of the other shrines encircling these central temples still lie in ruins today.

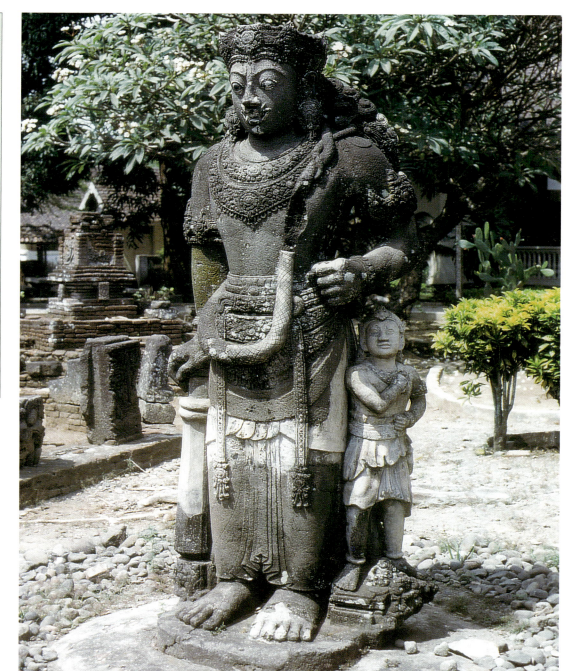

At the beginning of the 16th century, when the Majapahit empire had moved further east, a period of independent cultural development began on Bali. There had been a Hindu culture on Bali before this, strengthened at the end of the 10th century by the marriage of the Balinese prince Udayana to an East Javanese princess, the daughter of King Sindok; one of their sons, Airlangga, was to become an important ruler of East Java. In part, the history of Bali is characterized by the conquests by East-Javanese empires. These influences mainly found expression in south Bali, with the result that there is a marked difference between north Bali, which represents the "original" Bali, and south Bali, which was influenced by the Hindu-Javanese religion.

The first political and cultural center in Bali was in Gelgel, approximately four kilometers (two and a half miles) south of Klungkung. Standing testimony to this rule is the 18th-century courthouse, Kerta Gosa, one of the most beautiful examples of Balinese secular architecture. A staircase leads up to the open Pavilion of Justice, where cases were heard. The roof truss is decorated with very expressive frescoes in the *wayang* style. Being depictions of Hell, they remind Western observers of paintings of the Last Judgement, or of the nightmare visions of Hieronymus Bosch and Pieter Breughel. The lower rows of pictures vividly portray in a gruesome and detailed manner the possible torments of Hell; these would certainly have acted as a warning to those who had business in court of the harsh consequences of transgressions. The upper rows of pictures, by contrast, show paradise, with all the comforts that await the good and the pardoned. Alongside the courthouse is another building, the Bale Kembang, the "floating pavilion," the original purpose of which is not clear. Its roof truss is likewise decorated with frescoes in the *wayang* style.

Nowhere else on earth are there as many temples as in Bali. The number is estimated at around 20,000. There are family temples, temples serving several families, temples for individual territories, temples for all Bali, and the three obligatory temples for each village. "Temples in Bali are not buildings, they are open areas at holy places which have been venerated from time immemorial. Situated there are the great chairs made of wood and stone, and the thrones on which the invisible gods sit when the priest calls them."[6]

Before some of the main temples are described, we can first of all turn our attention to village temples. Every village typically has three temples, which are laid out along a mountain-sea axis: the mountains are considered to be the place of the gods, and the sea the domain of demons; the direction of the mountains (*kaja*) is seen as the direction of purity and godliness, whilst the seaward (*kelod*) direction symbolizes impurity and the demonic. These antagonistic powers must be brought into harmony by offering sacrifical gifts to the powers of both good and evil in equal measure. The temple, which is always situated on the seaward side outside the village and near to the burial and cremation areas, is called the *pura dalem*; this is where sacrifices to the creatures of the underworld are made. The *pura desa*, by contrast, is the central village temple, where religious ceremonies are normally performed, and also is a meeting place for the community. The *pura puseh*, finally, is always situated within the boundary of the village on the side nearest the mountains. In this ritual heart of the village sacrifices are made to the divine powers of the upper world.

The other temples, apart from the temples for the use of the whole state of Bali, are not general places of assembly and worship, which again makes them very different from churches, mosques, or synagogues. We can look briefly at a few of these main or state temples.

The temple of Besakih, the "mother of all the temples," lies at the foot of the highest mountain in Bali, the Gunung Agung (see page 338, top). This, the largest temple site in Bali, in which every village is represented by a sacred building, is an excellent illustration of the structure of a temple site. After climbing the seven stepped terraces, visitors enter by a double gate to the first courtyard, a kind of forecourt which symbolizes the earthly world, which has pavilions for the preparation of sacrificial offerings, rice stores, and resting places for the faithful. The second courtyard is reached through a covered gateway that looks as if someone had pushed together the first double gate, thus making the outer duality an inner unity. The central courtyard in effect forms the way through to the inner sanctum. Here we find the meeting hall and pavilions for the gamelan orchestra and for various cult objects. One last passageway leads into the third courtyard; this is the inner sanctum and so corresponds in holiness to the altar area in a Christian church. Here, shrines, pagodas, and altars dedicated to the deities are lined up next to each other. Characteristic of Besakih is the large number of Merus: wooden constructions with pagoda-like roofs covered in palm fibers that are piled up on top of each other and taper off in size as they rise. These symbolize the mythological world mountain, the seat of the gods. The number of roofs is always an odd number, from three to eleven (see opposite page). Shiva is given eleven roofs, Brahma and Vishnu nine, and the ancestors are allocated the other numbers. A wealth of small subsidiary temples adjoins the main site. The fact that the temple site is divided into three again symbolizes the Trimurti, the Hindu trinity of Shiva, Brahma, and Vishnu. As the indisputable main divinity, Shiva especially is honored in the inner sanctum.

A further important temple connected with the Besakih is the Goa Lawah, situated on the straits of Badung. Goa means "cave," Lawah "bat," and thousands of bats, regarded as holy, nest inside the

Pura-Taman-Ayan
Bali

These distinctive Merus, pagoda-like wooden constructions with roofs of palm fibers, symbolize the mythological world mountain, the seat of the gods. The number of roofs is always uneven: 3, 5, 7, 9, or 11. Eleven roofs is the number reserved solely for Shiva, nine for Brahma and Vishnu; the ancestors are given three or five. In the environs of the main complex there are different shrines and thrones for the various deities.

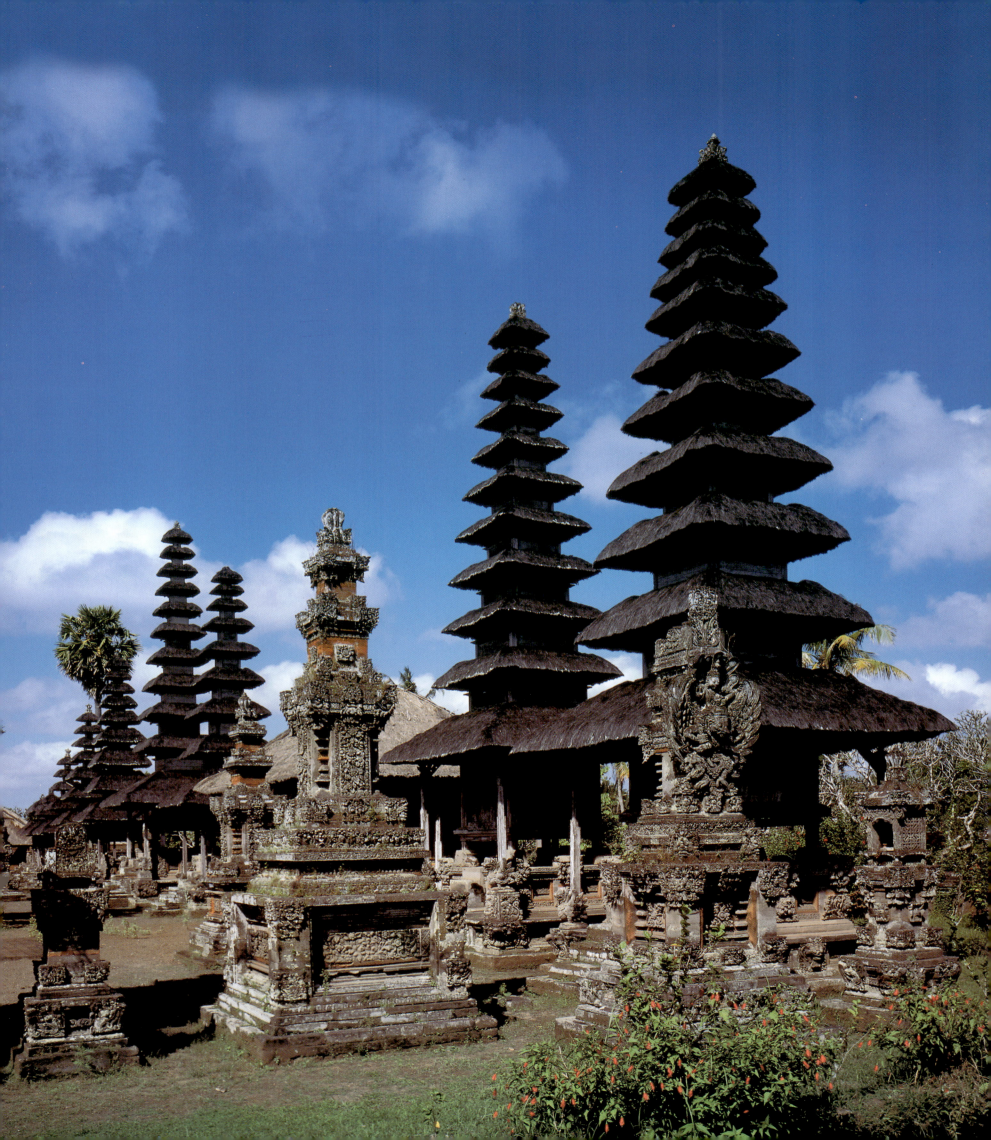

cave and on its exterior walls. This "cave of bats" leads deep into the mountain and is supposed to end at the Gunung Agung; in this way there is a direct link between this temple and the temple of Besakih. The snake of the underworld, Basuki, is supposed to live in the cave, and the first shrine at Besakih is supposedly dedicated to him; in the inner courtyard a stone throne is dedicated to him and to the mythical snake Antaboga. Goa Lawah is the underworld counterpart to Besakih, which is seen as occupying the upper world.

On the southernmost tip of Bali, on a high cliff facing the Indian Ocean, lies Ulu Watu (see opposite, bottom left). It is dedicated to the tutelary goddess of the sea, Devi Danu. The Pura Ulu Watu is one of the nine state temples and reflects the significance of the power of the sea.

A further temple dedicated to Devi Danu, the water goddess, is the Pura Ulun Danu situated on Lake Bratan in north Bali (see below). There is a row of Merus here, too, some of which project into the sea on a spit of land. Before people go into the Hindu-Balinese temple sites, they pass on the left of the double gate a pagoda in whose niches sit five meditating Buddhas, a sign of the adoption of elements of Buddhist belief into the Balinese form

of Hinduism. The elephant cave of Goa Gajah, near Ubud in central Bali, is a shrine which is constructed completely differently. Perhaps the elephant god Ganesha, the son of Shiva, gave it its name. Above the entrance, this cultural monument from the old Balinese era bears the grotesque face of a devil, a so-called Kala head (see right).

The cave is T-shaped. At the end of the passageway is the long part of the cave, where a triple *linga yoni* motif on a stone altar is found on the right-hand side, symbolizing the Trimurti. Ganesha sits enthroned on the left. In front of the cave there is a beautifully decorated bathing area with statues of nymphs spouting water.

Unlike on Java, which is now Moslem, Hinduism is still very much alive on Bali and the temples are still in use; in fact, this highly distinctive form of Hinduism (Agama Hindu Dharma), which has absorbed a range of local influences, plays a leading role in the recognition of the indigenous religions of Indonesia: these religions are counted as Hindu in order to fulfil the requirement of the Indonesian government, which states that only world religions can be accepted as religions in Indonesia, in other words Christianity, Islam, Hinduism, and Buddhism.

Opposite, top
Pura Besakih

The most important shrine of Bali is situated at the foot of the highest mountain, the Gunung Agung (3142 m). Typical of Balinese temples are the four Merus, which here form a veritable forest.

Opposite, bottom
Pura Ulun Danu

Lake Beratan, Bali

Top right
Goa-Gajah grotto

A.D. *1000–1100, Bedulu, Gianyar, Bali, with a Kala head above the entrance*

Above
Pura Ulu Watu

Bukit Jimbaran, Bali

Above
***Candi*, excavated from the Gunung Kawi**

A.D. *1000–1100, Tampaksiring, Gianyar, Bali*

This site consists of five temples. In one of the *candi* the ashes of Anak Wungshu, who reigned over Bali 1049–1077, are said to be buried. He and four other kings from the earliest period had built themselves this temple-tomb which was once guarded by a monastery. On the other side of the Pekerisan River are said to lie the tombs of their queens in four smaller *candi*.

Guardian in front of the *pura* (temple)

Stone, Bali

The grotesque face, with its bulging eyes, is reminiscent of Kala figures portrayed at the entrance gate of Javanese *candi*.

Opposite, left
Head of Avalokiteshvara

9th century, Andenit, H 31.1 cm, W 19 cm, D 21.6 cm, Central Java

The passive, introspected attitude is typical of statues in Central Java.

Opposite, right
Kubera (or Jambhala), deity of good health

9th century A.D., stone, H 74 cm, W 29.2 cm, D 28 cm, Central Java

The deity of health or well-being was very popular with the Hindus, the Jain, and the Buddhists during the Gupta period in India. Afterwards the veneration of this deity declined in India but continued to be popular in Central Java. He is also known as "Lord of the Jaksa" (spirits).

Sculpture

As we have seen, in Indonesia Hinduism and Buddhism, which were integrated into the original native religion, and adapted to local needs, developed into new forms. Some academics speak of "selective adaptation," others of "syncretism," and some of "localization." Individual forms, developed on Java and Bali, are described as Hindu-Javanese and Hindu-Balinese.

According to ancient written sources, both religions, Hinduism and Buddhism, were even regarded as one; for example, in the 13th century an East Javan king, Kertanagara, was known to be a supporter of the "Shiva Buddha" sect. The tendency to unite everything into one form is typical of the Indonesian island state; the words *Bhineka tunggal ika*, "unity in diversity," has been the motto of the Republic of Indonesia since 1945. This is clearly shown by the sculptures and reliefs on buildings, which display figures recognizable from both Hindu and Buddhist traditions.

The reliefs on Buddhist buildings such as the Borobudur contain scenes from the *Jataka*, stories from the life of the historical Buddha. There are also Buddhas illustrating the five "cosmic Buddhas" (four of them portray the four points of the compass, Akshobya, Ratnasambhava, Amitabha, and Amoghasiddhi). But the sixth Buddha at the Borobudur (mentioned above) is unique; he is to be found in the niches of the fifth terrace above the Buddhas of the four points of the compass and below the Buddha of the Central Point (of the compass).

The most important Hindu deities represented in temples are Shiva and his wife Durga; the bull Nandi, Shiva's mount; Vishnu, his wife Lakshmi, and his mount, the mythical bird Garuda; and Brahma with his mount, the gander Hamsa. Other frequently portrayed figures and motifs are, among others, Ganesha, the deity with the elephant's head, a son of Shiva, who is considered to be the god of wisdom and knowledge; the lingam or phallus of the god Shiva, which is revered as a symbol of his creative power and as a sign that the temple is dedicated to the godhead of Shiva; and Kala, who, according to Javanese belief, is a son of Shiva, and is depicted on thresholds above the doorway as a guardian of the entrance to a temple.

Traditional Arts and Crafts

Art, religion, and everyday life

The concept of art held by the indigenous peoples of Indonesia is very different from that commonly held in the West. In Indonesia, artistic creativity is seen as an aid to building a bridge between the living and the inhabitants of the other world, whether they be deities, ancestors, or spirits. It is also not important who created the work of art; the artist remains in the background. What is important is *why* an object is made; its function. Creating *objets d'art* purely for art's sake is quite foreign to this way of thinking. Presumably it was not until after the encounter with the West that artistic objects were made that were not only for religious use but also commercial use, for sale because their beauty appealed to foreigners. This "modern" development goes so far in some regions that the so-called *objet d'art* has completely lost its

ngayu originally meant "going upriver" (in contrast to *ngawa*, "going downriver") and the Ngaju do in fact live mainly on the upper reaches of the river. It is difficult to regard the Ngaju as one unified ethnic group since the culture and tradition of the people are different on every river bank, though in their basic characteristics they show several strong similarities. Nevertheless, the Ngaju language is spoken over almost the whole of South and Central Borneo and is regarded as the language of communication for this area.

From the middle of the 19th century onwards, evangelical missionaries from Germany lived in South Borneo; several of them took a keen interest in the religion of the Ngaju, and left detailed records of their observations of Ngaju life. In addition, they introduced the Latin script. The Ngaju

original sacred meaning and is now solely an item for the tourist trade.

In approaching Indonesian arts, we will first look at artistic work in terms of its sacred significance. In order to do this we will consider specific ethnic groups through broader cultural issues, such as their way of life, their religion, and the structure of their society. The first group we shall look at are the Ngaju Dayak of Borneo.

The Ngaju Dayak of Borneo

The word *Dayak* originally meant "inlander:" the Dayak are thought to be the original inhabitants of the island of Borneo, particularly the center; the Malays and the Chinese live on the coasts. The Dayaks, according to different languages and cultures, are divided into various tribes, notably the Iban in West Borneo; the Kenyah in East Borneo; and the Ngaju and Maanyan in South Borneo. In addition there are the predatory Punan. The Ngaju live along the rivers Barito, Kapuas, Kahayan, Katingan, and Mentaya. The word

themselves had no written language and handed down their tradition and religion orally from generation to generation. The missionaries were a mixed blessing. On the one hand we have the missionaries to thank for documenting Ngaju religious, cultural, and social life so well, and for bringing so many Ngaju objects to museums in the West. On the other hand, the missionaries contributed to the decline of the Ngaju, who gradually lost any respect for their own traditions and religion. Valuable though the documents and museum pieces are for our understanding of the region, they are of no value to the Ngaju themselves. They can hardly recover lost aspects of their culture by visiting museums or reading French or German books on the subject. In addition, the "educated" Ngaju nowadays show very little interest in their culture since they are keen to dispel the widely held view that they are a "primitive" people. They acquired this negative view from the missionaries, from the Dutch colonial power, and, more recently, even from the Indonesian government. It was not until 1980 that

Model of a Dayak boat

Before 1937, wood, rattan, cotton-material, palm-leaf, resin, L 67 cm, Dayak, Borneo, Staatliches Museum für Völkerkunde, München, Inv. No. W.19

The kind of dugout illustrated by this model, still in use today in Borneo, is carved from a single tree trunk. At the front the typical motif of a rhinoceros bird and a water snake can be seen, symbolizing the upper and lower worlds.

the government recognized their beliefs as a true religion and not just "superstition." Since then they have been able to practice their religion, and have gained certain individual freedoms, though even now they are experiencing discrimination, particularly when they seek political or government positions. And the Ngaju who are still living the traditional lifestyle are also facing profound changes in the modern world, in particular the disappearance of the rain forest. The hunting of certain wild animals, the unregulated development of gold mines, and the felling of ancient trees had been prohibited; but these rights, which the government had granted to them for generations, have now been assigned to foreign firms in the form of government concessions. Furthermore, there are serious problems caused by the arrival of new immigrant races, most of whom belong to other religions (for example Muslims from Java

and Madura). The Ngaju's religion is officially called Agama; by a bureaucratic slight of hand it is linked to Hinduism, though this is merely to comply with government regulations that states that only major world religions (such as Christianity, Islam, Buddhism, and Hinduism) will be given state recognition. The Ngaju themselves call their religion *kaharingan*, from *haring*, that is to say "from oneself, from living alone" — like the tree in the forest, which no one plants and no one cares for, but which is there nevertheless and survives. Looked at from a Western point of view, the word might be taken to mean "vegetate," or "merely exist." In this word, then, we can begin to see the difference between two very different philosophies of life: what appears to be negative from a Western viewpoint is something positive for those who practice *kaharingan*, or to put it a better way, something "natural."

Raft-huts by the river

1987, Tumbang Malahui, Borneo

In Borneo, houses are always built by the river, as the river represents the only plentiful source of water. Here people bathe, do the washing, and fetch water for cooking and drinking. The raft-huts serve as toilets.

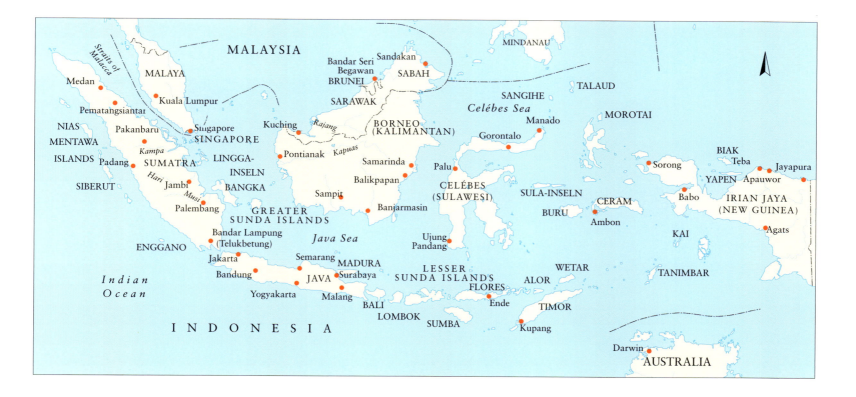

The religion of the Ngaju, like the other native religions of Indonesia, is not so clearly divorced from everyday life as religion is in the West. Religious practices such as going to church once a week, praying before a meal or five times a day, making a confession, and so on, are foreign to the Ngaju. But the Ngaju have rules of taboo that they have to observe absolutely, or, so they believe, bad luck would befall them; taboos such as never traveling on a Saturday, not interrupting eating (otherwise one would be bitten by snakes), not going into the forest to collect rubber in the rain, planting rice only in a certain month, not making too much noise when bathing in the river, not swimming against the current, not eating certain animals, and so on. Many of these rules of taboo are easy to explain, some are not.

Rituals are as much a part of the Dayak's everyday life as eating and drinking are. They hold rituals at every opportunity: before a long journey, when building a house, when healing the sick,

before accepting certain obligations, when there are problems they are unable to resolve. These rituals are held to consult the deities and ancestors, and to receive permission for the planned activities. In addition there are more important rituals that could be described as *rites de passage*, related births, initiation into society, marriage, and death. The ritual that is celebrated most lavishly is the death festival, because its purpose is to secure safe passage to the next world; the period in this fallen world is a "borrowed" life and death symbolizes birth into the eternal upper world, where the ancestors and deities live.

The Ngaju live in harmony with nature. They subsist on fruits of the forest, animals they have caught in the jungle, fish they have netted in the river, and the crops they have grown in their own fields. They keep pigs and hens as domestic animals, which they slaughter on specific occasions. They build their settlement on the river so that they can easily get to the water (see page 343). They also build their riverside houses on stilts, in order to deny entry to unwanted guests – enemies (in earlier times wars were fought that were closely linked to headhunts), evil spirits, wild animals (including tigers, orangutans, many sorts of monkeys, snakes, and rhinoceroses), insects (flies, scorpions, and spiders), as well as a large number of rats. The stilt buildings also served as a protection against floods since, after rain, the rivers can rise very rapidly.

The long house forms the living accommodation for a family group whose members are bound together by strong ties of loyalty (which would for example determine which side was taken in the event of a dispute with other members of the tribe, or in a war). When the group becomes too big, the members can move out and build their own long house, built to the same design but smaller. Usually there is only one traditional long house in each village; the Ngaju call this a *betang*, and they call smaller houses *huma*.

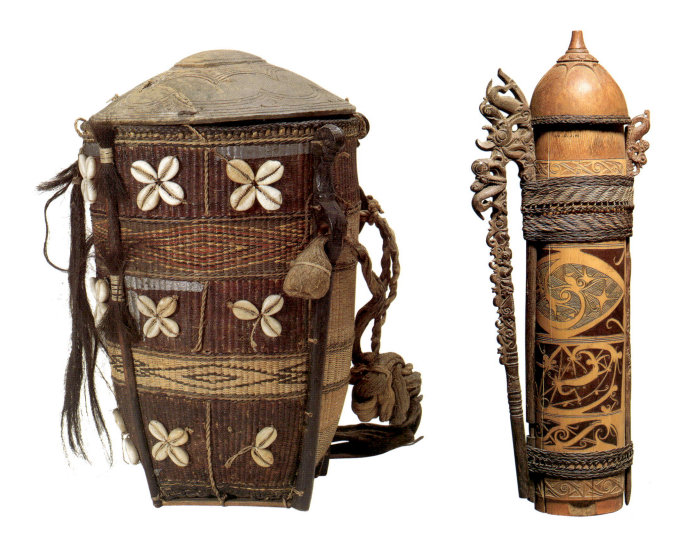

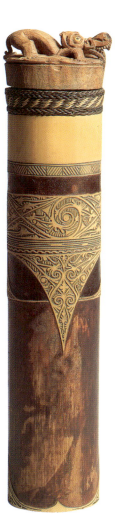

The Ngaju live on the upper reaches of the river and even today survive mainly from subsistence farming; that is, they plant and harvest for their own use and not to sell. Almost everything they need for daily use they can obtain from the fields and the forest. In the last 50 years, however, they have started to deal in rubber and rattan, which have now become an important source of income for the Ngaju. Other sources of income are, for example, panning for gold from the rivers, collecting semiprecious stones, chopping and selling wood, and catching game. When working the fields, the Dayaks use the slash-and-burn method of cultivation, for the land on Borneo does not produce many nutrients and is soon exhausted by cultivation. Besides clearing the land, the burning returns nutrients to the soil in the form of ash. After the slash-and-burn they plant the fields with rice, an event accompanied by grand rituals and celebrations in which all the villagers take part; a family will help other families with their planting, and will celebrate with them at the final festival. The Ngaju possess varieties of rice, passed down to them by their forefathers, that no longer exist on Java, and they carefully keep a supply of each so that the genetic range will be preserved and passed on to their children. After a year the rice is harvested and there is a thanksgiving celebration, an event that is often timed to coincide with the equally lavish festival of the dead. In fact the period

from planting to reaping is considered a life cycle, so ceremonies for the dead, which would disturb this natural cycle, are not held until it is complete.

As the field cannot be planted with rice again for three years, after the harvest they are used for the cultivation of herbs and spices. Most families own three fields, so that they can grow rice in one field every year, the other two being put to different use.

The fields, together with the small family huts, are usually about ten kilometers (six miles) away from the village, so it is not surprising that the Ngaju remain in their huts in the fields for most of the time, and not in the long house in the village. The long house is used for taking part in village life, meeting other family members, and holding rituals, events that strengthen the solidarity of the many inhabitants of the long house. The long house, then, functions not just as a place of residence, but also as a meeting place where members of the group can come together on important occasions.

The everyday life of the Ngaju

The everyday life of the Ngaju revolves around the necessities of life. They have either to plant, produce food themselves, or hunt for all their basic daily needs. Instead of going to the supermarket, they go into the forest to pick wild berries. The forest provides a wide range of fruit, vegetables,

Far left
Skull basket

Before 1876, rattan, wood, kauri snails, tinfoil, human hair, vegetable fibers, raffia, H 30 cm, dia at top 18 cm, Dayak, Borneo, Staatliches Museum für Völkerkunde, München, Inv. No. Gr.343

Center
Container for blowpipe darts

Before 1928, bamboo, wood, ratten, H 40 cm, dia 7 cm, Dayak, Borneo, Staatliches Museum für Völkerkunde, München, Inv. No. 28-30-21

Right
Container for blowpipe darts

Before 1928, bamboo, wood, rattan, glass beads as eyes for the dog on lid, H 25 cm, dia 4 cm, Dayak, Borneo, Staatliches Museum für Völkerkunde, München, Inv. No. 28-30-23

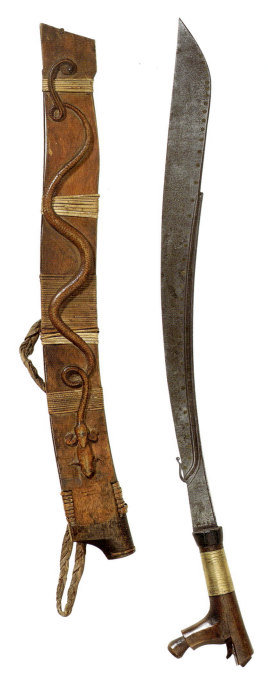

Knife, *mandau*

Before 1910, wood, metal, rattan, brass, vegetable fiber, L 63 cm, Dayak, Borneo, Staatliches Museum für Völkerkunde, München, Inv. No. W.10.788

The snake pattern on the sheath is interesting as it occurs only rarely in this form.

and salads. If they are lucky they catch some wild animals, an important source of additional protein. They also fish, leaving nets in rivers overnight and pulling them in the next morning. However, since the population is growing steadily, the rivers have been well exploited and no longer yield as many fish as they once did.

Nowadays there is also a little *warung* (small shop) in most villages, where the Ngaju can buy everything from washing powder to instant noodles. But the population has very little money, and so demand is not high. If someone sells his rubber or rattan, he generally goes into the provincial capital to buy clothes and items such as a radio, tools, or batteries. He usually spends all the money and returns home with full bags and empty pockets. The Ngaju are not used to saving or putting something aside; and why should they? The forest and the fields have everything they need. But for how much longer?

When they are not working in the fields, the women occupy themselves with handicrafts such as weaving hats or baskets (see page 344). The men on the other hand construct walls and roofs for the huts, make knives and other tools for hunting, including blow pipes and their darts, and repair the boats and the fishing nets. Most of the objects are tools of one sort or another, and they are provided with symbols that invoke supernatural powers and so protect the people using them. Manufacturing such objects is an important task that requires great skill, and anyone not very artistically minded is given simpler jobs to perform.

Favorite decorative elements of the Ngaju are the rhinoceros bird and the water snake (see page 344); they personify, respectively, the deities of the upper world and underworld. Very often both are represented together, the aim being to underline the unity of the elements.

Everyday items are also used in ceremonies. But in this case they must first of all be made into sacred objects by a priest, who will recite the "creation myth" of the objects in question. Each creation myth tells how the essence of the object was originally derived from the body of a hero from the upper world, whose death was necessary to improve the life of people on earth. It was in this way that the Ngaju received, amongst other things, useful plants, water, chalk, iron, and tools. With these creation myths the priest sanctifies the origins of objects and so sanctions its use in ritual; when a knife has to be sanctioned, for example, the priest will recite the creation myth of iron, which says that it came from the bones of a specific supernatural hero.

At least once a week, in the village or in the huts surrounding it, there is a ceremony for healing the sick, or for interpreting oracles, driving out of madness, and so on. Such events are regarded as a celebration, and people not immediately involved may be drawn to it; just as people in the West go to the movies or theater in the evenings, so the Dayak take part in a ceremony. Rituals that attract large numbers are also an opportunity to meet people from beyond their group, which could lead to new friendships or marriage.

The Ngajus' religious philosophy

In the sacred language of the Ngaju Dayaks, this world bears the name "river of borrowed life" (*lewu danum injam tingang*). Life on earth is a borrowed life, and at death a person returns to his place of origin. For this reason death is not a tragic event for the person dying; it promises admission to the longed-for eternal life in the village of the dead, *lewu tatau* ("rich village"). Its full name, *lewu tatau dia rumpang tulang, rundung raja dia malesu uhat*, provides a vivid image of the idea which the Ngaju have about their next world: "The village where bones don't strain and muscles don't grow weary; a village which lies on golden sand and whose sandbank is made of diamonds." People and objects in *lewu tatau* are the same as on earth, but everything is the other way round. What is left here appears to be right there, large becomes small, and whatever walks on its feet in this world, moves on its head there. Food is plentiful, for a soul will find all the rice (*gana*) that he ate on earth stored up for his use in the next life. The tree of life, *batang garing*, grows in the middle of the village of the dead. Its leaves are made of the finest cloth, which can be made into clothes. Its fruits are agates (*lamiang*) and its seeds are made of gold. The water of life, *danum kaharingan*, which never runs dry, flows in the trunk of the *garing* tree. His relatives and close friends live close by. This view of life in the village of the dead, freed from all the trials and tribulations of the earthly life, allows the Ngaju to view their departure from this life with great calm.

The rite of passage that begins at the moment of death finds its longed-for conclusion in the dead person's celebratory entry into the village of the dead. The journey between these two events is seen as one that lasts several years, in the course of which the body and soul of the dead person must pass through several important stages. In order to aid the dead person's journey through these stages, his relatives perform purification ceremonies by holding a primary and a secondary burial.

At the moment of death the soul (*hambaruan*) leaves its earthly resting place through the fontanel. A bronze gong (*garuntung*) is hung up at the entrance to the dead person's house and is beaten in a special rhythm (*titih*) as a sign of the departure of the dead. The members of the family dress the dead person in festive clothes and lay him out in the middle of the reception room in the house. In order that the power of sight and the freshness of the lips will also be preserved in the next life, coins are placed on the eyes and an agate on his lips. Immediately after death, the family engages a priest with special qualifications, the *tukang tawur*, who, by scattering rice and reciting certain ritual formulas, informs the people of the upper world (*sangiang*) of the death, and requests them to come down to earth and accompany the

dead soul into the next life. Part of the ceremonial room is specially set aside for those priests (*basir*) into whom the *sangiang* will enter and through whom they will enact the ceremony of accompanying the soul on its journey. The walls are lined with sacred hangings and on the ground large bronze gongs are placed side by side in a line (as a symbol of the water snake holding up the world); the priests sit on these while they recite the words of the ritual. For the first three days the body remains in the room on the bier, surrounded by precious "sacred heirlooms" (*pusaka*) and by gifts for the spiritual journey. Friends and acquaintances from the village call and say a last farewell. On the morning of the fourth day the wooden coffin is sealed and carried to the cemetery by priests and family members. The coffin is let down into a grave and covered with the dug-out earth in what to Western eyes may seem a rather shabby burial ground situated downriver. The bereaved mark the head end of the grave with a plain undecorated piece of wood on which only the engraved name of the deceased can be read; at the foot they place a small plate with sacrificial offerings.

If we find this funeral service somewhat cold it is only because we are unaware of the Ngaju Dayak's approach of death, and in particular of their concept of primary burial. At the moment of death the human soul breaks up into its four parts. A "breath-giving part of the soul," which escapes from the fontanel immediately after death, returns to the upper world (*lewu tatau*) and waits there for the time when it will be reunited with the other three parts of the soul at the second burial (*tiwah*). The second part of the soul, called *liau kaharingan*, the Ngaju see as the "dream-giving" soul. The songs of the priests accompany it into the *lewu bukit nalian lanting*, the village of souls, which is

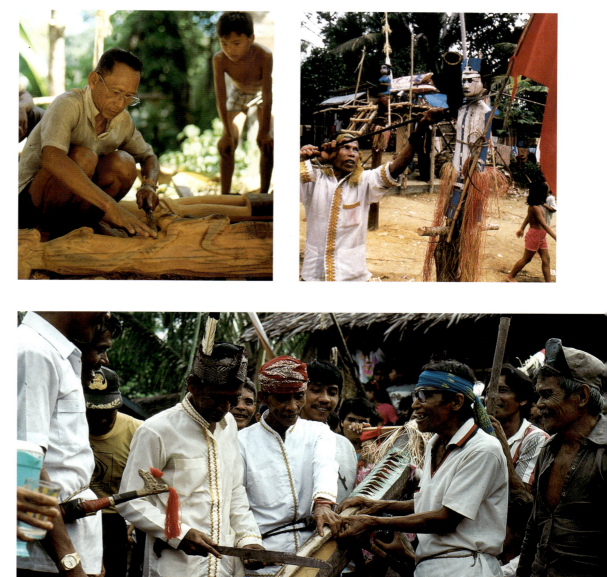

A *tiwah*, or festival of the dead

1987/88, in Tumbang Malahui, Central Kalimantan

The festival begins with an animal being bound to the sacrificial stakes.

Top left

A carver then makes a *sapundu*, a figure whose gender corresponds with that of the animal and who represents the soul of the assistant who will follow the dead person into the other world and perform all his chores.

Bottom

Women prepare a sacrificial meal, which serves as food for the souls of the dead on their way to the next world.

Immediately above

Before the killing of the animals, the climax of the festival, the sacrificial stakes are ceremonially set up.

Top right

At the end of the festival the images on the sacrificial stakes are stabbed as a symbol of a new life – the spouse of the dead person is now free to enter into a new marriage.

Sapundu carved from ironwood

1987/88, in Tumbang Malahui, Central Kalimantan

After every festival of the dead the sacrificial stakes from the main square are set up next to the appropriate ossuary. They thus stand in isolation in the landscape. As they are carved from ironwood, they have a long life, though of course they lose their color. The style of the figures is very individual, as every *sapundu* carver is free to use his own imagination.

situated in the third stage of heaven. The *liau kaharingan* remains in this village until the second burial; this stay in the third stage of heaven serves to purify the dead person from life in this world. The so-called "soul of the flesh and blood" is taken to the second stage of heaven, where it too has to await the second burial. The soul of the "mortal remains" (bones, hair, nails) is the fourth part of the soul. The flesh falling from the body is seen as the beginning of the purification process in this part of the soul. Not until the flesh has become one with the earth is the purification far enough advanced for the soul to be accompanied to the upper world, a process that comes to an end when the bones are removed from the grave. The sacrificial offerings at the grave are meant for this soul, too, so that it remains close to the grave and does not return to the village to make mischief.

The time the mortal remains spend in the ground is conceived as a symbolic pregnancy that precedes the birth into the next world. After two years at the earliest, by which time the body has been reduced to bones, the purification processes come to an end with the ritual of the transference of the bones, one of the most important religious events in the life of every Ngaju, his family, and the whole village community. The Ngaju call the festival of the dead *tiwah*, which means "being free, released from obligation." In other words the ritual is about the release of the dead person, who is finally saying goodbye to his earlier troubled life on earth and is also being released from the shadowy existence of the "intermediate stage." This is also a release for the surviving relatives, since the dangers which accompany every death for the dead person's family and the village community are now over. The decision to hold a *tiwah*, which may last four weeks, is made by the village leaders.

The Ngaju believe that the welfare and happiness of their dead in the next world is decided by the things they receive as sacrificial offerings on their last dangerous journey. These offerings have to reflect the status and the wealth of the dead person; if they do not, the living will incur his anger, and also lose face in front of the village. It is not uncommon for relatives who have to bury a high-ranking member of their family to get themselves into considerable debt in order to comply with all the demands made upon them by the full observance of these social and religious obligations. This pressure is mainly a burden on the families who have organized the *tiwah*. They are obliged to provide the most expensive sacrificial gift the Ngaju know – namely the sacrificial cow – to follow the soul of the dead into *lewu tatau*. The obligatory preparation of the sacrificial cow alone means a considerable financial burden, for since the Ngaju themselves do not breed cattle, they have to buy them at a price that quite often equals the money earned from collecting rubber for six months. In addition, they have to find large amounts of rice to feed the countless guests and family members who will attend; two or three pigs

and several chickens, which are necessary for the many smaller ceremonies; and gold and some cash to pay the priests (*basir*) for their work. Poor families who would find it difficult to afford a fully grown pig, and certainly not a cow, as a sacrificial gift, join in the ceremonies of the well-to-do. The families who contribute a sacrificial cow in honor of their dead erect a specially prepared sacrificial post at the main square. A day before the sacrifice of the animals, the participants engage woodcarvers, *tukan sapundu*, to carve a figure (*sapundu*) at the top of the post (see page 347, top left); the gender of the figure must correspond to that of the sacrificial animal. This figure is a symbol of the soul of the assistant who follows the dead person

(see page 347, top left)

Top
Feathers of the rhinoceros bird, *kalangkang garu*

At a festival of the dead, tiwah, 1987/88 in Tumbang Malahui, Central Kalimantan

The feathers of the rhinoceros bird serve as a "landing place" for those who dwell in the upper world when they come down to earth.

Above
An offering

At a festival of the dead, tiwah, 1987/88, in Tumbang Malahui, Central Kalimantan

Rice in palm leaves, *ketupat*, chicken, betel utensils, and holy water can be seen.

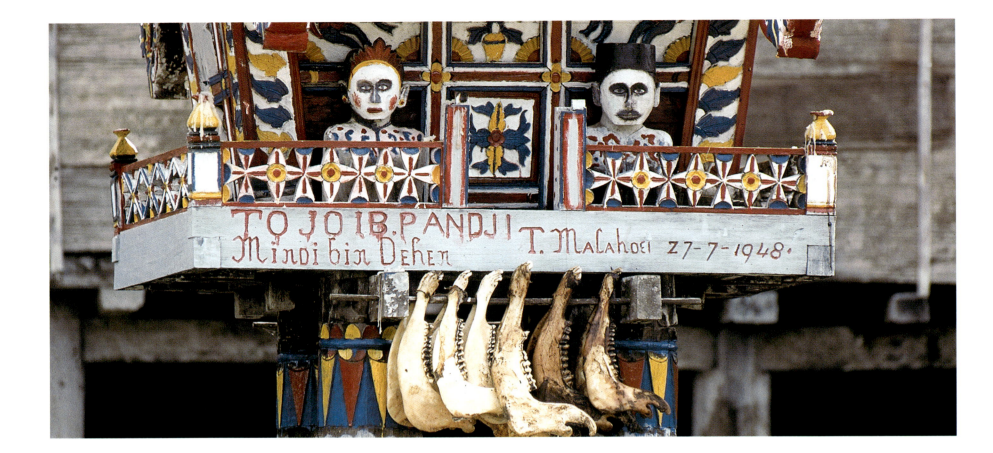

Ossuary, *sandung*

(Detail), ironwood, Tumbang Malahui, Central Kalimantan, Borneo

As we can see from the sign, this ossuary belongs to the Tojoib Pandji family, the founders of the long house in Tumbang Malahui. Only the members of the family are allowed to be interred in this ossuary. Whenever family members sacrifice a buffalo at a festival of the dead, its bones are hung up on the ossuary in remembrance. The colors of the ossuary are renewed at each festival of the dead.

into the next life and takes care of his needs there. It is probable that in earlier times, in place of a cow, enslaved prisoners of war were tortured to death at the *sapundu*. From the middle of the 19th century, however, the Dutch colonial rulers forbade this custom under the threat of death for the masters of the sacrificed slaves. One day before the animal sacrifice, these sacrificial posts are ceremonially erected. All family members are present and the posts, mainly made of carved ironwood, are raised with a loud cry.

During the second burial, the purification processes for the mortal remains and the various parts of the soul are continued and are finally brought to a conclusion with the entry of the soul into *lewu tatau*. In the second burial the family open up the grave of their relative, recover the bones, and remove all remains of skin and hair. A *basir* purifies the souls of these mortal remains by wafting a burning bamboo cane around them. The bones are then wrapped in colored cloths, laid on an upturned gong, and carried back in solemn procession to the village.

In the first ceremonies the *basir* call on the *sangiang* and make them come down into the ceremonial room. Feathers of the argus pheasant and the rhinoceros bird serve the *sangiang* as a connecting link between this world and the next, for it is through this bunch of feathers that the *sangiang* gain access to the assembly. They remain in the ceremonial room for the duration of the *tiwah*, protect all the people present, and play the essential part in ensuring the success of the proceedings. In order that the *sangiang* also feel

well received and cared for, the *basir* always have a range of sacrificial gifts ready for them: rice, eggs, cooked meat of domestic animals, utensils made of betel, and the blood of a sacrificial hen or pig (see page 349). The actions of the *sangiang*, which are described in the priests' songs, bear a close relation to the actions performed by the participants in the *tiwah*. In other words the participants' actions — carving and erecting the sacrificial posts (the *sapundu*), the building of the ossuaries and so on — are performed again by the *sangiang* and so "sanctified," their actions being accompanied, and described, by the songs of the *basir*. The fact that the *tiwah* is the most important religious event of Ngaju society is also reflected in sacred texts: before the souls of the dead embark on their last journey, the whole cosmos, the people and their community, are created anew by the recitation of the creation myth and genealogies.

In the ceremony held by the Nyakean, members of the family take leave of the mortal remains of their relatives by touching the skull one last time with their cheeks. Afterwards the bones are tied together in colorful cloths and buried forever in the ossuary, the *sandung* (see above, and opposite). The successful placing of the bones in the *sandung* is a symbol of the life of the relatives continuing happily in the next world. Thus the bereaved have fulfilled all their duties towards their dead relatives and can imagine them being safe and happy in *lewu tatau*.

For the Ngaju Dayak, death brought "impurity," which is why the rituals have as their central purpose purification. Nor was this

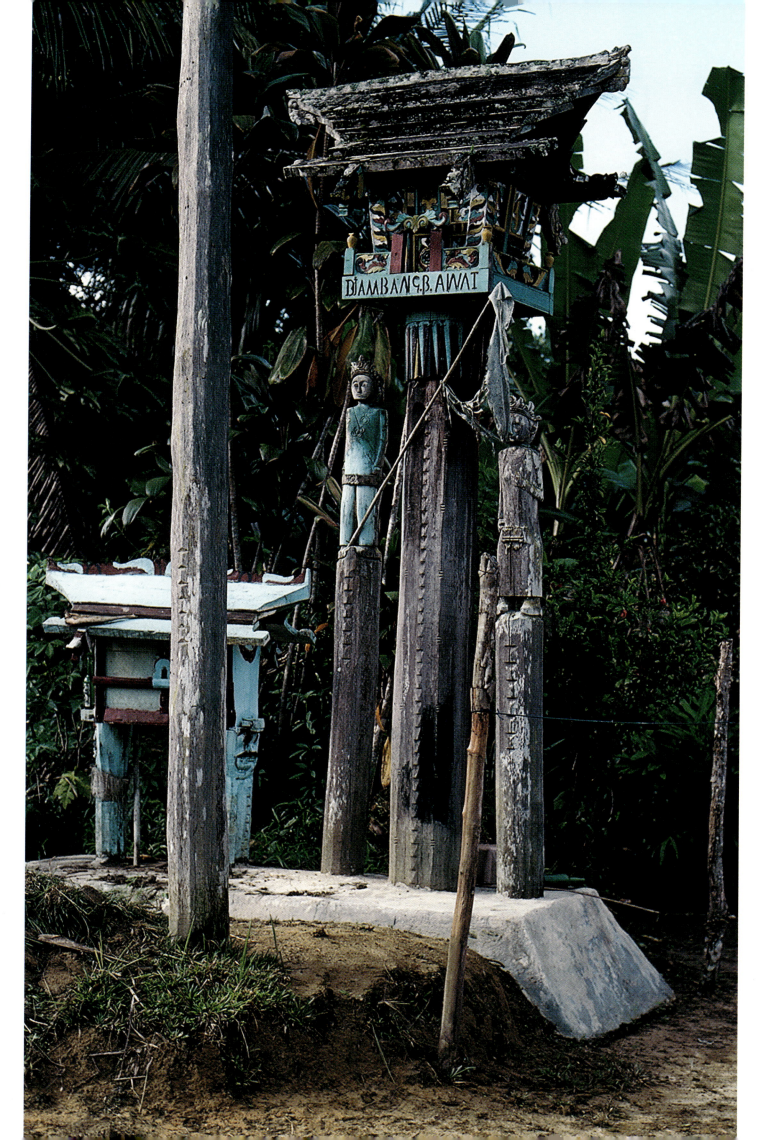

Ossuary, *sandung*

Ironwood, Central Kalimantan, Borneo

This is the oldest ossuary in Tumbang
Malahui, and probably dates from the end
of the 19th century. An ossuary standing
on two legs (or as here one leg) usually
indicates a "bad death" (death by acci-
dent), though in fact this is not the case
in this instance. The *sapundu* can be
viewed from all sides.

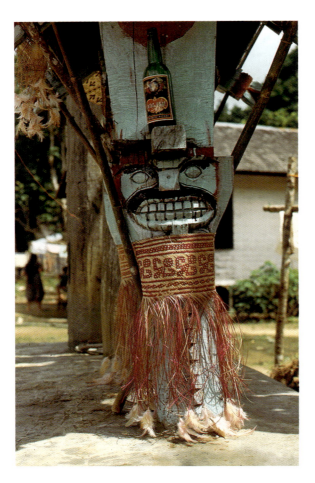

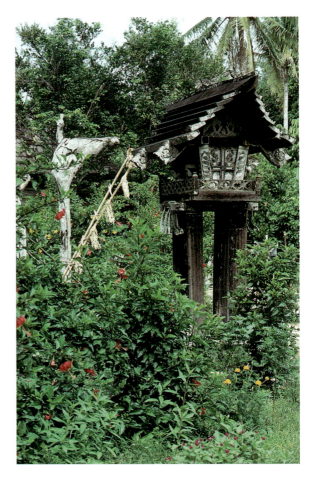

Ossuaries, *sandung*

Ironwood, Central Kalimantan, Borneo

Modern ossuaries are usually built of cement, as ironwood is becoming increasingly difficult to find, and therefore very expensive.

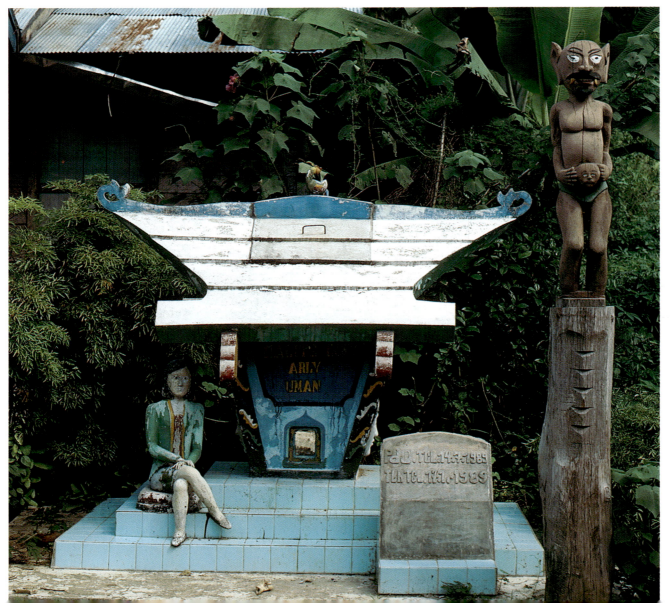

impurity restricted to the deceased; all the family members were affected, particularly the husband or wife. For just as the dead person leads a painful and uncertain existence outside society until his entry into *lewu tatau*, so the family suffer by being subjected to countless restrictions (*pali*). One of the hardest restrictions is that remarriage is forbidden until they have successfully helped their former partner into the next life. As the period between a death and the celebration of *tiwah* may be several years, these *pali* can place a great burden on the relatives of the deceased.

To remove the impurity from the spouses and other close relatives there is the *angkahem* ceremony. Wearing white robes, the funeral costumes of the Ngaju, the relatives of the deceased are taken out into the river on a boat and pushed into the river. As they disappear in the floodwater the water purifies their souls from the stigma of death. After this ritualistic cleansing, the people who have been purified slip into colorful clothes (note the parallelism with the purified bones, which were wrapped in colorful cloths) as a symbol of their full reintegration into the life of the village community. In one of the final ceremonies, the sacrificial posts, the *sapundu*, are stabbed with a spear by the bereaved spouses as a sign that they can now begin a new life and marry again; in other words, the period of mourning is over (see page 347).

Ngaju villages now display a wide range of ossuaries, including modern ones made of cement as well as old ones beautifully carved out of ironwood. Those ossuaries, which stand either on two or four legs, are also worthy of comment. The research literature on the subject records that ossuaries with two legs (or sometimes just one) were for those people who had died of unnatural causes, such as drowning, being eaten by crocodiles, or dying in childbirth. The four-legged type, apparently, were for relatives who had died of old age or after a long illness. But if you see a two-legged one and inquire what the person died of, then the answer is always "of a natural death." So it seems that today the cause of death is no longer of any importance, or perhaps that not everyone is aware of the distinction.

The mats made for ceremonial occasions are also expressions of the divine order. Such a mat contains sacred motifs, such as the tree of life, the upper world or paradise, and boats carrying souls. A motif often appears to a woman in a dream; that is, the motif is communicated to her by the beings who dwell in the upper world. In weaving the rug, the rules of taboo must be closely observed as the motif has in effect been created by supernatural beings; as a consequence, the rug may be used only for ceremonial purposes.

Ceremonial wall mat

Before 1963, woven rattan, L 138 cm, W 67 cm, Kuala-Kapuas, Borneo, Staatliches Museum für Völkerkunde, München, Inv. No. 63-3-4

The design on this ceremonial mat, which is used during ceremonies for the dead, depicts the next world, where the dead live. In the center is the tree of life, growing on golden sand. The birds flying in the air are probably the mythical Piak Liau, which live only in the village of the dead. The houses and seats are symbols of a regal life in the next world, a life without work and everyday cares; above them fly flags and ceremonial umbrellas.

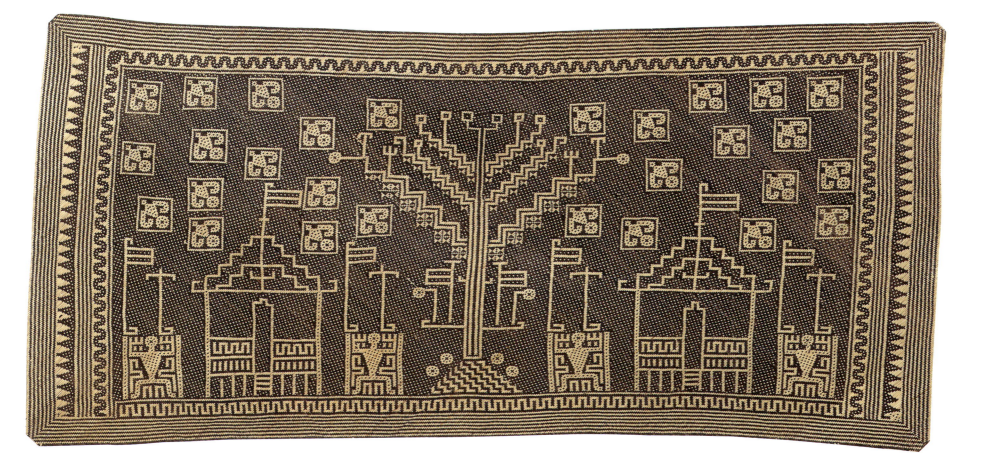

Tattoo motifs

1 and 4 scorpion or *asu* (Iban); 2–4 cotton spinners (Iban); 6 and 10 *andu* fruit (Iban); 7 *sabit*-cord (Iban); 8 dog (*asu, kenyah*); 9 and 15 scorpion-dog (*kenyah*); 11 *lukut* bead (Iban); 12 *tandan* fruit (Iban); 13 arm tattoo of a *kenyah* woman; 14 *trong* flower (Iban); 16 *salilang* coin (Iban)

The *lukut* bead was regarded as particularly precious, and was thought to be effective against illness. It was worn on the wrist on a cord, and so that it would not get lost it was later tattooed as a pattern on the wrist.

Below
Dogs and rhinoceros birds

Before 1928 or 1921, wood, L 20 cm, L 18 cm, L 38 cm, Dayak, Borneo, Staatliches Museum für Völkerkunde, München, Inv. No. 28-30-26, 28-30-24, 21-21-2

The dogs were guardians of a prince's grave. The rhinoceros bird (symbol of the next life) was also a typical motif of the Dayaks of Borneo.

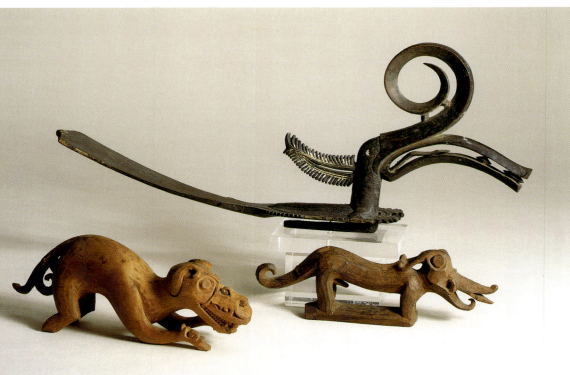

Other Sacred Arts

Tattooing (on Borneo)

Tattooing is also a sacred art, and is especially popular with men. It serves as spiritual protection and can also give the tattooed person supernatural powers, especially in war, when it is supposed to make a man invulnerable. The symbols depicted in a tattoo could have different meanings in different regions; that is to say that a certain motif could be interpreted very differently in North Borneo than in South Borneo (see left). Nevertheless, it is certainly not possible to have just any symbol or pattern as a tattoo, for they are closely related to a specific system of interpretation. There was a tattoo pattern in the Iban tribe that indicated that a man had already captured one head, or that a woman had already woven several scarves. In the Dayak tribe the tattoo artists are usually women, and for a dye they use a mixture of sugar-cane juice and soot from damar resin. As a template for the pattern they use pieces of finely carved wood whose pattern is dyed and then pressed onto the skin to form the required outline for the tattooing.

Sometimes the tattoos are too "hot" for some people, which means that they do not deserve those symbols or they do not have sufficient inner strength to be able to control the magical powers the symbol confers on them. In this case he will become ill and die slowly unless he is treated by a priest, who will have the tattoo removed or altered. These days tattoos are increasingly rare and many have largely lost their sacred significance.

The favorite tattoo motifs amongst the Dayaks are dogs and water snakes, sometimes combined with rhinoceros birds and spiders. With the Ngaju, patterns featuring butterflies are reserved for people of the upper world: the priests' songs describe people in the upper world who display special tattoos that should not be used by humans.

In some tribes on Irian Jaya (New Guinea), the men are tattooed at initiation ceremonies, which means that they do not consider a man to be mature until he has some tattoos. The usual motif is a crocodile, for they are regarded as the tribe's ancestors. On these occasions the tattoo artists are men, since women are not allowed to be present at male initiation ceremonies.

Sacrificial offerings

Contrary to commonly held views, one also counts as sacred arts the sacrificial offerings so lovingly prepared by the women for deities and ancestors, offerings that are used both in the important ceremonies and also in everyday life. The preparation of the sacrificial offerings, which consist of arrangements of food, plants, and flowers, necessitates hours of artistic work, patience, and inspiration. The forms they take vary from one region to the next and are precisely defined; knowledge about them is passed down orally from mothers to daughters. Unlike in the West, where "artistically

made" products are carefully preserved, the sacrificial gifts are destroyed after the ceremony, thrown away, or eaten by the family, since by the end of the ceremony the "essence" of the sacrificial gifts has been absorbed by the gods. On Bali, such sacrificial offerings are a part of everyday life, and every young girl is shown the technique of how the palm leaves (*janur*) have to be sewn together so that they retain a certain shape. Palm leaves are used over the whole of Indonesia for the preparation of sacrificial offerings.

The flowers and plants used usually have some symbolic meaning, and are intended to bring about the fulfillment of someone's wishes. For example, every part of the coconut tree is symbolic, though the symbolic meaning of each part varies from one tribe to the next. On Mentawai, the coconut symbolizes the unity of the society, whilst for the Ngaju it is seen as providing the "water of life," because the water inside the coconut comes, as it were, from nothing.

The banana plant grows easily in the region and so for the Javanese it symbolizes fertility and good luck. As a result there has to be no shortage of banana fruit and leaves at wedding ceremonies, their presence meant to confer on the bride and bridegroom fertility and a life of happiness.

The Balinese have to adhere to certain strict rules in the preparation of the sacrificial offerings, as for example the need to present rice and salt to the spirits in the morning, and flowers and incense sticks to the deities and ancestors in the afternoons. The rules about the arrangement of flowers depend on the deities for whom the sacrificial offerings (*sesajen*) are being made; on Bali they vary from village to village. Specific sacrificial gifts were also made for ceremonies for the dead, gifts the dead are intended to take into the next life. The

Sacrificial offerings on Bali, *banten*

Intended for a deity, such sacrificial offerings are placed on the *meru* (tower) of a temple. The offerings usually consist of plaited palm-leaves, sugar palms, fruits, various rice cakes, plaited coconut leaves, and flowers. The *naga*, above left, stands at the entrance gate and symbolizes the *naga* (serpent) Antaboga, who preserves the world. The *banten* portrayed above is intended for family *pura* (temples).

Offerings, *banten gebogen*

These gifts are intended for ceremonies in a *pura desa* (village temple). The arrangement is the same as in small sacrifices – at the bottom plaited palm leaves, fruits firmly attached to a banana plant, and various rice cakes; and above that flowers and plaited coconut leaves. The fruits vary according to the harvest, and apples are often used because they can be easily attached with a spike. The yellow color symbolizes purity. Such offerings can be up to a meter tall.

most important is the *angenan*, a coconut decorated with other objects. Wooden sticks are put into the coconut and tied together with threads of four different colors. The four elements are associated with the four main deities and the four cardinal points of the compass; the center is associated with Shiva. These four elements also symbolize the four essential parts of the human body: skin (and bone), flesh (and blood), nerves, and breath; and, in addition, as the fifth part, the bone marrow. This can be summed up as follows:

Part of Body	Color	Direction	Deity
Breath	Black	North	Vishnu
Skin and bone	White	East	Ishwara
Flesh and blood	Red	South	Brahma
Nerves	Yellow	West	Makadewa
Bone marrow	Multicolor	Center	Shiva

The Ngayu also offer sacrificial gifts at every ritual, each ceremony having its own specific form. For healing the sick, for example, an ancestral god, Raja Sangumang, is called upon and, at a ritual for the dead, the ancestral god Raja Duhung Mama Tandang. There is a "guest list" of ancestral gods appropriate to each ceremony and specific details of what they like to eat and drink; there are ancestral deities who like to eat boiled chicken, others prefer roast chicken. Apart from ancestral deities

who protect the people and always help them, there are also malign spirits who like to disturb and cause trouble. Among these, for example, are river spirits, forest spirits, and earth spirits. People have to offer them sacrifices in order to win their goodwill, and these spirits like only raw food, principally raw meat and blood.

An offering can consist of a wide range of things; apart from meats, plates are laden with *ketupat* (rice cooked in palm leaves that have been woven into distinctive shapes), rice, utensils made of betel, cigarettes, money, and other useful items. There are approximately 30 sorts of *ketupat*, each one appropriate to a specific recipient or ceremony (see opposite, left). The deity Raja Sangumang (the "protector of man") must be given *ketupat* in the shape of a chicken, other ancestral gods prefer a square *ketupat*. There are certain *ketupat* for ceremonies for the living, and certain *ketupat* for ceremonies for the dead. There are many other distinctions; among ceremonies for the living, for example, there is a clear difference between *ketupat* for a ceremony for healing the sick, and *ketupat* for a ceremony for requesting happiness.

The priests have to know what is necessary for each ceremony, and normally they enlist the help of their wives, who are responsible for the sacrificial offerings and know exactly what the individual ancestral gods prefer. Cooking and preparation of the sacrificial offerings takes up a

Below left
Offering, *angenan*

Before 1925, coconut shell, wood, rattan, cotton thread, little copper discs, H 54 cm, Bali, Staatliches Museum für Völkerkunde, München, Inv. No. 25-49-51/52/53/64

Below right
Offering, *cili*

Before 1925, palm leaves (lontar), H 33 cm, Bali, Staatliches Museum für Völkerkunde, München, Inv. No. 25-49-58b

An elaborate offering like this, made with palm leaves, is a representation of the deity for whom the offering is prepared.

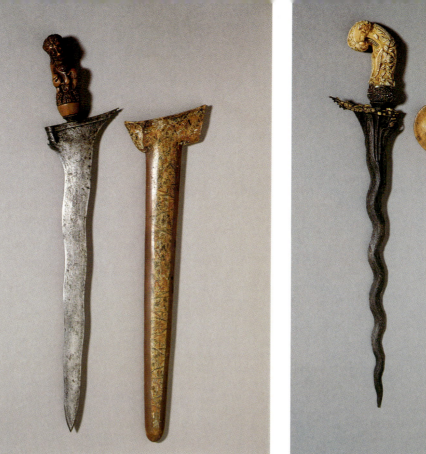

great deal of time and until now this knowledge has been passed down orally.

In some tribes the gong plays an important role in the ceremonies. In Indonesia the gong is not only a musical instrument but also a ritual object, and a form of communication. Beating the gong in a specific way will tell the villagers working the distant rice fields what is happening in the village, the message being conveyed largely by the rhythm with which it is struck. Gongs can call the villagers to a meeting, announce the beginning of a ceremony, or convey information about a death or the arrival of important visitors.

For the Ngaju Dayaks, the gong is used on ritual occasions to make the connecting link between the priests and the upper world, the vital link that enables the priests to perform the ceremony successfully. During a 40-day festival of the dead, the priests sit on the gongs or place their feet on them; in this manner the priests can summon up the inner strength necessary to remain in contact with the upper world.

Gongs are also sacred containers: they symbolize the "bathing pool for the dead," where the soul can purify itself on its journey to the upper world; and they also act as containers when the bones of the dead are taken from the grave to the ossuary.

The keris

A keris is a curved or straight dagger with an engraved damascene blade and finely carved hilt; it is confined exclusively to the Southeast Asian archipelago. The older shapes of keris are described as *keris majapahit* and *keris buda*. The *keris majapahit* can be recognized by its hilt, which

is welded on and is almost always in the shape of a human figure; the *keris buda*, by contrast, has a straight blade with an attached hilt. The oldest surviving keris date from the beginning of the 15th century, and it is thought likely that the keris spread over the whole archipelago with the expansion of the Majapahit empire (12th–16th century).

Every respected family possessed a keris to which supernatural powers were ascribed, and the keris was considered one of the sacred objects (*pusaka*) of a family, clan, dynasty, or even kingdom. Such a keris was passed on from father to son and had always to be taken care of, in other words regularly honored with a purification ritual and sacrifices (according to the Javanese calendar every fifth Tuesday (*kliwon*), that is, every 35 days). Since a keris was thought to possess a spirit, they were given their own name and addressed as *kyai, ki* ("grandfather"). And since a keris was regarded as a person, they, like people, were expected to want food and drink. If its owner forgot or neglected the ritual and sacrifice, misfortune would befall him. On the other hand, the keris protected the family from bad luck, evil, and hostility. Indonesian folklore is full of tales of people who were saved from evil by their keris, or who were the beneficiaries of miracles; one keris was credited with the power to knock on a wall when evil-intentioned visitors came.

Another popular story, dating from the end of the 19th century, relates to a prime minister (*patih*) of Mangkunegoro, who had to put down a rebellion. The rebels massed in front of his palace, ready to kill him. The *patih* came out of the palace, withdrew his keris from its scabbard and held it high. A halo of light immediately lit up the keris. None of the rebels dared to kill the *patih* and

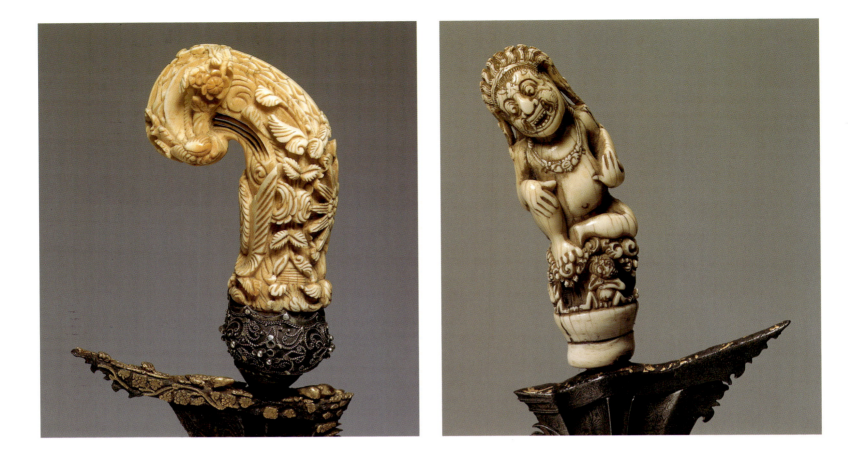

Left
Hilt of a keris

Before 1917, ivory, silver, metal, gold, L 10.5 cm (overall length 49 cm), Java, Staatliches Museum für Völkerkunde, München, Inv. No. 17-27-9

Right
Hilt of a keris

Before 1876, ivory, L 9.5 cm (overall length 44 cm), Java, Staatliches Museum für Völkerkunde, München, Inv. No. Gr. 598

instead knelt down and immediately ended their rebellion. The point here is that the *patih* was able to convince the rebels of the invincible magic power possessed by the keris, and through this he won their respect and awe.

Occasionally, a man had to sell his keris; many of the examples we see today in Western antique shops or museums were obtained in this way. Before a keris was sold, however, it had to be "de-souled," that is, it was taken to a priest or shaman to have its soul removed. When this was done, the keris no longer needed sacrificial offerings.

And occasionally a keris demanded too many sacrificial offerings from its owner, threatening him with disaster if he did not meet these demands. In such cases the keris was thrown into the river, with the result that the soul of the keris went "downriver" and so was banished from the world. Unlike the *mandaus* of the Ngaju (see page 346), which were given life by a creation myth, the production process of the keris was a sacred act right from the start. The keris maker (*empu*) fasted, meditated, and offered sacrifices so that the keris was forged in harmony with the nature and the status of the owner. If the keris was meant for a king it had to be forged one way, and if it was meant for a trader, it had to be forged in a completely different way; in other words, what was right for one person was not necessarily right for another. As a result, an *empu* sometimes took almost a year to complete a keris.

Great technical skill was needed to make a keris. Through the frequent folding together of bars of iron, or iron containing nickel (originally meteoric iron), blades of up to 100 layers of metal were produced. Approximately 5 kilos (11 pounds) of iron, 50 grams (1.8 ounces) of nickel, and 0.5 kilos (over 1 pound) of steel were needed for one keris; yet when made, a keris weighed around 0.4 kilos (1 pound). Through the folding, turning, chiseling, and filing of the iron and steel, a distinctive pattern (*pamor*) emerged that had a symbolic meaning (see opposite page). There are approximately 20 different named and recognized *pamor*.

The upper part of the blade is asymmetrical at the hilt and is often richly decorated with motifs; through these an expert can determine the origin and age of the keris. The curved blade is often associated with a snake or dragon (*naga*) and decorated accordingly (see page 359, left). The number of waves or curves (*luk*) is important: the more *luk* a keris has, the more valuable or sacred it is. The *luk* always have odd numbers, usually seven, nine, eleven, or thirteen. The significance of the number of *luk* has been given as follows:

3 *luk*: fulfills an owner's wish
5 *luk*: fulfills the wish to be liked and popular
7 *luk*: gives the owner dignity
9 *luk*: gives the owner dignity, charisma, and leadership qualities
11 *luk*: creates a high-ranking position and a good career for the owner
13 *luk*: creates peace and a balanced nature for the owner.

There are more than 50 different shapes of blades, all of which are identified by name.

The hilts of the keris are likewise works of art, and attract great interest from Western collectors

Opposite
Blade of a keris

Before 1937, steel, inlaid with nickel (pamor), semi-precious stones, diamonds, gold, overall length 47.5 cm, Java, Staatliches Museum für Völkerkunde, München, Inv. No. 37-12-1

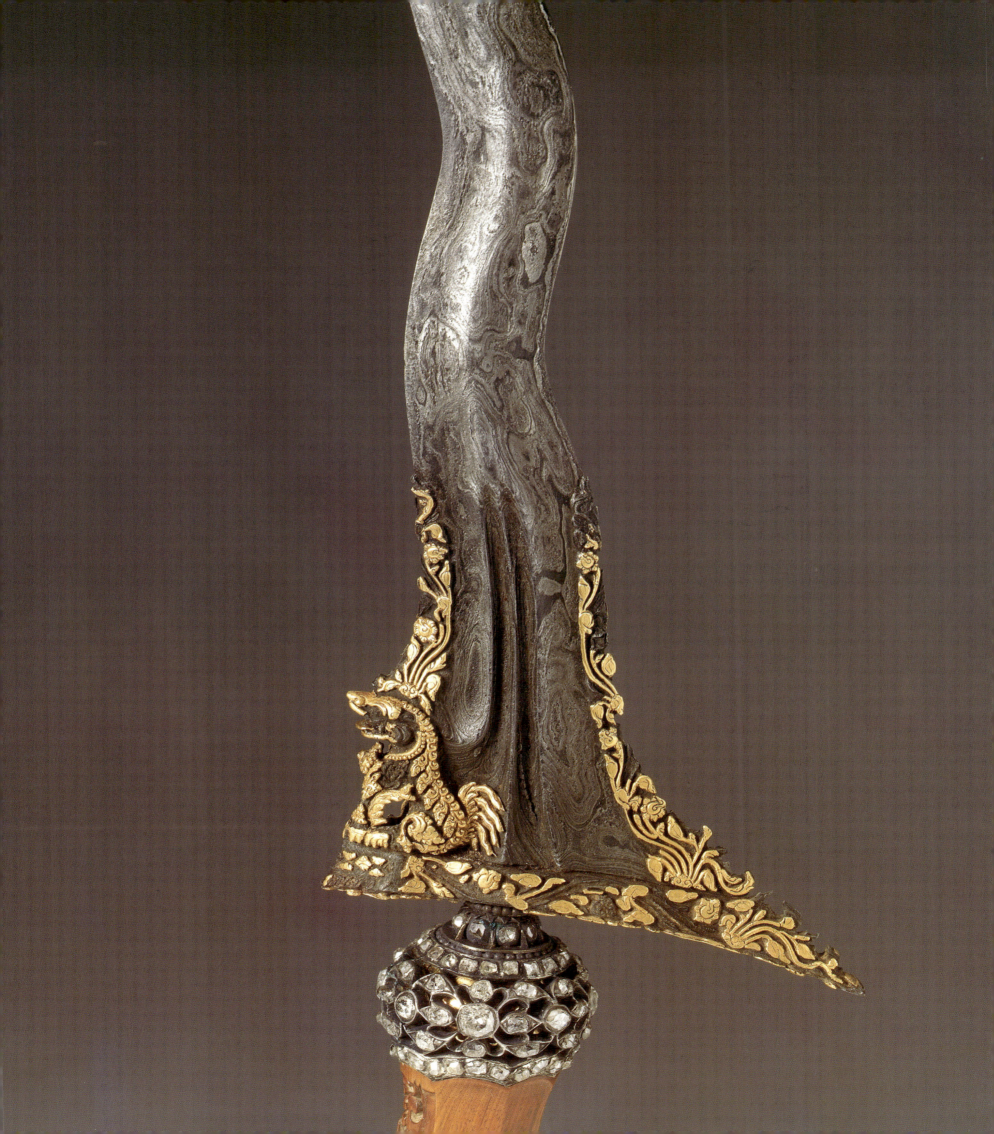

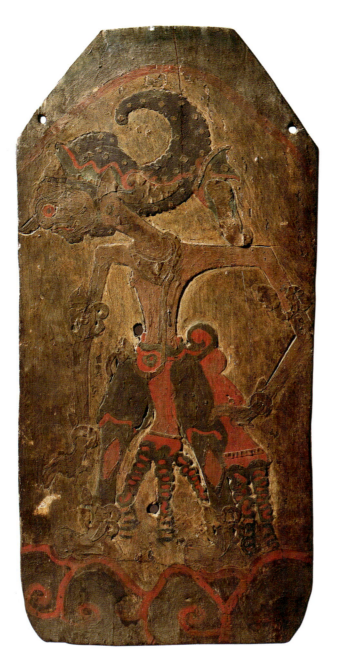

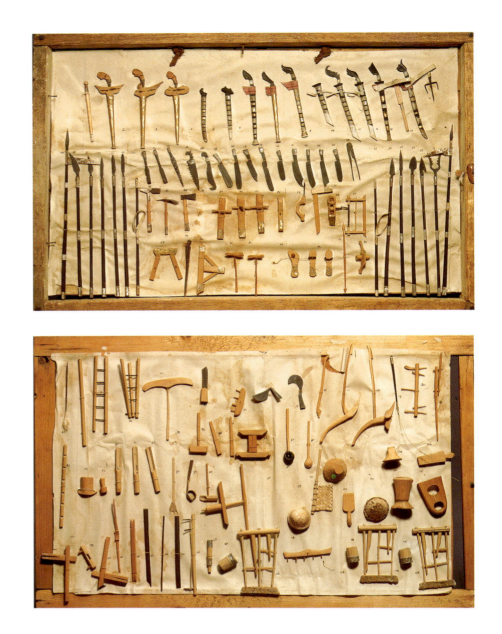

Keris board with *wayang* figure

Before 1928, wood, carved and painted, H 54 cm, W 25 cm, Java, Staatliches Museum für Völkerkunde, München, Inv. No. 28-30-1

An illustrated board like this serves as an appropriate setting for a keris imbued with magical powers. The board is decorated with the figure of Antareja, the son of Bima, who lives in the sea (underworld).

Everyday objects and weapons (box of models)

Before 1892, wood, horn, woven bamboo, gold and silver paper, L 53 cm, H 35 cm, Java, Staatliches Museum für Völkerkunde, München, Inv. No. 92.52

and museums. The material used is frequently ivory, bone, horn, or precious woods, and the shape either human or animal (see page 361). The sheath of the keris is made either of precious wood or brass, copper, silver, gold, or iron. It is mostly decorated with floral motifs (see page 359).

In old Malaysian chronicles such as the *Hikayat Hang Tuah* ("Story of the Hero Hang Tuah") or *Sejarah Melaju* ("Malaysian Story"), from the 16th and the 17th century respectively, it is stated that the ability to handle a keris played a fundamental role in a duel; mastering the art had to be learnt from an expert.

Keris served also as official gifts; for example, Susuhunan Pakubuwono X of Surakarta (1893–1939) had a keris made for the king of Gianyar in Bali, Anak Agung Ngurah Agung (1912–1960), and presented it to him on his official visit in 1928. Similarly, Sultan Hamengkubuwono VIII (1921–1939) from Yogyakarta gave Queen Wilhelmina of the Netherlands a keris with eleven *luk* as a present on the occasion of her 25th birthday in 1923.

To be looked after properly, a keris must be hung up, preferably at the head of the bed – never at the foot, as this would indicate lack of respect. Sometimes a keris board is carved specially to house a keris. As a sacred object of the Indonesian kingdom, a keris is kept in a room where the other sacred objects of the kingdom are also kept.

Secular Art

Everyday objects on Java

On Java, where Indian and Islamic influences were strong, crafts have for a long time been divided into the religious and the secular. We have already seen, for example, that the making of a keris had important religious aspects. Objects with a religious function also played a significant political role, for they not only conferred power on a ruler, they also acted as concrete symbols of that power. A king who could not display the objects that endowed him with sacred power was not considered qualified to rule the land.

But outside the palace (*kraton*), the Indian and Islamic influences were not nearly as noticeable. Today in some villages rituals are still performed that have nothing to do with either Hinduism or Islam, though they do contain a very large number of indigenous elements. Certain objects and tools still have their creation myths, which are recited at rituals. Unfortunately, most of these myths have now been lost, and so an interesting – and urgent – field for research presents itself here; certainly there are many questions still to be answered.

Modern art

In Palangkaraya, the provincial capital of Central Kalimantan, the city gates, official buildings, and houses are now decorated with wood carvings that display the principal symbols of the Ngaju: the rhinoceros bird and water snake. These symbols, however, no longer have any sacred meaning; they are purely ornamental. Symbols that originally reflected a view of the universe, that acted as a bridge between the macrocosm and microcosm, are now little more than aspects of eye-catching decoration. The depiction of the tree of life, which was originally used in important ceremonies, and often created specifically for them, is now used as an ornament on invitations to weddings and other events. Nevertheless, such motifs still offer the Dayak something to identify with, something they can use to set themselves apart from the many other ethnic and religious groups who have settled in Borneo, such as people from Java, Madura, and Flores.

Moreover, it would be unfair to disregard crafts in the tourist areas; even those objects which are often contemptuously regarded as mere tourist souvenirs, are often of very high quality as craftwork. Unless they are shoddy trinkets, it is perfectly reasonable to regard such products, though made largely for the tourist trade, as authentic examples of native Indonesian art.

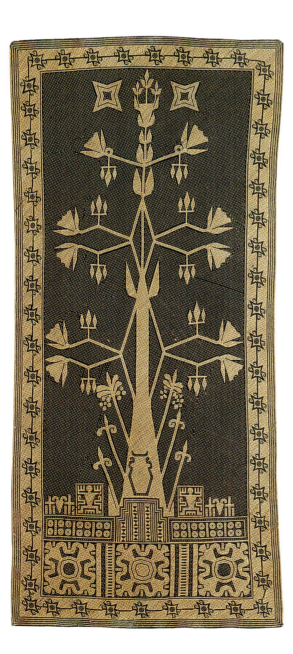

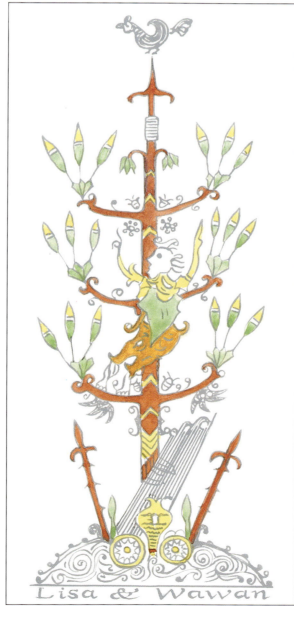

Lisa & Wawan

Below
Decorative carved coconut shells
Ubud, Bali

Far left
Ceremonial wall mat

Before 1963, woven rattan, L 186 cm, W 80 cm, Kuala Kapuas, Borneo, Staatliches Museum für Völkerkunde, München, Inv. No. 63-3-2

The leaves of the tree of life were thought to be made of gold, its blossoms of diamonds. It grows out of a sacred vessel, and ceremonial spears make up its shoots. At the top of the tree of life sit the two rhinoceros birds from which, in the mythology of the Ngaju Dayak, all life and creation itself originates.

Left
Tree of life

The tree of life, which symbolized cosmic order and was regarded solely as a sacred image, is today a very popular motif in the secular sphere. This is a wedding invitation.

The Performing Arts

Wayang on Java

The word *wayang* is often said to derive from the Malaysian word *bayang* ("shadow"). The fact that the word is Malaysian suggests that the shadow plays are indigenous, and were not imported from another culture. It also seems reasonable to assume that this art was linked to ancestral worship: in it, the shadows, which are assigned a supernatural role, are supposed to personify ancestors. However, this theory is somewhat unconvincing when we consider that the High Javanese and Balinese word for *wayang*, *ringgit*, does not mean shadow but "dancers," "theater," or "figure." In addition, the fact that particular colors are used to characterize the figures shows that it is not only the shadow that is important for the production.

By *wayang* the Javanese in fact understand the shadow theater itself, the plays, the puppets, and even the "stories from long ago." And this use of the term always refers to plays and puppets that are derived ultimately from the Indian epics the *Ramayana* and *Mahabharata*. As a result, the source of *wayang* has now been transferred to India. This theory is strengthened by the fact that the areas to which the *wayang* spread correspond to the Indianized areas of Indonesia, namely Java and Bali, and that shadow plays are known to have existed in Kerala, in the south of India.

And yet there is another aspect to this debate about the origins of the *wayang*. The academics who have studied the history of *wayang* have always searched for written sources, which tend to be Indian; but the performance arts in Southeast Asia are mainly traditions that have been handed down orally, and so their origins have remained largely inaccessible to scholars.

The Indian epic poems the *Mahabharata* and the *Ramayana* were translated into Javanese at the request of King Airlangga (1019–1049) of Empu Kanva. In the process of translation they acquired a Javanese character, which was in turn strengthened by the forms *wayang* productions took and also by changes deliberately introduced by the *dalang*, the puppeteers; the fact that the stories were handed down orally also led to gradual change. Despite all these subtle processes of adaptation, however, the basic characteristics of the ancient Indian stories can still be recognized.

The *Ramayana* is regarded as the older of the two epics, and the events it depicts take place before those of the *Mahabharata*. The story begins when a just king, Dasarata, allows the throne to slip out of the grasp of its rightful heir, Rama, as a result of the palace intrigues of the king's concubines, Rama's wife, Sinta, and Rama's stepbrother, Laksmana. Rama has to leave the court and go into the forest. One day the demon Rahwana, the personification of evil, falls in love with Sinta and abducts her. The story revolves around Rama's

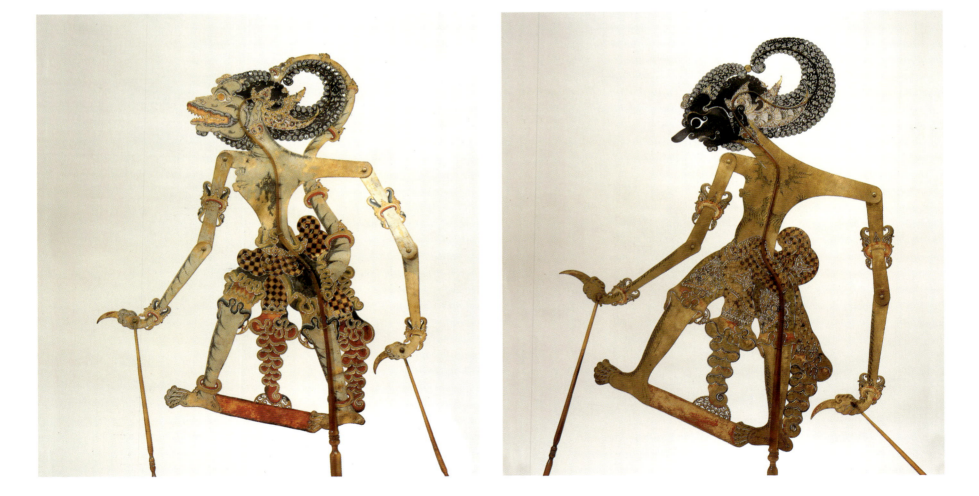

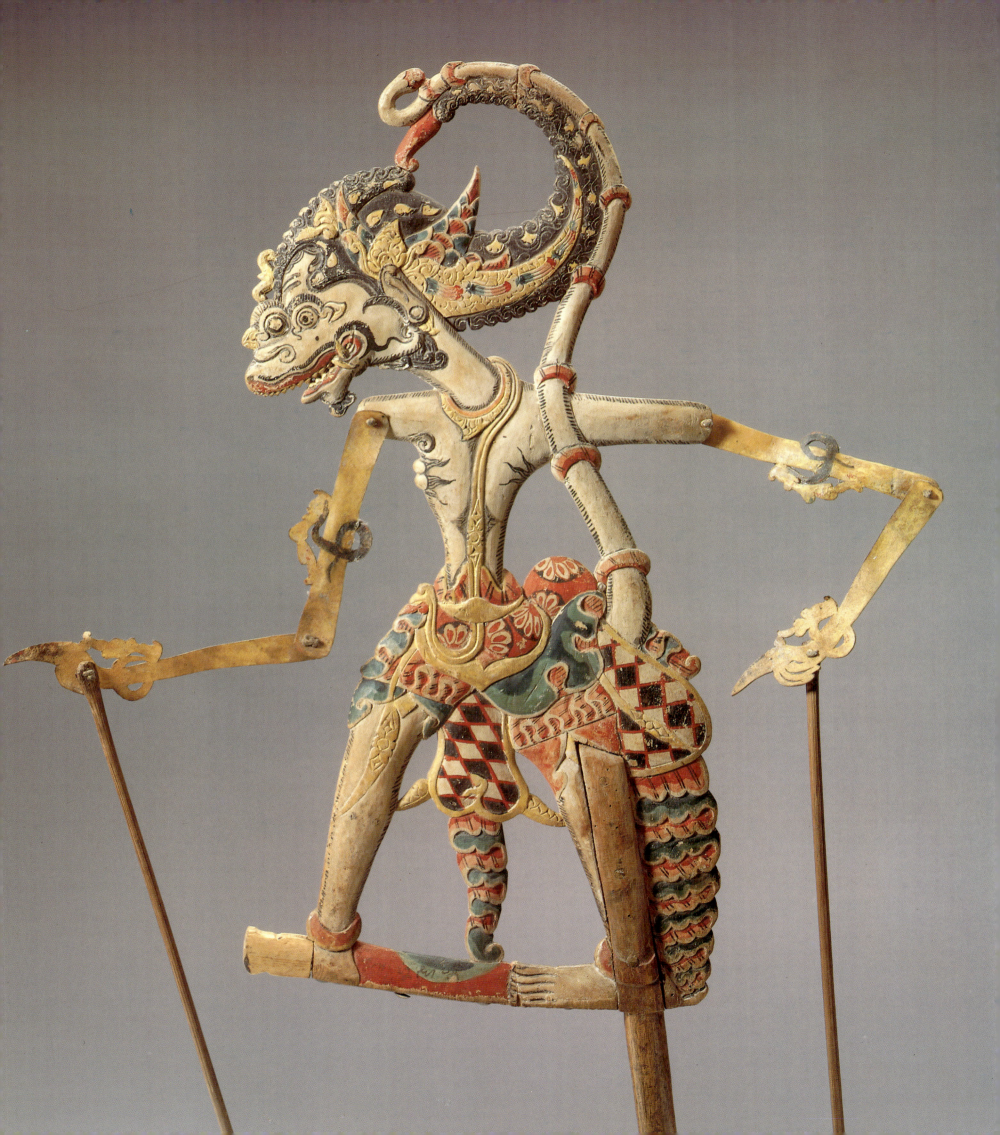

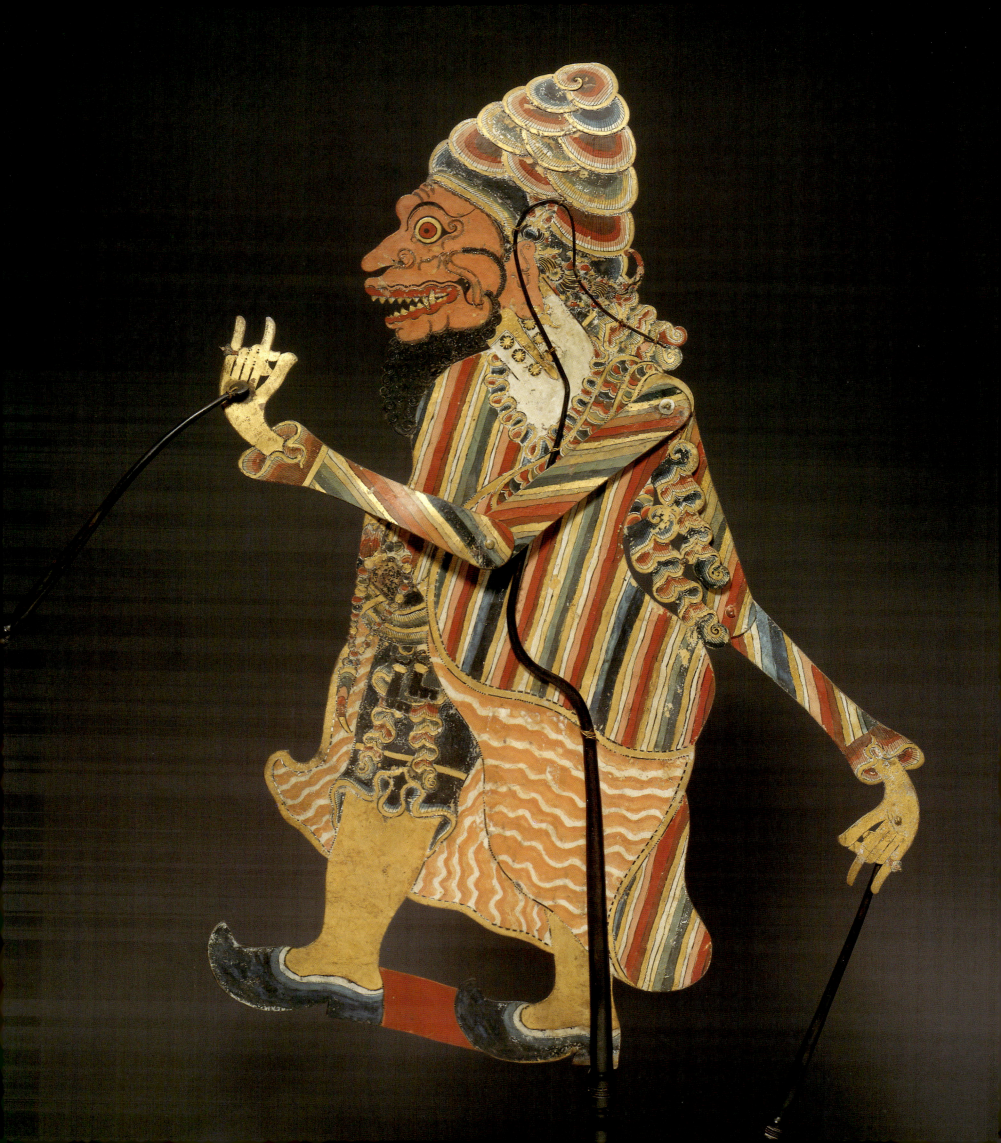

attempts to win back his abducted wife. He succeeds only with the help of Hanoman, a white monkey who, in Javanese eyes, epitomizes courage, honor, and nobility. Hanoman is regarded as the son of the wind god, Batahara Bayu, and this divine origin is symbolized by his *kuku pancanaka*, a fingernail that possesses supernatural powers (see page 364, left; and page 365). Rama himself is regarded as the incarnation of Bathara Vishnu, the Sustainer of the World.

Kumbakarna and Wibisana, the brothers of the villain Rahwana, provide a discussion point in Javanese philosophy. Kumbakarna, a good-hearted demon, can see his brother's mistakes but nevertheless fights on his side all his life. His behavior is interpreted as absolute loyalty to his family and clan. The other brother, Wibisana, does not want to fight on the side of the villain and goes to Rama to fight with him against his own kingdom; he wants to fight for good. This makes him, like his brother, a morally ambivalent figure, for his actions make him at once a traitor to those closest to him, and yet also a *ksatriya* (warrior-hero), one who always supports good and fights evil, even if this goes against his own interest.

The *Mahabharata* is the story of the descendants of Bharata, who wage war on one another. On one side there are the five Pandava brothers, the personifications of good, on the other the 99 Kurava brothers, the personifications of evil. The Pandava brothers are supported by Krishna, an incarnation of the Bathara Vishnu.

The Pandava brothers are the children of five deities, for their legitimate father, Pandu, as a result of breaking a taboo with his wife, Kunti, was not able to father children. The Javans identified closely with the five brothers: Yudhistira, the oldest is a gentle, honorable man; Bima, the second, is a coarse but courageous man; he is the son of Bathara Bayu (the wind god) who provides him (like Hanoman) with a *kuku pancanaka* (see page 364, right). The third brother is Arjuna, a goodlooking, romantic figure who has lovers, and children, everywhere; Arjuna is seen as the ideal *ksatriya*. After Arjuna come the twins, Nakula and Sadewa, seen as personifications of true *ksatriya*. Since Bathara Vishnu appears in both epics, the *Ramayana* and the *Mahabharata*, representations of the stories are seen in the temples as typical features of the Vishnu branch of Hinduism.

Many things can be described as *wayang*. The most important kinds of *wayang*, which are still very much vital and popular, are the *wayang kulit* (shadow theater using flat figures made out of leather); *wayang golek* (theater using wooden puppets); *wayang wong* (theater with human actors, dance drama); and *wayang topeng* (masked dance). *Wayang beber* (theater using pictures painted on paper scrolls) and *wayang klitik* (flat wooden figures) (see right) are hardly performed any more today.

The varieties of *wayang* can in fact be classified according to several criteria, namely the type of figures used, the method of production, and the form of play performed with these figures. *Wayang* plays were mentioned in old Javanese chronicles and inscriptions. The Wimalasrama inscription, for example, written around A.D. 930, contains the concept of *wayang wwang* (*wayang wong*, theater with human actors); another inscription in the Perot temple (about A.D. 850) contains the term *wayang topeng* (a masked dance).

In the didactic poem *Arjuna Wiwaha* from the era of King Airlangga, shadow plays are mentioned. Unfortunately, we have no evidence from this time as to which plays were performed. But the fact that they are mentioned in inscriptions and chronicles clearly shows that *wayang* plays were already in existence in the 9th century A.D. Since these inscriptions and chronicles were written for kings, these references to theater are exclusively about court productions. It is not known what forms theater took outside court circles.

Wayang kulit

Wayang kulit figures are produced from buffalo hide (see opposite). The hide is washed after being skinned and dried in the sun. When the hide has been smoothed down with a stone, it is wetted again repeatedly, each time being smoothed out and then left in the sun to dry. When the leather is ready, an outline of a figure is drawn on it and then cut out. The figure is cut and incised using about 20 different chisels and small wooden hammers. Finally the figure is painted, first of all in white, then in a black obtained from lamp soot. The decoration is applied with gold leaf. Last of all come the other colors, red, yellow, blue, and green, which are pigments dissolved in water.

The shapes and the personalities of the figures are very familiar to Indonesian audiences. In general terms the shape and color of a face clearly tell the audience about a figure's personality; figures with a red face are very emotional, unrestrained, and coarse; figures with a white face are refined and self-controlled characters; and figures with a black face are seen as mature and wise.

In Java *wayang kulit* is performed in the evening; normally a production begins at around eight o'clock and ends around four in the morning. They are performed during the day if they are part of an exorcism ritual (*ruwat*). On Bali, by contrast, they are normally performed during the day, and last for two to four hours.

The *wayang kulit* figures are moved behind a canvas screen, onto which their shadows are cast by a lamp. Research has suggested that the space in front of the canvas, where only the shadows can be seen, was traditionally for women and children; the space behind the canvas, on the other hand, where the figures themselves can be seen, was for the men. This division of space can also be seen, for example, in the traditional men's house in Indonesia, where women are not admitted. This is no longer the case in puppet theater, however, and today a man and woman can choose which side of the screen they want to sit on. Spectators who like

Opposite

A *wayang kulit* puppet of Bathara Yamadipati

Before 1890, buffalo leather and horn, H 95 cm, Java, Staatliches Museum für Völkerkunde, München, Inv. No. B.2008, 23.7

Bathara Yamadipati is the guardian of *kawah Candradimuka*, the crater in which all sinners are bathed in the hot lava, the equivalent of the Christian Hell. His shoes indicate that he is a deity.

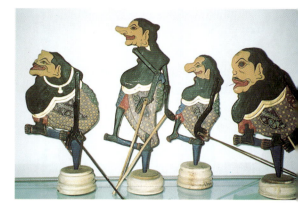

Wayang klitik puppets of (left to right) Semar, Petruk, Gareng, and Bagong

Wood and buffalo leather, in a workshop in Yogyakarta

The puppets personify the *punakawan*, the servants of the nobles in *wayang* theater. They provide the comic relief.

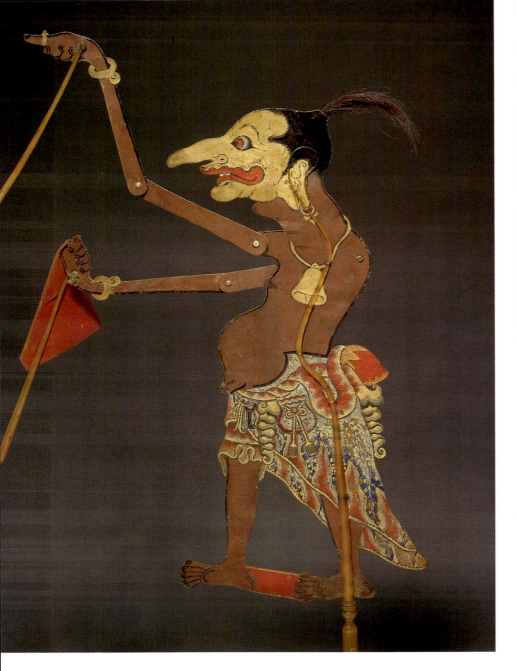

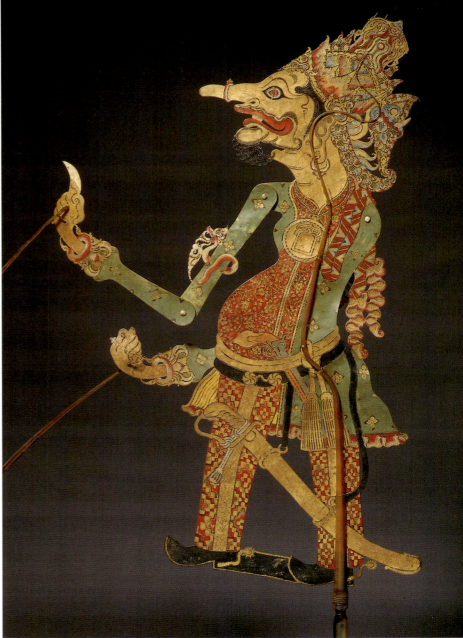

to be near the gamelan orchestra stay on the side where the figures are, which is of course where the *dalang* (puppeteer) sits.

Even if *wayang kulit* did originate in the south of India, it came to have a profound impact on the religion, social life, and thought of the people of Java and Bali. The *wayang* figures are regarded as ideal types, or as a typical image of a social type. People learn from *wayang* figures how to behave in social and personal life, for the *wayang* plays clearly embody Javanese moral concepts and ideals. The Javans know the motives and fates of the figures, and can compare them with their own; it is, in effect, a system of shared values and ideas. It is almost impossible to understand the Javanese mentality without any knowledge of *wayang*.

This led the author Pramoedya Ananta Toer to voice his criticism of Javanese feudal society by pointing out that all the important *wayang* figures are from the nobility; the ordinary people literally do not have a real role to play in the stories. It is also typical that the only figures who represent the people are the four *punakawan* who, as grotesque

clowns, provide comic relief (see page 367). They are personifications of the loyal servants of the aristocratic *ksatriya* (warriors, noblemen) and are mostly portrayed as deformed. However, Semar, the father of the other three (Bagong, Petruk, and Gareng), is regarded as the incarnation of Bathara Ismaya (the supreme Javanese deity, elder brother of Bahara Guru-Shiva). Thus it could be argued that the ordinary people are in fact the personification of the supreme deity, and are therefore imbued with true wisdom. The complexity of the figure of Semar has given rise to much debate, one important issue being that he is neither a man nor a woman—he can be seen as embodying the unity of the sexes and thus as overcoming the dualism that threatens to disrupt universal harmony.

Nevertheless, the fact that in *wayang* only the *ksatriya* are considered to be the personification of goodness and sublimity, the *raksasa* (demons) the personification of evil, and the *punakawan* the personification of the people, could also be seen as sanctioning a hierarchical society. This implicit feudalism was confirmed by Hamengkubuwono

VIII (1921–1939), who wrote a play called *Petruk dadi raja* ("Petruk Would be King"), in which he accords Petruk the central role (see opposite, right). But this is not as simple as it seems, for when Petruk becomes king there are catastrophes such as bad harvests, storms, and earthquakes. As a result, the gods convene a council in order to set matters right. They make Petruk renounce the throne and so harmony once again rules in the universe. This story is obviously a reflection of the concept of royal power entrained by the Javanese kings; they regarded themselves as descendants of Vishnu, who sustains the world and life on earth. Their divinely appointed role is to maintain the harmonious balance between the macrocosm and microcosm, for as soon as that balance is disturbed disasters and natural catastrophes occur. In this scheme of things, every living being has a fixed place in the hierarchy of life, and this applies as much to social life as to the natural order: an ordinary person becoming king would endanger universal harmony.

So in fact it can be argued that the acceptance of a strictly hierarchical political structure by Javanese society – which it seems was largely egalitarian before Indian influences took root – was facilitated and reinforced by *wayang kulit*.

The *wayang kulit* figures of Java differ from those seen on Bali, notably in their shape and in their character. The Balinese shape, which was taken over to Bali after the Islamization of Java, is regarded the more original one. The Hindu Majapahit empire was a powerful force until the end of the 15th century and ruled over Java, Madura, Lombok, and Bali, its center being in East Java. The rise of the Islamic Demak empire on the northern coast of Java at the end of the 15th century slowly led to the decline of the Hindu Majapahit empire, and the Majapahit royal family settled in Bali, where they were welcomed. They took their religion and culture to Bali and Lombok, which resulted in a creative intermingling of Javanese and Balinese culture. Many of the old Javanese chronicles (including those from the Majapahit era) were found on Lombok at the end of the 19th century.

The Balinese *wayang* figures, then, are considered the forerunners of present-day Javanese figures. It has been claimed that the Javanese *wayang* figures were deliberately changed after the Islamization of Java, that they were in effect made to look less human. Supporters of this claim point to the fact that the 14th-century *wayang* figures depicted in the temple of Panataran in East Java are very similar to the *wayang* figures of Bali, from which, it is presumed, they were derived. The striking differences arose (they continue) because of the Islamic ban on the depiction of human beings; when Islam was established on Java, the figures were "de-humanized." On Bali, which did not become Muslim, the figures remain the same.

Although the evidence supports this theory, I am of the opinion that the *wayang* figures were indeed changed because of Islamic influence – but not because of the ban on the representation of humans. They changed, developed stylistically, because of the merging of different cultural influences. The Javans believe that Islam was spread on Java by nine *wali* (holy men), who often drew upon indigenous tradition to bring their religion to the people. It is widely believed, for example, that one *wali*, Sunan Kalijaga, used the *wayang* shadow play to spread his message. He created new stories as well as new figures, and he changed the sequence of events in the *Mahabharata* and added Islamic teachings. As we have seen, the eldest Pandava brother, one of the central figures of the story, is Yudhistira. He cannot be defeated and cannot be killed, for he possesses a powerful mantra (a prayer or magic formula) known as the *serat kalimasada* (the "Kalimasada script"), which gives him supernatural powers. At first even he does not know what the *serat kalimasada* actually means. But one day he meets Sunan Kalijaga, who explains that *kalimasada* is a phonetic transcription of *kalimah sahadah*, words which everyone has to say when converting to Islam: "There is no other God but Allah, and Muhammed is his prophet." This interpolation by Sunan Kalijaga was clearly meant to show that even Yudhistira, one of the greatest heroes of Hindu mythology, was a witness to the truth of Islam.

The *wayang kulit* figures continued to enjoy great popularity during Java's Islamic period. From the 18th century the courts of Central Java experienced a cultural renaissance in which the *wayang* once again played an important role. The princes Mangkunegoro I and Hamengkubuwono I both reintroduced the *wayang wong* (theater with

Relief in Candi Panataran
14th century, East Java

The figures are thought to illustrate the earlier form of the Javanese *wayang* style.

Dancing *apsaras*

Central Javanese period, 9th–11th century, on the exterior wall of the Prambanan, Central Java

The *witarkamudra* hand gesture still appears in Javanese dances.

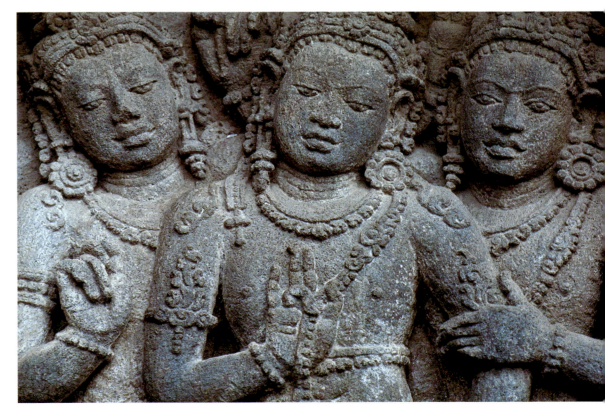

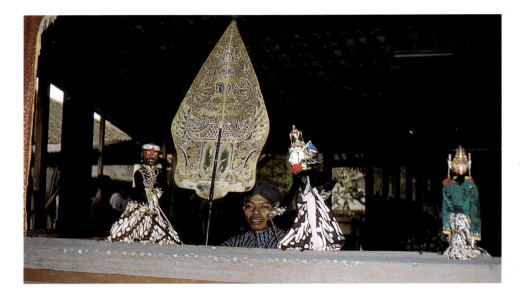

A *wayang golek* performance

Tasikmalaya, West Java

The *kayon* (tree of life) seen in the center symbolizes the cosmic order. Behind the stage the *dalang* (puppeteer) can clearly be seen.

Opposite
Wayang topeng, masked dances

From the Panji history Topeng Sekartaji, performed in the court of Mangkunegoro, Solo. Above, Panji Inu Kertapati, danced by Ari Mulyatno. Middle, Dewi Sekartaji, danced by Kurniati. Bottom, Menak Klana, danced by Daryono.

The villain Klana falls in love with Dewi Sekartaji, who herself is in love with Panji Kertapati. The two rivals Panji and Klana therefore have to fight a duel. The victor is Panji, who marries Dewi Sekartaji.

human actors) to the *kraton* (palace). In the courts, however, Islamic mysticism brought its influence to bear, redirecting the art of dance and gamelon music towards the meditative and pensive. We can assume that it also influenced *wayang kulit*, making the characters more sophisticated and full developed, in line with Javanese ideals.

The beginning of the 20th century is called "the age of the rise of the nationalist movement." Many Javanese, who had been educated by the Dutch colonialists, began to demand national independence; among the most important were Tjokroaminoto and Sukarno, and they both saw in *wayang kulit* an opportunity to spread their ideas among the population. Performances of *wayang kulit* gained in popularity with intellectuals, and the Dutch-educated Javans began to discover and appreciate their own cultural roots.

Even after Indonesian independence was proclaimed in 1945, Sukarno, the first President of the Republic, often went to *wayang kulit* performances and even engaged *dalang* to express his revolutionary ideas in the fight against the Dutch, who did not concede independence until 1949. Considered a *wayang* enthusiast, Sukarno possessed a deep knowledge of the mythology of the *Mahabharata* and the *Ramayana*. In 1965 there was a coup against Sukarno and he was ousted from power. Many of the *dalang* who had been Sukarno's mouthpiece were murdered, others were banned from performing.

When Suharto, Sukarno's opponent, came to power, it became illegal to stage a play unless the *dalang* had written down which play was to be performed and what the characters were going to say. In other words the government saw the effectiveness of *wayang kulit* and was determined to keep a tight control on its performances. This does not mean that it was suppressed, however, for Suharto himself used the *dalang* and the *wayang kulit* to make his government policies known; they were used for example to disseminate the government's programs on birth control, and to explain the five-year plan for national development.

Since the 1970s there has been a renaissance of the *wayang kulit*, and large audiences are now attracted. Since 1981 the government has also arranged a *dalang* congress, where the *dalang* have to draft a *lakon* every year on a theme chosen by the government, for instance *Semar mbabar jati diri* ("Semar Thinks about His Identity"). In this *lakon* the *dalang* have to set down a positive statement about state ideology, which is known as *pancasila* ("the five pillars").

The Javans were rediscovering their traditional culture. The court culture was developing a popular appeal, and a new elite was formed combining the old aristocracy and the newly well-to-do, a development marked by the fact that an honorary title once used solely by the nobility was now also conferred on the rich and influential.

Today there are new dramatic works with a considerably shortened performance time. They are called *wayang ringkas* ("shortened *wayang*") and *wayang padat* ("compressed *wayang*"). The repertoire of the *wayang ringkas*, which last three to four hours, is based on the traditional *wayang kulit*. In the *wayang padat*, by contrast, all the old rules are broken; new music is composed, new stories made up, old ones revised. Both of these new forms were developed by students at the College of Art in Solo (STSI), and also taught there. The idea came from *wayang* experts, who thought that the original performance length of nine hours would no longer be suitable for the modern age. Supporters of this style are *wayang* experts like Sri Muljono who wrote many books about the story, characterization, and interpretation of the *wayang*, and Humardhani, the founder of the College of Art in Solo.

The *dalang* in *wayang kulit* on Java

The influence of the *dalang* (puppeteer) is crucial in a *wayang kulit* production. He is the person who selects and produces the play, chooses appropriate music, creates an appropriate voice for each character, and uses his innate sense of the dramatic to hold an audience's attention for several hours. Moreover, and this for Westerners is the most unusual aspect of puppet theater in Indonesia, he plays a major role in rituals. The *dalang*'s profession cannot be learnt in a few years; he usually has to be brought up with it, so most *dalang* come from generations of puppeteers. Normally a son learns the skill from his father; there are women *dalang*, though today they are rare.

The *dalang* are often credited with special magical and supernatural powers. They are people who have a deep knowledge of mythology and Javanese philosophy, and in a sense are similar to clergymen in the West, for they play a similar role in the central rituals of life, the rites of passage. In earlier times it was also common to have a *wayang kulit* performance at a circumcision, to give thanks or to prevent illness. Recently the fees of a *dalang* have become quite high, and many families cannot afford to pay for the service he provides.

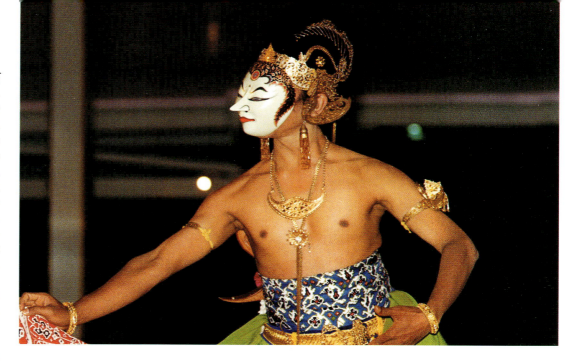

Generally there are two different categories of *dalang*, the village *dalang* and the court *dalang*. The village *dalang* are firmly anchored in their local community; they are advisers on medical problems and supernatural and other matters. The court *dalang* were (and are still) advisers to the royal family – on the issues of private life mostly, but also on state affairs. The court *dalang* enjoyed the reputation of being better educated, while the village *dalang* were closer to traditional practices. However, the dividing line between the two is flexible. A good village *dalang* might be engaged at court, too, and a good court *dalang* might be booked for important rituals in the village.

In the literature on the subject there is still vigorous debate about the relationship between the two *dalang*. On the one hand it is maintained that the original *dalang* were based in the court, and that the *wayang kulit* was a court tradition until the 19th century, when, becoming widely popular, it spread to the villages. On the other hand it is maintained that the original *dalang* were the village *dalang*, which were taken up by the court. Both views can be well argued, but it has to be admitted, frankly, that the *wayang* tradition was so firmly embedded in the life of the people that it is difficult to understand how it could originally have been a court tradition. The *dalang* schools, Padhasuka in Solo and Habiranda in Yogyakarta, were opened in 1923 and 1925 respectively, their aim being to improve the quality of the *dalang* and to give them greater intellectual weight. In my opinion the distinction between the court and village *dalang* has existed only from this time: the court *dalang* were those who had attended one of these schools, and the village *dalang* were those who had been trained by their fathers. In other words the village *dalang* continued to cultivate the tradition handed down orally, whilst the court *dalang* began to write down their *lakon*.

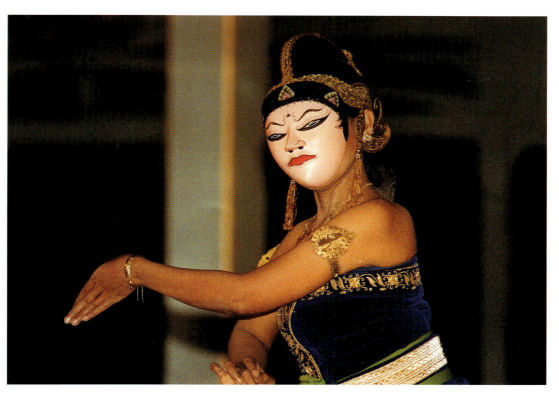

Whilst the performances described above fall more into the field of entertainment, there are also sacred *wayang kulit*. These refer to the *ruwat* ceremony (exorcism). Unlike other performances, this ceremony is exclusive to men (women are in fact forbidden to perform it). The *ruwat* ceremony is held during the day, from ten in the morning until four in the afternoon, and is an attempt to placate Bathara Kala, the son of Shiva, who likes to eat people. One day Shiva made an agreement with him that he could eat only certain people, an only child or one of twins, or the second-born of three brothers and sisters, provided that this child were of a different sex; in other words if the oldest and the youngest were girls and the second-born a boy, or vice-versa. Because of this, when such children are born a *ruwat* ceremony is held; they are also held to ward off evil spirits during illness and name giving.

Wayang topeng, the masked dance

According to documentary evidence, the masked dance performance known as *wayang topeng* was

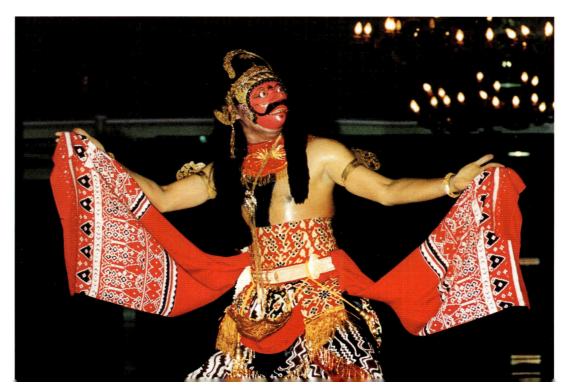

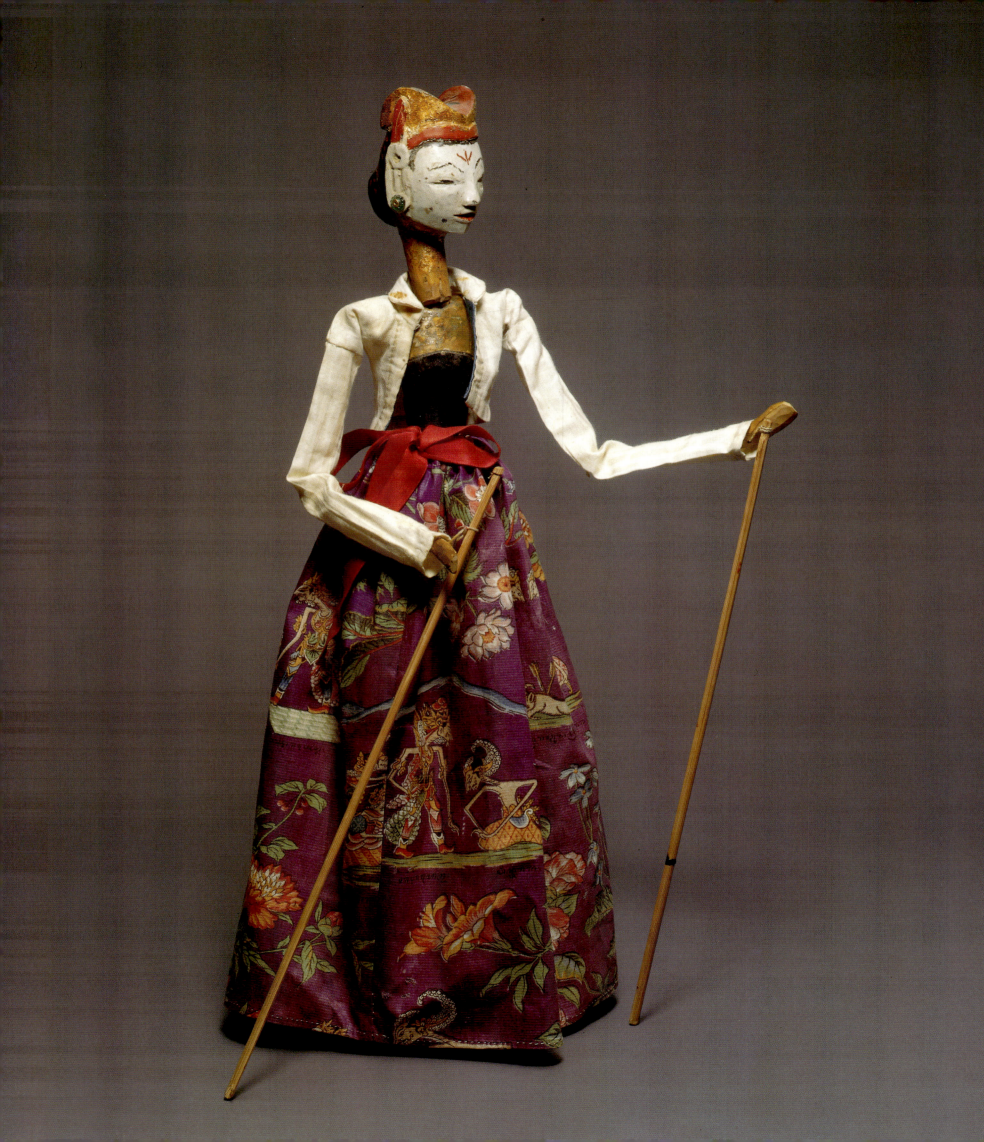

being performed as early as the 9th century A.D. Originally it was mainly used for the performance of tales from the *Ramayana*. During the Islamization of Java, however, *wayang topeng* became very popular, especially in the Islamic regions, notably those on the north coast, where it was used to spread Islamic principles. According to tradition the energetic *wali* Sunan Kalijaga designed his own masks, including all other eight *wali*. In this way he was able to spread Islamic teachings with the help of native traditions.

For the production of the *wayang topeng* there are several classics, such as those of the Menak Cycle and Panji Cycle (see page 371). These legends are based on the history of East Java during the Airlangga era (1019–1049). The Panji story is found throughout the Indonesian archipelago and is even found on the Southeast Asian mainland, in Cambodia and Thailand for instance, where it is called the *Story of a Javanese Prince*. Once again it is an oral tradition, which means that the stories vary from place to place. Researchers have attempted to make a comprehensive record of the various forms of the story.

Wayang golek

Wayang golek is a form of puppet play in which the puppets are three-dimensional (see page 370). It is found mainly in the west of Java, and along the northern coast. The *wayang golek* figures are a popular souvenir for tourists today (see top right).

The plays performed are stories from the epics the *Mahabharata* and the *Ramayana* (called *wayang purwa*), as well as incidents from Hindu-Javanese history (from the 10th century A.D.). Also very popular are episodes from local history after the Islamization of the coastal regions.

The *wayang golek* figures were not used for the plays based on the *wayang purwa* until the beginning of the 19th century, after the epics had proved popular in *wayang kulit* performances. In contrast, plays based on local and Hindu-Javanese history were already well known in the 16th century.

In *wayang golek* performances the *dalang* moves the wooden puppets by hand, the puppets are in full view (not shadows cast on a screen). His role is comparable to the role of the *dalang* in the *wayang kulit* performances. If he produces a play from the *wayang purwa* repertoire, the performance lasts from nine in the evening until sunrise. Historical plays on the other hand can be performed during the day, and they last about two hours.

The use of a *wayang golek* puppet in a *wayang kulit* performance is interesting. The appearance of the *wayang golek* puppet comes right at the end of the performance, the puppet performing movements used in the Gambyong dances (see page 375). The significance of this appearance, which seems unrelated to the theme of the play and the character of the performance, is to be found in the word *golek*, which also means "search:" the spectators, at the end of the performance, when they are just about to go home, are being encouraged by the

dalang to search for and to question the moral of the *wayang* performance they have just seen.

Wayang wong

Wayan wong, theater with human actors and dance drama, is often described as a human version of the *wayang kulit*. As already mentioned, the Wimalasrama inscription of A.D. 930 contains references to *wayang wwang* (*wayang wong*), and there is another inscription in the Perot temple, and dated A.D. 850, to *wayang topeng* (masked dance). The Wimalasrama inscription says that the story of the *Mahabharata* was always performed without masks, and the *Ramayana* with masks. This is still the case today, and largely for pragmatic reasons: in the *Ramayana* mythology an army of monkeys appears as well as an army of demons, and they can be portrayed particularly well with masks. But the other roles, like those of Rama and Sinta, are played without masks.

If we give any credence to these texts then we have to assume that *wayang* was performed between the 8th and 10th century A.D. Typically enough there is no evidence that *wayang wong* was performed between the 16th and 18th century — that is, after the ascendancy of Islamic rule. It is generally thought that *wayang wong* was not performed again without masks until the time of Mangkunegoro I (1757–1795); previously the performances were given only with masks.

On the other hand the Javanese scholar Soedarsono writes that during the Islamic period *wayang wong* had spread to the Islamic kingdom of Banten in West Java. "Islam was a religion of the people,"[7] he writes, alluding to the fact that Islam and popular culture spread in parallel and that what was regarded at court as high culture was not necessarily what was popular with the people. From this we can conclude that even if *wayang wong* was not in fact performed in the *kraton* after the Islamization of Java, it was nevertheless very popular with the people, and in particular in those regions where Islamic influence was strongest.

From 1755 the Mataram empire in Central Java was gradually divided into four princedoms, two in the Surakarta (Solo) region, the Pakubuwono and the Mangkunegoro dynasties; and two in the Yogyakarta region, the Hamengkubuwono and Pakualam dynasties. After the borders had been clearly marked out, peace ruled in Central Java for the first time. Having no need to pay for endless wars, rulers could now patronize the arts. There was still competition and rivalry, but now it was confined to the cultural field. Mangkunegoro I and Hamengkubuwono I had *wanyang wong* performed and commissioned new plays.

Hamengkubuwono I declared *wayang wong* productions a state ritual, and these, in effect, helped to legitimize his power. In them he was fêted as the successor of the legendary forefather of all Javanese kings, Bathara Vishnu, who maintains a balance in the world, in particular between the upper world and underworld. During the perfor-

Opposite

A *wayang golek* puppet

Before 1890, wood, cotton material, H 50 cm, Java, Staatliches Museum für Völkerkunde, München, Inv. No. B.1991

This character is probably from the play *Wong Agung Menak*, which helped to spread Islam on Java.

Top

***Wayang klitik* and *wayang golek* puppets**

Wood and buffalo hide, in a workshop in Yogyakarta

Above

A *wayang kulit* performance

Yogyakarta

The *dalang* (puppeteer) enacts the play behind a screen onto which the puppets' shadows are cast. The shadow side is very popular with the audience, especially with women and children, though some of the audience do sit with the puppeteer. The light is meant to resemble the sun. Traditional *dalang* like Ki Anom Suroto still use an oil lamp, modern *dalang* like Manteb Soedarsono, are already using halogen lamps.

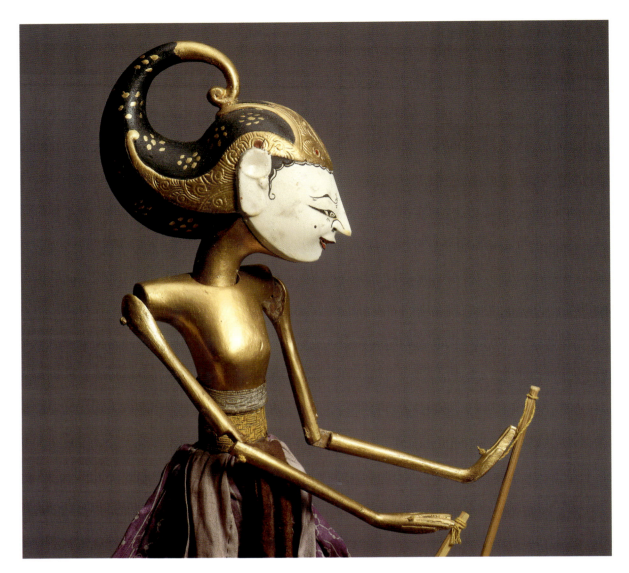

mances he sat in a sacred room, his face turned eastwards, to await the appearance of Vishnu.

The plays performed were mainly taken from the *Mahabharata* but also from parts of the *Ramayana*. The performances lasted two to four hours. The actors danced their actions, and words were both sung and spoken. At the end of the 19th century, Mangkunegoro IV created *langendriya*, a form of *wayang wong* in which all the words are sung. The *wayang wong* performances as we know them today began in the 18th century, and it may even be true that to some extent *wayang wong* was inspired by Western opera, a knowledge of which was brought to the region by the colonial powers.

The *wayang wong* performances are still popular today. After the declaration of independence by the Indonesian Republic in 1945, the courts lost their power, and their cultural life was restricted purely to rituals and ceremonies.

The *wayang wong* performances continued to develop, however, but outside the court; the repertoire was still taken from the *Mahabharata* and the *Ramayana*, though now only from a few scenes in the vast epics. The plays were also heavily adapted, so that finally they had very little in common with the originals. There are theater groups today who offer a performance every evening with their own dancers. They include Sriwedari in Solo, Ngesti Pandowo in Semarang, and Bharata in Jakarta. The actors are mostly ordinary people who do their regular jobs by day, such as giving *becak* (rickshaw) rides or selling souvenirs from their *warung* (stall), and who perform in the evening. They were not educated at an academy or an art college, but were taught the skill from childhood by traditional teachers. Many of them possess a natural talent and can also sing (*tembang*) very well. Their dancing ability is often not so distinguished but in *wayang wong* singing and dialogs with individually characterized voices are the focus of the performance. Since the 1970s such groups have been gradually declining in popularity, their main rival being television. Today *wayang* performances (*wayang wong* and *wayang kulit*) are broadcast at least once a week on regional television.

These surviving *wayang wong* groups, Sriwedi, Ngesti Pandawa, and Bharata, mainly appeal to the ordinary people and not the elite, and therefore have only a small chance of survival in the globalized modern world, especially as they only have limited funds at their disposal.

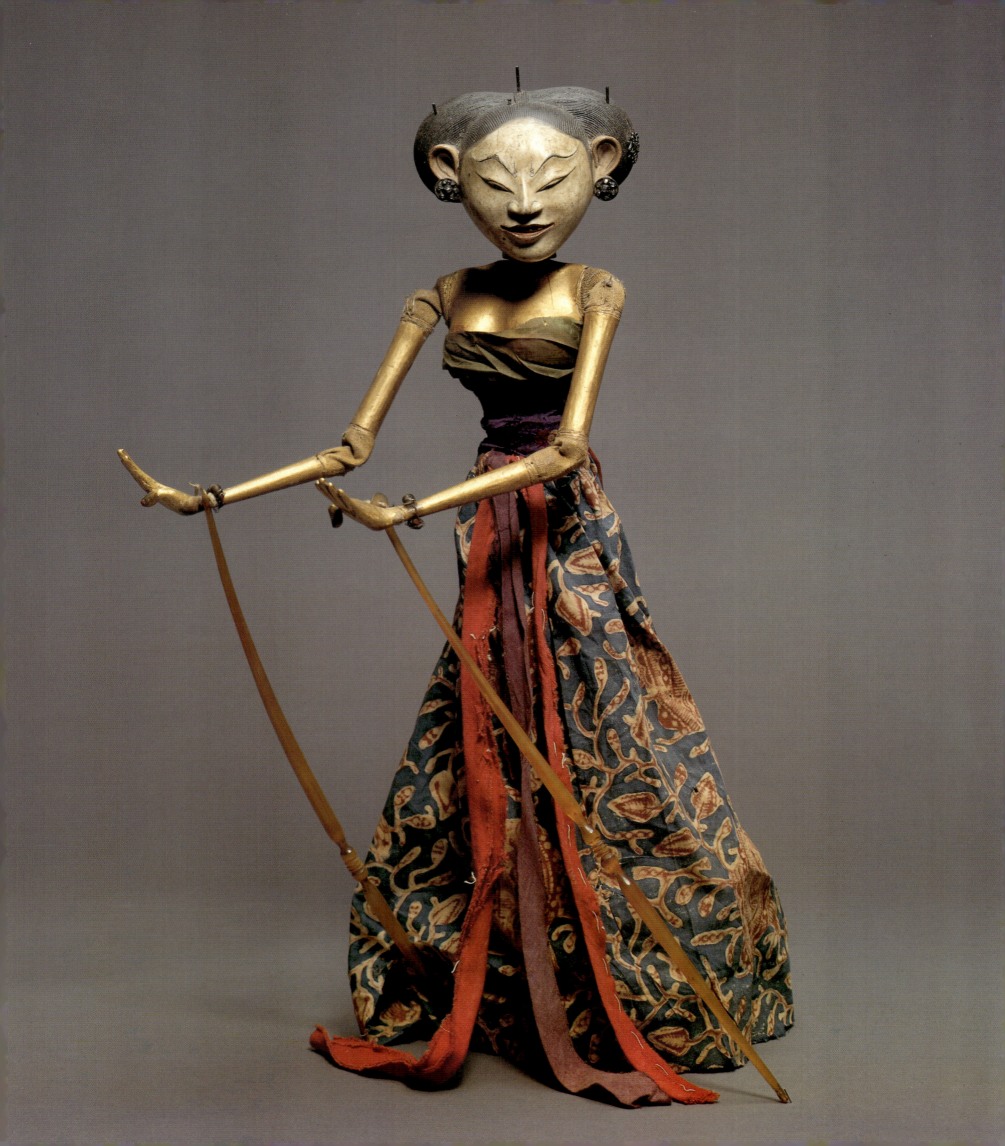

Recent Developments in Theater

Ketoprak

While the *wayang wong* genre was both handed down from father to son and also stylized at court from the 18th century onwards, a version of *wayang wong* developed in the 1920s, called *ketoprak*. *Ketoprak* is a kind of folk theater and is performed in dance, song, and spoken dialog. It is also interesting that its plays were taken from Javanese history, especially from the period of the transition from the Majapahit to the Mataram empires in the 16th and 17th centuries. The kings and *ksatriya* (warrior-heroes) do not play the main roles as in *wayang wong*; instead, the characters are the ordinary people, such as peasants and villagers, and particularly beautiful village girls. The hero is not Arjuna from the *Mahabharata* but a *jago*, a village hero. *Ketoprak* is a theater form that was developed in Yogyakarta, but outside the court. The performance lasts about two hours. The language used is not *kromo* (High Javanese, the language of the court) but mainly *ngoko*, colloquial Javanese. In the *wayang wong* and *wayang kulit*, on the other hand, High Javanese is used in dialogs, and in the introduction the *dalang* addresses the audience in Old Javanese. The *wayang* performance is in essence an aristocratic production, the *ketoprak* a village production. The dance movements in a *ketoprak* are not so stylized as in the *wayang wong*, and are sometimes combined with everyday actions, as in the theater. The movements of the men are often taken from the *pencak silat*, a form of boxing popular in Indonesia. *Ketoprak* is popular not only as it depicts recognizable characters and situations, but also because it is humorous and easy to understand.

Productions of *ketoprak* theater (and *ludruk* theater, which we will look at below) were also used in Sukarno's time to promote the ideology of the president and the Communist party. After the fall of Sukarno in the mid 1960s, the two folk theaters fell into disfavor.

In the 1970s, however, students of the Institute of Technology began to hold *ketoprak* productions on their campus. It is probably no exaggeration to say that, since then, *ketoprak* has become "socially acceptable" among young people and intellectuals. There are several reasons for this. The performances are short and the language, colloquial Javanese, is easy to understand (even non-Javans can learn it quickly). Moreover the subjects and stories are familiar (they are not, like *wayang*, drawn from little-known religious and mythological traditions) and their mood is cheerful and comic.

Ludruk

A folk theater known as *ludruk*, which is similar to *ketoprak*, developed in East Java, the center of the Hindu Majapahit empire, which flourished from the 12th century to the end of the 15th century. The following period, roughly from the end of the 16th century, saw the rise of the Islamic Mataram empire, with its capital in Central Java. When the Dutch reached Java, internal conflicts and intrigues in the Mataram dynasty weakened the empire and helped the Dutch colonize. They were directly helped by the princes of Central Java, who sought to grow stronger as the Mataram empire declined, and a hierarchical society was maintained there until the end of the colonial age.

In East Java, on the other hand, Javans likewise lived under colonial rule, but here the earlier hierarchical structures disappeared and the population became more freedom-loving and egalitarian than the Central Javans. Because of this they are still regarded to this day by the Central Javans as *kasar* ("coarse, unconcerned about etiquette"). It was in this freer East Javan social and political climate that *ludruk* developed.

Its repertoire is drawn from modern life and its protagonists are ordinary people, very often struggling against exploitation by the rich or against corrupt government officials. The length of a performance is about one and a half to two hours. There is hardly any singing, and no dance movements; the language used is a combination of colloquial Javanese and Bahasa Indonesia. In earlier times almost all the actors were male, with all the female characters being played by male actors or transvestites. This leads us to suppose that such groups, which traveled from one village to another, could not take women with them on moral grounds. Certainly ideas of morality had changed on Java, largely through Islamic influence (and on other islands, such as Borneo, Christian influence), and it would have been considered highly immoral for a woman to join such a group. This tradition of using male actors is still adhered to by the *ludruk*, and the prima donna is often a very pretty transvestite.

Sendratari

In the 1960s a new version of *wayang wong* was created, called *sendratari*. This new dramatic art form was produced for the first time in 1961 at the Prambanan temple at a full moon. The theater company Sendratari Ramayana was created by Kusumo Kesowo, whose aim was to bring art to the people (*seni untuk rakyat*). The plays are predominantly taken from the Ramayana.

Sendratari is purely a dance drama (there is no dialog) and the dance movements are extremely stylized. The male and female dancers have been educated at the schools of art. For these dancers, many of whom were members of the *kraton*, their engagement at the Prambanan marked the start of their professional careers; they had to practice regularly, 15 hours per week to be precise, and put on 30 performances a year. Moreover, they received payment for every appearance, a practice that was still unusual for this art form. Sendratari Ramayana employed about 28 principal dancers,

Opposite

Expression of the *rasa* (the nine emotions) in Indian dance.

The facial expressions are based on *Natyasastra*, a classic text on the art of dance.

1. *sringara*: love
2. *karuna*: sympathy
3. *hasya*: laughter
4. *veera*: courage
5. *raudra*: anger
6. *adbhuta*: surprise
7. *bhy anaka*: fear
8. *bibhatsa*: disgust
9. *shanta*: peace

Some expressions were also taken over for Balinese dance, particularly 1, 3, 4, 5 and 6. By contrast, Javanese dances do not employ these facial expressions, the faces of the dancers showing only a calm, meditative expression.

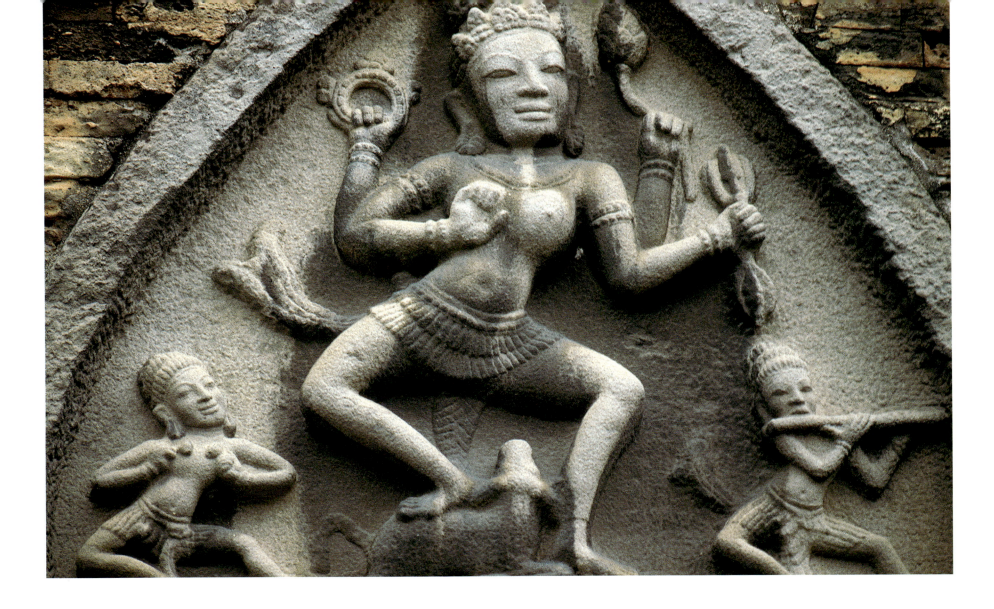

The Dancing Four-armed Deity Uma

Relief in Po Nagar, Na Trang, Vietnam

Here Uma, the wife of Shiva, is standing on her mount, the bull Nandi. At her side two musicians are playing. The Uma's S-shaped pose is also seen in Balinese dances.

404 supporting dancers, and approximately 123 gamelon musicians. The majority of the principal dancers from the early days in the 1960s still play an important part in the present-day dance scene. The Sendratari Ramayana at Prambanan, also called the Ramayana Ballet, which is produced by moonlight, enjoys great popularity today, especially among city people and tourists.

Since dialog and song are not used in *sendratari*, there are fewer rules to observe, and so it has become one of the most popular media with avant-garde dancers and choreographers.

Modern theater

In the 1960s a new era began in Indonesian theater. Theater groups in the Western sense were founded, the center of this development being Yogyakarta. Much impetus for these changes came from LEKRA (Lembaga Kebudayaan Rakyat, The People's Institute of Culture).

LEKRA was a Communist party institution committed to folk theater and to bringing productions to villages and to the *kampung* (poor areas of town). In this way they made *wayang wong* popular for people in the villages and the *kampung*, often using *ketoprak* and *ludruk*, forms of theater well suited to disseminating their populist ideology.

The language used in the theater productions was Bahasa Indonesia, which the 1928 Youth Congress had demanded should be made the national language. Unlike Javanese, Bahasa Indonesia, derived from coastal Malayan, makes no hierarchical distinction; it is, in effect, a more egalitarian language which can be used without distinctions of class. In Javanese, by contrast, there are several forms of the language, which are used to express grades of courtesy. The underclass has always had to use High Javanese (*kromo*) when speaking to the nobility or elders, and the colloquial language (*ngoko*) when speaking to equals. The nobility, on the other hand, spoke *ngoko* with the underclass and *kromo* with their equals. In other words the Javanese language strengthens and sanctions a hierarchical society, Bahasa Indonesia promotes an egalitarian society.

It is obvious that classical *wayang* productions support traditional Javanese ideals, including the hierarchical society, while modern theater productions provide an opportunity to criticize the feudalistic structures of society.

Of all the famous theater groups, two in particular should be mentioned: those founded by W S Rendra and Riantiarno. In 1968, after his return from abroad, W S Rendra, who in the meantime has become world-famous, founded a *bengkel*

teater ("theater workshop"). Here he experimented producing Western subjects and stories in a Javanese setting; *Macbeth* and Brecht's *The Caucasian Chalk Circle* were part of his repertoire. At first his plays criticized both politics and society, and as a result he was forbidden to make any public appearances, a ban in force from 1978 to 1986. At the end of this time his fighting spirit was broken; but his plays, and his influence, lived on. Originally a Catholic, he converted to Islam in the 1990s and has preached Islam since then.

Riantiarno directs the popular Teater Koma group, which likewise turns a critical eye on Indonesian politics and society.

Dance

Dance plays a very important role in Southeast Asia generally and in Indonesia in particular. It has been accorded many functions and meanings, and is performed at religious occasions and also at social events. And in Indonesia, the "religious occasions" still include such events as birth, social initiation, marriage, and death, in other words all those occasions that can be described as rites of passage – events celebrated with dance.

There are also many other everyday ceremonies – for example those associated with building a house, harvest thanksgiving, and healing the sick – in which dance was almost indispensable. There are different forms of ritual dance: there is the ritual dance performed only by the shamans or priests; another ritual dance is performed by all the people present. The presence of a shaman or a priest, whose function is to establish a link between this world and the next, is very important in a ritual dance. The dancers can help to forge this link by going into a trance.

Ritual dance also played an important role in Buddhism and Hinduism, as we can see from temple reliefs, which frequently depict dance poses (see right). These portrayals are found not only in Java, but throughout Southeast Asia; fine examples can be seen, for example, in the former Cham regions (see opposite), in Angkor, and in Pagan. These portrayals of dance from the various regions of Southeast Asia are all very similar, so it can be assumed that they have the same source. This was almost certainly the dance tradition of southern India, though throughout Southeast Asia this source underwent a long period of development and assimilation, during which a range of local elements were combined with Indian ones.

According to legend, Shiva gave people dance as a gift so that they could honor him by dancing; consequently dance and religion were inseparable. Around 200 B.C. a Brahman in India wrote down everything that was then known about the art of dance. His book is called the *Natyasastra* ("Book of Dance") and contains, among other things, guidelines for dancing, the representation of the nine emotions (*rasa*) conveyed by dancing, and the many symbolic hand positions (*mudra*) used.

The guidelines set out in the *Natyasastra* are strictly followed in the Bharatanatyam, a classical dance from the Tamil Nadu in southern India (*bhava*: feeling or mood; *raga*: melody, song; *tala*: rhythm; *natya*: dance). In Southeast Asian countries, the principles of the *Natyasastra* were adopted but gradually modified, though the basic characteristics of the Indian originals are visible everywhere. A position of two female dancers carved at Borobudur, for example, corresponds to the twenty-second Karana Ardha swastika from the *Natyasastra*; only the positions of the arms are different. Another relief at the Borobudur shows a female dancer whose feet – one foot with a raised heel, the other firmly on the ground – corresponds to the eighty-ninth Karana Sinha Vikridita. But here, too, the position of the arms is different from that of the Indian original.

The dances of Bali follow these Indian principles closely, especially in the representation of the

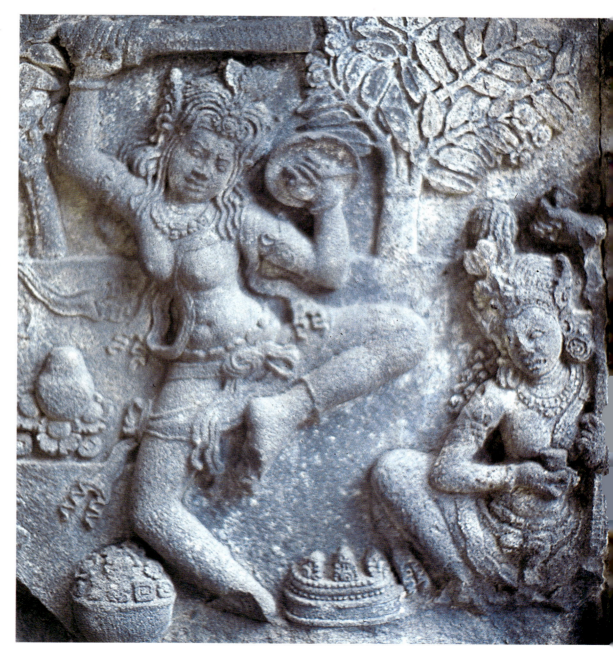

Female dancer with a shield and sword

10th century, Ramayana relief, Prambanan

The dance movement here resembles that of the dancing Uma of Po Nagar (see opposite).

Opposite; left, from top to bottom

The Bedhaya dance, a Yogyakarta version

The court of Yogyakarta. Dancers (from left to right): Istu Nurhayati, Retno Nuryastuti, Suprapti. Choreography: Rama Sasminta

Here the story of Arjuna Wiwaha is being performed in the Bedhaya version.

Opposite; middle, from top to bottom

The Serimpi sangopati dance

The court of Pakubuwono, Solo. Dancers: Noor Farida Rahmalina, Eko Kadarsih, Bray Sri Retno Handayani

A court dance, originally choreographed by Paku Buwano IV (1788–1820), the Serimpi sangopati was modernized by Paku Buwono IX (1861–1893). The dance was performed during negotiations with Dutch colonial officials about the ceding of the north coast of Java. The dancers were provided with a glass and a loaded pistol: the alcohol symbolized the willingness to negotiate, the pistol the dangers inherent in the negotiations going wrong.

The ritual dance, Kanjan

Tumbang Malahui, Central Kalimantan 1993

This dance may be performed only during a festival of the dead.

nine emotions (*rasa*) through facial expression. In comparison, those of Java were exposed to a range of influences, notably (from the 16th century onwards) those of Islamic mysticism, which transformed the dance movements by giving them a meditative character. Javanese dance movements are pensive, in the courtly style, and the facial expressions are not allowed to betray any emotion. In essence, Javanese dancing is a form of meditation, in which the dancer seeks to be united with the supreme deity.

The Indianization of Southeast Asia began as early as the 4th century A.D., and is marked by the spread of both Hinduism and Buddhism. The illustrations of dancing deities in the temples mainly show Shiva, his wife Durga, and *apsara* (heavenly nymphs). At Borobudur there is a representation of a Brahman teaching women to dance, which suggests that the art of dance, like religion itself, was spread by the Brahmans.

At this time the kings on Java had Brahmans brought from India to supervise the building of temples. The Brahmans not only provided the knowledge to build temples, they also performed the rituals that ligitimized the kings' claim to the throne. The Brahmans presented the kings as rulers chosen by the deities, figures who maintained the harmony of the universe. Their consecration took place ceremonially in the temple, and presumably sacred dances were performed in which the dancers represented the deities. This would certainly explain the portrayal of deities in a dancing pose. Another possible explanation is that the temples had to be sanctified before they could be used as sacred buildings, and so dances were part of the ritual of sanctification.

Dance also plays a very important role in the history of the kingdoms of Southeast Asia. As we have seen, in this whole region dance had a role to play in the religious ceremonies that legitimized the authority of the king, and also the origins and existence of kingdom itself. This role is illustrated by the story of a young prince who, around A.D. 800, is said to have visited a kingdom on Java (presumably Sanjaya or Singosari). Later he founded the kingdom of Angkor in Cambodia and called himself Jayavarman II. On his journey to Angkor he took with him Javanese dancing girls; they clearly had an important role to play in establishing the new kingdom. So it is no coincidence that the dances depicted in Khmer reliefs (see Volume II, page 16) are very similar to those of Java.

Between the kingdoms on the Southeast Asian mainland and those on the Indonesian archipelago there was at that time a great deal of involuntary cultural exchange. An attack by a Javanese kingdom on the Champa kingdom in present-day Vietnam is said to have taken place even before the 10th century A.D. In the 12th century, the Champa kingdom launched a campaign against Angkor and a long series of offensives and counteroffensives followed. During each conquest, the capital cities were destroyed and prisoners-of-war (including dancers) were taken from the enemy. A

Vietnamese document describes the conquest of the Champa kingdom by the Dai Viet kingdom of north Vietnam in 1471 in which 60,000 Cham were murdered and 40,000 prisoners, mainly dancers, musicians, and craftworkers, were taken. The fact that dancers were always taken as prisoners clearly shows the social and religious importance of dance at that time.

As we have seen, the kings of Southeast Asia were regarded as the earthly representatives of a divinity whose sacred power was conferred on them by the Brahmans during religious ceremonies. This sacred power manifested itself in the traditions and the insignia of the kingdom, which had to be tended and to which sacrifices had to be made. As long as these legacies still possessed sacred power, the authority of the king was assured. These sacred and protective legacies (*pusaka*) could be material objects such as a throne, weapons, shields, musical instruments (particularly the *gamelan*) – or dances. Usually when a kingdom was conquered these legacies were either destroyed or taken by the conqueror in order to demonstrate that the defeated kingdom no longer had any sacred power. In some areas this link between dance and the state is recognized today.

The central religious and political role played by dance helps to explain the spread of Hindu-Javanese dances on the mainland of Southeast Asia. In fact, the dances on the mainland may well have been more strongly influenced by Hindu-Javanese dance than by Indian dance. In the following pages we will look briefly at the two main traditions, ritual dance and court dance.

Ritual dance

In some ethnic groups in Indonesia dance acts as a medium between humans and ancestors or inhabitants of the upper world. Sometimes the dancers act as mediums by going into a trance and conveying messages from the ancestors and supernatural beings, often in a language which only the priests and shamans can interpret.

The Balinese dance Sang hyang dedari comes under this heading. A dance performed only in exceptional circumstances, such as serious illness or misfortune in the village, it is danced by small girls who, as "heavenly nymphs," proclaim in a trance the message of the gods and spirits.

With the Ngaju Dayak in Central Borneo, the sacred Kanjan dance is performed at the festival of the dead. It is danced at the end of every ceremony and sacrificial act, with all the participants in the ceremony forming a large circle and moving their arms up and down like wings. According to one interpretation, the dancers are meant to be imitating the rhinoceros bird, which is associated with the upper world. Another interpretation is that the arm movements are a ritualized portrayal of relief and joy at the successful outcome of the death rites. As the dance is very old (it was first recorded in 1858), no one knows its original meaning. The purpose of the dance, however, is

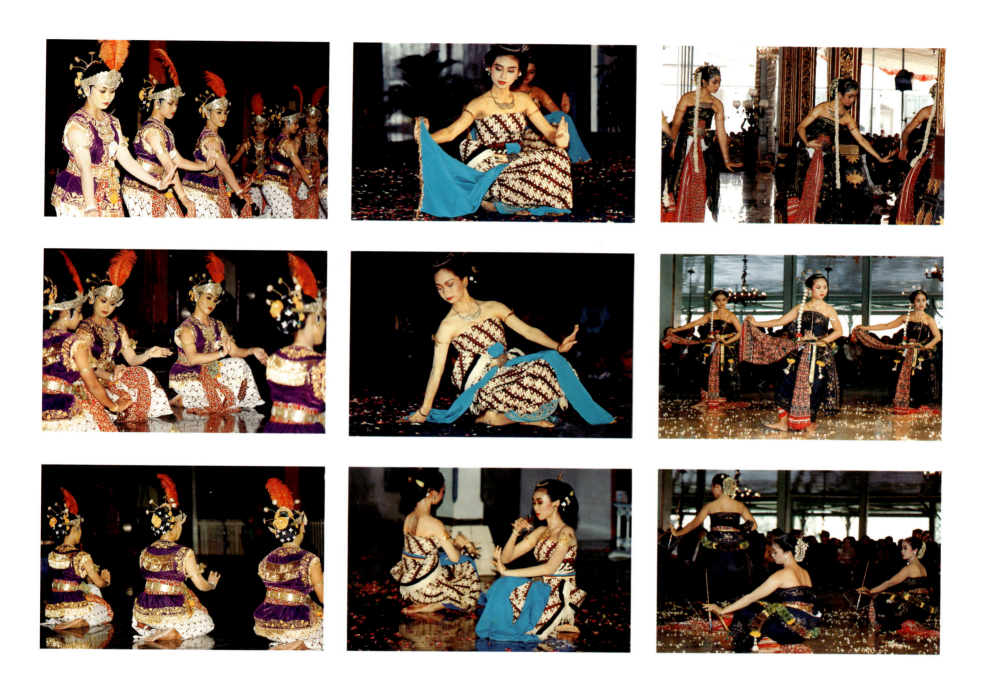

clear enough: it is a form of collective prayer and communal action that promotes feelings of solidarity and unity. The Ngaju describe the dance, which is accompanied by gong music with a special rhythm of its own, as a message to the upper world via the ritual (see opposite).

The Ngaju Dayak make use of every opportunity to dance. There are two major forms, dances for ceremonies celebrating the major events of life, and ceremonies for helping the dead reach the next life safely, forms that traditionally had never to be confused. Included in the ceremonies celebrating life, for example, are ceremonies for births, weddings, name-giving, house building, harvest thanksgiving; there are also ceremonies for healing the sick. The main dance accompanying them, the Nasai, is a circle dance; it is mainly the feet that move. It was originally the rule that the participants danced in a clockwise direction for life-giving ceremonies, and anticlockwise for festivals of the dead. This rule, however, seems no longer to

apply for the Ngaju Dayak; moreover, the Nasai dance is no longer exclusively sacred and young people like to dance it for entertainment.

Dances for the harvest thanksgiving festival are also well known on Java. In earlier times a prettily dressed young woman used to perform the dance, during which the men present could offer her money. The one who could pay the most could spend the night with her. This linking of dance and sex were meant to encourage the continued fertility of the fields. Today these dances are forbidden on moral grounds and are, allegedly, no longer performed. However, a relic of such dances is the Gambyong dance, which was invented at the end of the 19th century by a dancer called Mbok Gambyong. This dance was so famous that it was adopted as the court dance of the Mangkunegoro dynasty under the name of Gambyong pare anom and danced at official events. Its coquettish movements (*genit*) are meant to symbolize the openness and courage (*lincah*) of the Mangkunegoro girls.

Above, right; top
The sacred dance Bedhaya ketawang

The court of Pakubuwono, Solo. Dancers: Bray Sri Retno Handayani (in front), Noor Farida Rahmalina, Eko Kadarsih

Above right; middle and bottom
The dance Bedhaya anglir mendung

The court of Mangkunegoro. Dancers (from left to right): Martati, Dewi Kristianti, Darmasih

This dance was choreographed on the second anniversary of the accession to the throne of Mangkunegoro IX in 1989. Since the *kraton* (court) of Mangkunegoro, which is a sultanate, is not sufficiently important to be considered a true *kraton* but merely as a *pura* ("small court"), the Bedhaya dance is danced by only seven (instead of nine) dancers. For the same reason, the dancers are not dressed as brides.

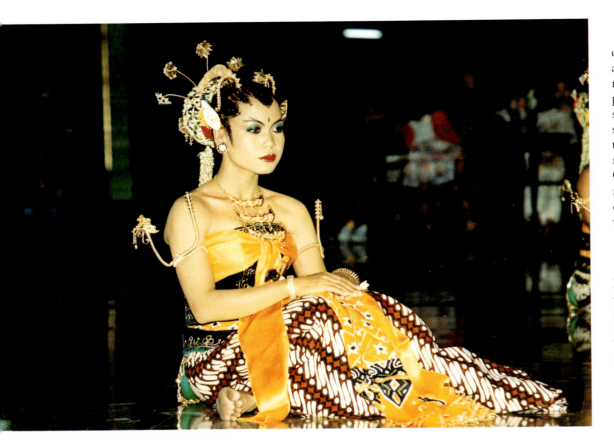

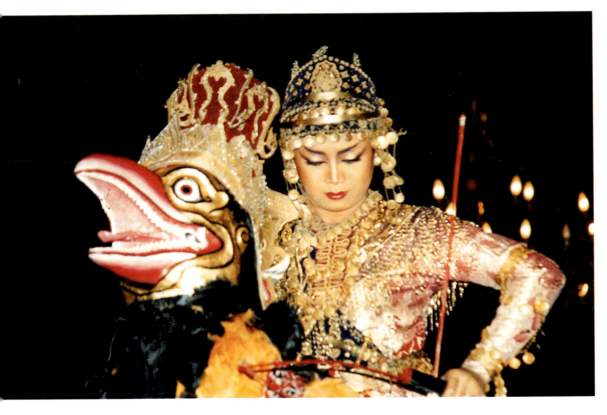

Top

Bedhaya sang amurwo bumi

The court of Yogyakarta

This dance was choreographed by Rama Sasminta at the request of the Sultan Hamengku Buwono X. In this version, the stories of Ken Arok and Ken Dedes are being performed, which exemplify the unity of Buddhism and Hinduism.

Above; and opposite, top left

An actress in the play *Tari Golek Menak*

Istu Nurhayati as Putri Widaninggar, and Retno Nuryastuti as Dewi Rengganis. Choreography: Rama Sasminta

This dance was choreographed by Sultan Hamengkubuwona IX, who imitated *wayang golek* movements in the form of a dance.

These dances contrast with the Ronggeng dance, which was originally danced in West Java at harvest thanksgiving festivals in honor of the rice goddess Dewi Sri; and the Joged dance, performed on Bali. In both of these dances scholars see signs of earlier matrilineal societies, since in both these dances it was normal for the dancer to be allowed to summon one of the male spectators to her. With the arrival of Christian and Islamic influences, the situation was reversed, so that the man offering the most money could buy the privilege of spending the night with the dancer.

Court dances

From 1755 the Mataram empire in Central Java was divided up into four princedoms: two in the Surakarta (Solo) region, the Pakubuwono and Mangkunegoro dynasties; and two in the Yogyakarta region, the Hamengkubuwono and Pakualam dynasties.

The rulers of Pakubuwono and the rulers of Hamengku Buwono have long argued as to which dynasty is the legal heir of the Mataram empire. In fact, the Hamengku Buwono are regarded as the official descendants, and possess the protective legacies of the Mataram (*pusaka*) as well as the sacred gamelan – but the sacred dance, the Bedhaya ketawang, has remained in the possession of the Pakubuwono dynasty. And so the Hamengku Buwono created a court dance called Serimpi Renggowati, which is performed at official functions in the *kraton* (the royal court).

It is a different situation in the Pakubuwono *kraton* in Solo. The sacred dance the Pakubuwono inherited, the Bedhaya ketawang, is mentioned in the Javanese chronicle *Babad Tanah Jawi* in the 17th century. The legend tells how Senopati the founder of the Mataram empire met the sea goddess Ratu Roro Kidul, who wanted to marry him. She said that if he married her he would be able to rule over the empire with her blessing. He agreed and promised that he would receive her once a month, and that his descendants would do the same. In exchange she promised him that once a month she would teach the Bedhaya ketawang dance to the maidens of the kingdom; the dance was to be performed once a year and was to be regarded as extremely sacred.

As a result, the Bedhaya ketawang dance had strict taboo rules attached to its performance, taboos the dancers and musicians had to observe. Only the king and members of the royal family are allowed to be present. The dancers must be virgins and they must not be "impure" (menstruating) when performing. Before the performance they have to fast and they have to stay awake the night before the performance; after the dance they are adorned like brides. It is said that during the performance, at which very many sacrificial offerings are made, the sea goddess appears and enters one of the dancers, who goes into a deep trance,

Top right

Sinta and Rama

Studio of Pudjokusuman. Dancers: Retno Widyastuti (Sinta) and Suhastanto (Rama). Choreography: Rama Sasminta

Bottom left

The Bandayudo dance

Danced by Radianto Wibowo (left) and Aryono (right)

Performed at Solo in the reception hall of the court, where the official home and foreign guests are received (not in the sacred area). The dance of the "brave soldiers" is a version that was choreographed by Sultan Agung (1613–1645).

Bottom right

Chinese princess in the play *Putri Cina Kelaswara*

Dancer: Istu Nurhayati in the studio of Pudjokusuman. Choreography: Rama Sasminta

The character represented here is probably a princess from the Champa empire.

though she continues to dance with the others. This dance was clearly meant to symbolize the union of the sea goddess with the king.

The dance was performed by nine chosen dancers who symbolize the nine emotions (*rasa*) and also nine points of the compass (including the center). It is performed only in November, on the anniversary of the founding of the empire, its purpose being the preservation of the empire and the confirmation of the ruling king's spiritual and temporal legitimacy. The Bedhaya ketawang dance can be seen as a sacred legacy, and it is treated like other sacred objects of the kingdom, in other words closely linked to rites of sacrifice and purification.

The tradition the four princedoms shared (or share) had the same origin; they divided in order to increase their power, a process that led to keen rivalry. As a result of this shared past, many dances are found in all the courts. Thus in every court there are versions of Serimpi and Bedhaya; the Serimpi dance is always performed by four dancers as a symbol of the four points of the compass (see page 381 center), and Bedhaya by nine dancers (see page 381, left column). There are also different versions or even newer creations of the Bedhaya dances, in which only the basic elements are adopted, but they are nowhere near as sacred as Bedhaya ketawang (see page 381, right).

Secular dance performances are mostly given by specialist trained dancers. They depict a narrative and are not an integral part of a religious ritual, though they were sometimes performed after such rituals. Today such secular dances are performed at weddings, at the reception of state visitors, and at opening festivals of sporting events (see below).

Female Javanese dancers were originally called *ledhek*, a word that is extremely pejorative. In fact it was often the case that the *ledek* were the mistresses of the nobility or the rich, and there were beautiful and famous *ledhek* who lived as concubines of the king. The word was not used of those who danced in rituals.

In the 14th century, according to old chronicles, secular dances were performed solely in palaces, mainly at the court of the kings, and were later used for welcoming guests of honor. These dances of welcome became increasingly significant, especially in Dutch colonial times, being a matter of course when officials of the colonial government visited a court. What had been a royal prerogative was now offered to the colonial masters.

After independence in 1945, welcome dances were performed in the palace of the first president, Sukarno, for foreign heads of state. Male and female dancers well known in the various regions of Indonesia were brought to the capital to perform, and were even sent abroad as national troupes. The

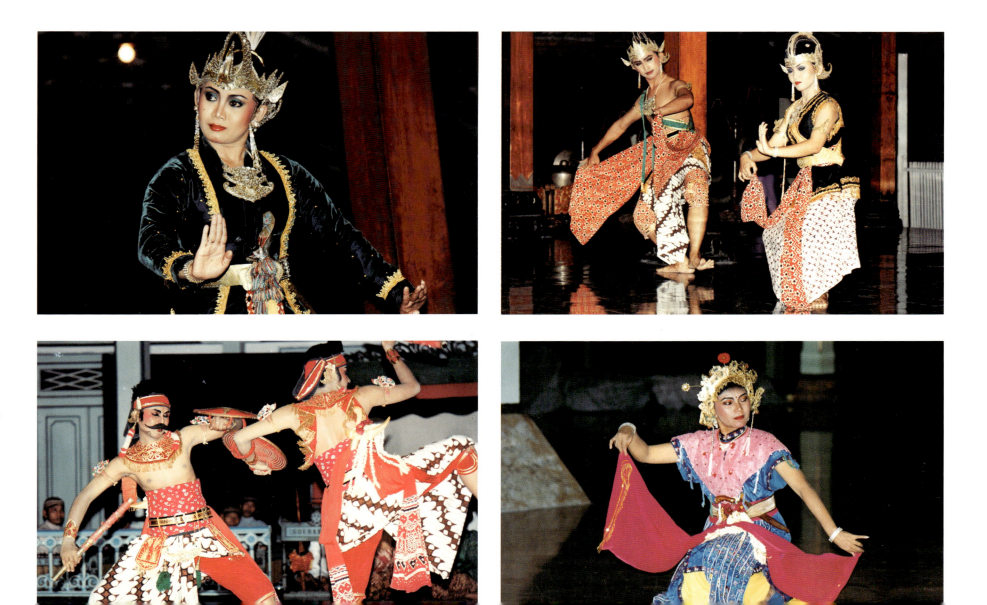

Didi Nini Towok in *Reincarnation*

His right-hand half represents a man, and the left-hand half a woman, a split persona that expressed the search for unity through the meeting of opposites.

Gusmiati Suid's dance group

Gusmiati Suid is an internationally famous dancer and choreographer. The basis of her training is *pencak*, the Indonesian version of Tai Chi and the Minang dance (from Sumatra). From 1972–1975 she attended the Academy of Music (ASKI) in Pandang Panjang (Sumatra), since 1984 she has been a lecturer at the Academy of Arts (IKJ) in Jakarta. She was the first Asian choreographer to receive, in 1991, the Bessie Award, a much-coveted distinction. The strength of her group lies in the vitality of the movements, which are based on the classical Sumatran dances.

dancers became famous at home and internationally, and were held in high regard by society; the pretty dancing girls were honored as prima donnas. With this the reputation of professional dancers, male and female, was gradually enhanced.

But there was a problem. It was not difficult to take to the capital dances from regions that already had secular dances. But in many regions the dances were mainly sacred ritual dances, intended for specific deities. When taken to the capital, these dances were performed totally detached from their cultural and religious context. On Bali, for example, a temple dance such as the Pendet, which otherwise was only danced for the gods, was frequently performed in the palace for national and foreign guests of honor. When the volcano Gunung Agung erupted in 1963, many Balinese believed this was a result of misusing such sacred dances.

So at a conference in Bali in 1971, agreement was reached to divide the dances into three categories: *wali*, sacred dances that can only be performed in the inner courtyard of the temple and exclusively as part of a ritual; *bebali*, sacred dances that are performed in the external courtyard of the temple, and can be witnessed by spectators; and *balih balihan*, profane dances, dances that do not form part of a ritual. But it should be noted that even *bali balihan* dances require a high standard of training. The conference also decided that *wali* dances were not, under any circumstances, to be performed for tourists or as welcome dances.

Modern choreographers

The encounter with the West inspired various groups on the Indonesian dance scene. There now are many choreographers developing their own styles; most of them are trying to develop a choreography which, though essentially contemporary, has its roots in classical Indonesian dance. The following are some of the leading figures working in contemporary Indonesian dance.

Bagong is considered the father of modern Indonesian choreography. This multitalented man (he is also a painter and forerunner of the modern batik artists) is trying to modernize Javanese dances by introducing new dance movements into classical dances. His home town is Yogyakarta, where he was trained in classical Javanese dance. In 1957 he went to New York on a one-year scholarship and studied with Martha Graham. He founded the Center for Art in 1978 in Yogyakarta (the Padepokan Seni Bagong Kussudiardja), where he has trained many students from all regions of Indonesia and abroad.

Bagong develops dance routines that bring together a range of styles, as can be seen in his play *Echo of Nusantara* (written in 1988 on the occasion of the opening of the Summer Olympics), in which he uses dance and music from different regions of Indonesia. His introduction of new themes into Indonesian dance is clearly illustrated by his play *The Life of Jesus* (1985).

Retno Maruti, one of the most famous classical Javanese dancers, trained in Solo and Yogyakarta. Her career began with the productions of the Sendratari Ramayana (the Ramayana Ballet) at the Prambanan, where she performed from 1962 to 1974. She later opened her own school of dancing, and began choreographing classical dance plays, mainly versions of the Bedhaya dances, in which she always complies with taboo regulations (sacrificial offerings, fasting). She is less concerned with capturing the meaning of the plays, than with portraying the beauty of the classical dances. Amongst other things, we have her to thank for the renaissance of old Javanese dances that had almost died out. Her production of

Dewabrata (1977), based on classical dances, allowed Indonesians to recollect their cultural roots, roots which are in danger of being lost.

Sardono W Kusuma, whose training was in classical Javanese dance, though in the late 1960s he studied for a year in New York with Jean Erdman, is now a world-famous choreographer. He seeks his cultural roots in all the regions of Indonesia, notably Nias, Kalimantan, Bali, and Irian Jaya, and mainly composes dance plays in which he employs ancient traditions based on breathing technique, meditation, and the development of inner strength. There is nothing esoteric about his works, however, for he is concerned to communicate a message and criticise politics and society. Among his well-known plays are *Lamenting Forest* (1987) and, as a result of collaboration with the Dayaks of East Borneo, *Passage Through the Gong* (1993), which he has already produced in Europe and Asia. His *Detik... Detik... Tempo* (1994) is a protest against the government's ban of a newspaper of the same name.

Didi Nini Towok, who was trained at the Academy of Dance (ASTI) in Yogyakarta, has reintroduced the tradition of classical transvestism into Javanese dance. Portraying both male and female characters, his dances express the coming together of opposites. This approach is common in Javanese dance tradition; male roles are often portrayed by women (such as the role of Arjuna), and male actors perform female roles in *ludruk*. His most famous choreographies are *Reincarnation* (1984), where his right half depicts a man and the left half a woman (see opposite, top left), and *Dwi Muka Dance* ("Two Faces"), in which he likewise uses two half masks to portray two characters. Didi Nini Towok continues the tradition of the masked dance (*tari topeng*) and

adopts many dance elements from the traditions of Cirebon on the north coast of Java (see right).

Prapto, who is not a trained dancer, has dedicated himself to the culture of his homeland, and now enjoys great acclaim from foreign dancers, who come to Solo to learn avant-garde dance from him. His motto being "Back to Nature," he asks his students to concentrate on the themes of earth, fire, air, and wind, and to construct their dances in response to these elements.

These trends in dance are purely performance arts, both classical and avant-garde, and now find a large audience. The annual Indonesian Dance Festival, which was started by Sal Murgiyanto, is evidence of a real interest in dance. Through colleges such as the IKJ (Institut Kebudayaan Indonesia), the STSI (Sekolah Tinggi Seni Indonesia), and the ISI (Institut Seni Indonesia), young artists are encouraged to draw upon classical Indonesian dances – either to develop modern choreography in terms of traditional elements, or to rediscover classical dances in danger of being lost. Even if ritual meaning is increasingly disappearing, the Indonesian dance scene is very lively.

Bendedictus Harto, who died in 1998, devoted himself to the ritual dances of Indonesia. He was a court dancer for 35 years and a lecturer at the school of art in Yogyakarta; he received an MA in California in 1990. One of the few modern choreographers who saw his role as being the revival of the ritual dance, he studied their meaning closely and even choreographed a ritual dance which he took back into the villages to perform. Not until a few years before his death did he receive any recognition from his fellow choreographers and dancers.

The transvestite actor Didi Nini Towok

Below
Modern choreography
Manggon

Dancers: Maria Darmaningsih and Nungki Kusumastuti

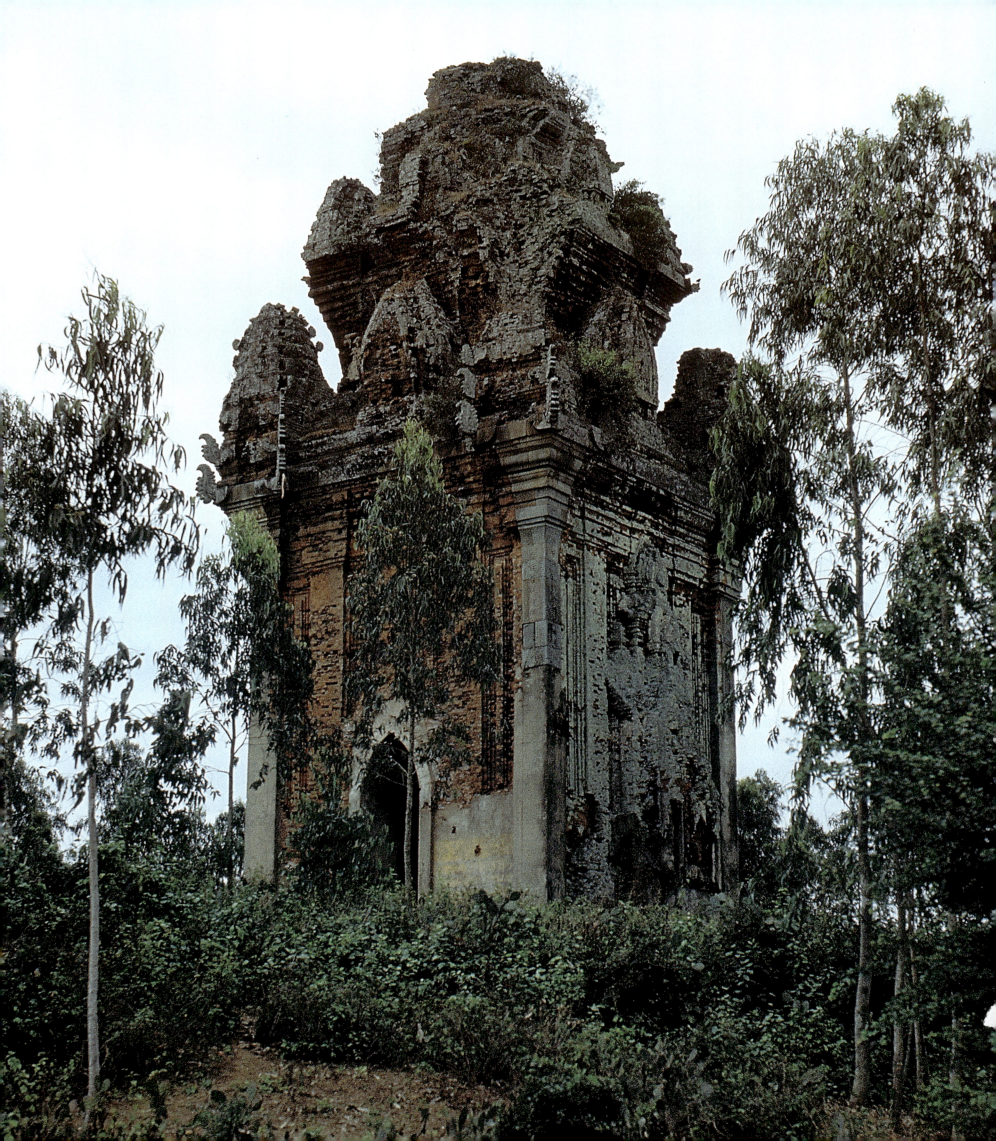

The Champa Kingdoms

The history of the Cham provides a classic example of the rise and fall of a culture. Cultural history does not run in a smooth line; it can pause or surge forward in the course of its historical development. In the Chinese chronicles, Lin Yi, the name given to the Champa kingdoms, is mentioned as early as the 3rd century A.D.; by the 10th century the Cham had colonized the whole of central and south Vietnam.

But gradually the Champa kingdoms were conquered by the Vietnamese, who were moving relentlessly southwards, and the Cham were overwhelmed by a new culture. Today the Cham live mainly in settlements in south Vietnam and Cambodia, where they have partly adopted the culture of the mountain tribes.

Canh Tien

11th–12th century, brick with inlaid sandstone elements, in the Quy Nhon region, South Vietnam

Because of its color, Canh Tien was called the "Copper Tower" by the French. The Vietnamese name Canh Tien, which means "nipple potato," is derived from its distinctive silhouette.

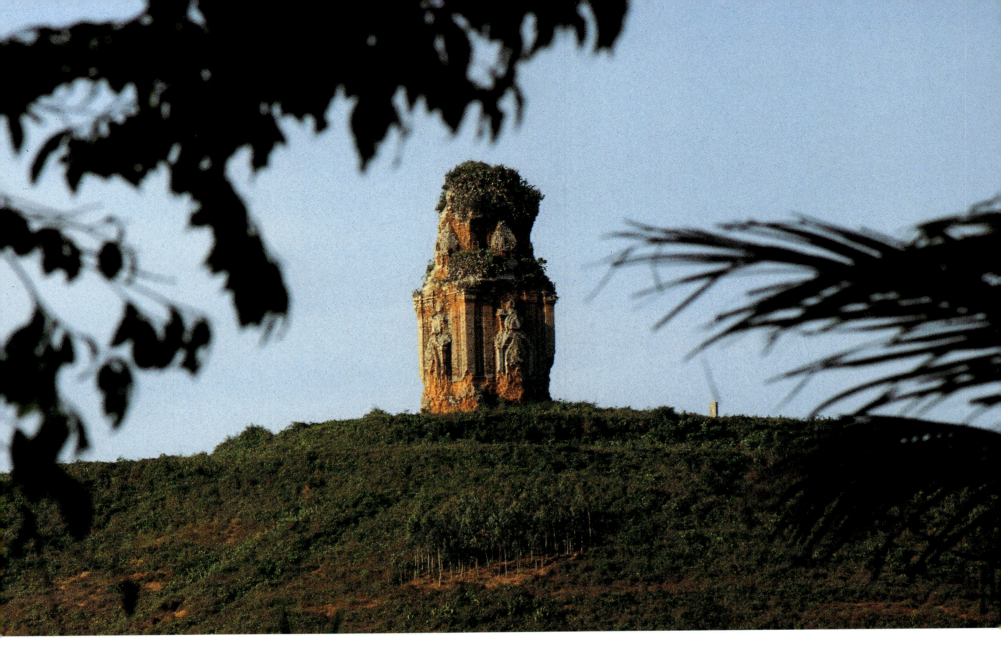

The Rise and Fall of the Cham

If you travel north through southern Vietnam to central Vietnam, you see abandoned ruins scattered on many of the hillsides, ruins from a past that has nothing in common with later cultures of this area, ruins as if from a world foreign to Vietnam. They are the last signs of the once-mighty Champa kingdoms, which flourished in this region between the 4th and the 15th centuries A.D.

The people of this civilization were the Cham, who today live scattered around settlements in South Vietnam and Cambodia. They numbered around 75,000 in the southern part of Vietnam after the census in 1984; around 50,000 live in closed Cham villages on the coast between Quy Nhon and Phan Ri, and approximately 30,000 in the Mekong Delta and Ho Chi Minh City.

The Cham language belongs to the Malayan-Polynesian languages, in comparison to the Vietnamese language, which belongs to the Austro-Asiatic languages. There is still little known about the Cham. The French rediscovered the overgrown temple city of My Son as late as 1898, and until the middle of the 20th century the culture of the Champa kingdoms was largely accessible only to French researchers, with the result that the majority of publications were written in French. Increasingly, however, Vietnamese and Japanese researchers are showing a keen interest, though they usually publish in their own languages and so their research is not readily accessible either.

To add to the confusion, the cities of the Champa originally had Indian names, but are now known by two-syllable Vietnamese names, so that the early capital Simhapura (4th–8th century) is now Tra Kieu; Pandurangga is Phan Rang; and Kauthara is Nha Trang.

The fall of the Champa kingdoms and Cham culture is a tragedy that has continued into the present. This decline was partly caused by the great "migration south" (*Nam Tien*) of the Vietnamese, a move brought about not only by changing social conditions, but also by attacks on the Viet by neighboring kingdoms. The migration south began in the 11th century A.D., when the king ordered the conquered land to be immediately settled by peasants and soldiers.

A sacred tower, *kalan*
Before 1471, South Vietnam

Until 1471 the former Cham capital, Vijaya (called Cha Ban by the Vietnamese), was situated north of Quy Nhon, near to the present-day Bin Dinh. Many ruins of the Champa kingdoms can be found in this region.

The decline of the Champa kingdoms was linked to the defeat of Vijaya (now Binh Dinh) in 1471 by the Dai Viet from North Vietnam; the king was killed along with 60,000 supporters, and 40,000 prisoners were taken north and settled in Hanoi. After 1471 the Cham were pushed even further south; in 1611 they reached the border around the town of Nha Trang, and in 1653 the border around the town of Phan Rang (see map).

According to tradition, the Cham settled the whole of central and southern Vietnam in the 9th and 10th centuries A.D.. They were divided into several distinct kingdoms, notably Amaravati (4th to 10th century), whose center was the temple city of My Son; Vijaya, the heart of Cham culture until 1471; and Pandurangga (8th to 18th century), whose temple city was Kauthara (Nha Trang).

Despite Vietnamese successes, Pandurangga was totally independent until the end of the 18th century. However, because of its unfavorable position between North and South Vietnam, Pandurangga was always dragged into wars between the two regions and finally became a vassal of the Vietnamese feudal lords of Hué.

In fact until 1930 Vietnam was still trying to destroy the last vestiges of Pandurangga's independence from within. This was done by settling Vietnamese families in the region; they pretended to adopt the laws of Pandurangga but gradually demanded autonomous rights from the kingdom of Pandurangga, and in this of course they were supported by the Vietnamese emperor.

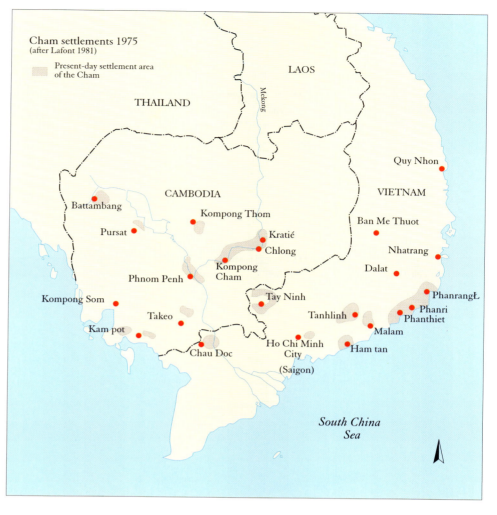

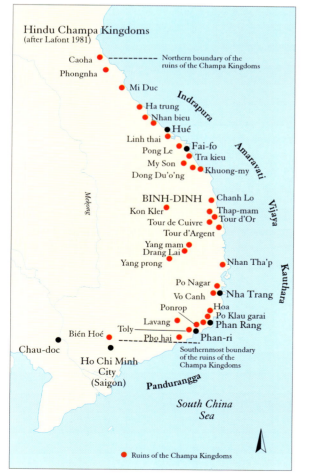

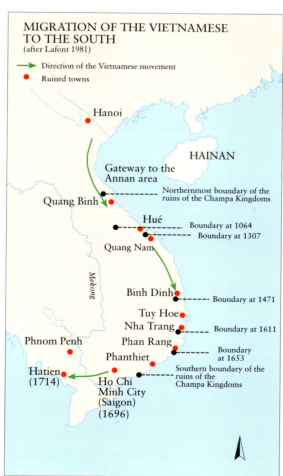

Above

The Cham settlements in the year 1975 spread across South Vietnam and Cambodia.

Far left

Many Champa ruins can still be seen in the vicinity of the former capitals.

Left

The great Vietnamese "Migration to the South" (*Nam Tien*). This map clearly illustrates the relentless progress of the Vietnamese, pushing the Cham further and further south.

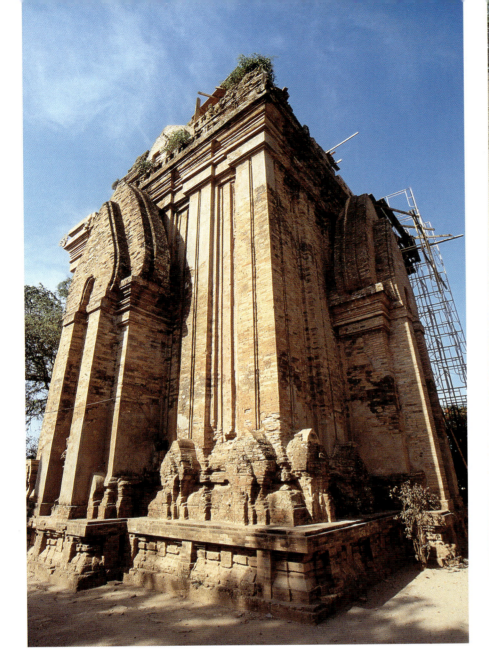

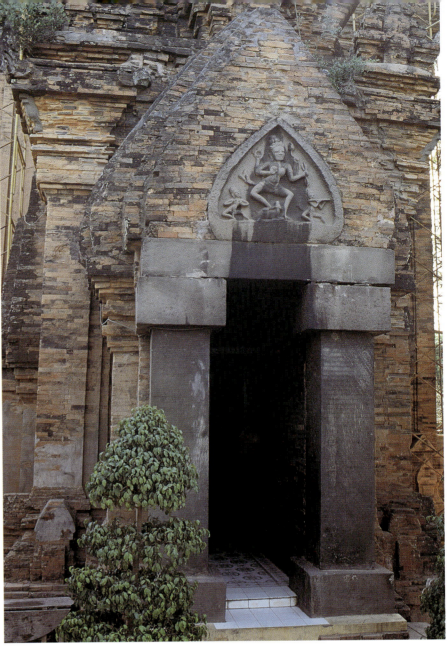

Left
A Champa *kalan*

9th century, Po Nagar

The *kalan*, the main tower of the temple group Po Nagar (Thap Ba) near Nha Trang.

Right
Po Nagar

9th century, sandstone relief, Po Nagar

Over the main entrance of the main tower the four-armed Uma, the wife of Shiva, dances standing on her mystic mount Nandi. At her side two musicians are playing.

It was these increasing independent regions within Pandurangga that finally brought to an end the last Champa kingdom.

From 1834/35 the Cham were "Vietnamized" under Emperor Minh Menh by an edict that required them to dress like the Vietnamese, speak the Vietnamese language, give themselves a Vietnamese name, and perform only Vietnamese rituals. Many Cham fled to Cambodia, where they enjoyed independence as a recognized ethnic group, most of them settling in the Phnom Penh area. Since the majority of Cham in Cambodia are Muslim they faced a particularly difficult time during the years of Khmer Rouge power and prolonged civil war.

In 1964, after years of struggle, the Cham living in Vietnam received formal recognition from the South Vietnamese government as an ethnic minority, a state of affairs that continues today. They mostly still live in their own settlements, though over the years of oppression and war a number fled to live with the mountain dwellers and to adopt their culture. Today approximately two-thirds of the Cham are Hindu and one third Muslim.

To judge from the surviving statues, the Champa kingdoms were predominantly Hindu, and Shivaist at that; the Buddhist period lasted from the 8th to the 10th century A.D. In the temple cities of My Son and Po Nagar, there are several lingams that were clearly associated with the devotion to the phallus of Shiva. These lingams are symbols both of the cult of Shivaism, and also of the divine authority of kingship, which Shiva was thought to confer on a king through the agency of a priest (see page 393).

The story of the Cham is marked by the many wars they waged with their neighbors. Because the Champa kingdoms dominated the fertile Mekong Delta, and had good access to the sea, envious neighbors attempted to wrest their natural advantages from them. They were at the mercy of attacks from Java (8th century), China (8th century), the Angkor kingdom in Cambodia (11th century), and, over many centuries, the Dai Viet from North Vietnam. The incursions from Angkor led to a long series of counter offensives by the Champa kingdoms from the 11th through the 13th centuries; this exhausting conflict was one of

Far left
Portal of a main tower

9th century, Po Nagar

A different deity is portrayed on each of the four sides of the portals. On the west side a deity riding an elephant can be seen, Bathara Indra.

Left
Shiva(?)

12th century, Thap Mam style, sandstone, My Son

Below
The temple group Po Nagar

7th–13th centuries, Po Nagar

To the left the main tower (9th century A.D.), in the middle the southern tower built in the 12th century, to the right the so-called west tower.

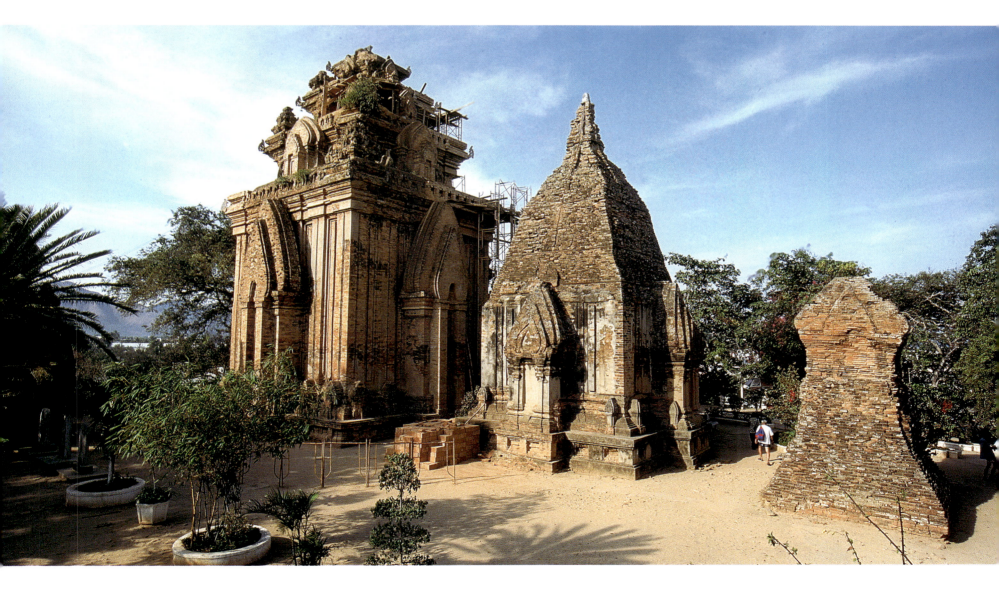

Left
My Son

10th–11th century

This drawing illustrates what has been called the "My Son A1 style," which reflects the strong influence of the central Javanese *candi* on Champa architecture.

Center
Entrance with decorations

10th–11th century, A1 style, temple city of My Son

The decorations indicate Javanese influence.

Above right
Deity on the exterior wall of the hall, *mandapa*

10th–11th century, My Son B5

The deity portrayed in a gesture of prayer.

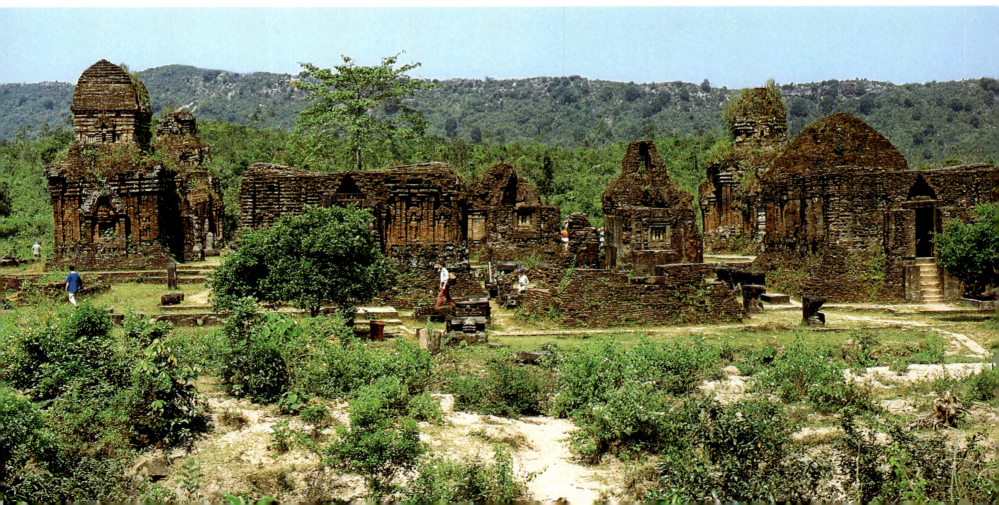

Above left
Lingam on a stone base

8th century AD, My Son

The lingam is a symbol of the worship of the Hindu god Shiva.

Above right
Jatalinga

Around 10th century, F1 group, My Son

A lingam which, portrayed showing the emission of semen, indicates Shiva's exceptional creative power.

Opposite, bottom
Temple city of My Son

4th–13th century, My Son, group B, C, D, around 60 km (37 miles) southwest of Da Nang

several factors that led to the steady decline of the Champa kingdoms.

These conflicts, however, brought about the golden age of art and architecture in the Champa. Between the 8th and 10th centuries they were influenced by Javan, and later, from the 11th through the 13th century, by Khmer architecture.

The Javan influence is most clearly seen in the ornaments in Cham temples and the Kala heads and *makara* figures, all of which are related to those in the temples of the Middle-Javan period, such as Candi Prambanan (9th century; see page 335), and Candi Sara in Central Java (9th century).

The temple city of My Son ("beautiful mountain") is not a single, unified complex, but a site the Cham kings built up over time. It was used as a place for rituals from the 4th through the 13th century. Temple cities were originally constructed about 30 kilometers (18 miles) from the capital but, since capitals were always moved after enemy attack, and the temple cities remained, My Son is now far more isolated than it was.

Cham religious architecture employed three types of buildings: a *kalan*, a tower-like sanctuary (see page 386); a rectangular "library"; and a *mandapa*, a large hall.

During the Vietnam war, My Son was designated for air attacks because Vietnamese resistance fighters were supposed to be living there. As a result, in 1968 the temple city of My Son was destroyed by US Air Force bombardments; of 70 temples only 20 ruins remained amidst an area littered with bomb craters and mines. Since 1981 there have been several efforts to restore My Son. A similar fate met the Buddhist monastery of Dong Duong, which was completely destroyed in the first Indo-Chinese war between the Vietnamese and the French.

Three hundred kilometers (180 miles) south of the first capital Simhapura (Tra kieu), in the region between Da Nang and Quy Nhon, lay the Cham capital Vijaya (A.D. 1000–1471). Around 12 Champa buildings remain in this area, mostly of carved brick with elements of inlaid sandstone, though a few are built entirely of sandstone.

The Champa temple towers were always built on hills, a strategic site to survey the surrounding area. Principally, however, these locations were chosen because they were regarded as the focus of magic powers, especially suitable for meditation and religious observance. This aspect also plays a part in the siting of Borobudur on Java, which

View of a Cham tower

12th century, brick with sandstone elements, Thoc Loc, north of Quy Nhon, by Bin Dinh, South Vietnam

Right
Royal pavilion

10th century, fully developed A1 style, carved brick with inlaid sandstone elements, My Son, group B5

Although the building was also meant as a hall (*mandapa*), it is presumably a "library," in which the ritual objects were kept. The roof has the traditional roof shape of houses in Southeast Asia, the saddle roof.

Below
Thoc Loc

12th century, north of Quy Nhon

The French called this tower the Tour d'Or, the "Golden Tower."

likewise was built in the middle of nature in an attempt to concentrate supernatural powers. As can be seen (see above, left), the doorways into Cham towers are shaped like a vulva. Like the central lingam, this could be interpreted as a fertility symbol, or perhaps as a symbol of the security of the mother's womb.

Po Nagar (Thap Ba) was mentioned as early as the 7th century A.D.; the last building, however, was not built until the 13th century. Originally the temple was dedicated to Uroja, the mother goddess of the Cham. The lingam in the interior, however, shows that Shivaist rituals were also performed there. According to Annelise Wulf, the temple was destroyed by the Javanese in A.D. 774 and again by the Khmer in A.D. 930, but was always rebuilt. It is the only temple that was in use right up to the present day, visited by both the Vietnamese and the Cham (see page 391).

The interior contains a lingam and an altar, on which, curiously, colored cloths and incense sticks can be seen, features more usual in Buddhist-Confucianist temples.

After the excavation of Cham sites at the end of the 19th century, the question was raised as to where the archaeological commission for Indo-China, the École Française d'Extrême-Orient in Hanoi, should house the finds. As a result, a museum was built in Da Nang, the former kingdom of Amaravati, and officially opened in 1939. Its 300 sculptures and reliefs make it the most important collection of Champa art.

The name Champa was known in ancient Javanese chronicles: there is mention made of a princess from the Champa kingdom who married a Javanese king around the beginning of the 15th century. This princess was a Muslim and so brought Islam with her to Java. This series of events is depicted in a warlike dance scene in which the Champa princess finally gives way to her Javanese opponent.

Further proof of the close links between the Champa kingdoms and Java—a relationship that has been insufficiently researched—is the similarity in dress. A publication from the École Française d'Extrême-Orient contains illustrations that clearly show that the clothing of the Cham was very similar to that of male and female Javanese dancers (a style no longer worn either by the Cham or by the Javanese).

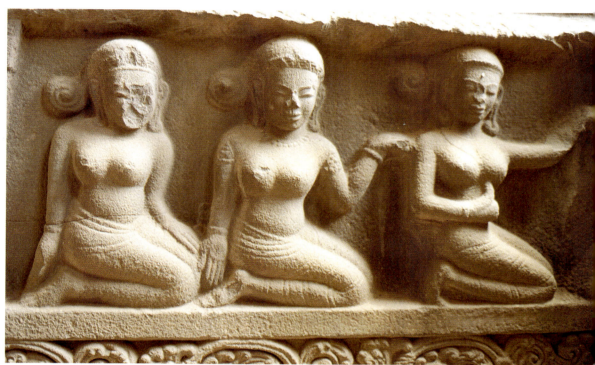

Left
Dvarapala busts

12th century Thap-Mam style, sandstone, H 107 cm, Da Nang Museum

The very round shape of this Champa face indicates Indian influence.

Below
Relief depicting dancing *apsaras*

Sandstone, H 38 cm, Da Nang Museum

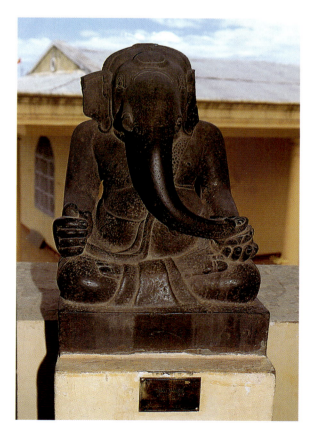

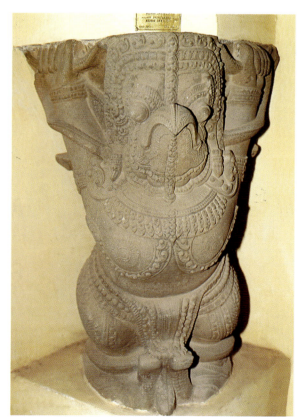

Far left
Ganesha in the *vajrasana* pose

10th century (?), My Son style, sandstone, H 50 cm, Da Nang Museum

Ganesha, the elephant-headed son of Shiva, is the Hindu god of wisdom and knowledge.

Left
Garuda as a container

12th–14th century, Thap-Mam style, sandstone, Da Nang Museum

Half bird and half human, Garuda is the mystical mount of the deity Vishnu.

Glossary of Chinese characters

This list of Chinese names and terms will enable readers to distinguish and identify unambiguously the terminology in the original and technical literature given in transcription in the bibliographies. Geographical names not applied to cultures are omitted, as are the names of rulers. The listings, including the names of contemporary artists and works of art, are given in "long characters."

Abaoji	阿保機	dou	斗
Afang gong	阿房宮	dougong	斗栱
		Du Fu	杜甫
ba	跋	Dule yuan	獨樂園
ba xian	八仙	dui	敦
Bada shanren	八大山人		
Bai Juyi	白居易	erbei	耳杯
bai ta	白塔	ercengtai	二層台
baici	白瓷	Erlitou	二里頭
baimiao	白描		
bao	豹	Fan Kuan	范寬
Baoen jing	寶恩經	fang (kopieren)	倣
Baohe dian	保和殿	fang (Viertel)	坊
baoping	寶瓶	fangding	方鼎
bei	杯	fanggu	方觚
Bei Liang	北梁	fanglei	方罍
Bei Wei	北魏	fangxiang shi	方向師
Beitang shuchao	北堂書鈔	fangyi	方彝
bi	璧	fantou	礬頭
bi ...yi	筆意	Feilai feng	飛來峰
bian (bian zhong)	編鐘	fei yi	飛衣
Bian Shoumin	邊壽民	feng	鳳
bianhu	扁壺	fengshui	風水
Bishu shanzhuang	避暑山莊	fengsu hua	風俗畫
Biyun si	壁雲寺	Fengxian si	奉先寺
bo	鎛	Fogong si	佛宮寺
Bogu tulu	博古圖錄	Foguang si	佛光寺
boshan lu	博山爐	Fu Baoshi	傅抱石
Boyuan tie	伯遠帖	Fuchun shanju tu	富春山居圖
		fugu	复古
Cao Cao	曹操	fugui	富貴
cao sheng	草聖	fupicun	斧劈皴
Cao Zhi	曹植		
caoshu	草書	Gao Fenghan	高風翰
Caotang ji	草堂記	Gao Kegong	高克恭
Changchun yuan	長春園	Gao Qipei	高其佩
Chen Hongshou	陳洪綬	Gao Xiang	高翔
Chen Qiquan	陳其銓	gao yuan	高遠
Chi bi tu	赤壁圖	gong	觥
Chu	楚	Gong Xian	龔賢
Chuci	楚詞	gongbi	工筆
Chunhua ge tie	淳化閣帖	gou	鉤
Chunqiu	春秋	goutou	勾頭
Cizhou (yao)	磁州（窯）	gu	觚
cong	琮	Gu hua pin lu	古畫品錄
Cui Zifan	崔子範	Gu Junzhi	顧駿之
		Gu Kaizhi	顧愷之
da cao	大草	guan	罐
da zhuan	大篆	guan	棺
Dai Jin	戴進	Guan (yao)	官（窯）
Dai Kui	戴逵	Guan Tong	關仝
dao	道	Guan Xiu	貫休
dayan ta	大雁塔	guanxingqi	冠形器
Di	帝	Guanyin	觀音
dian	點	guanzhuangshi	冠裝飾
dianfa	點法	gui	簋
ding	鼎	Gujin tushu	古今圖書集成
Ding (yao)	定（窯）	jicheng	
Ding Yi	丁乙	guo	槨
Dingling	定陵	Guo Si	郭思
Dong Qichang	董其昌	Guo Xi	郭熙
Dong Yuan	董源	guohua	國畫
Dongpo shanju	東坡山居	guyi	古意
Dongshan	東山草堂圖	haima	海馬
cao tang tu		Han	漢
Dongwang fu	東王夫	Han Fei Zi	韓非子

Han Gan	韓幹	lianhua	蓮花
Han Huang	韓滉	Liao	遼
Hanlin	翰林圖畫院	Lidai minghua ji	歷代名畫記
tuhua yuan		Lienü tu juan	列女圖卷
hao	號	Lienü zhuan	列女傳
He	河	Liji	禮記
he	盉	lin	臨
He Tianjian	賀天健	Lin Fengmian	林風眠
heng	橫	Lingnan (Schule)	嶺南畫派
hexi	和璽	Lingyin si	靈隱寺
Hongqi song	紅旗頌	Linquan gaozhi	林泉高致
Hongxue	鴻雪因緣圖記	lishu	隸書
yinyuan tuji		Liu Haisu	劉海粟
hu (Kanne)	壺	Liu Songnian	劉松年
hu (Tiger)	虎	Liuya luyan tu	柳鴉蘆雁圖
Hua ji	畫繼	long	龍
Hua shanshui xu	畫山水序	Longquan (yao)	龍泉（窯）
Hua Yan	華喦	Longshan	龍山
Hua yuntaishan ji	畫雲台山記	longyao	龍窯
Huaisu	懷素	Longyou	龍友
Huang Binhong	黃賓虹	lou	樓
Huang Gongwang	滉公望	lu	鹿
Huang Shen	黃慎	Lu Lengjia	蘆楞迦
Huang Tingjian	黃庭堅	Lü Shoukun	呂壽琨
hun	魂	Lu Tanwei	陸探微
Huqiu	虎丘	Luo Ping	羅聘
hutong	胡同	luohan	羅漢
		Luoshen fu	洛神賦
Ji chang yuan	寄暢園	Luoshen	洛神賦圖卷
jia	斝	fu tu juan	
jiaguwen	甲骨文	luotuo	駱駝
jian	間	Lüshi chunqiu	呂氏春秋
Jiang (Changjiang)	江		
jiashan	假山	Ma Hezhi	馬和之
jiehua	界畫	Ma Lin	馬林
jiejing	借景	Ma Yuan	馬遠
Jieziyuan huapu	芥子園畫譜	mao	矛
(auch Jieziyuan	（芥子園畫傳）	Mi Fei	米芾
huazhuan)		mijiao	秘教
Jigulu	集古錄	Min Zhen	閔貞
Jin	晉	mingqi	明器
Jin	金	miseci	秘色瓷
Jin Nong	金農	mo	摸
jinshi	進士	Mo Shilong	莫是龍
jue	爵	mogu	沒骨
Jun (yao)	鈞（窯）	Mojie	摩羯
Juran	巨然	momei	墨梅
		mozhu	墨竹
kaishu	楷書	Muqi	牧溪
Kong Zi	孔子		
Kuaixue	快雪詩晴帖	na	捺
shi qing tie		Nanxun	南巡盛典
Kuncan	髡殘	shengdian	
		Nanxun tu	南巡圖
Lanting xu	蘭亭序	Nanyue wang mu	南越王墓
lei	罍	neifu gongyong	內府供用
leiwen	雷紋	ni	擬
Li Bai	李白	(interpretierendes	
Li Fangying	李方鷹	Kopieren)	
Li Gonglin	李公麟	Ni Yunlin	倪雲林
Li Keran	李可染	Ni Zan	倪瓚
Li Longmian	李龍眠	Nü shi zhen tu	女史箴圖
Li Shan	李鱓	nüyong	女俑
lian	奩	Ouyang Xun	歐陽詢
Liang Kai	梁楷		
Liang Sicheng	梁思成	paifang	牌坊

pailou	牌樓	Shi wang jing	十王經
pan	盤	Shiji	史記
Pei Xiaoyuan	裴孝源	Shijing	詩經
pen	盆	Shiqu baoji	石渠寶笈
Penglai	蓬萊	shiren hua	士人畫
penjing	盆景	Shitao	石濤
pi	劈	Shizhuzhai shuhuapu	十竹宅書畫譜
pie	撇	Shoulao	壽老
pima cun	披麻皴	Shouxing	壽星
ping (Frieden)	平	shu	豎
ping (Vase)	瓶	Shu	蜀
Ping Shi	瓶史	shu (Speer)	殳
ping yuan	平遠	Shu qi yan shi	書七言詩
Pingquan shanju caomuji	平泉山居草木記	Shu su tie	蜀素帖
po	魄	shuimo	水墨
pomo	破墨	shuixian	水仙
Pomo xianren	潑墨仙人	Shuowen jiezi	說文解字
pou	瓿	Shuxue	書學
		Si jun zi	四君子
qi	氣	Si ti shu shi	四體書勢
qi (sonderbar)	奇	Si Wang	四王
Qi Baishi	齊白石	siheyuan	四合院
Qi'niandian	祈年殿	Sima Guang	司馬光
Qianfodong	千佛洞	Sima Jinlong	司馬金龍
Qianfoyan	千佛岩	Sima Qian	司馬遷
Qiaohua qiuse (tu)	鵲華秋色（圖）	Song si jia	宋四家
Qidan	契丹	Song tai zu zuo xiang	宋太祖坐像
Qin	秦	Su Shi	蘇軾
Qin (Zither)	琴	suanni	狻猊
Qing	清	Sui	隋
qing tu	清途	sushi (Suzhou-Stil der Balken)	蘇式
qingbai	青白		
Qingming shanghe tu	清明上河圖		
Qiu Ying	仇英	ta	搨
Qixia si	棲霞寺	ta (Pagode)	塔
qiyun	氣韻	tai ji	太極
qu	曲	Taihe dian	太和殿
qu	趣	Taihe men	太和門
Qu Yuan	屈原	Tao Yuanming	陶淵明
		taotie	饕餮
ren	仁	te zhong	特鐘
Renmin da hui tang	人民大會堂	ti (Aufschrift)	題
Renmin jiefangjun jinianbei	人民解放軍紀念碑	ti (kopieren)	提
Renmin yingxiong jinianbei	人民英雄紀念碑	Tian	天
Rong xi zhai	容膝齊	tianma	天馬
Ru (yao)	汝（窯）	Tiantan	天壇
Ru yuan	茹園	tianwang	天王
ruyi	如意	Tianwen	天問
		Tihua ji	題畫記
san da	三大	tongwa	筒瓦
San Huang	三皇		
san jue	三絕	wang	枉
sancai	三彩	Wang Cheng	王成
Sang luan tie	喪亂帖	Wang Chuan	輞川
shan	山	Wang Guangyi	王廣義
Shan gu ji	山谷記	Wang Hui	王翬
Shang	商	Wang Jian	王鑑
shang (degoutieren, genießen)	賞	Wang Meng	王蒙
Shang Di	上帝	Wang Qingfang	王青芳
Shang lin	上林	Wang Shi Yuan	网師園
Shanhai jing	山海經	Wang Shimin	王時敏
shanshui	山水	Wang Shishen	汪士慎
Sheli ta	舍利塔	Wang Shizhen (1526-90)	王世真
shen	神	Wang Shizhen (1634-1711)	王士禎
shen yuan	深遠	Wang Wei	王微
Shen Zhou	沈周	Wang Wei	王維
shendao	神道	Wang Xianzhi	王獻之
Sheng Maoye	盛茂曄	Wang Xizhi	王羲之
shengqi	生器	Wang Yuanqi	王原祁
shi	十	Wang Zhenpeng	王振鵬
shi wang	十王	Wei	魏
		Wei Heng	衛恒

Wei Xie	衛協	yiguan zhi bi	一管之筆
Wen Zhengming	文徵明	Yijing	易經
weng	甕	Yili	易禮
wengguan	瓮棺	yimen sanzhu juan	一門三竹卷
wenren zhi hua	文人之畫	Yin	殷
wenrenhua	文人畫	yin	陰
Wenxuan	文選	Yingzao fashi	營造法式
Wenyuan tu	文苑圖	Yinlu pu	引路菩
Wu	吳	yong (Glocke)	鏞
wu (japan. satori)	悟	Yongle da dian	永樂大典
Wu dai	五代	you	卣
Wu Daozi	吳道子	You chun tu	遊春圖
wu di	五帝	yu (Fisch)	魚
Wu Li	吳歷	yu (Gefäß)	鬵
Wu men	午門	Yuan	元
wu xing	五行	Yuanming yuan	圓明園
Wu Zhen	吳鎮	Yuan Ye	園冶
Wu zhong si cai	吳中四才	yuan zhong yuan	園中園
wucai	五彩	Yue	越
Wuma tu	五馬圖	Yuhua tai	雨花台
Wumen pai	吳門派	Yun Shouping	惲壽平
Wuniu tu	五牛圖	yunwen	雲紋
wuwei	無為		
		zao	造
Xi qing gu jian	西清古鑑	zao yuan	造園
Xi yuan	西園	Zaochun	早春
Xia	夏	Zeng hou yi	曾侯乙
xia	匣	Zeng hou yi mu	曾侯乙墓
Xia Zhan	夏瞻	Zhan Zijian	展子虔
Xianbei	鮮卑	Zhan'guo	戰國
xiang (Portrait)	像	Zhang Daqian	張大千
xiang ke	相克	Zhang Huai	章懷
xiang sheng	相生	Zhang Yanyuan	張彥遠
Xiangjiao	象教	Zhang Zhi	張芝
xiao	孝	Zhao Boju	趙伯駒
xiao cao	小草	Zhao Ji (Song-Kaiser Hui Zong)	趙佶
Xiao Sun	蕭愻	Zhao Mengfu	趙孟頫
xiao zhuan	小篆	zhe	折
xiaojinghua	小景畫	Zhe pai	浙派
Xiaoling	孝陵	zhen yan	真言
xie	榭	Zheng Xie	鄭燮
Xie He	謝赫	Zhenguan gongsi hualu	貞觀公私畫錄
Xiequ yuan	諧趣園	zhenmushou	鎮墓獸
xie sheng	寫生	zhi	之
xie yi	寫意	zhi (Pokal)	觶
xing	形	zhong (Glocke)	鐘
xingshu	行書	Zhongguo lishi bowuguan	中國歷史博物館
Xiwangmu	西王母	Zhonghe dian	中和殿
Xixiang ji	西廂記	Zhongshan ling	中山陵
Xu Beihong	徐悲鴻	Zhou	周
Xu Daoning	許道寧	Zhou Fang	周昉
Xu hua	敘畫	Zhu Da	朱耷
Xu hua pin bing xu	續畫品并序	Zhu Xi	朱熹
Xu Xi	徐熙	Zhuang Zi	莊子
Xuanhe huapu	宣和畫譜	Zhuangzi zi zai	莊子自在
Xuanzhi	宣紙	zi	字
xuanzi	旋子	Zi xu tie	自敍帖
		Zong Bing, auch Song Bing	宗炳，宋炳
yan	甗	zun	尊
Yan Liben	閻立本	Zuo zhuan	左傳
Yan shi jiamiao bei	顏氏家廟碑		
yang	陽		
Yang Fa	陽渢		
Yangshao	仰韶		
Yangzhou ba guai	楊州八怪		
Yanyu congzhu	煙雨叢竹		
Yao Tandu	姚曇度		
Yao Zui	姚最		
Yaozhou (yao)	耀州（窯）		
yeyi	野逸		
yi	意		
yi	義		
Yihe yuan	頤和園		

Notes

China

Acknowledgments

It is almost impossible to thank everyone in a few lines without leaving anyone out. Gratitude is due above all to my family and the friends who supported and encouraged me while my contribution was being prepared; to my college lecturers, whose knowledge formed a basis for my writings; to museums and curators at home and abroad, who provided access to their carefully guarded Chinese treasures and allowed many pieces to be specially re-photographed; to the photographers who chose perfect settings; to the librarians of the museums for Arts and Crafts and Ethnology in Frankfurt, who brought mountains of books from shelves and basements for my research.

My sincere thanks also to Zhao Lihua of Cultural Relics Publishing House, Beijing, for his friendly cooperation, also to the extraordinarily helpful international agencies, private picture suppliers and a good friend in Beijing who turned virtually every bookshop in the city upside down looking for specialist books for me.

Thanks are also owed to the friendly spirits of the publishing house, who got the book under way with patience and enthusiasm.

However, I should like to pay special tribute to the editor, Dr. Gabriele Fahr-Becker, for her confidence in me, and to Dr. Kotzenberg for her valuable suggestions.

Sabine Hesemann

A First Look at China

1 This follows thoughts expressed by Gombrich in *Art and Illusion* on the subject of perception and its influence on performing artists and recipients alike. Ernst H. Gombrich: *Art and Illusion*. Phaidon / Princeton Presp.
2 Quoted from http://www.worldnet.fr~plegac/musees/musee.html. Cernuschi dated 8 May, 1997, Copyright Asie Média 1997.

The Neolithic Era – Art in Stone and Ceramics

1 Chen Zhaofu: *China, Prähistorische Felsbilder*. Zürich 1989, p. 13.
2 Lei Congyun: *Religiöse Fundstätten des vorgeschichtlichen China und ihre Bedeutung*. In: Kulturstiftung Ruhr (ed.): *Das Alte China*. Munich 1995, p. 71 f.
3 Mary Tregear: *Chinese Art*. London 1980, p. 20.

The Bronze Age and the Shang Dynasty

1 J. Rawson: *Chinese Bronzes. Art and Ritual*. London 1988, p. 10.
2 E. Consten: *Das Alte China*. Stuttgart undated, p. 42.
3 Tsung-tung Chang: *Der Kult der Shang im Spiegel der Orakelinschriften*. Wiesbaden 1970, p. 160 f.
4 Op. cit., p. 34.
5 M. Tregear: *Chinese Art*. London 1993, p. 23.
6 R. W. Bagley: *A Shang City in Sichuan Province*. In: Orientations 1990/11, p. 62.
7 C. Clunas: *Art in China*. Oxford 1997, p. 19.

The Zhou: One Dynasty, Three Epochs, and the Great Philosophers of China

1 Zhuang Zi: *Tian zi fang*. For translation, cf. also Lin Yutang: *Chinesische Malerei – eine Schule der Lebenskunst*. Stuttgart 1967, p. 28.
2 Herbert Franke/Rolf Trauzettel: *Das Chinesische Kaiserreich*. Frankfurt 1968, 5th impression 1981, p. 48.
3 Jessica Rawson: *Chinese Bronzes: Art and Ritual*. London 1987, p. 42.

The Qin Dynasty: China Becomes a Nation

1 Shiji: Vol. 6, Qin shi huang ben ji liu.
2 Shiji: Vol. 6, Qin shi huang ben ji liu.
3 Lothar Ledderose/Adele Schlombs (ed.): *Jenseits der Großen Mauer*. Gütersloh – Munich 1990, p. 278.
4 Shiji: Vol. 6, Qin shi huang ben ji liu.
5 Arne Eggebrecht (ed.): *China – eine Wiege der Weltkultur*. Mainz 1994.
6 Shiji: Vol. 6, Qin shi huang ben ji liu.

Han China: Inventions and Discoveries

1 Bernhard Karlgren: *Schrift und Sprache der Chinesen*. Berlin – Heidelberg 1975, reprint 1986, p. 51.

The Advent of Buddhism

1 William T. de Bary (ed.): *Sources of Chinese Tradition*. New York 1960, p. 272.

The Jin Period: the Oldest Extant Scrolls

1 Lin Yutang: *Chinesische Malerei – eine Schule der Lebenskunst*. Stuttgart 1967, p. 38. A free translation. Cf. also the critical translation in Hubert Delahaye: *Les premières peintures de paysage en Chine: Aspects réligieux*. Paris 1981, p. 102: "Une peinture (étant faite) selon le principe de la conformité visuelle et de l'intelligence avec le sujet, si la ressemblance est réussie, l'oeil y répondra et l'esprit s'accordera avec elle."
2 Hubert Delahaye: *Les premières peintures de paysage en Chine: Aspects réligieux*. Paris 1981, p. 106.
3 Op. cit., pp. 121–122.
4 William R. B. Acker: *Some Tang and Pre-Tang Texts on Chinese Painting*. Vol. 1, Leiden 1954, pp. 3–5; Lin Yutang: *Chinesische Malerei – eine Schule der Lebenskunst*. Stuttgart 1967; Susan Bush/Hsiao-Yen Shih: *Early Chinese Texts on Chinese Painting*. Cambridge – London 1985; Li Zehou: *Der Weg des Schönen*. Freiburg 1992, p. 169 f.; *Zhongguo dabaike quanshu: Meishu, Renming da cidian (RMDC), Wenxuejia da cidian (WXDC), Zhongwen da cidian (ZWDC)*.
5 Lin Yutang: *Chinesische Malerei – eine Schule der Lebenskunst*. Stuttgart 1967, p. 40; and William R. B. Acker: *Some Tang and Pre-Tang Texts on Chinese Painting*. Leiden 1954.
6 Translation in Lin Yutang: *Chinesische Malerei – eine Schule der Lebenskunst*. Stuttgart 1967, p. 40; on p. 41 f., Lin Yutang provides an interesting survey of seven different translations of the first element, v. also William R. B. Acker. Leiden 1954, p. 4.
7 Shing Müller: *Entstehungszeit und Interpretation der Felsskulpturen am Kongwang Shan*. In: Münchner Beiträge zur Völkerkunde, Vol. 4, Munich 1994, pp. 97–124.

The Sui and Tang Periods

1 Michel Beurdeley: *Chinesische Möbel*. Freiburg – Tübingen 1979, p. 21.
2 Nanyuan: v. Chiu Che-Bing: *Espace paysager en Chine*. Unpublished dissertation, Paris 1983, p. 16.
3 Yang Xizhang: *The Shang Dynasty cemetery system*. In: Chang Kwang-Chih: *Studies of Shang Archaeology*. New Haven – London 1986, p. 49.
4 Cf. William R. B. Acker: *Some Tang and Pre-Tang Texts on Chinese Painting*. Leiden 1954, p. 166.

The Song Period and the Aesthetics of Simplicity

1 Quoted from Christopher Hibbert: *Die Kaiser von China*. Munich 1983, reprint 1989, p. 108.
2 Dieter Kuhn: *Status und Ritus*. Heidelberg 1991, p. 612.

China

Neolithic era	c. 6000–2000 B.C.	Western Jin	A.D. 265–316
Xia	trad. 21st.–16th cent. B.C.	Eastern Jin (in the south)	A.D. 317–420
?Erlitou culture	21st.–17th cent. B.C.	Southern and	
Shang	16th.–11th cent. B.C.	Northern Empires	A.D. 420–589
Erligang phase	16th–13th cent. B.C.	(including inter alia Beiwei 386–534,	
Anyang phase	13th–11th cent. B.C.	Northern Qi and Northern	
Shu culture	13th–10th cent. B.C.	Zhou dynasties 550–581)	
Zhou	1066/1045–221 B.C.	Sui	A.D. 589–618
Western Zhou era	1066–771 B.C.	Tang	A.D. 618–907
Eastern Zhou era	770–221 B.C.	Five Dynasties	A.D. 907–960
Spring and Fall, Chunqiu	770–476 B.C.	Liao (Qidan)	A.D. 907–1125
Warring States, Zhanguo	476–221 B.C.	Song	A.D. 960–1279
Qin	221–206 B.C.	Northern Song	A.D. 960–1127
Han	206 B.C.–A.D. 220	Southern Song	A.D. 1127–1279
Western Han era	206 B.C.–A.D. 8	Jin	A.D. 1115–1234
Interregnum of Wang Mang	A.D. 9–23	Yuan	A.D. 1279–1368
Eastern Han era	A.D. 25–220	Ming	A.D. 1368–1644
Three Empires	A.D. 220–265	Qing	A.D. 1644–1911
(Wei, Shu, and Wu, latter to 280)		Republic	A.D. 1912–1949
Jin	A.D. 265–420	People's Republic	since A.D. 1949

3 Dieter Kuhn: *Die Song-Dynastie*. Weinheim 1989, p. 70.
4 Op. cit., p. 70.
5 Fong Wen C.: *Images of the Mind*. Princeton 1984, p. 20; the Wade-Giles transcription has been replaced by hanyu pinyin.
6 Wu Hung: *The Double Screen, Medium and Representation in Chinese Painting*. London 1996, p. 79.
7 Helmut Brinker: *Die Zen-buddhistische Bildnismalerei in China und Japan*. Wiesbaden 1973.
8 In: Robert J. Maeda: *Two Sung Texts on Chinese Painting and the Landscape Styles of the 11th and 12th century*. New York 1978, pp. 81–84.

The Yuan Period: Under Mongol Rule
1 "They may all be classified as 'romantics' from an aesthetic point of view, and as 'expressionists' or 'idea-writers' from a technical viewpoint; but their individual temperaments are reflected in their handling of the brush and the ink." Osvald Sirén: *Chinese Painting, Leading Masters and Principles*. Vol. IV, London – New York 1956–58, p. 53.
2 Op. cit., p. 52.
3 The text of one of the inscriptions reads: "Zhang Wenjin, faithful disciple and member of the Jingtang Society, from Dexiao Alley in the village of Shunzheng in the district of Yushan, Xinzhou Region, is pleased to endow a set of altar utensils with an incense burner and vases as intercession for the protection of his family and the prosperity of his descendants. Inscribed on an auspicious day in the fourth month of the eleventh year of the Zhizhen era (1351). [...]" Translation by Rosemary Scott: Percival David Foundation of Chinese Art. London 1989.

Ming – Traditions and Innovations
1 Richard M. Barnhart: *Peach Blossom Spring*. New York 1983, p. 63.
2 Quoted from: Johann Wolfgang v. Goethe: *Gesammelte Werke*. Ed. by Richard Müller-Freienfels, Vols. 9/10, Berlin c. 1910.
3 Soame Jenyns: *Later Chinese Porcelain*. Glasgow 1971⁴, p. 18.

The Qing Dynasty
1 "This land [China] is the most populous and most cultivated in this world [...]", Denis Diderot, 1752.
2 Fong Wen C.: *Images of the Mind*. Princeton 1984, p. 180.
3 Craig Clunas: *Art in China*. Oxford 1997, p. 64.
4 Renée Violet: *Einführung in die Kunst Chinas*. Leipzig 1981, p. 150.

The People's Republic
1 Translated by the author from Guo Qingpan (ed.): *Zhuang Zi ji shi*. Taipeh 1972, p. 53 ff.
2 *"Political pop"* and *"Cynical Realism"*. In: Shelagh Vainker: *Modern Chinese Paintings*. Oxford 1996, p. 14.
3 Li Xianting: *Aspekte zur Geschichte der Modernen Chinesischen Kunst*. In: *China Avantgarde*. Heidelberg 1993, p. 49.
4 Wang Guangyi, quoted in Dieter Ronte (ed.): *China, Zeitgenössische Malerei*. Cologne 1996, p. 70.

Indonesia

Acknowledgments
I should like to thank the following people for their contributions: Professor Bernhard Dahm and Dr. Gabriele Fahr-Becker for the confidence shown in me, and Dr. Michaela Appel and the students of the South-East Asia faculty of the University of Passau for their discussion contributions.

Sri Kuhnt-Saptodewo

1 Achim Sibeth: *Mit den Ahnen leben. Batak. Menschen in Indonesien*. Stuttgart 1990, p. 115.
2 Op. cit., p. 119.
3 Mario Bussagli: *Indien. Indonesien. Indochina*. Translated by M. Stahlberg, Stuttgart 1985, p. 14.
4 Marijke J. Klokke: *Die Kunst Indonesiens*. In: Girard-Geslan, Mand: *Südostasien. Kunst und Kultur*. Freiburg–Basle–Vienna 1995, p. 328.
5 Op. cit., p. 345.
6 Vicki Baum: *Liebe und Tod auf Bali*. Cologne 1984, p. 14.
7 Manteb Soedarsono: *Wayang Wong. The State Ritual Dance Drama in the Court of Yogyakarta*. Yogyakarta 1984.

Selective Bibliography

China

Primary and secondary literature in Chinese

An Huaiqi: *Zhongguo yuanlin yishu* (The Art of Chinese Gardens). Shanghai 1986
Chen Congzhou: *Shuo yuan* (The Garden). Shanghai 1988
Chen Congzhou: *Yangzhou Yuanlin* (The Gardens in Yangzhou). Shanghai 1983
Chen Zhaofu: *Zhongguo yanhua* (Chinese Rock Pictures). In: *Zhongguo dabaike quanshu: Meishu*. Vol. 2, Beijing – Shanghai 1991, p. 1154
Chong Mingchen: *Zhongguo lidai yuanji xuanzhu* (Selection of Prose Writings about Gardens since Time Immemorial). Anhui 1983
Feng Zhongping: *Zhonguo yuanlin jianzhu* (Chinese Garden Architecture). Beijing 1988
Gugong bowuyuan cang lidai fashu xuanji (Selection of Calligraphy from all Ages from the Palace Museum). 26 vols., Beijing 1963
Gugong fashu (Chinese Calligraphy from the National Palace Museum). 21 vols., Taipeh 1962–1968
Gugong fashu xuan cui (Masterpieces of Chinese Calligraphy from the National Palace Museum). 2 vols., Taipeh 1970
Gugong shuhualu (Catalog of Paintings and Calligraphy in the Palace Museum). 4 vols., Taipeh 1965
Guo Qingpan (ed.): *Zhuang Zi ji shi*. Taipeh 1972
Han Lide: *Shitao yu huayu lu yanjiu* (Study of Shitao and the Huayu lu). Jiangsu yishu chubanshe. 1989

Henan bowuguan (Henan Museum): *Zhongguo bowuguan congshu* (Book collection of Chinese Museums). Vol. 7, Beijing 1985
Huang Binhong et al.: *Meishu congshu* (Compendium of Art). Reprint Shanghai 1975
Hubeisheng bowuguan (Hubei Provincial Museum): *Zhongguo bowuguan congshu* (Book collection of Chinese Museums). Vol. 14, Beijing 1994
Jieziyuan hua zhuan (Painting manual from Mustard Seed Garden). 4 vols., reprint Beijing 1982
Jin Shu (Jin Annals). Wei Heng zhuan
Li Keran shuhua quanji (Li Keran's Collection of Calligraphy and Pictures). 4 vols., Tianjin 1991
Li Yeh-shuang: *Shih-tao de shih-chieh* (The World of Shitao). Taipeh 1973
Lin Qing: *Hongxue yinyuan tuji* (The Fate of the Hongxue in Words and Pictures). Shanghai edition 1886
Liu Dunzhen: *Zhongguo zhuzhai jianzhu* (Architecture of Chinese Dwellings). Taipeh 1982
Liu Wanhang: *Qingtongqi shangxi* (Introduction to an Appreciation of Bronzes). Taipeh 1990
Lu Hezhi et al.: *Siweishuwu zhencang shuhua ji* (Collection of Calligraphy and Pictures from the Four Perfumes Chamber). Anhui bowuguan, Anhui meishu chubanshe, no place of publication, 1989
Lu Zhirong: *Qinshi Huang ling bingmayong peizangzhi zhi yuanyuan tansuo*. In: Wenbo 2, 1992, pp. 50–54
Nanyuewang mu yu qi (Tomb and Grave Goods of the King of Nanyue). Guangzhou 1991

Qin Shi Huang ling bingmayong keng yihao keng fajue baogao 1974–1984 (Report on Digs and Works relating to the Terracotta Figures from Pit 1 in the Tomb of the First Emperor). Beijing 1988
Qinding gujin tushu jicheng (Collection of Old and New Pictures and Writings Compiled at the Emperor's Behest). Reprint Shanghai 1885–1888
Ruan Changjiang: *Zhongguo lidai jiaju zhulu da quan* (Illustration of Chinese Furniture through the Ages). Taipeh 1992
Shanghai bowuyuan cang lidai fashu xuanji (Selection of Calligraphy from all Ages, from Shanghai Museum). 20 vols., Beijing 1964
Shen Zhiyu: *Shanghai bowuyuan* (Shanghai Museum). Beijing 1981
Sima Qian: *Shiji* (Record of Historians). Beijing 1959
Tianjin daxue jianzhu xi (Faculty of Architectural Studies, University of Tianjin; ed.): *Qingdai yuyuan xieying* (Outstanding Examples of Imperial Gardens in the Qing Period). Tianjin 1990
Tong Xi: *Jiangnan yuanlin zhi* (Survey of Gardens in the Jiangnan Region). Beijing 1987²
Tong Zhuchen: *Longshan wenhua*. In: *Zhongguo dabaike quanshu*. Vol. Kaogu, Beijing – Shanghai 1986, p. 290
Wang Leiyi: *Handai tu an xuan* (Selection of Han Period Decoration). Beijing 1989
Wang Shixiang: *Mingshi jiaju zhenshang* (Ming Period Furniture for the Connoisseur). Hong Kong 1985
Wang Yi: *Yuanlin yu zhongguo wenhua* (Gardens and Chinese Culture). Shanghai 1990

Wang Zhongshu: *Tong Jing*. In: *Zhongguo dabaike quanshu: Kaogu xue*. Beijing – Shanghai 1986, pp. 529–531

Yang Xiaoneng: *Zhongguo yuanshi diaosu yishu* (Early Chinese Sculpture). Hong Kong 1988

Yang Xiaoneng: *Zhongguo Xia Shang diaosu yishu* (Xia and Shang Period Sculpture). Hong Kong 1988

Zhongguo dabaike quanshu: Jianzhu (Chinese Encyclopedia: Architecture). Beijing – Shanghai 1988

Zhongguo dabaike quanshu: Kaogu (Chinese Encyclopedia: Archaeology). Beijing – Shanghai 1986

Zhongguo dabaike quanshu: Meishu (Chinese Encyclopedia: Art). 2 vols., Beijing – Shanghai 1991

Zhongguo gudai shuhua tumu (Catalog of Chinese Calligraphy and Paintings). 24 vols., Beijing 1987

Zhongguo jianzhu jianshi (Brief History of Chinese Architecture). Vol. 1: *Zhongguo gudai jianzhu jianshi* (Brief History of Classical Architecture). Architectural History Authors' Collective. Beijing 1962

Zhongguo lidai huihua (Chinese Painting of Successive Eras). Beijing 1978

Zhongguo meishu quanji: Huihua bian (Encyclopedia of Chinese Art: Painting). 21 vols., Beijing 1988

Zhongguo meishu quanji: Jianzhu yishu bian (Encyclopedia of Chinese Art: Architecture). 6 vols., Beijing 1988

Zhongguo shehui kexueyuan kaogu yanjiusuo (Archaeological Research Institute of the Chinese Institute for Social Sciences; ed.): *Yinxu Fu Hao mu* (The Tomb of Fu Hao). Beijing 1980

Zhongguo wenwu jinghua (Treasures of Chinese Cultural Heritage). Beijing 1997

Zhongguo wenwu jinghua (Treasures of Chinese Cultural Heritage). Beijing 1992

Zhongguo wenwu jinghua (Treasures of Chinese Cultural Heritage). Beijing 1990

Zhongwen da cidian (Encyclopedic Dictionary of Chinese). Taipeh 1973

Secondary literature in other languages

Abe, Stanley K.: *Art and Practice in a Fifth Century Buddhist Temple*. In: Ars Orientalis 20, 1990, pp. 1–31

Acker, William Reynolds Beal: *Some T'ang and Pre-T'ang Texts on Chinese Painting*. Leiden 1954

Avitabile, Gunhild/Stephan von der Schulenburg: *Chinesisches Porzellan*. Museum für Kunsthandwerk, Frankfurt 1991

Bagley, Robert W.: *A Shang City in Sichuan Province*. In: Orientations 11, 1990, pp. 52–67

Barnhart, Richard M.: *Li Kung-lin's Use of Past Styles*. In: Christian Murck (ed.): *Artists and Traditions*. Princeton 1976, pp. 51–71

Barnhart, Richard M.: *Peach Blossom Spring*. New York 1983

Barnhart, Richard M. (ed.): *Painters of the Great Ming: The Imperial Court and the Zhe School*. Dallas 1993

Barnhart, Richard M.: *Rediscovering an old Theme in Ming Painting*. In: Orientations, September 1995, pp. 52–61

Bary, William Theodore de (ed.): *Sources of Chinese Tradition*. New York 1960

Baschet, Eric (ed.): *China 1890–1938, Historische Fotodokumentation*. Vaduz – Zug 1989

Bauer, Wolfgang (ed.): *China und die Fremden*. Munich 1980

Beuchert, Marianne: *Die Gärten Chinas*. Munich 1988

Beurdeley, Michel: *Chinesische Möbel*. Freiburg – Tübingen 1979

Billeter, Jean-François: *The Chinese Art of Writing*. New York 1990

Böttger, Walter: *Kultur im Alten China*. Leipzig 1982

Boulay, Anthony Du: *Chinesisches Porzellan*. Frankfurt 1963

Brandt, Klaus J.: *Chinesische Lackarbeiten*. Stuttgart 1988

Bredon, Juliet/Igor Mitrophanow: *Das Mondjahr*. Vienna 1937

Brinker, Helmut: *Die Zen-buddhistische Bildnismalerei in China und Japan*. Wiesbaden 1973

Brinker, Helmut: *Zur archaischen Bronzekunst*. In: *China, eine Wiege der Weltkultur*. Hildesheim – Mainz 1994, pp. 52–62

Brinker, Helmut/Roger Goepper: *Kunstschätze aus China*. Zürich 1980

Bush, Susan: *The Chinese Literati on Painting: Su Shih (1037–1101) to Tung Ch'i-ch'ang (1555–1636)*. Harvard 1971

Bush, Susan/Christian Murck: *Theories of the Arts in China*. Princeton 1983

Bush, Susan/Hsiao-Yen Shih: *Early Chinese Texts on Painting*. Cambridge – London 1985

Butz, Herbert: *Die Südreise des Kaisers Qianlong im Jahre 1765*. Frankfurt 1989

Butz, Herbert: *Kraakporselein in der Sammlung der Grafen von Hessen-Kassel*. In: *Porzellan aus China und Japan*. Kassel 1990

Cahill, James: *Confucian Elements in the Theory of Painting*. In: Arthur Wright (ed.): *The Confucian Persuasion*. Stanford 1966, pp. 115–140

Cahill, James: *Hills Beyond a River: Chinese Painting of the Yuan Dynasty 1279–1368*. New York – Tokyo 1976

Cahill, James: *An Index of Early Chinese Painters and Paintings. T'ang, Sung, and Yüan*. Berkeley – Los Angeles – London 1980

Cahill, James: *Parting at the Shore: Chinese Painting of the Early and Middle Ming Dynasty 1368–1580*. New York 1982

Cahill, James: *The Compelling Image: Nature and Style in Seventeenth Century China*. Cambridge/Mass. 1982

Cahill, James: *The Distant Mountains: Chinese Painting of the late Ming Dynasty 1570–1644*. New York 1982

Chang, Kwang-chih: *Studies of Shang Archaeology*. New Haven – London 1986

Chang, Léon Long-Yien/Peter Miller: *Four Thousand Years of Chinese Calligraphy*. Chicago – London 1990

Chang, Tsung-tung: *Der Kult der Shang im Spiegel der Orakelinschriften*. Wiesbaden 1970

Chen, Zhaofu: *China, Prähistorische Felsbilder*. Zürich 1989

China – 5000 years. Exhibition catalog. New York 1998

Chinese Art and the Politics that drove it. See: http://ccwf.cc.utexas.edu/~irish/thesis/

Chinese Snuff Bottles. Sotheby's auction catalog, December 1996

Chinesische Szenen 1656/1992. Museum Rietberg. Zürich 1992

Chiu, Che-Bing: *Espace paysager en Chine*. Mémoire inédit de l'Ecole d'Architecture. Paris-La Villette 1983

Chiu, Che-Bing: *Yuanye, le traité du jardin (1634)*. Besançon 1997

Clapp, Anne de Coursey: *Wen Cheng-ming: The Ming Artist and Antiquity*. AA Supplementum. Ascona 1975

Clunas, Craig: *Superfluous Things*. Cambridge 1991

Clunas, Craig: *Fruitful sites*. London 1996

Clunas, Craig: *Art in China*. Oxford 1997

Consten, Eleanor: *Das Alte China*. Reprint, Stuttgart, undated.

Contag, Victoria: *Schriftcharakteristiken in der Malerei, dargestellt an Bildern Wang Mengs und anderer Maler der Südschule*. In: Ostasiatische Zeitschrift XVII, 1941, pp. 46–61

Contag, Victoria/Wang Chi-Ch'ien: *Seals of the Chinese Painters and Collectors of the Ming and Ch'ing Periods*. Hong Kong 1966

Creel, Herrlee G.: *The Birth of China*. New York 1954

Debon, Günther: *Das Lob der Naturtreue. Das Hsiao Shan Hua-P'u des Tsou Yikuei (1686–1772)*. Wiesbaden 1969

Debon, Günther/Werner Speiser: *Chinesische Geisteswelt*. New impression, Hanau 1987

Delahaye, Hubert: *Les premières peintures de paysage en Chine: Aspects religieux*. Paris 1981

Diesinger, Gunter: *Vom General zum Gott. Kuan Yü und seine "posthume Karriere"*. Heidelberg 1989

Dittrich, Edith: *Das Westzimmer. Hsi-Hsiang chi*. Cologne 1977

Eberhardt, Wolfram: *Lexikon chinesischer Symbole*. Cologne 1983

Ecke, Tseng Yu-Ho: *Chinese Calligraphy*. Philadelphia 1971

Ecke, Tseng Yu-Ho: *Emperor Hui Tsung, the Artist: 1082–1136*. Ann Arbor 1987

Egan, R. C.: *Ou-yang Hsiu and Su Shih on Calligraphy*. In: HJAS 49/1989, pp. 365–419

Egan, R. C.: *Poems on Paintings: Su Shih and Huang T'ing-chien*. In: HJAS 43/1983, pp. 413–450

Eggebrecht, Arne (ed.): *China – eine Wiege der Weltkultur*. Mainz 1994

Eichenbaum Karetzky, Patricia: *Arts of the Tang Court*. Oxford 1996

Empress Place Museum (ed.): *War and Ritual. Treasures from the Warring States*. Singapore 1993

Farrer, Anne: *Calligraphy and Painting for Official Life*. In: Jessica Rawson: *The British Museum Book of Chinese Art*. London 1992, pp. 84–88

Finsterbusch, Käthe: *Verzeichnis und Motivindex der Han-Darstellungen*, Vols. 1 and 2, Wiesbaden 1966/1971

Flitsch, Mareile: *Die chinesische Volksreligion*. In: Claudius Müller (ed.): *Wege der Götter und Menschen*. Berlin 1989, pp. 58–64

Fong, Wen C. (ed.): *Images of the Mind*. Princeton 1984

Franke, Herbert/Rolf Trauzettel: *Das Chinesische Kaiserreich*. Frankfurt 1968, 1981⁵

Fuchs, Walter: *Die Bilderalben für die Südreisen des Kaisers Kienlung*. Wiesbaden 1976

Gernet, Jacques: *Die Chinesische Welt*. Frankfurt 1989⁶

Gettens, Rutherford J.: Technological Studies. In: *The Freer Chinese Bronzes*. Vol. 2, Washington 1969

Giacalone, Vito (ed.): *The Eccentric Painters of Yangzhou*. New York 1990

Girmond, Sybille: Porzellanherstellung in China, Japan und Europa. In: *Porzellan aus China und Japan*. Kassel 1990

Goepper, Roger: *Vom Wesen chinesischer Malerei*. Munich 1962

Goepper, Roger: *Kunst und Kunsthandwerk Ostasiens*. Munich 1968

Goepper, Roger: *Das Alte China, Geschichte und Kultur des Reiches der Mitte*. Munich 1988

Goethe, Johann Wolfgang v.: *Gesammelte Werke*. Ed. by Richard Müller-Freienfels, Vols. 9/10, Berlin c. 1910

Hall, Robert: *Chinese Snuff Bottles I–IV*. London 1987–1991

Haus der Kulturen der Welt Berlin (ed.): *China Avantgarde*. Heidelberg 1993

Hayashi, Minao: *Studies on Yin and Zhou Bronzes*. 2 vols., Tokyo 1984/86

Heilesen, Simon B.: *Bilder von der Südreise des Kaisers Kangxi*. In: *Palastmuseum Peking. Schätze aus der Verbotenen Stadt*. Frankfurt 1985

Hibbert, Christopher: *Die Kaiser von China.* Munich 1983, reprinted 1989

Hildebrand, Achim: *Der fangxiang shi und das danuo-Ritual in Darstellungen der Han-Zeit.* In: Münchner Beiträge zur Völkerkunde, Vol. 2, 1989

Ho, Wai-kam, et al.: *Eight Dynasties of Chinese Painting: The Collections of the Nelson Gallery – Atkins Museum, and the Cleveland Museum of Art.* Cleveland 1980

Ho, Wai-kam (ed.): *The Century of Dong Qichang 1555–1635.* Seattle 1992

Ho, Ping-ti: *The Cradle of the East. An Inquiry into the Indigenous Origins and Ideas of Neolithic and Early Historic China, 5000–1000 B.C.* Hong Kong 1975

Höhne, Wolfgang: *Porzellan im Vogelbauer.* Dresden – Basle 1995

Hsü, Ginger Ch.: Scholar, Artist, and Art Dealer: Jin Nong in Yangzhou. In: Vito Giacalone: *The Eccentric Painters of Yangzhou.* New York 1990

Hubei Provincial Museum Art Gallery (ed.): *Lacquerware from the Warring States to the Han Periods excavated in Hubei Province.* Hong Kong 1994

International Colloquium on Chinese Art History. National Palace Museum Taipei 1991: *Proceedings, Painting and Calligraphy,* 2 vols., Taipeh 1992

Jenyns, Soame: *Later Chinese Porcelain.* Glasgow 1971

Ji, Cheng: *The Craft of Gardens.* Translated by Alison Hardy, Yale University Press 1988

Jochum, Alfons: *Beim Großkhan der Mongolen. Johannes von Monte Corvino (1247–1328).* Mödling – St. Augustin 1982

Johnston Laing, Ellen: *The Development of Flower Depiction and the Origin of the Bird-and-Flower Genre in Chinese Art.* In: BMFEA Nr. 64, Stockholm 1992

Karlgren, Bernhard: *Schrift und Sprache der Chinesen.* Berlin – Heidelberg 1975, 1st corrected reprint 1986

Kerr, Rose: *Later Chinese Bronzes.* London 1990

Kesner, Ladislav: *Likeness of No One: (Re)presenting the First Emperor's Army.* In: Art Bulletin, March 1995, Vol. LXXVII, No. 1, pp. 115–132

Keswick, Maggie: *Chinesische Gärten.* Stuttgart 1989

Knapp, Ronald: *The Chinese House. Craft, Symbol, and the Folk Tradition.* Oxford 1990

Koch, Alexander: *Untersuchungen zu tang-zeitlichen Kaisermausoleen in der Provinz Shaanxi.* In: Jahrbuch des Römisch-Germanischen Zentralmuseums Mainz 41/2, Mainz 1994, pp. 575–602

Koch, Alexander: *Kaisergräber der Tang-Dynastie.* In: Spektrum der Wissenschaft, 11/1996, pp. 100–107

Kohara, Hironobu: Hofmalerei der Qing-Dynastie. In: *Palastmuseum Peking. Schätze aus der Verbotenen Stadt.* Frankfurt 1985, pp. 90–95

Kotzenberg, Heike: *Bild und Aufschrift in der Malerei Chinas.* Wiesbaden 1981

Kotzenberg, Heike (ed.): *Chinesische Tuschmalerei im 20. Jahrhundert.* Munich 1996

Kuhn, Dieter: *Die Song-Dynastie.* Weinheim 1989

Kuhn, Dieter: *Status und Ritus.* Heidelberg 1991

Kuhn, Dieter, et al.: *Chinas goldenes Zeitalter.* Dortmund 1995

Lai, T. C.: *Ch'i Pai Shih.* Seattle – London 1973

Ledderose, Lothar: *Mi Fu and the Classical Tradition of Chinese Calligraphy.* Princeton 1979

Ledderose, Lothar (ed.): *Im Schatten hoher Bäume. Malerei der Ming- und Qing-Dynastien aus der Volksrepublik China.* Baden-Baden 1985

Ledderose, Lothar: *Chinese Calligraphy: Its Aesthetic Dimension and Social Function.* In: Orientations 10/1986, pp. 35–50

Ledderose, Lothar/Adele Schlombs (ed.): *Jenseits der Großen Mauer.* Gütersloh – Munich 1990

Lee, King Tsi/Shih Chang Hu: *Drache und Phönix. Lackarbeiten aus China.* Cologne 1990

Lei, Congyun: Religiöse Fundstätten des vorgeschichtlichen China und ihre Bedeutung. In: Kulturstiftung Ruhr (ed.): *Das Alte China.* Munich 1995, pp. 68–75

Lessing, Ferdinand: *Über die Symbolsprache in der chinesischen Kunst.* Offprint by the China Institute of Frankfurt. Sinica 1934/35

Li, Chu-tsing: *The Autumn Colours on the Ch'iao and Hua Mountains: A Landscape by Chao Meng-fu.* AA Supplementum. Ascona 1979

Li, Xianting: Aspekte zur Geschichte der Modernen Chinesischen Kunst. In: *China Avantgarde.* Heidelberg 1993

Li, Xueqin/Sarah Allan: *Chinese Bronzes: A Selection from European Collections (Ouzhou suo cang zongguo qingtongqi yi zhu).* Beijing 1995

Li, Zehou: *Der Weg des Schönen.* Freiburg 1992

Li, Zhiyan/Cheng Wen: *Chinese Pottery and Porcelain.* Beijing 1984

Lin, Yutang: *Chinesische Malerei – eine Schule der Lebenskunst.* Stuttgart 1967

Little, Stephen: *Realm of the Immortals: Daoism in the Arts of China.* Cleveland 1988

Loehr, Max: *The Bronze Styles of the Anyang-Period (1300–1028 BC).* In: Archives of the Chinese Art Society of America 7, 1953, pp. 42–53

Loehr, Max: *The Great Painters of China.* Oxford 1980

Loewe, Michael: *Chinese Ideas of Life and Death: Faith, Myth and Reason in the Han Period.* London 1982, reprint Taipeh 1994

Lui, Shou-Kwan: *Symbolism and Zen: A Contemporary Chinese Approach to Abstract Painting.* In: Oriental Art, III, 1973, pp. 302–305

Lutz, Albert (ed.): *Dian – ein versunkenes Königreich in China.* Museum Rietberg, Zürich 1986

Macintosh, Duncan: *Chinese Blue and White Porcelain.* Hong Kong 1994³

Maeda, Robert J.: *Two Sung Texts on Chinese Painting and the Landscape Styles of the 11th and 12th century.* New York 1978

March, Benjamin: *Some technical terms on Chinese painting.* Baltimore 1935

McMullen, David: *State and Scholars in T'ang China.* Cambridge 1988

McNair, Amy: *Recension and Reception.* In: Art Bulletin, March 1995, Vol. LXXVII No.1, pp. 106–114

Medley, Margaret: *The Chinese Potter.* Oxford 1989³

Merson, John: *The Genius that was China.* New York 1990

Moss, Hugh, et al.: *The Art of the Chinese Snuff Bottle.* New York – Tokyo 1993

Müller, Claudius (ed.): *Wege der Götter und Menschen.* Berlin 1989

Müller, Shing: *Entstehungszeit und Interpretation der Felsskulpturen am Kongwang Shan.* In: Münchner Beiträge zur Völkerkunde, Vol. 4, 1994, pp. 97–124

Murck, Alfreda/Fong Wen C. (ed.): *Words and Images.* New York 1991

Murck, Christian (ed.): *Artists and Traditions.* Princeton 1976

Nakata, Yujiro (ed.): *A History of the Arts of China: Chinese Calligraphy.* New York – Tokyo – Kyoto 1983

National Museum of History (ed.): *Buddhist Art in China.* Taipeh 1978

National Palace Museum (ed.): *Masterpieces of Chinese Calligraphy in the National Palace Museum.* Taipeh 1970

National Palace Museum (ed.): *Masterpieces of Chinese Portrait Painting in the National Palace Museum.* Taipeh 1971

Needham, Joseph: *Science and Civilisation in China.* Cambridge, post 1954

Paludan, Ann: *The Chinese Spirit Road: The Classical Tradition of Stone Tomb Statuary.* New Haven – London 1991

Pirazzoli t'Serstevens, Michèle: *China zur Zeit der Han-Dynastie.* Stuttgart – Berlin – Cologne 1982

Pirazzoli t'Serstevens, Michèle/Henri Stierlin: *Architektur der Welt, China.* Cologne, undated

Pohl, Karl-Heinz: *Cheng Pan-ch'iao, Poet, Painter, and Calligrapher.* Nettetal 1990

Qiao, Yun: *Alte Chinesische Gartenkunst.* Leipzig 1988

Rawson, Jessica: *Chinese Bronzes. Art and Ritual.* London 1987

Rawson, Jessica: *Ancient Chinese Ritual Bronzes: The Evidence from Tombs and Hoards of the Shang and Western Zhou Periods.* In: Antiquity 67, 1993, pp. 805–823

Rinaldi, Maura: *Kraak Porcelain – A Moment in the History of Trade.* London 1989

Ronte, Dieter (ed.): *China, Zeitgenössische Malerei.* Cologne 1996

Ruitenbeek, Claas: *Discarding the Brush.* Amsterdam 1992

Schafer, Edward: *The Golden Peaches of Samarkand.* Berkeley 1963

Schafer, Edward: *The Vermilion Bird.* Berkeley 1967

Schafer, Edward: *Hunting Parks and Animal Enclosures in Ancient China.* In: Journal of the Economic and Social History of the Orient, Vol. XI, Leiden 1968, pp. 318–343

Schlombs, Adele: Die Herstellung der Terrakotta-Armee. In: *Jenseits der Großen Mauer.* Gütersloh – Munich 1990, pp. 88–97

Schlombs, Adele/Eva Ströber (ed.): *Quellen – Das Wasser in der Kunst Ostasiens.* Hamburg – Cologne 1992

Schlombs, Adele, et al.: *Mit diesen Händen, Moderne chinesische Malerei und Kalligraphie der Künstler Gu Gan und Huang Miaozi.* In: Kölner Museum-Bulletin 4, 1992

Schmidt, Ulrich (ed.): *Porzellan aus China und Japan.* Staatliche Kunstsammlungen. Kassel 1990

Schmidt-Glintzer, Helwig: *Geschichte der Chinesischen Literatur.* Berne – Munich – Vienna 1990

Schmidt-Glintzer, Helwig: China und der Buddhismus. In: *Kunst des Buddhismus entlang der Seidenstraße.* Munich 1992

Schulz, Alexander: *Hsi yang lou.* Isny 1966

Scott, Rosemary: *Percival David Foundation of Chinese Art.* London 1989

Scott, Rosemary: *Elegant Form and Harmonious Decoration.* London 1992

Seckel, Dietrich: *Das Bildnis in der Kunst des Ostens.* Stuttgart 1990

Shen, Fu, et al.: *From Concept to Context: Approaches to Asian and Islamic Calligraphy.* Washington 1986

Sickman, Laurence/Alexander Soper: *The Art and Architecture of China.* Reprint of 3rd impression, London 1991

Simon, Rainald: *Chinesische Baukeramik.* In: Museum für Kunsthandwerk, Vol. 23, Frankfurt, undated

Simon, Rainald: *Chinesische Schatten, Sammlung Eger.* Munich 1997

Sirén, Osvald: *Chinese Gardens.* New York 1947

Sirén, Osvald: *Chinese Painting, Leading Masters and Principles.* 7 vols., London – New York 1956–1958

Sirén, Osvald: *The Chinese on the Art of Painting.* New York 1962

So Kam Ng: *Brushstrokes: Styles and Techniques of Chinese Painting.* San Francisco 1993

Speiser, Werner: *Lackkunst in Ostasien.* Baden-Baden 1965

Staatliche Museen Preußischer Kulturbesitz Berlin (ed.): *Die Meisterwerke aus dem Museum für Ostasiatische Kunst.* Stuttgart – Zürich 1980

Steudel, Carola: *Das Tier im Tiegel*. Darmstadt 1997

Stewart, Jan: *The Eight Eccentrics of Yangzhou*. In: Fong, Wen C.: *Images of the Mind*. Princeton 1984, pp. 436–440

Straßberg, Richard: *Inscribed Landscapes. Travel Writing from Imperial China*. Berkeley 1994

Sullivan, Michael: *The Birth of Landscape Painting in China*. Berkeley – Los Angeles 1962

Sullivan, Michael: *The Meeting of Eastern and Western Art*. London – New York 1973

Sullivan, Michael: Orthodoxy and Individualism in Twentieth Century Chinese Art. In: Christian Murck (ed.): *Artists and Traditions*. Princeton 1976, pp. 201–205

Sullivan, Michael: *Symbols of Eternity*. Oxford 1979

Sullivan, Michael: *Chinese Landscape Painting in the Sui and Tang Dynasties*. Berkeley 1980

Suzuki, Kei (ed.): *Comprehensive Illustrated Catalogue of Chinese Paintings*. 5 vols., Tokyo 1982

Temple, Robert K. G.: *Das Land der fliegenden Drachen*. Bergisch Gladbach 1990

Thilo, Thomas: *Klassische Chinesische Baukunst*. Leipzig 1977

Thürlemann, Felix: *Vom Bild zum Raum*. Cologne 1990

Tietze, Klaus: Vom ostasiatischen Großreich zur mongolischen Provinz. In: Wolfgang Bauer (ed.): *China und die Fremden*. Munich 1980

Timmermann, Irmgard: *Die Seide Chinas. Eine Kulturgeschichte am Seidenen Faden*. Cologne 1986

Tregear, Mary: *Chinese Art*. London 1980, reprinted 1993

Urban Council (ed.): *The Art of Xu Beihong*. Hong Kong, undated

Vainker, Shelagh: *Chinese Pottery and Porcelain: From Prehistory to the Present*. London 1991

Vainker, Shelagh: Ceramics for Use. In: Jessica Rawson: *The British Museum Book of Chinese Art*. London 1992, pp. 212–254

Vainker, Shelagh: *Modern Chinese Paintings*. Oxford 1996

Vandier-Nicholas, Nicole: *Art et Sagesse en Chine. Mi Fou*. Paris 1963

Vinograd, Richard: *Boundaries of the Self: Chinese Portraits 1600–1900*. New York 1992

Violet, Renée: *Einführung in die Kunst Chinas*. Leipzig 1981

Wagner, Maike: *Die Motive der bemalten neolithischen Keramik Chinas*. Leipzig 1993

Wagner, Maike: Jade – Der edle Stein für die Elite. In: *China – eine Wiege der Weltkultur*. Hildesheim – Mainz 1994, pp. 96–104

Walravens, Hartmut: *China Illustrata*. Wolfenbüttel 1987

Wan, Yi, et al.: *Das Leben in der Verbotenen Stadt*. Hong Kong 1989

Wang, Fangyu: *Bada Shanren's Cat on a Rock: A Case Study*. In: Orientations, April 1998, pp. 40–46

Wang, Zhongshu: *Han Civilisation*. New Haven 1982

Weidner, Marsha: *Latter Days of the Law: Images of Chinese Buddhism 850–1850*. Lawrence – Honolulu 1994

Welck, Karin von/Alfred Wieczorek: *Die Verbotene Stadt*. Munich 1997

Whitfield, Roderick: *Caves of the Thousand Buddhas*. London 1990

Wickede, Barbara v.: Architektur der Hauptstadt Xianyang. In: Lothar Ledderose/Adele Schlombs (ed.): *Jenseits der Großen Mauer*. Gütersloh – Munich 1990, pp. 190–198

Wiesner, Ulrich: *Chinesisches Porzellan*. Mainz 1981

Wiesner, Ulrich (ed.): *Herbstmond über der Tauterrasse*. Cologne 1990

Wilhelm, Richard: *Chinesische Märchen*. Cologne 1958

Wilhelm, Richard: *Li Gi. Das Buch der Riten*. Cologne 1981

Williams, Charles Arthur Sowerby: *Outlines of Chinese Symbolism and Art Motives*. Shanghai 1932

Wolter, Gustav-Adolf: *China-Spiegel*. Herford 1978

Wu, Hong: *Buddhist Elements in Early Chinese Art (2nd and 3rd Centuries A. D.)*. In: AA 47/3–4, 1987, pp. 263–315

Wu, Hong: *Art in a Ritual Context: Rethinking Mawangdui*. In: Early China 17, 1992, pp. 111–144

Wu, Hong: *The Double Screen, Medium and Representation in Chinese Painting*. London 1996

Wu, Yangmu: *The Techniques of Chinese Painting*. London 1990

Yang, Hongxun: Eine 900 Jahre alte Pagode. In: Institut für Geschichte der Wissenschaften (ed.): *Wissenschaft und Technik im alten China*. Basle 1989

Yang, Xizhang: The Shang Dynasty Cemetery System. In: Chang Kwang-chih: *Studies of Shang Archaeology*. New Haven – London 1986, pp. 49–63

Yu, Zhuoyun: *Die Paläste der Verbotenen Stadt*. Hong Kong 1988

Zheng, Zhenxiang: Fu Hao – eine königliche Gemahlin und ihre letzte Ruhestätte. In Kulturstiftung Ruhr (ed.): *Das Alte China*. Munich 1995, pp. 106–114

Periodicals

AA, Artibus Asiae, Ascona – New York (Engl.)

Art Bulletin (general art periodical, Engl.)

Arts Asiatiques (art periodical on East Asian art, Fr./Engl.)

BMFEA, Bulletin of the Museum of Far Eastern Antiquities, Stockholm (Engl.)

Bulletin of the School of Oriental and African Studies, London (Engl.)

Gugong jikan (bulletin of the Palace Museum, Chin.)

Gu jian yuanlin jishu (Techniques of traditional architecture and garden art, Chin.)

HJAS, Harvard Journal of Asian Studies (gen. research on Asian subjects, Engl.)

Kaogu (archaeological periodical, Chin.)

National Palace Museum Bulletin, Taipeh (Chin.)

Orientations (East Asian periodical, Engl.)

Weltkunst (gen. art history subjects, Ger.)

Wenwu (periodical about cultural treasures, Chin.)

Wenwu yu kaogu (quarterly dealing with cultural and archaeological subjects, Chin.)

Calligraphy

Arts from the Scholar's Studio. The Oriental Ceramic Society of Hong Kong and the Fung Ping Shan Museum, University of Hong Kong 1986

Chinese Calligraphy. Shanghai Museum. Shanghai 1997

Hickman, Money (ed.): *Japan's Golden Age. Momoyama*. Yale University Press, New Haven 1996

Ledderose, Lothar: *Chinese Calligraphy: Its Aesthetic Dimension and Social Function*. In: Orientations magazine, October 1986, pp. 35–50

Nakata, Yujiro: *Chinese Calligraphy*. Tankosha 1983

Rawson, Jessica (ed.): *Mysteries of Ancient China*. British Museum. New York 1996

Rosenfield, John, et al.: *The Courtly Tradition in Japanese Art & Literature*. Fogg Art Museum, Harvard University, Cambridge/Mass. 1973

Shimizu, Yoshiaki/John Rosenfield: *Masters of Japanese Calligraphy. 8th–19th century*. Japan House Gallery & The Asia Society Galleries. New York 1984–1985

Sogen, Omori/Terayama Katsujo: *Zen & the Art of Calligraphy*. London 1983

Stevens, John: *Sacred Calligraphy of the East*. Boulder – London 1981

Yue Ma, et al.: *Xi'an. Legacies of Ancient Chinese Civilization*. Peking 1997

Jade

Burkart-Bauer, Marie-Fleur: *Chinesische Jaden aus drei Jahrtausenden*. Museum Rietberg, Zürich 1986

Childs-Johnson, Elizabeth: *Ritual & Power: Jades of Ancient China*. China Institute in America. New York 1988

Chinese Jade. Exhibition catalog, London 1991

Chinese Jade throughout the Ages. Victoria & Albert Museum. London 1974

Chinese Jades. Archaic & Modern from the Minneapolis Institute of Arts. Tokyo 1977

Dr. Newton's Zoo. A Study of Post-Archaic Small Jade Carvings. London 1981

Forsyth, Angus/Brian McElney: *Jades from China*. Museum of East Asian Art. Bath 1994

Hansford, S. Howard: *Chinese Carved Jades*. London 1968

Hung, Wu/Brian Morgan: *Chinese Jades from the Mu-Fei Collection*. London 1990

Jade – a Traditional Chinese Symbol of Nobility of Character. National Museum of History. Taiwan

Keverne, Roger (ed.): *Jade*. London 1991

Laufer, Berthold: *Jade. A Study in Chinese Archaeology & Religion*. New impression, New York 1974

Loehr, Max: *Ancient Chinese Jades*. Fogg Art Museum, Harvard University. Cambridge/Mass. 1975

Nott, Stanley Charles: *Chinese Jade throughout the Ages*. Tokyo 1972

Smith, Bradley/Weng Wan-go: *China. A History in Art*. London 1973

Watt, James C. Y.: *Chinese Jades from Han to Ch'ing*. Asia Society 1980

Wills, Geoffrey: *Jade of the East*. New York 1972

Yee, Ip: *Chinese Jade Carving*. Hong Kong Museum of Art. Hong Kong 1983

Indonesia

Appel, Michaela/Rose Schubert et al.: *Borneo. Leben im Regenwald*. Öttingen 1995

Baum, Vicki: *Liebe und Tod auf Bali*. Cologne 1984 (1937)

Bhavnani, Enakshi: *The Dance in India. The Origin and History, Foundations, the Art and Science of the Dance in India-Classical, Folk and Tribal*. Bombay 1965

Boeles, Jan J.: *The Secret of Borobudur*. Bangkok 1985

Brakel-Papenhuyzen, Clara: *Character Types and Movement Styles in Traditional Javanese Theatre*. In: Ben Arps: *Performance in Java and Bali. Studies of Narrative, Theatre, Music, and Dance*. London 1993, pp 59–71

Brakel-Papenhuyzen, Clara: *Classical Javanese Dance. The Surakarta Tradition and its Terminology*. Leiden 1995

Brakel-Papenhuyzen, Clara: *The Sacred Bedhaya Dances of the Kratons of Surakarta and Yogyakarta*. Leiden 1988

Bussagli, Mario: *Indien. Indonesien. Indochina*. Translated by M. Stahlberg. Stuttgart 1985 (1981)

Buurman, Peter: *Wayang Golek. The Entrancing World of Classical West Javanese Puppet Theatre*. Singapore 1991

Carsten, Jane/Stephen Hugh-Jones: *About the House. Lévi-Strauss and Beyond*. Cambridge 1995

Chihara, Daigoro: *Hindu-Buddhist Architecture in Southeast Asia*. Leiden 1996

Clara van Groenendael, Victoria: *The Dalang Behind the Wayang. The Role of the Surakarta and the Yogyakarta Dalang in Indonesian-Javanese Society.* Dordrecht 1985

Clara van Groenendael, Victoria: *Wayang Theatre in Indonesia. An Annotated Bibliography.* Dordrecht 1987

Dawson, Barry/John Gillow: *The Traditional Architecture of Indonesia.* London 1994

Dumarcay, Jacques: *Histoire de l'architecture de Java.* Paris 1993

Eggebrecht, Arne/Eva Eggebrecht (ed.): *Versunkene Königreiche Indonesiens.* Mainz 1995

Fox, James J.: Comparative Perspectives on Austronesian Houses: An introductory essay. In: James J. Fox (ed.): *Inside Austronesian Houses.* Canberra 1993, pp. 1–29

Freeman, Derek: *Report on the Iban.* London 1970

Funke, Friedrich W.: *Dämmerung über Indonesien. Streifzüge durch Sumatra, Java, Bali und Celebes.* Bremen 1959

Geertz, Hildred: *State and Society in Bali.* Leiden 1991

Guémenée, Armand de: Das Schattentheater von Java und Bali. In: *Ich werde deinen Schatten essen. Das Theater des Fernen Ostens.* Berlin 1985, pp. 27–38

Hall, D. G. E.: *A History of South-East Asia.* 4th impression., London 1981

Hall, Kenneth R.: *Maritime Trade and State Development in Early Southeast Asia.* Honolulu 1985

Hatley, Barbara: *Ketoprak Theatre and the Wayang Tradition.* Melbourne 1979

Heine-Geldern, Robert: *Weltbild und Bauform in Südostasien.* In: Wiener Beiträge zur Kunst- und Kulturgeschichte Asiens. Vienna 1930

Helfritz, Hans: *Indonesien. Ein Reisebegleiter nach Java, Sumatra, Bali und Sulawesi.* Cologne 1978

Hobert, Angela/Urs Ramseyer/Albert Leemann: *The Peoples of Bali.* Oxford 1996

Holt, Claire: *Art in Indonesia. Continuities and Change.* Ithaca 1967

Hooker, Virginia (ed.): *Culture and Society in New Order Indonesia.* Kuala Lumpur 1993

Jessup, Helen Ibbitson: *Court Arts of Indonesia.* New York 1990

Kampffmeyer, Hanno: *Die Langhäuser von Zentral-Kalimantan.* Munich 1991

Kats, J.: *Het Javaansche Tooneel.* Vol. I: Wayang Poerwa. De Commissie voor de Volkslectuur. Weltevreden 1923

Kis-Jovak/Jowa Imre Nooy-Palm et al.: *Banua Toraja. Changing Patterns in Architecture and Symbolism among the Sa'dan Toraja.* Sulawesi – Amsterdam 1988

Klokke, Marijke J.: Die Kunst Indonesiens. In: Girard-Geslan, Mand et al.: *Südostasien. Kunst und Kultur.* Freiburg – Basle – Vienna 1995

Kuhnt-Saptodewo, Sri/Hanno Kampffmeyer: *Fluß des geliehenen Lebens. Begleitpublikation zum Film.* IWF. Göttingen, unpubl.

Kuhnt-Saptodewo, Sri: *Zum Seelengeleit bei den Ngaju am Kahayan. Auswertung eines Sakraltextes zur Manarung-Zeremonie beim Totenfest.* Munich 1993

Kulke, Hermann: *Kings and Cults: State Formation and Legitimisation in India and Southeast Asia.* New Delhi 1993

Leemann, Albert: *Bali. Insel der Götter.* Innsbruck 1979

Leigh-Theisen, Heide: *Der Südostasiatische Archipel. Völker und Kulturen.* Vienna 1985

Lévi-Strauss, Claude: The Concept of 'House'. In: *Anthropology and Myth.* Oxford 1987, pp. 153–159

Miettinen, Jukka O.: *Classical Dance and Theatre in South-East Asia.* Singapore 1992

Ng, Cecillia: *Raising the House Post and Feeding the Husband-Givers: The Spatial Categories of Social Reproduction among the Minangkabau.* In: James J. Fox (ed.): *Inside Austronesian Houses.* Canberra 1993, pp. 116–139

Pigeaud, Theodor G. Th.: *Literature of Java.* Vol. I: Synopsis of Javanese literature 900–1900 A. D. Catalogue Raisonné of Javanese manuscripts in the library of the University of Leiden and other public collections in the Netherlands. The Hague 1967

Poerbatjaraka: *Pandji-verhalen onderling vergeleken.* Bandung 1940

Rassers, W. H.: *De Panji-roman.* Leiden 1922

Rawson, Philip: *The Art of Southeast Asia. Cambodia, Vietnam, Thailand, Laos, Burma, Java, Bali.* London 1967

Rebling, Eberhard: *Die Tanzkunst Indonesiens.* Wilhelmshaven 1989

Rein, Anette: *Tempeltanz auf Bali. Rejang – der Tanz der Reiseseelen.* Hamburg 1994

Sather, Clifford: Posts, Hearths and Thresholds: The Iban Longhouse as a Ritual Structure. In: James J. Fox (ed.): *Inside Austronesian Houses.* Canberra 1993, pp. 64–115

Schärer, Hans: *Die Gottesideen der Ngadju Dajak in Süd-Borneo.* Leiden 1946

Schneider, Peter: *Geschichte des Wayang Purwa (Mahabharata) für Schattenspiel (Wayang Kulit).* Göttingen 1996

Schubert, Rose: Das Menschentheater von Java und Bali. In: *Ich werde deinen Schatten essen. Das Theater des Fernen Ostens.* Berlin 1985, pp. 45–62

Schubert, Rose: Das Repertoire des indonesischen Theaters Ramayana, Mahabharata und Panji-Zyklus. In: *Ich werde deinen Schatten essen. Das Theater des Fernen Ostens.* Berlin 1985, pp. 21–24

Sears, Laurie J.: *Shadows of Empire. Colonial Discourse and Javanese Tales.* London 1996

Sedyawati, Edi: The Dramatic Principles of Javanese Narrative Temple Reliefs. In: Ben Arps: *Performance in Java and Bali. Studies of Narrative, Theatre, Music, and Dance.* London 1993, pp. 174–185

Sellato, Bernard: *Hornbill and Dragon.* Jakarta 1989

Sibeth, Achim: *Mit den Ahnen leben. Batak. Menschen in Indonesien.* Stuttgart 1990

Snodgrass, Adrian: *The Symbolism of the Stupa.* New York 1985

Soedarsono: *Wayang Wong. The State Ritual Dance Drama in the Court of Yogyakarta.* Yogyakarta 1984

Spitzing, Günter: *Das indonesische Schattenspiel. Bali – Java – Lombok.* Cologne 1981

Spitzing, Günter: *Bali. Tempel, Mythen und Volkskunst auf der tropischen Insel zwischen Indonesien und Pazifischem Ozean.* Cologne 1983

Stutterheim, Willem: *Rama-Legenden und Rama-Reliefs in Indonesien.* Vols I and II, trsl. by Karl and Hedwig Döhring. Munich 1925

Sutlive, Vinson H.: *The Iban of Sarawak. Chronicle of a Vanishing World.* Illinois 1978

Taylor, Paul M./Lorraine V. Aragon: *Beyond the Java Sea. Art of Indonesia's Outer Islands.* New York 1991

Thomas, Lynn (ed.): *Chance and Continuity in Minangkabau: Local, Regional, and Historical Perspectives on West Sumatra.* Ohio 1985

van Reenen, Joke: *Central Pillars of the House. Sisters, Wives and Mothers in a Rural Community in Minangkabau.* West Sumatra – Leiden 1996.

Wagner, Frits: *Indonesien. Die Kunst eines Inselreiches.* Baden-Baden 1959

Wälty, Samuel: *Kintamani. Dorf, Land und Rituale. Entwicklung und institutioneller Wandel in einer Bergregion auf Bali.* Zürich 1997

Waterson, Roxana: *The Living House. An Anthropology of Architecture in South-East Asia.* Singapore 1990

Wilpert, Clara B.: *Schattentheater.* Hamburgisches Museum für Völkerkunde. 3rd impression, Hamburg 1982

Wirz, Paul: *Der Totenkult auf Bali.* Stuttgart 1928

Champa

Boisselier, Jean: *La statuaire du Champa, recherches sur les cultes et l'iconographie.* Paris 1963

Det Socia-Kulturelle Institute Campa Danmark et France: *Actes du seminaire sur le Campa.* Paris 1988

École Française d'Extrême-Orient: *Kerajaan Campa (Die Reiche der Champa).* Jakarta 1981

Lafont, Philippe: Tinjauan sepintas sejarah bangsa Cam dari Abad XVI sampai dengan Abad XX (Survery of the History of the Cham from 16th–20th centuries). In: École Française d'Extrême-Orient: *Kerajaan Campa.* Jakarta 1981, pp. 71–80

Le Bonheur, Albert: Kunst Champa. In: Girard-Geslan, Mand et al.: *Südostasien. Kunst und Kultur.* Freiburg – Basle – Vienna 1995, p. 7

Majumdar, Ramesh: *Ancient Indian Colonies in the Far East.* I. Champa. Delhi 1927

Mus, Paul: *India Seen from the East: Indian and Indigenous Cults in Champa.* Monash 1975 (1933)

Stern, Ph.: Hubungan seni rupa Cam dengan seni asing serta masalah penanggalan dalam seni rupa Cam (The interaction between Cham art, foreign influences on it and the dating of artefacts). In: École Française d'Extrême-Orient: *Kerajaan Campa.* Jakarta 1981

Unger, Ann/Walter Unger: *Götter, Geister und Pagoden.* Munich 1997

Wulf, Annaliese: *Pagoden und Tempel im Reisfeld – im Fokus chinesischer und indischer Kultur.* 2nd impression, Cologne 1995

Picture Credits

(tp=top, bm=bottom, rt=right, lf=left, cn=center)

The Art Institute of Chicago: Photo: Michael Tropea p. 327 lf; p. 341 lf; p. 341 rt

© Axiom, London: Photo: Gordon D. R. Clements p. 257 bm, lf; Photo: Jim Holmes p. 209 tp, lf; p. 363 rt; p. 340; Photo: Mikihiko Ohta p. 329; p. 337

Bayrische Verwaltung der staatlichen Schlösser, Gärten und Museen: p. 13 bm

Suse Becker, Frankfurt a. M.: p. 132 rt

from: E. Bhavnani "The Dance in India," Bombay 1965: p. 376

Bildarchiv Preußischer Kulturbesitz, Berlin: p. 65 tp, rt; p. 224 rt; Photo: Stüning p. 40; p. 65 lf; p. 65 bm; p. 128; p. 159 tp; p. 183; p. 194; p. 195 bm; p. 199; p. 228 rt; p. 231 cn, p. 232; p. 265 rt; Photo: Niedermeier p. 179 tp; p. 222 lf; p. 226; p. 233 cn; p. 249; p. 251 bm; p. 257 tp; p. 257 bm, rt; p. 264 tp; Photo: D. Graf p. 202 tp; p. 202 bm; p. 213 tp, lf; p. 222 tp, lf; p. 245 lf; p. 245 rt; p. 246 tp; p. 246 bm; p. 247 lf; p. 247 rt; Photo: Liepe p.107 tp, lf; p. 139 tp; p. 169 bm; p. 170 tp; p. 178 bm

Dr. Boesken & Partner, Hamburg: p. 69 bm; p. 121; p. 270 bm; p. 272 bm, rt; p. 285 tp; p. 310

© British Museum, London: p. 21 tp, lf; p. 26; p. 33 bm, rt; p. 49 rt; p. 56; p. 59 bm; p. 62 tp, rt; p. 100; p. 102; p. 107 bm; p. 108 tp; p. 109; p.110 tp; p.110 bm; p. 111 lf; p.111 rt; p. 112; p. 113; p. 116 bm; p. 160; p. 178 tp, rt; p. 186 rt; p. 228 lf; p. 231 cn, bm; p. 231 bm

from: Z. F. Chen "China: Prähistorische Felsbilder," Editoriale Jaca Book Spa., Milano 1987: p. 17 tp; p. 17 bm, lf; p. 17 rt

from: D. Chihara "Hindu-Buddhist Architecture in Southeast Asia," Leiden 1996: p. 325 lf; p. 325 rt; p. 327 rt; p. 328 tp, lf; p. 330 cn; p. 330 bm; p. 335 cn, lf

Christie's, London: p. 12 rt; p. 190

from: C. Clunas "Art in China," Oxford 1997, by kind permission of Oxford University Press: p. 193

from: "Contakt" 4. No. 19, Jakarta, October 1996: Photo: Didi Nini Thowok Collection/Anneke Senduk p. 384 tp, lf

© Cultural Relics Publishing House, Beijing: 19 tp; p. 20 bm, rt; p. 21 tp, rt; p. 21 bm; p. 22 tp, lf; p. 22 rt; p. 22 bm; p. 23; p. 24 tp, rt; p. 24 bm; p. 25; p. 28; p. 29; p. 30; p. 31 cn; p. 41; p. 42; p. 47 lf; p. 47 rt; p. 50; p. 51 lf; p. 51 rt, tp; p. 51 rt, bm; p. 52 tp; p. 53; p. 54 bm; p. 55 bm; p. 58 tp; p. 78 bm, lf; p. 81 tp; p. 82; p. 83 tp; pp. 84–85; p. 87 bm; p. 91 bm; p. 92 tp; p. 95 rt; p. 96 bm; p. 104 tp, lf; p. 104 tp, rt; p. 105 lf; p. 106 rt; p. 107 tp, rt; p. 117; p. 120; p. 127; p. 132 lf; p. 136 rt; p. 139 bm, rt; p. 145 lf; p. 145 rt; p. 145 bm; pp. 152–153 tp; p. 153 bm; p. 159 bm; p. 171 rt; p. 174 bm; p. 175; p. 177 lf; p. 177 rt; p. 178 tp, lf; p. 188; p. 217 bm

from: Chihara Daigoro "Hindu-Buddhist-Architecture in Southeast Asia," Leiden 1996: p. 325 lf; p. 325 rt; p. 327 rt; p. 328 tp, lf; p. 330 cn; p. 330 bm; p. 335 cn, lf

Alexander Dea: p. 371 tp; p. 371 cn; p. 371 bm; p. 381; p. 382; p. 383

Eko Djakaria, Jakarta: p. 384 rt, tp; p. 384 rt, cn; p. 384 rt, bm

© By courtesy of Eskenazi Limited, London: p. 27 tp

from: exhibit. cat. "Kunstschätze aus China," Zurich 1980, © 1998 by Kunsthaus Zürich: p. 32 lf; p. 129

from: exhibit. cat. "Legacy and Culture of the Champa Kingdom," Toyota Zaidan Foundation, Tokyo 1994: p. 392 tp, lf

from: exhibit. cat. "Das alte China," Essen 1996, Hirmer Verlag, Munich/© Cultural

Relics Publishing House, Beijing: p. 20 tp; p. 31 bm; p. 84 bm; p. 91 bm

from: K. Finsterbusch "Verzeichnis und Motivindex der Han-Darstellungen," Verlag Otto Harrassowitz, Wiesbaden 1971: p. 83 bm; p. 86 tp; p. 86 bm

Astrid Fischer-Leitl, Munich: p. 17 bm, lf; p. 44; p. 80; p. 81 bm; p. 343 bm; p. 389 tp; p. 389 bm, lf; p. 389 bm, rt

from: J. J. Fox "Inside Austronesian Houses," The Australian National University, Canberra 1993: p. 315 bm, lf; p. 319 cn; p. 319 bm

© Freer Gallery, Washington D.C.: p. 185 tp; p. 231 tp

from: W. H. Furness "The Home-Life of Borneo Headhunters," Philadelphia 1902: p. 354 tp

© Dr. G. Gerster/Anne Hamann Agency, Munich: p. 101; p. 104 bm; pp. 196–197; p. 209 tp, rt; p. 251 tp; p. 253 tp; p. 328 cn, lf; p. 339 bm, lf

Johnny Hendarta, Jakarta: p. 385 tp

© Hatakeyama Collection, Tokyo: p. 266; pp. 280–281 tp; p. 281 bm; p. 283

© HB-Verlag, Hamburg: p. 46; p. 210 tp, lf; p. 235 rt; p. 236 cn, tp; p. 236 cn, bm; p. 238 cn; p. 254 tp; p. 255; p. 256 tp; p. 263 tp, rt

Sabine Hesemann, Egelsbach: p. 13 bm; p. 49 bm; p. 114; p. 115 cn; p. 115 bm; p. 133 bm, r; drawing p. 172; p. 205 lf; p. 205 re tp; p. 205 cn, rt; p. 206 tp, lf; p. 206 tp, rt; p. 207 bm, rt; p. 208 bm; p. 210 tp, rt; p. 211 tp; p. 211 cn; p. 211 bm, lf; p. 211 bm, rt; p. 212 lf; p. 212 rt; p. 213 bm; p. 222 bm; p. 223 tp; p. 235 bm, lf; p. 236 tp, rt; p. 236 bm; p. 237 tp; p. 237 bm; p. 238 bm, lf; p. 238 bm, rt; p. 239 tp, lf; p. 239 tp, rt; p. 253 bm; p. 254 cn; p. 256 bm; p. 262 tp; p. 263 bm

© Hiroji Kubota/Magnum Photos: p. 103; p. 205 bm, rt

Hong Kong Museum of Art: p. 260 tp; p. 260 bm; p. 261 tp

Hopp Ferenc Kelet-Ázsiai Múzeum, Budapest: p. 234 rt

from: C. Hornung "Traditional Japanese Stencil Design," London 1985, © by Dover Publications Inc.: endpapers

Hanno Kampffmeyer, Haunstetten: p. 314; p. 315 tp; p. 316 tp; p. 316 bm; p. 343 tp, lf; p. 343 tp, rt; p. 344 tp; p. 347 tp, lf; p. 347 tp, rt; p. 347 cn; p. 347 bm; p. 348; p. 349 tp; p. 349 cn; p. 350; p. 351; p. 352; p. 380

Thomas Kindling, Munich: p. 125 rt

© Collection of J. E. V. M. Kingado: Photo: Dimitri Skliris p. 279; p. 282 lf; p. 282 cn; p. 282 rt; p. 284 lf; p. 284 rt; p. 285 (detail of p. 284 lf); p. 286 tp; p. 287

from: J. I. Kis-Jovak/Nooy-Palm et al. "Banua Toraja," Amsterdam 1988: p. 322 (drawing: Jova Imre Kis-Jovak)

© Könemann Verlagsgesellschaft mbH/ Günter Beer: p. 355 tp, rt; pp. 356/357

Jochen Konrad, Wiesenfeld: p. 393 rt; p. 394

© BIM/Helga Lade Photo Agency, Frankfurt a. M.: p. 79

Landesmuseum, Kassel: Photo: Ute Brunzel p. 218; p. 219 lf; p. 221; p. 241 tp; p. 241 bm, lf; Photo: Arno Hensmann, Gabriele Bößert p. 219 rt; Lindenmuseum, Stuttgart: p. 96 tp, lf; Photo: U. Didoni p. 18 tp; p. 19 bm; p. 116 tp; p. 214 bm, lf

Robert Lohbrunner, Munich: p. 355 tp, lf; p. 355 tp, rt; p. 390 lf; p. 390 rt; p. 391 tp, lf; p. 391 tp, rt; p. 391 bm; p. 392 tp, cn; p. 392 tp, rt; p. 396 rt; p. 397

Daniel Schwartz/Lookat, Zurich: p. 48 lf; p. 48 rt; p. 49 lf; p. 60; p. 62 tp, lf; p. 63; p. 69 tp; pp. 70–71; p. 72; p. 73 lf; p. 73 rt; p. 74 tp, rt; p. 74 tp, lf; p. 74 bm; p. 75; p. 76; p. 77; p. 78 lf; p. 78 rt; p. 88 bm, lf

Lotos-Film, Kaufbeuren: p. 11 rt, cn; p. 57; p. 62 bm; p. 88 tp, lf; p. 90; p. 92 rt, p. 93 bm; p. 94; p. 95 lf; p. 96 cn; p. 139 bm, lf

Thomas Mika, Langen: p. 264 bm

Rita Mühlbauer, Munich: (illustrations) p. 359 lf (x 4); p. 363 bm, cn

Michaela Müller, Dingolfing: p. 370;

Museum of Asiatic Art, Amsterdam: p. 233 rt

Musée Cernuschi, Paris: Photo: L. Degraces p. 35; Photo: Patrick Pierrain p. 96 tp, rt

Museum of Far Eastern Art, Bath: p. 288; p. 292 tp; p. 292 bm; p. 294 tp, lf; p. 294 tp, cn; p. 294 tp, rt; p. 294 bm; p. 295; p. 296 lf; p. 296 rt; p. 298 tp, lf; p. 298 rt; p. 299 tp, lf; p. 299 tp, cn; p. 299 tp, rt; p. 300 rt; p. 301 lf; p. 302 tp; p. 303; p. 304 tp; p. 304 bm (detail of p. 304 tp); p. 305 lf; p. 305 tp, rt; p. 305 bm, rt; p. 306 tp; p. 307 lf; p. 307 rt; p. 310 lf; p. 310 rt; p. 311 rt; p. 311 lf (detail of p. 311 rt)

Museum für Kunsthandwerk, Frankfurt: p. 225 tp; p. 225 bm; p. 244 tp

Museum of Jingzhou Region and Hubei Province: p. 25 tp; p. 25 bm, lf; p. 25 bm, rt

Museum Rietberg, Zurich: Photo: Wolfsberger p. 203; Photo: Wettstein/Kauf p. 229

Naprstek Museum, Prague: Photo: Jiri Vanek p. 227

National Gallery, Prague: Photo: Oto Palán p. 201 bm; p. 230; p. 258 lf; p. 258 rt; p. 259

National Geographic Society/Image Collection, Washington: Photo: O. Louis Mazzatenta p. 68; Photo: Todd Gipstein p. 89 bm

© National Museum of Denmark: Photo: Kit Weiss p. 45

from: N. N. "Kurze Geschichte der chinesischen Architektur," Beijing 1962: p. 133 tp; p. 133 bm, lf; p. 134 bm, lf; p. 179 bm; p. 204 tp; p. 208 tp; p. 210 bm; p. 236 tp, lf

from: N. N. "Ostasiatische Schriftkunst," Museum für Ostasiatische Kunst SMBPK, Berlin 1981: p. 149 bm; p. 151

from: N. N. "Dong Son Drums in Viet Nam," no place of publication, 1990: p. 315 tp, lf

© Palace Museum, Beijing: p. 10; p. 116 tp; pp. 118–119; p. 124 bm; p. 126 bm; pp. 140–143; p. 146, p. 147 tp; p. 147 bm; p. 148; p. 150; p. 154; p. 155; p. 156; pp. 166 tp–169 tp; pp. 200 tp–201 tp; p. 200 bm

© Palace Museum, Taipei: p. 149; p. 157; p. 161; p. 162; p. 163; p. 166 bm; p. 170 bm; p. 180; p. 181; p. 182; p. 184; p. 185 bm; p. 186 lf; p. 187; p. 250

By courtesy of the Percival David Foundation of Chinese Art, London: p. 172 tp; p. 173 tp, lf; p. 173 bm, rt; p. 174 tp, lf; p. 174 tp, rt; p. 189; p. 214 tp; p. 215 rt; p. 216 lf; p. 216 tp, rt; p. 216 bm; p. 217 tp; p. 220; p. 241 bm, rt; p. 242 rt

Porzellansammlung Dresden: p. 138 lf; p. 138 rt; p. 144 rt

© Private collection: Photo: A. C. Cooper, London: p. 297; p. 300 lf; p. 301 tp, rt; p. 301 bm (detail); p. 302 bm; p. 306 bm; p. 308; p. 309

© Private collection: Photo: Roberto Paltrinieri, Cadro: p. 278

© Rheinisches Bildarchiv, Cologne: p. 32 bm; p. 33 bm, rt; p. 34; p. 37 tp; p. 38 tp; p. 38 bm; p. 39; p. 91 tp; p. 122 lf; p. 122 rt; p. 124 tp; p. 130; p. 131; p. 165 tp; p. 165 bm; p. 192; p. 198; p. 234 lf; p. 248; p. 269

© Rijksmuseum voor Volkenkunde, Leiden: Photo: Ben Grishaaver, p. 27 bm, lf

Robert Harding Picture Library, London: p. 106 tp, lf; p. 134 tp; p. 134 bm, rt; p. 135 tp; p. 135 bm

Roemer & Pelizaeus Museum, Hildesheim: Photo: Sh. Shalchi p. 11 bm; p. 163 tp; p. 242 lf

from: A. Rolf "Kleine Geschichte der chinesischen Kunst", © 1985 by DUMONT Buchverlag, Cologne: p. 115 tp; p. 204 tp

Filippo Salviati, Rome: p. 290 bm; p. 291 lf; p. 291 rt

Franz Schertel, Passau: p. 312; p. 320 lf; p. 320 rt; p. 321; p. 323; p. 326; p. 330 tp; p. 330 tp; p. 331 bm; p. 332; p. 333; p. 334; p. 335 bm, rt; p. 338 tp; p. 338 bm; p. 339 tp; p. 339 bm, rt; p. 355 bm, rt; p. 369 tp; p. 369 bm; p. 378 lf; p. 378 rt; p. 386; p. 388; p. 392 bm; p. 393 lf; p. 395 tp; p. 395 bm; p. 396 lf

Petra Schweiger, Ingolstadt: p. 317; pp. 318–319; p. 319 tp, rt; p. 324; p. 335 tp; p. 367; p. 373 tp; p. 373 bm

© Shanghai Museum: p. 270; p. 271; p. 272; p. 273 tp; p. 273 bm; pp. 274–275; p. 276 lf; p. 276 rt; p. 277 tp (detail of p. 276 lf); p. 277 bm (detail of p. 276 rt); p. 293 tp; p. 293 bm (detail of tp)

Fendi Siregar, Jakarta: p. 385 bm, lf; p. 385 bm, rt

© Sotheby's, London: p. 43; p. 139 bm, cn

Staatliches Museum für Völkerkunde, Dresden: Photo: Eva Winkler p. 98; p. 144 lf; p. 215 tp, lf

Staatliches Museum für Völkerkunde, Munich: p. 14; Photo: S. Autrum-Mulzer p. 20; p. 27 bm, rt; p. 36; p. 54 tp; p. 55 tp; p. 61; p. 66; p. 87 tp; p. 88 rt; p. 89 tp; p. 93 tp; p. 105 rt; p. 136 lf; p. 137 tp; p. 137 bm, lf; p. 137 bm, rt; p. 158 tp; p. 173 tp, cn; p. 206 bm; p. 207 tp; p. 223 bm, lf; p. 224 lf; p. 233 lf; p. 239 bm, lf; p. 239 bm, rt; p. 240; p. 243 lf; p. 243 rt; p. 244 bm; p. 342; p. 344 bm, lf; p. 344 bm, rt; p. 345 lf; p. 345 cn; p. 345 rt; p. 346; p. 353; p. 354 bm; p. 358 lf; p. 358 rt; p. 359 lf; p. 359 rt; p. 360 lf; p. 360 rt; p. 361; p. 362 lf; p. 362 rt; p. 363 lf; p. 364 lf; p. 364 rt; p. 365; p. 366; p. 368 lf; p. 368 rt; p. 372; p. 374 and frontispiece of Vol. I; p. 375; Photo: M. Weidner-El Salamouny p. 164; p. 195 tp; p. 222 tp, rt; p. 223 bm, rt

Stiftung für Kunst und Kultur e.V, Bonn: Photo: Norbert Faehling p. 252; p. 261 bm; p. 262 bm; p. 263 tp, lf

Peter Thiele, Stuttgart: p.106 bm, lf; p. 108 bm

from: T. Thilo "Klassische chinesische Baukunst," © Köhler & Amelang, Vienna 1977: p. 209

© Tokyo National Museum, Tokyo: p. 290 tp

from: M. Tregear "Chinese Art," © Thames and Hudson Ltd, London 1997: p. 18 bm

Monika Uhl, Waghäusel: p. 207 bm, lf; p. 254 bm; p. 265 lf

Rolf Krause, Essen: diagram p. 167 bm

© Victoria & Albert Museum, London: p. 158 bm; p. 171 bm; p. 213 tp, rt; p. 214 cn, rt

from: R. Violet "Einführung in die Kunst Chinas," E. A. Seemann Verlag/ © Dornier Medienholding, Leipzig 1981: p. 58 bm

from: B.A.G. Vroklage "Das Schiff in den Megalithenkulturen Südostasiens und der Südsee," in : Anthropos, 31, 1936: p. 315 bm, rt

Yunnan Provincial Museum: p. 64; p. 97 tp, lf; p. 97 bm, lf; p. 97 rt; p. 99